BERNARD BERENSON · THE MAKING OF A LEGEND

BERNARD BERENSON
The Making of a Legend

ERNEST SAMUELS

with the collaboration of Jayne Newcomer Samuels

THE BELKNAP PRESS OF HARVARD UNIVERSITY PRESS

CAMBRIDGE, MASSACHUSETTS, AND LONDON, ENGLAND

1987

This book is printed on acid-free paper, and its binding materials
have been chosen for strength and durability.

Library of Congress Cataloging-in-Publication Data

Samuels, Ernest, 1903–
Bernard Berenson, the making of a legend.

Bibliography: p.
Includes index.
1. Berenson, Bernard, 1865–1959. 2. Art critics—
United States—Biography. I. Samuels, Jayne. II. Title.
N7483.B47S36 1987 709'.2'4 [B] 86-26447
ISBN 0-674-06779-7 (alk. paper)

To Benjamin, Jacob, and Michael

Contents

CONTENTS

CONTENTS

Credits

Special thanks are extended to the following for providing photographs and for granting permission to reproduce them: Harvard University (for the Harvard University Center for Italian Renaissance Studies), 1, 2, 3, 5, 6, 8, 9, 10, 11, 12, 13, 14, 21, 22, 23, 24, 25, 26, 30, 32, 33, 34, 35, 36, 37, 38, 39. Isabella Stewart Gardner Museum, 27. Beinecke Library, Yale University, 28, 29. Massachusetts Historical Society, 4. National Gallery of Art, 18, 19, 31. Smith papers, 7, 15, 16, 17, 20.

Preface

IT IS NOW more than a quarter century since the death of Bernard Berenson and one hundred and twenty-one years since his birth in the Pale of Settlement at Butrimonys in Lithuania, ample time for legend and myth to flourish unhampered by sober fact. In his eighty-third year Berenson wrote that he had become the subject not of one myth but of two, "a kindly flattering one" and one that was "hostile" and "damaging." It was the kindly myth which chiefly colored his late years. The worldwide adulation that marked his ninetieth birthday in 1955 was indeed astonishing, and, though he tried to enjoy it, it wearied even his resilient nature. Today the reaction of a more cynical age has brought to the fore iconoclasts who have promoted the hostile myth amid a cloud of rumors and conjectures.

It is the aim of this volume to cut through accumulated myths and legends to reach the truth which they have obscured. We have not attempted a systematic refutation of the accusations that have recently been made against Berenson; their falsity in key episodes is revealed in the documented narrative we tell. A word, however, is in order about the assertion that Berenson on occasion changed the attributions of paintings to facilitate their sale. These charges do not stand up under dispassionate scrutiny, for they are made in ignorance of the nature and history of connoisseurship or in willful perversion of the truth. Art-historical knowledge about the Italian painters steadily advanced during the years in which Berenson worked, in part through his own researches. Moreover, scientific techniques that were developed during and since his lifetime have advanced the degree of accuracy with which attributions can be made. Berenson himself repeatedly emphasized in his writings the tentative nature of all attributions. In the preface to the 1932 edition of *Italian Pictures of the Renaissance* he wrote: "Even unquestioned attribu-

tions are not trademarks, although collectors and dealers would like them to be. They are stepping-stones rather than goals." The truth of that statement is fully exhibited in the growing number of museum catalogues that record the successive changes of attributions of many Old Masters. Although Berenson often overpraised pictures, he steadfastly refused to approve attributions he could not honestly accept. As the art historian David Alan Brown wrote in his handbook to the 1979 exhibition at the National Gallery of Art, *Berenson and the Connoisseurship of Italian Painting*, "There is no evidence that Berenson ever made an attribution he did not genuinely believe at the time it was made."

To the readers of the first volume of this biography who have patiently awaited this one I owe a word of explanation. The materials at the Villa I Tatti and elsewhere proved so extensive that a substantial volume was clearly needed for the remaining fifty-five years of Berenson's extraordinary career. I immediately began work on it with the collaboration of Jayne Samuels. Because of a long-standing commitment we spent the succeeding summers at the University of Virginia helping prepare a multivolume edition of the letters of Henry Adams and subsequently edited the Library of America collection of the writings of Henry Adams. Jayne Samuels, intrigued by her reading of Mary Berenson's letters, took time out to publish a selection of Mary Berenson's letters and diaries in collaboration with her British colleague Barbara Strachey Halpern, Mary Berenson's granddaughter.

My initial interest in Berenson was inspired by the reading of his correspondence with Henry Adams in connection with the last volume of my life of Adams. Early in 1956 I visited him in Florence at his invitation to talk about Adams. Berenson was then in his ninety-first year. Ten years later I embarked on his biography at the suggestion of his literary executor, Nicky Mariano.

Though the documentary materials on Bernard Berenson outran all calculation, they made it possible to write of his life in all its complicated variety. That his way was strewn with many contradictions and inconsistencies, that his ideal of life-enhancing experience was often frustrated, that making a living as an art expert often seemed degrading to him, that his sensual and cerebral natures were often at war with each other, all these challenged objective scrutiny. My collaborator and I have at best hewn a path, we hope a meaningful one, through the difficult and wonderful terrain of his life.

High-strung and passionate in his likes and dislikes, egocentric and impatient of contradiction yet insatiable for friendship and affection, Berenson thrust his way toward what he called "the humanist ideal of the good life." He wanted, he said, to "get out" of himself "all that goes to

turn the animal into a human being, a work of art." His overriding passion for books and reading, for building a great library, became a tyrannizing obsession, and almost from the beginning he saw his library as the center of an institute of humanistic study to be presided over by the university to which he was fiercely loyal. At his death his collection would number fifty thousand volumes. Under the aegis of Harvard University that number has more than doubled.

From his earliest years Berenson was art-intoxicated, intensely absorbed in the process of empathic seeing, of absorbing into himself not only the manmade art of painters and sculptors but the art of visible nature as well. It was this extraordinary passion for seeing that led to his becoming the world's foremost connoisseur of Italian Renaissance art. Italian Renaissance painting early became his special province, and his writing about it gave a permanent impetus to its study and enjoyment in Europe and America. He became its chief proselytizer. In his old age he wrote in his diary, "As I look on life the only satisfactory part of it is my perfect loyalty to my job. It was to send all the fine pictures that came my way to America, and to see to it that they went there as by the painters who (to the utmost of my ability to find out) had painted them."

How much more Berenson achieved in the passage of these fifty-five years is a main subject of this volume.

<div style="text-align: right">Ernest Samuels</div>

Northwestern University
October 1986

Acknowledgments

THE chief documentary source for this second volume of the biography of Bernard Berenson has continued to be the voluminous archives of the Harvard Center for Italian Renaissance Studies at the Villa I Tatti in Florence, Italy, the depository of the Berensons' letters to and from some fourteen hundred correspondents, of some six thousand letters the Berensons wrote to each other, of their diaries and manuscripts, and of their miscellaneous personal and business records. The correspondence includes nearly two thousand letters and telegrams from members of the firm of Duveen Brothers and copies of many of the letters from the Berensons and Nicky Mariano to the firm. I am indebted to Harvard University for permission to quote from this material and to publish photographs from the archives. I am grateful to the I Tatti staff for their unstinted and cordial help. My special thanks go to Nelda Ferace, Assistant Director for Administration; to Fiorella Superbi, Curator of Collections and Archives; and to Anna Terni, Librarian. We have appreciated also the interest and hospitality of Professor Craig Smyth, Director at the Center at the Villa I Tatti during the times we were at work there in recent years.

Many individuals have aided in this enterprise, sharing their knowledge of the Berensons and making available letters and manuscripts. It is a pleasure to acknowledge their invaluable help. Foremost among these persons was Elisabetta (Nicky) Mariano, Berenson's literary executor, who first opened the I Tatti archives to me in 1965 and gave me every assistance and encouragement up to the time of her death in 1968. Professor Myron Gilmore, while he was the director of the Harvard Center, kindly suggested valuable avenues of research. Lawrence Berenson, Bernard's cousin and American executor, supplied many letters and elucidated them with racy vigor. Richard Berenson, Giles Constable,

Professor Michael Fixler, Jean Gimpel, Bernard B. Perry, Ralph Barton Perry, Jr., Peter Viereck, and John Walker, former director of the National Gallery of Art, have generously made letters available. Rollin van N. Hadley, Director of the Isabella Stewart Gardner Museum, provided microfilms of the Berenson letters to Mrs. Gardner, granted permission to quote from them and from Mrs. Gardner's letters to the Berensons, and helped in our researches. Barbara Strachey Halpern, a granddaughter of Mary Berenson, opened her extensive collection of the Smith family papers for my use.

I am grateful for interviews with Harold Acton, Sidney Alexander, Baronessa Alda Anrep, Elisabeth Berenson, Eve Borsook, David Alan Brown of the National Gallery of Art, Henry and Byba Coster, Marchesa Gilberta Serlupi Crescenzi, Mrs. J. Reed Dickerson, Professor Edgar Ewing, Edward and Jean Fowles, Barbara Strachey Halpern, Mason Hammond, Derek Hill, Professor Leon Katz, Hanna Kiel, Rensselaer Lee, Leon Loucks, with whom I talked about the Hahn painting, Agnes Mongan of the Fogg Museum, Count Umberto Morra, Mrs. Kenneth Murdoch, Bernard B. Perry, Sir John Pope-Hennessy, Fern Shapley, Fiorella Superbi and her father, Geremia Geoffredi, and Daniel Wildenstein. I wish to thank especially Luisa Vertova Nicolson, who assisted Berenson in his work in the years following World War II, for her memories of those years and for much valuable documentation.

I am indebted to the following for their courteous replies to my inquiries: Dr. Cecil Anrep, Peter Arnold of the Museums and Galleries Commission, E. A. Bayne, Richard Bretell, David Carritt, Professor John Coolidge, Lavinia Davies of F. D. Colnaghi & Co., Alan Fern, Dr. Louis Freedman, Philip Hofer, Mrs. Leonard Kaplan, Garnett McCoy, Dr. Gerda Panofsky, Mrs. John S. Panofsky, Professor Terisio Pignatti, Wesley Polling, Richard H. Randall, attorney Don Reuben, John Rewald, Joseph Rishel, Charles H. Ryskamp, Louis U. Rubenstein, Mrs. David O. Sargent, Sarah Sherman, Margaret Smith, Norman Spector, Daniel V. Thompson, William Royall Tyler, Hugo Vickers, Gore Vidal, Durrett Wagner, Janet Watts, Stanley Weintraub, and David W. Wright.

For their cooperation and for granting me permission to quote from materials under their care I owe much to the directors, curators, and staffs of the following institutions: The Art Institute of Chicago, The Ashmolean Museum, Fogg Art Museum, Freer Gallery of Art, The Dayton Art Institute, Dumbarton Oaks, Harvard University Archives, The Houghton Library of Harvard University, Isabella Stewart Gardner Museum, John Graver Johnson Collection in Philadelphia, The Library of Congress, Massachusetts Historical Society, The Metropolitan

Museum of Art, Montclair Art Museum, Montreal Gallery of Art, The National Archives, The Pierpont Morgan Library, Sterling and Francine Art Institute, University of Virginia Manuscript Division, Walters Art Gallery, Yale University libraries. I am indebted also to the National Gallery of Art for permission to use photographs from its collection of Italian paintings.

I wish especially to express my appreciation to the many members of the staff of the Northwestern University Library who patiently responded to our frequent calls upon them and to the library for making a study available to me before and after my retirement as a professor of English at Northwestern University.

For permission to quote from letters in their care or written by them I thank the following: Lennart Ahrén, First Marshal of the Court, Royal Palace, Stockholm; Cecil Anrep; Alan Kenneth Clark; Martha Gellhorn; Mary McCarthy; Luisa Vertova Nicolson; Jacqueline Kennedy Onassis; Adlai Stevenson; Louis L. Tucker of the Massachusetts Historical Society; the Estate of Edith Wharton; and Benedict K. Zobrist of the Harry S. Truman Library.

To the generous and expert research of Katharine Baetjer, Administrator of the Department of European Paintings of the Metropolitan Museum of Art, we are indebted for confirmation from the Duveen papers deposited at the museum of crucial episodes in the relations between Berenson and the firm of Duveen Brothers. Professor Sidney Freedberg, Curator at the National Gallery of Art, provided expert commentary on Berenson's attributions of Italian Renaissance paintings, and his colleague David Alan Brown has kindly reviewed the entire text. Professor R. W. B. Lewis read the volume in manuscript. For his corrections and suggestions I am deeply appreciative.

My wife and I are also grateful to Maud Wilcox, editor-in-chief, and her associates of Harvard University Press for their perceptive and sympathetic oversight.

E. S.

I end as a myth whose saga
I can hardly recognize.

Bernard Berenson
Diary, February 2, 1958

Prologue

SEVENTEEN years had run their course since young Bernhard Berenson arrived in Europe fresh from Harvard, avid to immerse himself in its cultural riches as a prelude to the literary career to which he aspired. Now in the spring of 1904 he was returning to Europe after a triumphal tour of the United States, not as a littérateur but as a world-famous critic and connoisseur of Italian Renaissance art. Pacing the deck of the *Kaiser Wilhelm*, he could lose himself in wonder at the chain of circumstances, of chance and design, that had marked his extraordinary rise in the world.

How remote had been his humble beginnings in the Lithuanian village of Butrimonys, where as a precocious Jewish boy he had pored over the Hebrew Hexateuch. What an odyssey his life had been. At the age of ten, with his mother and a younger sister and brother, he had left the pious household of his grandfather to follow his free-thinking father to Boston. In Boston he had haunted the public library, been nurtured by the Boston Latin School, and with the help of benevolent Bostonians had moved on from a year at Boston University to Harvard.

Recognized at Harvard as a brilliant student, he found an outlet for his literary ambition as a prized contributor to the *Harvard Monthly* and rose in his senior year to the position of editor-in-chief. A romantic and sensitive aesthete, he sought inspiration in the spiritualized hedonism of Walter Pater's *Studies in the History of the Renaissance* and resolved to follow his injunction to fill his life with the contemplation of beauty and exquisite sensation. For him as for Pater, success in life would be "to burn always with the hard gem-like flame, to maintain this ecstasy."

A fund provided by Isabella Stewart Gardner and other Bostonians sent him on from Harvard to Europe for the traditional Grand Tour. In Paris, London, and Berlin he fell headlong under the spell of the visual

arts, and with the help of friends he lingered in Europe far beyond the sponsored year. Inoculated with the virus of art appreciation, he feasted on the treasures of Venice, and, launched on his lifelong role as a "passionate sightseer," went on to hellenize in Greece and Sicily. On his return to Italy he gravitated to Florence and there became a disciple of Giovanni Morelli. In opposition to the German academicians, Morelli aimed to establish the connoisseurship of Italian art as an objective science. Inspired by his method, Berenson roamed the art cities of Italy and formed the resolve to know and identify the work of every Italian master.

When his pursuit of Italian paintings led him to England, he met and fell in love with Mary Costelloe, the talented wife of a Catholic barrister and the mother of two young daughters. Her Philadelphia family had followed her to England—her parents, Hannah and Robert Smith, Quakers who had turned evangelists; her sister, Alys, who married Bertrand Russell; and her brother, Logan Pearsall Smith, whose *Trivia* and other writings were to make him a figure in the literary world. Mary, romantic, restless, disenchanted with her marriage, and entranced by Berenson's eloquence, followed him to Florence as his pupil and lover. In 1900, a year after the death of her husband, she became his wife.

She proved an apt pupil. Berenson's constant companion in the museums and churches of Italy, she became his collaborator and a connoisseur in her own right. Urged on by her, Berenson produced an array of books and articles that set a new fashion in England and America in the appreciation of Italian Renaissance art and that established him as a highly knowledgeable connoisseur whose expertise was sought by collectors of Italian art. *The Venetian Painters of the Renaissance* of 1894 was followed by the scholarly monograph *Lorenzo Lotto* in 1895. In 1896 *The Florentine Painters* introduced art students to "tactile values" and the "life-enhancing" function of art. *The Central Italian Painters* followed in the next year. In 1901 and 1902 collections of his articles were issued in *The Study and Criticism of Italian Art*, First and Second Series, and in 1903 he published his monumental work *The Drawings of the Florentine Painters*, issued in two sumptuous volumes. The London *Annual Register* called it a "work which surpasses in value for the student and the collector any previous attempt in the same line and in other schools."

By happy chance the imperious Isabella Stewart Gardner was beginning to turn her energies from collecting rare books and antiques to collecting Old Masters at the time Berenson's first book appeared. Between 1894 and 1903 he helped her spend more than a million dollars on upwards of forty paintings. The famous Egyptologist Theodore M. Davis, a multimillionaire collector of art, also sought his services, as did

other collectors. By 1899 he could boast to his sister Senda that he had been earning the fabulous sum of at least $15,000 a year in fees and commissions.

Berenson's successes were indeed cause for wonder, and the warmth of the reception in the United States had been a dramatic confirmation of them. But his life did not lack dissatisfactions, and these must also have occupied his thoughts as he neared England, his first stop on his way back to Florence. Strong among these dissatisfactions were his relations with his wife. Their passionate liaison had been gradually transformed in the years before their marriage by her several love affairs and her fierce attachment to her children and family, which kept her in England for months of each year. Increasingly independent and self-assertive, she could no longer give him the selfless devotion he demanded. Yet a measure of affection and a common self-interest held the two of them together. They had become an efficient—and sometimes quarrelsome—team of art experts and critics.

At the time of their marriage the separate households they had maintained on the slopes of Fiesole, near Florence, had become one at the Villa I Tatti, lower down on a Tuscan hillside close to the tumbling waters of the Mensola and below the village of Settignano. It was a luxurious home that was becoming a cultural crossroads to an international elite. There the scale of living and entertaining they had adopted was proving increasingly expensive. Moreover, the recent visit to America made plain to Berenson that as eldest son he must become the chief support of his family in Boston. In addition Mary's daughters were making a substantial call upon his resources. And his passion to augment his library and to travel about Europe in quest of Italian art must not be denied. The years he had counseled Mrs. Gardner had made him prosperous, and his investments in American securities had grown; but now Mrs. Gardner, her collection largely completed, was becoming increasingly cautious in her buying, and the new clients he had hoped to acquire in the United States were as yet only promising prospects. It was reassuring that he had, while in New York, effected a connection with the prestigious art dealer Eugene Glaenzer, whose firm had an establishment on Fifth Avenue and headquarters on the rue Scribe in Paris. Already there was promise of reward from this quarter.

But as much as Berenson sought and welcomed new commissions, he found his involvement in the art trade a source of anguished dissatisfaction. As an idealistic aesthete he had quickly learned that the ethics of the world of art dealing were not those of Epicurus: to buy low and sell high was an imperative that could not be avoided, and conflicts of interest, dissimulation, and lavish puffery were an inevitable accompaniment.

[3]

Commerce in art was, in the term he and Mary used to describe it, the "pig trade," and he felt himself an unwilling captive and a victim of its devious ways. Though he attracted many warm partisans, his too-ready scorn of dealers and rival connoisseurs earned their dislike. As a result of his recent quarrel with the publishers of the *Burlington Magazine*, he could not expect in London the warm welcome the United States had extended him.

THE ACCOUNT of Berenson's life up through the six months he spent in the United States in 1903–04 is the story told in *Bernard Berenson: The Making of a Connoisseur*. *Bernard Berenson: The Making of a Legend* resumes the record of his much-accidented life, taking him through the years of his long association with the firm of Duveen Brothers, the leading international art dealers; through his experiences in the First World War, when he changed his name from the Teutonic Bernhard to Bernard; through the turmoil of the Second World War and its aftermath; and into his ninety-fifth and last year, during which, still active, he continued to compose his newspaper column for the Milan *Corriere della Sera* almost with his last breath. The influence of Walter Pater had stayed with him until the end of his life. To the very last he strove "to maintain this ecstasy." He was determined to be, as he wrote in his late diaries, a "Goethean gebildeter Mensch [man of culture]" and to get from himself "all that goes to turn an animal into a humanized being." Life, as Emerson taught him, was a process of becoming, and his ambition was "to become and be . . . a work of art" himself. His *Sketch for a Self-Portrait* and the many entries in the diaries of his last years record his attempt to achieve that ideal.

In that long and varied enterprise Berenson found every aspect of his life engrossing. As he grew older, he preserved the record of it with extraordinary care. His countless letters and those from his friends and acquaintances in Europe and America, from scores of scholars, art historians, political and literary figures, art dealers, collectors, lovers, and socialites, were a kind of treasury to be saved for posterity. However self-serving or obscure they may sometimes be, they arrest in their pages the peculiar savor of the passing moment before memory and reminiscence can edit the living experience. *Bernard Berenson: The Making of a Legend* attempts to capture these many voices of the past, these self-communings, and to exhibit Bernard Berenson the man in the full range of his personality and experience in the hope that a truer estimate of his character and achievement may emerge.

I

The Missionaries' Return

THE tour of the United States in the winter of 1903–04 taught Bernhard Berenson and his wife that their professional ministrations were urgently needed. American collectors had been gulled wholesale by unscrupulous dealers, their tastes in art were generally deplorable, and their conspicuous wealth cried out for more intelligent employment. Englishmen might stubbornly cling to the famous aliases which disguised their family heirlooms, but none would be as graceless as the American senator who invited his visitors to "come see my $40,000 Degas." New money bereft of taste and discrimination populated American collections with what Mary Berenson regularly dismissed as "horrors." Christian missionaries to darkest Africa bringing the true religion to the benighted heathen could not have found a better field for their services than these two emissaries to the New World. The women—and men—who flocked to Mary's lectures on art or deferentially buttonholed Bernhard for his opinion of their paintings could only have intensified the pair's sense of infallibility and self-importance. Berenson, not yet thirty-nine, had savored to the full the kind of deference that Americans gratefully lavished on visiting nobility.

The adulation and glittering entertainment the Berensons had received in America showed that the rich American collectors were more than ready for the services of an adviser whose innovative writings on art had set a new fashion in the appreciation of Italian Renaissance painting. In the world of art collecting a revolution was already under way in which Berenson was a principal actor: the pendulum of taste was beginning to swing away from the long-popular Dutch masters toward the early Italians. In New York the art dealer Eugene Glaenzer, with whom Berenson had concluded an alliance, had recently introduced into an exhibition of Old Masters an almost-unknown contemporary of Titian, Jacopo da

Ponte, and by the time Berenson landed in England the *New York Times* reported with "surprise" that the Ehrich Galleries had opened an exhibition "exclusively confined to early Italians." The writer declared that "a good many Americans besides Mr. Bernhard Berenson are studying abroad the primitive art of painters before Raphael." Soon afterward the newspaper said that many fine examples of Old Italians had already come into private collections, and it predicted that museums and public galleries would soon follow. Collectors would therefore be well advised to seek the help of expert connoisseurs, for "your average Tuscan looks upon the *forestiere* [foreigner] as a born fool if he makes any inquiry for antiques for sale."

Leading the American "boom" were John Pierpont Morgan, Isabella Stewart Gardner, John Graver Johnson, P. A. B. Widener, and Henry Walters. They were soon to be joined by many others. Berenson's preemptive forays on Mrs. Gardner's behalf had already "created a new scale of values." When Lord Darnley, instructed by Berenson's sale of the Titian *Europa* to Mrs. Gardner for $100,000, put his Titian *Ariosto* (*Gentleman in Blue*) on the market, $150,000 was raised by public subscription to save it from American predators. With Italian art in fashion and prices on the rise, Bernhard and Mary could end their United States adventure optimistic that their services would be sought and appropriately rewarded.

On March 21, 1904, the Berensons disembarked at Plymouth after a six-day passage on the luxurious *Kaiser Wilhelm* and went immediately up to London for a week's stay. It was not a week that Berenson could look forward to with any pleasure, for his star, which had risen brightly there a year ago, had almost immediately been eclipsed by the hostile luminaries of the reorganized *Burlington Magazine*. He had been crowded out of a share in the direction of the magazine and his name had been dropped from the masthead list of eminent international sponsors as if to mark his expulsion from the British Establishment.

He returned to London to find himself "surrounded by an atmosphere of storm," according to Claude Phillips, curator of the Wallace Collection. Art circles were abuzz with a recently published attack on Mary Berenson, and upon Bernhard as her alter ego, by Wilhelm von Bode, director of the Kaiser Friedrich Museum. Berenson had incurred Bode's wrath nine years earlier by ridiculing his critical methods and had thereafter compounded the offense by outmaneuvering him in the acquisition of paintings. More recently Mary, under the pen name of Mary Logan, had disparaged a German biography of Andrea Mantegna as a work "befogged by that German obscurity which the English language is incapable of clarifying." Bode's article in the widely circulated *Kunstchronik*

defended the book, which had now come out in an English translation by Standford Arthur Strong. "Of course," Bode wrote, "Berenson is fully responsible for what Mary Logan says." With his own brand of scorn he declared that picture dealing like Berenson's might certainly be useful to the critic, but the manners of the art trade should not be carried into criticism. As for Berenson's animus toward German scholarship, it was "probably due to the circumstance that Mr. Berenson is of Russian-German ancestry and . . . believes he must disown this among his present Anglo-American compatriots."

During his week in London Berenson met with Carl Snyder, an English editor in the employ of the American publisher August Jaccaci, and once again there was brought home to him the rivalries that plagued the art world. Jaccaci, a venturesome character who had become widely known as the art editor of *Scribner's* and *McClure's* magazines, had conceived a plan for a series of ultradeluxe volumes to be titled *Noteworthy Paintings in American Collections* and sold at $1,000 a volume. He proposed to reproduce the paintings and accompany each with a few brief essays by leading art critics. While Berenson was in the United States Jaccaci had tried to interest him in becoming a principal contributor: he wined and dined him in New York with influential people who might become subscribers, and he gave him letters of introduction to important collectors in Chicago, Pittsburgh, and Washington. Berenson saw the project as a source of unpleasant controversy over attributions and refused to join the enterprise.

Controversy of course was precisely what Jaccaci the journalist desired. "There is a big thing behind that," he wrote to Snyder of Mrs. Gardner's Giorgione *Head of Christ*. "We want a full discussion of this picture, the pros and cons as to its being a Bellini or Giorgione." Snyder, who had been commissioned to solicit essays from art critics in England and on the Continent, soon began to have misgivings about the scheme. "What will Mrs. Gardner say," he protested, "when you have four explicit essays detailing why a painting cannot possibly be a Tintoretto or a Titian and you can only get Mr. Berenson to back you up?"

As he plunged deeper into the jungle of the European trade in Old Masters, Snyder's reports to Jaccaci grew increasingly vivid. Moving from art capital to art capital, he found himself in an unsavory world of rumor, deception, double-dealing, multiple conspiracies among dealers, and cutthroat rivalries among the critic-experts, many of whom were known to indulge in occasional dealing themselves. In Berlin he broke out, "How absurd it all is to talk of 'experts'—what one praises to the skies, another sneers at as 'a palpable forgery.' . . . And the stories they tell about each other. Bode on Berenson, DeGroot on Fairfax Murray,

Rjemadyck on DeGroot and so on ad infinitum—if I care to listen—all crooks." He reported that experts like Justi, Hymans, and Frimmel studied documents, whereas Ricci, Frizzoni, and Cavenaghi "study the pictures," and the "contempt of the one type for the other is perfectly equal and very deep." Still all acknowledged Berenson's preeminence in his field. "To make a book beyond criticism Berenson *must be included*." His standing among professionals was "of the very highest." Since the Gardner collection was to be the "key" to the first volume, it was important to have Berenson back up his attributions.

Snyder's job at the London meeting with Berenson was to persuade him to take a leading role in the project. The interview lasted an entire morning. Berenson stuck to his resolve. "He was most charming," Snyder wrote Jaccaci, "although he was very straightforward and flatfooted about what he had to say. . . . I have not met his like in all my rounds of Europe. . . . The supreme type of the breed. He disliked the scheme of the book and would 'never mix with the mob.' " He detested Jaccaci's "mania for 'provenance,' " and as for attributions, he haughtily announced that other critics stood in the same relation to him "as say the astrologers of the days of Copernicus did to the true system of the heavens."

As a result of the multiplying complications of the project and the bankruptcy of the initial publisher, the first volume of *Noteworthy Paintings,* largely shorn of controversy, did not appear until 1907, the year of the financial panic. No further volumes were attempted, and the way remained open for an even more comprehensive volume about which Berenson had begun to dream. He had in fact broached the subject in the company of John Graver Johnson when surveying his collection in Philadelphia. "Your collection would form a good part" of it, he said. In it he would treat the Italian paintings in American collections "irrespective of ownership in some historic or artistic order." He begged Johnson for photographs of his collection and promised to keep him informed "of what is worth buying at a given moment." The project was to hang fire for a dozen years, emerging finally as *Venetian Painting in America: The Fifteenth Century.*

There was little to detain Berenson in London beyond the planned week, and it was undoubtedly with considerable relief that he crossed to Paris, where he was always warmly welcomed. Mary, who had suffered from lingering seasickness during the days in London, hurried on to I Tatti ahead of Bernhard, the villa made more attractive to her by the presence of her two daughters, Ray and Karin, aged seventeen and fifteen. She was disappointed, however, when they showed little enthusiasm for her proffered guidance in Italian Renaissance art. Bored

with the array of household chores and the temperamental behavior of the Italian servants, she soon felt herself again vaguely ill in "eyes and legs." Fortunately a new project promised diversion. Bernhard, she informed Mrs. Gardner, "talks . . . of leaving his library to Harvard, and I want to get it, little by little, thoroughly well catalogued."

In Paris Bernhard was in his element. Thanks to his cultivated friend the art historian Salomon Reinach, he had gained entrée to the palatial residence of Baron Edmond de Rothschild, a residence filled with "treasures untold in the way of engravings, drawings and books." He made a stunning impression on his hosts, he reported to Mary, when he was asked to identify the author of a particular head. "I said unhesitatingly David Ghirlandaio. Lo and behold on turning it over they found written in an old hand 'David Ghirlandaio.' Great impression! Pure luck, for I know but one or two drawings on which David's name occurred." On Easter Sunday, again in the company of Salomon Reinach, he visited the equally palatial residence of Baron Gustave de Rothschild, the seventy-five-year-old head of the Paris branch of the great banking family, whose magnificent house at 23, avenue de Marigny was one of the showplaces in the aristocratic locale near the Elysée Palace. Here he admired a "marvellous" Van Eyck and a "sublime" cameo of Theodora.

A more important object of admiration, as it subsequently developed, was the baron's daughter Aline, Lady Sassoon, the elegantly beautiful and sophisticated wife of Sir Edward Sassoon, still youthful in her mid-thirties. Quite possibly he had already encountered her among the St. Moritz society crowd, for on this occasion she asked to be remembered to his acquaintances the Rasponis. This meeting with her initiated another fateful turn in Berenson's life, for Lady Sassoon was not only an artist but also, like her father, a collector, and like him she was acquainted with the extraordinary salesman of art young Joseph Duveen.

A popular member of Paris and London high society, Lady Sassoon also had a place in French literary and artistic circles. In England she moved gracefully among the salons of Belgravia and Mayfair and was a member of the choice coterie of "The Souls," where wits and statesmen displayed their breeding and "discrimination of mind." Sargent's portrait of her, bejeweled and clasping the fold of an opera cloak to herself momentarily arrested on her way to her carriage, has a hint of sadness about her luminous eyes as though she already sensed that she had few years left before her. Edward, Prince of Wales, had been so charmed by her that after a visit to the avenue Marigny he named his yacht in her honor. Increasingly susceptible to beautiful women as though they were incarnations of a newly discovered Raphael or Titian, Berenson was

ing utility pole in front of his place in Englewood, New Jersey. Platt shared with Berenson a passion for collecting photographs of paintings, and the two men frequently added to each other's collections.

In spite of their frequent visitors Berenson chafed against his isolation, against not being part of an intellectual community. Florentine society was curious about the pair at the foot of Settignano, but, according to Placci, hesitated to make advances because of their "bearish reputation." This bearishness had grown out of their fear of being deluged with the local gossip for which Florentines were notorious. They managed to escape from their provincial confinement for ten days when their English Florentine friend Edmund Houghton took them on a motor tour in the vicinity of Siena, during which they unearthed "a few precious works of art," including two fine Sassettas. Bernhard carefully noted them for articles in his friend Don Guido's journal, *Rassegna d'Arte*. Mary, for her part, studied an extraordinary "pêle-mêle" of good and bad paintings in the communal palace, drawn from village and private collections, for an article in the September 1904 *Gazette des Beaux-Arts*. The tour further whetted their appetite for the marvelous new form of transport. "I no longer dare rough it as I used to," Bernhard confessed to Mrs. Gardner. "Our great desire now is to own a machine that will enable us to explore much farther . . . [and] to return to possible food and lodging for the night."

Since his return to Florence Berenson had again suffered from the bouts of ill health from which he had been relatively free during his travels. He ascribed them to "nerves," but Mary surmised that chronic dyspepsia was the more likely cause. She thought his shirking work was perhaps excusable "when you think that his early years were nourished on some black bread and vodka." That legendary experience now had the authority of fact in their household. There was, in any event, no escaping the pressures put upon him. Despite his promises to his publisher and Mary's prodding, he had yet to get on with the fourth volume in the series on the Italian painters, the *North Italians*. To urge him on Mary had prudently begun compiling the essential lists and photographs.

Whatever the cause of Bernhard's malaise, it became sufficiently conspicuous for his doctor, Yule Giglioli, to prescribe the air of St. Moritz. That therapy had to be postponed until August: he was expected in Paris to meet a delegation from the Metropolitan Museum and could not afford to excuse himself. Thus in late June Mary put away all their silver and their most precious paintings into their iron vault, and they set off for Paris again to challenge the future.

A Man of the World

I N Paris Berenson piloted Frederick Rhinelander, president of the Metropolitan Museum board of directors, among the dealers. Bernhard and Mary lunched with him, dined with Vice-President Rutherford Stuyvesant, and "were engaged on the morrow" to dine with the "deus ex machina, a wicked old boy named [William] Laffan," a member of the board. In Mary's eyes they all treated Bernhard as if it were certain he would be the new director of the Metropolitan. She breathed a prayer, "Would that something might come of it! let some droppings fall on me." She wrote her mother that they had an alternative in mind: "We are putting it into their heads that he will be much more useful *over here*." The thought of cutting themselves off from the life they had established at Settignano and their connections on the Continent and in England seemed much too hard to face.

Filled with visions of affluence, Mary hurried over to her family in England, abandoning Bernhard to several weeks of his usual round of business and pleasure in Paris. Acting as Stuyvesant's guide, Berenson took him about to see the dealers' offerings. They inspected the wonderful eighteenth-century things at Wildenstein's, moved on to Jacques Seligmann's, and wound up at Sedelmeyer's. They looked in at Knoedler's and then went to Glaenzer's to see an El Greco, "an astounding fantasia" which he was offering for $40,000. It was the *Adoration of the Shepherds,* for which Berenson's impecunious painter friend James Kerr-Lawson had been the intermediary. Berenson had been secretly promised a commission on the sale.

Much as Stuyvesant would have liked to acquire the El Greco for the Metropolitan, he did not have a free hand, and Berenson therefore offered it to Mrs. Gardner. Anxious about her finances, she held off. A few weeks later the Metropolitan people confronted the El Greco for an hour

Trevy, whose advice he often asked, saying, "I suppose I shall scarcely begin to rewrite my book 'till autumn so if you have your corrections ready by November say, it will do. I count on them." With the manuscript set aside, the jaunts into the countryside redoubled. Houghton acquired a new motor and off they all went again on excursions that seemed pure "bliss" and that allowed them to see "ten times as much" as formerly.

As spring merged into summer, I Tatti buzzed with activity. Rachel came on from Greece, and for a few days, with Senda still at hand, Berenson seemed in the midst of a family party. Mary's daughter Ray, who had just passed her entrance examinations at Cambridge, brought with her a novel she was working on, the setting a thinly disguised I Tatti with a principal figure inspired by "Uncle Bernhard." Soon Rachel departed for England to meet her fiancé, Ralph Barton Perry, and Senda was packed off to Bagni di Lucca for its restorative waters. The sixteen-year-old Ray received instruction from Houghton in driving his motor, and though she did back the thing into a ditch, her mother was gaily confident that "she fully understands the machine and drives really better than Houghton!"

Houghton drove them all up to Venice and there lent them the motor for ten days, whereupon Mary, with tyro Ray at the wheel, took Bernhard half way from Venice to Duino, where he was entertained in a castle overlooking the Adriatic by the "highly cultivated" Princess Hohenlohe. The princess took him about in her motorcar while he expatiated on the intoxicating scenery.

From Venice he had to entrain to Paris to review arrangements with Glaenzer, who counted on him for leads to marketable—and exportable—Old Masters. Mary joined him in Paris, and as soon as Lucien Henraux's new motorcar could be made to function, they all set out for a tour of central France and the coast of Brittany, a tour marred only by the inevitable burst tires. Mary dreamed of "a little automobile" for £100 for Ray that they could all use in England. She could raise £50, she told her mother, "if thee could lend me the rest." The project had to be deferred, but once admitted among Mary's desires, its fulfillment could not be long delayed.

When Mary went to England to spend August with the family, Bernhard proceeded to St. Moritz where, among his socialite acquaintances, he could again bask in the attentions of princesses, countesses, and marchese. His daily letters to Mary told of walks and teas, of *tableaux vivants,* of fancy-dress balls, and of uplifting conversation about culture and religion. Yet his tête-à-têtes with the Countess Serristori sometimes bored him when she came out "vehemently with some idea or formula

of mine to which I no longer attach great importance, if ever I did. I mean so little of what I say . . . because saying for me is at best an aphasic attempt at expression." Carlo Placci was of course among the regulars and so too was the flamboyant Count Robert de Montesquiou. Berenson drew closer to Lady Sassoon, who hung on his conversation like a disciple.

While still at St. Moritz Berenson learned that the marriage of his sister Rachel, then twenty-five, to the twenty-nine-year-old Ralph Barton Perry was soon to take place in London. He did not regard the match as a brilliant one, though he did concede that "at worst the life of a professor at Harvard is a life of dignity and interest for them that want no better." Mary assured him that Ralph had "won all their hearts. . . . Even mother likes him." Berenson evidently pleaded ill health for not attending the wedding, though to his wife he offered a less acceptable reason, if one may judge by her response: "I like thy patronizing tone about Rachel and her 'hoary anthropological rites'—pray weren't thy own much more hoary?!"

For all his success as an art critic and connoisseur and his obvious relish of high life in Paris, London, and St. Moritz, Berenson felt a gnawing sense of discontent, a feeling of ideals unrealized and of spiritual homelessness. From St. Moritz he poured out the litany of his defeated aspirations to his old English friends Katherine Bradley and Edith Cooper, the poetizing aunt and niece who published their effusions under the pseudonym Michael Field. Mary wrote of their distress that "thee is more dissatisfied with thyself each year that passes. *'It is not right,'* Michael [Katherine Bradley] kept saying, wherein she *is* right. Do try, dearest Bernhard, to think out a scheme of life that will satisfy thee. I will aid thee in *anything* thee undertakes."

The two women held a special place in his affections. He once confessed to Mary that "their conversation is to me the dearest on earth." They for their part piously treasured up his talk in their diary. Now in the midst of the distractions of St. Moritz, he told them that "along with Mary and in some respects more than she, you two are my only soul mates. I live so much more intensely with you and my mind flowers strangely and beautifully in your presence. . . . So in a sense I shall never be known except to you."

THE ONE MOST unsettling element in his life was Mary's long absences in England every year with her family. They left him periodically at loose ends and rudderless, for without her collaboration and management he seemed unable to work. His resentment of this aspect of their marriage was never much below the surface. In that August when Mary wrote to

him at St. Moritz that she had been seriously ill, he admonished her, "It is odd how regularly you do fall ill in England and especially in the country. Don't you think there may be a reason for it which once engraved with a needle in the corner of the eye might serve as a lasting reminder to do otherwise?"

After his four weeks at St. Moritz Berenson entrained with Placci for Paris to resume his place in the strenuous activities of the idle rich. Lady Sassoon invited him to a gala house party at Gustave Rothschild's Chateau Laversine, whose luxury surpassed anything Berenson had previously encountered. Israel Zangwill, the prominent Jewish novelist and playwright, was also among the guests, looking very much the "boulevardier." At the Rothschilds' the "patriarchal system was in full force," with "all sorts of incongruous Semitic descendants," as Bernhard reported to Mary, "gathered together under the grandparental roof." Mary mourned, "They have a score of motors, and Ray hasn't even a runabout!"

Berenson dined with Elsie de Wolfe and Bessie Marbury at Versailles and again saw much of Sardou, whose brilliant anecdotes he urged upon Sardou's son-in-law as material for an autobiography. Bernhard met "Madame Lucille," the Paris dressmaker, and immediately proposed that Mary, who had returned from England, put herself in the woman's hands, for he thought her present styles—including her "beloved Burberry suit—too horrible." "What a pity," she reflected. "It will be trying to resuscitate the 'restes de beauté' in a fat middle-aged, red-faced lady!"

With Mary and Placci in tow Bernhard went on to Chambéry in French Savoy to rendezvous with Placci's nephew for a drive to Aosta and the Piedmont. As the Great St. Bernard Pass was closed to automobile traffic, they crossed to Courmayeur in Italy over the Little St. Bernard and then drove south from church to church hunting for more examples of North Italian paintings. Mary's notebook was always at hand for Bernhard's commentary and attributions, and her hopes were high that they would finish the "Lists" and "pay adieu to all this part of the world and devote ourselves to Tuscany and Umbria."

Early in October they reached Don Guido's Villa Gazzada, lured there by the promise of a two-day motor tour. Their host was distracted by the usual crowd of noisy guests, and they had to settle for a short ride to Lecco on Lake Como. On the way back to Milan they hiked up a rocky mule path for three miles to Ardenno in pursuit of a Luini but found no Luini to reward the ascent. In Milan they dined with Lady Sassoon's sister and her husband. Unlike the exquisite Lady Sassoon, the Baronne Lambert was a "florid type of Jewish beauty" dripping with jewels, frills, and laces. Mary, quick to denigrate a rival, thought her "appalling";

Bernhard, who was fond of the woman, excused her shortcomings on the ground that she was on the verge of a nervous breakdown.

Home at last, after a three-month absence, Berenson turned to the rewriting of the *North Italians,* determined to free himself from what had become an incubus. Fits of "gloom and despair" alternated with spurts of creativity. Typing the section on prettiness and beauty, Mary felt the "new book is in some ways his best work" but, she told her mother, "so very cryptic" that she could not "imagine anyone properly understanding it but me! . . . Yesterday we had tea alone together and he couldn't do anything but groan over the problem staring him in the face, the problem of how to treat the painter Luini, his own and everybody else's first love in Italian art, whom he now abhors. 'I shall never do it, Mary,' he kept saying, and I had to encourage him by laughing at him and prophesying that when we next met for dinner it would be done. Sure enough about seven he came running into my room with a face of delight and handed me a half dozen pages of manuscript, and then lay down on the sofa to watch me read them. And he had written a rather charming thing ending with these words: 'How they enhanced one's dream of fair women, these painters so distasteful now; how they guided desire and flattered hope! Youth still looks at them with the same eyes, and from their Elysian seats they smile down at me with the words—"It is for the young that we worked; what do you here?" ' "

Mary was delighted to type the manuscript, "changed a lot here and there, little things, which nevertheless make a difference in the ease and clearness and then some serious things, too, about which we grappled for half an hour when I had finished." "The preliminary stages of all his best things," Mary explained to Mrs. Gardner, "are doleful litanies about being 'finished,' about having no ideas, about having lost his grasp and so on."

On December 12 Mary wrote that the book "is finished" but, "miserable man, instead of feeling elated, he feels . . . unemployed . . . with nothing particular to live for." Two days later she set out for England, leaving him in the care of a nephew of Henry Labouchere, Algar Thorold, an author and journalist. Berenson continued to tinker with the manuscript for another week, so that it was not until December 23 that Mary could applaud: "Hip hip hurray!!! . . . I feel thee has endless possibilities still." To Mrs. Gardner Berenson declared, "It was a book I hated to write and should not have written except for much urging and for its being a duty to do so. . . . I have just finished and instead of feeling any joy on a task done, I feel merely out of a job."

He was not out of a job for long. While awaiting Mary's return he learned that Charles Tyson Yerkes, the New York street-railway mag-

straight to the owners. Highly appreciative of his help, Johnson insisted on sending a liberal "honorarium." The "embarrassed" Berenson replied that when he asked for "tips" on the market, he had "meant that and nothing else." "On the other hand," he continued, "after the way you put it in your last letter, it would be churlish of me to refuse your money." Thereafter Johnson regularly sent "honoraria" and Berenson regularly accepted them, though as time went on, despite his assurances, Berenson came to have a pecuniary interest in some of the pictures he recommended.

Close as were Johnson's relations with Berenson, he was far too resourceful a collector to rely on only one agent. Herbert Horne also scouted for him and may well have procured even more paintings for him than did Berenson. Roger Fry acted for him as early as 1905 and was paid fees and reimbursed for expenses. Professor Langton Douglas, who was an avowed dealer, regularly took from him a 10 percent profit.

Berenson's initial relation with the Agnew firm of London illustrates the temptations inherent in the art trade. After Berenson became acquainted in 1906 with David Croal Thomson, a junior partner in the Agnew firm, he recommended their Piero di Cosimo to Johnson. Thomson thereafter wrote Berenson, "My senior partner is very firmly of the opinion that a proper honorarium must be paid you, simply by way of acknowledging the service you have done the firm." Soon afterward, Lockett Agnew, the senior partner, wrote to Berenson, "This should be looked on by us all as a first swallow in the coming summer making business with you which we shall welcome heartily." The firm proposed another expedient the next year when Johnson acquired a Callisto Piazza on Berenson's recommendation: Agnew's notified him that they were assigning him a "confidential credit" of $375.

By the first of September 1906 the chic hotels of the Upper Engadine in the Swiss Alps were largely deserted, and Berenson, restless to be on the move again, proceeded south to Nervi to make his peace with the faithful Donna Laura Gropallo, who was annoyed that her recent laudatory article on his career had failed to please him. Though unsuccessful as a playwright, she had great personal charm and her lovely estate above the sea delighted the nature lover in Berenson. The reconciliation effected, he stopped briefly in nearby Genoa to check his ever-lengthening Lists before going on to Venice for a much-delayed rendezvous with Mrs. Gardner. Her bank account revitalized, she demanded to be shown "a few things." Though she was sixty-six, Mrs. Gardner's driving energy was too much for him, and the week's activities left him worn out by her "egotism, her monstrous vanity, her utter lack of consideration." The "secret of her perpetual youth," he theorized, "is that she is a vampire and feeds on one young person after another." Yet, when shortly afterward she joined Bernhard and Mary at I Tatti for a few days, they

gave way to her charm. "She makes me feel she adores me," Mary confessed, "the wily old Circe! We sat out in the moonlight till nearly midnight, simply revelling in her society."

The Baronne Lambert arrived on this scene of felicity "as jealous as a wildcat" to find Mrs. Gardner monopolizing Bernhard's attentions. Mrs. Gardner held the field with "her very sweet voice and extremely warm and sympathetic eyes," but Mary felt that Bernhard was far fonder of Mme. Lambert, whose affection seemed more genuine than that of the self-absorbed mistress of Fenway Court. It was not a moment, however, for him to assert a preference. Mary reflected, "We owe so much to Mrs. Gardner really we can never think of her without gratitude."

Their feuding guests having left, Bernhard and Mary set off for Paris early in October, she to "baptize" a collection of "horrible" photographs for Salomon Reinach before joining her daughter Karin, who required an operation on her ear, Bernhard to tackle the Brancaccis about the Velasquez with which he had tempted Mrs. Gardner nearly two years before. She was now eager to make the acquisition. The hard-featured princess, he wrote, demanded a million francs ($200,000), but her husband, "who still has his wits about him," agreed to take 500,000. Roger Fry, he told her, was said to want the painting for the Metropolitan and Mrs. Potter Palmer was another competitor. Then, with a premonition perhaps of the vulnerable nature of the attribution, he uttered the caution, "Of course, I may conclude that the picture though wonderful is not Velasquez." But Mrs. Gardner's mind was already made up and she was in no mood for doubts. The welcome word came, "The picture is yours." Long accepted as an autograph portrait, *Pope Innocent X* in recent years has been ascribed by Philip Hendy as more probably belonging to the "school of Velasquez."

Having secured the Velasquez offer, Berenson left for Madrid as cicerone to Lady Sassoon and her companion Mrs. Leslie, a widow who was a member of the international set and the reputed mistress of the duke of Connaught. The way they "coddle me is almost laughable," he reported. Spain brought rewards, however, beyond the gratifying attentions of his two lovely charges. The cathedral at Toledo surprised him with its beauty: "The light plays upon the warm stone . . . and above all [on] the long spacious side aisles and suspends one's breath in ecstasy." In his hypersensitive state even the familiar Prado astonished him, though the light was bad "and most of the pictures looked chilled and shivering."

After he finished taking his notes, he gave himself up to pure enjoyment. "I revelled again as in my earliest days over the early Titian 'Bacchanal.'" They loitered long before Velasquez' dramatic *Surrender of Breda*, and even Lady Sassoon, who used to gallop through the galleries, slowed her pace. "Poor dear, she is so humble, so touching," he confided

Lady Sassoon took Berenson to the Duveen Gallery in Bond Street to look at the Hainauer Collection. He had agreed to accompany her on condition that his identity be kept secret. One painting so impressed him that he exclaimed to Duveen, "I'll pay you £30,000 for it," thinking to get it for Mrs. Gardner. Duveen turned to Lady Sassoon, "This fellow knows too much." Not long afterward, having guessed Berenson's identity, according to Behrman, Duveen invited him to become his adviser.

Edward Fowles, in his *Memories of Duveen Brothers,* tells a more prosaic tale. Duveen knew that Berenson had challenged some of Bode's attributions of the Hainauer Collection and he tried to hire the art historian Langton Douglas to check the Italian paintings. When Douglas had to beg off because he was currently working as an adviser to J. P. Morgan, Duveen sought out Berenson and paid him a fixed consultancy fee to inspect the paintings. Berenson "spent three afternoons in the upstairs galleries" and challenged a number of Bode's attributions.

Whatever the precise circumstances of their first meeting, Duveen, doubtless aware of Berenson's international reputation as a connoisseur of art, proceeded with his customary dispatch to establish an informal working arrangement with him. His first letter to Berenson, dated from London, December 18, 1906, warmly thanked him for introducing him to Mrs. Gardner. "I am sure," he wrote, "it will lead at some future time to pleasant business relations. She is indeed a very charming lady." Eager to establish himself with her, Duveen had an agent bring her "Velasquez" to London from Paris. He annoyed her, however, when he delayed sending it on to Boston in order to display it to his clientele.

Shortly before receiving Duveen's letter, Berenson made his first recommendation of a painting for his consideration. Duveen promised to look at it on his next visit to Paris and then added, "I hope if there is anything you at any time wish me to do for you in London you will not forget that I am entirely at your disposition."

In this cordial fashion an association began that would endure for thirty tension-filled years, during which Duveen's aggressive enthusiasms would frequently grate on Berenson's nerves at least as sharply as Mrs. Gardner's demands were wont to do. Two years were to go by before Joe Duveen's projects would engross the greater part of Berenson's services as an art expert, and it was not until 1912 that an elaborate contract spelled out the ambiguous terms of their collaboration. Until that date Berenson dealt with Duveen much as he did with the members of other Paris and London firms. Negotiations were carried on more frequently by word of mouth than by letter or cable. Often a transaction would be so confidential that, to prevent its possible discovery by a rival dealer, it would have to be deferred to a private face-to-face meeting.

V

The "Fourth Gospel"

WITH the Berensons' return to I Tatti from London in December 1906 it became clear that *The North Italian Painters* required further tinkering. The manuscript had lain unregarded since Bernhard had put it aside as completed the preceding spring. Reading it together, Mary and Bernhard fell to arguing over its shortcomings, both of them "discouraged and disgusted" with it. Bernhard declared that "if it is really as bad as [your] revolting way of reading makes it sound, [I] certainly won't publish it or anything else about Italian art." They would, Mary reported, "wrangle over it and then laugh, and then pick it to pieces and end by lunch time in collapse from ennui and fatigue." Finally they agreed to work on it separately, Mary making her suggestions in the margin "in the solitude" of her study and he considering them "without heat or passion in the solitude of his."

The arrangement worked. They got on "splendidly" with the book, and Mary believed they could finish the revision in a week unless Bernhard "up and casts it into the fire." He had, she thought, "taken a nervous hatred, owing to his earlier breakdown, to writing about pictures," and she vowed, "I shall never urge him to do it again, once the book is off our hands." That "breakdown" had followed his long-sustained labor on the *Florentine Drawings*. Berenson's mother-in-law agreed with her that she had been too demanding and warned, "If thee spur him on too far all his machinery may give out and thee will have him a helpless invalid on thy hands."

The tidying-up process of the new book continued to nearly the end of December 1906, and then the two collaborators began on the Lists. The "niggling work of verifying all the numbers and references" continued into January. A letter from Putnam complaining of the cost of setting up the Lists so angered Berenson that he vowed he would give the book to

Bell, and he wrote to Putnam offering to buy back the entire series. The tactic worked. Putnam withdrew his objections. Nothing remained but the writing of the brief preface. That final chore Berenson dated "Settignano, February 1907."

Completion of *The North Italian Painters* brought a return of intellectual panic. Work on the book had quieted for a time Berenson's inordinate desire for some Goethe-like achievement, for some literary work that would dazzle his contemporaries. Now he resolved he would take time by the forelock, time that seemed to be racing by while inspiration dallied. He would at once begin a new book. He desperately sat at his desk trying to remember what he had meant by "imaginative design," a topic that Mary and Placci had urged as the subject of the new book. Soon he wailed, "All is over. What will become of me?" To quiet the inner turmoil he took a walk in the neighboring woods, from which he returned to say he had crossed the bridge into middle age, though he thought it should be called "Muddle Age," for, as Mary noted, "he can't find a single clear idea in his brain." When he went out, she jested, "he was a decrepit moribund young man, but he came back a vigorous infantile Middle-ager."

Days passed at I Tatti with a few sentences "squeezed out." Soon these grew to paragraphs and Berenson felt surer of the direction of the new book. He discussed what he was attempting with his former collegemate Professor George Carpenter. In it, he said, he would "explain the thing in pictures that is equivalent to poetry in verse." " 'For heaven's sake,' Carpenter cried, 'stick to pictures and don't touch poetry. No one would read a word you wrote on anything but pictures.' " As Bernhard flattered himself that he had more to say about literature than about painting, Mary advised him to "bring out the book under another name. It would be great sport." The pair had "very interesting discussions" over the book that reminded Mary "of earlier days when we were keen and curious," but progress was slow and he was unable to insulate himself from the incessant distractions of their half-nomadic existence. The writing gradually ground to a halt.

Whether they were at work at I Tatti, traveling together, or united only through their daily letters, the tensions between Bernhard and Mary erupted at frequent intervals in flashes of recrimination, for each was an extraordinary bundle of suppressed desires for self-fulfillment and neither much given to compromise. His resentments seemed always near the surface and in explosion would ignite her own, though she usually managed to have the last infuriating word. What he found hardest to bear was her grudging and patronizing submission. A typical outburst followed when, some months after the fire, Mary finally settled the claim

against the insurance company for £100, much of it to go for the lawyer's fee. When Bernhard flew into a rage at the meagerness of the settlement, Mary took refuge in the woods, and on her return at lunch she read him a lecture on his ingratitude. He was making it "extremely unpleasant" for her to "take the practical burdens off his shoulders." It made her "loathe that sort of work." He angrily pushed away his plate and fumed, "Well, go on loathing it." The storm passed as always, the frequent quarrels followed as frequently by affectionate armistices.

It was mainly the disappearance of romance in their union that Mary regretted. It seemed so flat to be "merely friendly and devoted" and going on "with unsaid dissatisfactions and grievances." Bernhard required more devotion than she could give, she said, and yet she insisted she was fond of him and prized his conversation above that of any other person. His feeling for her was even more difficult to gauge, mixed as it was with his dependence on her as secretary and assistant.

The differences between them were perhaps unbridgeable. Mary yearned always to "escape into new lands of youth," which—Friday's Hill having been given up—now centered in Logan's home at Iffley near Oxford. Deprived of part of her loyalty, Bernhard resented having to share her with her family and her university protégés. At St. Moritz, even in the midst of idle flirtations, he would reassert his claims by ending his daily chronicle, "More and more thine." As for unfulfilled Mary, at forty-two she could tell her mother, "I think if I had another child I should be quite happy, but nothing could induce Bernhard to have one!"

IN FEBRUARY Bernhard had to go to Rome on business, as upset about it "as if he were starting for the North Pole." He dared not delay, for his expensive household and circle of dependents strained all calculation. The annual statement from his London banker, Baring Brothers, showed an alarming drain of funds, and husband and wife anxiously reviewed the past year's expenses. Somehow more than $17,000 had slipped through their fingers. Of that total $2,000 had gone to Bernhard's family and a like sum to Mary's children. This left "some £2700 [$13,500] which went for ourselves, books, pictures, traveling, charities, household, personal expenses," about £1,200 more than their investment income. This season they were being bailed out by Mrs. Gardner's purchase of the Velasquez, which would yield $10,000 from the seller alone, 10 percent of the purchase price.

Try as she might, Mary had no aptitude for retrenchment, and as for Bernhard, the love of luxury had become second nature. In Paris he now regularly took lodging at the Ritz. Expenses seemed always to outrun income. Mary would tell him that she knew they were spending too

much. "Can't we arrange a better scheme? . . . Thee has brains, do think it out." Think as hard as he could, he had but one resource, the art market. Soon he was to lament to Mrs. Gardner, "I have become a society lounger and money grubber and God knows what. It brings one in contact with the most distressingly odious people in the whole world, the dealers." Mrs. Gardner was all sympathy. She was disturbed that he must "make money. . . . You are not that kind and should always be under a shower of gold." The shower would come, but with it inescapable bondage.

The Berensons' addiction to automobiling became even more fixed when Placci's affluent nephew joined them in the spring of 1907 to hunt for more paintings and picturesque scenery. In May they roamed about Apulia to the very tip of the heel of Italy, Berenson bursting with nervous energy as always when on the trail of paintings and wearing out his companions in the process. Mary, who had already spent a month with Karin in England at Eastertime to oversee two more operations on her ear, had to leave the party to receive her and her doctor at I Tatti. Once again Bernhard was left without her indispensable help and with only the comfort of her apology for not being able to attend to "all thy business letters and affairs."

Vehement as Bernhard's frequent outbursts against mere connoisseurship may have been, his desire to expand and revise his Lists remained an obsession that was to stay with him to the end of his life. In July he motored about England in further search of unrecorded Italian paintings "in great houses." Much as he delighted in the beauty of the country estates, he felt the landed gentry of England still clung to feudal ideas which would take a lot of dynamite to stir. "If intellect were all," he declared to Mary, "I should apply the dynamite myself. But is it all?" It was gratifying nonetheless to come upon a Pordenone, a Masaccio, and a Pesellino predella treasured by these feudal relics.

In August, as he wrote Senda, he plunged into "the same old ridiculous life" at the Hotel Caspar Badrutt in St. Moritz. "I am getting too old to enjoy this spectacle of perpetual romping," he told her, "and that is about all the smart young people seem up to." There was no mention of Montesquiou, who remained in France this season, evidently occupied with his newest exotic book, *Le Chancelier des Fleurs, Douze Stations d'Amitié.* The copy he gave Berenson would be inscribed: "À Bernhard Berenson, en souvenir et en remerciement d'une bonne parole dans une mauvaise heure: une mauvaise heure qui ne passera point; une bonne parole qui durera [in remembrance and gratitude of a good word in an evil hour: an evil hour which will not pass; a kind word which will endure]." Berenson missed his company. One summer after his depar-

ture he had written him that he regretted his absence "as I have never regretted [that of] anyone else. I am your devoted slave, the true disciple of the parable." Fortunately, other friends were nearby to divert him, the Serristoris, Placci, the Rudinis, Gladys Deacon—lovelier than ever and more "mature"—and the enigmatic Florence Blood, the inseparable companion of the Princess Ghika at the Villa Gamberaia up in Settignano. The philosopher Charles Strong, his collegemate, who had married a Rockefeller daughter, showed up and he and Berenson "metaphysicised" together.

But it was Lady Sassoon, "his latest and most ardent flame," who now mainly engrossed Bernhard's affections. At Easter Mary had written sympathetically to him, "I hope thee will find her all thee could wish. I don't feel that anything would be taken away from me, even if thee gave her a great deal of thy love." She had assured him that if suffering came, "I shall sympathize with thee dear for I begin to love *thee as thee,* not only thee as my comrade." His first letter to Mary from St. Moritz told of his delight in Lady Sassoon. He found her "apologetic" and "affectionate," and yet he kept saying to himself, "I am wasting my time." He was also flattered, as always, by the attentions of Gladys Deacon, and he rehearsed her blandishments for Mary: "She said I was always right, and I was so playful, so gay, so witty, in brief there was no one like me."

While enjoying his holiday at St. Moritz, he was shocked to learn that under a new law passed in March 1907 an alien-born American who absented himself from the country for more than five years was presumed to have lost his citizenship and his right to a passport. He wrote in outrage to his sister Senda, "The worst of it is . . . that I, brought up in the most American way, and considering myself an American of Americans, am made to feel that because I am alien born and residing abroad, America means to disown me. That would be an irony of fate, for repeatedly I might have profited by becoming a British subject, and repelled the idea as apostasy. I suppose it is very old-fashioned to be sentimental about one's national allegiance, but it will cost me real pain to exchange my American for British citizenship."

He reluctantly asked Mary to make the necessary arrangements in London. Mary reported that although he would not have to appear in person to be naturalized, there were various forms which she would have to bring for him to execute. He soon repented his indignant haste and decided to postpone further action until he should revisit the United States in 1908 and attempt in person to rebut the humiliating "presumption" in Washington itself. The British naturalization was therefore "aborted" but not without considerable expense. When the bill came Mary said, "I feel as if drops of blood were oozing out of me."

THE PROOF sheets for the *North Italians,* which had begun pouring in from Putnam in June, pursued him to St. Moritz in August. The book, 159 pages of text and 182 pages listing the paintings, finally appeared late in November 1907, having gone through the most difficult gestation of the series. The élan which had accompanied the writing of the volumes on the Venetian, Florentine, and Central Italian painters had been missing, for the northern schools, with the exception perhaps of Mantegna and Correggio, had produced no one of really first rank, no one who met the high requirements of Berenson's theory of serious art. He recapitulated that theory in the final section of the new book. "All arts," he declared, "are compounded of ideated sensations, no matter through what medium conveyed, provided they are communicated in such wise as to produce a direct effect of life-enhancement. . . . In figure painting, the type of all painting, the principal if not sole sources of life-enhancement are TACTILE VALUES, MOVEMENT, and SPACE COMPOSITION, by which I mean ideated sensations of contact, of texture, of weight, of support, of energy, and of union with one's surroundings."

The North Italian Painters, following the pattern set by the preceding books of the series, examined critically the work of the leading members of each of the northern schools. Berenson acknowledged that the North Italian artists had their particular excellences but pointed out that in every case these were overburdened by their faults. Altichieri of Verona's "gift of direct observation" was accompanied by an "exaggerated love of costume and finery." Pisanello observed details even more closely and subtly than Altichieri, but his talent was deflected by his admiration of the trappings of "the sunset of Chivalry." Like all their fellows of the northern schools, these two artists were "apt to be out of tone spiritually" with the vitalizing forces of the Renaissance which inspired the triumphs of Michelangelo, Raphael, Giorgione, and Titian. Andrea Mantegna's naive, romantic passion for antiquity, for example, led him to Romanize Christianity in his paintings to the delight of "an over-Latinized Europe," whereas his Florentine contemporaries, unfettered by a desire to imitate antiquity, rendered its historical themes in a "pure Tuscan" idiom.

Each of the remaining array of painters—Cosimo Tura, Cossa, Ercole Roberti, Moroni, Liberale, and their fellows—fell short in one respect or another of meeting the requirements of serious art. Thus the Milanese artists' besetting sin—"prettiness"—the source at once of their inferiority and their popularity, was the result of a failure to achieve that "perfect harmony between tactile values (form) and movement" from which beauty is born. "Prettiness," Berenson explained, "is all that remains of beauty when the permanent causes of the sensation are removed."

Of the entire group of the North Italians Correggio came closest to genuine mastery. His most distinguishing trait was "a sensitiveness to the charm of femininity." He surpassed Raphael as a "finer and subtler master of movement," and at his best "his contours [were] soft and flowing as only in the most exquisite of eighteenth century paintings." He too, however, fell short of greatness. He lacked "self-restraint and economy," and the excess of movement in his paintings often confused the eye.

The shortcomings of these many artists foreshadowed the twilight of Renaissance art. The final section of the book, "The Decline of Art," sounded an elegiac note. "Art form is like a rolling platform," bearing successively action and reaction. The golden age of Italian painting recorded in the four volumes had passed. Great art could return only when the entire grammar of art should again be employed and artists should "again attain tactile values and movement by observing the corporeal significance of objects and not their ready-made aspects." In the three and a half centuries that had passed since the flowering of the Renaissance, Italy had "brought forth thousands of clever and even delightful painters" but had "failed to produce a single great artist."

The North Italian Painters was widely and favorably reviewed. In New York the *Independent* applauded it as being part of the "best appraisement that has appeared in English of Renaissance painting" and "the best of antidotes for Ruskin's intoxicating rhapsodies," and the *Outlook* recommended it as containing "as much value as may be found in any of the season's publications." The London *Spectator* thought it "a pleasant relief from the ordinary art criticism of the day which has become too microscopic." Franz Wickhoff in the Viennese art journal *Kunstgeschichtliche Anzeigen* praised the book's stimulating quality. The sections on Mantegna and Correggio, he wrote, "surpass thick volumes of false scientificality [*falscher Wissenschaftlichkeit*] and of banal taste."

Roger Fry, at his first sight of the book, wrote to Berenson, "You have surpassed yourself." Reviewing it in the *Burlington Magazine,* he praised the appended Lists as having "conferred a benefit upon students which it would be hard to exaggerate." His reservations about the essays on the individual artists are reminiscent, however, of Mary's strictures on the cryptic brevity of much of Bernhard's writings. It was a relief, Fry acknowledged, to be spared "longwinded and loosely written monographs," but Berenson's desire for "condensation and compression" led him to apply too narrowly the criteria of his theory, a proceeding that resulted in "a certain amount of distortion and exaggeration." Although Fry took issue with Berenson's too-reductive analysis, he had no reservations about the "brilliant" concluding essay, "The Decline of Art."

[47]

Whatever one's agreement or disagreement with the results of his approach, Fry stated, there was no question of "the absorbing interest" of the book.

Like the other volumes in the series, *The North Italian Painters* was frequently reprinted—eight times in the following twenty years. The English texts of the four books remained almost entirely unrevised. In later years Berenson quipped that one does not tamper with a classic. In 1930 the series was gathered into a single volume—*The Italian Painters of the Renaissance*—the English version of which was republished ten times in various formats, some lavishly illustrated, the latest in 1968. Versions in translation appeared in Italian, German, French, Dutch and Flemish, Serbo-Croatian, Russian, Swedish, Japanese, Spanish, and most recently, in 1971, in Hungarian.

The four books of the series came to be spoken of as "the Four Gospels," and their status as the bible of Italian art was once satirized in some verses the American poet Leonard Bacon reported hearing in Florence:

> Down the Via Tornabuoni
> March the ranks of Scorpioni,*
> Reading swiftly as they run
> Works of Mr. Berenson,
> Who sits tight in Settignano
> On his cinquecento ano,
> Praying for more Scorpioni
> On the Via Tornabuoni.
>
> *Slang for tourist spinsters.

V I

A Home in Exile

ON Saturday, September 14, 1907, Bernhard and Mary finally got together in Paris. Lucien Henraux lent them his motorcar and chauffeur, and in two days they already had six Loire chateaux "tucked under our jackets." Bernhard followed this expedition with a tour with Lady Sassoon in her motor, after which he felt inspired to lecture Mary on the nature of love: "Falling in love hasn't anything necessarily to do with the desire for physical intimacy—quite often that would never be thought of if there wasn't a convention to that effect. . . . But alas so few people have any other kind of intimacy to give but that. They are too self-absorbed, too dishonest, too unconscious of any real inner life. Of course, a spiritual, even intellectual intimacy is far more interesting but this requires character and brains."

Bernhard still did not quite know what his feelings were toward Aline Sassoon. She did not "really count" in his life the way, for instance, the Countess Serristori did. He tried explaining to Mary that she was "a cipher which has gained value as ciphers do by numbers placed before it—her wealth, her training, her position—but *she* remains a cipher all the same, though the total comes to millions." Whatever he meant by the metaphor, he felt closely bound to her, and ardent letters streamed back and forth between them. To Mary he tried to make light of the affair, but she grew uneasy when some months later she read an opened letter left on his desk addressed to Aline, "a wrong thing to do but I wanted to believe him and yet couldn't," she confessed to her diary. "He said he had thought and dreamed of no one else while he was at Siena [with Mary] and she must never doubt him, that he was too, too solo. . . . I cannot truthfully say I could write like that to anyone because I am really fonder of Bernhard than anyone else, and Scott, the only male human being I feel much drawn to, is too young. The idea of love of that sort

advanced two million dollars on condition that he be given first choice of "some thirty pictures," including the Castagno. Berenson, relying on Duveen's assurances that Morgan had in fact consented to the Castagno's being offered to Mrs. Gardner, proposed it to her for £12,500 along with *The Profile of a Lady* attributed to Antonio Pollaiuolo from the Hainauer Collection for £12,000. It has been "my dream and hope," he romanticized of the latter painting, "that this grand work of art would enter your collection. . . . I cannot tell you how highly I prize this marvellous profile." When she hesitated at the double outlay, he urged, "Please be resolute and let no difficulty stop you." When as a final inducement he reported that the Duveens would allow one, two, or more years for payment, she cabled her acceptance of both paintings.

The *Profile* arrived promptly. "Delightfulissima," she exclaimed. "How about the Castagno?" Unfortunately, Morgan's release had not yet been obtained. Mrs. Gardner was annoyed that the Duveens had exposed her to "double dealing." She did not care for people "who sing differently different days," and, not one to pull someone else's chestnuts from the fire, she abandoned the Castagno—and the Duveens—to Morgan.

The Profile of a Lady, which now carries the title *A Woman in Green,* remained attributed to Pollaiuolo at least until 1943. In Berenson's posthumous List of 1963 it became simply "Florentine." To Mary the sharp-faced woman seemed "hideous." More charitably Philip Hendy later wrote that the subtly rendered character was "less homely than monumental." Joe Duveen had first urged his uncle Henry to sell the "Pollaiuolo" to Benjamin Altman. Henry declined. He conceded it was a great painting "but I cannot pronounce the name of the artist. . . . I would stutter and look foolish. . . . Let B.B. sell it to Mrs. Jack Gardner."

Joe Duveen, immensely pleased to have drawn into his net the foremost connoisseur in Europe, courted Berenson's opinions with the greatest deference, but his assurances could not always be relied upon. Berenson had insisted that his name not be used by Duveen when negotiating for paintings, but that injunction was promptly disregarded. Before the end of 1907 Duveen asked him to pass on a reputed Botticelli, the photograph of which he was enclosing. "I have also taken the liberty," he wrote, "of telling the intermediary . . . that if you like the photograph the picture will be submitted to you. I hope you will forgive me mentioning your name but I will never buy a Florentine School Picture without your advice." So flattered, Berenson made no protest. He advised against the purchase, explaining that the painting was only of the school of Botticelli. Duveen wrote, "I appreciate your kindness very

much indeed. . . . We have, as you know, the very best customers in the world and we have to be very careful not to make any mistakes. . . . Therefore the assistance you are giving us in this manner is of enormous value." What cash value Duveen put upon this consultation was not indicated, and there was as yet no mention of a retainer.

IF LIFE in Paris and London spun outward in ever-widening professional and social circles, that of I Tatti seemed to reverse the spin, drawing the circumambient world into itself. There on the vine-clad slope of Settignano the Villa I Tatti received under its hospitable roof a growing procession of Berenson's friends and acquaintances. Though still only tenants in their rural domain, the Berensons, after seven years, had made of the place a cosmopolitan crossroads, a center of culture and elegant refinement that seemed as firmly rooted in the Tuscan soil as the olive orchards and vineyards.

One of the newer visitors, who was to play a major role in the transformation of the villa, was the young architect Cecil Pinsent. The adopted son of their amiable English neighbor, Edmund Houghton, the young man inspired the impressionable Mary to write in her diary: "Cecil Pinsent. Glorious." Otto Gutekunst, the dealer-connoisseur of Colnaghi and Company, came down, and his "bread-and-butter" letter gives an inviting aspect of his hosts. "There was a kind of blushful happiness over you both," he wrote, "and the whole of your castle and her majesty looked superb." Among the more notable callers early in 1907 had been Frank Jewett Mather, Jr., the popular American writer on art, who for a time thought to collaborate with Mary to publish her and Bernhard's notes on Italian art. Soon afterward, Bernhard's old friend Ned Warren showed up with his housemate John Marshall in the midst of their tour buying antiques for the Metropolitan.

At the end of May J. P. Morgan arrived at Assisi in a motor caravan during a buying tour with Roger Fry. The monks, in something of a frenzy, "bowing and scraping," enveloped Morgan with solicitous attention with the obvious hope of having him buy back their convent. Rumor had it that Morgan had bought all of Prince Strozzi's "rags and tatters for $160,000." Soon after, Fry dined with the Berensons at I Tatti, and though charmed with "Mariechen," he did not warm to Bernhard, who by this time had convinced himself that Fry was something of a charlatan. Fry wrote his wife that B.B. was "quite absurd wanting to catch me out over his pictures. So I said, 'I'm very tired and I'm not even going to try to think of the attributions so will you kindly tell me what *you think* of them.' That stopped it all, but he still tried to make my ignorance as apparent as he could with very little success."

On another occasion the Austrian poet and playwright Hugo von Hofmannsthal put in an appearance. Count Francesco Papafava, the Italian philosopher and economist, accompanied by his daughter and a certain Contessa Valmarana, joined him at tea. Young von Hofmannsthal, a leader in the new romantic movement in the German drama, had published *The Death of Titian* in 1892 when only eighteen and had now become the librettist for Richard Strauss. He and Berenson hit it off together as kindred souls, and in characteristic fashion Berenson drew him into his circle. Von Hofmannsthal continued to write to the Berensons until shortly before his death twenty-two years later.

Despite the stream of visitors at I Tatti and the recurring sieges of illness, whether bladder trouble for Mary or painful boils and intermittent dyspepsia for Bernhard, there was no letup in their professional activities. With dogged persistence Bernhard would pore over photographs each morning, pencil in hand, forever making his notes. Mary's example and prodding had done their work, and getting something down on paper every day—besides the endless correspondence—had now become an obsession. Since the book on "imaginative design" would no longer march, he took refuge in the Lists. Thus in the autumn of 1907 he informed Trevy, "I am working as hard as I can over the revision of my small books, and the preparation of a volume to comprise Lists and indices to all the Italian paintings known to me." The revision proved more of a hope than a reality. The Lists were insatiable of time and effort and engrossed much of his time and Mary's for the next quarter century until, greatly enlarged, they were finally published in 1932 in a single volume titled *Italian Pictures of the Renaissance*.

In early October the artist William Rothenstein descended upon I Tatti at Berenson's invitation to do his portrait. In his *Men and Memories* Rothenstein described life at I Tatti as he observed it that fall. Scott, his Oxford prizes fresh upon him, "dark-eyed and pale," looked "strikingly like a Botticelli portrait. . . . A wonderful talker, his talk at the Berensons' was something to be remembered. Berenson, too, with his astonishing intellect, delighted in the play of ideas; he could illuminate regions, however remote, not of art only, but also of literature, philosophy, politics, history, ethics, and psychology. And sometimes we gossiped; for there were armed camps and fierce rivalries in Florence then, as in past times; but the fighting was far less bloody, concerned as it often was with attributions rather than with Ducal thrones. Berenson, Horne, Loeser, Vernon Lee, Maud Cruttwell, all had their mercenaries—and their artillery."

When the sittings with Rothenstein began, Berenson was again out of sorts with an ailing liver. Rothenstein had asked for two-hour morning

sittings. Berenson countered: "I am a restless and altogether poor sitter
. . . so you must arm yourself with patience and I shall do my best to
diminish the need thereof." By the end of October the portrait was
practically finished. It depicted Berenson standing half-length in a dark
blue cloak, his face in three-quarter profile against a background of pale
blue hills and sky. The "melancholy rather sweet expression" corre-
sponded, Mary thought, "to what B.B. thinks he is like." At first she
thought it "very good," but a month later she confided that "absolutely
NOBODY can endure" it. Bernhard paid the artist's fee of £150 without
demur.

No doubt there was a too-romantic swagger about the pose and the
idealizing expression of the face, but the artist thought well of it. He
exhibited the painting the following year in England, the *Daily Telegraph*
commenting that it was the best thing in the exhibition. Their friend
Robert Ross had reservations. When he told Berenson that "neither his
friends nor enemies recognized any likeness in the portrait," Berenson
exclaimed, "I am vain enough to enjoy being exhibited as a portrait by
Will Rothenstein in the teeth of Floppy Fry and Gloomsbury and all its
hosts."

Berenson sent a photograph of the portrait to "Michael Field," and
Field, the niece, with whom he was still a very great favorite, thanked
Rothenstein in her distinctive idiom: "So glad we are you set Bernhard
against the spaces of Tuscany—the width and austereness. A sad Bern-
hard—the record of much nerve-suffering in the face, with such sensitive
chequer of clouds about it." To Bernhard himself she explained that she
had talked to the artist about him as a subject, "the entertaining design of
your ear, the floating Luna-curves of your eyebrows, your face always
evoked words, words, words . . . but what I care for in Rothenstein's
portrait is the wide abstract country round you and something caught in
your face and eyes of the country where the true Bernhard lives while his
appearance plays with duchesses."

While Rothenstein was at work on the portrait, he dragged off the
Berensons to meet Gordon Craig, the brilliant and erratic scene designer
who had again established himself in Florence. Craig was surrounded
with assistants of both sexes, all in "barefeet and sandals and square cut
blouses." Though he had broken off with Isadora Duncan and had left
her with their child, Deirdre, she was taking part in a performance at the
theater. Mary observed that her gauze was too crumpled to be transpar-
ent and the acetylene lights "smelled like Old Scratch."

Berenson, who usually dreaded "anything 'queer,' " was at first in-
trigued by Craig's radical ideas. When Craig came to dinner, handsome
and distinguished looking despite his wide-open collar and rustic san-

dals, he spoke, in a manner to utterly charm his hosts, of a theater of no words, "nothing but light, form and movement" and of "Cubes" as actors. He talked of Cubes "with Pythagorean rapture" and tossed back his long hair with a look of inspiration. Encouraged by the Berensons' interest, he soon was on such a footing with them that he proposed they devote their "lives and fortunes" to his revolutionary cause.

The Craig ménage was "a strange, unconventional, promiscuous household, all free love and flies," as Mary Berenson saw it, and they lived from hand to mouth on the uncertain sale of his etchings. But unconventionality in Florence was not restricted to Craig's villa. Neith Hapgood cited the example of Miss Blood, who had tried to make Neith's husband, Hutchins, fall in love with her and had torn off all her clothes in his presence, displaying her "unattractive nudity." "Let it be a warning," she wrote Mary, "always to keep on at least a chemise." Algar Thorold, their guest in the Villino Corbignano, told them of the extraordinary manners of his set in Florence. For instance, he said, a young woman about to be married "asked in her ignorance what to expect and the Count and Countess gave her a tableau vivant" that left nothing to the imagination. There was also a man "called Pasquale who provides boys, enfants Jesu, for the 'Brotherhood of Pederasts'" who congregated in Florence. No one of course knew what stock to take in Algar's sensational revelations.

Gordon Craig's proposal that the Berensons subsidize his theater effectually quenched their interest in him. He had chosen the wrong moment to approach anyone for financial support, for in mid-October the Panic of 1907 had paralyzed Wall Street. The press predicted that Tennessee Coal and Iron stocks, in which Berenson had shares and which had sold for more than a hundred, was likely to fall to sixty or less. At the height of the crisis J. P. Morgan took command and extracted pledges of $50,000,000 from his banking associates with which to save key institutions from bankruptcy.

When Berenson had returned from Paris on the eve of the Panic he was "feeling very poor" because no one would pay him. The Metropolitan Museum owed him £1,800, and about £1,000 more in various ways was due. The Berensons' account in Florence was overdrawn by £800. Their situation was further complicated by the news that their landlord, Lord Westbury, had decided to sell I Tatti.

In their despair they first considered a move to England, but the thought of being obliged to live the whole year round in England "with the cold and the dark" was too much for Mary, and England as a permanent residence away from the art treasures of Italy would not have suited Bernhard. Daunted by the thought of still more debts, he was "of a half a

dozen minds at once." But friends assured them that the property was bound to rise in value and that it could be bought cheap. A week later, on December 8, Mary reported to her family that they had offered 140,000 francs ($28,000) for the place. Their offer was quickly accepted by Lord Westbury, who had been losing heavily at the gambling tables of Monte Carlo.

The estate included, besides the Villa I Tatti, "two poderi [farm tracts] worked by two families with their oxen and horses" and several substantial houses—the carpenter's house alongside the mill on the *torrente* Mensola, two contadini houses with all their farm outbuildings, and the Villino Corbignano a short way across on the farther slope. The whole comprised perhaps as much as fifty acres. They felt they had to buy so much land to prevent its being built up with small villas which would block their view of the countryside. The Italian transfer tax of 10,000 lire brought the cost to $30,000. Mary optimistically calculated that the two farms would yield about a thousand francs each, the rent of the houses another thousand, and if the rent of the villa was figured at four thousand ("which it certainly would be raised to if we could have taken it on lease"), the total annual value would be seven thousand francs or £280 ($1,400) a year, "not a bad return on £6,000 [$30,000]."

They were able to make the purchase as a result of their intimacy with their banker friend Henry White Cannon. Through him they got a loan at "absolutely incredible terms, considering the present crisis," a loan at 6 percent secured by a mortgage to run for sixteen years. It was sufficient to cover the entire purchase price. In spite of Mary's self-serving arithmetic, the purchase would entail considerable added expense. The interest on the mortgage would be approximately £350 a year and the taxes £200, as against the rent of £80 which they had been paying.

The delight of owning their own estate was rapidly enhanced, at least for Mary, by the prospect of "improvements." She was sure the place had "possibilities of almost ideal comfort." A bathroom would be added upstairs and electric light installed. Water would be brought to the upper floor from their own spring in iron pipes. Arranging for the management of the property introduced them to the Italian hierarchies of domestic authority. In consultation with Placci they hired a *fattore,* who "watches that the *contadini* do not cheat us," and a *ragioniere,* "who watches the *fattore*. We are supposed to watch the *ragioniere*." Berenson had the novel experience of discussing with the staff the "delicate question" of replacing the oxen with cows and hiring oxen for sowing and reaping.

The "improvements" multiplied in the planning, which Bernhard surrendered largely to Mary. With the architect and the *fattore* at her heels she gave her orders with enthusiastic relish. A large kitchen would be

of how wasteful it was to bother about the who-is-whos-ity of such small fry."

Reading provided the one sure solace of a harried existence. Mary carefully recorded in her diary one day in February, "He has finished reading the *Italian Journey* and is now reading a book about Rome and Goethe. He is Goethe mad as he has been for years. He is also taking up physiology!!" The next day she wrote of his putting down a volume of Guglielmo Ferrero, the young Italian historian, and exclaiming that Ferrero "picks his conclusions before they are ripe." When the two volumes of Anatole France's *Jeanne d'Arc* first appeared, he asked her to bring them with her on her return from England. His appetite for print seemed limitless. His acquisition of books in almost every field, but particularly in art, would continue to accelerate until at his death the library would be worthy of the institute of which he dreamed.

Early in 1908 while in Rome Berenson forgathered with his Florentine companions Countess Serristori, the ubiquitous Placci, and the Polish collector Count Rembelinski, whose company he especially enjoyed, to make the rounds of St. Peter's and the Borghese Gallery, Rembelinski as always impatient of Berenson's slow progress. At the Borghese Bernhard stopped long before Correggio's *Danae,* which he thought "the greatest thing here . . . a perfect representation of the sexual spasm without the least suggestion of anything hot or gross." One day Gabriele D'Annunzio came by to try to persuade him to collaborate in a book of dialogues on Art, to be written by several critics, and Placci teased, "Everybody would observe what an awful plagiarist Berenson was."

Gladys Deacon too was in Rome, living in luxury with her mother, who had become the much-pampered mistress of Prince Doria Pamphili. Gladys, incalculable and willful, and now in her mid-twenties an enigmatic figure, seemed "busy spoiling her life in a hundred ways." "She dragged me away," Bernhard told Mary, "and bewitched me with [the] ever-growing charm of her mere sex, her infinite willow-the-wispness, her caressingness. . . . It was pure song without words sort of hour so that I cannot recall anything said." Hers was a vision that could, at least temporarily, displace that of Lady Sassoon. She was, he told her, his "beloved Gorgon," and anticipating a meeting with her at St. Moritz he could write, "We shall mellifluize about diverse irridescences, ungraspables, and intangibles." At the end of April, when she came to meet the Berensons at the railway station as they were passing through Rome on their way to Naples and the Floridiana, she was "so marvellous and radiant that people started as if they had been shot when they chanced to meet her." Mary noted that she was taller than her own five feet eight and a quarter. But if she stood a couple of inches over Bernhard, her

"deliciously slender and willowy figure," unlike Mary's bulk, put him at no disadvantage. Her great blue eyes exercised an uncanny charm, and Albert Spalding, the youthful violinist who was playing to many "bravos" on his tour in Italy, circled round her on the platform, "his eyes dancing with excitement and joy."

Bernhard and Mary returned to Florence from the comforts of the Floridiana in time to greet a fresh influx of visitors at the height of the social season. One of them, Gustave Schlumberger, the noted Byzantinist and social lion, appreciatively recorded in *Mes Souvenirs* his meeting the eminent socialist writer Gaetano Salvemini at the American-British ménage of the Berensons. He thought I Tatti a *veritable paradis*. On May 7 Placci joined the Berensons for a month's tour of Sicily in two automobiles manned by his nephews. They circumnavigated Sicily, visiting the chief classical sites and foraging for paintings, frescoes, and mosaics. In Palermo Berenson forced himself to see sixteen churches in a single morning before attending a huge ceremonial luncheon as guest of the Marsala wine people. When the party returned to the mainland, they went from one palatial villa to another calling on Placci's affluent friends before going on to Naples and the Floridiana.

Back at I Tatti by June 9, Berenson was immediately involved in the matter of "improvements" being commissioned by Mary. Decisions had to be made, for the work was to be done during their summer travels and their trip to the United States. They planned to build a new contadino's house, farther off, the present one to be ready "for any nice friend or relative to inhabit it." At the moment Bernhard was again spending most of the day ill in bed. Once revived, he took his place at the head of the table when Leo and Gertrude Stein came to dinner. He was not up, however, to the lively and alien chatter and, to Mary's embarrassment, said things "so horribly inapropos that one shivered." Berenson may have shivered a bit himself at Leo Stein's monologue on the virtues of thorough mastication, Fletcherizing food, for he spared them "no detail of the effect on the stomach and intestines."

Gertrude found her host a fascinating subject for analysis and inscribed in her notebooks characterizations of him in her special idiom. "He thinks he is great all the time but it isn't his mind; it is his moments of exquisite creative perception that completely expressed themselves. . . . The real sensibility in him is one of affection. . . . He likes the sensation of being tortured and being mellifluous is all B.B.'s sexuality amounts to, he is not sweet. . . . I think B.B. is intellectual, honest, sensitive on top, the below is the male version of the most perfect balance of flavor and lady which often slops over into a bad expression as when he wants and thinks he can do flavor straight."

he was deep in *Moby Dick,* long before its vogue—"Melville's horrible, fascinating, sublime, provincial, stupid, over-transcendental, but altogether irresistible, even when most prolix, Moby-Dick."

This season Montesquiou figured in his roll call of notables and of female beauties, but it was with Gladys Deacon, who inspired alternately fatherly and loverlike feelings, that Berenson most enjoyed "mellifluizing." "She has been monkeying with her face, as hitherto with her nose," he informed Mary; "consequently she has lost her beautiful oval and her mouth is queer. But she retains all her radiance." Her "elixir ways" still captivated, and Berenson spent an ecstatic day with her on the nearby glaciers.

While at St. Moritz he learned of Mrs. Gardner's second "muddle" with the United States Customs office. She wrote that she was being "forced to pay instanter $70,000, most of it for penalty for which there is absolutely no reason and that is only the beginning. They are holding over my head an extra penalty of $150,000, confiscation and imprisonment! No telling when you arrive I may be in jail. Otherwise I shall be here longing for you." She had unfortunately allowed or—as some hostile skeptics averred—persuaded her friend Mrs. Chadbourne to attempt to smuggle in a number of valuable works of art in a duty-free shipment of Mrs. Chadbourne's household effects. Mrs. Chadbourne had intended the shipment, according to Mrs. Gardner, as a "pleasant surprise." An inquisitive customs agent, struck by the size of one of the crates, opened it and gazed upon the *Hercules,* the five-by-four-foot fresco by Piero della Francesca which she had bought through her friend Joseph Lindon Smith in 1906. When the remaining objects of art were brought to light, the collection was formally appraised at $80,000. In the end the imbroglio cost her $150,000, the penalties plus the appraised value.

Berenson left St. Moritz on the new railway in a driving snowstorm, and by September 17 he had tumbled "into the very lap of the most refined, back-comforting, eye-caressing, tummy comforting, soul-soothing luxury" at the Villa Trianon, "every hair" on Elsie de Wolfe's head "and every stitch on her body singing together an ideated 18th century song of greeting." Left alone for a day, he picked up again *The Education of Henry Adams.* "You know," he wrote, "I have seldom looked forward to anything as I have to returning to this singular autobiography. . . . It is not easy reading, for the style is over-Jamesian for my intelligence, and assumes too much knowledge of last century history and personality." After finishing *The Education* he reexamined Elsie's copy of the *Mont Saint Michel and Chartres,* finding it "interesting and even remarkable. What coquetry not to publish such masterpieces! *Mais c'est un beau geste.*"

Henry Adams appeared at tea in the wake of his masterpieces, and Berenson was "amazed at his appearance. He wore a suit of rusty black, a cutaway of some twenty-five years standing, and looked like an elderly laborer, respectable when not in drink, but he has fascinated me and as he is really most unworldly he was not sorry to have someone to talk to and we chatted for an hour until our hostesses separated us." Adams reported to Elizabeth Cameron that Berenson had "the unpardonable fault of being intelligent and unsupportable, and, by the way, ill."

Mary was by this time in the United States, and Bernhard enjoyed his solitary stay in Paris to the full, dining out incessantly and matching wits and anecdotes with an ever-widening circle of friends and acquaintances. With Gustave Schlumberger, who took great pride in his aristocratic and military connections, he held inquest over their friend Salomon Reinach and his family. They agreed that Salomon was the most lovable of the Reinach clan, but Berenson, still smarting over his prudential silence among the anti-Dreyfusards at St. Moritz, felt that "at bottom Salomon despises me, and regards me as a scoundrel because I will not fight for Jewish old clothes, which even he won't wear on his back, although he will flaunt them as a flag."

One of his visits took him to Le Bréau, the artist Walter Gay's chateau. "My dear," he confided to Mary, "it is a dream of your and my kind of thing. Of course far grander than anything we can ever hope to attain." Nonetheless, it whetted his appetite for the improving of I Tatti. At Le Mans he recaptured his intoxicating first impressions of the stained glass in the cathedral where the bold union of Romanesque and Gothic architecture defied criticism. But on the outskirts of the town he encountered a portent that took the edge off his delight. Wilbur Wright's airplane was on view at the aerodrome where a short time before Wright had amazed the French experts by successfully flying a figure-8 course at speeds of up to fifty miles an hour. "I cannot tell you," Bernhard wrote Mary in New York, "how I disliked the thing, this innocent monster which will destroy the world I love, the world of level vision, or vision from down upwards, the world of privacy, the world to which our species, and further back, our genus has been used to for millions of years."

A REMARKABLE encounter with Matisse came on a day in October 1908 which began with a luncheon with the French painter Maurice Denis, a spokesman of the Nabi group of Gauguin's followers. For Berenson it proved "a modern art day with a vengeance." Denis' studio was filled with scores of paintings by his contemporaries, and Berenson was bewildered trying to grasp them; the painter René Piot was also present but

[65]

to a year's service at Laval University. Berenson had already had some correspondence with him, but they seem not to have met until this voyage. Gillet was dazzled by Berenson's erudite conversation as by "a stroke of intellectual lightning [*coup de foudre intellectuel*]." Berenson's psychological method of art criticism, he felt, overturned for him all the conventional notions of his youth and effected a kind of conversion. Much impressed by the younger man's lively interest, Berenson authorized him to translate his four books on the Italian painters of the Renaissance. Gillet began a translation of the *Venetians* almost immediately, but the work went slowly, and in the following years there was much friendly and fastidious consultation over its progress and its revision. Berenson suggested possible recourse for help to Salomon Reinach, to Charles Du Bos, and even to Henri Bergson. Bergson, he felt, would be the ideal reviser, but he thought it would be a crime to pile "yet another labor on his shoulders." He added, "Perhaps I may be forgiven for reminding you that I am too often too brief, or indeed confused, to be clear, and that you will require the patience of angels to penetrate my meaning to the point whence you will be able to reincarnate it in your lucid prose." World War I intervened, and it was not until 1934 that the complete translation came out in book form.

V I I I

America the Plutocratic

I N anticipation of Bernhard's imminent arrival, Mary had proceeded
to New York to engage accommodations for them. She had expected
that they would stop at the luxurious Plaza Hotel as they had five
years before but was shocked to discover that nothing was available
under seventeen dollars. She therefore reserved a suite of rooms at the
Park Avenue Hotel for six dollars a day. Bernhard joined her there when
he disembarked on Saturday, October 25. On Monday morning he pre-
sented himself at the Duveen Gallery just in time for an anxious confer-
ence over a bust that the Duveens had sold to Widener and that Berenson
believed might be a fake. How to recall the bust diplomatically required
earnest discussion. There were already signs that the dealers who had
supplied Widener were aware that Berenson had agreed to catalogue his
collection and were acutely unhappy at the prospect. Fortunately they
were spared embarrassment for several years, since the catalogue was not
ready until 1916, the year after Peter Widener's death.

The voyage on the *Provence* had been a rough one, and Berenson's
digestion and nerves had suffered so grievously that a visit to a doctor
famed for a kind of "nerve center massage" was deemed advisable. The
diagnosis—that Berenson's nerve centers did not throw off their waste
and thus poisoned him—left him unconvinced. In any event, within a
few days he was able to dine out enjoyably at the Colony Club with Miss
Marbury, who had already lined up four lectures there for Mary in
January 1909. Her hospitality proved too much for Bernhard, for a po-
tent Manhattan cocktail she persuaded him to try so undid him that he
could hardly raise his head the next day. Mischance or not, he had to
proceed on schedule. The "first law of the universe," he wryly jested,
was " 'Thou must muddle along somehow.' "

With the help of Mrs. Henry Cannon the Berensons engaged an apart-

ment for the return to New York in January at the Webster Hotel on East Forty-fifth—two bedrooms, a sitting room, and bath for eight dollars a day—and then they set off for Boston on the Knickerbocker Express, amazed by its luxury. They were put up at the comfortable home of Berenson's parents in Stockton Street in Dorchester, where providentially they were left much to themselves. The "little mother" tactfully avoided reproaching her favorite son for continuing his exile, and his choleric father tended to keep to himself, his son's interests now quite remote from his circumscribed world. Senda and Elizabeth were busy with their gymnastic classes at Smith, but Rachel was near at hand in Cambridge and much occupied with her lively baby, Ralph Barton Perry, Jr. Meanwhile more lecture dates for Mary accumulated—talks on Italian art at Wellesley College and at Bryn Mawr and a talk at her sister-in-law Rachel's home to Harvard faculty women, whose dowdiness, she said, made her feel positively chic.

Mrs. Gardner came out to visit the pair in Dorchester, and after explaining again how her friend had tried to smuggle her art works into the country in a misguided gesture of friendship, she announced she was selling some of her diamonds to pay her fine. Her friends must have been sympathetic, for the import duties had long irked and challenged the American traveler. Years earlier, for example, Henry Adams had written to Mrs. Cameron that the American diplomat Wayne MacVeagh and his wife "are coming up the lift, with much nervous alarm, at eleven and I am to tell them what to take home to cheat the Custom House."

Once settled at the Somerset Hotel in Boston, Bernhard and Mary were soon swept into a continuous succession of social engagements, lunching with the aged Edward Everett Hale, "as lively in mind and talk as a young man," with George Santayana, who was "most agreeable as he always is," and with the Ralph Curtises, who were much in evidence. It was their Palazzo Barbaro in Venice that Mrs. Gardner used to rent from Ralph's father. Curtis, whose wit constantly enlivened his letters and conversation, could not forbear referring at their meeting to their imperious patroness as "Was-a-bella." Mary found it all less interesting than before, but Bernhard, she reported, was "simply dripping with the milk of human kindness and finds everybody nice and enjoys people without expecting either conversation or intellectual sympathy."

One of the most agreeable gatherings was a "little lunch" on a Sunday at Mrs. Gardner's "Palace" at which the handsome Dr. Morton Prince, his wife, and Santayana joined in the kind of talk that the Berensons felt made for the art of conversation. Prince was the author of the popular *Disassociation of a Personality,* a subject in which Mary Berenson had

become engrossed. The Berensons also enjoyed being lionized at a huge afternoon reception which Barrett Wendell gave them.

In sharp contrast to these lively affairs was the Thanksgiving dinner at the Berensons' in Dorchester. "It was awful," Mary exclaimed. Soon afterward Bernhard and Mary escaped for a week to the luxury of Mrs. Peter Cooper Hewitt's estate at Tuxedo Park in the Ramapos Mountains, northwest of New York City, where they observed how vast sums of money could be used to "stave off ennui." They also dined with Ralph Adams Cram and his pretty wife and heard him boast that he was "a fervent Catholic" who was "able sometimes to believe as many as seven impossible things before breakfast." His Gothic-style churches were already becoming a striking feature of a number of American cities. Mary thought him a "belated and bigoted Ruskinian" who adored the Gothic and abhorred the Renaissance. Berenson, who had been greatly moved by Adams' *Mont Saint Michel and Chartres,* made room in his aesthetics for this heretical enthusiasm. He and Cram "vowed eternal friendship," and the two men exchanged affectionate letters until Cram's death thirty-three years later.

Page proofs poured in at the Somerset from Putnam for the new editions of *The Central Italian Painters of the Renaissance* and *The Florentine Painters of the Renaissance.* There were only minor changes in the text, but the greatly increased lists of paintings reflected the Berensons' diligent explorations. It was evident that the publisher could count on a steady, if modest, sale of the handbooks.

Welcome as were the royalties from Bernhard's books, they could by no means free him from his dependence on earnings in the art trade. He had brought with him several photographs of paintings offered by dealers in Europe, and these he showed with some success to prospective purchasers. By the end of 1908 he had earned $4,000 from the sale of three pictures. In addition Widener bought a painting from the Duveens on his advice, entitling him to a fee of $5,000. This was shortly followed by an unexpected check for $550, which the appreciative Johnson sent when he bought a painting that Berenson had happened to admire in a Washington collection. The gesture elicited Mary's delighted comment: "It certainly is a country where money is dropped around." Welcome too was an unexpected $1,000 from an 11 percent dividend on Berenson's Great Northern Railway stock.

One sale to Johnson gave the Berensons little satisfaction, though it enabled Bernhard finally to complete the payment of the $10,000 debt to Baring Brothers. It was the sale of the Perugino *Madonna* that he had once offered to Mrs. Gardner for £4,500. Mary had become greatly

attached to it, for it hung in her mother's house at Iffley. But their need for cash was insatiable, and Bernhard let it go to Johnson for £2,000.

Mrs. Gardner, still eager to add to her collection, managed to lay her hands on funds to buy a bronze bust through Berenson from Gimpel for $9,000. Not being an expert in Italian sculpture, Berenson relied on the assurances of Gimpel and Wildenstein that it was by Alamanno Rinuccini and dated from the 1500s. Though it was obviously aesthetically pleasing and full of tactile values, a quarter century later experts speculated that it was probably a nineteenth-century imitation. An important acquisition that Mrs. Gardner would make in February 1910 was the arresting *A Doctor of Law* by Francisco de Zubarán offered her by the Ehrich Gallery in New York for $22,000. She asked for Berenson's approval while he was still in the United States—"I should hate to like something you don't like." Mary had reassured her that they both admired it and added that Archer Huntington had been anxious to get it for his new Spanish museum and Philip Lydig for his "Red Room."

At the end of November 1908 the Berensons had returned to New York and were immediately entertained by Elsie de Wolfe at a large dinner and theater party to see Clyde Fitch's *The Blue Mouse,* a farcical intrigue in which an ambitious employee tries to obtain a business promotion by using his wife to play upon the president of the firm's weakness for pretty women. Both Berensons were revolted by the blatant vulgarizing of romantic love. Bernhard "nearly fainted with disgust," and they got back to their hotel in "absolute despair and gloom." The *New York Times* reviewer, perhaps made of much hardier and coarser stuff, described the play as a "sidesplitting comedy." Though the theatrical season glittered with the names of Ethel Barrymore, Mrs. Fiske, Anna Held, George Arliss, Lillian Russell, William Gillette, and Billie Burke, *The Blue Mouse* was the Berensons' only sampling of the New York stage.

When they were invited by J. P. Morgan to see his library, they were properly impressed with his wonderful book collection. But the "great many fine objects of art" appeared to them to be "mixed with forgeries." Morgan was "genial and pleasant" and promised to give Berenson a copy of all his catalogues. As they strolled about he remarked, "I hear you are going to Philadelphia to bust up Widener's collection."

Morgan's collections did impress Berenson, but what left a far more lasting impression on him was his introduction to Belle da Costa Greene, the twenty-six-year-old curator of rare books and manuscripts in Morgan's library. Belle Greene had been recruited by Morgan's nephew while she was working in the Princeton University library, where she had become expert in the cataloguing of rare books. Though she had

been in Morgan's service only four years at the time of her meeting with Berenson, she was already a trusted agent whose keen intelligence made her welcome to dealers and museum directors. As Morgan's protégée she was the darling of the rich and powerful with whom he associated, the Rockefellers, the Harrimans, and their like. Much sought after and flirtatious, she had the air of a mysterious princess. She was a svelte, dark-haired, strangely beautiful young woman, the dusky oval of her face suggesting an exotic origin—"Malay," Berenson afterward reflected. The forty-three-year-old Berenson had never met anyone with her singular glamour and vitality, and he instantly succumbed. His effect upon her was equally electric. If Mary sensed this sudden incandescence, she made no note of it or perhaps dismissed it as a passing fancy like so many others. Her first impression of Belle Greene suggests she thought her an unlikely candidate for a romance with the fastidious Bernhard. To her daughter Ray at Bryn Mawr she described her as a "most wild and woolly and EXTRAORDINARY young person."

Shortly after their encounter Belle Greene wrote to Berenson, "I am so glad that you are going to be *a real friend."* They at once began frequent meetings. Separated for a few days when he made a duty visit to Boston, she replied to his passionate avowals, "Dear Man of my Heart . . . I have been with you in thought every moment since you left me. I have wished for you at dinners, at the theater and opera; morning, afternoon and night, my thoughts have been wrapped around you, as I should wish to be."

So began the one romance in Berenson's life that would stand apart from all others in depth and intensity. None would cause him longer seasons of lovesick anguish. Its tumultuous course and gradual subsidence would be charted in the more than six hundred of her carefully treasured letters.

In December the Berensons proceeded to Philadelphia to begin cataloguing the John Graver Johnson Collection. Bernhard had written Johnson a few weeks earlier that if he was "still of a mind to have me catalogue your Italians . . . it would amuse me greatly, for from the art historian's point of view yours is certainly the most comprehensive collection in this country." At the same time he offered, among a few other possibilities, his own Dosso Dossi, which he had left with Glaenzer. "Squillionaires have not bitten. I need the money and I cannot bear to peddle pictures, so I am offering it to you at a price that will yield me a decent profit on my investment." Johnson took it without demur for $5,000.

The preliminary work for the catalogue went forward rapidly, though it came to a standstill on Berenson's return to I Tatti and the catalogue

was not completed until 1912, after much consultation by mail over photographs.

The Berensons' second assignment in Philadelphia was to begin work on a catalogue of the Italian paintings in Peter Widener's collection at Lynnewood Hall in nearby Elkins Park, where the refurbishing and extending of the magnificent galleries had already begun. The Berensons were touched by the humility of the seventy-four-year-old man who followed after them "asking of every picture, 'Mr. Berenson is this a gallery picture, or a furniture picture, or must it go to the cellar?'" and who was content if they allowed a picture to remain "though shorn of its great name." Fortunately for Berenson, Widener had been prepared for the worst by the recent visit of the great Dutch expert De Groot, who had already weeded out about 150 Dutch and Flemish pictures.

The "purified" list of Widener's Italian paintings which Berenson made at that time was to serve as the preliminary basis for the catalogue; added to the list would be the many paintings purchased by his son, Joseph, through the Duveens and other dealers with Berenson's advice or approval. In 1912 Joseph sent over "a list of the remaining pictures of the Italian school in our collection," noting the changes since the original list. "I can't but feel," he then wrote, "that the collection has been absolutely purified. . . . You really can't imagine how delightful the new galleries are with the elimination of all unimportant pictures."

Mary, on home ground in Philadelphia, gave three lectures to crowded chapels at Bryn Mawr on the new methods of art study illustrated with slides of "hands, ears, hair, etc.," a variation of her earlier lectures. After the first of the series, Carey Thomas assured her that hers was a better lecture than the one Roger Fry had given on the same subject. Mary had also prepared and copyrighted a thirty-eight-page booklet, "A Tentative List of Italian Pictures Worth Seeing," for the use of art students at Bryn Mawr. It sold like "hot cakes" there and at her subsequent lectures at the Colony Club in New York. Distinctly fashionable audiences attended her Colony Club lectures. At the first of the series Mrs. J. P. Morgan, swathed in black, sat in the front row. Bernhard was permitted to attend the second one, and "even he was very much pleased," saying she had "a real genius for that sort of thing."

The renewal of Berenson's passport proved a surprisingly simple chore. The head of the passport division said "with a wink, 'Of course you are obliged to stay abroad for the present for educational purposes'" and promptly issued the prized document. While in Washington Berenson called on the art dealer V. C. Fischer, who professed to be the intimate friend of John Hay, Senator Henry Cabot Lodge, and President Theodore Roosevelt. Fischer called the White House "to ask Teddy

when he could bring Berenson around." An invitation was immediately forthcoming, and two days later Berenson, accompanied by Fischer, presented himself at the White House and was ushered into the Cabinet Room. It was filled, he told Mrs. Gardner, "with Senators, Chiefs of Staff, *coiffés en hommes de génie,* generals, etc. . . . Finally doors were folded back and out stepped a small, younger, slighter looking man than I expected and walked up to us. . . . Fischer introduced me in the thickest of [German] accents as the greatest critic of Italian art in the world. . . . The President pleasantly remarked that he knew all about Mr. Berrington. . . . He then chatted truly delightfully, easily, cordially for exactly five minutes and then dismissed us." In his report to Mary Bernhard added a few details. Roosevelt had greeted them with "a most expansive smile" and "showed even his back teeth," and when they left he had said, "Goodbye, Mr. Berrington, *so* pleased to have made your acquaintance."

Mary was furious that Bernhard had been introduced to the president by a mere art dealer, but Henry Adams tranquilized her at one of his noontime "breakfasts" with characteristic irony, saying that "no one here was more intimate with the President" and that Roosevelt "had even lent Fischer his copy of *The Education of Henry Adams.*"

Time passed agreeably enough in Washington, where Bernhard and Mary had daily luncheon and dinner engagements. They called on Henry Adams' neighbor and longtime friend Mrs. Cameron, for whom Berenson had ambivalent feelings. Senator Lodge, at luncheon, lent them a copy of Adams' anonymously published novel *Democracy,* whose authorship Adams regularly denied. Their most frequent contact was with Henry Adams himself, who had overcome his initial dislike of Berenson. Berenson felt that " 'Conservative Anarchists' [Adams' favorite self-characterization] of our type do not easily find playfellows. But Henry Adams is a great resource." Berenson's conversation evidently had the necessary satirical bite to please Adams, who invited him back a number of times for "pleasantly pessimistic talk" of a world whose degradation of energy was now Adams' preoccupation. Adams found Berenson's air of sated worldliness agreeably diverting. "We are all becoming Berensons," he remarked to a friend. "I am frankly thirteenth century myself. He is fifteenth, which I think decadent."

During Berenson's weeks in the United States, relations with the Duveens had become very close. Confidential letters from the firm spoke of collections to be inspected and of paintings being negotiated for. Mrs. John Jacob Astor wished him to dine with her when he reached New York. Mary wrote that "dealers tell him his sayings are repeated from one to another, and that no one has such influence in picture selling."

The arrangement with the Duveens continued to be highly informal, the sort to be spoken in confidence and sealed with a handshake. Berenson remained free to trade on his own or through other dealers who were eager for his expert services. While in New York, for example, he received a cordial letter from David Croal Thomson, whose partnership with Lockett Agnew had just ended, telling of his new partnership with the French Galleries in Old Bond Street, in which situation he "would be perfectly free and would like to be in special relation with you."

Early in January 1909 Berenson, again in New York, went with Johnson to Henry Frick's palace on Fifth Avenue, and as they sauntered through the galleries Johnson took him into "corners to gloat on the way" Mr. Frick had been exploited by dealers. Frick proudly brought down his daughter Helen's school notebooks containing abstracts from Berenson's books, which he said were "much studied in fashionable girls' schools." His cordial reception inspired Mary's pleased speculation, "It may lead to something."

Most portentous of all was the fact that a succession of emissaries came to Berenson from Benjamin Altman, one of the Duveens' principal clients, asking for a conference. Berenson's hopes rose that here at last he might be invited to help form a great collection like Mrs. Gardner's. Summoned to Altman's "enormous shop" on Fifth Avenue, he could hardly believe his good fortune when Altman said to him, "Mr. Berenson, I like you and I'm going to trust you implicitly and never believe anything anyone may say against you. I want you to make me the finest collection of pictures in the world and make your fortune out of it too. I don't care what I spend, nor how much you make." The offer could not have been more breathtaking, though Berenson at once glimpsed difficulties. Right off Altman proposed buying the Quincy Shaw collection in Boston, and Berenson had to explain that it was promised by the heirs to the Museum of Fine Arts. To his alarm he also learned that prospective purchases would have to be approved by Altman's head buyer in Paris, a person whose chief expertise was in ladies' gowns.

Filled with hope despite these unfavorable omens, Berenson went to Altman with photographs of "four pictures of the very first order, a Velasquez, two El Grecos, and a Rembrandt," and was closeted with him and his personal adviser. When they emerged, "a look of weary discouragement had settled" on Berenson's face. Altman genially remarked that he was not going to buy anything unless it struck his fancy. Mary plunged in and said his "fancy needed education." His adviser "cast his eyes up to heaven in deprecation of such audacity but Altman asked to see the photographs again."

Altman's shopkeeper's caution irritated the Berensons. Besides he

seemed "hardly to know even a name," being accustomed to "Dutch pictures and pictures of the Barbizon school." And they suspected that his adviser feared Berenson would "try to impose *his* taste on him," precisely of course what Berenson had in mind. To cater to Altman's narrow taste "wouldn't be a bit of fun" and just to make money wouldn't be worth "our leisure and our preoccupation," Mary reflected. Still there was a chance, however problematical, of making a great collection. Berenson told Mary that he could do it only if she decided really to help him "and put their common work first."

Although Bernhard was disheartened at being obliged to deal with "such an ignorant old man" and with such "an insinuating and hostile counsellor," Mary enjoyed the byplay, thinking it perfectly natural that Altman should hesitate spending a half-million dollars on pictures he loathed "in the hope of educating himself." To add to Berenson's humiliation Altman complimented him on having the "makings of one of the best merchants he ever saw." In the sequel Altman proved an exasperatingly timid and meticulous client far different from Mrs. Gardner, Johnson, Widener, and Henry Walters, and the dream of creating another great collection gradually faded away.

By this time Berenson was very much in the confidence of "Uncle Henry" Duveen, who sought his judgment of the market even outside the Italian field. For example, when Joe Duveen offered £35,000 for one of the greatest Holbein masterpieces, the *Duchess of Milan,* for which the owner, the duke of Norfolk, was said to be asking £50,000, Henry thought the firm might go up to £40,000 if necessary. "Before doing so," he wrote Berenson, "I should like your views on the subject. . . . What is your opinion of the picture itself? . . . We should have your opinion before we do anything definite." Encouraged by Berenson's reply, the firm finally raised their offer to £50,000.

Late in January 1909 Berenson returned with Mary to Philadelphia to make further notes on Johnson's collection and to "see and catalogue four little pictures which Johnson had just bought, at a price unusually high for him." They were pictures which both Fry and Herbert Horne had guaranteed as genuine Botticellis. Horne, who resided in Florence, was an English art collector and the author of a book on Botticelli. Berenson looked at the pictures incredulously. "For heaven's sake, Mary, unhook them and bring them to the light, and see if they *can't* be Botticellis. I'd rather have lost a thousand pounds than have had this happen." It was a dilemma, for if they were not catalogued as Botticellis, it would "be the last straw" that would break Berenson's slim ties with the British art establishment. Berenson was so dismayed that for a moment he thought he would abandon the catalogue. Johnson, who natu-

rally had to be told that they were not by the master, suggested "with his lawyer's cunning," as Mary put it to her mother, that they could be put with later purchases into a supplement "not written by BB, and that he could [use] Fry's and Horne's own notes."

Berenson's disbelief must have been inspired largely by his mistrust of both Fry and Horne, for afterward on more sober and leisurely study he decided that the four panels were indeed by Botticelli and he so entered them in the catalogue and in his subsequent lists.

Again in New York the tempo of life was exhilarating and the air seemed full of promise. And once again Bernhard could spend blissful hours with Belle Greene. Business too had its flattering excitements. He turned down an offer from an important dealer of a retainer of $25,000 a year, fearful that it would spoil his reputation as a scholar to tie himself to one firm. He succeeded not only in attending to his own burgeoning affairs with the Duveens and other dealers as an expert consultant but also in disposing of some pictures for his friend F. Mason Perkins, who was living in straitened circumstances in Assisi. Lucy, Perkins' estranged wife, was working at the Metropolitan and was unhappy there. Mary, always eager to play "Providence," engaged her as Bernhard's secretary to lighten her own growing responsibilities. There would be "no danger to B.B.'s susceptible heart," she reflected, "for she would not live with them but come up from Florence."

Business and pleasure continued to be inextricably mixed in that affluent society. At a party at the Norman Hapgoods', Mrs. Hapgood's strikingly ornate attire made her look, Berenson thought, like "the Whore of Babylon." The Archer Huntingtons exuded flattery and wealth. Huntington particularly impressed Mary, for whenever they met he pressed her hand to his heart and boomed out, "This is the most wonderful woman in the world." At a select dinner party at Mrs. Otto Kahn's home, Bernhard and Mary both wept sentimental tears listening to the singing of "The Erl King" and "The Two Grenadiers," "an awful thing to do in such a select and squillionarish audience." The debauch of sentiment—and rich food—condemned Bernhard to bed and the consolation of an icebag. On a shopping expedition Elsie de Wolfe selected for Mary a dress of black satin and long lines of jet in an overskirt, and Bernhard was "in raptures" when he saw it. For a solid week dinners and luncheons filled their days until it was time to run up to Boston for a last visit.

At his parents' home Berenson experienced his usual letdown. He would stretch out on the sofa with his eyes closed and his thoughts adrift or talk "stocks with his brother." In Boston he sat for his portrait by Denman Ross and paid his court to Mrs. Gardner. A return to New

York on business allowed for more rapturous sessions with Belle. Mary, who stayed on in Boston to lecture at Fenway Court, seems to have been unaware of the romantic attachment which had developed between Bernhard and Belle. When she came down with a case of shingles in Boston, she summoned Ray to help her and arranged for Belle to be there "so the two girls will have some fun together."

In New York there was a farewell dinner party for the Berensons at Mrs. John Jacob Astor's home. The conversation at table concerned "the marvellous intellects of various demi-mondaines"; ironically, Lady Cunard was present, and they all knew that she had a bedfellow at the Plaza, "a horrid little English snipe" who had come over with her. An accident to the electric wiring in her room at the Plaza had made her liaison public. Born Maud Burke to wealthy parents in San Francisco, Lady Cunard had married Sir Bache Cunard in 1895. Though a loveless union, it had enabled her to establish herself as a leading London hostess with a penchant for "lions."

As if to put a seal on the success of Berenson's visit to America, the grateful Johnson sent him a present before he sailed, a check for $3,000 to express his pleasure in a picture that Berenson had got for him. "It will pay for our motor," Mary exulted. Affairs had gone so swimmingly that Berenson, to reduce the "horrors" of the voyage, took a parlor suite with a private bath on the *Mauretania* for their return trip. The "horrors" were further reduced by a circumstance Mary reported in a shipboard letter to Mrs. Gardner: "The end of our fantastic American adventure has been finding ourselves, all undeserving, in what is known as the 'Millionaires' Corner' at a table with Mrs. Potter Palmer." Bernhard was flirting with "the prettiest lady on board," the actress Maxine Elliott, "and with the naughtiest, Lady Cunard."

What Mary did not report—and did not know—was that Bernhard had ordered a gift for Belle Greene before leaving New York. It was a gift with a special significance, the sixteen-volume French edition of *The Thousand and One Nights,* his favorite reading. Nor did Mary know that he had sent a loving note to her from the departing ship. Her passionate answer, written on the "very night of the day you left me," followed him to London. On it he carefully recorded the omitted date: "March 17, 09."

IX

The Pursuit of Life Enhancement

THE Berensons landed in Liverpool on March 22, 1909, after a record-setting run by the *Mauretania* of just under five days. Though Bernhard may have been unhappy at parting from Belle Greene, he nevertheless managed to shine with his usual brilliance in the conversation of the "Millionaires' Corner." From London he airily reported to Mrs. Gardner that his time was divided between Mrs. Potter Palmer and the London dealers. At the moment Mrs. Potter Palmer's collection of paintings was tantalizing the dealers, for she had shown a desire to sell off her Barbizons, which she thought were unsuited to her baroque chateau on Lake Shore Drive in Chicago. When she balked at paying 10 percent commission to David Croal Thomson of the French Galleries, Thomson asked Berenson to use his good offices with her because "the real last word lies with your own influential self."

For the moment Thomson's difficulties probably took second place in Berenson's mind, for he had in his possession to read and reread Belle's letter of March 17. "Desire of my heart," it began, "To settle to what is before me—the hours, the days, the months and years without you—is to settle to a dull gray despair or else certain madness." She would love to be with him in London, "to see those wonderful things with your eyes. . . . If you see any of my friends tell them they are seeing the best of me in you." Three days later she was marveling, "What a large factor you have become in my life. . . . Whatever happens nothing can change or take from us the wonderful months we *have* lived together and if it is true as you say that a greater more glorious and all-filling joy is in store for us . . . then nothing that might come between us shall count in the least."

Berenson had enjoined her to write often and share with him the details of her daily life and her innermost thoughts. Thrilled to have such

an adoring confidant, she poured out her feelings at extravagant length, her bulky letters frequently crossing his. One can only guess at the character of his letters to her for, before her death in 1950, she destroyed all of them, but their fervor must surely have matched that of hers. Of one which he sent her at this time, she wrote that it was "a living breathing caress—it filled all my senses with a delicious intoxicating delight." If in the first months he flagged in the least bit in his attentions, she murmured, "Why do you write me only once a week?" When he reproached her for a similar lapse, she explained that her "Boss is so unaccountably prejudiced against you and even dislikes me to write to you."

Much indeed was "in store" for this pair of lovers. Berenson's joy would be liberally mingled with pain, and love would eventually subside into friendship, but that day was still years distant.

At the end of their crowded week in London, the Berensons parted. Mary set out for I Tatti eager to resume the "improvements" which she had happily envisioned, while Bernhard escaped to Portugal with his old friend Herbert Cook. Cook, who was chairman of his father's prosperous warehousing firm, had recently married the daughter of Viscount Bridgeport and now, with a party of friends, was headed for a three-week holiday.

In his diary letters to Mary, Bernhard described in loving detail his visits to the Cistercian abbey at Alcobaca and to the twelfth-century convent castle of the Knights Templars at Tomar. In the churches habit asserted itself and he pounced on mistaken attributions. At Cintra, where they all stayed at Cook's "enchanting" place, the scenery surrounding the picturesquely sited town enraptured him. On its solitary peak high above the town the battlemented Moorish castle seemed straight out of a child's picture book. Below one could stroll among the great gardens and trace the Moorish motifs of the old Royal Palace. A high point of their entertainment came when they banqueted at the chateau of the Marquis de Foz, waited upon by powdered footmen with blazoned stockings. From the younger Foz Berenson learned that the reason for his father's flattering attention was that he hoped to sell a Titian. Though Berenson was obliged to tell him that the painting was not a Titian, "both father and son behaved like gentlemen."

Holiday or not, business affairs had to go on. From Cintra he informed Mrs. Gardner of the liberal credit terms he had obtained for the Manet portrait which Thomson had offered her. There was, moreover, a good expectation that the United States import duty would soon be lifted and she would be spared that exaction. Then, lapsing into one of the frequent personal confidences which characterized his letters, he de-

clared there were no women in the house party with whom he could carry on a flirtation. "When I am not hard at work," he wrote, "I must have women . . . [to] be in love with."

More-insistent business affairs emanated from the Duveens in London and Paris, where Joe concocted vast schemes of acquisitions with his brothers Louis and Ernest. Joe was so impressed by Berenson's familiarity with all European art that he wrote him of a half-dozen miscellaneous projects which were in the wind on which he wanted his opinion when Berenson got back to Paris. Besides the Holford Velasquez, there were Werthheimer's John Hoppner, a Raeburn, two Gainsboroughs, a Donaldson Van Dyke, a valuable Lawrence, and a full-length Romney. "Of course I always bear in mind," Duveen wrote, "your caution never to give too high a price for a Romney." The most sensational project was his plan to acquire the duke of Norfolk's Holbein.

Plainly a new epoch was opening for Berenson, one in which the stakes ran into thousands of pounds sterling. Much as he detested the "real inferno" of the dealers' world and suspected the flattering enticements that Joe Duveen dangled before him, he could hardly resist. The end of his long years of anxiety about having sufficient money for his role of man of the world was in sight. Hence when Mary in her daily chronicle reported that complications were arising as the improvements multiplied at I Tatti, he wrote, "Let us do all we can to make ourselves comfortable even if it costs more now. . . . I approve of everything unless I jot things down to the contrary." At the safe remove of Portugal he saw at first but few things to alter.

The habit of daily letters posed its usual dangers of compulsive self-analysis and motive hunting. Buried discontents rose too easily to the surface. Geoffrey Scott's continued presence at I Tatti was unsettling to Bernhard. Mary assured him, "As he doesn't feel a spark of romance about me, although gratitude and affection, my excitement about him has come to an end, I almost regret to say. And I am not sure whether mere friendship, without a touch of sex, is possible to me. . . . I have more to say upon this and kindred topics, and perhaps at last, when we are together again, I can find tongue to speak out quite openly."

Bernhard often grew uneasy and suspicious at the glimpses she gave him of devious and unsounded depths of her nature. Sometimes, he wrote, he wished he had never known her. "I have seldom trusted you without being fooled. . . . Try once more to be truthful and loyal." She had, she admitted, formed the habit of taking paths "around to compass my ends," but only because of her "great dread" of his falling into a rage. She was now resolved to "shut the door on anything that tends to break

up or really damage the life we have undertaken in common with full and intelligent consent."

Delays and blunders in the work at I Tatti threatened new tensions. Her reports grew more disquieting. To Mrs. Gardner she confided that "everything has gone wrong." And to Bernhard she declared that if he wanted "thy home to be according to thy wishes thee will really have to come down and share through weeks of mess and disorder and really help grapple with the problems." Their great error had been to leave no one person in charge of the alterations. Besides they had been too off-hand in the directions they left with their *ragioniere,* Ammanati.

In Paris for a week after his trip to Portugal, Bernhard learned from Joe Duveen that he would not be needed there again until the first of June and would therefore be able to help Mary if she could use him. In reply to her anxious queries about the new electric wiring and the French chimney pieces, he cautioned that the wiring should be made invisible and that the chimney pieces should *"never"* be put on socles but let in flush with the floor. In his room at the St. James Hotel he pondered the troubled situation that clearly awaited him at Settignano. He was sure his villa would be uninhabitable for him, yet "a month's tête-à-tête dinners with Aunt Janet [Ross]" up at Poggio Gherardo would be unendurable. "If you send Scott away," he queried, "would there not be room for me at Villa Linda [a nearby pensione]?"

The Wideners were in Paris, and Widener's son, Joseph, took Berenson to see his father. Both Wideners were "greatly tickled" at having acquired a Greco for which "they flatter themselves that at last they had turned the tables and *done* somebody else." Bernhard acted as cicerone to Joseph on a visit to Seligmann's, and at lunch with him he saw Otto Kahn "doubtless digesting Holbein." It was a piquant though mistaken surmise. At Kleinberger's he saw "a too enchanting predella" which he offered to Johnson by letter, and at Wildenstein's he stopped to inspect a Rossellino. Then he spent two hours with Joe Duveen while Joe was waiting for a telephone message from London to tell him whether the duke of Norfolk had accepted his offer for the Holbein. When the message came that it had been sold to Knoedler's for Frick for £61,000, "Joe nearly went off his head. It was a terrible blow."

Duveen's disappointment must have been somewhat tempered by what happened shortly afterward. The public outcry in England against the exportation of the painting to America had become so great that the money to buy it for the National Gallery in London was raised in part by popular subscription. Rumor had it that Frick in a beau geste had made one of the largest contributions. The price of $305,000 must have de-

lighted the art-dealing world: it established a new plateau to which free-spending American millionaires would have to ascend in their quest for European masterpieces.

One morning Berenson met Duveen at the Maurice Kann house to inspect the important Kann Collection, which Duveen hoped to buy. Then he hurried off to inspect Gustave Schlumberger's objects of art and to lunch with him and Countess Charlotte de Cossé-Brissac. The emancipated and adventurous countess, who was allied with one of the oldest families in France, had become one of Berenson's closest friends. Later in the afternoon he went to see Maurice de Rothschild's collection of art, on which he was to report to Joe Duveen at six. Then, if he survived, he hoped to go "on a spree" with two women friends of twenty years ago.

While still in Paris he dined with Leo and Gertrude Stein. In spite of her bulk Gertrude looked "rather handsome." He kept glancing about with pleasure at some of the Matisses that cluttered the walls. Pleasure of a more intense kind came cascading to him at the Ritz by mail from Belle Greene. "Desire of my heart, I embrace thee," one missive began. When he sent her a photograph of I Tatti she protested, "When am I to have *your* portrait." A spot on her desk at home was waiting for it, she said. "What a relief and joy to turn to the abundance of your love," a rapturous letter exclaimed. "How wonderful that you wish to give me so much of yourself." She loved literature, for it sounded "the single note of love—love impassioned—burning—sensuous." Her rapt musing filled page after uninhibited page. "Goodnight dear, I sink into your arms," closed one recital; and in another, with shrewd instinct, she wrote, "I'll tell you a secret—you are *not* in love with me but with *Love*."

When in one of his letters to her he incautiously wrote sarcastically of J. P. Morgan, she begged him not to "jeer at my dearly beloved Boss. . . . In all the too few years I have known him in a unique way, he has been absolutely like a child in his confidences and the expression of his thoughts and feelings. . . . I wonder how many other people know as I do the utter loneliness in life. . . . He gives all and gets what? Only a sickening realization of his money and the world power it brings him." Her adoration for the suffering and near-angelic Morgan continued for a few pages in her large scrawl but did not long impede the flow of passionate endearments which Berenson found so life enhancing.

Life enhancing too was the pace of life in Paris, even though the sessions with the Duveens often proved unsettling. Joe Duveen, full of bustling energy, talked almost all the time, boastful of his successes and full of stratagems and magnificent projects in which he sought Berenson's advice. "His lack of culture," Berenson confided to Mary, "is only surpassed by his quickness in seizing hold of what one tells him and his

enthusiastic giving it forth the instant after as his primordial, eternal conviction." From one "purposeless and aimless" session of mere "talky talk," he came away convinced that the "Duveens want to keep me talking so as to get hold of my vocabulary and phraseology."

The sight that greeted Berenson when he arrived at I Tatti around May 1 was far from reassuring. The front terrace was a mass of rubble from the excavation for the new kitchen. The new contadina house stood too near the villa, and instead of being the pretty little yellow building they had envisioned, it had been made into an imposing habitation. Mary had feared that Bernhard would order it torn down, but the architect managed to placate him. At first Bernhard took the chaos very calmly and even agreed to buy a motorcar, Mary's "chiefest dream of earthly happiness." It was obvious that much remained to be done, but Bernhard thought that the new library joined to the back of the villa would at any rate be "splendid."

He put up with the tête-à-têtes at Aunt Janet's after all, but he trudged down to I Tatti with growing indignation at the desolation. "I am nearly dead with disgust, rage and despair over what has been done to our place," he wrote Mrs. Gardner. "God knows whether it will ever again be beautiful and whether I shall survive to see it."

By the middle of the month young Cecil Pinsent had come to work as supervising architect. Having "a passion for drains," he discovered that the man who had put in the sewerage pipes "did not know which connected to which." In the month that Berenson was present in the vicinity of I Tatti, one calamity followed on the heels of another. The discredited Italian architect Zannoni was displaced by Pinsent but too late to prevent his successfully suing for damages. The boiler burst and the water pump collapsed. That repaired, the bath overflowed and the walls of the new rooms had to be redone. The telephone produced unintelligible sounds. Berenson's sharp eye missed no instance of slovenly workmanship, and Pinsent lived in terror of his gaze.

Annoyance came too in the form of Joe Duveen's importunities dispatched from Paris. Joe was particularly anxious that Berenson keep in touch with Altman, who had himself twice written to Berenson for advice. "Have just bought the greatest Velasquez existing outside of Madrid [Captain Holford's *Olivares*]," Duveen wired. "Explain to Altman. Keep matter absolutely secret otherwise trouble with nation. Net £110,000. . . . Tell him he is getting first offer before Morgan." In a following letter Duveen urged Berenson to write Altman "your views in a very forceful manner. . . . Really his confidence in you is so great that we feel we can safely rely upon you to advise him to purchase the picture."

Bernhard dictated the requisite letter to Mary. He explained that he had known the picture for twenty years; that it was a great coup for the Duveens to have obtained it; that the Duveens were "great and courageous buyers"; that they had to use a secret intermediary because "a social stigma" attached to sales by Englishmen to Americans; that the picture was "from a purely painter's point of view of the finest quality of painting and the grandest design and the grandest and completest and yet most dignified characterization"; and that the price was indeed enormous but there was no other Velasquez of importance left unsold. Altman was not to be persuaded, and Duveen found a purchaser in Mrs. Collis P. Huntington, from whom the painting passed to the Hispanic Society of New York. The letter to Altman was to be followed by scores of similar ones during the next quarter century. They were usually typed by Mary, and no doubt often edited or even drafted by her, for she had much less distaste for the task than Bernhard.

There were of course other letters to be dispatched during the rush of "affairs" in the summer of 1909. One negotiation to be concluded was that with Gimpel and Wildenstein for the bust Mrs. Gardner was purchasing and another that with Thomson for the sale of the Manet to her. Mary reported to her mother that "B.B. is so deeply in the thick of many *affaires* that a large part of my time is taken in consulting with him, reading and perhaps copying his letters. . . . He depends on me more than I have ever really grasped. And what he is doing now is so much for the common good that I am more than ever inclined to sacrifice other things to him. . . . In a way he is really enjoying himself." One happy result of this flurry of business activity, she reported, was that Bernhard had been able to "pay off all the debt on our place."

Bernhard returned to Paris in early June, leaving Cecil Pinsent in charge with instructions to send him "estimates for everything before launching out." The situation did not improve after his departure. The tragicomedy of errors was to continue throughout the following year. Told that electricity could not be brought up to the villa, Mary was almost persuaded to have a costly generator put in. Saved from that expedient, she learned that the electrician had figured on a 150-volt line, though the fittings were rated for 60 volts. Then it was discovered that the incoming voltage would be 280. Workmen sealed the water-pipe joints with soluble putty, and the result was a hundred leaks. The new masonry settled, and the cracking plaster in Berenson's bedroom began to fall. To make matters worse, the plumbers somehow filled the washstand pipe with cement. More disheartening was the discovery that the fireplace in the library was set higher than the floor. The entire floor had to be raised. Additional pipes had to be run into the bathrooms when it

was found that there was not nearly enough hot water. Pinsent had had the peculiarly British idea that "everyone took cold baths."

In Paris, when not closeted with the Duveens, Berenson had to remain within call to advise important clients and to inspect for them and for other dealers collections that were coming on the market in anticipation of the impending removal of the American tariff. He found to his dismay that his connection with the Duveens brought with it burdensome obligations of a sort he had not hitherto experienced in his arrangements with other dealers. The Duveens were now laying siege to Altman and counted on Berenson's continuing help. "Uncle Henry" Duveen, who had come over from New York to confer with Morgan and with Altman in London, urgently wired Berenson in Paris: "It is of the utmost importance that I should see you today or tonight. Do not fail me."

Altman was resisting having his acquisitions channeled through the Duveens as Berenson, at Joe Duveen's insistence, had been urging. He would have preferred to have Berenson act directly as his employee and thus bypass the Duveens and their profits. In anticipation of Altman's arrival in Paris, Berenson returned to the disagreeable chore. "I am very little a businessman," he wrote to him, "and my tastes and habits are for the quiet life of the scholar. . . . There are only two things that I really feel I can do successfully, one is to pass upon the genuineness and the aesthetic value of pictures and sculpture, especially Italian, the other is to keep track to some extent of the worthwhile pictures and sculptures that come into the market . . . and I can prevent your being deceived in what you buy. . . . But as to acquiring these works of art, I am not well fitted to cope with . . . all the unpleasant details attending important transactions of works of art . . . and it would require more time and personal attention than it would be wise for me to take from my studies. . . . This is the reason I suggested to you to allow the Duveens to handle the more difficult purchases for you." Since Altman had turned down the paintings he had proposed, Berenson suggested that they visit together a number of galleries in Paris "so that I might arrive at a just opinion" of what he desired.

Altman temporized, making it clear that he did not wish Berenson to accompany him to dealers. Berenson, exasperated with having to cater to such an independent and stubborn client, burst out to Mary, "I can't tell you how wearied I am of the whole business and how I wish I had never heard of pictures, buyers, connoisseurs, and dealers"; and then, realizing the futility of his protest, he concluded, "Still, I am going to try it this time thoroughly and loyally." He swallowed his pride and gave up his month at St. Moritz to await Altman's return from a journey through Belgium and Holland.

X

The Red Robe

FORTUNATELY time did not hang on Berenson's hands during the interval of waiting for the meeting with Altman. There were friends in Paris and London to divert him and arrears of business to attend to. When he called on Henry Adams, they were joined by William Sturgis Bigelow and John Lodge, the senator's son. "We chatted in sham hilarious vein," he reported, "and then Adams took me to the Lydigs'." Adams accepted Lydig's dinner invitation, but Berenson had to decline because he was engaged for the Seligmanns'. A couple of days later he took Mrs. Lydig, a very wealthy member of the international set, to the Pavillon for Robert de Montesquiou's fête. At another function he encountered the novelist Paul Bourget, who "expressed a profound admiration for my *Lorenzo Lotto* and gratitude for having made him admire that sublime artist Alvise Vivarini . . . and implored me not to lose myself in aesthetics." Their fellow guests formed a circle and then "everybody thought of nothing but how to place his bon mot."

One day at an exhibition he encountered Henri Bergson, "a slight man, with rather sharp but not at all Jewish features, blue eyes, modest demeanor, frock coat and congress boots. He told me at once that my books were not only the best but a unique attempt at a philosophy of painting, that he thought them hard to understand but found them very illuminating. . . . All the time I was having the curious sensation of being with a mind exactly like mine and not superior. . . . And yet he has written books I cannot fathom. . . . He is the first thinker who has expressed an appreciation of me."

For July and August of 1909 Berenson made London his headquarters and traveled frequently back and forth to Paris as the negotiations with owners, dealers, and intermediaries moved in complicated and labyrinthine ways. If business continued to tyrannize his days, his evenings saw

[88]

him petted by high society at dinners and receptions. Mary, who was with him in the city through most of July, protested, "I do not want anyone to blame him for snobbishness, for that is the foundation of his business. . . . It is fortunate he enjoys himself among the rich, for they are the ones he *has* to frequent if he makes money. Only I wish I liked it more." To her mother-in-law in America she allowed herself to boast, "Tonight he is even dining with the Prime Minister."

In August Mary went as usual to her family at Iffley. Bernhard joined her briefly there and paid his respects to his redoubtable mother-in-law, who now presided over her brood in a wheelchair, impatient to be off, as she said, to her heavenly father. Senda was already there, having come on from a "wonderful time" in Greece and Crete, a vacation subsidized, as his family's always were, by Bernhard. Like her brother, Senda had developed a taste for luxury and a fashionably large wardrobe: to Mary's astonishment she spent eight hours packing her steamer trunk before sailing for Boston. Mary must have been struck by the contrast with herself. Only a few months before, Bernhard had urged her to buy clothes: "Surely you will need street clothes for London, no matter how little you stay in Paris. . . . A woman has no right to leave herself short of necessary clothes." Mary complied, but not without frequent complaints to her mother that she detested sessions with dressmakers.

During one of his returns to France Berenson spent a leisurely fortnight at the Villa Trianon, where Elsie de Wolfe looked like a "perfect bibelot" and J. P. Morgan's daughter Anne was very much in evidence. Senda, who had been vacationing in Paris, briefly joined them. Some of the usual guests put in an appearance, including Henry Adams, who had fallen, he said, "into the clutch of Berenson who eviscerates the world with a Satanic sneer." He took Berenson to inspect the pictures of "Madame La Comtesse de Franqueville (née Sophie Palmer)" at La Muette. Lady Sophie showed them all over the chateau while, as Adams reported to Elizabeth Cameron, "Berenson oilily sneered at the pictures." Berenson, keenly observant of his friend, noted, "Poor Henry Adams dragged a leg in a way that distresses me. It looked too much like approaching paralysis." It was a prophecy that would be fulfilled in 1912.

Berenson kept in frequent touch with René Gimpel, the junior partner of Nathan Wildenstein. After John Graver Johnson had declined to take a Schongauer that Gimpel had offered him, Berenson wrote Gimpel, "Since then I have done what I could to sell it and at last I have found a buyer." He cautioned, however, that if the painting turned out to be a forgery, "I shall take it back and I expect you to take it back from me." From London he wrote Gimpel of a conversation he had had with Baron Maurice de Rothschild about a Titian the baron had bought from Gimpel

and Wildenstein. At a gathering at Mrs. Potter Palmer's the baron had come up to him and said, "It was because you assured me Wildenstein's portrait was a Titian that I went and bought it. But now Bode comes and tells me it is not a Titian at all but a copy by Rubens or Van Dyck." "I talked to the Baron for an hour," Berenson reported, "telling him just what the difference was between a Titian and a Rubens or a Van Dyck. I hope I have convinced him."

In England there was time to make the rounds with Wildenstein to see what paintings were available from owners eager to divest themselves of their country's artistic patrimony for American dollars. The talk at the Duveens' London gallery flowed as furiously as ever of enormous deals in the offing, but Berenson's share at the moment looked highly problematical. It was a relief to retreat to the north of England to Lady Cunard's country house at Inverary, where his old acquaintance the "witty and Irish" George Moore was "very much at home." Before he became a novelist, Moore had served a long apprenticeship as a painter in Paris and had written much on modern art. "I can see," Berenson observed, "he means to pick my brains."

In London in the season's lull he had luxuriated in the art galleries, "feeling a perfect hatred of the 'expert' side of the business, and thoroughly enjoying the fine, un-Italian things because I knew so little about them." Then one afternoon he received word that his boon companion Count Rembelinski had died. His gloom was deepened by news that soon followed—Lady Sassoon was dying. Within a few days she too was dead. "You did not like Lady Sassoon," he wrote Mrs. Gardner, "but poor dear she was one of my familiars and life will be much poorer for her loss. But I feel far more the death of Rembelinski. . . . Him I shall never replace, for he was a wonderful combination of so many qualities I love in a man." The deaths inspired "penitential reflections on life in general and mine in particular."

Mrs. Gardner expressed sympathy for his losses, "even for that of the beautiful Hebrew because she meant so much to you." Passing to a more congenial subject, she added that since the new tariff act had been passed, the Manet could now be safely sent to her, and she invited his opinion on where to hang it at Fenway Court. The deaths continued to trouble him, and he felt moved to write, "They are the first. It is an epoch in one's life when one's dearest friends begin to go." Yet death was not for him the worst of evils. His annual meeting with the aging Egyptologist Theodore Davis had distressed him. "One could only wish he would die. He refuses to be pleased with anything." "That, by the way," he added, "is what we all must cultivate as we grow older, the will to be pleased."

The tariff act which repealed the duties on works of art over a hundred

years old was adopted on August 5, 1909. Congress repealed the duties, it was said, "to lure J. Pierpont Morgan's fabulous collection" from his London and Paris homes. According to rumor, Morgan had promised that the nation would have it all if the law was changed, and his collection was in fact brought to America in 1912 and 1913. Whether the rumor was true or not, the idea that the duties discouraged the "big millionaires" from bringing over their collections did enter the debates in Congress, and the repeal of the duties gave a great impetus to American purchases of art abroad and led to an era of unprecedented prosperity in the international art trade in which Duveen Brothers took the lead.

The interview with Altman finally took place in London on September 6 and lasted until midnight. Berenson reported to Mary that Altman "implored me to trust him" but added, " 'You do now, and when you leave me you won't,' which was shrewd of him. I found him, I confess, very attractive." The next morning he saw Henry Duveen, "anxious and haggard to know what Altman had said, and I to tell him what an intolerable, untrustworthy creature he was. . . . I feel like a cork on the wide, wide ocean. . . . I begin attendance on his Altmannic majesty tomorrow at 9:30. He is a vampire and God knows how profitably it will all end."

For the meeting Duveen had brought over a few Titians. "Altman and his train simply jeered and sneered at them," Berenson noted, "seeing in them no merit whatever." It was apparent that nothing could be expected from him but frustration. "If he despised those Titians and missed the [Velasquez] Olivares what that I can recommend is he likely to want?" Still he could not help liking the man, who, to his surprise, had "an eye" and for three hours at the Victoria and Albert Museum "generally pounced upon the right thing." While making the rounds with him, Berenson caught a distressing cold, and he fumed to Mary from the depths of his sickbed at the Ritz, "I truly believe that is all I positively shall have got out of that old sheenie of an Altman." Indulging his fondness for the Dutch school, Altman bought three more Rembrandts and "the great Ruysdael" from the Maurice Kann Collection, the collection which the Duveens had just acquired for $2,500,000. Immediately afterward he sailed for home, leaving Berenson to nurse his resentment and the loss of the fortune Altman had dangled before him.

Fortunately other Duveen negotiations showed more promise, and Berenson felt confident that he would be able to pay the bills that inundated Mary, who was back at her beleaguered post at I Tatti. He cautioned her, however, to use the utmost discretion in selecting the automobile he had decided they would buy, in order that they should start out with "a machine that we know to be perfect" and so avoid

unnecessary expense in upkeep. As for the continuing costly mistakes in the "improvements," she was not to worry about money. He thanked God that his London ordeal was almost over. "I cannot tell you how humiliated and degraded I have felt by it, in what a false position, how thoroughly *minchionaro* [taken in], by the Duveens, on the one hand, and the Altman crowd, on the other; by which I do not mean to say that I shall not make money out of both and fairly easily, but I hate the position of rage and discontent caused by knowing that I ought to make ten for every pound I get." As he was whirled from one negotiation to another with dealers eager to unload their precious wares on the insatiable Duveens, he felt a loathing for "the whole tribe." But he could not help adding, "I have made my bed and must lie in it." Courted by collectors and dealers, he decided to remain at the Ritz, feeling that its luxuries and faultless cuisine would fortify him for the rush of business affairs and the incessant socializing demanded of him. It was worth, he said, "all the money it costs."

Among his business enterprises one of the most successful of 1909 came from his getting sight "of the finest Hals out of Harlem that I remember having seen." It was a reputed self-portrait of Frans Hals and his family, which he was put on to by the resourceful David Croal Thomson. When he brought it to the attention of Joe and Henry Duveen, "they leaped up in the air. We had Thomson come at once." Berenson promised the Duveens that if they went ahead and bought the painting, he would stay on in Paris and help them sell it. As he estimated that he would thus earn £6,000, it would be worthwhile to "hang on." But there were delays, and when the Duveens insisted that he stay on for another two weeks into late October, at which time they expected to have acquired the Hals and to have sold it to Mrs. Collis P. Huntington, he "absolutely refused." He was induced, however, to accept a compromise, to take a ten-day holiday in Milan and Venice and return to Paris by October 21.

He joined Mary in Milan and "loved" their new motorcar. For a few days there were delightful excursions to Verona and Venice, visiting friends and hunting pictures. Then calamity struck. When they sent the automobile back from Venice with the chauffeur, it stalled on a railroad track and, according to first report, was tossed into a crumpled heap. Berenson took the news philosophically, saying, "You must expect such things with motors." As it turned out, the automobile was repaired for £160 and the insurance and railroad companies shared the cost. On their last day in Venice the Berensons bought a little Cima da Conegliano for themselves.

Immediately after Berenson returned to Paris, the Duveens completed

the purchase of the Hals, according to the press, for $400,000. The report, as was often the case, was erroneous. The actual cost was still impressive, $225,000. When the painting arrived at the Duveens', Joe Duveen "was in ecstasies" and kept poking Berenson in the ribs, saying, "You devil, you! But for you we should never have got it." Mrs. Huntington did not take the painting, and it was not sold until April 1911 when it went to Otto Kahn. It was subsequently acquired by Baron Heinrich Thyssen-Bornemisza, though by that time its identification as a self-portrait had generally been abandoned.

Thomson in a confidential letter to Berenson described the maze of complications which attended the acquisition of the painting, the kind of exasperating complications that Berenson had learned frequently accompanied important deals. Thomson had taken one of Joe Duveen's brothers to Westerham to meet with Colonel Warde, the owner, and his solicitor and an agent of the Agnew firm. They had been unable to budge the owner from his asking price of £45,000, and the deal was closed at that figure. The arrangement for fees was that the Duveens were to pay Thomson £500 and, if they made a "good" sale of the picture, an additional £1,000. Thomson was also to receive one-third of the 10 percent commission to be paid by the owner to the intermediary, a Mr. Bash. Three days after Duveen Brothers bought the picture they wrote as follows to Berenson:

We hereby agree to pay you the following sums in connection with the transactions enumerated hereafter: 1. [Otto] Kahn. £4,000. 2. Purchase of Velasquez. £3,000. 3. Purchase and sale of Titians. £4,500. Sale of Franz Hals. £6,000 or if not sold to Mrs. Huntington the same due to you on this latter transaction will be £4,500. It is understood that £5,000 will be paid to you on the first of January and £5,000 on the first of April.

The account came to a total of more than $80,000, and in addition there would be his fees from other firms. Berenson in an optimistic burst of exuberance wrote to Mrs. Gardner toward the end of the year, "I am making a great deal of money. . . . As long as I do, and I trust it will go on for some time, I mean to allow myself two luxuries, one physical and one moral. The physical one is a motor car and the moral that I shall charge you no commission for what you henceforth buy on my advice."

Through he continued to spend much of his days fretfully "hanging about" the Duveen Gallery or circulating among the dealers, he found time to enjoy the other side of Paris on which he thrived, the salons of friends and the exquisite cuisine of his favorite restaurants. He amazed himself at his own physical endurance. "I cannot understand where I get the energy to do all that I do. I am a physiological mystery to myself," he

told Mary. In the same letter, however, in commenting on Mary's tale of ill health, he said, "We are a pair." Only the night before, while dining at Larue's with Ralph Curtis and his wife, he had "fainted dead away. . . . They were angelic to me, put me to bed, put ice on my head and hot water at my feet, called the doctor, etc."

He saw a good deal of Henry Adams, who rather relished his admiration. "Berenson came to call," he told Mrs. Cameron, "and flattered me as usual till I promised to do anything he wanted." One day when Adams stopped at the Ritz to secure a table, Berenson came in to dine with Ralph Curtis, and Adams suggested they join forces. Ambassador Henry White came by and Adams placed him, "pleased as Punch," between Mrs. Curtis and Mrs. Peter Cooper Hewitt, "surrounded by all the beauty and wit of the Ritzian world." The fun, Adams added in his narrative to Mrs. Cameron, was that he gave the ambassador "a charming dinner at the expense" of the others, "for my share was only 56 francs." He gleefully concluded his account, "Did you know me to beat out the Jews when I was young and had my mind still."

Meeting Berenson shortly thereafter at Walter Gay's chateau Le Bréau, Adams noted, "Berenson is a quivering aspen, pale, shrunken, and coughing, but more cerebral than ever." When not having Berenson to dine, Adams kept track of his activities for his intimates. In one note he reported, "The great Berenson is here, on and off, deep in negotiations for pictures, and escorting of Mrs. Potter Palmer." In another he wrote, "I have not an acquaintance now living—unless it is Berenson—who bites hard enough to smart."

If Berenson flattered him, Adams reciprocated by his respect for Berenson's intellectual powers. Once, when deep in research for a book he planned to distribute to fellow professors of history, Adams had come upon the discoveries of Giacomo Ciamician, a professor at the University of Bologna who had done notable work on the nature of chemical affinity; he wrote Berenson, "When you get back to Florence, I want to know the name and position of Ciamician. . . . Some day, when you have nothing whatever to explain in the universe, explain me Ciamician."

To Mary, who especially relished news of his meetings with Adams, Bernhard passed on Adams' remark, "I shall depend on you to make me see and hear, if not to know, which is getting beyond my powers." After Bernhard's report of another encounter Mary commented, "Fancy Henry Adams becoming so cordial! To him who waits—." Bernhard had written that at a congenial dinner party well served with champagne "Adams must have had the champagne go to his head, for he was most maudlinly affectionate and flattering. They were all discussing Prince

Collier's book on England when he suddenly turned and said, 'I feel compelled to tell you that no man living could write so good a book on England as you. You have the knowledge, the insight, and the literary gifts.' At the last I protested . . . and he replied 'That is nonsense. You can say poignantly and clearly whatever you want to say.' . . . I protested that my mistress Italian art would not let me free." The affectionate mood continued when he called on Adams the next day and Adams promised to give him both the *Mont Saint Michel and Chartres* and *The Education* and asked him to read the manuscript of the new essay that he planned to publish, *A Letter to American Teachers of History,* in which, with characteristic pessimism, he concluded that civilization was doomed because of the irreversible loss of societal energy as part of the whole process of entropy.

As if to cap his successes of that season, Berenson began a friendship with the distinguished American novelist Edith Wharton, a friendship that became one of the most treasured of his life. Six years earlier he had met her and been repelled by her haughty manner, and they had kept a truculent distance between them ever since, more on his part than on hers. One day late in September 1909, as he was about to leave Henry Adams' apartment, Mrs. Cameron came in with a woman he did not recognize. "It was Mrs. Wharton," he told Mary. "She did not look the least like the woman we met six or seven years ago." A week later he dined in the upper chamber of Voisin's as the guest of Adams, who had also invited Mrs. Wharton, Berenson's collegemate Morton Fullerton, and Mrs. Cameron and her twenty-three-year-old daughter, Martha. He and Mrs. Wharton chatted, gossiped, and exchanged limericks. She "was affable to the last degree," he wrote, "and so I buried the hatchet and called on her yesterday."

Edith Wharton was a peripatetic member of the Anglo-American society. The new motorcar had given a pleasant acceleration to the movement of its members. She too had the virus that had infected Berenson and his wife, and had just published her *Motor Flight through France.* She and Berenson now met as important personages, each in his own right, and behind her regal bearing he found not hauteur but deep warmth. By this time her mentally ailing husband had been packed off to America, and she had blossomed emotionally in her rapturous if brief liaison with Morton Fullerton. Before he left Paris at the end of October, Berenson was on the friendliest footing with her. At Christmas time when he sent her a copy of Logan's recent *Songs and Sonnets,* she responded with a collection of her own, *Artemis to Actaeon,* which contained a deeply felt sonnet sequence of her secret love for Fullerton.

Beneath the surface of Berenson's enjoyment of Paris society there

continued to smolder a deep-lying vein of discontent whose red glow flamed up amidst his amicable and solicitous letters to his wife. Old grievances and suspicions surfaced united to new ones. Mary had not succeeded in concealing the depth of her affection for her protégé Geoffrey Scott. Her strenuous efforts to find a post for him had the result, Bernhard wrote, "of revealing to everybody that you are madly in love with him." He was irritated also to learn that Mrs. Potter Palmer had been unable to see Mary in Florence because she was "racing about" with Cecil Pinsent. But deeper than all else was the sense of helplessness he felt in the face of her immoderate attention to her family in England and the relentless push of her ambition for them and for him.

It was with a feeling of helplessness too that he responded to the incessant pressure from the Duveens. The great burst of business activity of the summer of 1909 began to subside a little as the autumn waned, and Bernhard wrote that "business is chequered, so full of ups and downs I simply do not know where I am." The endless conferences with the Duveens bored him, and their rejoicings over the great purchases by Altman, Huntington, and Widener and the enormous profits thereon, in which his own share seemed inadequate, left him with the sense of having been exploited. "It makes me sick when I hear from Duveens how much they are making and dissatisfied with my share." Between Mary and the Duveens he perceived himself to be the consenting victim of complicated injustices for which there no longer was a remedy.

The passionate letters that continued to cross the Atlantic between him and Belle Greene served to heighten his disillusionment with Mary. He bitterly reproached her for her lack of wifely devotion. Mary, who did not yet realize the intensity of his love for Belle Greene or of his jealousy of Geoffrey and the way in which these feelings were all mixed up with his distaste for the art trade, was puzzled by the violence of his expressions of unhappiness.

A moment of revelation came to Berenson one night after attending Eugene Brieux's play *La Robe Rouge,* a depiction of the moral corruption worked by ambition and pride. It struck him as a ghastly allegory of his own condition. The story is of a provincial prosecutor who covets promotion to a more lucrative post and the red robe of office which accompanies it. His wife, concerned for the advancement of their children, presses him to disregard his moral scruples in a judicial system that rewards guilty verdicts. He prosecutes an innocent man for murder but then repents of his zeal even though his repentance costs him his promotion. The man is acquitted but the harm is irrevocable; the wife of the accused has been forced to testify to her long-buried criminal past, her

husband casts her off, and in her despair she kills the prosecutor who coveted the *robe rouge*.

"It made me so unhappy," Bernhard wrote to Mary, "that despite all the gaiety of a supper at Paillard's, I could not sleep. I live a life of excitement and external gaiety. I do what I can to be a man and to submit to the common lot, but when I go to a play where human misery is touched upon, I realize in what agony, how very close to the brink of tears and torture, my days are passed ever since our return from America. Our situation, I mean between you and me, is nearly more than I can bear and you seem deaf to reason, to pity, to common humanity, and with that I abominate my relations to the whole art dealing and buying world. It seems my lot to be victimized, bamboozled and exploited all around."

Mary acknowledged that she had been indiscreet in advancing Scott's ambition, but she assured Bernhard that her friendship with him was "now quiet and suitable and satisfactory." Bernhard accepted her protestations, though with obvious reserves, and a courteous truce resumed, even to the affectionate *x*'s at the end of his letters.

He arrived at I Tatti on October 30, 1909, to a sort of "Royal Entry" which Mary, with her love of pageantry and fun, had prepared for him. Drawn up in a double line on the terrace, alongside of Mary and Trevy, were all forty workmen and six servants. Bernhard brought with him the eighth-century Javanese stone Buddha head he had purchased from Bing, the Paris dealer whose place had become a center for the growing vogue of collecting Oriental art. Mary thought the Buddha head "creeping with tactile values" but otherwise hideous. For Berenson its purchase marked the beginning of what was to become a very expensive hobby.

It was a dramatic homecoming, and later that day the way was prepared for a different sort of drama that lay in the future. René Piot, a French artist whom Berenson knew and liked, came to call, bringing with him a plan for decorating the twelve lunettes of their spacious new library with a series of scenes in fresco illustrating Virgil's *Georgics*. "He is the one person who paints nowadays in real old fresco," Mary explained to her mother, "and we like his work very much." They were attracted by his conception, and in a rash moment the thing was commissioned.

If the royal entry was a success, nothing else about the renovated villa pleased Bernhard, and none of Cecil Pinsent's many blunders escaped his searching glance. Doors were unshuttable, handles unturnable, and locks immovable. There was "not a trace of a home or a possibility of quiet work at a desk," he lamented to Barrett Wendell. To Johnson he em-

broidered the theme: "There are at least 50 blackguardly scalawags sing-
ing opera tunes and swigging wine over the premises." Within a few
days the appearance of calm he had initially managed disappeared, and he
began to rage as each new piece of slovenly workmanship came under his
eye. He motored off with Mary to Siena for several days to escape the
confusion, and she agreed to return with him only on his fragile promise
to be "good natured."

For a few days he took refuge with the Princess Ghika at the beauti-
fully maintained Villa Gamberaia and on returning said of their own
place that they had always lived in a pigsty. To Mary it was "the worst
matrimonial crisis" of their lives. "It has brought to light all the latent or
semicovered up differences between us. . . . B.B. wants perfection in
physical surroundings and his taste for luxury is modelled on a style of
life (and income) I have absolutely no desire to emulate."

In the continuing chaos there was little opportunity for serious work.
The disorder had made him actually ill, but after the first volcanic explo-
sions he calmed down and they found solace in buying two "ruinously
expensive" Signorellis. He spent more time languishing in bed than out
of it. Mary was convinced that enduring him through these periods of his
"horribility" showed that she really loved him. It did not help matters,
however, that she felt it was her wifely duty to help him get over "his
weaknesses" and hence could not "pet him and make things as easy for
him as my heart tempts."

X I

The Ixion Wheel of Business

T HE year 1909 had put Berenson in sight of genuine affluence, but
the result was that his writing on art was entirely pushed aside.
In the intervals of travel and constant negotiation there was little
time for leisurely reflection on aesthetics. Before leaving for America in
the fall of 1908, he had managed to produce a three-page article on a
newly discovered Lorenzo Monaco for the *Rivista d'Arte*. Five years
would pass before he would publish another article. *The Florentine Paint-
ers* and *The Central Italian Painters* were reissued in 1909 with greatly
expanded Lists, but of fresh prose there was none. The British publisher
J. M. Dent & Sons appears, however, to have pressed him for a new
book, and Berenson turned to his two essays on Sassetta published in the
Burlington Magazine in 1903 as a possibility. Mary had counseled against
reprinting the essays, thinking they were not good enough for a book.
Her opposition, by a kind of reflex, may have been enough to have
determined him. The small book, *A Sienese Painter of the Franciscan
Legend,* came out in 1909.

A deeper motive may well have led to the publication. Again and again
Berenson had reproached himself for his involvement in the art trade, he
who in his youth had aimed at the disinterested worship of Beauty.
Publication of his idealized portrait of Saint Francis, who had married
Lady Poverty, seems a symbolic act of contrition for his surrender to
mere money making and material possessions, for in Saint Francis he had
depicted the ideal of his nostalgic, if futile, dreaming: a man who had
attained "the most unattainable of emancipations, the emancipation from
oneself." He dedicated the book to Count Rembelinski, the friend whose
death he so recently mourned.

The favorable reception of the book showed that Berenson had lost
none of his authority. The *Dial* concluded its appreciative summary:

"Although small as to size, the books of Mr. Bernhard Berenson are never otherwise than significant as to art criticism." The London *Athenaeum* pointed out that Berenson was awakening an appreciation of Sassetta by showing his spiritual affinity to Oriental art, and the *Nation* thought the book "opened the large question of imaginative as contrasted with realistic design." But the *North American Review* threw out a challenge that sank deep into Berenson's consciousness. While praising Berenson's earlier books as perhaps the soundest expression of the aesthetics of painting, the writer admonished him that "the day of little books is past." The book was "good," but it did not have "the firm reality of the great book he owes his generation." Again and again Berenson tried to formulate his "great" book on aesthetics, and each time it eluded him. It seemed to lurk in his inkwell, and it remained there resisting even provisional expression for nearly forty years.

An observation by Arnold Bennett in a November 1909 issue of *New Age* must have impressed him as an admonition to persevere. "I find confirmation of my own view [of the discord between artists and critics] in other arts than my own," Bennett wrote. "The critical work of Mr. Bernhard Berenson, for instance, seems to me wonderful and satisfying. But when I mention Mr. Berenson to a painter I invariably discover that that painter's attitude . . . is well—, aristocratic." Forty-five years later Berenson, recalling Bennett's comment, wrote: "I owe him a debt. He was the first, not himself an art critic, to write about me."

The beginning of 1910 had brought no diminution of the confusion at I Tatti as Berenson, afflicted with dyspepsia, tried to keep clear of the workmen and, often from a sickbed, to carry on his business affairs. Pictures had to be checked against his library of photographs, nearly inaccessible books consulted, and much conferring completed with Mary to determine attributions or track accounts with dealers. His rages against the pervasive disorder became a recurring feature of life. Dealers were almost daily visitors, each with a pet project.

The wonderful flood of pounds sterling that poured into his account at Baring Brothers in London alternately dazzled and alarmed him, for expenditures seemed always to outrun income. At the opening of 1910 Mary told her mother that B.B. had £12,000 owing to him and that they were "really very well off"; still, a delay of a week in a remittance of £5,000 was "horribly awkward" because they had put off creditors to the first of the month in expectation of it. The scheme of improvements to the I Tatti estate as generously interpreted by Cecil Pinsent called for ever-increasing outlays. When their *fattore* explained that the new farmhouse would cost £2,400, they half hoped that the work might be abandoned, but the momentum of extravagance could not be stayed nor their

array of dependents in England and America reduced. Friends had already begun to refer to I Tatti as "Berenson's Folly." As the improvements dragged on, Berenson told Mrs. Gardner that he had "wasted almost a hundred thousand dollars" on the estate, three times what he had paid for it.

The cost of maintaining a chauffeur and reimbursing him for the incessant repairs and servicing added a fresh anxiety, delightful as the new motorcar was proving to be on excursions about the countryside and down to Rome. "At this rate of expenditure," Berenson reflected in some bewilderment, "I cannot possibly afford an auto." But the stream of remittances from his clients and dealers in Europe and America discouraged prudence, and by November of 1910 he had bought another automobile and thus owned both "a big and little motor." The second purchase assured that one car at least would always be in running order.

Joe Duveen opened the year's correspondence with a succession of anxious queries. He was worried about a picture on which Berenson had changed his opinion since his 1901 List: "Should we buy the picture and then cause endless difficulties?" To that there could be only one answer: avoid trouble. Lord Cowper's magnificent Raphaels were being shown at the Grafton Galleries: "Wire whether they are authentic. Are they in good condition? Must have your advice." Their authenticity, Berenson assured him, was unquestionable. Duveen subsequently acquired the small Cowper Madonna and the Niccolini-Cowper Madonna and sold the first to Peter Widener for $836,000 and the second to Andrew Mellon for $1,166,000. Both masterpieces fortunately ended up in the National Gallery of Art in Washington.

Tied to the Ixion wheel of business, Berenson began to learn that its revolutions governed his goings and comings with unexpected rigor. Hitherto he had regulated his life with almost methodical care, with excursions planned long in advance, itineraries carefully laid out, and each day's schedule prescribed. True, Mrs. Gardner had issued her royal commands and he had submitted in his fashion, but they had required that he dance attendance only at yearly intervals. He now had to do with a far more demanding sovereign, one whose disarming friendliness and good humor covered an inordinate ambition to prevail and bend his associates to his purposes.

Duveen's deferential but insistent demands could not be ignored, and toward the end of January 1910 Bernhard, improved in health, set out with Mary for London. On their stopover in Paris a hurried consultation with a dealer before breakfast earned him a tidy £340. He wrote Senda, "As for me I am here to make money and I may say I am making it by the handful."

In London Berenson throve on the solicitous attentions of titled pic-
ture owners who, eager to repair their fortunes in a booming market,
sought his expert opinion. Fees seemed to rain upon him. A transaction
from which he had expected £700 brought a check for £1,100. Mary
found Bernhard "a very jolly companion" amidst this golden aura, and
she was pleased that "people do seem to appreciate his work."

Berenson's interest in Oriental art, which had been inspired long ago
in Boston by his sight of the Chinese paintings at the Museum of Fine
Arts in the company of Ernest Fenollosa and Denman Ross, had now
grown to a passion, and when Sidney Colvin showed him his Chinese
paintings, Berenson persuaded Joe Duveen to buy them for £200. He
lunched with Mrs. Randolph Churchill, who had just refurnished her
house, and the contrast with what he had left at I Tatti filled him "with
rage and envy." He improved the few weeks in England by inspecting
the paintings at Downton Castle and other country places and by travel-
ing into Shropshire for a first sight of romantic Ludlow Castle across the
meadow. It was such "a castle as I dreamt of . . . as a boy reading the
history of England."

Before leaving England Berenson was persuaded to make a quixotic
gesture on behalf of the candidacy of Philip Morrell, Lady Ottoline
Morrell's husband, who sought to enter Parliament as a Liberal M.P.
with the active support of Bertrand Russell. Mary forwarded Bernhard's
check for £200 to Alys with the comment, "He says it is really satanic of
him to lend it for such a purpose, for he hates the idea of Bertie's wasting
his fine intellectual powers on politics! Also he is a Tory, and has a fearful
dread of all this Liberal-socialistic legislation." Morrell's candidacy
failed.

On the way back to Florence, accompanied by Mary's daughter Ray,
the Berensons stopped off at Milan to check progress on Cavaliere
Cavenaghi's restorations on their Signorellis, and then Bernhard went
off to confer with his old friend the art historian Dr. Gustavo Frizzoni,
who was eager to dispose of several paintings. Berenson offered them to
Johnson, whose most recent acquisition had been a Titian for £4,000. As
Johnson's tastes were broad and his ambitions as a collector modest,
Berenson could not forbear remarking to him, "I'd rather earn your
penny than Altman's thousand pounds." Johnson took four of Frizzoni's
paintings.

Just at the moment when the removal of the American customs exac-
tions had greatly stimulated the demand for Italian paintings, the Italian
government adopted more stringent regulations governing their export.
A progressive export duty was now in effect. When difficulties were
posed in connection with Johnson's purchase of a Neroccio de' Landi

from Aldo Noseda, a collector, Berenson exclaimed to him, "I brutally confess I have an infinite contempt for their Dago laws, and nothing would give me greater joy than to break them, if I did not live here, and under flash lights as it were." What especially disturbed him were the whimsical decisions that seemed to govern the granting of export licenses, the *permessi*. For the moment the difficulties attending *permessi* discouraged his search in Italy for suitable paintings, and he unsuccessfully proposed a Roger Van der Weyden to Mrs. Gardner.

It was the hypocrisy and corruption that surrounded the enforcement of the Italian laws that most irritated him. Later that year when he was confined to bed for some weeks with his recurring illnesses, he wrote to Henry Adams that his illness had saved him from being troubled by "all the great Italian defenders of their artistic patrimony who wish to sell me their recently purchased ancestral treasures." He had been shocked to learn earlier in the year that 4,000 lire ($800) was the highest salary of a full-fledged gallery director in Italy and that the inspectors who passed on exportations got only 2,000 lire. "Imagine," he wrote Mary, "giving people so exposed to temptation $400 a year."

The press of dealers and intermediaries who came up the Vincigliata road to I Tatti had so increased by February that Berenson employed F. Mason Perkins "to do all the mediating work in buying pictures, seeing the dealers, beating down their prices and arranging to get the pictures safely out of the country." It was work that bored and exasperated Berenson. He resented the fawning offers of secret commissions, having long ago learned the anguishing reflections they could inspire. Not long after his return from England a Paris dealer sent a photograph with a check for 2,000 francs and asked that Berenson inscribe an attribution to Moroni on the back of it. He declared that Berenson had so identified the painting in his shop and that the Canadian collector Sir William Van Horne, to whom he had sold it, now wanted Berenson's certification. When Berenson protested that he had never seen the picture and returned the check, he was offered 15,000 francs to get the dealer out of his difficulty, an offer he indignantly rejected. It was disgusting, Mary commented to her mother, "to have one's nose rubbed in such cheating."

Sufficient progress had now been made on the alterations of I Tatti that the services of Cecil Pinsent and Geoffrey Scott were no longer needed. Pinsent, who had been in charge, declined further salary, protesting that no one was ever paid so well. The two young men took quarters in the Via delle Terme and set up as consulting architects. The fame of the new library at I Tatti soon brought them three new clients.

Whatever satisfaction Berenson was now able to take in the spacious additions to the villa, the graceful flight of stone stairs that curved up-

ward from the entrance corridor, and the newly opened vistas to the outdoors, was embittered, as he wrote Roger Fry, by the loss of a whole year at a time of life when good working years can at best not be many. "We are now," he explained in March, "where I expected to be a year ago." His relations with Fry had settled down to a wary friendliness. Fry had found J. P. Morgan an uncongenial taskmaster, and he had applied for the Slade Professorship of Fine Art at Cambridge, an appointment for which he had to wait thirteen years. "America has failed me," he had written Berenson, who had provided a warm testimonial in support of his application.

Alternations between Bernhard's good humor and his despair marked the rhythm of the Berensons' life during the late winter and spring of 1910. Beneath the surface there coursed a new source of malaise that surfaced during a visit with Ralph Curtis at the Villa Sylvia at St. Jean-sur-mer. There, away from Mary's irony, for she did admit to rubbing "things in a bit," he aired his grievance in a letter to her. He wrote that he had returned to I Tatti the previous November autumn with a hunger for her society in the weeks he languished in bed with a nervous illness. "Either you were too busy in the morning, or at night you came so late you were too tired to stay." He had come home "hoping for healing in your arms. But alas I felt you cold and stiff." He denied he felt repugnance to her as she had charged. True, as Mary had known for some time, he was greatly drawn to Belle Greene, whose visit he was eagerly expecting that summer, but she was still, he argued, "only an adventure while you remained forever." Then he declared, "I must keep you, but if keeping you obliges me to let go of Belle it will be so hard that it may not be worthwhile." Mary strove to be tolerant. "If Belle comes over and makes thee happy I shall most heartily enjoy seeing it." There the matter rested like a banked fire.

Work had now been resumed on the Johnson catalogue, for which more photographs arrived amidst negotiations for new pictures for the collection and discussions of attributions. The typing as usual fell to Mary's lot, but interruptions multiplied. Joe Duveen came down to Florence with his brother Louis in mid-March looking for bronzes and majolica, having first asked Berenson to "look around to see whether there is anything for our consideration." He particularly had asked Berenson to look at a picture being offered by the dealer Salvatori. His impression, he said, was that it was not by the master, "but I am not a sufficiently good judge to venture upon an expert opinion."

Joe and his brother Louis proved "much more agreeable than we dared hope," Mary noted, and to her great satisfaction "they admired the new library extravagantly." In his bread-and-butter letter Duveen alluded to

the family lawsuit in which the eight brothers were involved on the breakup of their father's firm. He had been "boxed up" with his solicitors and barristers but was now pleased to say that it had all ended "satisfactorily for me."

Joe emerged, in close association with his uncle Henry, as head of the reconstituted firm. Soon he was able to inform Berenson that the opening of their gallery in the place Vendôme would be celebrated on May 1 with a great exhibition of their many new acquisitions. There were also, he wrote, "some very important messages to give you that are so private that I cannot write them." Berenson managed to avoid the opening, evidently suspecting the public-relations use that Joe would wish to make of his presence.

As a semblance of order began to assert itself at I Tatti, the formal dinners and luncheons multiplied. One catches glimpses of the Zangwills, the sculptor Hendrick Andersen, the Princess Liechtenstein, Cecil Spring Rice, Lawrence Binyon, and such regulars as Placci and Hortense Serristori. Theodore Davis made his annual appearance, but the dinner was marred when without warning Berenson fainted dead away. It was the sixth occurrence that year. Sometimes the fainting was associated with outbursts of anger, on one occasion so violent that Mary locked the door to his room. Dr. Giglioli could only counsel self-restraint and prescribe for the customary ailing liver. After still another hysterical rage he advised that Bernhard seek psychiatric help. During that outburst, while Mary and Elsie de Wolfe, who had come down with Bessie Marbury, tried to calm him, he cried out that he hated the house, hated all Italy, that life was a hell, and he would run away. The fit passed as quickly as it had come, and by the time Elsie left, it was clear that her feminine charm had tranquilized him.

As spring bloomed on the hillside, Berenson implored Edith Wharton to come and provide a change of conversation. "Drains and furnaces, short circuits and deaf telephones, . . . drunken servants and Othello butlers are all the talk I have been hearing." Mrs. Wharton was unable to come, but there were other distractions. Bernhard's unmarried sister Bessie, frail in health, came over for a rest, looking prettier than ever and at the beginning of her stay so unobtrusive in her wants that Bernhard and Mary found her thoroughly likable. His uncontrollable rages disturbed her, however, and she declared that she could not imagine "having a man at all—after what she knows of her father and brother" at home and Bernhard here and the ill manners of Pinsent and Scott. She was to remain unmarried to the end of her very long life.

One of the more striking sights to amaze the household that season was the apparition at the door of Gertrude Stein, "fat beyond imagina-

tion," Mary recorded, in the company of "an awful Jewess, dressed in a window curtain, with her hair completely hiding her forehead and even her eyebrows. She was called Toklas." It was the only visit of Gertrude's alter ego. Neither Gertrude nor her brother Leo stood on ceremony, and they came over whenever the spirit moved. They were easily accommodated with a "free meal" at tea time, hardly an expense at this period since their new fad was to eat almost nothing.

For music the Berensons no longer had to depend solely on evening musicales. Their "latest joy," as Bernhard wrote Mrs. Gardner, was a Welte-Mignon player piano, which required no knowledge of a score or fingering but only the energy to pump the pedals and to change pianola rolls. In quiet intervals he could divert himself as a virtuoso. Mary, he added, was "motor mad" and "young people mad" with males preferred. His own pleasure in the convenience of the motorcar, though more restrained, was real enough. In a jaunt to Rome by way of Grosseto late in April 1910, he and Mary were joined by Prince Franz of Liechtenstein, an avid amateur of art, and they had only one breakdown on the way.

In early May they drove to Caprarola, thirty miles north of Rome, to visit Mrs. Baldwin, Gladys Deacon's mother, at the historic Renaissance Villa Farnese, where she had been installed since 1908 by her devoted admirer Prince Doria. There they found luxury and grandeur enough to satiate even Berenson's dreams of dazzling elegance. The broad spiral staircase that mounted to the first floor rose so gently it was said a horse could ascend it. The gardens with their plashing fountains and sylvan figures, their blue-and-white peacocks, and masses of flowers were of a nature that overwhelmed envy with sheer delight. Berenson must have returned to Pinsent's rather elaborate landscape plans for I Tatti in a chastened spirit.

With the approach of summer Henry Walters, again reconnoitering for pictures in Europe, came down to Florence "just to see," as he confided to Elsie de Wolfe, "what kind of man B.B. is." What the "jolly, good-natured, shrewd old bachelor of 61" saw obviously pleased him, for he commissioned Berenson to buy regularly for him and proposed an annual budget of $75,000. "It will mean £1500 a year," Mary joyfully reflected.

Berenson's arrangement with John Graver Johnson had already settled into a steady course of acquisitions and the sharing of art-world rumors. Every week or so Berenson would pass on word of something that had come up for sale, a Moroni, a Veronese, a Sebastiano del Piombo, usually at a modest few hundred pounds, though an occasional rarity ran into thousands. He kept in view Johnson's "legitimate repugnance to further

Madonnas." Johnson would pick and choose at his pleasure and grate-fully remit the 15 percent fee for expert services.

Joe Duveen's summonses became more urgent as the firm's American clients came abroad for the summer's buying of art. Berenson arrived at the Ritz and walked over to the Duveen's new gallery to listen for several hours to Joe's masterful plan of campaign. The jovial assurances im-pressed him as more talk than substance, and once again he found his mornings "wasted . . . hanging around the Duveens. It makes me hate my relations with them." But if the Duveens bored and frustrated him, Paris offered its usual satisfying social diversions which kept him trotting about the Faubourg St. Germain to bask in Edith Wharton's "fairy god-mother" charms or touching down at the Villa Trianon to visit with the "nymphs" there, as his friend Ralph Curtis dubbed the members of their *ménage à trois,* Elsie de Wolfe, Elizabeth Marbury, and Anne Morgan. Henry Adams, established once again in the avenue du Bois de Boulogne, suggested Berenson's enticing someone to dine with the two of them.

The summer of 1910 was, as usual, a peripatetic season, punctuated by a stay with Mary and her family at Court Place at Iffley in Oxford, in lieu of taking a "cure" at Bad Gastein as Bernhard had first planned. At Iffley, comfortably isolated in bed among his books, he could hear the congre-gation of the nearby church "piping its thin notes to their sort of comic rural Dean of a God." Soon on the move again, he returned to London, where for a time he was entertained by the company of Senda, who had come over for a holiday. Widener showed up, and he took him to Sul-ley's, the London dealer with whom he had close relations. His chief task, he wrote Mrs. Gardner, was to "persuade trillionaires to buy pic-tures," a chore that required attendance at the Duveens' London gallery, where he was overwhelmed with talk. "I won't go there again until I am seriously called," he wrote Mary. When finally a messenger came saying that "Mr. Joe" wished to see him, he told him "to tell Mr. Joe that while my time was far less productive than his it was no less precious . . . I would gladly come provided he made an appointment" and "stuck to it." Given that promise, he did go, but though he found Joe "most cordial," his assignment was deferred till the morrow. "Meanwhile I have the formal assurance I shall have £5000 in the autumn. Now you can feel less anxious about my land hunger." He had recently bought the farm plots across the road from I Tatti to provide a buffer against en-croaching villas.

At one meeting with the Duveens he witnessed a great row over whether they should "go in for Italian pictures or not," at least on a much greater scale than before. The question remained open. During a

lull Henry Duveen told him that Altman had been angered by Berenson's remark, which had been reported to him, that all he got from him was a bad cold.

Whenever business affairs permitted, Berenson gave himself up with alacrity to London society. He had become a prominent public figure and a popular guest, and his appearance that season in Reginald Turner's novel *Count Florio and Phyllis K* must have entertained his English friends. Turner, a friendly acquaintance, amusingly satirized his penchant for prolonged study of a painting with a magnifying glass, especially when on the track of a forgery. When "Barnard Barnardsohn" scented a fake, he wrote, his "eyes glowed. . . . 'It's quite a good piece of work,' he said, looking at it ferociously. 'It seems almost a pity to spoil it. But its time has come at last.' " And "Barnardsohn" proceeded to "scrape and chip" to reveal the imposture. It was the same Turner who, when conducted through I Tatti, playfully gushed, "How Duveen!"

A grand party at Lady Cunard's found Bernhard in the company of fashionable acquaintances like Maurice Baring, Lady Lister, Lewis Malloch, Harry Cust ("including his whole harem"), Lady Horner, and Mrs. Leslie. At Lady Elcho's dinner one night he had "the time of his life." "I sat between her and Arthur Balfour. . . . We talked of anthropology, history, William James, American politics, etc. It was very light, thoughtful, exquisitely comprehending but not witty." His letters to Mary bristled with notables—Cavendish-Bentinck, Lady Charles Burford, Lord Brook. Mrs. Asquith, catching sight of him, was all sympathy: "How pale you're looking. You must have been very ill." He dined with Lady Ottoline at her London residence, where he met the young playwright Channing Pollock. He went out to Knole to call on the Sackville-Wests and in the evening dined with Louis Duveen. He kept up friendly relations too with Charles J. Holmes of the *Burlington,* who was now Slade Professor of Fine Art, and with Holmes and Sir Charles Holroyd he looked appraisingly through George Salting's pictures which were to come on the market.

But though the summer days in London passed in agreeably distracting fashion, emotionally Bernhard was only marking time, for he was awaiting the arrival of Belle Greene.

XII

Idyll with Belle da Costa Greene

BELLE GREENE arrived at Claridge's in high spirits on August 18, 1910, with a French maid and a mountain of luggage. Bernhard dined with her and they "chatted till midnight," so rapt in each other that "for the life" of him he could not recall "who, or what, or why." "I am all in a whirl," he exclaimed to Mary, "for she is the most incredible combination of sheer childishness, hoydenishness," intermixed with "sincerity, cynicism and sentiment."

Mary, herself bemused with Geoffrey, sagely advised him, "You are getting old. Make the most of it, if thee can without doing her harm." Bernhard was quite ready to follow her advice. Belle's incendiary letters had kept him in a fever of expectation. "I would kiss you until you cried for mercy," she had written in May, "and I would cuddle up in your arms and go to sleep with my mouth on yours and my heart on yours with your hands in my hair and with mine round your neck."

He wondered, after a few days with Belle, what the exotic creature would grow into. "Who can tell? Perhaps I shall count for something in that. But as yet she is much more cerebral than sensual. Of the erotic there is little in her and under the mask and manner and giggle there is something so genuine, so loyal, so vital, so full of heart . . . that . . . my impressions vary from minute to minute." Afloat in good feeling, he ended the letter to Mary, "Goodbye my darling. Even though polygamous I am not the less yours."

He was to be Belle's companion during the most of the month that followed. She had come over to make purchases for J. P. Morgan's collections, and manuscript dealers were eagerly seeking her patronage. Bernhard accompanied her to shop in London and Paris before they set out for an exhibition of Eastern art in Munich. At one place he happened to call her attention to a fine manuscript for which £8,000 was asked.

Interested in it, she cabled Morgan, and, to Berenson's amazement, Morgan told her to use her own judgment. At another place she calmly used her carte blanche to select a half-dozen expensive medieval manuscripts.

The wonder of this belated romance colored all of Berenson's thoughts. He ruminated on it, incredulous of his good fortune, and kept turning it over in his mind, verbally probing his feelings. He felt a kind of terror of "this incredibly unlooked for love that is being given me," a fear of its illusory character. Just before setting off with Belle, he reflected for the benefit of Mary, who was once more trying a reducing cure, "When shall I grow up, cool off, settle down?" He felt a "desperate desire to mortgage the future forever." Perhaps, he mused, he did not have "enough strength for actual emotions," for "putting such new wine into an old bottle." Baffled by the tyrannous rush of feeling which mocked the orderliness of his life, he went on with his soul searching: "No, I ought to confine myself strictly to ideated sensations. . . . But again something in me loves the actual that I am getting now."

Mary had become reacquainted with Belle Greene in London before leaving for the reducing spa. Reflecting on that encounter when she got back to Iffley, she admitted to Bernhard, "I was really quite charmed by Miss Greene and wish this might be the beginning of a permanent relation such as our middle-aged, bourgeois romantic souls sigh for." She could not forbear, however, adding some motherly advice: "One thing dear, I want to say in thy ear, Don't boast to her, either of thy moral or intellectual qualities. . . . Excuse this marital word but I want thee to appear at thy best."

Mary's liking for psychologizing more than matched Bernhard's. She too had sat at the feet of William James. As a friend of her family, James had been wont to call the matriarchal Hannah Smith the "Mother of Pragmatism." Now Mary urged Bernhard, "Tell me all thee can. . . . There is something fundamental, even mystical in loving a person. . . . It is the nearest we get to how God must love his creatures." Love "opens the heart," so much so, she ventured, that "I truly believe thee is fonder of me than thee ever has been." When this declaration elicited a complicated analysis the upshot of which was that he did not love her "at this minute as preoccupyingly as I have at times," Mary hurried to explain that she was not referring to "the present moment." As for his analysis that "a torturing preoccupation seemed essential" to love as a passion, she countered that "the excited state of nerves doesn't comprise the whole of love." So, like fellow researchers, they continued to exchange their findings.

After sightseeing and shopping in Paris for fourteenth-century manu-

scripts, Bernhard and Belle proceeded to the Munich exhibition. "The Renaissance is no longer my North Star," he had confided to Edith Wharton. "The tide of my interests is flowing fast and strong eastward." To Senda he wrote that the exhibition was a "perfect wonder . . . beyond expectation instructive." Knowing her puritanic scruples, he avoided any mention of Belle Greene. To Mary he was more voluble and intimate. "I feel so grateful," he said, "to what you are and the way you are taking this new situation, so simple, so natural and yet from any conventional point of view so extraordinary." But soon the idyll had an alloy: the "terrible business of dodging acquaintances has begun." Though painfully distracting, it was necessary because word of their companionship might give offence to J. P. Morgan and even arouse his jealousy.

Bernhard's daily letters to Mary must have thoroughly satisfied her appetite for candor. "In the evening," he recorded in Munich, "I read aloud a great deal of French and English verse (How one returns to one's old tricks but with what stiff joints!). She likes my reading probably because she likes to look at my eyes while I read." He basked in the pleasure of her discoveries in the museums, all so new and fresh to her. "I cannot conceive," he exclaimed, "one person caring more for one person than she for me." Then, as a kind of caution, he appended, "A sheer miracle it is. I get what I can out of it now and what a glory it will be to look back to."

At the moment Mary, who had returned from England, was herself en route to the Munich exhibition with Geoffrey Scott, who was as passionately attached to her as she to him. The pair reached Munich after Bernhard and Belle had moved on to Italy. It now appeared that the chaperon who was to meet Belle in Rome would not be available. Bernhard begged Mary to take her place, explaining that Belle expected to call on "her boss's favorite dealers" and they would undoubtedly spy on him and report to Morgan. "It is very necessary that he should suspect nothing. . . . I would suggest that you bring Scott along. Four is always easier to manage than three and it perhaps would make it pleasanter all around." Though put out by his request, she wrote she would be "glad" to help him.

On their way to Rome Bernhard and Belle traveled to Bologna, where he ran into the Blumenthals, prominent American acquaintances of his. Since they too were planning to visit Perugia, he decided to escape their company by going instead to Siena. He would show Perugia to Belle on the way back from Rome. "All this dodging about," he lamented, "half spoils my pleasure." The amorous pair of sightseers detoured to Ravenna, where Bernhard marveled that his companion was "incredibly and miraculously responsive and most of all to the things I really care

most about." She was in fact the "most responsive person excepting your beloved self," he assured Mary.

Mary fell ill with her recurring bladder infection and so did not have to sacrifice herself for Rome after all. A chaperon of sorts did turn up, "a poor specimen of a poor type of striving, silly moneyed American female," in Bernhard's unflattering portrait, whose endless chatter made Belle "waspish" and Bernhard "miserable." The "idyll as idyll" was over, he feared. "After three corrupting weeks" with him, Belle's meeting with the chaperon dropped her "into the worst fit of the blues."

The idyll could not be prolonged in any case. Miss Greene had to busy herself daily with Morgan's dealers in Rome, and Berenson had to return to Paris to inspect a collection for Duveen. Not one to spend time in his beloved Paris merely on necessary chores, he arranged to dine with Henry Adams. "My life is that of a black beetle," Adams had written. "It is you who are occupied and useful, appreciative and decorative." Dinner under such auspices could only be delightful. Berenson found a cordial welcome also at Mrs. Cameron's table in the company of Ambassador Henry White.

While Bernhard was busy in Paris, Belle Greene's business required her to go to Florence. At Bernhard's urging, Mary took her about. "Show her only the very best," he said, "the Pazzi [chapel], the Giottos at Santa Croce, the Medici, the opera del Duomo." Belle's presence in Florence seemed to heighten her ardor for him. "I could not have believed it possible," she wrote, "that anyone would become so much a part of me and my life as you have."

After inspecting the collection for Duveen, Berenson returned to I Tatti where, to Mary's great relief, he professed himself to be pleased on the whole with the condition of the villa. Piot's frescoes had at first alarmed them, but for the moment they did not excite revulsion, for Piot had "modified the vulgarity of the nudes and opened out a soft landscape behind." In any case Berenson had a more diverting subject of contemplation. He hurried off to Perugia to join Belle on their deferred study of Perugino. After Perugia they went on to Venice, where they were met by Mary, Geoffrey Scott, and Cecil Pinsent. The whole party, including Miss Greene's maid, put up in "a splendid suite." The incessant sightseeing, the exchange of visits with the Humphrey Johnstones and the Ralph Curtises, and "a magnificent banquet" in their sitting room one night with Placci, Princess Mary of Greece, the Countess Czernin, and a few Americans gave little opportunity for the continuance of Bernhard and Belle's intimacy. Belle, however, thrived on the limelight.

The crowding distractions in Venice seemed to him the result of Mary's passion for managing things to his disadvantage, and at the first

opportunity he renewed his accusation that she regularly deceived him, that her deeds were "evil and her heart black." She retaliated that she had had to lie to spare his feelings and then to prove her point infuriated him with a dash of truth-telling, namely that Pinsent had got a new architectural commission through Charles Loeser, with whom Bernhard was at odds. His immoderate outbreak in Belle's presence so offended her that she vowed she would "give it to him hot and heavy" when he took her to the Accademia. Her reproof worked. Later in the day he sought out Mary and pleaded with her, "Mary, don't go back on me. I've nobody and nothing in the world but you," an avowal which she took to be an apology.

When after a week the party broke up in Venice with Bernhard going to Paris with Belle Greene and Mary returning to I Tatti with Cecil and Geoffrey, Mary reviewed their life together in the light of their recriminations in Venice. "We used to quarrel dreadfully even before I fell in love with [Hermann] Obrist," she reflected, recalling one of her clandestine affairs of the 1890s, "and it was generally (not always) because I either concealed things from thee or misrepresented them. Of course this was worse each time I fell in love partly because thee would not believe that *that* need not alter a really devoted already existing relation. . . . So I have fallen into the ways of not telling thee a good many things that I feel would arouse scorn or wrath or opposition. . . . Poor Bernhard, it has been thy cross and a heavy one."

By the time Mary's letter reached him, Belle Greene had departed to London with her maid and baggage, apparently unruffled by the thought of her separation from him, a fact which left him desolate. After a sleepless night he felt he understood the temptations of Saint Anthony. He acknowledged that the bottom had dropped out of things. However, a three-hour chat with Henry Adams set him up somehow, and he remarked to Mary that when he recently dined with Adams and his friends, he "could not help contrasting his world with Belle Greene's. What a relief it was to be in his."

But no matter how he tried to rationalize his feelings, he was tormented by Belle's absence. It was true that during the day living went on and he was cheerful and carefree for hours. He enjoyed seeing Madame Réjane (Gabrielle Charlotte Réju) in a play, dined convivially with a German tenor and his wife, and wrote letters. He unburdened himself to Ralph Curtis during luncheon at Larue's and received "excellent but, I fear, useless advice." Archer Huntington also listened sympathetically. Bessie, taking a rest cure in Paris, reported his cross-gartered state to Senda and widened the circles of concern. "Everything seems so very far away, so unreal, so objectless," he anguished, and the solitary nights in

his rooms at the Ritz were "sheer hell." His letters were so filled with woe that Mary demanded, "What *is* the matter with thee that thee is so miserable? Is it just love sickness? Or has thee the horrid suspicion that it was only an adventure for her. . . . I hope to be a raft for thee, my dear, but I'm not the stately luxurious yacht thee requires."

In the midst of Bernhard's alternating misery and euphoric distractions, there came a "singular catastrophe" to the Duveens which Berenson feared might upset all his plans and "also endanger the immediate future, i.e. the £2500 I am expecting." The details of the catastrophe were served up in the press with considerable relish. On the Jewish Day of Atonement, October 13, 1910, the United States Customs Service with biblical rigor sprang its long-prepared trap. The Duveen firm was charged with evading millions of dollars in customs duties by the wholesale undervaluing of art objects in the years before the repeal in 1909 of the import duty. Agents arrested Benjamin Duveen and seized Henry Duveen when his ship docked in New York. A bookkeeper of the firm, at odds with Benjamin Duveen, learning that the Customs Service paid informants liberally, had betaken himself to the head of the service. Reportedly the undervaluations had been made with the paid connivance of customs officers. The Duveens were to be made a spectacular example in New York as Mrs. Gardner had been pilloried in Boston. The Customs Service put in a claim for ten million dollars and criminal proceedings were begun against various members of the firm.

Serious as the blows were, they did not in fact cripple the firm. The London and Paris branches held their own. The gallery in the place Vendôme was bringing luster to the firm. Berenson's alarms somewhat subsided when the check for £2,500 arrived with the assurance that a similar sum would be paid on the first of November.

Though Berenson's dependence on Duveen had grown, his services were still much sought after by other dealers. As if to exorcize her worries about their extravagance, Mary carefully noted some of the potential fees outstanding that autumn. In a long memorandum she listed fifteen negotiations, for example, that were pending with Nathan Wildenstein, the most prestigious dealer in Paris. They generally called for a fee of 10 percent. In a few instances Berenson was down for a share of one-third or one-half the profits. Prominent among the expected purchasers were Mrs. Potter Palmer of Chicago, Maurice de Rothschild, Mrs. Gardner, and the American capitalist Thomas Fortune Ryan. She also noted that the Steinmeyer firm of Paris had agreed to share one-third the profits on the sale of a Lotto. "Were I only rapacious and mercenary enough," Berenson confided to Johnson, "I could, while the vogue lasted, spend every minute amassing a fortune."

Belle Greene made a flying visit to Paris for a brief reunion with Berenson before going back to London to pack for her return to America. It brought him little relief. In a dark mood he prepared a will and sent it on to Mary. What made him "long for death," he told her, was that he was "overwhelmed with an emotion too powerful" for him. "I can give physiological details but really Dante's *Vita Nuova* gives a better description of my state." Belle was his unattainable Beatrice, and he chivalrously resolved "to be a providence to her for the rest of my days." When Mary scoffed at his idealizing portrait of Belle, he begged, "Please, Mary, don't think such thoughts. They nearly kill me. . . . I know the child is perfectly sincere, disinterested, utterly abandoned in her love for me."

On learning that Belle had sailed, he dared to hope that he would "begin to calm down." And calm down he did, briskly resuming his circuit of the dealers and his cultivation of his friends in Paris. His relations with Henry Adams were now so cordial that Adams gave him one of the few copies of his privately printed book on Tahiti, *Memoirs of Arii Tamaii*. Ralph Curtis told him that gossip had it that Belle Greene had used him as a mere "valet du place." Berenson replied that he had "so little vanity and amour propre" that he was delighted that people should think so. He dined again with Adams and reported that they "moaned and groaned over time and tide and man and woman and our friends and enemies and had a very good time."

Just when he felt he had mastered his unruly heart, something would remind him of Belle's absence or a cable or letter would come from her so reviving his sense of her presence that it plunged him again into "blubbery" grief. Mary did her best to give him solace. She would put everything aside, she said, and join him if he needed her or she would set off with him on diverting travel. "Our affection is such a sure thing I feel as if it would comfort thee even in thy lovesickness, as thine always did me. . . . How different from all I had hoped for thee, dearest."

She told him that they were all working hard to prepare the villa for his return, that the work in fact was almost finished. But again and again some new mishap thwarted her until he announced that he could not further delay his return, that if she wished she could lead him into his bedroom "blindfolded, and I promise to stay there until you are ready to show me the house." He declared that once he had rested he would "put the whole accursed thing up for sale to the highest bidder. . . . I feel as if the house was the only thing that holds me to a past which I would gladly have done with. . . . If only you were even in as good health as I, I should be seriously inclined, house or no house, to give it all up and

disappear from circulation until I have joined a new road or got the full conviction that there is none."

He marked time a bit longer in Paris, conferring a few times with Joe Duveen, who flattered him with attention. He consulted also with Nathan Wildenstein and paid court to Jacques Seligmann, whom he desired to "neutralize" amidst the competition for desirable paintings. There were teas and dinners at Edith Wharton's hospitable apartment in the rue de Varenne, where writers and artists congregated and tried out their bons mots. Berenson's friendship with Mrs. Wharton had by this time ripened into an amiable camaraderie. He thought her "human, cordial, even devoted," and reported that she "prophesied I was to do far more interesting writing than any I had ever done yet." Then, with the unfaded recollection of Mary's and Logan's strictures in his mind, he added that she "went so far as to say she liked my prose."

He arrived at I Tatti on November 13, 1910, in a peaceful mood. It did not last long. Piot's workmen, still busy with the frescoes, were ever more objectionable. Mary had learned to her horror that they "always obeyed the call of nature from the big window on the terrace." But worse than that, when the furnace was lighted an appalling stench rose from the little basement room. It was later learned that the workmen had used the place as a water closet, and as a result the floor had to be excavated to the bedrock. Worst of all were the frescoes themselves. Perhaps if Piot had worked from the drawings that the Berensons had approved, the results would not have so painfully disappointed them. Unfortunately, excited by the possibilities of the conception, he had made new drawings. André Gide, to whom he showed them, privately thought they lacked "the decisive quality, the gravity, even the attractiveness of the first ones."

The small preliminary sketches, with their suggestion of a classical landscape with graceful nudes disposed about like figures out of Virgil's *Georgics,* had seemed pleasant enough, but when they were modified and transferred to the plaster in vivid colors in the first four lunettes, the effect could only appall the domestic jury. Shortly before Bernhard's return Pinsent had written in his notebook: "Unanimous decision to destroy Piot frescoes. But nothing is to be said. It is to take shape FIRST in B.B.'s mind." When Bernhard looked up at the arresting apparitions, he could only shudder at the "lunatic optimism" with which he had commissioned the work. The frescoes would have to go, but he was undecided whether "to cut them out, whitewash them, or cover them with canvas."

As only four of the frescoes had been completed, he wrote to Piot as tactfully as possible that his means did not permit him "to indulge in

such luxuries. . . . My eye is formed on pictures faded and ruined by time. . . . All this does not imply any criticism of your art as art." From Paris a month later Lucien Henraux reported that Piot took his dismissal with dignity but with great sadness, a report which made Berenson miserable with a sense of guilt. In his reply to Berenson's letter Piot hoped they would remain friends and leave the frescoes in oblivion—and friends they did remain. Not long afterward the frescoes were covered with canvas—peeling the frescoes from the wall to return them to Piot had not proved feasible—and the wall was restored to its blank state. Nearly seventy years later the canvas was removed—Mary and Bernhard long since at rest—and the offending frescoes, their colors still fresh and startlingly vivid, were once again visible.

Confronted with the disaster of the frescoes, Bernhard again suffered from neurasthenia. The slightest noise upset him. The prevalence of garlic in the cook's cuisine nauseated him. The extended debate over the garden plantings exacerbated his nervousness. Nor was it any comfort to behold in his sister Bessie, who had returned from Paris, symptoms that mirrored some of his own. Her insomnia drove her to hours of tears, and her fits of nausea were strangely like his.

Once again Berenson took to his bed for most of the day, where he brooded impatiently over Mary's untidiness and her easygoing ways. "Shocking so young as I am," he wrote to Henry Adams, "and already so out of sorts with the house of life I smuggled into so expectantly at twenty." Yet he was obliged to admit that he was "perfectly enchanted" with I Tatti "as Mary had succeeded at last in knocking [it] into shape." He relished "the sound of water rushing down streams which meet at the bottom of my garden. . . . And the whisper of the wind in the trees is very soothing." From Paris Adams, somewhat chary of sympathy, replied ironically, "You have the singular good fortune to be in bed and read books. Here we are not allowed to stay in bed and we have no books to read. We flit through the gloom and hover on the bridges, always in the dark with the water close below." Adams passed on the doleful news to Mrs. Cameron, "Berenson is in bed ever since he got back, and talks of his back and of nausea. I suspect his nerves are all gone. So are mine!"

"Young Duveen," Mary's characterization of the hyperactive Joseph, who was but five years her junior, came down to Florence the first of December, and Berenson, out of bed again, spent the day with him on business, returning "very tired and awfully cross." Duveen's habitual affability never succeeded in hiding from Berenson his determination to have his own way. Nor could his crassly commercial outlook have cheered him in his already melancholy state. To further roil his spirit, word arrived that the Italian government had impounded the two beauti-

ful Signorellis being cleaned by Cavenaghi for which export licenses had been withheld. Mary descended upon the Uffizi official to disentangle the matter while Bernhard fulminated against the Italians. Heightening his feeling of persecution was a letter from the director of the Brera Museum boasting that he had managed to get a "fine Lotto out of the country to sell in London."

The one glimmer of light that relieved the gloom at the end of the year was that a new secretary, the "very capable and business-like" Maurice Brockwell, who was doing a catalogue of the British National Gallery, was soon to replace the temperamental Lucy Perkins, who had obtained a divorce and to the Berensons' relief had decided to quit and set up as an art dealer. Berenson's dependence upon Belle Greene's letters had meanwhile grown to an obsession. Toward the end of the year she protested, "This is my *fourth* letter to you this week—insatiable man." Her own appetite was hardly less ravenous. "You may as well know now," she told him, "that I keep them. . . . What does it matter if some one at some time, anyone, should see the letters. . . . I am so proud and happy to love you." His depression was not relieved by her blithe Christmas injunction to remember those "divine nights. . . . There are millions more in store for us."

Christmas Day did nothing to lift his spirits. At the ten o'clock mass there was a great gathering of dependents, while he lay in bed groaning that he was "finished" and Dr. Giglioli urged repose upon him. All but Bernhard had hung up their Christmas stockings. The peasants came with eggs and figs, and Mary, resentful of the custom, distributed the usual cash bonuses. Before the year ended, a further misfortune struck. A heavy squall blew down three of the fine cypresses which Berenson prized, and in spite of the efforts of a crew of two dozen workmen, they could not be saved.

Thus ended a year which had begun with so much promise. The undreamed-of riches which the Duveens had promised hung in the balance while their lawyers in New York argued with the United States Custom Service, the Great Good Place that Bernhard and Mary had dreamed of creating when they left for America nearly two years ago still lacked the final touches, and the romance on which he had lightheartedly embarked at the Morgan Library had become a Nessus shirt of torment.

1. *Lady Aline Sassoon, 1903*

2. *Bella da Costa Greene, about 1909*

3. Berenson, 1909

4. Henry Adams, crayon sketch by John Briggs Potter, 1914

5. *Geoffrey Scott*

6. *Elsie de Wolfe*

7. *Nicky and the Anrep family:*
Alda, Bertie, and Cecil, 1920

8. *Mary Berenson and*
her great-grandson, Roger, 1935

9. Elisabetta (Nicky) Mariano, 1918

XIII

A Marital Truce

GLOOM settled ever deeper over I Tatti in January of 1911 as Bernhard brooded over the impasse in his relations with Belle Greene. Work on the Johnson catalogue "proceeded very, very slowly." "Each item," Berenson temporized, "entails my consideration of the whole master or even group." His sister Bessie's presence only deepened his melancholy. The luncheon table often had a funereal character, with Bessie weeping and Bernhard leaning his head on his hand and scarcely saying a word as he toyed with the bland dishes prescribed by Dr. Giglioli. Their commiseration with each other had the depressing result, according to Mary, of their "both saying ten times a day they wish they were dead." Nevertheless, Bernhard professed that he enjoyed being with his sister and trudging about the countryside with her.

During January Senda, alarmed by Bessie's account of Bernhard's infatuation, decided to talk with Belle in New York and sent a box of pink roses ahead as a peace offering. The two women talked quite frankly together. Belle told her that she did not wish to marry at all, but if she did marry, it would be for "money—*much* money." Senda cautioned Bernhard, "You would be separated in *two* months. . . . She would never for one moment wait upon you, make paths easy and smooth for you." Besides, she concluded, "You could not live without Mary and you know it more than anyone else." As for his crossing over to visit Belle, even Belle thought it "utterly foolhardy." Belle's report to Bernhard differed considerably from Senda's. Senda, she wrote, "considers me a 'body snatcher' and a professional flirt." The mission proved a failure, and the protestations of eternal and undying love on both sides went on.

Belle kept Berenson posted on the state of the New York art trade following the disaster which had struck the New York branch of the Duveens. The Seligmann establishment had almost been caught in the

[119]

Custom House dragnet, but Seligmann had fortunately destroyed his papers. For the moment, trade was paralyzed and only Knoedler's was said to be doing any business. Joe, however, went his confident way in London and opened the new year for Berenson by telling him they had several orders for fine Italian pictures: "As you know, [we] have determined to make a speciality of that school." He envisioned success, "as our clients here are realizing that we will deal with only the very finest and authenticated works. . . . You more than anyone will realize how disastrous a false step would be in our new enterprises." With the growing passion by rich collectors for "names," Joe repeated the counsel toward the end of the year that they must have "only the finest authentic works. . . . One mistake with a single client" would mean ruin.

The caution was hardly needed, for Berenson's chief pride—not to say vanity—lay in the superiority of his attributions. He was keenly aware that his livelihood depended on his preeminent reputation, and that in the intense rivalry of the art market that reputation was a prime target for his competitors, who hungrily chewed on every morsel of hostile innuendo. Once after a morning with Otto Gutekunst, he wrote to Mary that Otto told him "horrors are being said . . . how I will do anything for money, lend my authority to any lucrative attribution. . . . It simply did not touch me for my heart is pure."

Bernhard's continuing preoccupation with Belle Greene put something of a strain on the truce he maintained with Mary, and they wisely took leave from each other for a month, Mary taking refuge with her family at Iffley and Bernhard heading south to the Capuan comforts of Ralph and Lisa Curtis's Villa Sylvia at St. Jean-sur-mer on the Riviera. The change revived him, and he informed Bessie that he was enjoying "all the luxury, all the pretty clothes and playful ways of their crowd." It might be "deplorable," he acknowledged, but he enjoyed it "as I enjoy the sunshine and the warmth."

The vacation did little, however, to ease the struggle with Mary, especially because while they were still at I Tatti, she had looked at a letter to Belle Greene which he had left open on his desk. In it he had said that his whole existence was a nightmare and that every happiness he could ever receive now and for all his future must come from her hands. Away from I Tatti Bernhard wrote letters to Mary so burdened with suicidal thoughts that she wrote to Belle, as she confessed to Bernhard, to let her know "the havoc she has wrought in thy nerves and the way she has taken the point out of life for thee and in a large measure for me too." Mary now had ample reason to regret her encouragement of the affair. It had been a "miscalculation" on her part. "I thought to give thee happiness," she lamented.

Bernhard demurred that "apart from bad health, what makes me far unhappier than anything connected with Belle is the tangle you and I have got ourselves into. . . . All Belle has done is to give you an instrument for tightening the knot." The real cause of his despair, he said, was that at bottom Mary did not try to understand him, even though for so many years he had turned himself "inside out" for her inspection. "What I would like is what I no longer hope for. . . . I would like you to take great, great pleasure in being with me, in keeping house for me. I would like you with spontaneity and eagerness to put me first in everything. . . . I want if possible to have a house and possessions of which I am the real master or if I can't and find that instead they are more a burthen than anything else, I want to give them all up, everything, everything. I want to be able to dream of Belle, and to be with her once every while. . . . So it comes back to the fact that the vital difficulty is the lack of perfect sympathy between us."

Berenson's notion of the ideal marriage had its peculiarly masculine and romantic features, reflecting the male chauvinism of that period; Mary's, expressed less explicitly in her analytical letters than in her conduct, anticipated the freedoms of a later generation. In their nine years of premarital intimacy each had had ample opportunity to observe the idiosyncrasies of the other and to discover their divergent social ideals. What they learned had not resulted in either tolerance or forbearance. Bernhard's ideal of marriage could hardly have been drawn from the many cynical unions of the fashionable world which he loved to frequent; rather, it owed much, it would appear, to the world of his childhood and to his idealizing of his mother's self-sacrificing role in their household. Mary had been his devoted and admiring pupil and he had been for her a liberating influence, but the rebel whom he had loved could not return to the sort of marital bondage from which she had fled. Once when Bernhard and their friend Rembelinski had confessed to her and the discontented Countess Serristori their "poetic cult for women," Mary had written in her diary, "I cannot say I find in my heart a mystic cult of Man. I wish I had."

However emotional their disagreements, they regularly recorded their movements as their letters flew back and forth, and always with endearing salutations and leave-takings. So after pages of recriminations and reproaches, Bernhard told her, quite matter-of-factly, of going over to the casino at Monte Carlo with his friends and being driven out by the stifling air. Undoubtedly there was much self-serving testimony as they analyzed themselves and motives too confused and obscure to be put into words. Both had a penchant for self-deception, yet in the main they took each other's measure and reluctantly reconciled themselves to their part-

ner's shortcomings as they self-righteously indulged their own.

During the quiet February Berenson spent at the Curtises' Villa Sylvia, he went in to Nice to consult with Brauer, a dealer who had been a useful source of paintings. When Brauer smugly inveighed against the sins of the Duveens, Berenson looked him in the eye and observed that while "all he said was true, it was as true of every other dealer." A few days later the London dealer Arthur J. Sulley came to call "and drew an awful picture of the Duveen situation" in New York, saying that "Uncle Henry" had sold all the Fifth Avenue lots on which they had planned to build. "Personally," Bernhard commented to Mary, "I doubt whether I have any other feeling except perhaps relief. They were too overwhelming and rather frightening and I as lief they were snuffed out." Besides, he added, "I doubt whether I shall lose by it financially. Sulley, for instance, is clamoring for the kind of thing that the Duveens were so keen about." "I fear my poor enemy-friends, the Duveens," he wrote Mrs. Gardner, "are 'clobustered' as a firm."

Berenson had had a variety of business arrangements with Sulley, sometimes expertizing pictures or locating them for him for a set fee and on occasion disposing of one from his own collection, sometimes acting as an intermediary for the sale of a picture to the Duveens, and occasionally sharing in the profits of a transaction in which he was agent and expert. At the end of 1910 he had received £2,090 as his share of the profits on the sale of a Van Dyck which he had bought with Sulley.

Easeful as life was at the Villa Sylvia, the month of inaction finally palled on Berenson and he became eager to "return to the familiar habits and pottering that I grace with the name of work." Before leaving, he dashed off a report to Henry Adams, whose habitual pessimism he attempted to match in his own way. His winter, he said, "was rather disagreeable, weak back, nausea, bad temper, sorehead (in every sense of the word) and fearful misanthropy." His only "surcease" had been in books. Having read Adams' 1910 *Letter to American Teachers of History*, which applied the Second Law of Thermodynamics and entropy to human history, he besought Adams to tell him what "further symptoms you have noticed of the running down of the cosmic clock." Adams' voluminous response showed no diminution of his own energy. In his hyperbolic style he declared, "Literature is a blank, Art does not exist. . . . There is not vitality enough in our world to keep it from senile—or infantile—paralysis. . . . All this has been the theme of my winter's study." Having heard that Berenson was ill again, he concluded, "I hope your confinement has wider horizons, and you can enlarge mine."

Berenson returned to I Tatti from the Villa Sylvia for the spring round

of visitors almost restored to good humor, and Mary was able to record that B.B. was "a real angel" and sometimes "so witty that we die laughing." She found him "a delicious companion" now that he was "nice." When at Easter the Berensons' little chapel was crowded with their dependents, she was moved to reflect that it was "rather awful to think how many people live off of B.B.'s interest in Italian art." She counted "seven servants, six contadini, two masons, one bookkeeper, one estate manager, and their wives and children and then me, with a mental trail behind me of all the things I do and the people who look to me. And then B.B.'s whole family. Really it is a lot for the shoulders of one poor delicate man."

With the approach of spring, luncheons, teas, and dinners for eight became the order of the day. Berenson enjoyed his role as lord of the manor, but the social activity kept work on the Johnson catalogue at a standstill. Jefferson Fletcher, one of his classmates and now teaching at Columbia University, came up with his wife, a sister of their friend Robert Morse Lovett; they had followed Salomon Reinach and his wife. Reinach returned alone somewhat later to dazzle the Berensons with "an indescribable mixture of erudition, shrewdness, and damn foolishness . . . that takes your breath away." He argued, for example, that it was important to fix the epoch when "the back of a woman's neck came to be recognized in art and literature." Another I Tatti familiar, Dan Fellows Platt, now entirely turned connoisseur and collector, came with his wife and one of the directors of the Metropolitan Museum to a particularly fine formal dinner at which Berenson must have enjoyed the lively shoptalk more than the meager victuals Dr. Giglioli allowed him. The French painter Jacques Emile Blanche and his wife were the center of another dinner party. Blanche, known for his lively conversation and wicked tongue, was a member of Edith Wharton's Paris circle.

One of the most animated discussions that enlivened the I Tatti dinner table occurred when the twenty-eight-year-old John Maynard Keynes took on the banker Henry Cannon, and they held the guests absorbed until nearly midnight with talk of "economics, trade, and taxation." By contrast, on the following day the Egyptologist–art collector Theodore Davis impressed Mary as "a complicated and exhausting bore." After lunch "the whole riffraff from the Laboucheres" descended upon them and somehow fell to talk of "love and the sufferings of the rejected." It was a subject on which the lovesick Bernhard must have had views, but Mary did not record them. The women in the gathering let it be known that fashionable women prized Berenson's friendship because it gave them "an intellectual cachet," and besides, "he had the power of making them feel twice as intelligent as they usually felt."

A new initiate in the I Tatti circle was young Count Hermann Keyserling, whose love of philosophical speculation about world culture and spiritual regeneration chimed in with Berenson's humanism. Berenson described him to Henry Adams as "a vital Dionysiac giant of a young Baltic *junker*," whose *Prolegomena* "may help you pass an hour not too heavily." The two men had three days of "uninterrupted talk." Keyserling, then at the beginning of his notable career as a popular thinker, was at this time most widely known to society gossips as having been engaged to Gladys Deacon.

The traffic at I Tatti had grown to formidable proportions. "Many are students or collectors whom we can't refuse, others are dealers and millionaires whom business obliges us to see," was how Mary described it. "The corridors are quite crowded with dealers every forenoon and the terrace crowded with motors every afternoon." Berenson quipped that he "receive[d] like a dentist every morning and like a *femme du monde* every afternoon." And of course each dealer expected them to believe that he was "the only honest man in a gang of thieves."

Of the millionaires, Henry Walters of Baltimore, now Berenson's "chiefest buyer," was one of the most congenial, and when he arrived Berenson "put him to work almost at once," showing him all he had bought for him and stating "the price of each article." He was "most appreciative . . . constantly surprised . . . such splendid things for him so cheap." As a "great collector of Persian things," he admired an illuminated manuscript that Berenson had recently purchased for himself from the Paris dealer Bing for 16,000 francs ($3,200) and he pleased his host by assuring him that the price was very reasonable.

Late in April 1911 Mary was summoned to Iffley. Word had come that her mother was dying. On the first of May the redoubtable matriarch achieved her last ambition, release into glory. Mary arrived too late for that moment, but she was in time for the cremation. "We saw the fire take mother's body today," Mary told Bernhard, "and now nothing is left but our memories." Though Hannah had wanted them to "rejoice" at her death, her three offspring were "heartbroken." To Johnson Berenson commented, "My grand old mother-in-law died a few days ago, very happy to be going, but leaving a terrible void behind her in the lives of her children. None of them were weaned, least of all my wife."

Mary found it hard to return to I Tatti and its recurring tensions. Bessie's gloomy state was aggravated by the recent announcement of her sister Senda's engagement to Professor Herbert Abbott, a fellow teacher at Smith and the son of Lyman Abbott, the famous preacher and editor. The formal social rituals at I Tatti contrasted sharply with the easy camaraderie of Iffley, and Mary fantasized that she would have to "take

my eggs out of B.B.'s basket, for I find they're getting addled there." A further cause for her distress was the discovery that Bernhard, who was so "very selfish about his own things, is giving some of his loveliest pictures" to Belle Greene.

The news of Senda's impending marriage delighted Bernhard, for at forty-three she had seemed a confirmed spinster. He wished, though, that she could get away from provincial Smith College to "Harvard, or Columbia, or even Chicago." The marriage took place in Boston on June 15 and Bernhard dispatched a present of $2,500. Almost on the same day that Senda was married, Mary's daughter Rachel (Ray) broke the news that she and Oliver Strachey, a dozen years her senior with a little daughter Julia, had been married at the Registry Office in London. Oliver, an elder brother of Lytton Strachey, was one of the ten children of Sir Richard Strachey. "Uncle Bernhard" matched his wedding present to Senda with a similar one to Ray.

Arrangements with the Duveens began to take a significant turn in April when Louis Duveen came down to I Tatti to propose taking up business "on a vaster scale than ever." More collections were coming on the market, and Joe pressed upon Berenson the importance of inspecting them to be sure nothing of value escaped. Later in the year Louis was worried about Volpi, the Florentine restorer: "We are afraid he over-restores things." He therefore asked Berenson to introduce the firm to the most highly regarded of all restorers, Cavenaghi in Milan.

The business correspondence fell, of course, on Mary, and her very rudimentary shorthand grew more elliptical as Bernhard's dictation increased. More and more, the Duveens and other dealers came to treat her as Berenson's business partner, often addressing their inquiries directly to her. And Berenson would generally shift irksome letters to her thick-skinned typewriter. When experts had informed them that Piot's frescoes could not be peeled from the wall for years, it was Mary who had to write to him to say they planned to cover them up. The frescoes had become notorious. Early in the year Mary's mother had written that she had heard from the Marchese Visconti-Venosta that "they were perfect monstrosities, tomato red naked women set in bright blue landscapes."

With the heat of summer again signaling the usual exodus, the Berensons vacationed together briefly—at Mary's urging—at Mrs. Baldwin's Palazzo Farnese at Caprarola. They parted at I Tatti on the twentieth of June, 1911, Bernhard heading for Paris and London and Mary remaining behind until the end of the month in order to put I Tatti into summer trim. This last was a formidable task. As a preliminary, four men had to "swathe" the library for the covering of the frescoes. All the carpets had to be rolled up and carted off, a picture restorer mended cracks in their

pictures, all woolen things were put away in camphor, a carpenter repaired furniture, a few frames were regilded, mosquito netting had to be mounted, a decorator put stucco ornaments on a wardrobe, all the mattresses were unstuffed and restuffed, servants carted off books to be bound, three workmen were putting the finishing touches on the new little French salon, and Geoffrey Scott busied himself taking measurements for another library room to be attached to the back of the large library. All the activities were accompanied by a constantly ringing telephone.

For a final couple of days before her departure Mary took an agreeable motor jaunt in the company of Geoffrey Scott. After she left for England, Scott and Pinsent seem to have taken up bachelor quarters in the villa and to have commandeered whichever one of the two automobiles was in operating order. When Senda and her husband arrived that summer on their honeymoon to join Bessie, they had to defer to Mary's protégés and use the streetcar.

In a progress report to Mary during the summer, Pinsent spent six pages detailing the work under way: fireplaces were being rejuvenated, the canvas covering the Piot frescoes was being stretched, the secret door into the new library was being installed with its hidden mechanism of wheels and wires which Pinsent had bought in Germany, and wiring was being put in for heaters and electric stoves. In addition lightning rods had to be installed, a pebble pavement completed, and stone installed for the curving stairs leading down from the terrace to the garden below. These and a dozen other tasks remained to be done before Bernhard would find I Tatti habitable.

XIV

"The Flavor of Dust and Ashes"

I N Paris for a few days in July 1911, Berenson was met by the news
that the United States Customs Service officials were intent on
making a salutary example of the New York Duveens. On Henry
Adams he left "the dark suspicion" that he "was depressed by the Du-
veen affair." But the depression proved transitory. He crossed to London
and ensconced himself in a comfortable suite at Claridge's fashionable
hotel, much buoyed up by the news that Belle Greene might be coming
over before the summer was out. He wrote her of his "friendly" en-
counter with J. P. Morgan at his mansion at Prince's Gate, and on
Morgan's return to New York she sent a grateful response: "I told him
all the nice things you said about his treasures."

The running debate with Mary over Belle Greene continued its ana-
lytic course, accelerated by the efficient British postal service. He told her
of the great esteem that Belle's friends had for her, but Mary was not to
be placated any longer. "I am often tempted," she replied from Oxford,
"to give up trying and to go back to the conventional attitude thee
always took to my 'affaires.' . . . I assure thee the variations between
intense sympathy and amused contempt this affair of thine has caused me
to pass through have been most agitating." She would have felt better
about it "if this affair had made thee happier, or if it seemed to be
improving my character."

For Bernhard there had been "lots doing" in London while he con-
ferred with the ever-sanguine Joe Duveen and shuttled between Sulley's
and Agnew's galleries with quick trips to country houses to appraise
collections for the dealers. At the Dowdeswell gallery he was much taken
by a Saint Catherine and asked Mary when she came down to London to
look at it, "for I want your approval." He counseled her to ignore the
price and consider only "the desireableness of the Catherine." He wanted

[127]

her approval also for two other paintings, and he charged her to insure a number of their paintings—the Signorellis at £2,500; a prized Bellini *Madonna,* a Guardi, and a Sebastiano for £2,000 each; and several others for lesser figures. The Bellini was one of Berenson's most satisfying acquisitions. He had bought it three years earlier for £1,000, having recognized a Bellini Madonna underneath the dirt and cracks. Cavenaghi's skillful restoration came "out very grand and noble," and since Berenson had nothing at all like it in the house, it became a permanent part of his collection.

As always in London Bernhard moved happily from one fashionable luncheon engagement to another. One with Addie, the cultivated wife of Otto Kahn, marked the beginning of a brother-and-sister friendship. He dined also at Lady Cunard's with Arthur Balfour, the former prime minister; Lord Curzon, the recent viceroy of India; and his own old acquaintance Sir Lionel Henry Cust, art historian and joint-editor of the *Burlington Magazine.* They had, he reported, three hours of the "drollest talk."

Hoping to come to a more friendly understanding with Mary, he joined her at Iffley for ten days. She did not find the visit pleasant, and the presence of two of her daughter Karin's girlfriends proved "indigestible" to him. He managed to tell her that if he had life to live over again he would marry a woman who would have "no other thought or interest but himself with a capital H." To Bessie she queried, "How can men be such monstrous fools? . . . Human nature isn't made so. . . . Men are not so thrillingly absorbing as all that except in that fatal brief period of being in love."

With Mary obviously content to spend the remainder of her summer at Court Place at Oxford among her kin, Bernhard had once again to fend for himself. There being no urgent business to hold him in England, he decided to pick up his old life again at St. Moritz after an absence of three years from that spa. At the Hotel Caspar Badrutt life resumed its familiar pattern, with only small changes in the cast of characters. Teas, dinners, dances, and tableaux vivants kept the celebrants busy, though Berenson avoided the dances in favor of conversation and walks about the jeweled lake in the sunshine. The Countess Serristori provided soothing companionship. Joseph Widener was on hand with his wife to discuss art or his other great passion, horse racing. Berenson was also very friendly with Henry White, the former American ambassador to France who had been dismissed by President Taft in 1909. Berenson's lengthy narratives to Belle Greene brought her comment: "My but you are the giddy one—for a frail and delicate person you can put in more festivities than any other such invalid I ever heard of."

At St. Moritz an unexpected and dramatic encounter with Charles Loeser proved painfully unsettling. Loeser was a Harvard classmate and fellow Florentine from whom Berenson had long been estranged as a result of their rivalry as connoisseurs of Italian art. An interested observer was Mabel Dodge, the rich and personable young heiress who with her architect husband had renovated the Villa Curonia at Arcetri across the Arno from Florence. Accompanied by Loeser, she and her husband had driven over to St. Moritz from the hotel at Maloja Pass. Berenson, catching sight of her and not noticing Loeser's presence, ran after the carriage. "I shivered for what might happen," Mabel excitedly reported to Gertrude Stein. To her amazement, she witnessed a "remarkable denouement." Berenson doffed his hat and extended his hand, saying, " 'How are you Loeser?' and they *shook hands*. Then we had some talk together—he all trembling and *quite* pale—and then drove off. 'The first time in fifteen years,' said Loeser meditatively!" The rift between the former friends was to remain unbridged for a number of years more.

Mabel Dodge made the most of her opportunities for her autobiographical books as she circulated among the villas. She recalled, "We were always talking trecento, quatrocento, cinquecento or discussing values—lines, dimensions, or nuances in knowing phrases. . . . At the Berensons' they played a guessing game that consisted of spreading a lot of photographs of paintings on a table and then taking one, somebody would cover it with a piece of paper out of which a little hole was cut, so that only a fold of a cloak, or a part of a hand would be seen, and everybody would guess, by the 'treatment,' who had painted it. That was considered the way to pass a really gay evening up at I Tatti!"

In late summer Bernhard and Mary met in Holland, where they were "greatly perturbed" over Rembrandt, whom, Mary said, "we both abhor." Perhaps they were remembering Altman's passion for the artist. There was little time for gallery going or travel, for the Duveens were impatiently awaiting Berenson in Paris. Mary went on to her uncongenial job at I Tatti of getting the house into order for Bernhard's return and trying to reestablish control over the volatile staff of servants. After a brief initial meeting with Joe Duveen in Paris, Berenson managed to get away for a visit to Edith Wharton and a dinner with Henry Adams.

Relations with the Duveens had entered a new and much more demanding phase. "They are occupying and preoccupying me a great deal," he told Mary. "They are on the warpath. They want me to go to Scotland, Ireland, to Burgundy, to a chateau, etc." A couple of days later he wrote, "I have been closeted for hours staying with the Duveens and there is plenty doing and plenty of money coming. At present they don't owe me a farthing, bad luck to it." The pressure on him grew more

intense. "I had the most dreadful time for hours and hours against the aggressive monopolizing will of the Duveens," he wrote a week later. "They want me to spend all my time in their office or running about for them. I resisted stoutly and on the whole successfully."

The experience made him long to get home and "get to work," though Mary's too frequent and detailed reports of her troubles in running the household gave him pause. "I am not blaming you," he said. "Italians, God love them, are what they are. . . . I wonder whether you would not be personally happier if I were out of the way and you could gypsy it about with young people in a battered discolored [motorcar]." As for the difficulty she was finding in setting up the library, it was clear it would become "unmanageable without further arrangement and a good catalogue."

When Bernhard returned to I Tatti on October 1, 1911, still buoyed up by the promise of Belle's visit, he was "very much pleased with everything" and "clasped Cecil's hand in both his, apropos of the small new library, and said it was the best thing Cecil had done and far surpassed anything he had hoped for." He also enthusiastically approved the elegant little eighteenth-century salon. He wrote Walters that the work on the new library had progressed so rapidly that he found it is "a dream of scholarly seclusion." A month later, in the midst of fresh proposals to Walters, he said he was still rejoicing in the Tuscan sunshine, finding the house delightful and his new secretary promising "to be a tower of strength."

Walters' check for the Daddi which Berenson had first offered to Johnson helped staunch the heavy outflow of funds which was now the normal state of affairs. Among the new pictures which Berenson offered to Walters was a Madonna by the Florentine painter Cosimo Rosselli. "Mary has the bad taste not to like it," he exclaimed, "although it is one of the best things that this not inconsiderable artist ever did." At £500 it was not to be resisted. Walters took it and also, for a mere £200, a panel by the Abruzzi goldsmith Nicola da Guardiagrele. He hoped Berenson could find an "interesting Sassetta 'at a poor man's price.'"

Berenson's extensive correspondence with Walters dealt largely with the pictures that he turned up for his consideration—and frequent acceptance. By this time the style of his recommendations followed a familiar pattern. For example, in the case of a painting believed by its owner to be a Titian but which Berenson was certain was "by the ablest of his followers, Polidoro Lanzani," he wrote, "I want you to buy this canvas not only on its intrinsic merits which really are all but the highest, but also because short of a miracle we are not likely ever to come across a real Titian of the 'Sancta Conversazione' type. Even if we did, the price

would be fabulous. This canvas we can have at the very reasonable figure of £2000."

This letter to Walters had a special interest, for it concluded with a paragraph which displayed Berenson's long-standing antipathy to the military adventures of the Italian government. In 1896 he had strongly disapproved of the imperialist adventure in Ethiopia which had ended in the Italian rout at Adowa. Now the new Nationalist party had pushed Italy into war with Turkey over Tripoli. "This unspeakable war in Tripoli," he wrote, "is keeping our Italian acquaintances away from us. They are too well aware what they would think of any one else who committed murder and robbery upon peaceable householders. . . . A people like the Italians which so recently became a nation not by its own strength but through the sympathy, pity and powerful aid of stronger nations, has no right to become the cowardly oppressor of weaker races."

With Bernhard's return from Paris the villa had begun to fill up again with guests. Edith Wharton and her long-time friend the American lawyer Walter Berry, with maid and chauffeur, came on from Ravenna and were soon off motoring through the countryside with Bernhard while Mary kept an eye on Pinsent's progress with the garden and the making of the wood below, for which three hundred ilexes had been ordered. The changeable and moody Karin, who had finished her studies at Newnham College, Cambridge, was on hand to be indulged by her mother. The dashing Mrs. Peter Cooper Hewitt, whose £100,000 a year greatly impressed Mary, had to be taken motoring by Berenson. Mary Crawshay, the sister of Sir John Leslie and one of Berenson's favorite London hostesses, had also to be put up with her maid. The company was further swelled by Ralph Curtis and his wife. Indeed the house was "crammed," the confusion compounded by the usual procession of dealers.

The enthusiasm for Maurice Brockwell had soon dwindled and in his place the new secretary and part-time valet, Lancelot Cherry, was now at work. Cherry, Oxford educated, came fresh from three years' experience in a city bank. He confided to Scott that he was horrified by "the troops of middleaged females who surge through the house. . . . Wharton, Crawshay, Strong, Priestley, Blood." He did not know that such people existed and he believed his employer sought them out "like rare needles in a haystack." At least one male leavened the bustling crowd— tall, studious Trevy, who browsed at his leisure in the library. The disarray in that room had been put "in perfect order" by Cherry.

In the midst of all these distractions, a cable came from Belle Greene: since Morgan had decided not to go to London for the sale of the Huth

Collection, he would not come to Europe at all that year and she would have to forgo her visit. The news stunned Berenson. With the cable in hand he "turned away and burst into bitter tears." Further explanation was slow in coming, and he went about desolate and half-frantic. Mary, ready as always with advice, suggested he cable, but she made him take out the expression "endless love." Belle's answering cable explained that she had been so "blue and miserable" that she "had no heart to write." The letter that came on its heels commanded, "Never question my absolute love." According to Mary, Bernhard at once became a new man and joyfully returned to penning his endless effusions. He seemed more in love than ever and told Mary that if Morgan died and left Belle unprovided for, he would support her. "Isn't it funny?" ran Mary's baffled comment to her sister.

When James Kerr-Lawson came from London to hang his "decorations" in the *salotino*, Berenson's initial pleasure in the elegant little salon subsided. The "decorations" seemed as inappropriate as Piot's frescoes had been in the library. His forehead in a cold sweat, Berenson went down to face the "ordeal" with Kerr-Lawson. The painter took the rejection as resignedly as Piot had, comforted perhaps by the recollection that Berenson had recently rescued him from penury by selling one of his Old Masters to Henry Walters, thereby saving, as was said, his "honour." A few months later Berenson again came to the rescue of Kerr-Lawson and his wife when they were "almost down to their last £5" by selling another one of their pictures, "after endless troubles," for £2,000.

When the autumnal rout subsided a bit, Berenson turned at long last to the demanding task of the Johnson catalogue. Soon he was putting in six hours a day at his desk. "I return to my fool job," he wrote to Barrett Wendell, "and enjoy the tracking of infinitesimal painters like foxes to their lairs." But the congenial study was an imperfect antidote for his discontents. His sister Rachel and her two children, little Ralph Barton, a child of five, and Bernhard's namesake, a year-old baby, moved into the Villino Corbignano across the way to spend the winter there as his guests. To his surprise he took to the infant. "Even I with my Herod-like disposition," he wrote his mother, "enjoy seeing him." In a letter to Senda, Rachel reported that though Bernhard seemed better than the year before, he was easily upset and distraught.

The situation grew no more cheerful when his sister Bessie began "railing at fate," inspiring her exasperated brother to offer to pay for a trip to Egypt to get rid of her. Nor did it help matters that in the absence of a servant she would not "lift a finger." Mary thought her the most "life-diminishing" person she knew. "Absolutely spontaneous speech is at present quite impossible," Rachel reported. Few days passed without

"outbursts of contradiction of Mary. He accepts nothing she says . . . an extraneous something is consuming him." The "something" was another long hiatus in Belle Greene's letters. "What food for thought in this whole situation," Rachel concluded. "Culture almost over-acquired, great wealth amassed, exquisite beauty enhaloing their lives, yet the flavor of dust and ashes."

The flavor of dust and ashes was deepened that December of 1911 when Berenson received a long and rather formal letter from Charles Loeser telling of the recent death at forty-four of Enrico Costa, the brilliant young companion with whom, twenty years earlier, Berenson had made the compact to devote their lives to connoisseurship, not to stop "until we are sure every Lotto is a Lotto, every Cariani a Cariani, every Santacroce a Santacroce." Their intimate collaboration had lasted four years until 1893, when Costa was obliged to leave for South America. For a few years he had lectured at the University of Bogotá on art. When afterward in the summer of 1909 he returned to Italy to resume his passionate study of European art, he became a protégé of Berenson's adversary Loeser and an intimate of the art historian Carlo Gamba, and he dropped out of Berenson's sight. The promise of some great accomplishment by the talented Costa was ended by his premature death. The loss of so dear a friend to Loeser and now to death was not easily to be borne.

WHATEVER private uneasiness the Duveens may have felt about the civil and criminal actions against them, they exhibited no public anxiety and plunged ahead to keep their place at the head of the procession of dealers as though in command of unlimited resources. In a sense they were, for when the customs claim was settled for $1,800,000, J. P. Morgan, who was much attached to "Uncle Henry," directed the First National Bank to advance money to cover the duties and the $50,000 in fines levied in the various criminal actions. Morgan prudently accepted as security Altman's debt to the firm. An onerous condition of the settlement required the New York branch to suspend importations for fourteen months, until the spring of 1912. The lawyer who had engineered the settlement thought it so favorable that he sued the Duveens for additional compensation. The press reported that the whole affair cost the Duveens two and a quarter million dollars. As for the ex-bookkeeper who had turned informer, the Customs Service paid him a bounty of $50,000. He was promptly sued for $5,000 by an office associate who claimed he had been promised that sum for supplying part of the incriminating evidence.

Now firmly committed to their decision to make a specialty of Italian paintings, the Duveens began to deluge Berenson with queries. With the

costly Customs Service imbroglio safely weathered, they assured him that business in New York was again going on "very nicely." Morgan was looking for a fine Piero della Francesca: "Do you know of one?" Joe asked Berenson to cable at length his views on a painting offered by an old lady in Quebec and sent on a batch of photographs of other paintings as well for attribution. He reported that Altman, who evidently had absorbed some of Berenson's instruction, was "very pleased" with the fine Mainardi tondo "which you so much advised us to buy." Duveen succeeded in selling Altman a number of other Italian paintings before his death in 1913.

For some months the Duveens had had their eyes on a spectacular collection of sculpture from the Martelli palazzo in Florence that was expected to come on the market. It included the famous marble, long ascribed to Donatello, which had been in the family since the fifteenth century. Joe Duveen assured Berenson shortly before the end of 1911, "We are quite prepared for the Martelli business when you are. . . . Are you quite sure that you have the affair in your own hands?" Berenson believed he had. Rumors, however, were already afloat that a dealer planned to offer the marbles to J. P. Morgan or to Thomas Fortune Ryan. It soon developed that still other fingers were in the pie. In early February Berenson learned that Salvatori had called on Ernest Duveen in Paris offering to act as an intermediary and it appeared that he was acting for, or in concert with, Stefano Bardini in Florence, who had told him that Morgan would offer $160,000 for one of the smaller items.

The main stake was the unfinished *David,* and the maneuvering for it became intense. Mary told her sister. Alys, that they were "living in a most agitated way," having received in one day no less than fourteen telegrams connected with its sale. Louis Duveen cautioned Berenson not to make an offer: "Once you give your hand away we shall be done for," as the sellers could then play one bid against another.

While the Martelli business hung fire, Berenson went down to Naples for two weeks early in March 1912 to enjoy the diversions of the Villa Floridiana and his favorite masterpieces at the Naples Museum, grateful, he airily remarked, that his hostess, Mrs. Harrison, had pulled him away from "any temptation to sacrifice any serious part of my remaining days to the frivolity of making money." Fortunately Mary remained at I Tatti, for in his absence important transactions came to a head and she had "the fearful responsibility" of buying two pictures for £8,000 each. "It terrifies me," she wrote Berenson's mother, and to her sister she declared she was "hopping around like oysters in a stew seeing dealers for B.B." Louis Duveen wrote to her from Paris, "All the married

members of Duveen Brothers feel a little envious'' of her husband's having ''such an excellent *locum tenens*.'' He cautioned her not to mention the firm's name ''on any account'': ''You are buying for an anonymous person.'' For one of the pictures, a Botticelli, the offer was to be made only on condition that the painting be delivered in Paris. ''Naturally, we will have nothing to do with getting it over the frontier.''

Summoned to Rome by Joe, Berenson went ''not only for darling Joe's sake but for less vital reasons of business and study.'' He no sooner got there than he heard from Florence that the Martelli business had reached a critical point. He immediately notified Ernest Duveen, and Ernest cautiously authorized him to offer £70,000. Then he heard from Florence that the sellers were considering £72,000, whereupon on his own responsibility he matched the offer, but to no avail, for on his return to Florence his butler, Arthur, told him that the dealer Brauer wanted to see him about the marbles. It seemed to him the cat was quite out of the bag. ''If I had been given authority to close, as I begged you, for £86,000,'' he reproached Louis, ''the affair would have been settled.''

He was furious at having had his hands tied, and he raged at the folly of the Duveens. ''In their excitement,'' he suggested to Mary, ''they may have thought I neglected their interests.'' His ever-ready suspicions rose to the surface: Ernest Duveen must have enlisted Salvatori and thus undercut the efforts he had been making, and if he had not, he protested, they should have ''flatly denied'' it. Louis responded that he and his brother Ernest were ''deeply hurt'' at the imputation that they had not been wholly honest with him.

So many other projects were in train that it became useless to dwell on his complaint. The excitement subsided and somewhat later Joe Duveen inquired in a conciliatory manner, ''What is the latest concerning Martelli? Do you think after Mr. Morgan has turned them down and so many dealers followed suit that it would be possible for you or us or someone else to make an offer now of about £60,000?'' A week later he observed, ''The whole affair has been spoiled by so many dealers knowing the price asked for them.'' He now authorized Berenson to offer £50,000 to acquire the *David* for ''stock.'' The expedient failed, and seeking to mollify Berenson the Duveens wrote, ''The capacity for lying is abnormal with some Italians and you have been the victim of such misrepresentation.'' ''Volpi, Bardini, Trotti, Salvatori, all working independently,'' they pointed out, had pulled one string after another, and Volpi had brought Wildenstein into the matter, so the Duveens had also to promise him an interest in it. ''Your loyalty to us is always immensely appreciated,'' the letter went on to say, and it is ''certainly reciprocated.''

A further complication may well have been the difficulty of getting an export license.

Four years later, with the art market depressed by World War I, Joseph Widener bought the *David* and a bust of a youth by Rossellino for £45,000, permission for exportation having been given to the dealer Fenaro on condition that other important sculptures in the collection remain in Italy. The ascription of the *David* to Donatello, early given by Vasari, remained unchallenged until 1959 when John Pope-Hennessy, in a study based on its style, concluded that it was the work of Antonio Rossellino, a younger contemporary of Donatello. Though inferior to Donatello, it was "one of the finest quattrocento sculptures outside of Italy."

Disappointing as the Martelli affair was, it did not stem the flood of demands the Duveens were making for Berenson's services. Joe, who never lost sight of the main chance, cast a covetous eye upon Berenson's chief client, Henry Walters, and he urged Berenson to bring him into the Duveen fold. "I know that you are the person to do it. . . . Do you know all of his movements?" Berenson appears to have declined that chore. In any case, Walters was not a good prospect. His tastes were more modest than those of Duveen's clients, and he bought with a kind of frugality.

One of Berenson's chief business responsibilities was evaluating the contents of collections in which the Duveens had become interested. For example, he was called on to review the pictures in the Weber Collection. Louis Duveen told him, "We shall in the end act on your advice," and Joe Duveen asked for separate letters of authentication on each of the paintings brought from the collection to be shown to prospective buyers. "[I] trust you will make them as interesting as possible, as we are sure you will," he wrote.

Berenson's recommendations for purchases had by now settled into an established pattern: his précis of each painting discussed its merits, its place in the oeuvre of the artist, its condition, and finally its price. In a long letter to Louis Duveen urging the purchase of three of Baron Lazzaroni's offerings, he wrote, for example, "One of the pictures is a simply delicious tondo of a Madonna and Angels by Raffaellino del Garbo. It is on wood of pleasant size (about 30 inches) and fresh strong color. It is the last word in composition, line and sentiment of the formula invented by Filippo Lippi, perfected by Botticelli and pursued by Filippino Lippi. It is of course neither Filippo, nor Verrocchio, nor Botticelli. It is however just under these greatest masters, and to many of pure heart and humble mind, more genuinely attractive. I must add Raffaellino del Garbo is one of the well known names in Italian art. . . . The price of this Garbo is 50,000 francs."

While the Martelli business was still pending, Berenson received an urgent summons in March 1912 to meet Henry Duveen, head of the New York office, at Monte Carlo. As he had suspected, the chief reason for the summons was that the firm wished him to approach J. P. Morgan to interest him in Italian paintings. "I quickly showed him it was not to be thought of." However, "Uncle Henry" kept after him into the following year, finally provoking him to protest that it was untrue that Morgan had a good opinion of him. "I know from unimpeachable sources of which I am not at liberty to say more that Mr. Morgan dislikes me personally more than ever." (His unimpeachable source was, of course, Belle Greene.) "In any case," he elaborated, "I am a very poor salesman, a wretchedly incompetent diplomat, and not a bit of a flatterer."

Hollow as the protestation was, especially in the light of his ingratiating letters to Mrs. Gardner, he had more compelling reasons for declining the chore. The work he was already doing for the firm, advising the three branches and working up letters of authentication, left him with less and less leisure to pursue his researches and to resume his writings. "If I stop my researches I shall lose my eye. If I stop my writing I shall lose my reputation and authority," he explained to Henry Duveen. "Whispers already are getting harsher and louder that for money I am sacrificing my gifts and my higher calling. . . . Not that I object to making money but I want to make it with scrupulous honesty and absolutely aboveboard. . . . It would be fatal to cheapen me to the rank of a disguised salesman. . . . You live for business. . . . It is your whole life and a splendid life I respect and approve and at times envy but this is to me a nuisance, a necessary evil. . . . I practice it only as a means to an end. The end is not to enlarge my business and to pile up money but to enlarge my mind and to pile up understanding. All the millions of my compatriot billionaires could not induce me to give up more than I give you now." The line that Berenson had drawn between his activities and those of the Duveens was one that during the remainder of their long association he tried hard not to cross in spite of incessant pressure.

Life at I Tatti had now developed a peculiarly complicated social and business character. Dealers beat the accustomed path to Berenson's door of a morning bearing their purported treasure, and he was still loath to turn them away. When a Milanese suddenly appeared at the top of the steps one day "waving a small picture" which "B.B." recognized as "a pretty little Sassetta," he "took it at once." But the morning traffic remained usually invisible to his guests. Old Parisian intimates like the Countess Charlotte de Cossé-Brissac came for a few days to stimulate his conversation. In January 1912 Bessie decamped for the tour of Egypt and

Greece, much to Bernhard's relief, and soon after her return in March she departed for home. His sister Rachel and her husband, Ralph, expected soon to leave for a tour of Greece. As his guests in the villino on the hillside across the way, they had kept pretty much to themselves with their children, their only complaint being that Geoffrey Scott was never allowed to come or go "except in the motor," whereas they had to trudge down the dusty road "to the very slow tram" at the Ponte a Mensola. Though Bernhard praised Geoffrey's "brilliant mind, keen wit, and charming personality," Rachel thought him a lazy parasite.

Despite Mary's patronage, Scott and Pinsent had not thrived in their business as architects, and Scott rather despaired. Their end-of-the-year statement told the story: "Receipts £470, Expenses £760." But fortunately for the pair their small commissions were soon supplemented by plans for continuing work on the garden and on the interior of the Villa I Tatti. By the time Berenson got to Paris for his regular sojourn in June, Pinsent could report to Mary in England that the drawings for the projected cascade were under way, the gateway for the outside wall was designed, the piers for a new wall were up two meters, and the rest of the house was divided off by screens and temporary safety doors so that dust could be kept out and workmen could pass through the openings. The alterations would "give a distinct impression of greater size and ampleness to the first floor, and make you feel at last that you have got some room." Pinsent had already put in some cypresses in the garden forty feet tall so that the Berensons could enjoy them during their lifetime. He expected that all would be ready, as promised by the contractor Somigli, by August 31. That talented fellow, he assured her, understood drawings and even did his calculations with a slide rule. He was "a distinct exception to the usual Florentine type."

Berenson had completed the manuscript for the catalogue of Italian paintings in the Johnson Collection by the end of 1911, and Mary spent much of January 1912 transcribing it. It was especially gratifying that Johnson had responded to Berenson's plea to reproduce "everything of artistic or historical importance" by authorizing all the illustrations he had asked for. At intervals in the following months he tackled the Widener catalogue and by June it too was completed, "so now the winter's work is off our minds."

X V

The "Merchants" and the "Expert"

ONE day in late March 1912 Berenson's passion for walking in the neighboring woods took him up the Vincigliata road into the secluded dell in which lay the tiny lake and Grecian temple constructed by the first Lord Westbury. When he attempted to leave the area, the key broke in the lock of the gate. There was nothing for it but to climb over the wall and jump. He miscalculated the height and fell to the ground, injuring his back. The result was a curious aesthetic and mystical experience which he described to Edith Wharton: "The instant of pain was followed by a most extraordinary appreciation of the beauty before me, and an expectation that I should never see it again. I did not want to live like the heroine of *Ethan Frome*." The pain, he said, brought a "mysterious euphoria with it," the Tuscan landscape had never looked lovelier, and to his surprise he felt "so alert, so patient, so pleasant, so charitable."

Berenson took advantage of his injury to find solace in the spring of 1912 at the Curtises' villa on the Riviera. "So here I am," he wrote Edith, "aching and merry and enjoying solid Bostonian talks with the astronomer Percival Lowell." His amiable mood had been disturbed, however, by her latest story, "The Long Run," in the *Atlantic Monthly*. "Certain phrases" in the tale of a Harvard poet who compromised his ideals to become a rich industrialist, he told her, "made me feel the mental equivalent of biting on a sensitive tooth, and the whole story as if I had hit my crazy bone." It seemed a parable of his own fate. Though the Duveen projects were time-consuming and troublesome, they promised the financial security for which he had long hoped. But there was no blinking the fact that his research and writing had descended from Goethean visions to the prose of catalogue making. And the increasing tempo of business with the firm foreshadowed a new stage in their

relations, one that might permanently close the door for escape from the trap into which he had fallen. As the dependence of the Duveens upon his expertise grew, they were increasingly anxious to bind him to the firm for a term of years and have first claim upon his services. Already there was talk of the desirability of a written contract.

Mary drove up in their automobile to join Bernhard at the Curtises' so that they might spend a week on their return revisiting the provincial galleries of Italy. She came down with a cold, however, and had to return to I Tatti by train, leaving Bernhard, who was quite recovered, to make the tour with Mrs. Shields, the secretary of the expatriate British writer Vernon Lee (Violet Paget). Mary hoped the trip would at least take his mind off Belle Greene, whose "fat" letters she forwarded to him. Belle's after-hours dissipations, which she merrily recounted, had recently evoked his puritanical reproaches. In one lengthy screed she burst out, "You despise everything I write, do or say and everyone I know." Her anger did not last, and it was not long before she thanked him for "the dearest letter you *ever* wrote to me. . . . I kiss your mouth and cling to you as I remember doing the night in Venice." Nor did he neglect to ply her with impressive tokens of his love. "I am quite overwhelmed by my Daddi," she wrote. This was Bernardo Daddi's *Madonna and Child Enthroned with Four Saints*. It had been preceded by his gift of Spinello Aretino's *The Angel of the Annunciation.*

Ralph Curtis found it hard to understand Berenson's attention to so many other women, and when Berenson returned to I Tatti he begged for an explanation. Berenson prepared a little essay and, pleased with its implications, showed it to Mary, who diverted her sister, Alys, with a copy. "You ask me," he wrote, "why I waste so much of my time on women seeing that in general, I have so poor an opinion of them." It was only poor of them in the mass, he explained, or in the case of "a *permanent relation* based on submission of their impulses and interests to mine. . . . But outside of these solemn and impossible relations, women can be and are delightful 1) as playthings, 2) as playmates, 3) as stimulants, 4) as inspiration. A man's mind has as much need of a female mind as a male of a female body." After point four Mary inserted, "He might have said as consolation."

"You may deplore it, and most men have," his disquisition continued. "With the Jason of Euripides, you may rage against the arrangement of the gods which compels us to plant our children in a female body instead of in our own loins. And as with the body so with the mind. The female stimulus is scarcely less necessary for the mental than for the physical procreative act. And in the state of permanent warfare between the sexes, it is sweet to have breathing spells of illusion, halcyon days in the cold

winter of our discontent when we seem to enjoy a truce from the struggle of self-assertion to abandon oneself to the abandon of a woman who seems to live and breathe only for us . . . to pick out with a lobster fork all the sweetness that life has to offer in its most inaccessible tentacles. . . . For . . . each moment has its cash value, and it is that cash value we must insist upon particularly when it is at once pleasant and not too expensive. *Eviva la vita.* Though it slay me yet will I trust in it. B. Bacchus.''

Curtis demurred. "*My* verdict after half a century of rather varied experiences is that [women] contaminate one's sense of honour. They are enervating 'playmates' and are very fragile 'playthings' which generally get out of order a week after Xmas." Berenson was not to be swerved. When Eugene Glaenzer came in to see him at the Ritz in Paris that summer and sighed "he had done with women," Bernhard commented to Mary, "Lucky man, I expect to have done with them only after I am cremated."

Berenson had never been quite so peripatetic as during the remainder of the spring months of 1912 and perhaps never so happily diverted by the frequent change of scene. During one of his brief I Tatti sojourns he surveyed the work on the garden and, to the alarm of Cecil Pinsent and Mary, made copious suggestions for changes. Fortunately he soon departed for another short visit to Naples. In April there was an excursion to Venice, for the reconstructed campanile was to be dedicated on Saint Mark's Day, April 25, at a spectacular ceremony.

On his first enchanted visit to Venice in October 1888, he had been sure that Venice would haunt him "for ever and ever." And haunt him it had. He had returned to it again and again. And on each return for more than a dozen years the old campanile, which had survived nearly a millennium, had filled his sight. In 1902 the huge tower had collapsed into an appalling heap of rubble. It had now been rebuilt to its former glory, and the great bell, the Marangona, which had escaped damage, hung once more in the lofty belfry.

Berenson and his friends had special tickets for the celebration and managed somehow to get through the enormous crowd which packed the Piazza San Marco to reach their seats just under the Doges' Palace. Colorful banners hung from the pillars, and when the battle flag of the cruiser *San Marco* soared aloft on the rebuilt campanile, the cannon boomed and the bells in the belfry chimed. Deep amidst their music came the rhythmic clangor of the Marangona. Suddenly a single trumpet note sounded, thousands of children broke into the ancient chant of "La Cantata del Campanile," and two thousand carrier pigeons fluttered aloft to carry the news to all Italy. Then, escorted by a colorful detachment of carabinieri with blue and scarlet plumes in their hats, the ecclesiastical

procession of prelates and bishops in gorgeous copes proceeded from the Basilica to the platform facing the duke of Genoa for the ceremony of consecration. Again the cannon boomed and the bells jubilated. "I began to sob and blubber and choke," said Berenson, "and I had quite a time calming myself down. . . . It is too terrible how subject I am to being literally overwhelmed by irrational emotions, the emotions of the crowd. No wonder I dread them."

Back at I Tatti before going to Paris in June on the way to London, Berenson accumulated a supply of paintings for Henry Walters, who, when he came, took them all. This would make it easier, Mary reflected, for "B.B. to give Ralph and Rachel the Cambridge house" for which they had been hunting. His sister Senda and her husband, Herbert, were also house hunting, but Berenson felt he could afford "only one house at a time"; Rachel's need was more pressing because she had two children. Senda agreed. As for Bernhard's suggestion that she and Herbert try for a university and leave Smith College, the sad fact was that Herbert did not have a Ph.D., and besides he was too unworldly to push for advancement.

In Paris there were the obligatory hours of clamorous strategy at the Duveens in the place Vendôme. At his hotel from nine to eleven he held levees "with people hot on each other's heels." Arthur Sulley came for a long conference "while other suppliants were kept at the door." Baron Lazzaroni brought over "his new Bellini, damaged but attractive." Joe Duveen would have to look at it.

More agreeable were the excursions to the Villa Trianon to talk with the enterprising theatrical agent Bessie Marbury and to admire Elsie de Wolfe's newest wardrobe. As Mary had accompanied him, he persuaded Elsie to take her in hand. Mary submitted with what grace she could. After an agreeable chat with René Piot, Bernhard went to see Henri Bergson. "I found him rather aged," he wrote, "living austerely. . . . The poor man is most wretched over his unsought for popularity. . . . He is going off to the Jura to work night and day preparing lectures and writing books. He again assured me that after all his reading on aesthetics he found my books alone of interest." At the Triennial Exhibition "the only good thing was a Matisse landscape, good but not very much better than a Sargent."

On his forty-seventh birthday, June 26, 1912, Berenson, following his yearly custom, wrote to thank his mother for the "gift of life." "I am very much in love with life," he declared, perhaps feeling it desirable to assuage her anxieties about him since neither Mary nor his three sisters concealed from her his sessions of ill health or his changeable and violent moods. Nevertheless, he wrote, he felt an epoch coming to an end.

Something of the bloom of existence had vanished, he had philosophized to Walters. After "forty we begin to look at things with the cold eye of reason and reason is suicidal. The truth is life is a miracle enacted for the delectation of childhood and youth." It was clearly time to put his affairs into some kind of order.

As a first step he and Mary prepared their wills. More important, however, was the need to systematize his relations with the Duveens. These had now become a confusing welter of arrangements contained in scores of letters and cables and oral understandings. The basic "convention" with which they had worked was that he should receive "a fourth of the profits on all Italian works bought" on his advice. It was a liberal arrangement and no doubt had overcome some of his dislike of the firm, but too many contingencies remained in limbo, particularly what claims his wife and their two families might have in the event of his death.

He moved toward entering a formal contract with the Duveen firm with considerable reluctance, realizing, no doubt, that a contract would limit his freedom in dealing with other firms and subject him to more tyrannous demands upon his time. Yet a contract would at last assure him a measure of financial security. To the conservative Johnson, who had warned him against the Duveens, he justified his services to them and to other dealers on the ground that his attempts "to help the squillion-aire buyers directly" through him as an adviser had been rejected. "If I refused my help to the dealers, Altman and the others would probably pay no less but get no return at all. . . . I hate the sordid hypocrisy," he continued, "which would pretend that one did all this for nothing. I get my ample remuneration which I earn as amply and honourably. . . . And economizing Mr. Altman's or Mr. Morgan's money should be no concern of ours." "I could never see the least reason," he subsequently explained, "for being ashamed of making money out of such professional knowledge of mine as happens to command a market price."

Having enjoyed the life enhancements of Paris, he crossed over to London to be available for the contract negotiations. Physical London displeased him after the agreeable amenities of Ritzian Paris in the spring. The Claridge Hotel seemed dilapidated: "windows not opening, no shutters, electric lights not working, valet abed, and motors hooting, hooting, hooting all night." A three-hour luncheon with Edith Wharton helped to lift his spirits, as did one with Henry James. "What I enjoyed most about him was William's merry twinkle that I discovered in his eye." James, he thought, was "complete," in need of no further stimulus from the outside world, a state quite unlike his own.

Social London soon offered its delights, and Berenson eagerly escaped from the evils of the dealers in Old Bond Street to the flattering company

of Princess Polignac, Lady Elcho, Lady Herbert, Lady Ripon, and other aristocrats. He bowed to Nijinsky and to Diaghilev, "his lover and impresario," and encountered Leon Bakst, "who turned out to be an old acquaintance." The ballet *Swan Lake*, attended in the company of Lady Sybil Cutting, the Fiesole neighbor to whom he was much attached, struck him as "just an ordinary leg show."

With Edith Wharton and Henry James at hand there was commiserating talk of Henry Adams, who on April 24, 1912, had suffered a stroke and lay paralyzed in America. A stream of letters of concern went back and forth across the Atlantic among his worried circle of friends, and the devoted Elizabeth Cameron hurried to be as close to his bedside as his family would allow. "The world will be a different place without that kindly light—and clear," she wrote Berenson. "Yes," he agreed, "it will be a greyer and frostier world for all of us who loved him, when his stimulating mind and affectionate heart are here no more. I can't tell you with what zest I used to give up everything else of a morning and rush to his rooms in the hope of finding him for a talk." In June she wrote that Adams was recovering. Barrett Wendell sent confirmation: "Adams has rallied wonderfully."

Learning that Adams was with relatives in Lincoln near Boston, Berenson teased him, "I hope they are not smothering you with kindness." He told of having completed the Johnson catalogue of nearly five hundred Italian pictures—"Four-fifths of them were enigmas" that he had solved as best he could. "Of course I have missed some solutions and gone astray in others. Any other pair of eyes would see something that somehow escaped my attention." For relaxation, he said, he preferred the society of women, "like the rest of us" (for he knew Adams' preferences). "Rather funny is it not for the likes of me to have access to a Balfour or a Curzon through some fluffy females." He had talked, he said, with Henry James, who "discoursed upon the cant and rawness of the Britishers, from whose island he nevertheless never wishes to depart again."

Adams promptly dictated a long and characteristically whimsical reply. His other correspondents were unreliable so "I fall back upon you as my staff and hope. . . . If you hear of anything, whether literary or artistic, you would confer an enormous grace upon us by letting us know. Really, you would do something more, for you would cure me of a terrible habit I am falling into of taking for granted that the world is coming to an end, and that there never will be anything more that I feel any interest in. Stir it up please."

Berenson conscientiously did as he was asked, and their exchange of ironies continued into the autumn. "What a grand time you will be

having," Berenson wrote, "with a *loge d'avant scène* in our quadrennial national Saturnalia. Foolish foreigners ask me what it all means—Taft, Woodrow Wilson, Theodore Imperator Caesar, and I tell them . . . as human nature is everywhere human nature, the pent-up *Ausgelassenheit* [exuberance] once in four years is allowed to have its course. . . . We grace the orgy with the appearance of political purpose and call it a presidential election." Europe was becoming so Americanized that "pride in plumbing seems thoroughly to have replaced pride in spirit." As for literature, his young uppercrust friend Philomène de Lévis-Mirepoix was creating a flutter with her book *Cité des Lampes*. The Irish writer John M. Synge was "dead and gone," "but surely his 'Playboy of the Western World' and his 'Tinker's Wedding' are real works of art. And so to my utter amazement is George Moore's 'Ave Atque Vale.' " As for worlds ending, "Why should we care, when twenty life-times would not suffice to let one drain the cup of beauty and interest distilled for us by the Poet."

While Bernhard was enjoying London and uneasily anticipating contract negotiations with the Duveens, Mary at Ford Place, Arundel, where Logan and Alys were now living, was eagerly waiting to preside at the birth of her daughter Ray's first child, as twenty-five years before her own mother had presided at the birth of her first child, Ray. The baby, a girl, was born on the seventeenth of July, 1912, and was named Barbara. Like her matriarchal mother, Mary was pleased that it was of the more admirable sex.

Bernhard sent on for her critical enjoyment a letter from Lady Sybil, whose widowhood had left her at loose ends. In it she confessed how great her dependence upon him had grown. She feared that on her return from a visit to America there would be "no kind person to take me to see beautiful things animate and inanimate." Her letter, Mary prophetically observed, gave one "to think, as the French say. She has evidently become very fond of thee." Berenson's thoughts had been again turning to the women in his life. In his chronicle to Mary he noted, "I am coming to the conclusion that none of the women that I frequent are satisfied with friendship. I fear they either want passion or the offer of it. Way down they resent one's giving them friendship." Even Madame de Cossé-Brissac said one day, "with a distinct ring of regret in her voice, 'Vous ne me jamais pris en femme [You never regard me as a woman].' "

Though the birth of Mary's first grandchild opened a new chapter of maternal pleasure for her, Bernhard's reports from London troubled her. In spite of herself and her emancipated principles she knew jealousy. As she ruminated over her discovery of one of his "amours," it was but a short step to recrimination. He defiantly responded, "Time and again

have I told you that you knew little about my 'amours' and again that I would not tell you anything about them until I was sixty or sixty-five and time and again you have teased me to tell you. . . . I have no idea what particular amour you have found out. For all I know it is not authentic, a false attribution in fact.''

The contract negotiations finally got under way in London in mid-July of 1912. "Three hours of talky talky with the Duveens who rather upset me," he informed Mary. "We are to meet with lawyers in a few minutes, insisting on some formal legal statement which would enable my heirs to recover the very considerable moneys which may be due my estate from the Duveens. . . . The lawyer and I could have done it all in an hour at the utmost. But in a way the Duveens are so stupid and at such cross purposes that God knows how many more sittings will be necessary." With the layman's impatience Berenson grossly underestimated the difficulties which had to be confronted. The contract which finally resulted ran to more than twenty pages and was not ready to be signed in Paris until the twenty-fifth of September. The parties to it were described as the "Merchants and Bernhard Berenson, citizen of Boston, Massachusetts, residing at I Tatti, Settignano, Florence, Connoisseur of works of art, and hereinafter called the Expert."

The contract was to take effect retroactively as of July 1, 1912, and run for five years. The Expert was not to be in the exclusive employ of the Duveens, but he was required to give the firm first refusal on any "first class Italian pictures" of which he had knowledge or potential control and to supply "every possible information concerning Italian pictures and other works of art, their history, their owners, and any dealings or negotiations so far as the Expert has knowledge or belief or any opinion or any opinions or criticisms concerning them." If the firm declined a proposal, the Expert could offer it to a collector but not to another dealer. He was also to abstain from arrangements with other dealers in which he was paid a fee based on a percentage of the purchase or sale price; for his advice in such cases he was to charge "a fixed monetary sum." The provisions governing arrangements with other dealers quickly succumbed to complications.

The provision that was to prove most troublesome was the one requiring that pictures bought on Berenson's advice by each of the three Duveen galleries were to be entered into a special book called the "X" Book, the original of which was to be kept in the Duveens' Paris gallery at 20, place Vendôme. Excepted from this provision were transactions for which "private and separate arrangements" were made, a purchase on shares, for example. A fee of 25 percent of the net profit was to be paid on purchases entered in the "X" Book. Berenson was strictly en-

joined to keep secret the fact that the Duveens compensated him on a percentage basis. Accountings would be made half-yearly, on August 31 and February 28, and it was to be "distinctly understood" that the fees paid were to be regarded as for "services rendered" as a consultant and not as "commissions." If the Duveens took back a picture from a buyer or exchanged it for another, "on any terms they see fit," Berenson was to be debited the amount of his fee and charged 5 percent interest, the intention being "that the Expert shall follow their fortunes in such matter." Despite this last feature, which proved particularly irksome to Berenson, it was stated that the arrangement between the "Merchants" and the "Expert" was not to be "deemed in the nature of or in fact a partnership agreement."

Sir William Plender, chief partner of the London accounting firm of Deloitte, Plender, Griffiths and Company, was identified as the "X" who would serve as arbitrator to deal with the Duveen accounting firm of Westcott, Maskall & Company. To maintain secrecy only partners of these firms were to have any knowledge of the transactions. The contract expressly stated that the agreement "shall be kept absolutely secret by both parties and by the executors, administrators, and heirs of the Expert," who were to attempt no communication with the Merchants in the event of the Expert's death but apply for any moneys that may be due to his estate to "X" and accept his settlement without question.

The following passage provided the rationale for the curiously detailed provisions of the contract: "This agreement is based upon the very considerable value attaching to the opinion and belief of the Expert concerning the authenticity, history or criticism of Italian pictures and other works of art . . . [and also] upon the fact that the dealings of the Merchants in Italian pictures and other works of art are necessarily of a singular and exceptionable nature . . . frequently involve long credits or the return of works of art . . . [and] on many occasions very special arrangements as do not normally take place in ordinary business."

The keeping up to date of the "X" Book and of the "X" Ledger, in which both purchases and sales were recorded, became from the very outset a recurring and complicated tussle among the three branches. Moreover, much to Berenson's annoyance, Joe continued to hold on to the substantial balances and to credit Berenson with 5 percent interest rather than disgorge all of the highly useful "float." In wiring the firm, Berenson was to sign himself the code name DORIS. The Duveens were to be LOUBEATA in London, OCTAVUS in Paris, and LOGHOFF in New York. The many cables and telegrams that came to I Tatti made very little use of code language and were usually transparently intelligible.

Joe Duveen may have hoped to monopolize Berenson's services—and to some extent he succeeded—in the firm's campaign to dominate the

trade in Italian Old Masters, but there was a troublesome ambiguity in the arrangement. The provision entitling the firm to first refusal on "first class" pictures of which Berenson had "knowledge or potential control" could not apply to those submitted to him for attribution by other dealers. And what were not "first class" pictures left much to Berenson's discretion. Hence Berenson felt relatively free to continue counseling other dealers. The customary 10 percent of the profit on sales or other rewards which they pressed upon him may have been overshadowed by Duveen's 25 percent, but their fees would help him indulge more freely his taste for books, objects of art, and luxurious living.

Principal among these auxiliaries was Arthur Sulley of London, whose business relations with Berenson continued until the year of Sulley's death in 1931. Berenson's friendly relations with Otto Gutekunst were similarly long-lived. Once when Gutekunst reported to Berenson the gossip that the Duveens had exclusive call upon his services, Berenson replied, "I wrote you about your version of the Venus and Adonis not as a matter of business but to prove to you the falsity of the amiable charges against me by Bond Street that I am not free to give my opinion to all and sundry." In a friendly gesture he returned Otto's check for £500.

Berenson's association with the famous Nathan Wildenstein, his son Georges, and grandson Daniel paralleled that with Arthur Sulley and continued at intervals to the end of Berenson's life. Relations with the F. Kleinberger Company of Franco-American art dealers endured for nearly forty years, during which Berenson supplied critical opinions and certificates of authenticity. The 174 letters from the firm reflected an especially close collaboration. The connection with Julius Boehler of the Munich firm of Boehler and Steinmeyer was equally durable. Anxious to have Berenson's favor, Boehler wrote, after Berenson had expertized a Pontormo in 1911, "Of course for your trouble I should be very pleased to give you a share in the profit or make any arrangement which would be convenient for you." During the twenties the occasional fees from Boehler would run from $1,500 to $2,000.

Among the many Paris antique dealers who had branched out into picture dealing was amiable Jacques Seligmann, an important rival of the Duveens in the sale of objects of art. He was, he confessed to Berenson, "picture blind." He therefore relied much on Berenson's judgment. Seligmann worried about Berenson's uncertain health and advised him to take life easier: "You have got money enough today," he wrote in 1915, "and you will easily make a lot of money more." When Jacques's young son, Germain, joined his father in the business, he achieved his first success by urging his father to call in Berenson to identify a small Venetian altarpiece. It proved to be the *Madonna and Child with Saint*

Jerome and Saint John the Baptist by Cima da Conegliano. After Lord d'Abernon thereupon bought it in 1919, it passed into the hands of the Duveens and came to rest at last in the Mellon Collection. At his first meeting with Berenson Germain recalled seeing "a delicate-looking man —his expressive hands, his delightful manner, his soft, well-modulated voice, pronouncing decisions that one felt were beyond appeal." Father and son were to call upon Berenson from time to time until as late as 1949.

René Gimpel was another of the Paris dealers who was eager to call upon Berenson's services. Gimpel's father, who died in 1907, had been a partner of Nathan Wildenstein. Only twenty-six at the time, René took over his father's share of the business as a junior partner. Later, as a brother-in-law of Joe Duveen and now in business for himself, his ar-rangement with Berenson called for a fee of 25 percent on profits "real-ized whether on buying a picture on your advice or your giving an attestation." Much as Gimpel appreciated Berenson's expertise, he re-sented being patronized by him. In the pages of his diary—published posthumously—he fantasized an imaginary dialogue with Berenson's spirit: "If small and agile tigers could speak they would have your voice and your intelligence [*ta voix et ton intelligence*], feline Pole," with "velvet paws and killer talons of steel."

THEIR respective missions in England completed, Bernhard and Mary went their separate ways. Instead of returning to St. Moritz in August, Bernhard took his chronic ailments to Carlsbad for a four-week stay to be x-rayed, diagnosed, and treated. The best that the learned physician could tell him was that he had too big a head and too small a stomach, that the muscles of his stomach and intestines were too flabby to hold his food in a proper posture for digestion. Hence he must stuff and of course drink the waters. Mary, from an opposing necessity, headed for Aix-les-Bains with her sister and cousin Grace to try again to subdue her resur-gent corpulence.

Glad to learn that she was "beginning to melt at last," Bernhard again lectured her on the importance of attending to her wardrobe. She went to Paris at his urging to get a supply of dresses. Elsie de Wolfe took her down to Worth's for long hours of fittings. When Bernhard joined her, she appeared at dinner at Edith Wharton's in a new evening gown, which kept slipping off her shoulder. Bernhard "rather liked it, for I looked fashionable at last."

It was mid-October of 1912 before Mary was reequipped and the contract with the Duveens finally signed. In spite of the lateness of the season the Berensons drove back to I Tatti in an open touring car and "paid for it" in chilly discomfort. Bernhard found that his "runners,"

who had scoured the country for Italian paintings for four months, had "gathered in a very scanty harvest." He was able to offer Walters only a single picture. Only three more turned up in November. The Duveens, "very much concerned about the scarcity of great Italian pictures," hoped that at least "one or two might spring up from time to time from unexpected sources." Joe admonished Berenson, "We must control all fine Italian masterpieces." In this succinct fashion Joe defined what he thought were Berenson's responsibilities under the new contract.

What were acceptable masterpieces unavoidably pitted the Berensons' taste against that of Joe Duveen. Of a Lotto portrait, for example, Joe wrote that it seemed to him a picture of a man in pain "as if he had lost a shilling and found a sixpence or has been jilted." Lotto, Duveen felt, unfortunately specialized in "sorrowful countenances." He drew the line also at portraits of men with beards.

Another subject of dispute arose from his preference for paintings whose colors were fresh and vivid. Paintings acquired from private collections were often "in dire need of cleaning" and restoration. They would be sent off to the Paris restorer Madame Helfer for treatment, and knowing Joe's taste—and his impatience—she had a tendency to overpaint. Joe, himself realizing the need for more careful restoration, again asked Berenson to employ for the firm his friend Cavenaghi, the artist long recognized as "the most scrupulous of all restorers." When, however, a Bellini which they hoped to submit to Benjamin Altman seemed to languish at Cavenaghi's, Louis urged speed. Berenson had to explain that it would be "a grave mistake" to rush the restoration, as each layer of glaze must be thoroughly dried or in a year or two it would look different from the rest of the painting. He also insisted that he must see the restored painting before it was sent if he was to "guarantee its quality." Thus instructed, Louis agreed that Cavenaghi should not "rush the work in any way."

The difficulties of restoration were of course complicated by the growing dispute among art critics over how much restoration was permissible or justifiable. Purists resented any alterations though they might accept some cleaning. Yet few if any Old Masters in their transit through the centuries had escaped restoration or even change as the result of chemical changes in the pigments.

How puzzling the matter could be is illustrated by a painting which Berenson enthusiastically recommended to Joe Duveen earlier in the year, the *Portrait of a Young Venetian* by "the rarest, most wonderful, most fascinating artist of the Renaissance—Giorgione!" He spoke also of its "miraculously fine state." It was then owned by the Countess of Turenne of Florence. The Duveens sold it to Altman with Berenson's

certification. Berenson had first encountered the painting at the exhibition of Venetian Old Masters in London in 1895, there exhibited as a Giorgione. In his iconoclastic article which rejected attributions wholesale, he had remarked that the painting, though not a Giorgione, was "of exquisite quality" but of "deplorably bad preservation." In the seventeen years since his first view of the painting, it had evidently been very skillfully restored and he had forgotten his first impression. Wilhelm Bode referred to the painting in an article in *Art in America,* shortly after Altman's purchase, as superior to the Berlin version, "more colorful, deeper in tone," and betraying "a later period in the more powerful turn of the head." He too admired the "preservation" of "this splendid portrait" by Giorgione.

Nearly sixty years after the sale, when the painting had passed to the Metropolitan Museum, Professor Francis Haskell, while not denying the attribution, referred to the painting as "this sad, but still moving ghost of a picture." What had happened, according to the art historian Terisio Pignatti (1969), who for his part concluded it was the work of "the young Titian," was that "the painting has been extensively damaged through cleaning, which has thinned the color . . . allowing the ground to show through in some parts." Shorn of much of the color that had entranced both Berenson and Bode, the painting, previously attributed to Giorgione and Titian, is now given entirely to Titian.

XVI

Last Season of the Belle Epoque

THE immigration of European art into America before World War I paralleled the flood of human immigrants, which reached a peak by 1913. The multimillionaires who operated or controlled the great industries employing the newcomers populated their homes and private galleries with thousands of real and dubious masterpieces which had come to the United States largely through the help of the international art dealers, firms like Duveen, Knoedler, Seligmann, Glaenzer, Kleinberger, and Wildenstein-Gimpel, and the press made the names of the great collectors and the enormous prices they paid for prized acquisitions familiar to an awakening public. Isabella Stewart Gardner, J. P. Morgan, the Wideners, and Benjamin Altman had led the pack, with Henry Clay Frick, Clarence Mackay, Jules Bache, Henry Walters, John Graver Johnson, Henry Osborne Havemeyer, and their lesser competitors following at a distance. Gifts and loans of the new acquisitions to the growing number of public galleries were opening new worlds of aesthetic experience.

Hence it was that the *New York Times* welcomed the first number of *Art in America* as appearing "at precisely the right time." Its editor, thirty-three-year-old Wilhelm Valentiner, who had earned his doctorate in art history at Heidelberg, had been brought from Germany to serve as curator of decorative arts at the Metropolitan Museum. From the beginning Joe Duveen recognized *Art in America*'s great potential for educating the taste of prosperous Americans, somewhat in the way the *Connoisseur* served the British. He not only subsidized his "beloved magazine" in its first years but also helped the young editor recruit his first contributors.

Berenson was one of the six contributors to the inaugural issue of January 1913. His contribution marked the beginning of his seventeen-

year association with the magazine. Preoccupied with getting the Johnson catalogue ready for the press when the request for an article reached him, he turned back to a 1911 unpublished piece, "A Nativity and Adoration of the School of Pietro Cavallini in the Collection of Mr. John G. Johnson," in which he argued for a pre-Giottesque Italian origin for the painting— in spite of its strikingly Byzantine elements—on the basis of its similarity to a Cavallini mosaic in Rome. The lead article by Wilhelm Bode dealt with the dating of the earliest Rembrandt. Similar problems occupied the other contributors—Valentiner, Frank Jewett Mather, Jr., Joseph Breck, and Allan Marquand—thus establishing the scholarly character of the magazine.

The satisfaction that Berenson felt in being included among the first contributors was no doubt clouded by the prominence given to Bode and the choice of Bode's protégé Valentiner as editor. He had protested to Henry Duveen that if he stopped writing he would lose his reputation and authority, yet with Valentiner's invitation in hand he had to face the fact that he had published nothing for four years. Hence when he returned to I Tatti in the fall of 1912, his thoughts ran back to the book he had envisaged long ago when Jaccaci had sought his collaboration. He now saw it as an extended study of Venetian paintings in America. Soon Mary and his secretary, Lancelot Cherry, began the hunt for appropriate photographs for his examination.

There were of course the usual distractions, an incessant procession of visitors and house guests. René Gimpel and his bride, a sister of Joe Duveen, made an agreeable impression. Charles Platt, the "squillionaire" architect, as Mary called him, came for a brief visit. Edith Wharton spent nearly a month at the villa, giving Berenson a chance to pamper her as much as she always indulged him at Hyères. A dedicated writer, she kept to a regular schedule of work and made few demands on her host. Santayana also showed himself the "ideal guest," considerately staying in his room until lunch. During his visit in November there was much philosophizing with their neighbor and Bernhard's college classmate, Charles Augustus Strong, and with the resident philosopher of the Florentine colony, Alfred Benn, who had dedicated his book *Modern England* to Bernhard. At a succession of luncheons and dinners Santayana held forth on the three realms of being on which he was then engaged and showed an interest in "everything except art." He reported that his host "is full of espirit, and there is a stream of distilled culture flowing over us continually in the form of soulful tourists and weary *dilettanti* who frequent this place." Clive Bell, the London art critic, husband of Vanessa Bell and an intimate of the Bloomsbury group, disdainfully

remarked after his visit that I Tatti was "full of Old Masters, mysterious countesses and unspeakable Americans."

In the midst of things, Mary suddenly had to hurry over to England to see her doctor about a mysterious illness. Her doctor, she wrote, said she might expect "to be laid up very soon, but he couldn't give a date." During her absence Bernhard "burst out" by buying a large Chinese Buddha, for he had become enamored of Oriental art, having already obtained a number of pieces—a "fine bronze," a vase, a small statue, and other items—from the French dealer Leon A. Rosenberg. He was also unable to resist "two little clerics" who came up with a small picture, "mostly" Botticelli, for which they asked 20,000 francs ($4,000) but, after some haggling, sold for 8,000. Hitherto he had thought of his collection of art as "representing merely his normal activity as a man of taste," as he put it to his friend the art critic Frank Jewett Mather, Jr., in deprecating a famous colleague as "merely a collector." When he unpacked his summer purchases, however, he "suddenly realized" that he had become "the thing he loathed—a collector."

Her medical treatment completed, Mary made a quick visit to her children and the new grandchild, saw three of Bernhard's intimates in Paris—Edith Wharton, Mrs. Cameron, and Madame de Cossé-Brissac—dispatched some business chores, and got back to I Tatti in time for Christmas mass for their dependents in the chapel. In her absence Bernhard, who had been critically studying the appearance of Arthur, their new valet, decided it would be more elegant if he wore livery. Mary balked at this ultimate expression of fashionable living and ordered a plain black suit and white gloves for the servitor.

The talkfests continued into the January evenings and were joined by the intellectual Eugénie, the "talkative single track" widow of Berenson's one-time adversary Standford Arthur Strong. Once a vehement partisan of her husband, she was again on good terms with the Berensons. Sometimes the discussions became so vigorous that the ritual camomile tea was brought in early to quiet the contestants. A new name dropped into one of their conversations, that of Sigmund Freud, who, as Mary explained to Alys, "traces all our character to the influence of our very earliest years even before we speak." The subject was to become one of Mary's obsessions and arouse Bernhard's greatest scorn.

If conversation was a pleasure to Bernhard, reading was an urgent necessity, and it filled almost every interstice of his crowded days, whether in books on art, antiquity, biography and history, or fiction as demanding as Dostoevsky's *Idiot*. He ventured into unknown waters, however, when Gertrude Stein sent him a special number of *Camera Work* (August 1912) with illustrations of the work of Matisse and Picasso

and a two-page introduction to each artist in her nihilistic prose. In a concluding passage on Matisse she declared, "Everyone would come to be certain of this thing. This one was one, some were quite certain, one not greatly expressing something being struggling." Evidently pleased by the phrasing, she repeated it in several variations in the piece on Picasso.

Berenson thanked her for the "extraordinarily fine reproductions" of the works of Matisse and Picasso and after due contemplation continued, "In a moment of perfect peace when I feel my best I shall try again to see whether I can puzzle out the intention of some of Picasso's design. As for your prose I find it vastly more obscure still. It beats me hollow, and makes me dizzy to boot. . . . But I'll try again."

Not talkfests nor reading nor business chores kept Berenson from his desk in the early months of 1913. Fortunately the noise of continuing improvements at I Tatti—three new upstairs rooms and a bathroom—did not reach him where he spent his mornings "spinning out his articles," as Mary said, "faster than I can type." In swift succession he wrote a note on Pietro and Antonio (Antonello) da Messina, which appeared in an Italian version in April in his friend Don Guido Cagnola's *Rassegna d'Arte,* and three substantial articles published in French versions in Charles Ephrussi's *Gazette des Beaux-Arts* in March, June, and September. The original versions of the *Gazette* essays would be included in his *Study and Criticism of Italian Art,* Third Series.

In the *Gazette* article on the Antonello *Madonna and Child* in the Benson Collection, Berenson took pleasure in correcting Tancred Borenius' attribution of a painting to Antonello's son Jacopo, a painting which had been "successfully hiding as a work by a chubby provincial named Marcello Fogolino." It did not daunt him that a dozen years earlier he had himself accepted that attribution in his *Lotto.* Berenson now concluded that its author was Antonello himself. "I should recognize the left hand here to be [Antonello's] by its shape as by its action." The other two *Gazette* articles, one on a *St. Justine* in Milan and the other on four triptychs in Venice, reflected his revived interest in the work of the great Venetian Giovanni Bellini. As a beginner, twenty years earlier, he had attributed the *St. Justine* to Alvise Vivarini, an artist he had "labored almost fanatically to revive and enhance" in order to show his influence on Lorenzo Lotto: "To roast my pig, I had at that time to burn down the whole house." His detailed review of the work demonstrated, he felt, the superiority of the *St. Justine* to Alvise's "poverty stricken works."

Earlier he had also ascribed the four triptychs in the Church of the Carità in Venice to Alvise. At the beginning of his study of Venetian art, he wrote, it had "scarcely occurred" to him "to question attributions,"

unless they were "flagrantly inconsistent with the little knowledge [he] had already acquired." Now that he could give "undivided attention" to the Venetians and look at the panels "in the light of all" he had "seen, thought and learnt since," he was convinced that they were "in essential the creation of Bellini's brain" and were executed by his assistants, a product of his studio, "or just outside it." The analysis indicated that Berenson was beginning to move toward what would be called an "expansionist" theory of attribution.

A comparison of the French versions of the *Gazette* articles with the original versions reveals that the French translator, probably the very Gallic Salomon Reinach, did not hesitate to revise the text in accordance with his notion of French decorum or to subdue or delete Berenson's autobiographical touches, so that the whole tone of the essays became more judicial, more impersonal, and more elegantly phrased. Picturesque and colloquial expressions fell by the wayside. A "chubby provincial" and "Venetic clodhopper" became simply a "peintre provincial." Diffuse paragraphs of commentary were omitted.

When Berenson published the articles in his *Study and Criticism of Italian Art,* Third Series, in 1916, he disregarded the French improvements, preferring his own highly personal, discursive, and frequently exclamatory style. It was a style which reflected that note of personal intimacy with a painting and its author and all their kinships which so irresistibly attracted his companions when he acted as their cicerone. There may have been egotism in it, nourished as it was by the deference so widely paid to his opinion, but no other style would so well have suited his exuberant self-assurance.

During the early months of 1913 a puzzling contretemps arose over a reputed Bellini which the Duveens had purchased from Robert Langton Douglas. Berenson accepted it as genuine on the basis of a photograph, and it was submitted to Cavenaghi for cleaning and restoration. Shortly thereafter Mary Berenson informed Edward Fowles, the Duveen factotum, that Cavenaghi had given it up because it had turned out to be a modern imitation. Berenson apologized for having given his authentication and proposed that the cost of the "forgery" be charged to him. "All of us [experts], we are half a dozen at the utmost," he explained, "know well enough how likely such things are to happen. The vulgar, however, expect us experts to be infallible, and if this mistake of mine got abroad it might be damaging to you." Louis Duveen hastened to reassure Berenson that he should not think for a moment that the mistake was going to "shake our confidence in you. There is only one Mr. Berenson and I am sure my partners will take the same view." The matter would go no further: "I shall entirely erase it from my mind." Although Douglas is

said by Fowles to have supplied a complete provenance for the painting, Terisio Pignatti, author of a comprehensive study of the works of Bellini, reports that he can find "no trace" of the picture in his files.

When urgently summoned to "important" conferences by the Duveens, Berenson sometimes exaggerated his illnesses and thus obliged them to see him on his own turf at I Tatti. There he could comfortably display his finds without the hubbub of the Paris gallery. On one foray "Uncle Henry" came to tea and stayed to dinner. "The time flew as when Scheherazade recounted tales to the king," ran Mary's amused report. "He is a wonderful genial old rogue. . . . He as it were unbuttoned himself and told dramatically long tales of contests with various American millionaires. . . . He is quite wild to get more Italian pictures. . . . He would pay us £5000 at once for six or seven of our things, he said! I do so wish B.B. would let them go."

A short time before Henry Duveen's visit, Joe had written that Mrs. Otto Kahn was in Italy, and he besought Berenson to arouse her interest in the "fine Italian pictures" in which the firm dealt. Addie Kahn was a diminutive five feet tall, and Berenson, from the height of five feet seven, could look down upon the attractive matron of thirty-seven with benign concern. Her husband, Otto, who had been taken in as a partner into her father's prestigious banking firm of Kuhn, Loeb and Company at the time of the marriage, had become a leading financier and the Maecenas of the Metropolitan Opera Company. To her as a talented sculptress fell the main responsibility for building the family's notable art collection.

Immediately after Henry's departure in February Berenson took Mrs. Kahn and a companion to Siena, and was so charmed by her and she by him that they became fast friends and exchanged hundreds of affectionate letters until her death in 1949. She shared his enthusiasm for the Italian Renaissance, and masterpiece after masterpiece which he helped her acquire came to adorn the walls of the Kahns' splendid homes.

One of the paintings which later went to the Kahns was the profile of Giuliano de' Medici which a dealer, Baron Michele Lazzaroni, had shown to the Berensons on a visit to I Tatti. They spent hours looking at it and studying photographs. "With wonder and surprise," as Mary put it, they came to the conclusion that it was by none other than Botticelli. The painting was of extraordinary interest to them, for two portraits of the young Giuliano de' Medici were known to them at the time, one in the Morelli Collection in Bergamo and the other in the Berlin Museum. Though they each had their champions as authentic Botticellis, Berenson, along with other connoisseurs, regarded them both as copies. This painting then, he and Mary believed, was the original that had not been known to be in existence.

The painting made a sensation at the Duveens' gallery. "We have all been dreaming about this picture," Louis exulted. "For myself I could not sleep at all. It seems almost incredible that we should have here a portrait of a handsome boy by Botticelli himself. I am sure that when Mr. Altman sees this picture (it will naturally be shown to him first) he will drop his walking stick and throw up his hands in amazement."

Altman declined to take the painting, and the ever-resourceful Duveen immediately began the search for other possible purchasers. Benjamin Altman died in October 1913 at the age of seventy-three, leaving an estate estimated at $45,000,000 and a priceless art collection. J. P. Morgan had died in March, "the last to buy paintings without an authentication from Bernhard," Mary boasted to Bernhard's mother. "Now no important buyer will do without it." To Berenson's surprise the absence from the art market of Morgan's extravagant purchases did not produce "a great slump," as might have been expected. Prices, he told Johnson, "have been steadily rising" and in Paris were "positively orgiastic." Morgan may be dead "but his soul goes marching on."

Berenson's quixotic resolve to support Belle Greene if Morgan should neglect her proved needless. The will left her $50,000 and assured her employment for life as librarian at a salary of $10,000 a year. Belle's black-bordered missives, however, kept Berenson straining on her leash. "You are all I have left now," she wrote. She expected to stay on at the Morgan Library at least for a year and hence could not come abroad. (She was to continue at her post until her death in 1950.)

That she continued to hold an ardent place in the hierarchy of Berenson's women admirers was painfully apparent to Mary. In May of 1913 Mary wrote to her own much-treasured confidant, Geoffrey Scott:

Only my conscience does prick me a little remembering that I encouraged B.B. in the affair partly for my own reasons. I think if I had been strictly against it, he would really have kept it at the cool safe distance he has kept all his other escapades and fancies. I thought it would make up to him for the unhappiness of all the building upset and for not finding me very satisfactory (which I wasn't), but I also thought it would leave me much freer, which it did, as you remember. So I am honestly and truly responsible for its gravity.

What complicated Mary's situation was the fact that Bernhard would have to return to the United States before the end of the year to avoid the cancellation of his American citizenship under the 1907 law. The Duveens also strongly urged his return for business reasons. After much soul searching Mary told Bernhard, "I have decided to go to America with thee," though, she felt obliged to tell him, she could not "feel an atom of friendliness" for Belle Greene. Her decision, she confessed to-

ward the end of the summer, had not been easy to arrive at. In the mixture of devoted understanding and patronizing reproach habitual with her, she wrote, "All thy talk for a long time past has been eminently reasonable, granting the crazy fact of being in love with a person so unsuited to thee by circumstances and nature and habits, but thee has been as secretive as death about the kernel of that craziness."

What disturbed her was his denials that he any longer felt "that 'all over love' which as thee said thee yielded to only twice." Her instinct told her that, on the contrary, he was "consumed with physical desire" for Belle. She admitted that she had come upon confirmation of that fact one day at I Tatti when, "upset with doubt," she had surreptitiously read a page of a letter he was writing to Belle, "an outburst of overwhelmingly lyric adoration" containing the sentence "All I have and all I am are yours." "Bernhard, people of thy age *cannot* write these things as a poetic exercise." What she was careful not to reveal to him was that her feelings about his passion for Belle were not the only reason for her reluctance to make the trip. Her intimate letters to Geoffrey Scott showed that she dreaded the long separation from him that the trip to America would entail.

The Berensons left Florence in June 1913 for their customary summer travels. Before parting—Mary to join her family in England and Bernhard to attend to business and pleasure in Paris—they prospected for pictures and gathered notes for the Lists for a few weeks in northern Italy and in Germany. The stop in Munich had its bittersweet moments for Mary, for they lunched with Hermann Obrist, the artist with whom she had been infatuated during the nineties. Obrist showed them his famous fountain, which he saw did not please them.

Their departure from Florence left a vacuum among their neighbors, as Florence Blood reported to Gertrude Stein: "The Berensons had left before I arrived and really though they are neither young, or fresh, or cubistic they are the best the place affords and when they have gone what is there?"

The social kaleidoscope in Paris displayed its usual glitter. At the Villa Trianon Bernhard reveled in Elsie de Wolfe's "petits soins and last touches of daintinesses." At a fashionable gathering, again in the company of Edith Wharton, he encountered his former neighbor Gabriele D'Annunzio; D'Annunzio's suffering mistress, Madame de Goloubeff, who reputedly always carried a revolver; and another of D'Annunzio's worshipers, Marie Murat. Long an admirer of Berenson, D'Annunzio had once written, "To be habitually joined with a rare spirit like yours would be of priceless value to me [*pregio inestimabile*]." The poet's flamboyant extravagance and his often sordid sexual escapades among

women, high and low, had made his situation in Paris precarious, though he was still welcome in ultra-chic circles. At their meeting Berenson "conjured" him to return to Italy, "prophesying disaster if he did not." Afloat in the literary and sporting world of Paris, D'Annunzio was to hang on until the coming of World War I, when the "syphilitic, debt-ridden Don Juan" would return to Italy to become the strident ultra-nationalist hero of his homeland.

At the Steins' Berenson found Gertrude "really looking handsome," the clean-shaven Leo "priest-like," Mabel Dodge "heavenly," and Picasso "a delightful toreador-like gamin." When he chaffed Picasso about his latest "declension" into cubism, Picasso "protested like Luther that he could not do otherwise." He visited Henry Adams, convalescent in his luxurious "attic" on the avenue du Bois de Boulogne, attended by Louisa Hooper, his adoring niece, and by Aileen Tone, the young musician who had been engaged as his watchful companion. Miss Tone sang to them twelfth-century *chansons,* the collection of which had become Adams' hobby. "I don't know when I heard anything so lovely, so poignant and yet so restrained," ran Bernhard's comment to Mary.

A tête-à-tête with Henri Bergson ranged over the things in America which had impressed him on his recent lecture tour. They also talked of the essay which Karin Costelloe, Mary's daughter, had written defending him from the charge of anti-intellectualism, Bergson declaring it the most intelligent critique he had ever read, "illuminating even to himself." A lunch at Reinach's exposed Berenson to "two hours of vertiginous talk on every possible topic," with the famous bibliographer Seymour de Ricci as a participant. Thus the days passed in Paris in a dizzying but pleasurable succession of meetings with his circle of intimates—Walter Berry, Paul Bourget, Abbé Mugnier, Ralph and Lisa Curtis, Madame de Cossé-Brissac, Rosa Fitz-James ("the best hostess I have ever known"), and Philomène de Lévis-Mirepoix—all members of the fashionable upper crust of cosmopolitan Paris.

Business of course had to be attended to, and during a duty call on the Duveens he listened for two hours to their interminable "I say, I say" as they broached their plans for still-greater coups. He deplored their "stupidity," which he felt was matched by the "stupidity of their buyers," and he had little taste for Joe's "bluster, cajolery, flattery and heartless resolution to achieve his purpose." On another day he called on Jacques Seligmann, who "looked like a figure out of Michelangelo's 'Last Judgment' and as violent."

When Berenson got over to London, he learned from Sir William Plender's office that the Duveens "had handed in no account whatever" as required by the contract. They would therefore have to be "hounded"

into it, a necessity that was to become all too frequent. The account, when it was finally rendered on December 1, showed that the fees accrued to July 31, 1913, amounted to £19,358, of which £1,500 had been paid to Berenson on October 3, leaving a balance of £17,358, on which 5 percent interest was to be paid. Large unpaid balances were to be a continuing worry to Berenson in his relation to Duveen as his desire to increase his investments and achieve a stable income grew more obsessive.

In London there was much visiting with Edith Wharton and Henry James. James, he felt, seemed "shy" of him, and a suspicion of lurking anti-Semitism crossed his mind. At the home of Lady Charles Beresford he encountered Roger Fry, and "for the first time in nine years" he sensed no feeling "of hostility emanating from him. . . . I was glad to meet him again." With Edith Wharton and Walter Berry he heard the great Russian basso Chaliapin in *Boris Godunov*. He dined with George Moore, "who would not tell me how literature had gone to taxes but other sagas and the time passed and lo before we knew it, it was midnight." He conferred with the archaeologist Sir Arthur Evans at the Ashmolean Museum in Oxford; dined again with Lady Beresford, who "spit venom at Lady Cunard"; listened to the talkative John Singer Sargent, who, when Berenson suggested he paint King George V, vowed he would not "take any more humans"; and squired Lady Cunard to her "grand box" at the opera. Mary, with her family at Ford Place, Arundel, passed on to him the gossip of the uninhibited antics of the "Gloomsbury doings" which she had picked up from her daughter Ray. They were " 'horripelent' as thee says."

The three delightful weeks in England were marred by "very serious and urgent affairs" to which Joe Duveen summoned him with diplomatic apology. A "very important" collection which they had just acquired must be inspected. Ten days later he was called upon to appraise "a great picture" from Vienna which had to be returned the same day. He spent considerable time also with the Duveens on pending sales and with other London dealers checking on a multitude of negotiations. Henry Walters had come abroad on his regular shopping tour for works of art, and he looked in on Berenson, who found him "as dear as ever but gloomy about things in America," where socialism seemed on the rise as it was in Europe. Nevertheless, he bought all the things that Berenson offered him.

In August at Brides-les-Bains, where Mary had retreated, she heroically lost about 20 of her 200 pounds while enjoying the company of Bessie Marbury and Elsie de Wolfe. She began her ordeal, she confessed, with a gratifying "bust" at the dinner table. Scott, who had just com-

pleted a draft of his book *The Architecture of Humanism,* came for her at the end of the cure and motored her back to I Tatti. Bernhard, with his various missions accomplished in England, was now ready to begin a highly novel experience that he projected with Edith Wharton. They would make an extended tour of the art cities of Germany, where he would bring himself up to date on the Italian paintings coming into private and public collections.

Before 1913 Berenson had been Mrs. Wharton's cicerone on very short excursions. The trip they now planned was to take four weeks. They had discussed it in mid-July but at her insistence the date had been left open. She was, she said, determined to finish her novel *The Custom of the Country* before their departure. Berenson, impatient to be on the move, crossed to Brussels ahead of her, believing that her delay was more on Walter Berry's account than on account of her exhausting struggle with her novel. She arrived at the Grand Hotel in Luxembourg on August 17 rather thoroughly run down but with an entourage that amazed him. It included her butler–major domo, her young chauffeur, her traveling maid, and her lapdog, Nicette, all comfortably disposed in a large and expensive motorcar. For one who had satirized Berenson's luxurious style at the Ritz, it seemed oddly ironic. Hotels had to meet her fastidious standards, and when they did not, new ones had to be hunted out. It was "the most thoroughly luxurious party I have ever travelled with," Bernhard told Mary. His own high standards of comfort paled in her shadow.

Her fastidiousness took other forms as well. Berenson learned that though Edith "hates beards," she graciously tolerated his. "How fascinating I must be if she can put up with mine," he reflected. That the clean-shaven Joe Duveen disliked paintings of bearded men may well have strengthened Berenson's preference for them. To the end of his life he was to prefer the look of Old World and Renaissance distinction his shapely beard conferred on him.

For perhaps the first time in his life Berenson found himself second in command of a tour, and the position proved irksome. Edith had expected to take a week's holiday with him in the wooded countryside before getting down to serious gallery going, but Berenson dissuaded her in the name of the higher duty. When she collapsed in Cologne and generously offered her car and chauffeur to Berenson to continue his tour without her, her need for rest seemed genuine, and a repentant Berenson accompanied her to a rural resort in Thuringia. But he chafed at the delay and a few days later wondered whether she was "shamming" illness "so that she could have her own way."

Edith did not share Berenson's passionate interest in the formal qualities of paintings, and, in spite of his example, she did not enjoy the

leisurely scrutiny of stylistic details. "She sees only the subject," he complained to Mary, "and in the subject only what appeals to her literary sense." In the company of her entourage, forays off the beaten path in quest of neglected masterpieces proved frustrating. "You can scarcely understand the misery of trying to find anything with her in her car," his complaint continued. "Edith travels in the first place for motoring, then for porcelain baths, then for country, and finally for Eighteenth century architecture and gardens." She also liked places "haunted by a great writer" and had therefore swung him out of his course to visit Goethe's Weimar, thus cutting him off "from Copenhagen, from Oldenburg, from Rugen, from Stalsund, and a score of other delightful things in the north. In my younger years I should have boiled over with indignation and left her in a rage."

As a companion, he conceded, she was delightful, always ready to talk on a multitude of topics. It was a pleasure to chat with her, for she was "quite inexhaustible, and so easy to amuse and please." She did like the pictures at Altenberg, though she lingered for only ten minutes. "One would think she could not bear art. I wonder what she and Walter Berry find to admire in travel?" By the time they reached Dresden, he concluded that "art is a sealed book to her."

Edith's reports to Mary provided an amusing counterpoint to Bernhard's frequent complaints. She had thought she would not be of much use unless she had a "week's holiday in a greenwood," but Bernhard "fancied I was just uncertain and coy and a little gentle persuasion would soon cure me of that idea," and it took her collapse in Cologne to change his opinion. Forty-eight hours of rest and his promise to take her for a week "to a place where there were a great many trees and no pictures did much to advance" her convalescence. They started for Oberhof, where she was "credibly assured there is not a single picture," but after "loitering at the Frankfort gallery for an hour or two," Bernhard "became unmanageable again and insisted on conducting the remainder of the trip on principles of his own, which involved reconstructing the solar system with an audacity undreamed of by Galileo." As self-appointed navigator he assured them they were going east while they "were actually plunging into a particularly showy sunset," with the result that they wound up at Fulda only a few kilometers from Frankfurt.

In the management of the motorcar he was proving "an intelligent pupil, a trifle headstrong at times but lively, intelligent, anxious to learn" and making progress in his "motor training." "He has learned from bitter experience to give his address when he sends an 'answer paid' telegram for rooms at a crowded hotel, and has found out that to pull up a motor window with a jerk and leave it dangling does *not* constitute

shutting it and that keeping one's eyes on the map instead of looking at the points of the compass, or asking the indigenes where one is, is not an infallible way of reaching one's destination. . . . He has learned several useful things that appear to have been omitted from his earlier education:—Going through galleries with a firm step instead of gaping and dawdling, letting Nicette sit on his lap when she feels like it, getting out of the motor to ask the way of an intelligent-looking person on the corner instead of calling to the village idiot or a deaf octogenerian from one's seat; and abstaining from shallow generalizations such as, 'You'll always find it safe in Germany to follow the telegraph poles' or 'On mountain roads there are never any crossroads.' . . . Such, dear Mary, have been the results of our first eight days of travel and my pupil's aptitude and eagerness to learn give me every hope of continued progress. I take pleasure in adding that he is good-tempered, punctual, and polite and always brushes his hair for dinner and puts on a muffler when it is chilly."

Mary, who knew so intimately Bernhard's vagaries, undoubtedly relished Edith's irony as well as Bernhard's admission that "it is good discipline being with other ladies. It teaches self-control. I wonder if Edith has even an inkling of how often she has brought me to the verge of exasperation. She is not sensitive in the least to my moods." From Berlin he wrote, "This is the first time I come as a Ritzonian. I no longer can roam the streets looking into all the shop windows, peering into all the faces, so Berlin is now a place of museums, theatres and drives. . . . She can't conceive of taking a glass of water elsewhere than in a hotel . . . [and] has no notion of what it is to wander about the streets." At their "marvellous" hotel the beds were in alcoves, and when Edith found she would not be able to read in bed she was "almost" hysterical. "A meal scarcely goes by without her returning nearly every dish." Yet she could be "an enchanting companion."

In Berlin they attended Strauss's *Ariadne* and Wagner's *Ring*. "It is absurd," he wrote, "to judge Wagner musically alone. It is sublime, cosmic, and teleological drama full of simple but suggestive symbolism that makes one feel and think as if going on a mighty tidal wave of inspiring emotions." He renewed acquaintance with Max Friedländer at the Kaiser-Friedrich Museum; approved a Correggio that Julius Boehler brought over for his opinion; got out to Potsdam in spite of Edith's delaying tactics in the pine woods; and talked with Denman Ross, whom he encountered at the museum, and found him "generally unintelligible" since he was "in a mood of looking at everything as a Turkey carpet."

Though Edith had brought along a Baedeker guidebook for Austria and a custom's triptyque for the motorcar to cross the frontier, she was

now anxious to get back to Paris, having learned that Walter Berry had returned there from his cure, and it seemed to Berenson that she put on a "somewhat martyred air." On September 2 they parted amicably. Though he had generally enjoyed her company and did not relish the thought of continuing his travels alone on trains, "yet it will be something of a relief to be without her. . . . Her moods and her temper colour her daily life too much and tend to impose themselves on her companion to his discomfort. I suspect she knows this well enough but claims the privilege of genius."

Whatever her reservations, Edith soon afterward wrote appreciatively to Berenson: "I took back *d'un oeil attendri* on every stage of our little trip, and should regret more and more my unlucky physical and mental incapacity to profit by it more fully if that chance hadn't brought out in my travelling companion such treasures of indulgence and dearness that they have made me more and more his affectionate friend."

Berenson must have felt that the tour of the North German galleries to which he had eagerly looked forward could be easily resumed at a more convenient season with Mary. He was unaware that events were moving in the Balkans which were to defer that experience for nearly ten years. He had given no more than passing thought to the turbulent political currents in Europe except as they affected Italy, whose seizure of Turkish Tripolitania had angered him. The Italian victory over Turkey opened the door to Greece's attack on Turkey, a short war in which Serbia and Bulgaria also joined. A brief truce followed this struggle, and, in July of 1913, while Berenson was still in London, the Second Balkan War broke out with a complicated array of allies. A peace treaty was signed at Bucharest on August 10. By the time Berenson left Berlin an uneasy quiet had settled upon the Balkans and restored the illusion of peace, an illusion that would be abruptly ended in the following year by the guns of August that heralded World War I.

Thus it was in that last season of the Belle Epoque that Berenson journeyed to the Schloss Gratz in the mountains of Austrian Silesia to spend a few days with Princess Mary and her husband. He liked the princess, he thought, "because of all possible facets the feminine prism can show" she exhibited one or two he had not yet seen in combination with the others. At night there was a desultory talk of politics with the prince but nothing of sufficient moment to record for Mary. A week in Vienna stirred old ecstasies and memories. The sight of the paintings in the gallery "brought back my first visit there with George Carpenter twenty-five years ago," he reminisced to Mary, "then with Enrico Costa twenty-three years ago, and with you a year later. What adventures of the soul and mind many of these represented."

Louis Duveen kept track of his itinerary, so there was no slackening of chores to be attended to—an "important Botticelli" at Graz to be evaluated and an analysis of the Aynard pictures, which Berenson regretted he could admire only as "school" pictures. As soon as he got home he was to inspect a purported Giorgione at Grassi's and send his report. According to Fowles's account he also appraised that fall a *Madonna and Child* which a couple had brought from St. Petersburg, and confirmed the ascription to Leonardo. Joe Duveen agreed to pay a staggering one million pounds for it, confident that the Wideners would be eager to have it. He was, however, persuaded to include a clause in the contract giving Czar Nicholas II a prior option. The czar promptly exercised the option. It was a grievous setback for the Duveens—and for Berenson, who conjectured that the offer had simply been a trap by the owners to get his valuation.

Berenson's last stop before returning to I Tatti was Venice, where his pleasures were dampened by word that Louis Duveen hoped to go over to America on the same boat with him. "We particularly want you to be in New York by the first week in November," Louis wrote, "as we have so many important things on which we need your guidance and help." Berenson drew back from that too-cordial embrace. He felt "very gloomy over financial prospects and the chances of continuing with the firm," for the Duveens, he was convinced, had begun to show signs of "getting restive" under his "unyieldingness" and were even showing tendencies to "worship at other altars."

"They are continually at him," Mary confided to her family, "to make him say pictures are different from what he thinks, and are very cross with him for not giving way and 'just letting us have your authority for calling this a Cossa instead of School of Jura' or 'allowing us to take it if you will approve us calling this by the master's name, as it is so close, etc., etc.' They sent up an emissary the other day to say a certain picture here had been pronounced an early Titian by Dr. Sirén, Dr. Bode and Dr. Gronau and why couldn't B.B. agree—and although he didn't, he thinks they have bought the picture all the same, and that is the beginning of the end." It might become necessary, she felt, for them "to draw in our horns, for we have been living not on income, but on incoming capital." And she added, with her usual blitheness, "If it were not for the various people I love to give money to, I should not be at all sorry to be poor again." However, they had "plenty of stored up capital to last us the rest of our lives if we sold our things." It was high time, nevertheless, for Bernhard to go to America "to re-establish, if he can, his prestige, or else economize, very, very considerably."

XVII

America Revisited

AFTER a last farewell to the aesthetic delights of Venice, Berenson returned to I Tatti late in October 1913, with scarcely time enough to do anything more than join Mary in packing their steamer trunks in readiness for the departure for Paris on November 19. All the time he felt "the ebbing tide of health flowing fast away." Geoffrey Scott, who was to be left in charge of I Tatti, would see to the furnishing of the rooms which had been recently added to the villa. His main enterprise, however, would be revising the manuscript of his *Architecture of Humanism*.

Shortly after the Berensons left, a beautiful young woman of twenty-six who was visiting the Giulianis at their villa above the nearby village of Scandicci was taken by Byba Giuliani to call on an English couple occupying the Berensons' villino. She was Elisabetta Mariano, the Nicky Mariano who was to play a leading role in the life of the Berensons, a role that she would one day record in her book *Forty Years with Berenson*. During her visit the tall, thin Scott, his pince-nez spectacles clipped to the bridge of his nose, showed her through I Tatti. It struck her as "fascinating and awe-inspiring." The cypresses which the Berensons had planted in a long avenue leading up from the road were, she remembered many years later, "growing up well but looked puny against the majestic old cypresses near the house." The romantic Scott was attracted to her, an attraction that would later invite Mary Berenson's matchmaking proclivities.

At the moment Mary's thoughts were on more mundane matters. From Paris she went on to Ford Place to take leave of her family and to see her doctor, who prescribed as an addition to her array of nostrums "the new medicine—mineral oil." In London she anxiously checked the New York hotel prices and learned that at the best hotels they had risen

to twenty to thirty-five dollars a room, with suites going at fifty to seventy. Concerned about the need for economy, she obtained accommodations on the British White Star liner *Olympic* for £52 instead of more luxurious ones at £250.

Bernhard stayed on at the Ritz in Paris for a week. The dealers, he said, had little for him to see. Carlo Placci dropped by with a budget of quite unreliable speculation: the Panama Canal was a fiasco and Japan and Mexico were preparing to conquer the United States. The world press rang with word of the ritual murder trial of Mendel Beiliss in Russia, but it appeared to awaken no memories in Berenson of the barbarous folklore of his Lithuanian childhood. He saw Elizabeth Cameron at Edith Wharton's and was "as much as ever impressed by her elegance and grande dame manner." An amiable René Piot reported that a Paris journal had asked Carlo Placci to do an article on Berenson. Edith Wharton summoned him for a last dinner with Paul Bourget and the duchess of Clermont-Tonnerre; he made the rounds with Karin Stephen to the Bergsons and the Reinachs; and he accompanied Lucien Henraux to the Art Decoratif exhibition "to give them attributions for their Italians." The Duveens showed him their new Raphael at an interview that "really was too lively."

Bernhard and Mary rendezvoused at Cherbourg on December 1 ready to board the luxurious *Olympic*. They sailed on December 3, once more to challenge fortune in the homeland which they had abandoned.

The *Olympic* docked at New York on December 10, 1913, seven days out of Southampton after a "pretty rough crossing" that tried sealegs and stomachs. A warm greeting awaited Bernhard from Belle Greene. She had secured comfortable rooms for the travelers at the Belmont for thirty dollars a day, a hostelry well away from the city shelters where thousands of the city's poor had taken refuge from the unprecedented cold. To Berenson the New York skyline exhibited a vigorous faith in the future. "The skyscraper has fulfilled my prophecy and become articulate," he reflected. "That is perhaps the most interesting contribution that we have made to the world's art."

On the front pages of the newspapers much space was given to the growing rebellion in Mexico, where the Zapatistas pressed hard against the federal troops in one sector while General Francisco ("Pancho") Villa routed them in another. Talk grew of American intervention, but for the Berensons it was all too remote for mention. More relevant was the fact that Elsie de Wolfe had just contested the constitutionality of the new federal income tax and that her suit had been thrown out of court.

Within a month Berenson was himself deep "in the tangles of the new income tax." He spent hours on it and still could not understand it. By

comparison with the forms of three-quarters of a century later it was a marvel of simplicity. The tax was levied on net income to be arrived at simply by deducting expenses from gross income. In some quarters there was outrage at the exactions, but in long retrospect they can arouse only envy. The rate was 1 percent on the first $20,000 after a deduction of $4,000 for a married couple, with progressive increases up to a maximum rate of 6 percent on net incomes over $500,000. Berenson's situation posed interesting complications since he received income from investments in America ($3,000 at this date); book royalties; and fees from American clients, from the Duveens in Europe, and from other dealers. The pocket ledger which he carried with him showed little aptitude for systematic bookkeeping and must have required considerable inventive interpretation.

Berenson's reunion with Belle Greene appeared to revive their ardors, though at a lower temperature. Now with an independent income she was much more her own mistress, and her almost daily chronicles when he was not in New York were filled with her activities at the Morgan Library and the names of the eminent personages who catered to her. In one letter she teased him with Bessie Marbury's opinion that "I would never really possess your soul until I had in some way attached a title to my name, or a string of pearls to my neck."

Mary looked on at the affair with a kind of clinical detachment, explaining to Scott that she thought it "the most natural and sanest thing to *let* his unkillable affection for her run a simple unchecked course, guarding as much as possible against annoying scandal." Such a course assured her own freedom, which she had in fact "always more or less taken" though with "many material hindrances." She surmised that Bernhard's happiness lay in continuing the affair and "gradually humanizing it."

On Christmas Day in Boston Bernhard and Mary went out to the "dreaded family dinner," she fearing that he would be tongue-tied as usual before his too-adoring mother. Happily the presence of his two brothers-in-law, Ralph Barton Perry and Herbert Abbott, decently loosened his tongue. He missed seeing Barrett Wendell when he called at his home but elicited the heartwarming message, "I should have glowed with joy to tell you to your face how much your friendship, in fact your mere existence means to me." They learned that Bertrand Russell had accepted an invitation to lecture at Harvard, but the news could hardly have given them pleasure, for Russell had moved out of their orbit when he separated from Alys in 1911.

In Cambridge and Boston there were the usual "highbrow" dinners and a visit to the Museum of Fine Arts to see the Chinese acquisitions. Berenson communicated his enthusiasm for Chinese art to Mrs. Gardner

when he visited her at Fenway Court and offered to help her make "as fine a Chinese collection as you have of Italian." He brought tears to her eyes when he told her that "although he had found her fascinating and wonderful before, he had never loved her until this time, for she had never been lovable." She said it was true, that Okakura Kakuzo, the Japanese mystic at the Museum of Fine Arts, had taught her to seek to love instead of to be loved, and now at seventy-four she felt herself a changed person, all hardness of heart gone. The Berensons thought that at last, without the hypocrisy that had for so long colored so much of their intercourse with her, they could "really care for her as a human being."

The practical-minded Mary urged that they visit Sir William Van Horne in Montreal inasmuch as he was the foremost Canadian collector of art. Van Horne had recently retired from the presidency of the Canadian Pacific Railway. Though wealthy, he could not compete with the Wideners and the Morgans, and in addition he admired mostly Dutch and Spanish masters. To make prospects worse, they found him laid up with inflammatory rheumatism and his "luxurious and overheated mansion" cluttered with hundreds of "indifferent pictures." The visit to their hospitable host and to three other Montreal collections proved unprofitable. "Provincial America," they agreed, "is one and the same whether millionaire or modest. They have no taste."

The two travelers returned to New York in mid-January 1914, this time to the luxury of a suite at the Ritz-Carlton, to confront a flood of invitations to dinners, musicales, the theater, and the opera. At one musical function Bernhard disgustedly contemplated the backs of "overdressed" Vanderbilts, Astors, Stuyvesants, Schuylers, Harrimans, and Goelets, crammed into high-fashion gowns that seemed to him quite foreign to the bodies of their wearers. It was but the beginning of a week's entertainment in which he flourished though he professed feeling "very detached and alien." Mrs. Peter Cooper Hewitt gave the most sumptuous of the parties in their honor. The dancer Ruth St. Denis performed for the forty guests and was followed by a couple who slithered violently through the mayhem of the French Apache dance. Tangoing followed, and Berenson remarked that this world was no longer "Ritzonia" but "Tangonia."

Berenson sent a full report of their diversions amidst the New York "social blizzard" to Edith Wharton, who of course knew New York society from the inside. In her reply to his letter from the "New-Ritz Vortex" she conceded that it must be very nice to be "petted and feasted" but then added, "I don't see how you can stand it for more than two or three weeks of that queer rootless life." She underestimated his appetite

for society. He informed Ralph Curtis that they were "feasted and toasted everywhere" but had not yet encountered the "intellectualistic phase. . . . One hears of it having discussions at teas on syphilis (favorite topic), homosexuality, prostitution, etc. When someone the other day asked, 'Why does [Walter] Berry come to seduce the minds of our women?' Frank Crowninshield sighed, 'If only he left them in any interesting condition.' " Berry had put Crowninshield in touch with Berenson, and as the new editor of the sophisticated *Vanity Fair* Crowninshield asked Berenson to dash off "an ironical, or whimsical, or satirical" article of a couple thousand words "to set an example for other men to follow. . . . I can pay you four cents a word." Berenson was not tempted.

In New York Berenson became acquainted with Paul Joseph Sachs, a wealthy member of the family banking firm of Goldman Sachs & Company. A diminutive and scholarly young man of thirty-six and a diligent collector of Italian and Flemish drawings, Sachs took an instant liking to his visitor with whose work he was already familiar. Sachs was then on the point of retiring from the banking business to become an assistant to Edward Forbes, director of Harvard University's Fogg Museum. What then began as admiring deference to Berenson ripened into an enduring friendship between the two that made Sachs Berenson's most devoted and important supporter at Harvard.

Perhaps Berenson's most intellectually challenging encounter was his meeting with Simon Flexner, director of the Rockefeller Institute for Medical Research. The foremost epidemiologist in world medicine, Flexner had recently discovered the virus of poliomyelitis. When he had married Helen Whitall Thomas, a cousin of Mary Berenson, in 1903, there had been family objections over the fact that he was Jewish; Mary, impressed by his great distinction, had scoffed at the obstacle. A man of immense culture, his "exquisite courtesy, good taste and refinement" made Berenson feel "abject and almost suicidal." The contrast between Flexner's world and the world of wealth and fashion by which he had been seduced seemed to him overwhelming.

Despite the distractions of the city, Berenson managed to see Belle Greene almost every day, but his "experiment" was obviously not going well, for she resisted his efforts to change her character and her hectic way of life. Still he defended her, declaring that she was "overworked and neurasthenic." Mary, not one to stand by idly at such a juncture, had a "real talk" with Belle, who told her that though she was devoted to Bernhard she was not "one particle 'in love' with him," and never would be again, and urged Mary to make him understand that fact.

Whether to allay any jealousy on the part of Mrs. Gardner or because she was herself taken in by Belle's professions, Mary assured the mistress

of Fenway Court that the "young librarian at the Morgan Library" showed no "signs of wishing to blow the dead ashes into flames." The "signs" may not have been visible, but Belle's messages to Bernhard, which resumed their almost daily flow when the Berensons traveled about, assured him that he was "all in all to her." His need for reassurance did, however, place something of a burden upon her. After his departure at the end of March 1914 she wrote, "Much as I adore you, this daily epistle is getting on my nerves." After her return to Florence Mary revised her estimate of the intensity of Bernhard's involvement, telling Mrs. Gardner it was "only fair to let him create a little life of his own as his heart is rather empty of intimate figures," whereas she had "him and five other beings to love and adore," including especially her granddaughter, Barbara. To Scott, she confessed that he too was of that choice company.

High society and business tended as always to become inextricably mixed. Berenson helped the young Rockefellers select some things on approval at the Duveens' New York gallery, which rivaled in architectural elegance the "little palace" in the place Vendôme. The richly classical façade of the massive structure on Fifth Avenue at the corner of Fifty-sixth Street, its Corinthian pilasters surmounted by an imposing pediment with sculptured figures in the tympanum, guaranteed the value of the treasures within.

Luncheons with the Rockefellers followed, and he and Mary found themselves "incredibly busy" taking Mrs. Rockefeller, Mrs. Harriman, and other millionaire ladies to see pictures, hoping "to inspire them with the desire to form collections of their own under *our* guidance." Nor did Berenson neglect calling on one of his own very appreciative clients, Grenville Winthrop, a New York lawyer who was making a "nice little collection" of Old Masters, a collection that eventually went to the Fogg Museum.

There was such a stream of callers, all viewed as prospective buyers, that sometimes, to economize effort, Bernhard took charge of one party and Mary commanded another. And their effort was yielding results. By the first of February Mary could report that Bernhard "has already made plenty of money," though it would come in during the next four or five years since people paid slowly. Her euphoria about their finances prompted her to buy and ship to Florence "a little Ford" to run herself.

After a hiatus of almost four years, Mrs. Gardner was again turning to Berenson for acquisitions. Through Sulley and Company she acquired *A Boy in a Scarlet Cap* by Lorenzo di Credi for $25,000 and a "severely monumental" *Madonna and Child with a Goldfinch* by Bernardo Daddi for $7,000. She was soon to purchase also the colorful and elegant profile of

A Young Lady of Fashion attributed to Domenico Veneziano with which he was tempting her. It came from Boehler and Steinmeyer at a cost of $60,000. It has since been assigned, by other authorities, to Uccello or to the painter known as the Master of the Castello Nativity. A few additional purchases followed before the end of the year.

The most spectacular transaction of the Duveen firm concluded while Berenson was in New York was the sale to the Wideners in January 1914 of the small Cowper *Madonna and Child* by Raphael, an exquisite portrait of pensive maternity. Duveen had queried Berenson about it in 1910 when it was shown at the Grafton Gallery. Joseph Widener had balked at taking the Botticelli portrait of Giuliano de' Medici, the painting which had made such an enormous impression on the Duveens and which Altman had refused. He said he thought it was not important enough for his gallery.

Mrs. Gardner too was much interested in the painting—the name Botticelli had long had a special magic for her. Joe Duveen reported to Berenson that she had come down to New York "to ask especially about the Botticelli which she is very anxious to acquire." He explained that Otto Kahn had been hesitating over the high price for it, but Mrs. Kahn was "still crazy about the painting," and he therefore asked Berenson how he was to act. Superior financial resources evidently carried the day: the painting went to the Kahns for $100,000.

Amidst their many successes worrisome gossip reached the Berensons: Wilhelm Valentiner, the curator of decorative art at the Metropolitan and editor of *Art in America,* and Sir Hugh Lane, the wealthy former proprietor of the Marlborough Gallery, were said to be "doing all they can" to oust Berenson from public confidence. Since the Berensons made no secret of their low opinion of the Italian paintings at what they called the "Necropolitan" Museum, it was understandable that Valentiner should be joining Berenson's detractors, and Sir Hugh Lane, who was now much involved with Lady Gregory in establishing a public gallery in Dublin, was a rival expert whose confident attributions of Old Masters Berenson had sometimes challenged.

Rumors of American "enemies" were dispiriting, but when Berenson went out to Detroit to study again Charles Freer's great collection of Chinese paintings and bronzes, he was so warmly received that he felt he had regained a footing, and Mary was "relieved to see poor old B.B. happy again." Freer brought out his Chinese paintings and Berenson felt himself pass "from ecstasy to ecstasy." Freer proposed that they all go to China together in 1915, and Mary delightedly informed Geoffrey Scott that in that event he could accompany her and Belle Greene could accompany Bernhard.

Their busy schedule next took them to Northampton to attend a re-
ception which Senda and her husband gave for them. The "little mother"
came over from Boston with Mary to see, if not hear, her famous son.
He made up for his silence by writing, shortly afterward, to congratulate
his parents on their fiftieth wedding anniversary. "Life," he averred to
his "Beloved Mother," "is a very mixed dish even for the most fortu-
nate. Yours has been full of self-sacrifice and hardships. Yet I hope that in
memory at least the colour of the whole is not too grey."

From Northampton Bernhard and Mary went down to Baltimore on
March 3, 1914, in the midst of a heavy blizzard to begin work in Henry
Walters' huge private museum. More palatial than Mrs. Gardner's, it
was crammed with art objects of a half-dozen ancient cultures as well as
with hundreds of paintings. Berenson proposed dividing Walters' Ital-
ians into three groups—good, bad, and indifferent—and disposing of the
rubbish and forgeries, though Walters "loves them all." He also per-
suaded Walters to adopt a plan for buying about sixty genuine Italians to
replace the rejects. The delightful week ended in a flurry of note making.
They left a formidable list of the scores of paintings which they thought
ought to be removed, but Walters apparently could bring himself to
discard only twenty-three of them.

From Baltimore the Berensons proceeded to Washington, their valet,
Henry, in whose hands "B.B. was like a bottle-fed baby," having gone
ahead to unpack their trunks at the residence of a friend on I Street, a
short distance from Henry Adams' home in Lafayette Square. Adams
had invited Berenson to call on him in Washington inasmuch as he was
not likely "to move far" at that season. In his mortuary style the seventy-
five-year-old Adams explained, "No one knows me, all my contem-
poraries having died in the Third Crusade: but we still have some new
songs of theirs." Berenson had responded that he would like to "hear
Miss Tone sing us a Noel from the days when people believed the whole
blessed fairy tale." He remarked that he had seen Henry's brother
Brooks twice at the Quincy house but had not "hit upon a subject of
conversation to please him." However, in a letter which reached the
Berensons just before they sailed, Mrs. Gardner informed them she had
dined with the Brooks Adamses and that she "loved to hear him admire
you both."

In Washington Berenson had their joint passport renewed and he
stopped in alone on Henry Adams, Mary having been prostrated by a
heavy cold. They talked about Georgian poetry and enjoyed hearing the
plaintive melodies of Aileen Tone's repertoire. Mary's cold brought on a
depression so severe that she thought she was dying. Her mind filled
with final thoughts, she seized her pen and addressed a testamentary

letter to Bernhard: "If I die thee will take thy chance of a different happiness and without doing any wrong to me. If I have any wishes left they will be for thy happiness and well being." She begged him to provide £100 a year to each of her descendants "(if thee continues rich)" and to give her daughter Ray a house like the Perrys'. "My dear, we've been together so long and so well there aren't any 'last words.' Thee never bored me and I have always loved thee. Mary." Soon recovered, she was her optimistic self again, and a few days later when they stopped at Bryn Mawr to visit her cousin Carey Thomas, president of the college, she gave "a little talk" on art to the young women, the only missionary lecture she managed to give on this tour.

The pair hurried on to Philadelphia, where Johnson showed Berenson "endless letters of praise" for his catalogue *Italian Paintings,* which had been issued in a private edition of three hundred copies in 1913. Even before its completion Johnson was so pleased with it that he had sent a check for £1,000. Berenson's graceful acknowledgment modestly protested his generosity but then admitted that "when the draft came, I at once recalled a glorious Sha-Nameh with 32 early 16th century Persian miniatures that I longed to possess, and how far your gift would go to pay for it." The sumptuous catalogue was an impressive achievement and Berenson was understandably proud of this first venture into catalogue making.

There was time in Philadelphia for a last dinner at the Wideners', where the Cowper *Madonna* by Raphael was already in place in the gallery at Elkins Park. The "ubiquitous Duveens" followed Berenson to Philadelphia and summoned him into town for more important conferences. One matter that Berenson undoubtedly raised was the past-due state of the accounting, for he had in his hand a "private and confidential" letter from Sir William Plender's accounting firm asking, "Do you want us to write again strongly and insist upon prompt delivery of the accounts or do you wish us to allow some further time to elapse?" There was little to be done in the face of Joe Duveen's repertory of excuses, but Berenson's dissatisfaction was becoming chronic and his impatient and repeated demands on the firm made him appear insatiable.

The Berensons returned to their luxurious base at the Ritz-Carlton for a last few days in New York. While there Bernhard received an account from Edith Wharton of an incredible scandal that was wracking France with a plot suitable for the Parisian stage. Gaston Calmette, editor of *Le Figaro* and a strong supporter of President Poincaré, had got hold of some highly compromising letters that Joseph Caillaux, a cabinet minister, had written to his mistress. Wishing to silence Caillaux, who had been advocating friendship with Germany in opposition to Poincaré's

anti-German policy, Calmette had threatened to publish the letters. At this point Madame Caillaux, armed with a pistol, descended upon the offices of *Le Figaro* and mortally wounded Calmette. Edith had got the dramatic details of the incident from their friend Paul Bourget, who happened to be at the offices intending to see his friend Calmette. Tumult followed in the Chamber of Deputies when the Radical Right and the Socialists who opposed Poincaré's bellicose policies abandoned words for fisticuffs. "I wish you'd been in Paris during the week after the Calmette murder," Edith added. "It was extraordinary." What was to be even more extraordinary, as he would learn, would be the sensational trial of Madame Caillaux later in the summer.

Passport secured and business attended to, the Berensons prepared to return to Europe. In her goodbye letter Mrs. Gardner wrote, "The joy of this winter has been seeing you both and the sadness of spring is your going away." Among the four hundred first-class passengers on the outward-bound *Olympic,* which sailed on the morning of March 28, 1914, they had as friendly companions Henry Cannon; Dr. Morton Prince, whom Mary urged to come to I Tatti; and Mrs. Peter Cooper Hewitt.

Berenson just missed the Easter Sunday supplement of the *New York Times* that reproduced in color thirteen of the "Gems of the Altman Collection," part of Altman's bequest to the Metropolitan Museum. One of the paintings featured was the *Portrait of a Young Venetian,* attributed to Giorgione. The caption read, "This is the most valuable painting in the Altman Collection." It was, of course, the painting Berenson and Bode had praised for its fine condition. In the same issue, the couturière Madame Susanne Joire, another fellow passenger on the *Olympic,* was quoted as deploring the appearance of American men on Fifth Avenue. They were clean shaven, she said, "like French servants." "In Paris, the officers wear the mustache and the great men wear beards or whiskers. . . . It is hard for a man to look like a grand seigneur with no beard." Berenson's carefully trimmed Van Dyck unquestionably met the highest Parisian standard.

XVIII

The Darkening of Europe

THE spring and early summer of 1914 showed peaceful enough to deceive cosmopolites more politically conscious than the Berensons. When they landed at Southampton on April 4 after a "horrid crossing," no hint appeared in the press of the conflagration that would engulf Europe within a short four months. In the Americas "Dollar Diplomacy" had given way under Wilson and his secretary of state, William Jennings Bryan, to military intervention in Mexico. Vera Cruz had been bombarded and occupied but the proceeding was as local an affair to Americans as the tumult in Northern Ireland was to the British. There Ulstermen by the thousands were arming to resist the imposition of home rule, which would subject their provinces to an all-Ireland parliament. France for its part was winding up its military campaign in French Morocco under General Lyautey.

The ever-mounting arms race among the European powers had become so thoroughly accepted by the public as a normal fact of existence that the photographs of new battleships of the powers gave a kind of reassurance of peace to the patriots of each country. The many accidents on land and sea made their little sensations in the press. The society pages glittered with coronets; parades and pageantry marked King George's visit to Paris and President Raymond Poincaré's visit to the czar. In England and America elaborate plans were under way for the celebration of the centenary of peace which had followed the Treaty of Ghent. Even as late as July 6, more than a week after the assassination at Sarajevo of the Archduke Francis Ferdinand and his wife, the Vienna correspondent of the London *Times* reported, "There is no ground for anxiety as to war." And two days later the British and German fleets met at Kiel in a display of "brotherhood in arms" as the bluejackets from both navies "made merry ashore."

The prospect of an unchanging and hospitable world lay before the Berensons as they entrained for Paris bearing the memories of their highly successful visit to America. Mary went on to Florence to ready their home for Bernhard's return, while he stayed in Paris for a few days. F. Steinmeyer cabled the gratifying news that Mrs. Gardner had taken *A Young Lady of Fashion*. Berenson wrote Mrs. Gardner that his friend Victor Goloubev, a Russian expert on Oriental art, was offering to sell a Chinese carved votive stele of the Sixth Dynasty which Denman Ross agreed was the finest Chinese sculpture that had appeared on the market. It was priced at $11,000. Mrs. Gardner promptly bought it and impatiently requested delivery, although it was on loan to a noted French museum. Berenson bought two very fine Chinese paintings for himself that were so expensive he did not know how he would raise the cash to pay for them.

He dined with Elizabeth Cameron and found her "more affectionate than illuminating." Edith Wharton was off on her royal progress to Algiers with the literary critic Percy Lubbock and friends. In the diminished Paris circle Berenson conversed with Henry Adams' friend Mrs. Henry Cabot Lodge and her entourage over the state of the world. Adams' habitual pessimism and echoes of Senator Lodge's disgust with Wilson's Mexican policy evidently flavored the talk. "They sang the usual song, how the world was coming to an end," Berenson said, "and I told them the melody was pleasant but the words nonsense." On April 12 he signed out of the Ritz and headed home.

After stopping off for a few days to visit the Curtises at the Villa Sylvia, Berenson reached Florence in an agreeable state of mind, glad to get back to his desk to sort out his notes for the book which he had been projecting on the Venetian paintings in American collections. He was "now never a nuisance," Mary communicated to her sister. "His character has certainly changed . . . I am awfully glad for him for his rages used to poison him." His health also appeared to be on the mend, thanks in part to the energetic ministrations of Naima Löfroth, the tall young Swedish masseuse with the "fine figure and pugdog face" who had become a permanent member of the household staff.

For a month Dr. Morton Prince stayed on in Florence as the Berensons' guest. A prominent neurologist and professor at Tufts Medical School, Prince had become an authority on abnormal psychology. He had been a member of the commission that found Harry K. Thaw sane after his murder of the famous architect Stanford White. At the time the Berensons were in Boston, he was under a cloud of gossip, accused of financial irregularities, marital infidelities, and a scheme to make his wife disinherit their children. Boston society, including Mrs. Gardner, had

closed its doors to him. The Berensons, convinced that he was innocent, had taken up his defense. Mary now wrote Mrs. Gardner that Bernhard and Prince were sitting in the Lemon House, a tile-roofed structure below the I Tatti terrace, discussing "Isabella's fascinating nature" and proposing that he show her his income tax papers and joint account with his wife, Fanny, so that she could help him become friends again with his children. Mary's plea did not succeed.

Prince's experimental approach to the psychology of the unconscious provided a congenial subject for discussion, for Berenson had been steadily moving in his psychological theory of art appreciation toward a more subjective and intuitive approach. A trace of their conversations on Prince's experiments with hypnosis was to surface in Berenson's essay on Leonardo da Vinci when he suggested that "post-hypnotic suggestion" was a factor in Leonardo's reputation.

No sooner had Prince departed than Edith Wharton, returning from her exciting tour of Tunisia, settled in for a visit "with all her troop of servants." Fortunately she lightened the burden by being "very jolly and amusing." Geoffrey Scott's *Architecture of Humanism* had come out shortly before her arrival; she was so impressed by it that she reviewed it in the *Times Literary Supplement* as a "brilliant and discriminating book."

In his preface Scott gratefully acknowledged Berenson's "many suggestive points." He had in fact ingeniously transferred to architecture Berenson's conception of "tactile values." "The tendency to project the image of our functions into concrete forms," he declared, "is the basis, for architecture, of creative design." Barrett Wendell exclaimed to Berenson that he did not "feel quite sure" whether Scott's ideas were "universally true or universally paradoxical." Berenson agreed: "Your impression coincides with mine, although in a sense he is my pupil." Paradoxical or not, the keen insights of the book rescued Scott from the reputation of being a self-indulgent dilettante and paved the way for his remarkable *Portrait of Zélide*.

If the season at I Tatti passed serenely, violent disorders elsewhere in Italy revealed the discontents that seethed below the surface. A revolutionary rising against the monarchy was suppressed after three days of bloodshed and much damage to churches and public buildings. The leaders were the anarchist Enrico Malatesta and the fiery Marxist editor of *Avanti,* Benito Mussolini. The significance of these events seems to have been quite lost on the colony of expatriates in Florence and its environs. Their world appeared to them so secure that Berenson took the "momentous decision" to build a third and larger library which would complete the circuit around a central court and allow access back again to the main structure. Cecil Pinsent prepared the plan and the work started.

[179]

While Berenson began work on his *Venetian Painting in America,* Joe Duveen waited impatiently for his return to London and Paris. He plaintively reminded Berenson that he had promised to bring to the gallery a millionaire couple from Baltimore, and, still on the lookout for prime Italian paintings, he asked whether he could see his way clear to dispose of his precious "Baldovinetti" and the Sassetta "triptych" of Saint Francis. "I think I can sell them for a big price to Mr. Lehman." Berenson declined to part with his treasures.

With work on the new library begun, Bernhard and Mary set out again on their travels, Bernhard heading for Paris and Mary for a Swiss spa in still another attempt to trim her weight. In a note sent to the Hotel du Rhein, Joe Duveen deprecated, "I do not suppose for a moment that you will feel sufficiently well to come here." He would therefore call at six, "after you have had a refreshing cup of tea and feel rested." Berenson was actually in good fettle; during the afternoon he went over a provisional catalogue of the Walters Collection with Henry Walters and then held a levee for a procession of callers. He obviously preferred to keep Joe in his place.

When Joe and his brother Ernest put in an appearance, they were in a very real state of alarm about the authenticity of the Botticelli *Giuliano.* A complicated chain of events lay back of their anxiety. The announcement of the sale had created a sensation, for on April 1, 1914, the London *Times* had devoted an editorial to Otto Kahn's very fortunate acquisition through the Duveens of this hitherto unknown Botticelli. The current issue of the *Burlington* used a reproduction of the picture as its frontispiece and featured a "note" on the portrait by Roger Fry. Mary had also published the painting in an article in the April *Art in America.* All of this publicity seems to have aroused a fervent wish among Berenson's enemies to challenge the attribution.

By midsummer the campaign against the painting was in full swing and there was no way of avoiding the agitating conferences at the Duveen Gallery. Bernhard feared that the controversy might "lead to a collapse" of his relations with the firm. Mary, however, felt that "they will probably come around," for "they cannot do without thee in regard to Italian pictures." But, she added, "if thee really and truly wants to get out of it, why we *can change* our extravagant way of life." There was no more talk of quitting. Brought up short by her suggestion, Bernhard telegraphed to her: "No catastrophe expected. Building at I Tatti must go on." Mary promptly informed "Dearest Geoffrey," "So you are safe anyhow. . . . But evidently our feet are set upon the path of worldliness and riches and the devil take the hindmost."

What had happened was that Herbert Horne, who had done a percep-

tive monograph on Botticelli, had asked the Duveens for a photograph of the *Giuliano* as soon as he learned of the sale. The Duveens sent him one over the objection of Berenson. Meanwhile the Italian government got wind of the affair, and Corrado Ricci, a member of the Italian Fine Arts Commission, demanded of the reputed seller, Count Procolo Isolani of Bologna, whether he had sold a Botticelli to the Duveens. The count, of course, could honestly say that he knew of no Botticelli having been smuggled out of his collection. Even Baron Lazzaroni, the intermediary, had not known that it was a Botticelli until Berenson had subsequently identified it. Ricci inferred from the count's assurance that the picture was not authentic. The "happy tidings," as Berenson reconstructed the affair, went from Ricci to Giovanni Poggi, from Poggi to Carlo Gamba, from Gamba to Charles Loeser, and reached "the hospitable ears" of Horne. Horne, having seen only the photograph, accepted Ricci's inference and promptly wrote to Walter Dowdeswell, a Duveen associate, declaring the painting a forgery.

The Duveens were panic-stricken and questioned Lazzaroni's honesty and Berenson's competence. The only thing that would satisfy them, they insisted, was a declaration by the count that the picture had in fact been in his family for generations. Lazzaroni came back to London in triumph from Bologna with the required letter and a photograph of the painting on the back of which the count stated that it was one of twenty-eight which he had brought down from his villa and sold to Baron Lazzaroni. Joe Duveen proposed showing the documents to Horne, but Berenson, seconded by Henry Duveen, objected that it would set a "dangerous precedent to be accountable to anyone as a tribunal." To protect himself from Joe's impulsiveness, Berenson kept possession of the documents.

Peace was slow to arrive, and "important" conferences on the subject continued in London. "Ernest [Duveen] is in a funk," Berenson reported, "and can't get over it and Joe who is very impressionable can't get over it, so again I don't know what rash thing Joe will do." It seemed to him that "they are hysterically possessed by a demon of self-destruction and I fear I cannot exorcize them." Berenson was convinced that a "systematic campaign has been made against the Botticelli which however is only the whipping boy, from both Florence *and* Berlin. . . . Dowdeswell reported that Sirén had been dinning into all their ears that I am a hopelessly discredited person!" Fortunately, in spite of Ernest's skepticism, "Uncle Henry and Louis [Duveen] and Dowdeswell seem unshaken." Joe, in his anxiety, wanted to rush to the Kahns to forestall criticism. Berenson got ahead of him and "in a casual way . . . told Mrs. Kahn all the gossip emanating from both Berlin and Florence."

Berenson managed to remain fairly calm in spite of the controversy. He had the satisfaction of seeing himself cited as an authority in the *Times* in connection with a painting, *La Schiavona,* which Wildenstein and Gimpel had sold to Herbert Cook for £40,000 for his father's gallery at Richmond. According to the *Times* story the picture, "carefully cleaned by Professor Cavenaghi" and on exhibit at the Burlington Gallery, had once been called by Adolfo Venturi a Bernardino Licinio and had therefore been allowed export, but "a critic who ranks still higher [than Venturi] in England and America, Mr. Bernhard Berenson, now writes, in a letter which we have seen, that it is not only an original Titian, but one of the finest existing works of the master."

Berenson's ten days in early July 1914 in Paris passed agreeably enough when out of range of the Duveens' importunities. In his daily chronicle to Mary he tried to communicate the flavor of his social encounters. He reported that Edith Wharton "rather defiantly" proclaimed she had never read ten lines of Congreve. After dinner with Henry Adams, Paul Bourget told of his horrified sight of his friend Calmette's death throes. Later Aileen Tone entertained them for nearly two hours with her *chansons.* Adams remarked that the best talkers he had known were Jusserand, Roosevelt, and Bryce, Jusserand best at initiating conversation, Bryce at displaying the greatest mind, and Roosevelt at winning an argument only by shouting down his opponent. Alone with Walter Berry in his book-lined library, Berenson relished an hour's talk about travel and India and for the first time found Berry "genuinely lovable." Visiting again with Henri Bergson, he heard him say of Karin's thesis on him that "if women would not regard it as an insult he would say she had a strong masculine intellect." At dinner with Boni de Castellane, whose glitter had begun to fade since his divorce from Anna Gould and her millions, he found the food poor, the women rather "tarnished handsome and boring," the men "nullities"; the evening was relieved for him only by "some Volga songs that carried him away." A large dinner party at Mrs. Cameron's yielded a cordial invitation by the Peter Cooper Hewitts to sail along the Dalmatian coast in August. "Cooper," he said, "told me more about color in a few minutes—I mean stuff worth knowing—than I have heard in all the rest of my days."

One morning after a strenuous "confab" at the Duveens, he adjourned to a luncheon meeting presided over by the aging polymath Gustave LeBon, whose antidemocratic *Psychology of the Crowd,* published in 1895, had made him famous as a pioneer social psychologist. "We hated each other at sight, at least he hated me," Berenson exclaimed. "He is utterly spoiled, as may God save me from being in my senility." The meeting, attended largely by members of the Institute of France, did not scintil-

late, but fortunately Berenson sat next to Aristide Briand. "He has a mind of extraordinary clearness, vitality and freedom from every form of cant. It was a joy to hear him talk," Bernhard wrote to Mary. "You are so ignorant," he teased her, "that I may do well to remind you that he has been premier and will be again—if he likes."

When Berenson crossed to London on July 10 to confer once again with Baron Lazzaroni and the Duveens about the Botticelli, there seemed to be nothing to disturb public tranquillity save the chronic deadlock over Irish home rule. He spent a quiet Sunday luxuriating for hours among the Chinese treasures at the British Museum and the Oriental collection of the archaeologist Sir Aurel Stein. "How little I really cared for and felt twenty years ago," he mused. "The life of the eye is at last a very real one for me." For the moment he felt quite out of things in England. Nobody seemed to pay the least attention to him, he wistfully meditated. "How different from Paris!"

To counter the threat of civil war in Northern Ireland, army recruiting in England had stepped up, and Bernhard now learned that their secretary-librarian, Lancelot Cherry, had enlisted. When he informed Mary, she immediately wrote to Geoffrey that the librarianship might be available to him. "It may mean so much if we can pull it off." Then, as the prospect of attaching him permanently to I Tatti rose in her matchmaking imagination, she went on, "Think—! Even the Nicky [Mariano] rumor might come true, so eager is my Geoffrey to become what he fondly hopes will be 'settled.'"

Mary had first met Nicky the preceding spring at a small party Scott and Pinsent gave in their flat in the Via delle Terme. She invited her to lunch at I Tatti, and it was on that occasion Nicky had her first encounter with Bernhard. He looked, she afterward recalled, "elegant and aloof and somehow very intimidating." They did not meet again until after the war. During the weeks that followed, however, Mary saw her frequently and pictured her as securely established at I Tatti as the wife of Geoffrey Scott. Nicky left in June to visit her sister, Alda, and her brother-in-law, Baron Anrep, at Schloss Ringen in the Baltic provinces of Russia. Absence worked its usual chemistry on diffident Scott and when the outbreak of the war threatened to block her return, he urged her to "please get into a train at once and come here. I am told it is quite easy by way of Sweden." The prospect somehow did not entice her, and she spent the war years with her family in Estonia.

Berenson's mornings in London were largely preempted by the Duveens, whose anxieties about the Botticelli continued until the outbreak of World War I eclipsed all lesser concerns and Horne's challenge disappeared from notice. The painting, now in the Crespi Collection in Milan,

has remained within the Botticelli canon to the present day, though not without challenge. For Berenson there were time-consuming appeals in London for an accounting and audit of the Duveen books. Plender's representative explained that "short of taking legal proceedings" they could not compel the Duveens to be prompt. The firm therefore had to accept the Duveen statement that the balance of fees owing to Berenson on January 31, 1914, was £37,000 plus 5 percent interest. Unfortunately the beginning of the war paralyzed the international transfer of funds and no payments could be made.

The gathering storm in the Balkans inspired little public concern in England and even less in America. Mrs. Gardner continued eager to improve her collection, and on Berenson's recommendation she bought from the French dealer Demotte two French reliefs of three figures from Parthenay for "150,000 fr [$30,000]" and a Romanesque portal for "80,000 fr [$16,000]." An 1876 engraving of the portal depicts it "in situ" in a medieval home in La Réole, France. The "lower bodies" of two of the statues of kings are modern restorations.

In London Chaliapin was starring in Moussorgsky's *Boris Godunov, Ivan the Terrible,* and *La Khovantschina* at the Drury Lane Theater, and Fokine and Karsavina were performing in the ballets *Petrouchka* and *Spectre de la Rose.* The operas attracted such crowds new to opera pro-tocol that letters to the *Times* complained of the latecomers and talkers in the audiences. At a concert conducted by Debussy, Berenson found himself "absorbed" by the sight of Chaliapin in the audience, "entirely changed in appearance" offstage and talking like a professional musician all through the concert. When he visited the British Museum with Mary Crawshay and learned of the museum's attempt to buy an early Sung painting, he joined the effort to raise the money for it. The conversation with Miss Crawshay happened to turn to Belle Greene. "I told her," Bernhard related to Mary, "what a perfect brick you had been through it all."

He had "a long talk" with Prime Minister Herbert Asquith, who was very much preoccupied managing a divided Cabinet on the explosive Irish question, but the conversation got round, evidently on Berenson's motion, to Italy's recent aggression in North Africa against Turkey, and it pleased him to note that Asquith "spoke in terms of withering con-tempt" for Italy. Asquith's insular detachment from the problems of the Continent seems to have been typical of British opinion. Even when the Austrian ultimatum to Serbia came a week later and Asquith thought it "a possible prelude" to a European war, he declared, "Happily there seems to be no reason why we should be anything more than specta-tors."

On Sunday, July 16, 1914, the news broke that Austria had ruptured diplomatic relations with Serbia. To the French, absorbed in the dramatic Caillaux trial that had just ended with the acquittal of Madame Caillaux, the news came "as a bolt from the blue." Berenson, visiting at Theydon Mount near Epping, north of London, wrote to Carlo Placci, who was at the Bayreuth festival, "It is very exciting here now what with Ireland on the one hand and Servia on the other. . . . Sympathy here seems to me strong for Austria and I don't believe that in case of war England will support Russia." With such reassuring thoughts Berenson joined Mary at Ford Place, in southern Sussex, expecting to remain there until August 5. What they would do afterward he had not decided, "perhaps visit Scandanavia, perhaps even go to St. Moritz," to which he had not returned since the summer of 1911.

A stunning succession of events now intervened to alter all plans. The Austrians bombarded Belgrade on July 29 and Russia immediately began mobilization. On the thirty-first Germany sent an ultimatum to Russia to stop mobilization and on the following day, without waiting for a reply, declared war on Russia. The dominoes began to fall. France, as an ally of Russia, immediately ordered a general mobilization. Two days later, anticipating the formal declaration of war against France, the German troops entered Luxembourg and demanded free passage through Belgium. On its refusal the invasion of Belgium began. At midnight August 4, 1914, a somber British Cabinet voted to honor its commitments to Belgium and France and enter the war. To his colleagues Lord Grey of Fallodon sadly observed, "The lamps are going out all over Europe; we shall not see them lit again in our lifetime."

At first it was thought that Germany had overreached itself by rushing into a war on two fronts. Besides, France had been relieved of fear of invasion from the south when Italy, after protesting Austria's unilateral action, declared its neutrality on August 3. The first reports of French successes from the battlefront in northern France gave a false sense of security, and except for the flood of volunteers and conscripts to the cantonments, the momentum of life for noncombatants ran on for a time almost unchanged. Mary had fortunately motored to England from her Swiss cure a few days before the invasion began.

The Berensons had been at Ford Place only a few days when the Cabinet's fateful decision was announced. Scandinavia and St. Moritz ceased to be possibilities; even Italy had seemed doubtful in its neutrality. Ford Place, in the "lovely country between Arundel and the sea," became their "delightful refuge." There Bernhard relaxed among Logan's books in "a big cedar-panelled room looking out on a rose garden." Israel Zangwill was a near neighbor and old ties were renewed. Zang-

will's interest in a Jewish homeland still engrossed him: as head of the Jewish Territorial Organization he had recently published a long letter in the *Times* reviewing the obstacles placed in the way of his plan for a British-Jewish colony in one of the "empty places" in the empire. Having broken with the Zionists, who favored Jewish settlement in ancestral Palestine, he now found himself in an impasse, for the doors were closing everywhere against the multitudes of refugees from the Russian pogroms and his efforts to establish a British-Jewish colony in Africa, though supported by Joseph Chamberlain, had ended in frustration. Three weeks later when the Ottoman Empire came to the support of Germany, Zangwill returned to the Zionist fold.

The opening of hostilities found Joe Duveen vacationing at Evian and Henry Duveen reduced to "casual office work" in Paris. Terrible as the struggle was, Henry drew some consolation, he wrote Berenson, from the news that "up to the moment, things are going mightily bad for Germany." But the early reports of successful counterraids proved illusory. The heroic défi, *On ne passe pas* (They shall not pass), thrilled the French people, but the frightful cost was to be learned on September 6, 1914, at the First Battle of the Marne, which turned back the German advance with the help of the reserves rushed to the front from Paris by taxicabs.

Bernhard advised his brother back in Boston that "all hopes of business are over" and that he was instructing his New York brokers to pay all his American dividends to him. He agreed with his brother that Germany had "a marvellous war machine," but he was confident it would be destroyed. "This is not a war between nations, but between good and evil. . . . The evil is overwhelmingly on the side of Germany." He hoped that his house was "fairly safe." Cecil Pinsent was in charge. But, he added, "I put no trust in the American consul, for I am halfway criminal, being an expatriate and of alien birth."

Not long afterward his brother, once again invited to join in a business venture, asked Bernhard for financial help. "I cannot help feeling," Bernhard replied, "that your straightforwardness, and quixotic honesty and unsuspiciousness will be taken advantage of. . . . I personally prefer you as you are, poor, innocent, honorable and even gullible." To Senda, who was traveling in Italy, he wrote, "It is the completest and most unexpected disaster. I was unprepared and caught with big sums owing me and myself owing other sums." Hence he could give her only modest help. Mary informed her that they had dismissed their secretary, their valet, and their chauffeur and had stopped building and buying and were having difficulty meeting their "habitual overdrafts" at Baring Brothers. Among their friends the war had begun to make its terrifying levies.

Lucien Henraux's four sons were at the front and so were Salomon Reinach's nephews. Berenson's friend Victor Goloubev's seven sons had joined their units. By war's end all seven would be dead.

Hard pressed for funds, Berenson anxiously requested several thousand pounds of the Duveens but learned from their accountants that, like all other dealers, they had closed their galleries and offices. In desperation he wrote directly to Henry Duveen in London, who responded that the firm's funds were blocked by the unsettled financial conditions in America but that when the moratorium was lifted at the end of November they could promise a check for £5,000 and that meanwhile he could provide a few hundred pounds for current needs. Berenson's anguished plea to Joe brought a more concrete response, a check postdated to December 5 for £5,000 to stave off creditors and an offer to remit four or five hundred pounds in the meantime. A new anxiety was also about to be added: his stepdaughter Karin had announced her engagement to Adrian Stephen, son of Sir Leslie Stephen, at thirty-one still unsettled either in business or profession.

There had been some thought of returning to London, but Berenson decided against it because, as Mary said, "when we see the bands of young men enlisting we burst into tears." In his enforced leisure, Berenson and his brother-in-law Logan visited Henry Adams at Stepleton House at Blandford, Dorset, where Adams had taken refuge in the absence of Elizabeth Cameron and her daughter, Lady Lindsay. Berenson wrote to Mrs. Cameron from her desk, where he was enjoying, he said, the Tudorlike paneling of the room, so curious a touch in the "Anglo-Venetian architecture" of the house. Adams seemed to him to be "looking extraordinarily well" and to be regretting the idea of having to leave "this fair haven." (He was booked to sail on the *Olympic* on November 4.) He is "happily quite as Anti-Prussian as myself," though "not so eager and excitable as the rest of us and I envy him. I am a wreck over it." To Mary he admitted that though the house had but one bathroom and was poorly lighted, he would "love a house so beautiful and so secluded." With Adams in "good form" and Aileen Tone's *chansons* to entertain them, if only "those damned Duveens would pay up, I should be enjoying myself."

Bernhard and Mary argued a good deal about the wisdom of returning to Italy, for the changing rumors about Italy's neutrality made a firm decision difficult. He toyed with the idea of going back to America and spending the winter at Harvard. In that event Mary, unwilling to be separated from Geoffrey Scott, declared her resolve to leave on the same day for Florence. As the war news worsened, Bernhard decided that there was no choice but for the two of them to return to the United

States, but his insistence that she accompany him stiffened her own determination. In a rage he demanded that she sign a statement that if "any misfortune happened in Italy," it would be her fault. Each attempt to make her change her mind, she told Geoffrey, made her more sure that "I belong in my own house."

In the daily clash of wills hers proved the stronger, and Bernhard began to envision the likelihood of his own retreat to I Tatti. Back at Ford Place after his visit with Adams, he occasionally ran up to London to confer with Henry James, Sir Lionel Henry Cust, or James L. Garvin. Henry James, ardently pro-British, at seventy-one envied the young men who could act in the "great cause." Cust, surveyor of the king's pictures, had now to consider what protective measures to take as the prospect grew of zeppelin raids on London. Garvin, editor of both the *Observer* and the *Pall Mall Gazette,* had long written of the German peril and urged an alliance with Russia, and his belief in England's sacred mission in the war provided a refreshing reinforcement of Berenson's views. In London Israel Zangwill took Berenson to see Prince Kropotkin, the exiled revolutionary anarchist. The talk turned inevitably to Russia, and Kropotkin declared that though he hated the Russian government, he thought it "likely to do less harm if it prevails than Prussian militarism."

Though the bottom had fallen out of the international art market, a few chores continued for the New York office and for Berenson's American clients. A typical cable from the Duveens read: "Understood your cable Bellini but not Titian stop if picture not Titian please say so naming your attribution praise it highly intimating [the client, presumably Frick] did right in purchasing it. Duveen." Before year's end Berenson agreed, at Joe Duveen's urging, to contribute an article to *Art in America.* Wilhelm Valentiner, the editor, who had been visiting his native Germany, had been shipped off to the front, and Berenson's friend Frank Jewett Mather, Jr., now professor of art and archaeology at Princeton, had taken over as acting editor. Henry Duveen promised to remit a second £5,000 as soon as the Italian moratorium was lifted.

The French victory at the First Battle of the Marne had stabilized that section of the battlefront, and the heroic resistance of the British Expeditionary Force in the trenches at Ypres stopped the German advance to the Channel ports. The hope of a quick victory by either side soon faded, however, and the bloody stalemate in the trenches of the western front began. Having survived the first appalling onslaught, France, outside the war zone, became safe for travel. Weary of the provincial and pacifist society of Arundel, the Berensons crossed to Paris by November 10, 1914, and were lodged at Edith Wharton's apartment at 53, rue de

Varenne for ten days. Accommodations at the Ritz were reduced as a section had been set apart to care for wounded soldiers.

Edith Wharton was busy all day with war relief work at the *ouvroir* she had established nearby for seamstresses who had been idled by the patriotic sewing circles which had sprung up. Her energies also went into another relief project, as reported in the European edition of the *New York Herald* of November 22: she and a group of her friends had established two hostels where some of the refugees who were flooding into Paris from Belgium could be housed and fed. Among the chief contributors heading the published list were Edith Wharton herself and Bernhard Berenson, each down for a thousand francs.

In Paris after the bucolic quiet of Ford Place Berenson felt in his element again. There were people to share what had now become "almost his keenest interest . . . the discussion of international politics." Practically all of Europe was now in the struggle, and the old scores of a hundred years since the Congress of Vienna demanded settlement. "People treasure up his words and repeat them everywhere," ran Mary's admiring comment to Senda. "I don't wonder he likes being here." They saw Reinach almost every day, compared notes with Henri Bergson, and talked with the poet-novelist Abel Bonnard just before he left for the front. Civilian Paris slowed to a near standstill, the streets nearly empty, the smart shops closed, and the theaters dark. The government was still in its temporary refuge in Bordeaux. Berenson's French friends greeted him "so grave and earnest" in their anxieties that he felt a kind of reverence for them. "I love them like this," he told Mrs. Gardner.

It now seemed unlikely that Italy would enter the war on the side of its nominal German allies while Austria held so many Italians subject in the Tyrol. And Bernhard was now ready to return to I Tatti because he had formed "a rather romantic friendship" with Lady Sybil Cutting, their "neighbor in the Villa Medici." She had become one of his avid pen pals, constantly seeking his advice and filling her endless pages with philosophic musing. An attractive widow, cultivated but talkative, she had been an agreeable resource in the Anglo-American colony in the Tuscan hills. "You can imagine I encourage that all I can," Mary informed Senda, little dreaming what that encouragement would lead to. "It begins to cast Belle Greene into the background and Sybil is *such* an improvement on that horrible creature."

The war cast a sobering shadow upon the two expatriates. It was hard not to think of death as each day's newspaper printed its somber column of French and British officers "Dead on the Field of Honor." Mary instructed her daughter Ray, "If we die, thee and Oliver [Strachey] and

Karin had better go down with Adrian [Stephen] and arrange things. I think the photos and art library might be sold together and Messrs. Duveen would buy the pictures or some of them and perhaps Mr. Charles Freer of Detroit would buy some of the Chinese things. . . . But I hope not to die now, when there is such a slump in works of art!" Leaving such mortuary reflections to Mary, Bernhard looked forward to the return to his desk and leisure for the book on the Venetians in American collections, which had begun occupying his thoughts.

And so with travel by train interdicted by the movements of troops and materiel, Bernhard and Mary motored all the way across the south of France and on to Florence. They saw almost no one on the roads "but soldiers and officers." Bernhard could scarcely have foreseen that he would not cross the frontier again for two years.

XIX

A Time for Writing

FOR the first time since Bernhard and Mary moved to I Tatti, the
social season of the expatriate colony on the Fiesole slopes came
and passed in 1915 with few foreign visitors to disturb the quiet of
their daily lives. Their aristocratic Italian friends had yet to be won over
to the Allied cause, for their natural ties were with the Austrian and
German nobility, and when the Countess Serristori, who was strongly
pro-German, came to stay early in the new year, Berenson's tact was
severely tried. For him, as he wrote to Barrett Wendell, this was "a
religious war if ever there was one," and though he continued to write in
kindly fashion to his German friends, he thought them "temporarily
insane."

The war continued to dominate his thoughts as he pored over the
many newspapers to which he subscribed. "I wish we were officially less
neutral," he complained to Mrs. Gardner. "This should not be a war but
a crusade." And in one letter to Wendell he burst out that he wished the
new year would see the downfall of "the unholy alliance of Jesuitized,
financialized, mercantilized militarism known as the German Empire."
Ironically a translation of his little book on Sassetta had been published
recently in Germany, his only appearance in print during 1914. A long
and appreciative article on the English edition of the book by Emilio
Cecchi in the Rome *Tribuna* in April of 1914 had at least kept his name
before the Italian public.

The Duveens wrote that affairs in their line were almost at a "stand-
still," though there seemed to be a great interest in Sienese pictures,
"caused no doubt by your last visit here." Their agent Dowdeswell was
in Florence at the moment trying to buy the Chigi Sassetta and the
Angeli Neroccio, though the sale to Philip Lehman would at best, they
said, yield only their commission. Moreover, seven paintings had been

rendered unsalable because of a fire aboard the French steamer *Missis-sippi*. The news that Dowdeswell was foraging in what Berenson regarded as his exclusive territory did not please him, and he soon protested to the firm. He was assured that there was no intention of having Dowdeswell trespass "upon your domain. . . . You surely do not imagine that we regard him as an expert!" They had stationed him in Florence merely "for the purpose of being informed of what is being done in the world of art generally in Italy." Berenson's suspicions of Dowdeswell's role were only temporarily assuaged.

A letter from Henry Walters turning down the offer of a Caravaggio supplied confirmation of the paralysis in the American art trade. It was "utterly impossible," Walters wrote, to think of buying works of art "during the present condition of depression in business in America." A railroad in which he was a director had suffered a 50 percent decline in income, and business in the South was "absolutely stagnant." He had, however, been able to send another remittance to Baring Brothers for Berenson's account. Because of the business recession he had delayed opening his gallery for the winter, but finally he had gone down to Baltimore, rehung the paintings, and personally revised the catalogue before sending it on to the printer. This was the catalogue which had been prepared with the help of both Mary and Bernhard.

With few visitors to distract him Bernhard regularly labored in his study during the winter months of 1914–15 and Mary carried on her typewriting for him in the library, happy to be at work, "especially when Geoffrey sits opposite also at work." Her scheme to have Scott made Bernhard's secretary had succeeded. It was frustrating to Berenson that he could not in person vent his fury on the barbarians from the north. His bellicose rhetoric inspired Mary's comment that since he was "unable to wield the bayonet and unwilling to advise the World at this crisis he has gone back to work and is to send an article to America at the several times cabled request of the editors of the magazine." He was "writing one of his heavy-handed articles," she told Alys. "He begins his sentences fairly well, but then slips in conditions and hangs on modifying clauses, and adds hints and innuendoes till the result is more like a tapeworm than anything else."

Tapeworm or not, the richly allusive article, the first of a series titled "Venetian Paintings in the United States," took shape with surprising rapidity. The floodgate of his reflections on Venetian paintings in America swung open as if he were driven to make up for the years of bondage to the art-dealing world. The six articles of the series were published in *Art in America* in February, April, June, and December of 1915 and in February and April of 1916, and they were followed in June

and December 1916 by two more articles, also on Venetian painting in the United States. The articles reviewed the historical development from the thirteenth through the fifteenth centuries as illustrated by the more than 130 paintings in American collections.

When the second article in the Venetian series, treating of Vivarini and Crivelli, appeared in April, Joe Duveen cabled his appreciation and asked the "further favor" of an article on Mrs. Gardner's last-year's purchase of *A Young Lady of Fashion*. As the painting had been purchased by her from Boehler and Steinmeyer, Joe's request was to some extent disinterested. In no mood to do favors for Joe, Berenson declined.

Once the Italian moratorium was lifted, Berenson was able to draw on his accumulated earnings and his anxieties about meeting expenses subsided. At intervals of several months the Duveens sent Berenson checks for £5,000 against the large balance owing to him, so that he could inform his brother, "My affairs are not so much bad as in a muddle, and I have no idea what the future will be like. However, I anticipate no difficulty in making the usual home payments." Work on the new library addition resumed under Cecil Pinsent's direction, with the usual infuriating blunders of the Italian workmen; their most recent exploit demolished a wall and flooded the servants' hall.

As the war progressed, Italian neutrality soon became neutrality against Austria, for popular resentment of the long Austrian occupation of the Italian provinces of Trentino and Alto-Adige had never slackened. Now the Italian nationalists cried for the rescue of their humiliated countrymen and they were joined by the Socialists, who hoped the war would be the means of bringing down the Italian monarchy. Popular feeling ran so strong that as early as January 18, 1915, Berenson wrote to young Louis Gillet, who had just been promoted to captain, that he would not be surprised if Italy entered the war in spite of the Germanophiles and clerics.

On May 5 D'Annunzio returned from France to deliver the oration at the unveiling of the statue of Garibaldi at Quarto near Genoa, and his fiery and mystical invocation of Italian liberty stirred the crowd to a frenzied clamor for war against the hated Austrians. To Berenson his one-time neighbor's "spouting of 'Grab and glory' " seemed as detestable as the German self-glorification. The news of the torpedoing of the *Lusitania* with the loss of twelve hundred lives on May 7 horrified the world, and tremendous crowds surged through the streets of Rome to attack the German and Austrian embassies. Two weeks later Italy declared war on Austria and ordered a general mobilization.

Berenson, like many Americans abroad at the time, was disgusted by President Wilson's stubborn neutrality in the face of the sinking of the

Lusitania, and he raged that "the utmost that will happen is that Wilson will let his whiskers grow." Lancelot Cherry, his former secretary-librarian, and Henri, his valet, were with their regiments at the Dardanelles; within six months both had been killed in action in that ill-fated campaign, and he reported to Edith Wharton, "All my servants are crying their eyes out." Inspired perhaps by Edith's example, Mary enlisted about a dozen women to make felt slippers and socks to protect the feet of the wounded from the cold floors of the hospitals, and Bernhard, as Mary wrote Senda, "promised so many monthly payments" to the Red Cross and local and national charities "that we haven't a cent left without selling out."

His checks to Edith Wharton's war relief projects brought a warm response: "Beautiful and welcome as your cheque is, it seems negligible besides the good letter that brings it." He missed the stimulation of Edith's robust intelligence and wrote to her, "This human world of ours is at best a rickety craft, and now that it is being reduced day by day, one fain would cling closer to the few shipmates one has found in life. The Lusitania business has done for me. . . . It is so much beyond the worst I conceived possible in the conduct of organized gregarious society that it seared and withered all my capacity for response." He followed her involvement in relief work with repeated contributions, and a year later she wrote, "I'm full of compunction about accepting the twenty pounds for you have already splendidly supported my many charities."

After the morning's stint on his articles, Bernhard as regularly had himself driven up to the Villa Medici on the road to Fiesole to spend the afternoon with Lady Sybil, whose frail elegance increasingly attracted him in spite of her compulsive talkativeness. The spirituelle young daughter of an Irish peer, Lady Sybil Desart had married Bayard Cutting, a rich American, in 1903. Cutting died of tuberculosis seven years later, leaving her comfortably established at the Villa Medici. It was not long before it was taken for granted in the Berensons' circle that she had become Bernhard's mistress. He usually dined with her twice a week, sometimes accompanied by Geoffrey Scott, who began also to be drawn to her. Neither development brought pleasure to Mary, weakening as it did her hold on both men. Her only consolation was that Belle Greene had retreated to the background.

As the months passed it turned out that the war was actually stimulating the sale of art in America. Lucrative war contracts began to breed a new generation of millionaires who succeeded the generation of the "Robber Barons." Joe Duveen wrote from New York, "We have had a tremendous season here—in fact the greatest in the history of the firm." Duveen's boast was soon reflected in Wilhelm Bode's article in the May

1916 *Die Kunst* in which he bitterly commented that in the course of the next few years the museums of New York, Boston, Washington, and Chicago would equal or surpass the great museums of Europe as the natural result of the enormous sums of money accumulated by the munitions makers who were arming Germany's enemies.

The Duveens made important purchases from the Morgan estate— Chinese porcelains, eighteenth-century furniture, objects of art, and the magnificent Fragonard Room, which they sold at cost to Henry Frick to encourage his patronage. Belle Greene, Joe informed Berenson, had been very "considerate and kind to us. . . . In fact she admitted that she was anxious to oblige us because of your friendship for us, and this is something we very highly appreciate." The letter must have amused Berenson, for Belle had earlier written how she had outmaneuvered the Duveens: they had offered two million for the porcelains and she had successfully held out for three. As for the Fragonard Room, which had cost $300,000, she sold it for $1,250,000.

Although the Duveens had disposed of only one Italian painting in the first half of the year, they kept after Berenson to acquire paintings for their stock for the booming market, especially since Frick and Lehman were showing a growing interest in Italian paintings. Frick, Joe said, "was exceedingly pleased to get your cable about the Bellini and the School Titian. He is beginning to realize now that there is only one man to look up to for the best advice on the Italian School." The Bellini to which Duveen referred had been jointly acquired by Duveen, Knoedler, and Colnaghi. It was the large and beautiful painting of Saint Francis receiving the stigmata with outstretched palms as he stands in the foreground of an idealized landscape that recedes upward to a crenellated castle in the far distance.

Toward the end of May 1915, with the first three articles safely in print, Bernhard took to the road again, accompanied by Mary and Lady Sybil, to restudy the painters of the Italian Marches on the slopes of the Apennines. Wartime travel, they soon discovered, had its perils. When they reached Urbino, they found the hotel crowded with frightened refugees from Ancona, which had been bombarded by the Austrians. The next morning at Fossombrone they were all arrested on suspicion of being Germans, and their car had to be rescued from a frenzied mob. It was their first encounter with what Berenson called "spymania." They retreated to Perugia and then struck south to Aquileia in the Abruzzi. Their adventures were not yet over. Shortly after Bernhard walked out alone to study the celebrated façade of the Basilica de Santa Maria di Collemaggio on the edge of the town, a messenger hunted out Mary and the rest of the party and told them that Berenson had been arrested. They all went

over to the jail, where they discovered that he had been saved by a kind-hearted police officer "from being torn to pieces by the excited populace" who had taken him to be a German spy.

By easy stages they reached Rome, none the worse for their terrifying adventures and, for Berenson at least, with undiminished passion for tracking down the unregarded art treasures of remote churches. The tumultuous outpouring of patriotic fervor in Rome convinced him that not diplomacy but enthusiastic popular support for the war had been the decisive factor in bringing in Italy on the side of the Allies. Rome had asserted itself as the real capital of Italy, whereas the United States had no real capital "to express the popular will." If New York had been the capital, he felt confident, "we should have been in a state of war with Germany."

After several days of note taking in Rome, Bernhard and Mary parted company, she to go up to the spa at Fiuggi, where she was joined by Janet Ross for a brief reducing cure, and Bernhard to return to Florence with Lady Sybil. Mary reported to Alys that the "cure" was a fraud: she had gained a kilo. She regretted, she wrote Bernhard, that *his* fiftieth birthday would not have the éclat of hers, which had been "such a splendid success owing to your generosity," but she hoped, not without irony, "that Lady Sybil would honor the day."

With the prospect of having to spend the summers of the war in Italy, Berenson detoured to the pass at Consuma "exploring hotels" with Lady Sybil. On the back road to Vallombrosa amidst the woods of birch and conifer high above the distant Arno, they looked in on the comfortable two-story peasant house solidly built of stone owned by the Marchesa Peruzzi, William Wetmore Story's daughter. They found it attractive and Berenson resolved to write to Story's son, Julian, to ask whether it could be rented. Nothing came of that negotiation, and it was not until twenty-three years later that the house, known as Casa al Dono, became Berenson's summer refuge. Back in Florence Berenson again immersed himself in writing the remaining articles for *Art in America* and also articles for *Rassegna d'Arte Antica e Moderna*.

The "spymania" reached "fabulous lengths" in Florence that summer. Self-appointed patriots, American as well as Italian, kept coming up to I Tatti to inquire whether Berenson was "really a German spy." There were indications also that Berenson was under suspicion in Washington. The American consul broke out in fury one day at dinner with Berenson against the ambassador at Rome for not having formally protested to the government the arrest and mobbing of Berenson at Aquileia.

When the British colony at Florence learned that wounded officers

were soon to land at Leghorn, some seventy miles to the west, there was much rivalry among the hostesses for putting them up. Bernhard reassured Mary, who was eager to offer their house, that there would be sufficient accommodation for the convalescents. The officers arrived from Leghorn, and four Australians wounded in the savage fighting at Gallipoli were after all allotted to the Berensons. They were put up in the rustic Villino Corbignano on the hillside across the road from I Tatti, an old-fashioned stone farmhouse that dated at least from the seventeenth century. Berenson ameliorated the rather Spartan comforts by supplying ample food, wine, and cigars and by having wires run so they would have electricity. Reports of the men's rough behavior in town disgusted Mary. Bernhard hoped to get more scholarly officers assigned to him in the future so that they might frequent the library at I Tatti and help supply the lack of intelligent conversation. Lady Sybil enjoyed fussing over her contingent of British officers who, she told Bernhard, hated to slaughter. Berenson countered that his Australians were not so highly evolved—that although they liked the Turks, "the sport of potting them was too tempting."

Though one group of convalescent officers succeeded another in the villino, none of them provided intelligent talk. Once Bernhard even had a contingent in to dinner, but the patriotic chore palled on him and seems not to have pleased Amerigo, the new butler. The men sensed their host's lack of enthusiasm and they did not hesitate to let on to outsiders that they felt they had been insulted. They were nevertheless immensely impressed by the great collection of paintings and books at I Tatti, amazed that a private owner could have so many.

In spite of the difficulties of wartime travel, Mary had insisted on visiting her family in England after her cure at Fiuggi. En route she stopped off in Paris for a few days at Edith Wharton's in the rue de Varenne and marveled at the vast extent of Edith's war relief activities. She also called on Henry Duveen and found him still jubilant over the business prospects of the firm, an optimism that Bernhard did not share. Because of his distrust of the firm, Berenson felt that there would be little room for him in their grandiose plans.

The days passed pleasantly enough at I Tatti. It was a lovely summer, and after each day's work Berenson and Scott drove up into the hills in the Ford to stroll in the familiar paths through the umbrella pines. "Of course I ought to be moaning and groaning about the war," he told his mother. "But the world is too beautiful and work too interesting for that." The mood carried over into a letter to Mary in which he fell to musing sentimentally about his meeting with her at Bank Holiday time

in August 1890. "Half my existence has gone by since then. . . . Even now it is difficult to think of my life as separate from yours. . . . I love you still, less glamorously but so much more really."

He told her he had recently received a "glowing devoted" letter from Belle Greene too voluminous to send, which left him mystified by her lapses into such long silences. Mary was all sympathy. She thought it "rude and horrible to a degree selfish and inhuman" not to write letters, not understandable to us "who belong to the civilized class of humanity." A "brilliant letter" from Edith Wharton reported that the ailing Henry James had completed his expatriation by becoming a British subject. Bernhard could not resist passing on to Mary a parody of the "Lost Leader": "All for a mouthful of drivel he left us."

Though the German submarine campaign had begun to take its toll of transatlantic shipping, there was still little interruption of the mails and for a time no military censorship of letters. Berenson urged his brother to write freely. "This is not Germany," he exclaimed. "You can say anything you like, as indeed you can in England and France." His favorite, self-indulgent Senda, continued to be rather exigent in her requests. He suggested that if she needed more money she should mortgage her house and he would pay the interest. She had also asked for a picture or two—a tender subject with him, except when the recipient was Belle Greene, and he had assured her he had none left, having got "rid of odds and ends when we came to the final hanging."

The purse strings did relax somewhat and Mary found renewed scope for her benevolent impulses. Bernhard admonished her, "Of course I'm glad you have got a little car for Ray but I must warn you that it must form no precedent either for herself or for Karin." As for their own Ford car at I Tatti, he reported that the Australian officers used it most of the time. He was chagrined to learn of his friend Zangwill's remark that "the war was just as much England's fault as Germany's." An unpleasant debate had been avoided when Alys "tactfully proposed a game of croquet." The constant antiwar talk Mary was exposed to in England in the family circle palled on her. Feelings ran strong in her family, for Karin and Adrian vehemently opposed the war and Ray and Oliver supported it and were engaged in war work. Nor could Bertie Russell be ignored. He had "adopted the Gospel of Nonresistance as a mystical religion which he preaches with apostolic vigour."

At I Tatti work on the library was nearing completion and the villa began to take on an almost palatial character. The estate still seemed vulnerable to encroachment on one side; and it was therefore with much satisfaction that Bernhard informed Mary that their *fattore*, Ammanati, could get the two remaining small farms for only 75,000 lire, approxi-

mately $12,000 at the then rate of exchange. With that purchase in view, he was disappointed to learn that Mary's share of the estate of her Aunt Lill (Elizabeth Smith) was less than he had counted on: like her brother and sister she was to receive $5,000 in cash and an equal sum in trust. Her income from all sources would then amount to about £1,200 a year. She suggested that Karin's promised wedding present of £500 should come from the cash legacy. Bernhard disagreed. "I am afraid if any of it falls into her hands now, she will spend some of it on the 'Stop the War, Pity the Blessed German lambs,' or kindred fads." And with his gorge rising he continued, "It is with Germany we have to deal, the most murderous, unscrupulous, barbarous, irreconcilable, unassimilable state entity the world has ever seen."

By the end of August Mary, weary of the pacifist debates and charmed by Bernhard's letters, confided, "I shall be so *very* glad to get back. What luck I have in having such a delightful companion to return to!" Bernhard was quite ready for her return. Though his frequent visits to Lady Sybil's had continued, her preoccupation with her contingent of high-ranking convalescent British officers had begun to bore him. Besides, having passed his fiftieth year, he was wryly noting the signs of aging. The grayness of his beard, he discovered one day while shaving, was not caused by dried lather as he had lightly assumed.

In mid-September 1915 Mary returned with her maid Elizabeth to find Bernhard "quite angelic in temper" and happily engrossed in his manu-script. I Tatti bustled with Mary's war work. There was much need for felt slippers as the returning troop trains brought back their pitiful car-goes of wounded. The Italian armies had forced the lower passes of the Dolomites and had driven the Austrians back from the frontier to the line of the Isonzo; they had also seized and dug in on Mount Nero but at such a heavy cost that the losses were not published.

In October the great attack on Mount Sabotino began as the wintry storms enveloped attackers and defenders in the frigid cold and snow. Wave after wave of Italian troops flung themselves in vain against the frozen cliffs that bristled with Austrian artillery, and it was not until the summer of 1916 that the mountain fortress was captured. On October 27 Berenson's old friend the forty-two-year-old Gaetano Salvemini spent a last evening with him before leaving for the front. A month later he was invalided home with frozen feet, having cried with pain for three weeks.

Try as he might, Berenson had not been able to ignore the urgencies of the war news in the newspapers that had brought their conflicting reports to him in all the languages of the belligerents. His relish of the Tuscan countryside during the year had often given way in his letters to his exasperation with the conduct of the Allies. He was disgusted with the

way the French and English diplomats had botched matters in the Balkans so as to drive Bulgaria into the arms of the Entente. "I cried to heaven," he wrote, "almost as much as at the monstrous folly of the first attack of the Dardenelles." There was no diminution, however, in his loathing for Germany. The Teutonic spelling of his name so oppressed him that in the late summer of 1915 he decided to drop the "h" and give his name a French character. Henceforward he would be "Bernard." The alteration had Mary's enthusiastic approval and she began at once to practice the new spelling. "B.B.," of course, continued to suffice for ordinary occasions.

The transformation of Goethe's Germany, whose culture and literature was so much a part of Berenson, into an aggressive military machine preoccupied him. He read nothing but German history and memoirs. To Barrett Wendell he wrote, "I want to understand how they became such obscene fiends in such a short time." The book that impressed him most was Jacques de Dampierre's scholarly study showing the sources of German imperialism and its tactics of terror in prewar German writings. He sent a copy of the just-published French edition to Henry Walters, who replied that though personally he would have preferred that the United States had declared war on Germany, he thought Berenson was mistaken in thinking that the people, in opposition to President Wilson, wanted it. To Paul Sachs at the Fogg Museum, who also deplored American neutrality, he wrote, "Americanism has been to many of us, and not least to most of us expatriates, a religion almost more than patriotism. We should have declared our moral horror of Germany's doing at the very start and excommunicated her."

The intellectual stimulus that the war had brought in its beginning had, he admitted to Elizabeth Cameron, long ago died away. Although he could not help reading the papers and discussing them, he did so with disgust for them and contempt for his own silliness. "Gnashing one's teeth in impotent rage is about the most distressing condition an unregenerate mortal can be reduced to." To Barrett Wendell he put the matter in much the same way: "One's intellectual and spiritual interest in the war which at first had marked something like a mental and spiritual revival in all of us has exhausted itself. . . . The soldiers tell us they have long forgotten why they are fighting and almost whom. . . . They fight to win."

The articles that seemed to issue pell-mell from his pen offered the one sure escape from his sense of futility. "The Bellini" appeared in *Art in America* in December 1915; "The Autograph Paintings of Giovanni Bellini," in February 1916; and "Mr. Frick's 'St. Francis,'" in April. In June he analyzed a Bellini recently acquired by John North Willys, the Toledo

motor magnate, whose collection was reputedly the largest in Ohio, and in the following December a Bellini recently acquired by Philip Lehman, of the New York banking firm. These last two articles were added to the series when *Venetian Painting in America* was published. Berenson also published during 1915 and 1916 an article on the *Annunciation* of Masolino in *Art in America* and six articles in the *Rassegna d'Arte Antica e Moderna* on various paintings of the early Venetians, of which two on Carpaccio would be included in *The Study and Criticism of Italian Art, Third Series.*

As 1915 drew to a close, Berenson looked back on its passage with a degree of complacence. "Except for some six weeks in May and June in the Abruzzi and Rome," ran his comment to Wendell, "I have not stirred. Despite the gloom and horror into which the newspapers plunge us each morning I have kept unusually well. . . . For a year I have lived an all but cloistered life. . . . My secretary Geoffrey Scott was with me and we had long and almost adolescent talks." Then, turning to his writing, he continued, "I have been drowning care in hard work and have nearly ready the first volume of a study of Venetian painting. It is going to be perfectly unreadable, pure pedantry. This war has given me such a horror of 'ideas' that I will never indulge in them again, at least not in print." The "horror" of course passed with the war, and a compelling need to indulge in "ideas" colored his writing for the rest of his life.

X X

Paris in Wartime

FORTUNATELY for Berenson's writing during 1916 he was not greatly harassed by the Duveens or other art dealers. Early in the year when he was asked by the London solicitors of the Duveen firm for copies of his original "certificates" to help settle a legal dispute among the Duveen partners, he impatiently replied that he had none and that they, being "business people, which I am not," should "have all the machinery for keeping their documents filed and indexed." During the course of the year twenty-nine letters and cables from Louis Duveen reminded him of the irksome responsibilities for which he begrudged the time, though the firm reduced its debt to him by very considerable remittances. Mostly he was asked simply to confirm an attribution or to give a valuation of a painting the firm wished to purchase. When, for example, he was sent a photograph of Lord Weymss's Lorenzo di Credi, he urged its purchase. In another communication he acknowledged that he liked a "Filippo Lippi" but he "denied its being autograph." When asked what price ought to be paid for a group of Baron Arthur de Schickler's paintings, he cabled, "Would pay £20,000 for Verrocchio, £8 for Alvise, £4 for Pintoricchio, £6 for Antonello." Early in the year he got wind of a fine Piero della Francesca from one of his correspondents and suggested it be offered to Mrs. Gardner or to Frick. Mrs. Gardner resisted Joe's glowing blandishments, and the painting ultimately reached the Frick Collection.

At the beginning of 1916 Mary had hastened to England to manage things for her daughter Karin, who was expecting her first child. Bernard had protested the interruption and its implications for the future: "I wish her well and with all my heart I want you to do what you think best. On the other hand, it is rather difficult for me to return and stay at I Tatti with a new cook and nobody to help me out in my work. Should

your absences tend to grow more frequent, I should, I fear, be sorely tempted to chuck the whole business, which as a business, sometimes becomes intolerable, and which I certainly should not carry on either for myself or by myself. I hope it will not come to this."

His mood, as so often before, changed as he grew accustomed to Mary's absence. For a respite he ran down to Rome, and once in the Vatican galleries petty concerns dropped away. In the Stanza della Segnatura he raptly studied Raphael's paintings, "particularly as color, which seemed to me ever so much finer than I used to think." Taken about to dealers by his friend Count Pasolini, he discovered a bust that he liked better than one he had thought of recommending to Henry Walters and he countermanded the letter he had asked Mary to forward to Baltimore. When Aristide Briand and his associates, in Rome for a high-level conference, came to Berenson's hotel, he "enjoyed seeing those French rulers come in, slouch-hatted and creased-coated, and making no pretense, as we Americans always do when official, of being if not great feudal lords, at least tremendous patricians." He met Paul Claudel, a leading French diplomat and Catholic poet, "simple, cordial, and charming," and talked with his military aide, who told him of the atrocities in Belgium and how "systematic they had been." One forenoon he encountered Corrado Ricci, "looking aged and diabolic," and vehemently rhetorical about the Austrian attack "on his dear Ravenna." Ricci was keen on excavating the ancient imperial forums. "I naturally encouraged him about digging, for I believe that Italy should spend every available centime of her art budget on that."

Karin's baby arrived, and Mary delightedly reported it was a girl, "Thank God." As usual she regaled Bernard with her daily budget of gossip. Trevy, their poet friend, "who they say is perfectly mad . . . wants to give in to the Germans at every point. He says every man who enlists is a 'skunk.' " Henry James seemed strong but his mind was going. Lady Ottoline had thrown over Bertie Russell "for a young writer named Lawrence, whose novel *The Rainbow* has been suppressed by the censor, greatly to the indignation of that ass Philip Morrell." She finally tore herself loose from the nursery and on her way home stopped off at Paris, where Bernard commissioned her to pick up three Chinese paintings that he had bought two years before.

The two were soon working amicably together and were rejoined by Scott, who had been temporarily detached to assist Edith Wharton in her labors. Word came that Herbert Horne, whom Berenson had come to regard as a traitorous friend, was dying in his austere palazzo in the Via de' Benci. Mary went to see him, and he asked her to tell "B.B." that "he should not take it amiss if he, too, had wanted to 'play the game' and

have some rewards, where B.B. had such success," and he asked to see him before he died. Touched by the message, Berenson went down to his bedside. "We talked of the many years that we were intimate," he told Johnson, "and how sweet they were." Horne died the day after Berenson's visit.

Mary, remembering that it was Horne's collaboration with Roger Fry that had led to the break with both men, wrote to Fry after Horne's death, wondering "whether you and B.B. couldn't be friendly again. . . . You still have so much in common." Fry responded directly to "My dear B.B.," explaining that Mary had told him all about Horne's death "and how you and he were reconciled at last. . . . It seems absurd that for want of a little insight we should deprive ourselves of the pleasure we should both get from talking together. So let us try to meet again in some leisurely way as soon as this infernal war which separates and destroys all is once over."

Berenson answered in friendly fashion but with a degree of unforgiving self-righteousness: "Dear Roger," he wrote, "With all my heart, and now let me tell you something. Years before I ceased seeing Horne, I knew perfectly well what he was, for evil as well as for good. I stopped seeing him for that one and only reason, that I suspected him of having with his subtle, violent cunning managed to estrange you from me. . . . It was like a wound that would not heal. I hope we have not run out of possible contact with each other in the intervening years. There is left in all this the possibility of much affection and the revival of many delightful memories."

Bernard showed his reply to Mary before mailing it. It filled her with some misgivings, and she hastened to supply a long gloss to Fry a few days later, recounting that when Trevy or someone else told Bernard "that Horne had put you against him he had been so hurt that he said he would never go near Horne again. You were a necessary part of his imaginative life . . . even if chiefly as an irritant." Her letter continued:

By this time I think I really know the ins and outs of B.B.'s character. At the bottom of everything is a curious lonely wish to be loved. It acts just the wrong way, often, making him very suspicious of *not* being loved. . . . On the other hand, when he feels people do like him, he becomes very genial and winning and gives himself unreservedly. . . . However, there are several other thorns to his nature. One of them is a great recklessness of statement about things where he doesn't feel responsible (combined with an utter unscrupulousness if it comes to argument), while at the same time holding himself and everybody else to strict account on subjects he really does know (or thinks he knows) about. . . . That is the secret of his "touchiness" about attributions. . . . Another thing which imposes on ladies and drives men to thoughts of murder is his occasional manner

of seeming to think himself omniscient. To us who know him this manner is merely funny because he is so winningly ready at other times to confess and even point out his follies. But in renewing friendly relations with him there's the chance that he may sometimes drive you wild that way. . . . I have just thought it wise to warn you of the difficulties.

It was not a letter that she could show to her husband, yet its patronizing tenor must have often been dinned into his ears throughout the enduring truce of their marriage. In her desire to manage affairs she seems once again to have overreached herself, for the two men drifted even further apart. But though Berenson may have distrusted Fry, he did not withhold praise when he thought it due. In his *Venetian Painting in America* he wrote in reference to Fry's note in the *Metropolitan Bulletin* on a *Madonna and Child* by Bartolomeo Montagna, "It would not be easy to point to a short article on a newly discovered picture that is more appreciative, better informed and more delightful."

During the spring and summer of 1916 there was no slackening in the pace of Berenson's literary activities. Frederick Sherman was readying the articles which had appeared in *Art in America* to serve as the core of Berenson's book *Venetian Painting in America,* and the George Bell Company in London was preparing to publish *The Study and Criticism of Italian Art,* Third Series. Much of Berenson's time was therefore taken up in 1916 with both projects. He was also at work on a lengthy and thoroughly "destructive" article on the work of Leonardo da Vinci for inclusion in the Third Series.

"I am fearfully busy, writing, correcting and revising the two books I am getting out," Bernard wrote his brother in July. He did not, however, forget the family in Boston, who were moving to a new address. To Abie, who was a kind of major-domo, he sent $1,000 to "help pay for moving and furnishing" and to his mother and Bessie another $250 for a vacation. He also arranged to pay for a piece of land and a house at Northampton for Senda and her husband, prompting Mary to remark to her sister that when the time came she could ask the same for Ray and for Karin. Mary was persuaded to give up her summer visit to England in exchange for a few weeks at a cure in Switzerland with Karin and the new grandchild.

With all work on his two books finally completed and the proofsheets out of the way, the whole strangely linked ménage—Bernard and Mary, Scott and Sybil—retreated to the seashore at Marina di Massa north of Pisa to sun and bathe. Peace was shattered when Karin wrote asking for £500 in order to take over a dairy farm to produce milk for babies as an alternative to war service. Berenson erupted, "uttering bestialities," but after he subsided he agreed to give her the wedding present he had

promised and also to invest half of a further sum he owed her, presumably from her aunt Lill's inheritance. His annual allowance to her of £200 remained unscathed in spite of his dislike of her pacifism. Within a year Karin and her husband discovered they had no calling for dairy farming and they were allowed to expiate their pacifism as simple farmers.

Reflecting on Berenson's volatile emotions, while they were all at the seashore, Mary wondered whether it was his not being "an Anglo-Saxon" that made him so different "from all the rest of us. He is really difficult. Even Sybil feels it acutely. She and Geoffrey and I seem to understand each other at once and B.B. enters as a foreign element with claims and demands and desires none of us can understand or sympathize with. . . . But he is *so* nice and interesting and delightful, it's a pity he is a 'foreigner.' "

To Bernard's great annoyance, Mary proposed to visit her family in England rather than to go with him to Paris for a few weeks as he urged. At once a tug of war began. "Mary," he said, "I'll give up the whole thing and stay here till the war is over if you will do the same." She had no interest in the bargain, for her little granddaughter Barbara, on whom she doted, needed an operation and her daughter Ray was close to confinement with another child. He clung to her "tremendously," she told Alys, "and can't bear my travelling in war time!" And yet "every fibre in my being drags me back to Ray in her trial." Bernard, who said he would like to spend a year in Eastern travel, complained, "How can I with a squaw who needs to run back to her papooses every four months?"

Like a prisoner in a cell she plotted means of escape. "I just must come. I mean to start on the tenth [of October]," she wrote, though she had not yet broken the news to Bernard. She won her "final grapple" and rejoiced that she would get to England in time for the birth. It turned out there was no need for haste. Five weeks later she wrote to Bernard in Paris. "Ray is so ashamed of her delay and sends many apologies to thee. She has done all she could—hot baths, night and morning, etc., etc., and still the reluctant infant refuses to enter the world." The infant, of the "inferior" sex, fortunately made his entrance a few days later.

After the long isolation in Italy, Berenson rejoined his circle in Paris with the liveliest relish. Edith Wharton, drained of energy by her war work, had eagerly awaited his reviving presence. "I long and thirst for our talks and walks," she wrote, "and refuse to decline into old age without a last halt on a hilltop in the sunset with you." Settled once again in the luxury of the Ritz, Bernard wrote daily to Mary of life scarcely touched by the privations of war. From the Villa Medici the bereft Lady Sybil lamented, "I fear you have practically *decided* to stay in Paris."

Berenson's days passed in the usual run of fashionable dinners and luncheons, but he prized most the hospitality of Edith Wharton in the rue de Varenne, even though there Paul Bourget, Walter Berry, and the rotund Abbé Mugnier, vicar to the *haute monde* of Sainte Clothilde, talked much of the fearful losses on both sides in the battles of the Somme. The Abbé spoke pessimistically about the seemingly inexhaustible forces the Germans could still draw on thanks to the prevision of great leaders like Bismarck, whom Berenson had to agree was "the most wonderful intelligence known to history."

At Walter Berry's there turned up a "queer fish" whom Berenson had not seen for years: "Finally and portentously, there was Bob Herrick. His mouth was smaller and the rest of his face rounder, and quite grey. He looked disapproving, contemptuous, hating and when he talked, it was drily and coldly." Herrick had come to Paris as the foreign correspondent of the *Chicago Tribune*. Though he was an ardent supporter of the Allies and had in his recent "Recantation of a Pacifist" in the *New Republic* declared that "War is a great developer as well as a destroyer of life," he was opposed to American intervention and his opposition must have had a chilling effect upon his auditors.

Berenson had his first encounter at Salomon Reinach's with the slim-waisted and seductive young lesbian Natalie Barney, whose "physical radiance" drew him into a long and sexually frustrating friendship. Reinach had once said, "Surely 'the wild girl from Cincinnati' and the 'sauvage du Danube' were meant to meet!" Reinach's amusing labels for the pair may have been rather fanciful, but after all he had seen Berenson through the lovesick months of his infatuation with Belle Greene and was no stranger to his other romantic attachments.

A rich expatriate American whose unconventional love poetry gave her the sobriquet of "Amazon of Letters," Natalie Barney had established a fashionable literary salon in the rue Jacob with a Doric temple in a corner of the garden dedicated "A l'Amitié." The roster of habitués and visitors came to include all the brightest names in Paris, from Cocteau and Colette to Gertrude Stein and Rilke. She relished the conversation of scholars like the classicist Reinach, the Orientalist Joseph Mardrus, and the art critic Berenson, her chameleon wit keeping serious thought afloat. In her memoirs she recalled the meeting with Berenson as "one of those lightning bolts of friendship. . . . From then on we remained *fidelement et tendrement* attached to one another."

To the American colony in Paris the most worrisome matter at the moment was the possible reelection of President Wilson, who was seen as a staunch supporter of neutrality. When the Republican candidate, Charles Evans Hughes, went down to defeat, Walter Berry exploded to

Berenson, "G——d d——n it all to H——l, four more caterpillar years as they might have said in Egypt in plague time." There was also the disturbing appointment of Louis Brandeis to the Supreme Court, confirmed by the Senate in May 1916 after a long and bitter controversy. A Jew and an active Zionist, Brandeis was a Boston lawyer who was regarded by many in the business community as a radical reformer. His egalitarian philosophy worried Berenson and he therefore put the question to Otto Kahn. Kahn reassured him: "On the whole, I believe that the forebodings which Mr. Brandeis's appointment . . . has aroused in some quarters will not be realized." He thought, however, that the appointment "at this particular juncture" was open to serious "criticism" as a merely political move to win the Jewish vote.

Berenson's concern about American politics soon gave way to more pressing personal matters. For some time he had known that Belle Greene was planning to come to Europe. Mary had concluded that that was the real reason Bernard had decided to go to Paris. However, when Belle wired him that she was in London and invited him to come over, he declined. He cited the difficulties of getting permission to travel, but a more compelling reason was that he did not fancy sharing her with the troop of sycophants who now thronged about her as the potent agent of the Morgan Estate. He was sure, he wrote Mary, that "her head will be turned." There may also have come to him gossip of her romantic attachment to an Englishman. Nor did he invite her to join him in Paris, where he felt most at home. Her kind of "High Life" seemed less attractive to him now that he had discovered the allurements of Natalie Barney's salon in the rue Jacob and felt himself falling under the mysterious spell of that extraordinary creature.

Bernard's show of indifference to Belle alarmed Mary. The Duveens, she wrote, would be "endlessly grateful to thee if thee could detach Belle from Jacques Seligmann and make her more friendly to them. . . . If she is a faithful ally to thee she could help thee a lot, I fancy; but it is clearly impossible to do anything with her by letter." She was sure that Bernard "could pull wires and get across very comfortably," and if he did not go she thought that Belle "might really turn against" him and do him "a lot of harm." He doubted that it was worthwhile to try to please Joe. He "encourages every vile plotter against me and would drop me like a hot potato the moment he did not need me."

Louis Duveen showed up in Paris to talk with Berenson about his tyrannical brother. Joe was "a vulgar, impulsive bully" who ran them all, and Louis said he intended to leave the firm next May. The interview left Bernard with a bad taste in the mouth for "Duveen and business and the struggle for things." "I cannot tell you," he fretted to Mary, "what

loathing all that part of my past and present inspires me with." He doubted that even she realized "how much of life is scarred and fouled by that connection."

With Joe and Louis at loggerheads, Berenson grew increasingly concerned to lessen his dependence on the Duveens. Arthur Sulley was a London dealer whom he respected, and he urged Mary to examine one of his pictures "and be as nice and sympathetic about his daughter as you can." He also commissioned her to urge Dowdeswell to buy their Giovanni di Paolo, which Louis had agreed was worth £1,500. It was a picture the Berensons had bought from Lady Henry. "Please do what you can, for money is more not less valuable in a time like this."

Concerned about their finances, Mary proposed that they go to America for a few months as he had originally urged. "Going together I shouldn't so much mind it. But we mustn't put the ocean between us." Bernard objected that though his presence in America might be "very profitable . . . I fear it would lead to my becoming totally a dealer or to a bad smash. . . . I doubt that even a severe retrenchment would move me from my determination to get no deeper into the dealing world. For me it is hell." A week later, after a "horrid morning with Louis Duveen" listening to his complaints about his partners, he nevertheless supposed that "the best on the whole is to stick to them. We'll pull through somehow."

By the end of November 1916 Mary had got her daughter through the early days of baby Christopher and had obtained a nurse for her granddaughter Barbara, Ray being too busy with public work "on a small income" to attend to that chore. After some difficulties with the American consul in London about her visa, she finally rejoined Bernard in Paris about the first of December to start out with him on a three-week holiday in neutral Spain with Count Serristori's sister Sophie. For Bernard it was a relief to escape the pressures at the Duveen offices and the grim wartime aspects of Paris, where unending streams of wounded were arriving every day from the front. For Mary the journey provided her first view of the Italian treasures of the Prado. Day after day they returned to the museum, where, as Mary recounted to Alys, "B.B. pores and pores over each picture asking himself aloud of each detail how he would know it was by the painter if it was isolated from the rest of the picture."

Berenson may well have felt that the Spanish holiday had been earned. His two books were to come out simultaneously in the United States and in England before the end of the year. A letter from Sherman caught up with him in Madrid: "It is hard for me to find a word fine enough to express my gratitude to you for allowing me to publish so much of the work in *Art in America* without expense."

By the first of the new year Bernard and Mary were back at the Ritz, and within a dozen hours he had signed up for a solid succession of luncheons, teas, and dinners for the next few weeks. The sordid necessities of business with the Duveens and other dealers could be relegated to the interstices. For Mary the social carnival that followed wearied her flesh, especially because of the exhausting séances at the dressmaker's trying to fit her corsetted amplitude into the latest fashions. She marveled at Bernard's social agility and wryly jested, "He spreads his leaden wings and flits from flower to flower." Bernard was in his element in the high life of Paris with its kaleidoscope of personalities and sophisticated talk, liking it "the way he likes pictures, instinctively." Few dinners glittered more delightfully for him than those at the Baroness Rosa Fitz-James's. Mary found them overpowering but conceded that Bernard had a certain genius for making new friends whom she liked to see afterward.

When in mid-January 1917 they packed for a trip south to visit the Curtises at the Villa Sylvia, Mary recorded that "B.B. has had a *succès fou* here, especially among the semi-Apaches and very fashionable young women." Following the brief visit with Ralph Curtis on the Riviera— "the last of the boulevardiers," Bernard called him—the Berensons settled down again at I Tatti late in January. To Dan Fellows Platt in America he described his three months' absence in Paris and Madrid as "a perfectly elegant time." As always when writing to friends, he completely erased from consciousness the penance he was obliged to pay to the art trade for his "elegant time."

At the very moment he was trying to bring off one of the most spectacular transactions of his career. The previous October, while still in London, he had learned from the art dealer Arthur Sulley that he expected to acquire the famous Giovanni Bellini *Bacchanal (The Feast of the Gods)* from the duke of Northumberland. Berenson had once mistakenly attributed it to Basaiti. In a footnote to his just-published *Venetian Painting in America* he referred to it as "Bellini's own unfinished creation . . . which Titian did not disdain to complete." As for his earlier attribution to Basaiti, he acknowledged, "I alone was guilty of this act of folly."

Berenson had promptly written to Mrs. Gardner and whetted her curiosity by telling her "in confidence" that an extraordinary painting to crown her collection might come on the market for $600,000. On his return from Madrid he alluded to the "great secret," saying he was writing to the owner "for permission to divulge it." A week later he broke the news that the painting was "the world-renowned masterpiece" *The Bacchanal* by Bellini. It could be hers for half a million dollars. In page after page he eloquently lauded "the greatest creation of Italian

painting." Mary, at his command, followed with an equally enthusiastic panegyric and enclosed photographs supplied by Sulley.

In the course of his exhortation Berenson expressed the wish that "Dearest Isabella" might have made "heaps of money in the manufacture of arms and ammunition" thus doing "a holy deed in helping to destroy Will-Hell-me [the Kaiser] and all his hosts." She declared the staggering price for *The Bacchanal* was out of her reach; moreover, she would have no stock in "blood money," though it was indeed true that munitions makers were "rolling in billions." In spite of her obvious yearning for the painting, she was obliged to decline. She lamented, no doubt with her usual exaggeration, that she was down to a "dwindling nest egg of $300,000." Berenson, however, was not finished with *The Bacchanal*. He would try again with another client four years later.

XXI

Venetians Restudied and Leonardo Dethroned

BERENSON'S *Venetian Painting in America: The Fifteenth Century* was his first important work since *The North Italian Painters of the Renaissance*. Though "nominally about Venetian pictures in America," it was, as he confided to Barrett Wendell, really "a re-study of the history of Venetian painting." He had returned to the subject, he said, with a fresh eye, and the result was "disastrous" to his youthful conclusions. He was, however, unrepentant: "I had my fun then and I have it again now." At times, excited by the war news, he had been tempted to burst into print in imitation of H. G. Wells and Arnold Bennett & Company, but he had remembered Wendell's counsel to "stick to my last . . . God knows it was hard, for nothing has so absorbed me as this war. And so, mindful of your advice I began this book."

Nearly two-thirds of the contents of the substantial volume formed a kind of supplement to the eight articles reprinted from *Art in America*. In the ampler pages of the book he was able to use the magazine articles as points of departure for discussions of many subordinate figures in smaller American collections, all illustrated by 110 pages of half-tone reproductions. The preface, dated July 1916, stressed the intensely personal character of his observations: "I have made the stray pictures in our collections the pretext for saying what I wanted to say about their authors in general. . . . In some ways this form suits me as it suited my master, Giovanni Morelli. Like him . . . I prefer to avoid such systematic treatment as entails dealing with materials either at second hand, or out of dimmed and attenuated recollection." If he avoided the rigors of a systematic treatment of the interrelations of the painters, their followers, and imitators, he did strive to establish the place of each artist in the historical chronology of the fifteenth century. "It is my conviction that we shall make little progress in knowing or understanding Venetian

painting in the fifteenth century until we have established chronology on a sound basis," he wrote in discussing Winthrop's Belliniesque *Madonna*. "I am appalled when I think of the nonsense that for so many years has been written and spoken regarding Venetian art, and the more so, as I myself have been one of the worst sinners." For him the process of revision of attributions was ongoing and perpetual, and an attribution or a date, however positively asserted, could be only provisional. The art critic and historian had a freedom that the art trade usually denied to the professional expert.

Berenson not only corrected some of his "youthful conclusions," he also tackled the more mature ones of other critics in the field. For example, in his analysis of Henry Frick's *St. Francis* he wrote: "According to Mr. Fry this most noble work is not by Bellini at all but by Marco Basaiti. Mr. Fry surely would not have fallen into this error had he considered the chronology of this work." He also warned against the "attributions, estimates, or conclusions" of the "archivist" Dr. Gustav Ludwig and his associate Pompeo Gherardo Molmenti, "not that they are infallibly untrustworthy; but nearly so."

The book touched a sensitive nerve of British critics, for, as one of them put it, "many of the works" considered in the volume "were once the glory of English collections." Reviewers, though respectful, did not hesitate to set forth points of disagreement. The London *Times,* cautioning that all previous efforts to provide a historical sequence for the Venetians had been unsuccessful, questioned whether Berenson had fully settled the matter. In his *Lotto* twenty years earlier, he had attempted a reconstruction of the period around Alvise Vivarini; "now Alvise is summarily, and we think wisely dethroned and a new edifice is erected in which Antonello da Messina and Giovanni Bellini assume prominence." But though the new edifice seemed rather illusory, the book had the value of "presenting a familiar subject from an entirely fresh point of view," and because of "its speculative character" the book was "packed with matter for critical controversy."

Venetian Painting received more appreciative treatment in America. *Art and Archaeology* declared that "the scholar will see in it a brilliant study of the whole development of quatrocento art in Venice." Frank Jewett Mather, Jr., in an enthusiastic anonymous review in the *Nation* predicted that readers of "Mr. Berenson's articles on Early Venetians in American Collections in *Art in America* will be delighted to have the series somewhat amplified and in book form. Of his attractive task Mr. Berenson has made a joyous adventure writing always with the gusto of liking and misliking. The obvious importance of the book lies in the display of the surprising richness in America in Early Venetian painting."

[213]

Berenson's companion volume, *The Study and Criticism of Italian Art,* came out in England just after the turn of the year, the American publication following in May 1917. The provocative lead essay on Leonardo da Vinci, which he had written almost a year earlier, had no relation to the remaining six pieces, which continued the discussion of Venetian painting. These were, he deprecated, mere "studies in what one may call the casuistry of chronology." In his brief preface he justified including the da Vinci essay on the ground that it "may interest the general reader." A destructive reevaluation of Leonardo, the piece was more likely to infuriate than interest him. It reflected Berenson's violent revulsion against the outpouring of sentimental idolatry which had deified Leonardo following the theft of the *Mona Lisa* in 1911 and its recovery two years later. As the most famous painting in the world the *Mona Lisa* had become an international fetish along with *The Last Supper* in Milan, which in its ruinous state continued to inspire ecstasies of indiscriminate piety.

Berenson had not been the only one to experience a "fierce reaction against the 'legend' " of Leonardo. D'Annunzio had been reported as feeling "satiety and disgust" with the lavish homage being paid to him. And a French painter, Orthon Friecz, confessed the Mona Lisa's "artificial and dreary smile" had ceased to be attractive. Leonardo's admirers had been quick to answer such attacks. It may have been something of a last straw to Berenson to read Sir Lionel Cust's pious advice in the October 1915 *Burlington:* "Whenever Mona Lisa shall re-appear to smile upon her votaries in Paris, let her be accepted as the harbinger of a new era in criticism when it shall be a nobler duty to maintain and add to the worth of a great work of art, than to undermine and belittle it." A little earlier Berenson's friend Herbert Cook had published a defensive article in the *Gazette des Beaux-Arts* on the "charme particulier" of the Benois *Madonna* and the works of the young Leonardo in which he asked, "Don't we run the risk, as a result of much research and over-subtle analysis, of reducing Leonardo to a shadow of himself?" Among the paintings that Cook welcomed to the Leonardo canon was *Ginevra de' Benci,* which, he wrote, "Morelli, followed by my friend Berenson," had given to Verrocchio. It was not until 1932 that Berenson put aside his doubts and attributed the painting to Leonardo.

Berenson's essay was an extraordinary confession of aesthetic error, of how he had been taken in by the Leonardo cult and taught to admire the icon paintings of its worship. "As a boy," he wrote, he "felt a repulsion for Leonardo's 'Last Supper.' The faces were uncanny, their expressions forced, their agitation alarmed me. They were the faces of people whose existence made the world less pleasant and certainly less safe." He re-

membered feeling that the figures were too big "and that there were too many of them in the room." Forty years of experience had gone by and he had gazed endlessly at the painting, "eager to let it hypnotize me if it could." He had tried to find in it "all that the rhetoricians persuaded me they had felt; and I dare say I, too, ended in speaking in tongues." Yet he could not ignore the ugly details. "What a pack of vehement, gesticulating, noisy foreigners they are, with faces far from pleasant, some positively criminal, some conspirators, and others having no business there. But I never dared say it out loud."

Later when he beheld the *Mona Lisa* in the Salon Carré, "breathing its lifeless air, with the nasty smell of fresh paint in my nostrils, occasionally stealing a moment's rest on the high stool of an absent copyist," he tried to match what he "really was seeing and feeling . . . with the famous passage of Walter Pater." Reality could not be withstood, and "an enchanted adept died in me when I ceased listening and reading and began to see and taste. What I really saw in the figure of 'Mona Lisa' was the estranging image of a woman beyond the reach of my sympathies . . . a foreigner with a look I could not fathom, watchful, sly, secure . . . and [with a] pervading air of superiority. And against this testimony of my instincts nothing could prevail." By degrees, however, he learned to revel in its mysterious landscape, its "conscious art," its bold and large conception, and its imposing simplicity, and he joined his voice "to the secular chorus of praise." Had he not written in his *Florentine Painters of the Renaissance* as long ago as 1896, "We shall seek in vain for tactile values so stimulating and convincing as those of his 'Mona Lisa' "? But his lingering doubts would not die. When the rumor reached him one summer's day in the high Alps that the painting had been stolen, his suppressed feelings were released. "She had simply become an incubus, and I was glad to be rid of her. But I did not dare even then. Who was I to lift up my feeble voice against the organ resonances of the centuries?"

There were other works attributed to Leonardo about which he had misgivings, "objects of worship in the imaginary temple of Leonardo." The face of Saint John "leered" at him with an exaggeration of all that had repelled him in the *Mona Lisa* and in the *St. Anne*. He could not conceive "why this fleshy female should pretend to be the virile sundried Baptist, half starved in the wilderness. And why did it smirk and point up and touch its breasts?" On the other hand, his "whole heart went out to the portrait of the girl known as 'La Belle Ferronière.' I was on my own level again, in my own world, in the presence of this fascinating but yet simple countenance with its look of fresh wonder." In his uncertainty he had assimilated it to Boltraffio because it was more like Leonardo's imitators than like Leonardo himself. For a time "I resented

this beautiful thing because I could not name its author. . . . I fear, however, that in discussing Leonardo we cannot safely count her as his. But whose in all the world if not his, and if his, in no matter how limited a sense, in what moment of his career could he have created her?" It was a question that he would be summoned to answer—yea or nay—in 1923 in the sensational lawsuit brought against the Duveens by Mrs. Harry Hahn.

All of his "doubts, questionings, and spiritual combats might have remained confined to his breast," Berenson continued, "but one unhappy day I was called upon to see the 'Benois Madonna' [a picture that had turned up in Russia some few years earlier]. I found myself confronted by a young woman with a bald forehead and puffed cheek, a toothless smile, blear eyes, and furrowed throat. The uncanny anile apparition plays with a child who looks like a hollow mask fixed on inflated body and limbs. The hands are wretched, the folds purposeless and fussy, the colour like whey. And yet I had to acknowledge that this painful affair was the work of Leonardo da Vinci. It was hard, but the effort freed me, and the indignation I felt gave me the resolution to proclaim my freedom."

Why then had Leonardo been so highly admired through the centuries? Berenson thought it was owing to his invention of two painterly formulas—*chiaroscuro,* the creation of illusion through light and shade of vanishing planes, and *contrapposto,* counterpoise, or the twisting of the human body on its own axis—which had been made into dogmas in the teaching and practice of art. Leonardo's failures stemmed from his "over-intellectualism." His "absorption in the science of his craft ruined the artist" and was responsible for the "contrast between his spontaneous genius, as manifested in his drawings, and the quality of most of his highly elaborated paintings." "Florentine art tended to be over-intellectual, and of that tendency Leonardo was the fullest exponent."

"The ultimate aim of art is ecstasy," Berenson asserted, "and any diversion that prevents our reaching that state is bad." Leonardo misused his cherished formulas and sacrificed to them the aesthetic moment. Only one of his paintings was "a truly great masterpiece," the happily unfinished *Adoration of the Magi* in the Uffizi, and "had he completed it he might have ruined it as he did the Hermitage 'Madonna.' " It was unlikely, he concluded, that Leonardo would maintain his standing as one of the supremely great painters. Berenson let stand his original praise of Leonardo in all the reprintings of *The Florentine Painters,* but he appears never to have recanted the vehement polemic against the merits of his paintings.

When Edith Wharton received her copy of the *Studies,* she wrote, "I

must dash off a word of gratitude and rejoicing, for on the very first page I find an 'execution' of 'The Last Supper.' Ever since I first saw it (at 17) I've wanted to bash that picture's face, and now, now at last, the most authorized fist in the world has done the job for me. Hooray!!!" Later she wrote from war-diminished Paris, "The only cheerful thing that has happened here is your Leonardo. Walter [Berry], Charley [Du Bos], and [Paul] Bourget and I are licking our chilly chops over it. . . . It's *splendid* and such a glorious sample of the big book you promised me to write. . . . How I wish you were here that I might gloat with you successively over each admirable point. . . . The way your mind dominates your erudition and takes a right view of the whole matter makes me feel as if I were sitting over a good fire."

Edith Wharton's violent image had its counterpart in the press. The *Literary Digest* quoted at length from the essay and from a review in the *Boston Transcript* which declared that Berenson had "torpedoed Leonardo . . . without warning and sent him to the bottom." *Current Opinion* in New York saw the iconoclastic essay as "a sensational reevaluation of Leonardo's position" and quoted key passages from the "brilliantly based attack." The most favorable review was the one in the London *Connoisseur*. "Mr. Bernard Berenson," the writer declared, "is among the few erudite critics on art whose writings display a marked and distinctive personality. . . . Though one does not see eye to eye with Mr. Berenson in his suggestion of the causes which lead to Leonardo's unique position in art, one must agree with most of his searching and discriminating criticism regarding his work."

Earnest defenders of Leonardo were not lacking. The London *Times* accused Berenson of trying to strike "a popular note" in joining the current avant-garde rebellion against traditional values when he argued that "science, logic, and attention to technical problems are ruinous to the artist." The writer resented the depreciation of *The Last Supper,* which he called "for all time the recognized illustration of the Sacrament of the Eucharist." As for the remaining six essays, they reflected the spurious "reconstruction of Venetian painting to which Professor Venturi and Mr. Berenson have set themselves and by which incidentally a good many second-rate pictures in American private collections are acquiring first-rate names." The *International Studio* expressed its disapproval of the Leonardo essay with energetic brevity. "The author admits such want of sympathy with a certain phase of Leonardo da Vinci's work as is generally considered to place a critic's estimate out of court." The *Nation* also took issue with Berenson. Although "inclined to agree . . . that Leonardo has been overestimated, we by no means share the individual appreciations or depreciations upon which Mr. Berenson's view is

based. To him 'The Last Supper' is restless in a sinister way, to us it is a tranquilizing masterpiece."

Despite such protests, Berenson's disenchantment with Leonardo's paintings, especially with the *Mona Lisa,* helped inspire a vogue in "smart connoisseur circles" epitomized by Marcel Duchamp's mustached caricature of the enigmatic lady. In the long run, however, the attacks have not lessened the enormous critical interest in Leonardo's genius nor weakened the magnetism of his few paintings upon the popular imagination. The enshrinement of the *Ginevra de' Benci* in 1967 in the National Gallery in Washington at a reputed cost of six million dollars would suggest that Berenson's pessimism was premature.

XXII

From Art Expert to Military Adviser

ERENSON'S wartime isolation at I Tatti troubled him—he felt
tongue-tied for want of auditors—yet he could not return to
Paris because it was no place for Mary. In the absence of Geoffrey Scott, who was now an attaché at the British embassy in Rome, she
too was bored. Berenson continued to pay Scott his salary of £75 a
quarter, despite his annoyance with Mary's obsessive interest in him.
Cecil Pinsent, who had joined the Red Cross, had been "kicking his
heels" in Florence and involving the Berensons in ever-increasing expenditures for improvements. When he finally obtained the command of a
Red Cross section on the Italian front, Berenson supplied him with an x-ray ambulance.

Running the large villa and the surrounding farms became more
difficult as servants were called up for the army. Ammanati, their *fattore,*
was fortunately exempt, having a son at the front. Mary at times felt the
place beyond her ability to handle. As she pointed out, it was also a
library-museum and the many thousands of books were a prey to larvae
and the masses of photographs to fungus. Besides, great bundles of
books came from the binders, "half-bound and all in a muddle." Sometimes, himself overwhelmed by the threatening chaos, Berenson would
exclaim in despair that he would "cut and run"; then the next moment he
would order more books and plead with his correspondents to send more
photographs of Italian paintings.

In the absence of visitors and house guests, letters became even more
of a necessity. Those he awaited most eagerly were the ones from Natalie
Barney. Remy de Gourmont, the famous Symbolist critic who had been
her Platonic lover and literary mentor, had recently died, and she now
proposed that Berenson succeed him. That role did not appeal to him,
especially as he believed he was "far more pleasing to the eye" than de

Gourmont. His romantic advances to her had posed a puzzling challenge to her lesbian nature. "I am too perplexed in all my feelings and sentiments," she had written, "to know what or how I am just now. . . . B.B., what shall I say—just *sans phrases* or verbal agility, that I'm glad you're here and that I know you." When she tried to set the tone of their friendship by sending him a slim volume of her verses and a copy of the letters of Remy de Gourmont, he cautioned her, "I fear I cannot replace the friend you have lost. It would be absurd to compare myself to him in any way"; besides he had to be away from Paris nine-tenths of the year and when there he did not have "the leisure of spirit essential to seeing one person beyond others." "Why not get away at once and come to stay with us?"

Some of her verses he was able to admire with romantic fervor. More often they offered an occasion for sentimental and philosophical musings. When she sent him her book *The Woman Who Lives with Me* and noted on the flyleaf that she could not come to I Tatti, it touched off a long stream of self-analysis that half-revealed and half-concealed the nature of his complicated frustrations: "Disappointed I am—at least one great part of me, the whole of me that still thirsts for experience as experience and receives it always with ardour and never looks back with regret. That part of me had, I confess, taken the upper hand. But there is another great part of me which has always been the greater part . . . to dream intensely, and ask of the not-me no more than it should come just enough into my ken to dream about. . . . This is very egotistical, and would be thin and poor if it were all of me, but there is ever and ever and ever so much more—so much in fact that looked at from within I can come to no conclusion with regard to myself. . . . I grind out pedantic studies which waste my soul, and you who are much more exquisite and above all ever so much more of an artist, you write cryptic short stories like the one I am now returning—with regret for I should like to keep it. . . . Evidently it shadows forth one of your *vous,* and I want to know as many of them as will not kill and devour me. For of course you have such too. We all have cannibal selves."

For all its circumlocution the drift of his thought arrived at its destination. Like a character in one of James's late novels, he had a "cannibal" appetite for affection and domination and a desire to search out and relish every cranny of thought and feeling in the object of his passion, just as he sought to possess every detail of a painting he admired. That Natalie Barney was profoundly unattainable left him, when he was an old man, with fond memories of "those bitter-sweet days of intense living." He could never forget that he had once been madly in love with her.

If thoughts of Natalie Barney filled his reveries they could not extin-

guish his anxieties about the desperate course of the war. When the longed-for word came at last that the United States had entered the war against Germany, he was so excited by the news that he dashed across the corridor to embrace Ammanati, who was going over the household accounts with Mary. His dislike of Wilson changed to admiration when he read Wilson's stirring address to the joint session of Congress on April 2, 1917, asking for a resolution that a state of war existed. Wilson's speech, so full of high idealism, seemed to herald the dawn of a new era. Germany's war, Wilson declared, was a "challenge to all mankind." The object of the United States was "to vindicate the principles of peace and justice . . . as against selfish and autocratic power. . . . The world must be made safe for democracy. . . . To such a task we can dedicate our lives and our fortunes."

"I feel suddenly converted to democracy and republicanism," Berenson exclaimed. "I don't think better of either than before, and I see all their squalid drawbacks but all in all these are less dangerous and destructive than ruling castes and monarchies." He hoped that his brother, Abie, although now forty-four, would go to Plattsburg for officers' training. "It will do you a world of good," he said. "How I wish my country realized that never was a crusade more holy. . . . All descriptions of the Evil One are of angels compared with what the Germans really are like. If I were a well man, even at my age, I should join one or the other of the armed forces in some capacity." Bernard's hope for Abie went unfulfilled, for he was as little fitted for military service as his elder brother.

Berenson's gratification at the entry of the United States into the war was clouded by the divisions he found among his Italian friends. It continued to pain him to hear the pro-German sentiments of the Countess Serristori. As for Carlo Placci, who telephoned his congratulations "that we too are at war," he soon learned that, like D'Annunzio, Placci saw the war not as a democratic crusade but as an opportunity for Italy to share in the territorial spoils.

Edith Wharton, knowing Berenson's ardent patriotic sentiments, promptly wrote to him from Paris after the formal declaration, "Why on earth don't you ask for a job in our embassy here? They are sure to be wanting polyglots now." For the moment he was not ready to make any decision, being perplexed about his and Mary's situation in Italy. But to prepare for any contingency, he registered on May 11 at the American consulate in Florence as a citizen of the United States and deposited his last will and testament with the consul with the directions that in the case of his death in Italy his body should be cremated.

The needs of the Italian war machine grew more and more exorbitant

as General Cadorna pressed back the Austrians higher and higher into the Alps, with enormous losses on both sides. Civilian shortages demanded increasing retrenchments, especially in the use of motor vehicles. The "big car" at I Tatti had to be stored away, and the "tiny Ford" which Belle Greene had obtained for Mary was converted by Hugh Parry, their chauffeur, into "a fairly comfortable four seater." Ten thousand dollars went patriotically into the 8 percent Italian war loan. In the midst of the unsettling prospects, Berenson's thoughts turned increasingly to the future of his villa and its treasures. Long ago when Mrs. Gardner established her museum in the Fenway, he had begun to dream of leaving his collections to Harvard. The dream had by now become an obsession— and the despair of Mary. She suggested to Alys that she bring Ray's daughter, the five-year-old Barbara, to I Tatti in the hope that Bernard might become so much interested in her grandchildren that he would think of them as his heirs and so get over "his foolish idea of turning it into an 'Institution.' " The stratagem could not be managed in wartime.

The forecast that the war would accelerate the outflow of art to America was soon confirmed by the Duveens, who informed Berenson that they were encouraged "financially and morally by the entrance of the American troops into the fighting." In May 1917 Louis was urging, "By no means stop buying." The pictures could be put away until the export *permessi* were issued. "Business should be good after the war as many Americans have made large fortunes. . . . They may not buy openly as they do not wish to make a bad impression by spending money on luxuries."

That spring the relations between Louis Duveen and Joe grew increasingly tense, and Louis, instructing Berenson to go ahead with a purchase, explained, "I do not consult New York any more as I find that if I like a thing after you have recommended it, it is quite sufficient and I am quite prepared to-day to buy anything on your recommendation as I find results have been good." At times Berenson must have felt swamped by the number of requests that poured in from the firm. Whereas in 1916 there had been only twenty-six communications, in 1917 there were sixty-two from January to March and seventy-five from April to December. Before the year was out Mary would have listed the dispatch of opinions on 108 days on some 250 paintings giving or denying authentications, suggesting valuations, or recommending or discouraging purchase. The Duveens' eagerness to increase their stock of Italian paintings led to their proposing pictures to Berenson with such undiscriminating enthusiasm that his rejections vied with his approvals.

With foreign travel largely interdicted by the war, Berenson coined the summer's intermittent leisure into a succession of articles that flowed in

the wake of the two published collections of essays. Mary, unable to visit her adored family in England, welcomed a chance to get away from "Frumpignano"—her epithet for Settignano—for Rome, where she could enjoy "long and intimate conversations" with Scott. Her absence this time seems to have actually given an impetus to Bernard's writing. In July he reported to her that he had singlehandedly "corrected" two articles returned by the typist and sent one to Sherman for *Art in America* on "Ugolino-Lorenzetti" (the first of two articles on the artist to whom he had given the name of his two teachers) and one to Reinach for the *Revue Archéologique* on "An 'Assumption of the Virgin' by Turino Vanni at Bayeux." He added that he was "busy preparing" an article "on Solomon and the Queen of Sheba to crush Sirén."

Osvald Sirén, the young Swedish art historian who had recently become curator of the National Museum in Stockholm, had published an article in the May issue of the *Burlington Magazine* in which he established that Berenson had been mistaken in attributing to Matteo di Giovanni a Ferrarese marriage salver in the Museum of Fine Arts in Boston. Sirén argued that the salver, which depicted Solomon and the Queen of Sheba, was painted by the Umbrian artist Boccati. Berenson took to his now greatly augumented photograph files to combat the attack. He admitted that he had been mistaken in those early days of the science back in 1897 in his attribution to Matteo. "To speak the truth," he continued, "I now feel doubts on the subject of most of the works which I have not reviewed in the course of these last years. . . . Today our knowledge of second-rate artists, formerly so rudimentary, is now very complete." Granting that he had been wrong in naming Matteo, "one has the right to be astonished at an erroneous attribution to Boccati in the face of all the evidence now available disproving Boccati's authorship." He thus evened the account with Sirén, who earlier, in a "sumptuous" catalogue of the Jarves Collection at Yale, had rejected a number of his attributions. The exchange of amenities between the two critics did not, however, dampen their occasional scholarly correspondence during the next forty years.

When there came to Berenson that summer from the Yale University Press in three quarto volumes Arthur Kingsley Porter's *Lombard Architecture,* accompanied by a folio collection of 244 plates of illustrations of architectural details, he wrote to Dan Fellows Platt at Princeton to inquire who the author was. He had received, he said, "without a word of explanation his stupendous work on Lombard architecture." "He and I are kindred spirits," he added. His appreciative letter to the thirty-four-year-old Porter drew a flattering response: "I have read and reread and admired your works so intensely, that an autograph from you carries

with it the romance of a relic. I wish I dared believe you that there is a kinship between my method and yours. I think it may be so in the sense that your scholarship has been my inspiration." In this fashion began one of the most intellectually rewarding friendships of Berenson's life. His voluminous correspondence with Porter on art and archaeology would continue almost to the day of Porter's tragic death in 1933.

At the end of the summer the Berensons escaped briefly from the heat to a resort in the mountains near Vallombrosa where they enjoyed one of the "grandest views" of the valley of the Arno, a view that would in a few years bring them back as regular summer residents. Gaetano Salvemini, who had been invalided out of the army, was Berenson's companion on donkey rides to the mountain top. The mountains provided relief from the heat, but there was no escaping troublesome business concerns. The struggle among the Duveen brothers had come to a head early in June 1917 with Joe, Henry, and Ben of the New York gallery endeavoring to get rid of Louis and Ernest, who were in charge of the business in London and Paris. Louis explained to Berenson that the New York members, annoyed that Ernest had left the Paris branch to enlist in the French army, had become convinced that the money which the firm made was "being made only by them." On Louis' behalf Berenson wrote to Joe in New York expressing his disapproval.

Responding for Joe, Edward Fowles protested that Louis had not been at all conciliatory and that since the partnership agreement ended on May 31, Joe and Henry had bought the goodwill of the firm and the New York and Paris premises. The trouble among the Duveens, he blandly assured Berenson, was "not of such a nature as to cause enmity, as between the Brothers Seligmann," whose feud had become notorious. In July Joe anxiously cabled Berenson that since the contract with him remained in force, he assumed that he would go on acting "for us as heretofore" and avoid associating "himself with Wildenstein, Louis, or others." Berenson replied that though he feared that without Louis in London it would be difficult to acquire Italian pictures in England, he would stick with Joe "because I believe in you but you must make it worth my while by your keen pursuit of Italian picture business."

The apparent break between Joe and Louis disturbed Berenson because it had delayed the usual quarterly remittance of £5,000, and, more important, because it made him uneasy about the future of the firm. Aware of Berenson's feelings, Joe dispatched Fowles to Florence in early September to reassure him that "the firm was still in business and that his own position was unchanged." Among the matters to be aired were Berenson's right to buy Italian sculptures for the firm and the more

delicate question of the extent to which Berenson might continue to advise other dealers.

During his week at I Tatti Fowles learned the unvarying summer's routine that governed a guest's stay: after luncheon one lolled in a shaded hammock trying to nap in the oppressive heat; later as the sun declined toward the west, tea was brought out. Afterward one walked down the stone stairs through the limonaia and the garden paths past the pools that Pinsent had laid out to the ilex wood and back through the upward sloping avenue of cypresses to the terrace, from which was visible the ring of hills against the hazy blue of the sky. The evening dinner, presided over by Berenson faultlessly dressed in his dinner jacket, would be followed by coffee in the library. Promptly at 10:30 a servant handed one a cup of the customary camomile tea, a signal for all to prepare to retire.

In response to Fowles's urging, Berenson reluctantly agreed to meet with "Sir Joseph" in Paris. He and Joe had not seen each other since the beginning of the war, and Joe presumably was anxious to reestablish his personal authority. Fowles reserved rooms for Bernard at the Ritz and for Mary at the St. James and Albany, having been prepared for this diplomatic arrangement by witnessing a lively dispute between them. "Our marriage," Mary told him, "is not of the usual type, but a union of intellects." She also shared with him her dissatisfaction with her treatment in their partnership. "I want my share of the profits resulting from our joint efforts for my daughters and granddaughter; B.B. on the other hand wants to raise funds to endow a foundation . . . for the benefit of students of Harvard. I agree that his wish is commendable, but each time I ask for my share of our earnings, he makes a great fuss."

In spite of the annoyances of business, Berenson had been able to devote some time during the late summer and early fall to more congenial projects. Frederick Sherman had persuaded him to gather together his articles on Sienese painters for a book which he hoped to bring out before Christmas. Bernard and Mary prepared the manuscript and collected the illustrations, but Sherman then announced that publication would have to be put off until the following year.

In October an urgent call came from Glaenzer and Seligmann for Berenson to come to Paris to examine a "Leonardo" that they hoped would be a "gold mine." Since Berenson was already committed to meeting Joe in Paris, the proposal offered a more congenial inducement. Mary was delighted at the interruption because it would permit her going to England for a long-deferred reunion with her family.

The "gold mine" proved to be only dross, an eighteenth-century copy of the Louvre La Belle Ferronière. Joe Duveen evidently anticipated a

noisy meeting over the question of Berenson's services to other dealers and placed mattresses at the doors of his apartment at the Ritz "so that others would not hear." Berenson forestalled the stratagem by arriving for the appointment not at the apartment but at the firm's offices at the place Vendôme, and Joe, obliged to meet him there, calmed down. Fowles wrote that "after a long talk they reached an amicable settlement," but it was one that did not really tie Berenson's hands. He continued to resist Joe's every effort to monopolize his services.

While Berenson was settling affairs with the Duveens, Edith Wharton went ahead with her plan to find patriotic employment for him. She turned for help to Walter Berry, who, as a prominent international American lawyer in Paris and a popular advocate for American intervention, had been "replacing everybody as the real representative" of his country. Berry helped Berenson in the first instance in obtaining a military pass from the American Mission. Signed by Lieutenant Royall Tyler, with whom Berenson was already acquainted, it authorized his travel in the war zone.

Berry busied himself to find a suitable post for him, while Berenson toured the devastated areas in northern France with Edith in her Red Cross car on the way to the hospital with which she was connected at Compiègne. In one village they encountered workers clearing out a well that the German troops had fouled with refuse. Berenson offered to pay for an electric pump to restore the water supply. They joined Elsie de Wolfe at her quarters in Compiègne, where she worked with her patroness Madame Henri de Rothschild. Elsie told of treating a poor soldier whose face had been burned away. He mumbled, "Je voudrais vous donnez un sourire pour vous remercier [I wish I could give you a smile to thank you]." To Berenson the journey through the war-ravaged countryside was unnerving. He felt the "spectre of sordidness and the nightmarish visions" were so frightful that they "surpassed anything I could feel as pity."

Lunching with Edith Wharton and Walter Berry back in Paris, Berenson was given the good news that "our government was really anxious to have me for just the job I am fit for." It would not require more than "three hours of office work a day," and it would be work that Mary could help him with when she returned to I Tatti. While the details of the appointment were being worked out, Mary wrote approving his plan to stay on in Paris. Bernard, however, fell prey to misgivings. "My heart begins to fail me," he wrote. "I think of my library, my leisure, my work, and have a fear of inchoating my holiday life with the aridity of a work-a-day one." Rumor soon had it that he had joined the army and had been commissioned as an officer. Santayana wrote to Berenson's

brother-in-law Logan, "How curious that Berenson should be a captain in the U.S. Army. We are living in a world of wonderful changes and this one is typical." He was in fact offered a commission, but, as he wrote Platt, he turned it down because "I have too much sense of the ridiculous to don a uniform at my age and with my physique."

Bernard reported to Mary on December 6 that he had dined at Edith's with the Royall Tylers, and Tyler had "significantly" asked him to come round to his office. This he did the next day, whereupon Tyler offered him "what may ultimately amount to being general but secret and unofficial adviser, with regard to things Italian and German too, if I can manage both, to our general staff." He would not have any official rank or uniform—"which will distress you no doubt, nor shall I have office hours." His job would be "to see and hear and report." She was to say that he was "loosely" attached to United States Intelligence and, if asked, "on the German side of it." She could, however, confide in the United States consul Dumont in Florence. He also instructed her to enlist Salvemini to sound out opinion, though he needed to be cautioned not to "swallow Carlo [Placci's] Austro-Papal blarney." He further requested that she have extracts made from the Italian press so that he could follow the people "on our side" and the "bad ones opposed to us—the pseudo-Prussians, the Teuton-idolators, the Clericals, etc." Mary thereupon engaged Salvemini's wife for the job at 200 lire a month.

To facilitate the sending of information to Berenson, Consul Dumont sent off a communication to Ambassador Thomas Nelson Page in Rome quoting Tyler's certification that Bernard Berenson "is employed in the Intelligence Section of the General Staff, American Expeditionary Forces, as a First Class Interpreter and has been assigned to duty with the American Mission, Bureau Interalliés Paris." The title was to serve as a cloak for his intelligence duties.

The international situation was now in a state of tremendous flux as a result of the decisive American intervention, and the rumors of peace initiatives vied with speculation concerning the probable postwar settlements. Colonel Edward House, President Wilson's personal representative, noted that Baron Sonnino of Italy "is as difficult today as he was yesterday. . . . If his advice should carry, the war would never end, for he would never consent to any of the things necessary to make a beginning towards peace."

The military council's deliberations were made even more difficult by the collapse of the provisional Russian government under Prime Minister Kerensky, the government which had replaced the czarist regime in the spring revolution. The October coup d'état led by Lenin and Trotsky had ushered in the Bolshevik dictatorship, and Kerensky fled the coun-

try. Amidst growing anarchy, negotiations began at Brest-Litovsk for a separate peace with Germany. The enormous chaos in Russia, the factional struggles, the strikes, mutinies, and confiscations impressed Berenson as if "the whole of Russia were behaving like characters in a Dostoevski novel."

The winding down of the war on the Russian front in the late autumn of 1917 had had grave consequences for Italy, for it released tens of thousands of troops to spearhead an Austro-German offensive under General Von Ludendorf on the Alpine front. Soon news came of the appalling rout of the Italians at Caporetto and the loss of all the territory that had been won in two years and a half at such enormous cost. When Berenson realized the extent of the catastrophe he told Mary, "It prevents my sleeping and eating and makes me unhappier than any public event that has taken place in my lifetime."

Mary had gone on to I Tatti "to put things in order for a long absence," Berenson wrote Mrs. Gardner, and he was now established in the apartment of the Ralph Curtises at 40, avenue du Trocadero, while they wintered on the Riviera. He expected Mary soon to rejoin him. Their anxiety about the safety of the villa had grown with the rapid advance of Von Ludendorf's combined armies to the line of the Piave, where the shattered Italian army was being regrouped to make a stand. Though Berenson did not expect the actual intrusion of enemy troops into Florence, he worried that the unoccupied villa might be commandeered to house refugees.

Bernard sent Mary careful instructions concerning the safekeeping of his masses of correspondence. The "merely personal stuff" could be left locked up, but business letters of a delicate nature, like those relating to Otto Gutekunst and Mrs. Gardner, were to be hunted out in the various cubbyholes in which he kept them and, together with the Baring and Duveen correspondence, the Duveen Code Book, and his copy of the "X" Book, placed in a "strong iron-shod trunk" and entrusted to Lady Sybil at the Villa Medici. The trunk was not to be identified with his initials. And looking ahead to his summer's duties as a civilian agent of the army, he listed the clothes to be sent to him in Paris—green knitted waistcoat, pearl gray summer suit, blue summer suit, yellow boots, summer waistcoat, tail coat, morning coat, and all his best summer underclothing and pajamas. These would supply his uniform. Thus he embarked on a role for which his gregarious nature peculiarly fitted him. The art of conversation in which he was adept might after all have practical political value.

XXIII

Domestic Crisis

BERENSON'S evaluation of Italian war aims was inevitably colored by his long-standing antipathy to Italian imperialism. The price of Italy's entry into the war on the side of the Allies had been set in the secret annexes of the Treaty of London of April 26, 1915. Italy was to receive the Trentino, the Tyrol to the Brenner Pass, the provinces at the head of the Adriatic, and Dalmatia down to Cape Planka. In 1917 the Italian Foreign Minister Sidney Sonnino openly declared a protectorate over Albania. Berenson, outraged by the move, freely expressed his disgust with Sonnino's ambitions, and his view soon got back to Carlo Placci, who promptly denounced him to his circle of friends in Florence for carrying on anti-Italian propaganda in Paris.

Placci's vehemence spilled over on Mary at I Tatti. When Berenson first heard of Placci's accusation, he had expostulated to him, "So you want me to go on with *inni ed elogi* [hymns and praises], and the whole pack of swindling lies that has brought so low the country I love best on earth, and its people whom I regard as a marvellously gifted one. . . . I do here all I can for the *real* Italy and not the pseudo-Prussia of the last thirty years." After learning of Placci's tirade to Mary he added: "It is true that on arriving here I felt so bitter against your pro-Boches on the one hand and against your Nationalists on the other that I did speak against them. . . . If your representatives here had a grain of wisdom they would instead of conspiring against me . . . attempt to use my knowledge, my authority, and my possible influence for the Italy we all love together. . . . As for you, my dear Carlo, there is in my heart under much annoyance and exasperation a profound affection for you." Placci's affection for Berenson was equally deep, and six months later when he came to Paris the two old friends "sat and groaned" together over their troubles.

In the midst of her safeguarding work at the villa, Mary received the devastating news from Geoffrey Scott that he was engaged to marry Lady Sybil. At first she put on a brave front to cover her anguish by telling Bernard she was sure the marriage would fail. But soon she was reflecting that Geoffrey would be lost to a person whose notorious affair with Bernard had publicly humiliated her. "Thee will not forget," she reminded Bernard, "that Sybil was thrust down my throat so that it is hard to get the taste of her out of it." Sybil had confided to her that "it was thy Pisgah sights" which prepared her for Geoffrey's promised land.

To complicate matters, Geoffrey, who was himself a vessel of troubled emotions, implored Mary almost daily not to abandon him. Lady Sybil similarly pleaded with Bernard to continue writing to her: "Don't give it up because I am going to marry Geoffrey." Mary's plans for somehow binding Geoffrey permanently to I Tatti lay shattered. There was no alternative but to tell Sybil as gracefully as she could that she approved the marriage. Sybil responded that, knowing how much Mary cared for Scott, "I think you *would* tell me if you thought it all very amiss."

Once more the psychological duel between husband and wife resumed. Bernard declined comment "on the you, Geoffrey, Sybil triangle." "For me," he said, "I feel deliciously, benevolently out of it, with a faint touch of irony and humor." How very deeply Mary was hurt by Geoffrey's defection she soon began to discover. In her misery she saw no alternative but to break with him. For years, she reminded him in her heartbroken reflections, they had shared all "their thoughts and hopes." Even his difficulties and love despairs "welded us together." She felt his marriage a death sentence, and, weakened by a current illness, she wished life might end "along with the best thing in my life." She could not pretend that her love for him was like that of a mother. It was "a strange creature" they had snared in the net between them. What stood in the way of their remaining friends was that he was marrying the woman she most detested in the world, one whose "unsuitable" intimacy with Bernard had dug a chasm across which Bernard and she could now only make friendly gestures.

Bernard, who too easily forgot his own suicidal despair over Belle Greene, offered no sympathy. "Geoffrey," he told Mary, "has always been an aspiring little brother of the rich and well placed." The union with Sybil would free him from dependence on the Berensons and replace it with the more acceptable dependence on a rich wife. "Your heart bleeds for the penguin escaped from under your wings," Bernard's remorseless analysis went on. He had the small grace to add, "And I am not at all out of sympathy with you."

Berenson found his work for the Army Intelligence Section much to

his taste, for it involved him in conversation with the political and financial leaders who were converging on Paris. From time to time he sent reports of what he had gleaned to Royall Tyler for transmission to the embassy. His keen relish of his task came out in his long account to Mary of his first high-level meeting on December 8, 1917, with Prime Minister Eleutherios Venizelos of Greece. Venizelos had formed a separate government at Salonika and, with British and French support, aimed to force the abdication of the pro-German King Constantine. The two men were joined by Clarence Dillon, a leading American banker and assistant chairman of the War Industries Board; Colonel Theodore Dillon, assistant chief engineer of the American Expeditionary Force; Vasiliy Maklakov, the ambassador to France appointed by the provisional government of Russia; and Sultan Mohammed Aga Khan III, leader of the Muslim minority in India and the Middle East. It was the Aga Khan who had directed his millions of followers to support the British war effort.

For Mary's benefit Bernard recounted the discussion, which Venizelos had dominated. There was a minute's embarrassment at the beginning, and Berenson, fearing "a frost," boldly asked some "whopping question." Venizelos instantly took it up, inspiring Berenson to "pose question after question." Venizelos said he had to return immediately to meet an attack on the Salonika front, an attack for which the Greek army was not ready because the Allies had delayed sending supplies. Greece, he asserted, was still being treated by the allies as a blockaded enemy, and he told of his conference with Lloyd George in which he had pointed out that his subordinates still treated the Greeks as enemies. When Berenson asked about the contention that the Greek people were not behind him, Venizelos pointed to his successes in the elections. As for the Bulgarians and their pretensions to "Balcanic hegemony," he could not understand Lord Grey's "infatuation" with them. Berenson suggested that that was in the misguided "Gladstonian tradition" of carrying on a bankrupt policy. Everyone knew Bulgaria would support Germany. Then talk turned to Rumania, and Maklakov spoke up saying Rumania could not conceivably resist a Russian attack. Having carefully rehearsed for Mary what took place, Bernard copied out what he had said about Venizelos for use in his report to Tyler. Tyler afterward told him that the report had reached headquarters and had been much appreciated.

The pattern thus established was to continue for two years. One conference or interview followed another, accompanied by a succession of political and society luncheons and dinners. Notes and visiting cards piled up, witnesses to scores of conversations with envoys, ministers, heads of military missions, and members of the French cabinet. Berenson

met with Eduard Beneš of Czechoslovakia and became a friend of the exiled Kerensky. All was grist to what must have been a series of voluminous reports to the Intelligence Section, reports now buried in the War Department Archives apparently beyond the reach of its employees. It was to be for Berenson a remarkably life-enhancing existence: an encounter with Jules Cambon, secretary-general of the Ministry of Foreign Affairs, might be followed by one with Henri Bergson or the anthropologist-geographer Jean Brunhes, professor at the Collège de France. Joseph Grew, acting chief of the Division of European Affairs in the State Department, came by for talk. Before the war he had been the chargé d'affaires at Vienna. Like many another visitor he began a long friendship with Berenson. Henry White, former ambassador to France, whom Berenson had known as a member of Henry Adams' circle, was soon to make an appearance as a member of the American Peace Commission. Berenson also maintained contact with Ambassador Joseph E. Willard, who came up from his post in Madrid.

During the early weeks of 1918 the prospect of an Allied victory remained in doubt and the transport of American troops and materiel to France on a massive scale had yet to be managed. The French and British pressed the American command to supply reinforcements to their terribly battered units rather than wait, as General Pershing was insisting, for the creation of an army under the American flag. In the midst of divided counsels and in the absence of a unified command, the European Allies could not bring themselves to enunciate a statement of war aims that might unite world opinion against the Central Powers. President Woodrow Wilson on January 8 decided to implement his pledge to make the world safe for democracy by dramatically issuing his Fourteen Points as the basis for peace. The underlying theme was that peace should be unselfish, just, and impartial. For the Allied statesmen there was no choice but to appear to support Wilson's idealistic program as the price for American intervention.

Like many other high-minded Westerners Berenson embarked on his duties in the service of the "crusade" against the Boches and their hated minions with only a slight perception of the jungle of cross purposes hidden beneath the Allied acceptance of "war aims." The claims of the Italians under the terms of the "secret" London Treaty, which by now were common knowledge, were to prove but the first installment in the catalogue of sordid agreements. Berenson's many months in Paris gradually became an education in disillusionment.

Berenson found himself "fearfully active," going from one political luncheon after another with no time for writing anything, "except rubbish of a highly impersonal nature and uttermost futility." To Barrett

Wendell he was soon confessing that it was not so much the military disasters "due to British folly" that depressed him as the muddle of political matters which made him "at times doubt whether in ultimate aim there is all the fundamental difference between the two camps of belligerents that I had innocently believed." He was also finding that members of the American colony openly sneered "at our ostensible aspirations" and boasted that "they cover 'healthy' annexationist intentions. If I thought so I should give up the ghost. Were this war to end in a mere shuffling of the cards, in an unchanged lust for subjugation, this earth would be no fit home for the likes o' me."

While the armies measured their bloody gains in a matter of yards, new weapons were introduced to terrorize civilians far from the battlefronts. Berenson became accustomed to taking cover when the sirens blew in Paris. On one sortie German planes managed to drop seven bombs, killing twenty-four persons and wounding sixty. Even more sensational was the emplacement of an enormous long-range cannon behind the German lines that was able to drop shells on Paris from forty miles away. The press promptly named it "Big Bertha" after the wife of the inventor. "The air raids rather excited and keyed me up," ran one of Berenson's reports.

His long reports to Army Intelligence often took hours to draft. Other hours saw him closeted with Allied journalists to avoid "the worst of all moral tortures . . . the ever increasing and never ceasing sense of impotence." Listening to Otto Kahn at a gathering, he thought "it was just a shade painful to hear him talk against the Germans with an accent that still betrayed his origin." It was Kahn who had been doing much to rally German-American support for the war effort, addressing mass meetings in the heart of German-American centers like Milwaukee on such topics as "The Poison Growth of Prussianism."

Though much of Berenson's time was taken up plying statesmen and politicians with his diplomatic queries, there were frequent intervals for his social existence. He was Edith Wharton's favorite dinner companion, often dining with her tête-à-tête. On one occasion he made her "scream with laughter" by giving her "a truthful account" of his and Mary's hostile first impression of her. She confided that she had been overcome with shyness though she had longed to meet them, and she "moaned thinking of the years we lost." The home of her friend Walter Berry was another center. At a dinner party there which sparkled with a "Cleopatra-ish" female and the Aga Khan, Berenson first met the "pilgrim of the night," Marcel Proust. It was eleven o'clock, Bernard reported to Mary, when there "entered a dark rather long-haired man—obviously of letters—and [he] was introduced as Marcel Proust. In voice

and diction singularly like Montesquiou. We exchanged compliments and he assured me that my books had been bread and meat to him. . . . I confess I often wondered while reading *Du Côté de Chez Swann* whether my books had not influenced him."

Proust had long known of Berenson's early writings on the painters of the Italian Renaissance, having become a devotee of the early Italian painters from his addiction to Ruskin. Like a pupil of Berenson he would undertake a journey simply to study a single painting. He wrote to his friend George de Lauris in 1906 that he once asked Ruskin—"his work and not his spirit alone"—what he thought of Berenson. He gathered from Ruskin's writing that more important than a correct attribution was learning "what either the master or his work was good for." "All the same," said Proust, "I would very much like to know Berenson." And he inquired in the same year, "Have you any idea of Monsieur Berenson's fortune (*dans le sens le plus vulgaire du mot*)? I will tell you why it interests me and I would also be glad to know what there is of Berenson in French or translated into French." Louis Gillet's translation was years in the future, but as a contributor to the *Gazette des Beaux-Arts* Proust could have had convenient access to Berenson's many articles in that periodical. Why he wanted to know how rich Berenson was, was never revealed in his published correspondence. Berenson was already a legendary figure in the Paris beau monde at that date, and Proust may well have been curious to know how an art critic like Berenson could afford to move in the affluent circles that Proust himself frequented.

Parisian friends invited Berenson to meet Aleksei Peshkov—"Maxim Gorki." As he and Gorki strolled home together the evening after their meeting, the sense of their distant homeland seemed to draw them together and Berenson mused, "What a dear creature he is!" The unpredictable Gorki, though himself an ardent revolutionary, had stormily criticized his friend Lenin's tactics and the excesses of the Bolsheviks. He had come to Paris, however, to use his great prestige as a literary figure to oppose the threat of foreign intervention. Reconciled with Lenin, he returned to Russia to devote himself to preserving its cultural and artistic heritage.

Berenson saw much of his friend André Gide, who he thought was not at his best on art. One day he took him to the Durand-Ruel art gallery to see the contents of the studio of Degas, who had recently died. The art chatter of the crowd annoyed Berenson, and his "picture soaking" was constantly interrupted by acquaintances; he went away with a sense of having been "baffled" of his purpose, a feeling compounded later at a gathering where the talk about Degas exasperated him. "We kill the

thing we love," he fumed. He felt more at home in the company of the novelist Paul Bourget, who was "at his best very profound," as when at the salon of Rosa Fitz-James he conjectured that Richelieu had founded the French Academy because "he realized that literary people were dangerous folk who had to be tamed."

Occasionally Berenson escaped for a few days of convivial distraction at Elsie de Wolfe's Villa Trianon. There he felt himself back to his "real self . . . in the midst of visual values that call back all that I have striven and lived for." Troops of callers filled the exquisitely furnished rooms till late in the evening. General Tasker Bliss, United States Army chief of staff, "a simple nice old boy," talked to him about the uses of the "regimental bands," but far more interesting was an "enchanting rather negroid youth named Cole Porter," who "improvised ragtime music and words really droll." The meeting with the composer launched a friendship that lasted for forty years.

With the war drawing to a close, Paris became a magnet for old friends and acquaintances, and these required cultivation. The Roman Duchess Grazioli, who used to entrance him at St. Moritz, joined him at lunch with Gladys Deacon's sister Dorothy Radziwill, the Spanish painter Ignacio Zuloaga, and the Russian correspondent of the London *Times* Emile Joseph Dillon, who was, according to W. T. Steed, "the ablest, most cultured, and most adventurous newspaperman I have ever known." Dillon undoubtedly interested him most, for not only was he an authority on Russia, he also had friends among all the leading statesmen of Europe. "It is a fair sample," Berenson reported to Ralph Curtis. "I have literary greats and at times scholars, but generally war men like *Myself.*" Among the more agreeable of the "war men" was his friend Eric Maclagan, art historian and museum curator, who had become head of the Paris bureau of the British Ministry of Information. Like the "unemployed old sinner" Ralph Curtis, he had "a pretty nose for entertaining indecencies."

Fortunately for his peace of mind, Mary remained at I Tatti until the middle of February 1918 looking after their treasures in the intervals when she was not ill in bed. With faithless Geoffrey Scott off in Rome, she had only Algar Thorold for companionship. He had taken up Buddhism and soon had Mary grasping at that straw for consolation. Bernard scornfully commented, "What utterly formless, shapeless, flatness, all that Buddhist literature is cursed with, compared with our Bible for instance or even the Koran." With much time to brood on her grievances, Mary unceasingly rehearsed them all for him with her usual prolix eloquence. In his own justification Berenson insisted that he had

been "on affectionate terms to the very end with Geoffrey." As for Lady Sybil, "one of the most enchanting moments in my life was when I learned that Geoffrey had taken her to his bosom."

Life in Florence had been appallingly dull for him, Bernard reminded her, and gave "insufficient experience and exercise" of his social instincts, and in their little world Sybil was the least impossible person. "Besides she had an attractive house at the distance of a pleasant walk." Her means and her literary interests made her companionship easy and desirable, but "I had enough of it long ago. Then came the 'tyranny of tears' and the coward fear of giving pain. . . . But one thing I never could or would conceal from her and that was that I could get on very well without her." He urged Mary not to cut herself off from Geoffrey, and he proposed the very role which Geoffrey had offered, that she continue as his "mother confessor."

In spite of Mary's many pathetic entreaties to join him in Paris, Bernard pressed her to remain at I Tatti until she was recovered in health. The prospect of her coming to Paris in her anguished state as a semi-invalid alarmed him. And as if to placate her, he redoubled his endearments, only to have her protest she would be happier if "there was some 'distinction of quality' between the nice things said to a wife and those to a mistress." Finally he yielded assent to her joining him, and Louis Duveen promised to see "that Mrs. Berenson has every assistance possible on her journey to Paris."

Mary established herself in his apartment at 40, avenue du Trocadero, in mid-February. Unfortunately Bernard had now embarked on a thrilling new affair with Baroness Gabrielle La Caze, an emancipated cosmopolite who had conceived a boundless admiration for him. A highly cultivated and fun-loving person, she was the center of a group of scholarly intellectuals which included "the mediaevalist Joseph Bédier, the geographer Jean Brunhes, the Sinologists Sylvain Lévi and Paul Pelliot," and her overtures proved irresistible to Berenson. He was like the guest in the medieval fable, as Nicky would one day write, who "liked to have the roast pigeons fly into his mouth." In the intense glow of his new attachment, he was unwisely moved to ruminate to his distracted wife that all he would care "to take from this world to the next" would be the "memory of [her] young eyes, of Miss Greene's, and of Madame La Caze's . . . at a sexual crisis." The Epicurean appraisal haunted Mary for many months. Coming in the midst of her illness, she felt it "destroyed her universe." The effort to keep up appearances proved beyond her strength at fifty-four. Her condition steadily worsened and her nervous depression over the loss of Geoffrey, whose marriage to Sybil was to take place early in May, became so intense that, according to family

report, she attempted to throw herself out a window. Her daughter Ray came over from England to take her to a London hospital, her state being such that she had to be drugged for the departure ("chloroformed," as she afterward recalled).

Her emotional and physical suffering continued—anguish over Geoffrey's marriage and despair over Bernard's rejection of her and the prospect of undergoing an operation for her female ailments. But neither anguish nor pain could interrupt the torrent of letters. "If it weren't for thee," she wrote Bernard, "I should cry upon death to deliver me from the horrors of life." She thanked him for the gentleness he had shown in Paris and added that should she have an " 'accident' as a result of the operation please remember always that thee gave me a very happy and interesting 26 years for which my soul is now full . . . of understanding and appreciative gratitude."

The inflammation which followed the operation brought "mental and emotional pain beyond description," and yet strength remained to try to put it into words and to adjust accounts between them. Bernard wondered, for example, what confidence of theirs she had shared with Geoffrey, and she frankly admitted that to allay Geoffrey's fear of "not finding Sybil possible sexually, I did permit myself to reassure him on that point from what you said about her being *très accomplie au lit*." However rationally she sometimes wrote, it was obvious she was in the midst of some sort of nervous breakdown, and Bernard, who felt certain his presence would only exacerbate it, kept putting off going over to England. Much to his relief, Mary had taken refuge in a sanatorium, instructed by him to spare no expense for her treatment.

His work for Army Intelligence was of a sort to give full play to his passion for human society. "Nearly every meal is still a symposium," he exclaimed to Ralph Curtis in a style to match Curtis's jocosity, "and every tea a flow of soul." "In the evening your so fragile furniture almost broke under the weight of discourse between the Russian ambassador, Otto Kahn, [Maurice] Pernot, and [Arthur] Raffalovich. . . . Troy is burning and Sparta starving while Clytemnestra is preparing a bath for Agamemnon and Aegisthus lurks in the shade." At a luncheon with the Abbé Mugnier and the former ambassador to Russia Maurice Paléologue, he heard "wonderful tales of Hugo, Renan, Chateaubriand, and Ste. Beuve." At this or another meeting with Paléologue, he seems to have freely expressed his heterodox opinions about European politics. They were opinions that did not sit well with the ultraconservative French diplomat. He did not forget them and three years later, to Berenson's considerable embarrassment, he passed them on to the United States Naval Intelligence in Paris during the "Red scare."

[237]

There came a lull in Berenson's official duties that spring during the tense months of the great German offensives with which General Ludendorf hoped to break the stalemate on the western front. For the time being the chief concern of the American command was to deploy the divisions that were arriving in France. As there was nothing he could do to help in that enterprise, Berenson made plans to go to the Pyrenees with Madame La Caze, whose ardent missives challenged action. He broached the matter to Mary with his usual remorseless frankness. In her nervous, disordered state she was at first reconciled to his going. She thought it unlikely that he would give up "love affairs for years to come (why should you?)"; hence she would try to cultivate "the surface indifference" which had worked "moderately well." A few days later, however, she threatened to kill herself if he went off with Madame La Caze. The threat, and a telegram from her doctor, brought him to his senses, and he promptly wired that he would cross to England on June 20.

In order to travel in wartime he had needed to bring his papers up-to-date. In his application for registration as an American citizen of alien birth, which had gone off to Florence for Consul Dumont's signature, he described himself as "art connoisseur and expert" whose "legal domicile" was in Boston, where he paid his American income tax, and whose "temporary local address" was the Villa I Tatti, Settignano. In place of the easygoing standards of the past, the applicant had not only to affirm his "desire to remain a citizen of the United States and intent to return thereto permanently" but also to state when he would return. Berenson gave "two years, or when my business shall permit." So armed he hastened to London.

10. Two of the four René Piot frescoes at I Tatti

*11. Corner of main library,
built 1909*

12. Last addition to library (second-floor stacks), about 1950

*13. Salon with Sassetta panels
from* St. Francis *polytych*

14. Reception salon

15. Berenson with Barbara and Ursula Strachey, 1919

XXIV

"The Dragon's Eggs"

BERENSON established himself in a comfortable flat in St.
Leonard's Terrace in the Chelsea district of London and em-
barked, full of misgivings, on the role of comforter to Mary.
To his mother on his fifty-third birthday he wrote, "I have given up my
busy, interesting, and enchanting life in Paris to give myself up to her
entirely." He did in fact spend much time with her, but he also got away
for a delightful week in the countryside where life was "so comfortable
and deliciously restful to old bones." Though at first he felt a lack of zest
to plunge into society, having been away from London for nearly four
years, he was soon seeing people from the American embassy and many
of his English acquaintances. London at night in the "black-out . . . had
an eerie aspect" and rationing and restrictions made entertaining some-
what difficult, but he found his friends "easy to please."

Some of his time in London had to be spent in the art trade, for his
expenses and those of his dependents continued to mount. During the
winter and spring of 1918 in Paris he had occasionally conferred with
René Gimpel and other dealers, but his chief professional work con-
tinued to be with the Duveens. Though the contract with the firm had by
its terms expired in 1917, business was being carried on as if it were still
in force.

Requests for his expert opinion came at frequent intervals from the
Duveens as the firm sought to increase their stock. In the first months of
1918 he was asked to pass on the authenticity of more than a dozen
paintings. Berenson met with Joe Duveen and found him looking "tre-
mendously fit." Joe told him that Uncle Henry, who was very ill in New
York, was probably dying, but assured him that his disappearance from
the firm would make no difference to business, which was excellent. He
boasted that Frick was in his pocket and the Huntingtons too. In London

Berenson also renewed his acquaintance with the art critic Charles J. Holmes of the National Gallery, whom he went to see to refute the charge made by the gallery's "practical wood expert" that a famous *Madonna and Child* he had assigned to the fifteenth century was painted on American basswood. The painting had been quietly withdrawn from exhibition. Berenson was unable to win him over. Several years later scientific investigation established that Berenson was correct: "the wood was 450 years old and not 50."

Away from Mary, whose moods swung disconcertingly from "deepest despair to cheery hopefulness," Berenson fell back with relief to the pleasures of London life that centered about the famous hostess Lady Sybil Colefax. At one of the dinner parties at which he was host he gathered together a choice company of old friends, Gilbert Murray, Lawrence Binyon, and Percy Lubbock. George Moore joined them and gleefully outraged everybody with his "half naughty" and perverse way of talking about literature, especially about Russian literature. Turgenev and Tolstoy "spoiled everything with moral prejudices" and Dostoevski was simply "confused." Murray concurred, saying that he had read *The Brothers Karamazov* "twice with increasing disgust." Berenson enjoyed several days with Santayana, whose philosophic flights continued to puzzle him. "More than ever he is one of the gods of Epicurus," he reflected, "but with a penetrating subtle yet vigorously constructive mind." Santayana had saved enough money to resign his uncongenial role as a professor at Harvard and, having been caught in England by the outbreak of the war, was much relieved to settle down in Oxford.

Berenson returned to Paris on October 1, 1918, leaving Mary in the care of Logan and Alys in their home at Chilling on the coast of the Solent. The two had set up house together after Russell abandoned Alys in 1911. Berenson could not afford to remain in England, he explained to Mrs. Gardner, and pay income tax there "on top of all I pay at home and in Italy." On the day he left he wrote Wendell that the end of the war seemed at last in sight, for Bulgaria had surrendered. The previous year Wendell had retired, broken in health, after forty-five years at Harvard as student and teacher. Berenson urged him to write his autobiography, adding, "I dream of doing something similar." He thought that his by comparison would be "thin and meagre . . . and yet I too may leave a book of some value."

The mood in Paris was far different from what it had been in June when he left. The expectation of victory was in the air. Marshal Foch had launched his great counteroffensive in August, and the American armies had reduced the St. Mihiel salient. Under the overwhelming assault of the French, British, and American armies the Hindenburg line had

crumbled from the Channel to the Vosges, and the ravaged cities of Belgium and northern France welcomed their liberators. The German request for an armistice was turned over to the Inter-Allied Conference which had been set up at Versailles, and the terms of what was in effect unconditional surrender were worked out. The German delegation did not reach the French lines under a white flag to accept the onerous conditions until November 7, 1918, the Austrians having already signed an armistice with the Italians on November 3, and the fighting was abating on all fronts.

As the complicated drama began to unfold in Paris, Berenson found himself sought out by participants in the many rival negotiations, and he lent a willing ear to the tales of the secret machinations among the powers. He resumed his daily "chronicle" to Mary with hardly a break, always recounting, after disposing as best he could of her criticisms of his behavior toward her, what he had picked up concerning political developments and contentions over the division of the spoils. He learned, for example, that when Alexander Kerensky escaped from Archangel in disguise, he had been landed in England. His arrival had been kept secret because negotiations at that time were being carried on with the Bolsheviks. When the negotiations broke down, he was dramatically ushered to the fore. A charismatic figure in the opening months of the Russian revolution, Kerensky had been a prominent lawyer who had joined the cause of reform as a moderate socialist revolutionary. He had risen to prime minister of the first provisional government after the fall of the czar in February 1917.

On October 30, 1918, Kerensky wrote to Berenson that he was alarmed by reports that the United States "is supposed to refuse the recognition of the Provisional Government re-established at the National Congress and insists even on the cessation of the future development of the allied operations in European Russia." He deplored the absence of Russia from the Allied War Council, which was discussing the provisions of the armistice, and warned that a feeling of mistrust of the Allies was being created "which will lay the foundation for new severe international conflagrations. . . . I am convinced, dear Mr. Berenson, that you will use all your influence and that you will help Russia with all your energy."

Neither Siberia nor much of European Russia had yet come under the control of the Bolsheviks, and civil war was in progress. The refugee members of the provisional government had set up a democratic anti-Bolshevik government, and as its representative Kerensky sought de facto recognition for it by the British. The Allies, however, had different aims and supported Admiral Alexander Vasilievich Kolchak and the re-

actionary elements led by Anton Ivanovich Denikin. That policy, Kerensky warned, would assure the ultimate success of the Bolsheviks. What most shocked him was the discovery that immediately after the collapse of Russia the British and French laid plans for the dismemberment of Russia into spheres of influence. Even while Kerensky's plea was in Berenson's hands, the United States had already agreed to join the Allies in sending troops to collaborate with Kolchak, who had gathered around him "the forces of the Old Regime." Berenson's virulent anti-Bolshevik attitude would seem to owe much to his friendship with Kerensky, with whom he kept up a correspondence for a number of years.

Of equal concern to Berenson was the future of Italy's relations with her neighbors on the Adriatic. When early in October Berenson had a luncheon meeting with two members of the about-to-be-created Jugoslav government, Ante Trumbić, the prospective minister of foreign affairs, and Petar Jovanović, the prospective secretary in the Ministry of Foreign Affairs, Trumbić impressed upon him the difficulties that lay ahead because of Baron Sonnino's unyielding desire to control the Adriatic shores. He predicted that bad blood between the Italians and the Slavs would be bound to persist.

Paris swarmed with fellow Harvard alumni, and Berenson enjoyed the thrill of a reunion dinner at which scores of them appeared in khaki. When he visited the pleasant little house of Brand Whitlock, the refugee American ambassador to Belgium, he was rashly assured that the Flemish separatists, whose dislike of French culture was deep-rooted, had no political influence. That impotence was not to last. Often the host at luncheon meetings, Berenson commanded a wide range of political and social gossip. At one gathering Jean Cocteau brought rumors of possible armistice terms as well as the piquant news that Marie Murat was to be D'Annunzio's next mistress and the more improbable information that the flamboyant poet was coming to Paris as an agent for aircraft firms.

Weekends with Elsie de Wolfe and her diverting entourage at the Villa Trianon had their special charms and they also provided a useful listening post. While at the villa he learned that someone at the Council at Versailles had asked that Italian troops be allowed after the armistice to occupy all the lands claimed in the Pact of London. It was enough, he said, to "make one regret almost that the Americans came into the war." Ward Cabot told him Marshal Foch had "implored" that the armistice be delayed for five days; he could then "guarantee no German army would remain." Wilson would not hear of it, perhaps, Berenson thought, because he dreaded a too-complete victory which would remove all restraint upon the greed of the Allies. General Pershing had also protested

that the proposed armistice was premature. Foch, as head of the Supreme War Council, set the draconian armistice terms, and these were perforce accepted by the United States.

On November 11, 1918, the guns at last fell silent and the German envoys signed the armistice document in Marshal Foch's railway car in the forest of Compiègne. Colonel House cabled to President Wilson, "Autocracy is dead. Long live democracy and its immortal leader." All the pent-up expectation burst out in tremendous emotional demonstrations in the streets and squares of Paris as everywhere else in the Allied world. Strangers embraced and danced in jammed streets. Two days earlier the disenchanted Berenson had expressed his dread of "all the follies that will now lay the dragon's eggs to be hatched as the years go by," a dread which "takes away all the satisfaction I might have for my conceit in having always believed in our victory." He was overcome with sadness at the sight of the "people bawling, squealing, tooting penny whistles, making every kind of animal noise." He suddenly felt alone in Paris and was overcome by "a dreadful fit of convulsed sobbing."

Members of the Duveen firm had already gathered in Paris, confident that peace would open the floodgates releasing European art for their money-burdened clients in America. They were polite to Berenson but had little time for him. "I am drifting," he told Wendell, "living in a state of humiliating impotence, owing to too absorbing an interest in public affairs." He was obsessed with the thought that Europe was "swinging back so surely to the glorious and predatory past" and that "the harvest of the war will be as poisonous as its conduct has been murderous." But impotent or not, he felt a compulsion to "meddle" in the tumult of politics that swirled about the Quai D'Orsay, the Palace of Versailles, and the hotels that overflowed with delegations and hundreds of omnipotent journalists.

The commotion soared to fever pitch with the arrival in France on December 13 of President Wilson, hailed by delirious crowds as the savior of Europe. But the worldly-wise members of the American colony did not share the enthusiasm of the crowds. Cynical pragmatists, they insisted that "European affairs were none of America's business." To Mrs. Gardner Berenson admitted that he thought it a pity that "Parsifal" Wilson "could not remain in the Sinai of the White House thundering forth commandments . . . which were truly admirable, noble, and of constructive benefit. . . . Gods should not leave their heavens."

With H. Wickham Steed, foreign editor of the London *Times*, Maurice Pernot, and Walter Lippmann, Berenson set up a weekly political luncheon to which each of them brought one or two others. Lippmann was

to prove an especially valued friend. The brilliant young author of *A Preface to Politics* had in October of 1917 been recruited as one of Secretary of War Newton Baker's secret intelligence team, vaguely called "The Inquiry." A strong supporter of Wilson's pacific war aims, he had helped prepare a memorandum, "The War Aims and Peace Terms It Suggests." In Paris he had been called on by Colonel House to prepare a detailed explanation of the Fourteen Points and especially of the proposed League of Nations for presentation to the Allied armistice commission, but his liberal views prevented his being given a place on the American negotiating team. Shunted off to routine assignments, he rapidly grew disillusioned with the peace process and his role became less that of agent for Baker and House than that of an investigative journalist. Thus from different sectors of Army Intelligence the two idealists, Berenson and Lippmann, made common cause.

As Berenson sized up Lippmann after their first meeting, he saw a face "curiously full of power and calm and depth." Later they had an "almost heart to heart talk" and Lippmann "revealed himself, on matters international at least, entirely of our way of thinking," Bernard reported to Mary. "He has a loathing of propaganda which he declares has inevitably been turned into an instrument for reaction and annexationism. I hope that his solid common sense in loathing everything imperialistic and his hatred of all militarism will pull him through." He feared, however, that "his opinions may matter as little as mine. . . . It is too late for opinions or ideas."

With the war over, Elsie de Wolfe's hospitable villa provided a refuge on weekends for many of the high-placed officials who eagerly welcomed a change from Paris tables d'hôte. The company at the villa was "boisterous and in high spirits," with the irrepressible Harry Lehr, former arbiter of New York high society, setting the pace. When the crowd went off to a dance, Berenson stayed behind to talk with General Thomson, who "aired his strong Bolshevik sympathies." They were sympathies that Berenson vigorously rejected, and he wrote to Mary that most of the Bolshevik "leaders are Jews filled with hatred and resentment and bloodthirstiness." Sitting beside the Aga Khan at luncheon, he listened skeptically to his professed interest in Bertrand Russell's philosophy. "I doubt whether he has read a page of him," he commented. During a talk with Melchior de Polignac he was told that "the wave of fierce chauvinism that had overwhelmed France" on the eve of President Wilson's arrival was engineered entirely by Georges Clemenceau, who was living up to his sobriquet of the "Tiger."

The company at the Villa Trianon weekends almost always had its mixture of literary as well as military and political figures. On the eighth

of December, for example, Jean Cocteau shared the stage with Robert Trevelyan, Augustine Birrell, and Royall Tyler, who had been recently promoted to captain. Berenson tried without success to keep the party French-speaking, and Cocteau was "snowed under." Cocteau took some of them to a dealer to see a large *Madonna and Child* by Picasso, which Berenson thought nearly as good as a Jordaens. The dealer also showed them a little Ingres, "as lovely as any Raphael." It was a painting, Bernard said, "I would have acquired at any price before my confidence in all sorts of things was shaken."

As he contemplated the influx of thousands of emissaries from all the governments of the victors, the vanquished, and the newborn countries, accompanied by "un-commissioned interlopers" like himself, Berenson wondered whether as much as "one percent of the Wilsonian program will be realized in practice." While the stringent terms of the peace were being drafted by the Supreme Council at Versailles and the maps of national territories were being redrawn, the principal activity on the periphery of the deliberations was talk—endless, unceasing, and argumentative. Every political claim had its high-placed advocates who urged their proposals upon the foreign officers.

At one meeting an array of eminent persons was harangued by ex-foreign minister Gabriel Hanotaux on his solution for the German question: prolonged occupation of the Rhineland. "Hanotaux held forth all the time," Berenson reported, "making it impossible for others to talk and he uttered such monstrous nonsense about Germany that I marvelled how such a swinish chatterer should have attained such authority and reputation." Hanotaux asserted that the Germans were not really beaten: they had stopped only when "their comfort and ease and well-being" were menaced. He had already submitted to the Ministry of Foreign Affairs his proposal to "free the populations west of the Rhine from Prussian tyranny." The occupation of the Rhineland and the Saar took place soon afterward.

With the signing of the armistice travelers could once more cross to Europe in safety and old ties could be reestablished. As he made his social rounds, Berenson one day encountered Aileen Tone, who had returned in the company of the political and social leader Mrs. J. Bordon "Daisy" Harriman. From Miss Tone he could learn the details of the last days of his old friend Henry Adams, who in the spring of the year had died in his sleep at the age of eighty. Disillusioned and pessimistic, he had been "anxious to go." She had ministered to him to the end and as a pious Catholic had arranged the room in which his body lay as a "chapelle ardente" with burning candles. For Berenson as for Edith Wharton, Adams' passing broke a much-treasured link with the past. Berenson had

greatly admired Adams, even while he sensed a certain distance between them. He felt indebted to the old man for having aroused his interest in the Middle Ages, and in after years he came to think of himself as his disciple.

Berenson kept up his tantalizing relation with Natalie Barney, mixing, as he said, connoisseurship with Lesbos. She seemed to him to know everything and understand everything "although she has studied nothing." Edith Wharton in ʾited him to dine alone with her on Christmas Day, and the following day he was again at Elsie de Wolfe's villa. There some forty guests listened to Cole Porter sing "some of his delicious songs" and Elsie gave a dramatic reading. After luncheon the celebrants danced while Berenson observed: "It gladdens my senile heart to see people amusing themselves so innocently and spending their energy so unproductively."

Seething beneath this glamorous and diverting life of politics and society and hidden from all his friends, except sympathetic Edith Wharton, was the lacerating debate with Mary, who bitterly resented her exclusion from his company. As she nursed her grievances, she brought up the one that had most deeply wounded her self-esteem, his reminiscence earlier in the year of the most exquisite sexual experiences of his life. He conceded that it had been a foolish thing for him to utter those "unfortunate words," but argued that they were "loathsomely untrue in the sense that your disordered spirit insisted in giving them." He implied that he had simply intended an aesthetic observation such as he might have made of supremely great paintings. "Were I sure that the real trouble between you and me was over that matter, I could undertake never again to have sexual intercourse. But I cannot forego what amounts to a real need, for a certain kind of society and social amusement. When I am not absorbed in work I love to go out, to see pretty women, to have illusions about their power of understanding and appreciating what I like to say. I love as well to take part in society life and feel that there I am realizing a big part of myself." Hence he feared that since she abhorred that life, it would be folly to have her in Paris with him.

If he admonished her to conquer her jealousies and half-mad discontents, she for her part and at even greater length depreciated his political activities and his susceptibility to female charms. "I am inclined to think," she wrote, "that in spite of thy historical knowledge, or perhaps because of it, thee is not likely to make a mark in practical politics, where thy vehemence puts everyone of the opposite way of thinking. . . . I think the sooner thee gets out of it the happier thee will be." And as for his pleasure in the festivities at Elsie's Villa Trianon, she thought she could view them, if not for her intense "nervous suffering," as "leniently

and amusedly without any more disgust than one gives to the contemplation of the habits of strange beasts and insects." Nevertheless, she insisted, she longed for his society. He objected that in a Paris overrun by delegations there was "not a hole in the wall to be had."

She received an invitation from Elizabeth Cameron to visit her at year's end at Stepleton House at Blandford. But Stepleton House proved an uncheerful refuge, for the death of Henry Adams had been followed a few months later by the death of Elizabeth Cameron's husband and by the death of her daughter, Martha, the last so crushing a blow that Martha's gravesite on the grounds of Stepleton House became an altar on which Mrs. Cameron sometimes flung herself. Mary soon returned, therefore, to Hampstead to stay for a month with her daughter Ray, who was much occupied with her unsuccessful bid for a seat in Parliament, a bid wholly financed by Berenson.

Bernard's coolly rational explanations for keeping her at a distance gave Mary as little surcease as his denials of being in love with another woman. "Although I am very fond of one or another and still another," he said, "not one would keep me, nor indeed my love of the life I live here. . . . I cannot join you, as I long to do, while you are capable of getting poisoned by a casual harsh or searing word of mine. Nor can I join you while you insist on giving my amorous adventures the importance that you do in the history of the past twelve months." Women, he said, took little of his dreams and none of his thoughts "except as they are human, adolescent-minded and attractive . . . machines of pleasure, and sleeping with [them is] seldom the goal of my relationship or even the accidental end."

In one of her letters she admitted to having felt "jealousy, hatred, and gnawing envy." Bernard thereupon admonished her that if she would now fight against those sins, she would become "a far more interesting, more companionable person. . . . Hitherto you have been a child, a mere animal, delightful and sustaining and comforting but only, or little more than, as a physical force. Of the deeper realities of humanized people like myself, of people shall I say with souls you would not hear." Cut to the quick, Mary jotted in the margin, "My God, his conceit, selfishness, snobbishness. Good heavens, what a revelation of self-satisfaction and cruelty to me. I wish I were dead. I have never known him." She fortunately did not communicate her private outrage, and their exchange subsided into less turbulent psychologizing.

In the midst of their most recent recriminations, Bernard told her of receiving an official invitation from the duke of Alba for the two of them to go to Madrid in May to "help them hang the Italian pictures in the new rooms" in the Prado. Mary quickly agreed, but then, remembering

the proposal he had once made when Belle Greene came to Italy, she added that she would be delighted to go but not as a chaperon to another of his loves. Her unsettled emotions remained a stumbling block to her joining him in Paris, and she finally consented to return to I Tatti late in February 1919 to "untie the knots," as Bernard told Wendell, "our 'estate' and household have wriggled themselves into during our long absence."

The voluminous letters of the acrimonious year-long debate between the two adversaries were carefully filed away by each of them to join the thousands which had preceded them, as if life depended on their being kept for posterity. No despair would tempt them to destroy the life record that each entrusted to the other. Time in its flight might wait for no person whom it hustles off to oblivion, but their written words might prolong their earthly identity.

X X V

Spoils of War and Art

I N mid–October of 1918 Frederick Sherman brought out Berenson's *Essays in the Study of Sienese Painting*. It gathered together the articles he had published during the preceding year and a half in American, French, and Italian periodicals. The ninety-four pages of text embellished with sixty full-page illustrations demonstrated the lines of filiation among the Sienese artistic personalities.

The chief instrument in his researches, Berenson explained in the preface, was his reliance on chronology: "Never have I thrown my nets so wide or been so painstaking in gathering up the facts that go towards determining a date." To illustrate that more was needed for the understanding of a painting than rapturous contemplation, he recounted a disarming anecdote. Once as a beginner in a gallery in tow of his mentor—perhaps Richter or Frizzoni—he had gushed with emotion before a painting. His companion, who "perchance, was growing impatient with my neophytic aphasia," cut it short with "Yes, yes, but please observe the little pebbles in the foreground." Among his intimates, Berenson concluded, " 'Observe the little pebbles' has become a phrase for all detailed, at times ludicrously minute, comparison upon which so large a part of my activities are spent."

The book was reviewed in both America and England, and generally with appreciation. Walter Pach, writing in the Chicago *Dial,* thought that though "the ordinary student of art" might not be equipped to evaluate the arguments, he could "enjoy with the critic the zest of his researches and the ingenious fitting together of fragments which reconstitute some lost personality of the quattrocento." The writer of the review in the London *Times Literary Supplement* observed that "of all the papers in the book, the most instructive in its drawing of fine distinctions . . . between the work of a master and that of a close and intelligent

follower" was the concluding one on "Guidoccio Cozzarelli and Matteo di Giovanni." In it Berenson had revised his attribution of one of Henry Walters' paintings, assigning it to Guidoccio, Matteo's pupil. "Mr. Berenson makes out a good case for his surprising change and in doing so gives this volume the piece of criticism which will perhaps prove to be its permanent attraction."

The change of attribution appears not to have disturbed Walters. "I have enjoyed immensely your interesting analyses," he wrote Berenson, "and the delightful way in which you are always able to present even the dryest facts." Walters, who had retired on the first of the year from the wartime Railroad Administration in Washington, reported that he knew very little about current art matters in the United States, for he had been careful to keep himself "out of the way of temptation." He declared, however, that the new tax laws would have a serious effect "on some of us who have been collectors, in that our ability to purchase will be so much curtailed." As for President Wilson, who had arrived in Europe, he thought him "unfortunately a little too much a Socialist, with theories that are beautiful, but not all of them practical."

It was becoming all too clear that Wilson's ideal of a just peace with "covenants openly arrived at" was suffering the usual fate of an admirable theory confronted by an implacable fact. As the disillusioned Colonel House would write, "No tribal entity was too small to have ambitions for self-determination." During the months after the armistice, rumors of Wilson's difficulties eddied about Paris "in the gilded salons of the great," and it was being said, as Berenson facetiously recounted to Ralph Curtis, "that Parsifal has fallen victim to the flower maidens, and that is why he occasionally plays the role of Titurel." He regretted that the "author of *The Spoon River Anthology* is not here to write epitaphs of all and sundry."

In January 1919 with the approach of the first plenary session of the Peace Conference at Versailles, the behind-the-scenes confidences to Mary grew more portentous. Sonnino, ran Bernard's comment, seemed to be "having it all his own way, secret diplomacy, no recognition of Yugo-Slavia . . . and his rival Lenin . . . is tramping westward and southward but likely to lose Petrograd and even Moscow." To Mary's entreaties that he return to Florence he remonstrated, "I do not see how I can tear myself away now at last when I am going to have a chance of bringing my ideas home to influential people." Besides, he confessed, the political activity "distracts, amuses, and absorbs me. . . . And there really is a chance of contributing a winged word, of driving home an idea that may help the decision as to whether Lenin, Sonnino, or Wilson are to rule the world."

In the early weeks of the year Berenson had long talks with Walter Lippmann and passed on to him what he heard from his various informants of Wilson's disturbing compromises. He and Lippmann dined with Melville Stone, the elderly and autocratic head of the Associated Press, whom Berenson found intolerant of even "a very mild and sketchy opposition." Shortly afterward he took Lippmann to the E. J. Dillons to meet Take Ionescu, the veteran Rumanian cabinet minister. Berenson pumped Ionescu "for hours," and what chiefly stuck in his mind was his insistence that it was not Kaiser Wilhelm but Admiral Alfred von Tirpitz, the architect of the German navy, who was most responsible for precipitating the war. Later Lippmann and he went to see Prime Minister Venizelos, who was persuaded to talk "on all the questions of the settlement." The upshot of the interview seemed to be that "everything may be upset by the British and the Italians refusing to buy any more of our pigs." Then at a meeting with Steed, Joseph Pulitzer, and Pernot, Berenson got Steed to "tell Pulitzer the whole story of Italo-Jugo-Slav relations" in an effort to offset the Italian propaganda. A most disturbing recent development had been the resignation of Leonida Bissolati from the Italian cabinet. As a supporter of Wilson's proposed League of Nations and an advocate of conciliation with the Jugo-Slavs, Bissolati had violently quarreled with the Italian foreign minister.

Lippmann, despairing of carrying through "our program," announced that he was returning to America. "He assures me," Bernard said, "that my worst fears with regard to Wilson's coming over have come true, and that Wilson will go back satisfied that everybody has accepted his words." He could not be dissuaded from leaving at such a critical moment because "the only control one has over a government is through publicity," and publicity was a weapon he could employ only by going back. From America, after he had returned to his post at the *New Republic*, Lippmann wrote that the superpatriots feared contamination by Europe and besides "the people are shivering in their boots over Bolshevism, and they are far more afraid of Lenin than they ever were of the Kaiser." Years later Berenson reminded Lippmann of their colloquy when he had come to see him in his office in the corner of the rue Royale. "You were still in uniform at your desk. I came to ask you whether you were aware that we Americans were being betrayed . . . and that a most disastrous peace treaty was being forged. You said nothing, but your eyes were filled with tears. I have loved you since."

Of the political leaders Berenson was most impressed by Venizelos, and he met more often with him than with any other leader. At one long interview Venizelos told him that he believed the British would offer Cyprus to Greece. He also stated that at a meeting with Sonnino, the

Italian had reproached him for harping on the Dodecanese islands, which the Italians coveted. He agreed with Berenson that an Allied investigative mission ought to go to Moscow before attempting intervention and certainly ought to consult "all shades of Russian opinion," including Kerensky, to see that no reactionary government was established. He believed that the land ought to be given to the peasants, with compensation to the landlords, and, completing the European survey, he advocated home rule for Ireland "with Ulster permitted to follow its own course."

Eager to have Venizelos carry his case concerning Greece to influential Americans, Berenson arranged a meeting with "Daisy" Harriman, who had vigorously campaigned for Wilson and had become an important figure in the Democratic National Organization. An ardent suffragette, she had come over to England in an official capacity to investigate the working conditions of women in the munitions factories and after the armistice had come to Paris to take charge of the Red Cross Motor Corps. Not yet fifty, she was an immensely energetic person and in Washington the mistress of a notable political salon. She regarded Berenson as "one of the most charming of the everybodies who spent the winter at the Ritz," and recalled that "several times a week during breakfast at Laurent's he drew about him the progressive liberal figures of the Conference." At one of their occasional luncheon meetings she confided to him she could not make up her mind whether to marry again. Berenson reported that he "strongly urged her not to unless she could not help it." She did not remarry, and many years later Franklin Roosevelt appointed her ambassador to Norway.

It was at the home of the Baroness La Caze that Berenson had met Eduard Beneš, then a young statesman of thirty-five and a tremendously active spokesman for Bohemia "as the center of a new states system." Berenson and Pernot managed to snare him for a dinner at which he expounded his scheme for a "loose confederation" of Poland, Jugoslavia, Rumania, and the Magyars. "Like most sensible folk," Berenson noted, "he regards the union of Germany and Austria as the safest solution." Beneš told him too how at the last minute the Austrian emperor and the archduke tried to win him, "a despised and persecuted exile, over to a compromise." A "quiet modest individual," Beneš asked Berenson to use his influence to put him in contact with the State Department. This Berenson effected with the help of Felix Frankfurter. Beneš and Berenson met off and on until, shortly after the Peace Conference, Beneš gave a "farewell luncheon" to all who had helped him.

When young Gaetano Salvemini, dismayed by the resignation of Bissolati, came on from Italy to try to marshal opinion against Sonnino's

reactionary policy, Berenson took him over to one of his weekly luncheons to confer with important journalists and with delegates from the ethnic minorities of the defeated empire. On another occasion he arranged a luncheon for Joseph Pulitzer "to see something of the best French journalists." Joseph Reinach did most of the talking, "a revelation of the average well-to-do French mind . . . interesting, if not very wise." At the invitation of Joseph Grew, who had just been appointed secretary-general of the American Commission to Negotiate Peace, he lunched at the Ritz to meet the Robert Lansings and the Franklin Roosevelts. The clatter of the fashionable place made conversation difficult. "At every table was a party, and everybody was looking and craning their necks at everybody else." He did have some talk with Secretary of State Robert Lansing and found him "a very average man, far from stupid, but equally far from brilliant." Assistant Secretary of the Navy Roosevelt made a far different impression—"a radiant youngster of thirty-seven, and not looking that, keen and piercing and jolly" but as a husband blessed "with one of the most hideous . . . females ever seen."

In the great Hall of Mirrors at Versailles the Supreme War Council held its first plenary session on January 18, 1919, each of the Allied leaders accompanied by his foreign minister. A commission on the League of Nations was set up a week later; its final draft of the covenant did not receive approval until May 28. Day after day the serried ranks of diplomats listened to the many anxious petitioners who advanced their claims for national identity, claims they had already aired among the hordes of journalists and well-wishers.

As the days passed and confusion deepened, Berenson began to take an apocalyptical view of the crisis. "All I want," he informed Curtis, "is that [Wilson] should down Bolshevism of every kind and type. I suppose it is really Lenin or Wilson, and I greatly prefer Wilson." His vehement speaking at luncheon and dinner tables against British, French, and Italian territorial claims soon gave him the reputation of being a radical, and the next ironical step could have been foretold. At tea one day with the Bourgets, his chauvinistic host greeted him like a "naughty boy," with a loud "Hello Bolshevik."

One day he had occasion to meet the fifty-nine-year-old General Pershing. The general unbent and showed himself "the most utter jollier imaginable, with a smile like Granville Barker's only more so on a face more manly [and] a most powerful skull." At a tête-à-tête dinner with Mrs. Harriman he listened until midnight to her admiring talk of Woodrow Wilson. A few weeks later, after learning of the obstacles being thrown in Wilson's path, he wrote to Mary that if Wilson "did not look sharp, he would turn out to be a bigger and more disappointing Kerensky."

[253]

By that time Berenson's disillusionment with the peace negotiations was so nearly complete that he had little heart for further political meddling. He begged off attending a meeting in Paris which Felix Frankfurter, who was back as one of Wilson's legal consultants, urged him to attend to meet some of the leading members of the Zionist delegation. Frankfurter was particularly optimistic about Zionist prospects, having recently received a letter from Emir Faisal of the Arab kingdom of Hedjaz stating that it was "a happy coincidence" that Arabs and Jews, "cousins in race," had come to Paris "to take first steps toward the attainment of their national ideals together." "We Arabs," he had written, "especially the educated among us, look with deepest sympathy on the Zionist movement."

In his own alienated and disenchanted state Berenson appears to have had small interest in the matters before the Zionists. As an Arabic scholar he may well have felt more keenly the clear indications that Britain and France, determined to divide the Arab world, would not honor the recent British manifesto proposing the creation of an independent Arab state including Arabia, Lebanon, and Syria and excluding Palestine. Apparently he had already met some of the delegates to the Zionist meeting, for he was to carry on a friendly political correspondence for a number of years with Judge Julian Mack, head of the Zionist delegation, as well as with Thomas Lamont and Felix Frankfurter. Twenty years later Frankfurter wrote of the wonderful talks he had had with Eduard Beneš in Berenson's company.

However much Berenson was absorbed with political developments during the first three months of 1919, the art trade as always imposed its demands upon him. There were the indispensable visits to the Wildenstein and other galleries to learn what new treasures had come on the market. He took pains to improve his relations with Arthur Sulley. His respect for Sulley was widely shared. As René Gimpel noted in his diary, "There are three great art dealers in London: Agnew, Colnaghi [Gutekunst], and Sulley, each of very good reputation, but Sulley comes first by dint of his incomparable fairness." In mid-January Henry Duveen died. His death brought consequences more serious than Joe had predicted. For a time it threatened to put the firm in liquidation, and as a result payments to Berenson were delayed. With his usual acumen, however, Joe persuaded his brother Louis to buy out Uncle Henry's shares and allow the firm to continue. The prospects were excellent, for the multimillionaire Frick had been making major purchases.

The day after Henry's death Louis wrote to Berenson that Joe had cabled him about the *Portrait of a Venetian Gentleman,* which the firm had now acquired from Lord Rochdale, and the Andrea del Sarto *Portrait of a*

Lady, bought from the Carfax Gallery. Both paintings had been lent on approval to the veteran steel magnate in his Fifth Avenue palace. Joe wanted letters from Berenson about both portraits—especially a "logical important letter" about the Titian. Louis remarked that he did not know what Joe meant by "logical," but at any rate "you can see what he wants, you to enthuse in your letter regarding its importance." Joe could then show the letters to Frick and "I suppose settle the sale of the pictures."

Berenson complied in the midst of his "humbler" but yet necessary tasks in connection with the Peace Conference. Now convinced of the attribution to Titian, he abandoned himself to a flood of appreciative hyperbole to proclaim it "as one of the grandest achievements of human art. . . . Every trait in it bespeaks energy concentrated on one supreme purpose. If only one could guess what that purpose was. Perhaps the author of 'The Ring and the Book,' perhaps Browning could have told us." His letter had also to justify his change of attribution. Twenty years earlier, he explained, Giorgione was so sacred a name to him that he was "afraid of becoming the dupe" of his own enthusiasm, for he had not yet learned to distinguish between Giorgione and the Giorgionesque Titian." Returning a few years ago to the "glorious task" of studying Venetian painting, he "naturally had occasion to revise a certain number" of his youthful opinions. The "higher the quality of a work of art the less it is capable of quantitative quasi-geometrical demonstration. . . . One's sense of it is based on something deeper and much less tangible, on one's accumulated experience and trained taste." "It occurs to me," he concluded, "that the carping youthful or senile critics might question [whether] your portrait is an original. . . . I can only pit my authority against theirs and do not fear the issue of the contest." The letter on the Andrea del Sarto, if less argumentative, was equally enthusiastic and confident.

Perhaps Berenson's extensive explanation was a little too "logical" for the cautious and ailing Frick; he took neither portrait, and a week before his death in December of 1919 he requested Joe to remove from his gallery all the paintings he had decided not to buy. In the following year, presumably with the help of Berenson's report, Duveen sold the *Portrait of a Venetian Gentleman* as a Titian to Henry Goldman of New York for $125,000. The painting finally came to rest in the Kress Collection at the National Gallery of Art. The Andrea del Sarto went to Mrs. Francis F. Prentiss for $105,000.

The subsequent history of the paintings provides an illuminating commentary on the art, science, or craft of connoisseurship. The Rochdale portrait has through the years been given to Titian by, among others, Valentiner, Venturi, Suida, Offner, and Pallucchini. Earlier Cook and

Richter opted for Giorgione, as did Phillips and more recently Pignatti, the Giorgione authority. In the National Gallery of Art it is now "attributed" to "Giorgione and Titian." But the tale is not yet told. Harold E. Wethey, in his monumental study of *The Paintings of Titian,* takes issue with all his predecessors. The portrait strikes him as "disagreeable. . . . only a minor artist could be responsible for this picture, so thoroughly unpleasant both in form and content."

As for the Andrea del Sarto, Berenson, on further reflection, identified it in his 1932 Lists as a studio picture. In the preface to that extensive compilation he expressed a sobering warning: "Even unquestioned attributions are not trademarks although collectors and dealers would like them to be. They are stepping stones rather than goals." Six years before that time he wrote to Paul Sachs, "I do not flatter myself that my attributions are final, but I dare hope that, at worst, they are on the way to truth and not to error." Such qualifications were usually avoided in his letters to dealers' clients. They required either "yea" or "nay" in their investment in art, and if "yea" they desired enthusiastic confirmation. Hence Berenson confined his scholarly reservations to his books, his articles, and his correspondence with professionals.

The ending of the war had acted like a strong tonic on Joe Duveen, and as soon as his chief aide, Edward Fowles, was demobilized in February 1919, he saw to the refurbishing of the Paris premises in the place Vendôme, which had been used by the British military. Fowles resumed his activity as a chief intermediary with clients, selling and buying paintings, and he frequently sought out Berenson for his opinion and advice on possible purchases.

As the market began to boom, Joe was much in evidence in both London and Paris and he did not hesitate to interrupt Berenson's patriotic duties. One urgent note in late February read: "Can you come to see me at the office at 5 or 5:15 when we can have at least an hour or an hour and a half of undisturbed talk? We shall see Mr. [William] Salomon [of New York]. Avoid discussing any of the pictures we bought from Lazzaroni as I am now negotiating the sale of all of them to him." These and a few score others found their way into the "X" Book that year with Berenson's valuations.

The great activity of the Duveens during 1919 can be judged from the fact that the inventory of their purchases ran to thirty pages. There can be little doubt that rival dealers were equally enterprising as the war-ravaged aristocracy sold off their objects of art. An article in the London *Times* noted what seemed to be a paradox in the art market—a multitude of sales by estates and needy owners accompanied by a rapid increase in prices. The increase, it was explained, was the result of purchases by the

new rich. Similarly the great development before the war of collections and museums in Germany had come with the rise of "a new rich class, chiefly Jews," who formed collections "with the best advice." In both countries "the influence of Morelli and after him of Berenson" had stimulated the taste for early Italian pictures.

By late March 1919 the press was reporting that the Big Four were deadlocked over the question of reparations and that the impasse was aggravated by the French demand that the Rhine be made the new frontier. Irritation was growing in Paris over the delay in drawing up the peace treaties. The blame was laid on Wilson for having insisted on giving priority to discussion of the covenant for the League of Nations. The Italian delegates, angered by Wilson's opposition to their claim to Fiume, voted to quit the conference if Fiume was not assigned to Italy, and they did absent themselves in a huff for a few weeks. The chaos was confounded by continued warfare and revolution. In Berlin the Red Spartacist revolt almost succeeded. In Hungary a Bolshevik revolution did succeed and was under attack by Czech troops from one direction and Italian troops from another. To the north there was violent opposition by the Germans to the establishment of a Polish corridor to the Baltic.

Hence there was ample reason for Berenson to decamp as Lippmann had done earlier. Nothing further could be accomplished in person. To Mary at I Tatti he inquired whether they had contributed to a school that she had praised highly. "If so, that is deductible from our American income, of course." He noted that "our Italian tax of 27 per cent would make it impossible to remain in Italy if it were seriously applied. You must find out, and we shall make our bed accordingly." He also instructed her to check whether any of their export permits had expired on their paintings. She was to renew those still in force and try to bring out on her next trip the other paintings, "if not too big." She should also try to bring "all our Chinese paintings that you can, particularly the scroll with the Botticelli-Masaccio figures and all the Persian miniatures, especially the finest of all, the early 15th century's." He was of two minds whether he would ever return as a resident to the Italy that he had come so profoundly to distrust. In any event their most valuable possessions would be safer in their vault in London. Already there was a sign that a new Italy was about to be born: the renegade Socialist, Benito Mussolini, had just founded his Fascist party in Florence.

Toward the end of March Berenson headed for Edith Wharton's haven on the Riviera, hoping to purge his mind of the political frustrations of Paris. With the bitter taste of Italian intransigency in his mouth, he had little stomach for Florence. There disorder was afoot that would erupt in the first week in July 1919 with widespread looting that reached I Tatti

itself. A mob of young men declaring they were sent by the Chamber of Labor to requisition all wines and foodstuffs broke open the cellar door and made off with twenty-one bottles of whiskey, two of cognac, three of champagne, ten of Rhine wine, and six flasks of oil. Mary duly filed a claim against the delinquent authorities with the American consul.

At Hyères Berenson surrendered gratefully to the cordial hospitality Edith Wharton offered. They were, she remarked to him, as comfortable with each other as a pair of old shoes. The contrast of her own relation to Bernard was too much for Mary. Filled with resentment, she responded, "I cannot but suspect Edith has been making you feel a martyr or a soulful angel." Struggling to bring order to the neglected household, she felt specially put upon reading what a delightful time he was having in Edith's company, surrounded by the "beauties of nature" and listening to Edith reading the opening chapters of her new novel, *The Age of Innocence*. With bitter sarcasm she burst out, "Whenever you give me permission, I will end my encumbering, unenjoying and unenjoyed existence." As was her wont, she soon apologized for her desperate reproaches and, worried about her mental state, she pleaded, "Dear old companion we *must not be separated now*. I do believe thee like the law of gravitation when I am in my right mind. . . . Please hang on for my sake, Bernard. I am lost without thee, lost sometimes with thee, it is true, but recoverable."

One chore that Mary performed that April was to have a profound influence on both her life and Bernard's. Learning that Nicky Mariano was now safely back from Estonia, where she had stayed out the war, she offered the attractive young woman of thirty-two a job at I Tatti as a librarian-secretary. Miss Mariano eagerly accepted the offer, being at loose ends in the gloom of postwar Florence. Having learned from Geoffrey Scott that a knowledge of Latin would be necessary, she assured Mrs. Berenson that she could "pick it up again quite easily," as she had had lessons in her childhood in Naples with her professor father and was only out of practice.

Berenson's own list of desired qualifications, as retailed from Hyères to Wendell, was more extensive: "I need a secretary who is a good librarian and at the same time can revise my bad spelling. . . . As he has to be a member of the social and even family circle the choice is a difficult one. So few too have the competence, e.g. an acquaintance with French and German, Italian and Latin and fewer still want to exile themselves in such a social and musical void as Florence." If Mary's choice of a secretary to succeed Geoffrey Scott was not entirely governed by Bernard's criteria, she could hardly have chosen more wisely, as the event would prove.

[258]

Scott, romantic and emotional, resumed his pursuit of Nicky, despite his marriage to Lady Sybil, but his troubled state was only too obvious and Nicky discouraged his ardent advances. He submitted after a fashion, telling her, "I am going to be very good and contented and happy on your account; I am also going to break the furniture sometimes and throw things about the room, not being a dear cold-hearted philosopher like you but wholly composed of flesh and blood." It was clear too that the tangle of his relationship with Mary had revived after her return to I Tatti. He later wrote reproachfully to her that Nicky's being taken on had "ruined his old home for him." His marriage to Lady Sybil was scarcely more than a year old, but their incompatibility, as Mary had foreseen, was all too evident. Their divorce did not take place, however, until 1926 after Scott had given up his post at the British embassy in Rome and was living in England. From London the gentlemanly Scott sent Lady Sybil the statutory evidence to use against him.

XXVI

An "American Bacchus"

REJUVENATED by the few weeks at Hyères and with the duke of Alba's cordial invitation in hand, Bernard went up to Paris in May 1919 and summoned Mary from I Tatti to join him for the visit to Madrid. James Fitz-James Stuart, the seventieth duke of Alba, a vigorous sportsman of forty-one, was a notable collector and writer on art. Berenson had met him on a previous journey to Spain, and during the intervening ten years they had kept in touch with each other. Educated in England, Alba was proud of his English blood. If, as has been said, Berenson relished the titles of his friends, Alba furnished satiety: at his death in 1953 he was said to have had the largest collection of titles in Europe outside of members of the royal families. He had been a member of the Spanish senate from 1911, and when the Board of Patrons of the Prado Museum was created in 1912, he was named its first chairman.

Berenson had also known the recently appointed director of the Prado, the art historian Aureliamo Bereute, from as far back as 1906. Bereute had undertaken the immense task of reorganizing the collections, and Berenson's help with the rehanging of the paintings may well have been considerable, for he remained in Spain for most of three months. The rehanging proved a temporary expedient. Ten years later the difficult process was repeated, though without Berenson's help.

During the Berensons' stay in Madrid, Alba arranged for a prince of the blood to take them about almost every afternoon to inspect the private collections of "Spanish grandees" whose names, Mary informed Bernard's mother, were "more wonderful than their pictures, alas." Alba lived in suitable splendor with his brother and sister in his enormous palace "Liria," located in the midst of its own park in Madrid. It was there one day in June that Bernard and Mary came to dine. Platoons of

servants in blue velvet knickers and gold lace attended them as they sat down in the great dining hall hung with Gobelin tapestries to "dine off gold and silver plate."

Berenson's friendship with Alba, sustained by scores of letters, continued until Alba's death, though troubled for a time by Alba's support of Franco. In 1939 Franco appointed him ambassador to Great Britain; in 1945, disenchanted with Franco, he resigned to support Prince Juan, the future king of Spain.

Early in his visit Berenson developed a passion for primitive Spanish art and he proselytized for its study. In one place he discovered a valuable "primitive" painting. It was thereupon put on exhibition in the Prado and a fund started for its acquisition by the nation. Queen Mother Maria Cristina welcomed the Berensons to a special audience to express her appreciation. They found her "very jolly and full of good sense." Shortly before their departure for Paris in late July, the authorities offered Berenson a decoration for his services. He modestly declined the honor.

With the signing of the peace treaty with Germany on June 28, 1919, Paris began to return to its normal bustle. Reporters and members of delegations streamed out of town, leaving the executive commissions behind to implement the complex provisions of the treaty. One day Berenson encountered Beneš at a luncheon, "disheveled and suave and subtle as ever," holding forth against the Latin policy of the fait accompli. Berenson noted a change in himself: "All the international affairs suddenly seemed" to him "mere phonographic . . . of time long silenced in the real world."

Mary, much recovered in health and mind, crossed over to Big Chilling to her adored grandchildren, while Bernard fell back into his accustomed ways. René Gimpel, invited to visit him at the Ritz that summer, jotted down in his diary Berenson's pronouncement that Spain was "the only place in the world to study French art. Your thirteenth century stonecutters had all the grace of Watteau; all your churches are restored, but down there they're pure."

Edith Wharton, relieved of her war work, had carried out her plan for a summer and autumn residence at a convenient distance from Paris and had acquired a handsome property in the village of St. Brice-sous-Forêt, a short motor drive north of Paris. The low-lying house and spacious gardens were shielded from the village street by a high wall. There Berenson found himself one day early in August "inaugurating Edith's new villa, extraordinarily comfy, dainty and charming, nothing wanting to please a chastened eye and sobered sense." The village noises in the early morning were its only drawback. Edith, busy with housekeeping, pressed on nevertheless with her writing and found in Berenson a dis-

criminating critic. Listening to her read from her projected book on Morocco, he thought it "pedantic and vague" and urged her to stick to fiction. He thought her *Age of Innocence* was getting "better and better," displaying "more solid psychology and deeper humanity," and he found himself envying her mastery. "I feel so finished," he remarked, "and she is still climbing the heights."

At his international crossroads post at the Ritz, Berenson drew an array of visitors into his hospitable net. Young Prince Paul of Yugoslavia, now grown up and a student at Oxford, came by during the college vacation for a long talk with his mentor in art. Their voluminous correspondence would flourish until Berenson's ninety-second year. Baroness La Caze returned to Paris from her travels and he dined with her. He wrote that he found her looking "haggard, wan and ghostlike," and to illustrate how unfit he was for adventures, he informed Mary that having eaten next to nothing that day, he "nearly fainted away while at the table" and went home to bed. "Such was the redoubtable 'lovers' meeting, that you used to dread in your bad moments."

He also met with the Kingsley Porters. The brilliant young archaeologist and art historian had come to France in 1918 from his post at Yale University to serve as liaison adjutant to the French Commission of Historic Monuments to aid in the preservation of art in the war zone. His work now nearing an end, Porter was in something of a quandary about his future and discussed long with Berenson whether he should return to Yale or accept an offer at Harvard. Berenson was able to speak well of both schools. Porter did return to Yale as a full professor, but in 1924 moved on to Harvard, hoping to combine living in Cambridge with residence in Florence, for which, he said, he was homesick.

Berenson, full of enthusiasm for his "last love," medieval sculpture and architecture, found a fellow enthusiast in Porter, whose *Medieval Architecture: Its Origin and Development* was already something of a classic in the field. With the Porters he sallied forth into Burgundy to study the subject. To Berenson their journeyings evoked memories of Henry Adams, whose *Mont Saint Michel and Chartres* had first opened his eyes to the wonders of medieval art and architecture in France. When after a week the Porters had to leave to meet a commitment in England, Berenson continued his pilgrimage to Amiens, Chartres, and Bourges before returning to Paris.

Dorothy Straight, who with her late husband had subsidized the *New Republic,* was also in town and she begged to be taken to the Louvre. To Berenson she and her husband had seemed "ultra-radical," and he anticipated having a "heart to heart talk" with her on the perils of the peace. For the present, however, he was content to show her and her compan-

ions "the Babylonian and the twelfth century Christian sculpture . . . things which were most pleasant to my present mood."

Among the new acquaintances he made that summer, the most challenging and unpredictable was Carl Hamilton, a kinetic and enterprising young capitalist of thirty-three who had made a killing in scarce copra oil during the war. Born into a poverty-stricken family in Pennsylvania, Hamilton had begun as a shoeshine boy in his hometown and had later found work in the steel mills. Through the interest of a clergyman he was brought to the notice of Mrs. E. H. Harriman, who helped him to an education at Andover and at Yale. Now confident that he was a man of destiny, he had determined to cap his financial success by joining the ranks of the great art collectors. He had read Berenson's books at Yale and, carrying an introduction from Joe Duveen, quickly attached himself to him.

"Carl Hamilton has bobbed up again," Bernard wrote to Mary, "and is clamoring for me." Hamilton's enthusiasm was contagious and Berenson mused, "If I were free of all obligations of loyalty to the Duveens I should be tempted to invest in him. There really would be a chance of a partnership between money and taste." Hamilton pursued Berenson with his grandiose visions, and after one three-hour tête-à-tête with the brash enthusiast, Berenson wrote, "He seemed like clay in my hands, inviting me to do whatever I willed. He wants to buy up the world but I do not know how he is to pay for it. Perhaps he will pan out. He may be a wonder. We made all sorts of proposals to each other." It was arranged that Hamilton should go on to I Tatti when Mary returned there in September.

Mary, meanwhile, had come up to London from Big Chilling to meet Joe Duveen at Joe's request. She found him ready to crow with joy: he had just been informed by Lloyd George that he was to be knighted in recognition, as reported in the *Times,* of his "public services, more particularly in connection with the extension of the Tate Gallery of British Art." Mary went with him to "pick up his knighthood." Resuming their long-interrupted business relation, he confided that Mrs. Rockefeller, "who always asks after thee," had "begun nibbling upon Italians." He therefore wanted Bernard and her to go over to America "to clinch it." Mary also visited Arthur Sulley's gallery and again enjoyed the sight of Bellini's *Feast of the Gods,* the painting which Mrs. Gardner had declined to buy nearly three years ago in spite of both her and Bernard's eloquence.

Sulley now hoped that Joe Duveen would buy it from him, and he therefore asked her to have Bernard tell Sir Joseph that Madame Helfer would clean the painting. Sulley also urged the Berensons to go to the

United States, for if Duveen did not take the Bellini, a rich American would. Duveen, for his part, boasted to Mary that he was going to buy the "Bridgewater" Titians, which with his usual élan he described as "the greatest pictures in the world." Mary interposed that she thought the Bellini *Feast* was "just that," a remark that made Duveen "very thoughtful." Bernard hoped that she had not encouraged Joe's strategy, because he did not plan to go to America until the autumn of 1920. "I shall see plenty of him here in September," he said, "and then I must return to my studies. I am beginning to get rusty as an instrument. I do not intend to end as a charlatan." His recent immersion in late medieval art called for some sort of expression.

Mary took up her duties again at I Tatti in mid-September and promptly set Miss Mariano to work. The young woman, rather over-awed by her responsibilities, came down from the Villa Rondinelli in San Domenico each day after an early luncheon to pick up the work in the library of her predecessors, Cherry and Scott. The arrival of Carl Hamilton provided an exciting distraction. Mary took his art education in hand and, accompanied by Nicky Mariano, toured the galleries of Florence, Siena, and Padua, amazed again and again by his instinctive attraction to the finest of the masterpieces. She readily succumbed to his charm, finding "something exhilarating, infectious and intoxicating about this American Bacchus." He seemed "a savage, uncultivated child of nature" with a Franciscan love of all human beings—especially 'Boys.' " His singular tastes came out before the Titians: "He doesn't like nude women much." Impatient to add to his collection, he offered to buy their precious Lorenzettis "and nearly everything else" and grew cross at her refusals.

Their conversation happened to turn one day to a painting the Berensons owned which was stored in London for safekeeping. What followed has been much garbled in the retelling. The painting was *not* hanging at I Tatti. The space where it had hung was apparently visible and thus must have been a cause of Mary's allusion to it. From allusion to impulse was but a step. Mary explained to Bernard: "But (don't be cross) I have promised to *give* him our little Pesellino of St. John in the Desert. We were speaking of it and he said he must buy it and as we were having a very intimate jolly talk I said, 'Carl, has anyone ever made you a present?' 'Why no,' he said. 'Well I'm going to give you that little picture. I should love you to have it and I know B.B. would too.' I cannot tell thee how touched he was. I did it spontaneously, but on thinking of it I believe it will be the best investment we ever made. Carl has a thousand plans for making thee rich. I said I'd send the key to our safe and he can get it in London and enjoy it all the way over." Two days later she wrote

Bernard that she felt a bit anxious "how thee will take the Pesellino gift. I cannot think my impulse was wrong."

If Bernard disapproved of the gift, he made no mention of it to Mary at the time. When Hamilton, "smartly dressed and very cordial," dropped by in Paris for "a half hour chat all over the place," Bernard gave him the key and the photos of the paintings in the safe. Mary had overlooked one formality, an authorization signed by both Bernard and her. This was soon forthcoming. "How stupid of them to require both names!" she exclaimed to Hamilton. "I am so sorry for the extra trouble you have been put to."

The oft-repeated tale that Berenson did not know of Mary's generosity to Hamilton and furiously reproached her obviously has no foundation. It may well be, however, that Bernard did become furious when soon afterward Richard Offner, who saw the painting hanging in Hamilton's apartment in New York, cabled to tell him that the painting was not a Pesellino but was actually a far more valuable Domenico Veneziano, part of the predella of the Saint Lucy altarpiece. It is not improbable that in long recollection Bernard laid the whole blame on Mary, since she was the one who had proposed the gift. The painting later fell into the hands of the Duveens—probably to pay off some of Hamilton's debts to the firm—and in 1942 was sold to Kress for $450,000. It finally ended up with the rest of the great Kress Collection in the National Gallery of Art.

While the "Dionysiac" Hamilton was enchanting the susceptible Mary Berenson at I Tatti, the Kingsley Porters showed up in their quest for a "second residence" in Florence, a quest that had "wonderful moments," as Porter wrote Berenson, "but was on the whole futile and fatiguing." They visited villa after villa without finding what they wanted; the elegant Gamberaia on the Settignano heights was "a dream," but he feared it would remain one since Hamilton was after it and "I am no match for him when he wants something." For Porter the visit to I Tatti was among "the moments of pure joy in Florence." Before the Sassetta *St. Francis* he "shivered with delight."

Bernard was a little daunted by Mary's golden vision. He told her that he was willing "to do a great deal" for Hamilton "but all business must be carried on through the Duveens. I want no more but less time and thought wasted on money-making. . . . I can make all I want out of them with the least waste of self." As for Carl, he would like to "direct him and civilize him." It was obvious that he had much to learn. He came back from a visit to Gimpel's gallery with William Salomon declaring that the fourteenth-century paintings there were "no good." Berenson went to look at them himself, and "of course he was all off."

Dazzled by Hamilton's display of wealth, Mary bethought herself of

The Feast of the Gods (*The Bacchanal*) languishing in Sulley's gallery for want of a suitable collector. Who could better appreciate it than the art-hungry Hamilton? In spite of Bernard's injunction against bypassing the Duveens, she wrote him of her delight in the painting and sent him a copy of her letter to "a friend" about it, the ecstatic letter which she had sent to Mrs. Gardner in 1917 at Bernard's bidding and which she was to publish, perhaps to please Hamilton, as the main part of a brief article, *"The Feast of the Gods,"* in *Art in America.*

A month later Hamilton bought the picture from Sulley for an undisclosed price. Sir Joseph learned of the transaction and cabled Berenson that he was "distressed" and "puzzled" by the violation of their customary arrangement. In reporting the contretemps to Hamilton, Mary light-heartedly explained that the scruple of fair dealing was "about as effective in nearly all cases, as the Hague Convention about usages in war." In spite of Duveen's effort to "muzzle" him, her husband reserved the right "to advise any friend of his, whether one of his clients or not, if his opinion is asked." She admitted, however, that Duveen's annoyance "makes me a little uncomfortable, for it certainly was I who told you about the picture."

If Mary had hoped to profit monetarily from the transaction, that hope was doomed to disappointment. Within a year Sulley was obliged to repossess the painting, Hamilton having greatly overextended himself. Late in 1921 Sulley and Agnew sold it to Joseph Widener under the title *The Bacchanal* at a price running into "hundreds of thousands," according to the press. Widener declined to give the precise figure, saying, "I don't want the price to overshadow the great artistic importance of this painting." In due time it went with his collection to the National Gallery of Art.

From Paris Berenson informed Mary that he was at last admitted to the presence of Sir Joseph, and "his bluff and pretentiousness and *fausse bonhomie* and vulgar cynicism" left him such a wreck that he could hardly sleep afterward. Duveen sneered that Hamilton was good "for only a paltry 30 or 40 thousand pounds a year and that is not business." The next evening Bernard had another audience with "the new" Joe, "and he talked me blind and again into sheer exhaustion and a sleepless night."

Berenson lingered on in Paris until early October 1919. Though it was "becoming socially fascinating," the life there had begun to tell on him, and after his two years' absence from I Tatti he longed to "have it all behind me." To his aging mother he wrote that he had just dined with Arthur Balfour and still saw "many so-called 'great' people, but it does not any longer amuse me. I pine for my books and pictures and writing."

One of the "great" persons who did interest him at a tête-à-tête luncheon shortly before his departure was young William C. Bullitt. A letter from Lippmann had prepared him for the encounter. On his return from a secret mission to Moscow with Lincoln Steffens, Bullitt had been exasperated by Wilson's apparent hypocrisy about the notorious secret treaties, and at the Senate Committee hearing he had "blurted" out the truth about the "behind the scenes negotiations." "When there is an almost universal conspiracy to lie and smother the truth," Lippmann had commented to Berenson, "I suppose someone has to violate the decencies." Berenson observed of his luncheon companion, "He is consumed with self-importance but is truthful in the main."

Bullitt's consuming grievance against Wilson had grown out of the short shrift given to the treaty he had brought back from Bolshevist Russia. The account he gave to Berenson and that Berenson later passed on to Nicky was that, to his surprise, he had obtained "very satisfactory terms" from Lenin and brought the treaty "back to Paris in triumph." He was unable to get an appointment to see Wilson until evening. Meanwhile Lloyd George "got hold" of Wilson "and told him about it and then Wilson huffed and would not receive him nor hear the treaty mentioned, so it fell through." "It might have made the difference," Berenson remarked. "Imagine that piece of petty vanity having such awful consequences."

The more Berenson thought of the solitude and rest that awaited him amid his books and paintings at I Tatti, the more impatient he grew to be off. It was high time to return to his desk. A last tedious chore in Paris, applying for the required emergency passport, ended on a pleasant note. For an hour and a half he endured "a sort of third degree of prying and silly questions." Then his interlocutor asked, "Have you a spare photo?" With some irritation Berenson replied, "Yes, what for?" The young man answered, "I should like to stick it in one of your books." Pleased at this unexpected notice, Berenson agreed to look at the young man's little collection before leaving Paris on the deluxe train to Rome, which was again in service. Thus reassured that his writings had their appreciative audience, he embarked for the twenty-four-hour run to Pisa, transferred for the short run to Florence, and arrived at I Tatti on October 9, 1919.

An Island of Relative Solitude

BERNARD was only too ready to lean on Mary's ample shoulder when he arrived at I Tatti in a "very tired and collapsed state" to resume his life as a host and scholar. Mary could once again ready materials for his work and relieve him of the vexing demands of his business correspondence, a task that she relished. "Paris," she assured his mother, "is washed away." He did not know what he would write next but "it may be something on medieval sculpture." The sculpture of the twelfth and thirteenth centuries in France had become an obsessive hobby, and he bent over the heavy volumes from his library like a man gorging himself after the end of a famine.

He found the "relative solitude" an agreeable change from the two years of luncheon meetings and conferences. It was pleasant, he reflected, to see the same two or three faces daily. The presence of Mary's seven-year-old granddaughter Barbara considerably thawed his "Herod-like" feelings about the very young. "I am discovering how very charming the society of children can be," he acknowledged to his mother. He was also finding Miss Mariano, his "female secretary . . . as perfect as she should be and very good company to boot." She was particularly companionable because she was "as super-national a person as myself and it is pleasant to be able to discuss the day's events without treading on hypertrophied corns. Her father was a well-known Neapolitan theologian, her mother a Baltic lady of good family. . . . Her story has a 'Winter's Tale' interest and she has no small gifts of narrative." Her gift of narrative would find full expression seven years after his death in her *Forty Years with Berenson*.

There was much reading to catch up with, for new books had piled up in his absence, and he often took refuge in bed with a book in hand, though even there he was never quite free from calls on his expertise.

Mary would come to his bedside and take down his dictation in a wondrously abbreviated script. Since she often signed business letters in her role as her husband's business associate, inquiries were frequently addressed directly to her. Her usual plea for speaking for Bernard was his illness, or at least indisposition, a plea made more often to protect him from annoying importunities than was warranted by the fact.

Sir Joseph asked not only for pictures but also for Renaissance furniture, marbles, and terra cotta. "My husband asks me to answer your letter," Mary wrote, "as he has come home so tired he has been ordered to bed to rest. . . . If we let it be known that we want some objects of that kind, some good ones no doubt will be forthcoming," she assured him, while pointing out that "up to now you did not seem to value his opinion on anything but pictures."

An inquiry from Edward Fowles about a reputed Luini drew the reply signed by Mary, "It looks like a fine Luini. Would not be too dear at 100,000 francs." Louis Duveen sent on some photos of a Carpaccio and asked for Berenson's opinion. Mary, after conveying Bernard's apologies for not being well enough to write, reported that the painting was "perfectly authentic. . . . We are really enchanted with it." As for the Mainardi and the Pinturicchio sent by Baron Lazzaroni from Paris, the former was "the best Mainardi in existence." Her husband hoped both paintings would pass into the possession of the firm. Then she turned to the recurring delays in the payment of accrued fees. "The idea of money gives my husband an attack of neurasthenia, and he more and more leaves me to pay all bills and keep our accounts." Louis replied that he was sorry to learn that "Mr. Berenson is not well again," adding, "It is a pity that he should be worried." He would cable New York at once to send the check.

Hamilton's purchases were now on a scale to erase Sir Joseph's sneer. In a fresh agreement with the Duveens, he agreed to pay $860,000 for eleven paintings within two years at 5 percent interest. A month later he added four more paintings, raising his total debt to $1,100,000. Though the spread between the cost of a painting to Duveen and the sale price varied widely and though some of the Hamilton paintings had been in "stock" for three or more years, there was nevertheless expectation of handsome profits. A Costa portrait which had cost $7,500, for example, was sold to him for $40,000; a Crivelli acquired for $20,000 went for $75,000; and a Fra Angelico bought for $31,000 sold for $50,000.

Some clients, of course, bargained more effectively than others. A Bronzino portrait of Eleanora which came to the firm for $10,000 sold for $85,000, whereas Kleinberger, the astute Paris dealer, got a Fiorentino *Virgin and Child* for $8,500 which had cost the firm $6,000 and the

Fogg Museum bought a Simone Martini *Nativity* for only $10,000 which the Duveens had taken in at $8,000. There were occasional losses as well. The Worcester Museum bought an Antonazzio Romano for $2,900 for which the firm appears to have paid $4,000. What the net profits were on the many scores of transactions must have often baffled the accountants who had to deal with the three widely separated galleries of the Duveen firm and with the accounts of clients who often bought on long-term credit and frequently returned pictures or turned them back as part payment on new purchases. Adding to the complications of the bookkeeping were the disbursements for cleaning and restoration, insurance and shipping, and payments to intermediaries and to joint owners. Sir Joseph must himself have sometimes wondered what his cash resources were, and he put off sharing profits as long as he conveniently could.

Walter Dowdeswell had now set up headquarters in Italy. Though Berenson had had friendly relations with him for many years, he continued to question the value of Dowdeswell's work as an intermediary in Italy and found his presence there one more hateful annoyance. He remonstrated that Dowdeswell was too inexperienced to do business with wily Italian art dealers and, more important, that his being known as a Duveen agent was having the "effect of enormously raising prices." Among a number of paintings which Dowdeswell had recently recommended for purchase by the firm was a Jacopo Bellini owned by the shrewd Venetian dealer Italico Brass. Fowles, anxious to mollify Berenson, managed to get down to Florence to call on him despite a railway strike. Berenson insisted that Dowdeswell "was spoiling good chances of obtaining pictures" and that his "hands were tied" while he remained in Italy. He could have got the Bellini for much less than it now was being offered for if Dowdeswell had not forestalled him. A few days later Fowles wrote from Paris that Dowdeswell had frantically wired that he had seen the Bellini and a quick decision must be made. Fowles added that the price was still too high, considering they would have to pay 10 percent to Dowdeswell and 6 percent "to some brigands" who had taken him to Brass. "As you know Mr. Brass personally I am sure you will come to a satisfactory arrangement." A satisfactory arrangement was not achieved, and Fowles came to believe that Berenson had deliberately "spoiled the negotiation" in order to teach the firm a lesson for engaging Dowdeswell.

Berenson's reproachful requests for payment passed through Fowles's hands so frequently that he came to regard Berenson as thinking too exclusively about his fees. The Berensons for their part suspected that the firm was too cavalier in its bookkeeping, if not actually dishonest. In the spring of 1920 Mary plaintively complained to Fowles, "We do not

know where my husband stands financially with the firm." The payment due in January was still unpaid and "we are decidedly embarrassed." A week later when Fowles sent a list of the firm's purchases, she pointed out that it did not include those purchases made on her husband's "recommendations" in which Fowles had not participated. "If we were suspicious people we should be troubled by the fact that he has not been systematically informed whether or not pictures have been acquired which he has recommended and consulted about, but which have not been directly negotiated either by himself or you." She ironically conceded it might be "easy to overlook them in such stirring business that occupies Sir Joseph but in all fairness the point should be attended to in a more thorough manner." She particularly asked Fowles, "What has happened, by the way, to the Jacopo Bellini which belonged to Brass?" It was plain that neither Bernard nor she wanted to spoil a negotiation which might yield a substantial fee.

Louis Duveen soon indicated the value he put on Berenson's services. He bluntly informed Dowdeswell that inasmuch as Berenson had expressed the wish to have Italy for himself, he was to go immediately to Zurich and leave the Bellini matter in Berenson's hands. He followed up his action by reminding Berenson that now that Dowdeswell had "left Italy for good," it was important that he get "in touch with all the people in all the towns as much as possible, as we are leaving Italy entirely to you." It proved too late to salvage the Bellini.

Three days after he recalled Dowdeswell, Louis Duveen suddenly died following an operation for cancer of the liver. Ernest Duveen immediately took charge of the London gallery and Fowles of the gallery in Paris. Fowles now began to be associated even more closely with Berenson. "B.B. worked hard to find good Italian paintings for which Joe was clamoring in New York and I was in constant touch with him at this time," he recalled. "I often received letters from him two or three times a week." The requests for payment finally bore fruit, and toward the end of March Joe agreed to send £10,000 sterling "at the beginning of April." At the same time Fowles reported that the New York office had at last supplied the needed information for the "X" Book, and he sent a list of the pictures entered in it. The number ran to more than seventy, representing paintings of practically all the Italian schools. Their best client for the Sienese school, Fowles wrote, was Carl Hamilton. Mary, much more sanguine about Hamilton's future than Bernard, wrote Hamilton that they would be glad to advise him for no fee, but would, in exchange, appreciate tips on good investments. How weak a reed Hamilton was did not become apparent until more than a year later during the recession of 1921–22.

Though Berenson may have "washed" Paris away, he had not lost interest in politics. When he learned that the Senate had not approved the peace treaty with the necessary two-thirds majority in November 1919, he was pleased that "our reprobate Senate has turned down the cup of iniquity brewed by the conceit and one-track-mindedness of Wilson on the one hand and on the other, [by] the hoary drabs whose mushy abominations have long infested the various foreign offices of Europe." The treaty was not approved until the following March. The recent Italian elections in which the Socialists made great gains pleased Berenson as a "complete disavowal of the monstrous and impotent imperialism" of those who had misruled Italy for the "past miserable thirty years." He evidently discounted for the moment the rodomontade of his one-time friend D'Annunzio, whose theatrical seizure of Fiume had flouted the League of Nations.

If I Tatti was an island of "relative solitude" and peace for Berenson, the Italy that lay beyond it showed disorder. Violent strikes by Syndicalists and Socialists in Milan and Rome spread to Florence, and on one day while Bernard was deep in the Middle Ages Mary busied herself putting "all our pictures and objects of art into the asbestos safe." There was no escaping some contact with the revolutionary ideas that were unsettling Tuscany and other sections of Italy, for Salvemini, who had been an independent member of Parliament, regularly put in an appearance. Despite the large gains the Socialists had made in the Italian parliament, the delusive specter of Italian bolshevism raised by Catholic peasants at Bergamo who cheered Lenin's rule in Russia was not easy to exorcize. The Socialist League in Florence had enlisted seven thousand peasant families, and their menacing demonstrations had forced most landlords by April to grant reforms in their contracts with tenants, including the elimination of forced labor. Elsewhere widespread peasant strikes continued and workers' seizures of some factories obliged the government to take them over. In Fiume D'Annunzio postured before his troops as dictator and threatened war against the government if it tried to oust him. His escapade would not be liquidated until December of 1920.

To the expatriate Americans and Englishmen the confused drama in the city below could have only an unreal and somewhat theatrical character. Salvemini may not have agreed with Berenson that Germany was being too harshly punished, but they were on common ground in their antipathy to the Italian "Nationalists" who supported D'Annunzio and to the extremists of both the Right and the Left. The "bolshevism" that the Fascists were cynically to identify as the fate from which they saved Italy had in fact been unable to take root there. From the politically

conscious Salvemini Berenson doubtless learned of the sinister agitation of Benito Mussolini, the renegade Socialist whose small cadre of henchmen had begun to sport their version of the black-shirt uniform first worn by D'Annunzio's *arditi*, as they would also borrow from the poet's arsenal the use of castor oil upon their opponents. By the time of the Fascist march on Rome in 1922, Berenson and Salvemini would enter the ranks of avowed anti-Fascists.

Berenson may have enjoyed "relative seclusion" on his verdant hillside below Settignano, but his passion for congenial company required a stream of invited guests. They came and went little affected by the social turmoil engulfing Italy. Mary's brother, Logan, had settled in for the winter, and he reported to their sister in England that "in spite of strikes and fears of Bolshevism and all the contemporary troubles, life goes on at this villa in great comfort and leisure" much as it was before the war, "only we are all five years older, and the trees have grown, the gardens become more perfect. . . . It's a strange beautiful uncanny house, full of great rooms and corridors and libraries and pictures, and full too of taboos and distant sound of thunder and imprecation echoing about the corridors." He found it "immensely amusing" to watch how strangers, eager to make a good impression, would unknowingly break the taboos and bring on themselves "the most appalling condemnations."

The most frequent "regulars" in attendance at I Tatti, while Nicky Mariano labored in the library or showed visitors through the house, were Carlo Placci, who could always be counted on for toothsome gossip, and the ever-faithful Countess Serristori, witty and still elegant at fifty and with a great talent for drawing out Berenson in pungent talk. Trevelyan too was much in evidence in the spring of 1920, free to poetize at his leisure and startle the unwary with his idiosyncrasies as when, after a cooling dip one day in one of the garden ponds, he strolled about stark naked to dry himself. Salvemini's wife happened to see him and announced that a species of savage was promenading about as if it were the most natural thing in the world.

At the end of April 1920 a trio of free spirits came up from a holiday in Rome—John Maynard Keynes, whose book on the Peace Conference had made him a celebrity in England and Europe, and his artist companions Duncan Grant and Vanessa Bell, whose paintings had recently been exhibited in Paris with those of Roger Fry. Habitués of uninhibited Bloomsbury, they found the daily ritual at I Tatti, where Berenson now presided *en grand seigneur*, depressing. Vanessa and Duncan, as friends of Fry, knew also that their tastes in art would be suspect, and when they voiced them "the atmosphere darkened." Vanessa took a deep dislike to

Berenson's manner and wrote to Fry " 'cursing the horrors' of life at I Tatti in spite of the extreme comfort of the place, the Louis XV furniture, and exquisite breakfasts in bed."

While Vanessa sat "almost invariably wrapped in sulky silence" during the visit, Keynes held forth at length about some of the persons at the Peace Conference whose wickedly stupid antics he had left out of his book. They all attended a large reconciliation dinner party at Charles Loeser's villa, celebrating the end of the vendetta between Loeser and Berenson, at which Loeser unfortunately confused Grant with the celebrated Keynes. Grant, more resilient than Vanessa, was unperturbed by the alien environment and remained grateful that Berenson's writings had freed him from Ruskin's influence and had taught him to appreciate the "life-enhancing" qualities of "tactile values" and "ideated space composition."

Mary undoubtedly enjoyed the Bloomsbury visitors more than Bernard did, but the advent of Belle Greene was another story. Now the undisputed mistress of the Morgan Library, Belle had come abroad on one of her buying missions and headed for I Tatti and the delights of a reunion with Berenson. She was, as Nicky observed, not only intelligent and full of vitality, but physically "a provocatively exotic" type. Her effect on Berenson was all too apparent, and soon after her arrival and before dinner was announced Mary, in spite of her heroic resolves to stifle her jealousy, angrily retreated to a darkened sitting room. Bernard sent Nicky to find her, but she would not return and asked only that a Bach music roll be set going in the player piano. Resolutely keeping to his libertarian principles, Bernard drove down to Rome to spend several days there with Belle. Parry, who had returned from military service, was again at the wheel. Mary was left to enjoy being tyrannized by her little granddaughter. Bernard came back to I Tatti with Belle, and the remainder of her visit seems to have passed without major incident. Soon after her departure, however, Mary went off to the Fiuggi spa for ten days to diet and to free herself from "the insane thoughts" inspired by Bernard's "loves."

On June 2, 1920, three persons arrived whose lives thereafter would be closely linked to I Tatti: Nicky's sister, Baronessa Alda von Anrep; her husband, the refugee Baron Egbert; and their young son, Cecil. Mary saw them as a useful addition to the I Tatti establishment, and by autumn Nicky and her kinfolk took up residence in the Villino Corbignano on the hillside across the road.

In spite of business and social distractions and his preoccupation with medieval sculpture and architecture, Berenson completed a twenty-page illustrated article for the October 1920 issue of *Art in America* on the

Christ between Saint Peter and Saint James Major which Carl Hamilton had acquired through Duveen in 1919. He had at first declined to contribute to *Art in America* when he heard there was a likelihood of Valentiner's returning from his German war service to edit the magazine, protesting that the magazine should not become the "German dumping ground" he believed it had been under Valentiner. Frederick Sherman assured him that an excessive "Boche influence" would never again be allowed to "parade" itself in his pages: his aim was to keep the magazine up to a standard that Berenson would approve. So assured, Berenson had submitted his article.

The Hamilton painting had long gone under the name of Margaritone d'Arezzo, but when the Duveens bought it from the Comtesse Bertrand de Brousillon, Berenson concluded that it was an early work of Cimabue. Acquired for $39,000, it had been sold to Hamilton for $150,000. Repossessed by Duveen, it was sold to Andrew Mellon in 1937 as a Cimabue. The authorship of the painting has been the subject of considerable dispute. Sirén, Venturi, Muratoff, Valentiner, and Toesca ("tentatively") supported the attribution to Cimabue, and it would be thus assigned in Berenson's posthumous Lists. Others like van Marle, Salmi, Salvini, and Zeri proposed a variety of authors, including "follower" of Cimabue, and it is as the work of a "follower" that the picture now hangs in the National Gallery of Art as part of the Mellon Collection.

The painting was one of four which Hamilton loaned to the Fiftieth Anniversary Exhibition at the Metropolitan Museum, which had just opened in May 1920 with an impressive list of lenders, including among others Otto Kahn, Jules Bache, Henry Goldman, and William K. Vanderbilt. The "Cimabue" was particularly admired by artist-critic Walter Pach in his review of the exhibition. "Our Cimabue," he wrote, "is as far a reach toward the heights of the world (or beyond them as Roger Fry prefers to state it) as man had made." The other three Hamilton masterpieces were the Bellini *Bacchanal,* a Mantegna *Judith and Holfernes,* and a Piero della Francesca *Crucifixion,* which he bought from Duveen for $50,000. It is a striking illustration of the wildly speculative nature of the art trade that when Hamilton had the *Crucifixion* auctioned in 1929, Duveen bought it in for Rockefeller for $375,000.

Berenson's article, titled "A Newly Discovered Cimabue," contained, as his writing often did, a touch of autobiography. Having been led during the war years, he wrote, "to a deeper study of the monuments in all forms of art in the centuries preceding the period of the Renaissance . . . I have become aware of two things which bear upon what I have to say here—one, that this was perhaps the very greatest period of art since

the Greeks . . . the other, that it has not been studied, on its pictorial side at least, with scholarly conscientiousness." What most interested him and led to his attribution were the parallels he saw between the figure of Christ in the triptych and the Christ in the apse mosaics at Pisa and at San Miniato in Florence.

Before departing for a month in Paris, Berenson dispatched filial greetings to his mother across the widening chasm that separated his interests from those of his family in time to reach her by June 26, his fifty-fifth birthday. "What can I say?" he wrote. "I suppose that all in all I do not regret having been born." He enclosed a check for $500 and promised another soon so that she could permit herself "the luxury of an outing." He also assured her that he and Mary would be visiting her by the end of the year. Joe Duveen's visions of postwar prosperity had not allayed his recurring anxieties about the future. With the Great War well over, it was time to cultivate the new American millionaires it had created and also to renew acquaintance with the survivors of the older generation. Moreover, another five years would have passed since the renewal in Washington of his claim to American citizenship and he would need to put in an appearance again for a renewal of his passport.

The rise in prices and the obstacles to travel as a result of the war furnished unpleasant surprises. The Berensons' dependence on their motorcar and chauffeur had now become second nature. When they decided to take the car to France and England, they learned that a deposit of 45,000 somewhat depreciated francs were required to cross the frontier. Making inquiries for their planned visit to America, they discovered that a modest cabin on a big ocean liner would cost $2,000. By July 2, 1920, the pair were at the Ritz in Paris, and within a day or two Mary went on to England, accompanied by the motorcar and chauffeur.

The days in Paris passed swiftly for Bernard as he resumed his role as man of the world. Gimpel read to him an "intolerably real farce" that he had written about a millionaire American buyer and a Paris picture dealer. Natalie Barney fascinated him as much as ever. At her "temple" in the rue Jacob, he talked with a pair of avant-garde poets, Paul Valéry and Ezra Pound. He thought Pound "an ultra-Europeanized yank from Idaho, superficially attractive." As the enterprising agent of Harriet Monroe, editor of Chicago's *Poetry* magazine, Pound had become a literary entrepreneur, encouraging and advising T. S. Eliot, James Joyce, and others in his brash and staccato style. A supremely self-confident prophet of the new in literature, he impressed Berenson as being "worthy" of his biblical namesake who had revitalized the Jewish religion. A kind of rapport developed between them, and Pound kept in touch with his new acquaintance for several years.

In one characteristically untidy letter from Rapallo, Pound addressed himself "To the respected Behrenson [sic] for 'egregious' I will not call you: May I recommend to your mercy two young friends now I believe in Firenze, and who have sufficiently cast off the usual stigma of humanity to enter our somewhat exalted sphere. Case 1. Miss Olga Rudge . . . who must be a fairly good violinist, as bad music annoys me. Case 2. Adrian Stokes, a savage and somewhat more ultimate Briton, with decorative appearance, who is seeking some sort of . . . I leave it to you . . . superfactural, perhaps, comprehension of the Quattro Cento. The verbal manifestation being wholly . . . no not incomprehensible, but couched in a metaphoric language that shows only indubitable mental struggle on the part of the protagonist."

Paris was as usual a crossroads for Americans, and Berenson walked and gossiped with Santayana, conferred with Denman Ross, and accompanied Richard Offner to the Louvre, to which he returned to see the collection of Manets, Cézannes, and Degas. Their paintings seemed "old friends" and he was impressed by "how well they wear. Manet best of all." He called on Seligmann, and the old man fumed that the new law about the export of art was a plot against him. With Ralph and Lisa Curtis he drove in the Bois de Boulogne and fancied himself "sick for home, the library and my work." At Rosa Fitz-James's salon he discussed aesthetic theories with Paul Bourget. Pleasantest of all was his brief stay at Edith Wharton's villa at St. Brice-sous-Forêt, where she read to him her article on Henry James. He found it "a great relief to hear this human account after the mystical nonsensical reviews of Virginia Woolf and others." He and Edith had some "good talk," though he had to confess that by "good talk" he meant that he did most of it.

In London Mary found plenty to do to keep her busy. At the Duveens she encountered Sir Joseph, full of "fervor and loving kindness . . . full of confidence in thee," and "bursting over with Royalty and Aristocracy." He told her that "Dionysius" Hamilton had not yet paid up and already owed $2,000,000 to the firm. Duveen appears to have crossed to Paris a day or two later, for on the twenty-first of July 1920 he signed a document which provided that the contract of 1912 "shall be treated as if it had been continued" from the first of July 1917. Two provisions were added: either party could terminate the agreement after six months' notice and the same percentage of fees that applied to paintings would also apply to Italian sculpture. In addition he appears to have agreed informally to pay £5,000 semiannually against fees already earned. The formalizing of the relationship came as something of a relief to the Berensons, for it assured the firm's support for their projected visit to the United States. A few weeks later Joe informed Berenson that the firm

had booked passage for him and Mary on the *Olympic* for November 17.

With Bernard's approval Mary rented a place for them to spend August near Haslemere in Wessex, the "very place," he told Mrs. Gardner, "where I first fell in love with her on August 4, 1890." After four "harassing" days in London he reached the Georgian mansion known as "Copyhold." It was on a hillside a short way above Friday's Hill, the house once occupied by Mary's parents. Nearby was "Mudhouse," an adobe dwelling which Mary's inventive daughter Ray had built in the hope of revolutionizing rural housing. "How I wish you were here," Berenson exclaimed to Mrs. Gardner, "in this Sleeping Beauty's bower of verdure." The charms of the refuge, however, soon palled in Mary's company, and he complained of feeling "nervous and irascible" and of having "lost all pleasure in the people I used to see."

It was with some relief that he took himself off to France to travel for three weeks in the company of Baroness La Caze to study medieval sculpture as far south as Arles and Avignon. They were joined by Elsie de Wolfe, "which made a great difference to comfort and expense." In the museum at Toulouse he found sculptures which "almost made a complete series from B.C. to 1600," and he concluded that the Visigoths had picked up various elements, including the pointed arch, before going on to Spain. The Kingsley Porters happened to be at Toulouse, and they all "had a very exciting evening exchanging impressions."

While Bernard wandered hither and yon in central and southern France, Mary descended upon Brides-les-Bains with her sister, Alys, to resume the battle with her incorrigible flesh. When Bernard wrote of some of the difficulties of travel off the beaten paths, she conceded, with due irony, that "the way of the aging aesthete is (in some respects) indeed hard." Of course he had "a perfect right to travel around" with his mistress "to see the things I should have loved to share with thee." He suggested that she had less reason to "feel jealous and shut out" now that age tempered "both passion and poetry and dreams." That assurance, she declared, "is not one to make me happy."

Travel in such agreeable company considerably revived Berenson, and he expatiated as winningly as always to his companions on the marvels he encountered and attended too to the business letters that tracked him about France. In one, Fowles informed him that Sir Joseph desired him to keep the hours of twelve to one open on Mondays and Tuesdays on his return to Paris. He survived the October conferences, thanks, it appears, to other distractions. When Gimpel called on him at the Ritz one morning at ten, "he was lying down," Gimpel noted in his diary. "His small face, like that of an anemic lion cub, looked very tired. He seemed

ill, and I asked him how he felt. He replied very gravely, 'I'm in love, it's stupid at my age. . . . I haven't slept.' " Gimpel wryly added, "And I asked him yesterday for news of his wife." Soon afterward Berenson fled for solace to Beaulieu for the companionship of Ralph Curtis and, thus restored, entrained for home.

Once at I Tatti Berenson groaned "at the thought of tearing himself out of his library" for the impending voyage to America. A welcome remittance arrived from René Gimpel, who had just ended his partnership with Nathan Wildenstein. Grateful for Berenson's help in a recent sale, he sent a check for 50,000 francs, although that sum represented more than a third of what he would realize. He felt it proper, he wrote, not to reduce the amount promised because it was their first "affaire." There was distraction in a visit by the editor of *Century* magazine, Robert Underwood Johnson, and his wife; though "a dear fellow," Johnson set too hard a pace. As D'Annunzio threatened war and the press reported increasing discord over the peace settlement, Berenson was moved to parody Longfellow's "Psalm of Life." "What can you expect," he wrote in disgust to Ralph Curtis, "after the last fifty years inspired with and by the profound conviction that you must act in the sordid present, rage within and the devil overhead. . . . A history of the last five years might appropriately be entitled 'The Cannibal Out-Cannibaled, or the Further Adventures of the Duke of Rigoletto.' Apocalyptically yours, B.B."

The final arrangements for the Berensons' departure for America were made easier when the Kingsley Porters agreed to stay at I Tatti during their absence and pay all bills, including the wages of the gardener, heat, and food. Best of all, Nicky Mariano would be there to look after things. "We both think Nicky is a nearly perfect human being," Mary told Alys. "It is a daily joy to see her coming in and to hear her charming voice. What luck for us!"

XXVIII

Suspect in the Promised Land

THE Berensons departed from Southampton on the *Olympic* on November 17, 1920, their destination in New York not the Ambassador Hotel as Berenson had originally planned but Carl Hamilton's luxurious apartment at 270 Park Avenue. Hamilton had been persistent in his invitation that they be his guests in spite of Berenson's excuses, and he met them at the dock with his two Japanese servants, reporting that he had already moved to a hotel and his apartment was theirs. Bernard had acquiesced with some misgiving but Mary had had no reservations. The great advantage, she said, was that they could entertain as much as they liked instead of going out all the time. It was a comfort also to have housed with them her maid Elizabeth, who doubled as Bernard's valet.

The walls of Hamilton's apartment were hung with a large array of unpaid masterpieces, evidence to the Berensons that Hamilton's much-visited collection had "boomed the Duveens tremendously." It was not long, however, before they learned that the recent downturn in business had greatly embarrassed Hamilton, whose enormous debt to the Duveens cast a shadow on his prospects. It seemed obvious to them that he was using them "as decoy ducks, in order to strengthen his credit." Ironically enough, the November issue of *Art and Decoration* had just published a full-page reproduction of the Bellini *Bacchanal* and named Hamilton as a "possible successor to the giants of American collecting" who had recently died.

Carl was courting at the time a very rich young socialite, Alice De Lamar. The Berensons thought him on the verge of becoming engaged, a development they favored because the marriage would help rescue the improvident financier from his difficulties. To Mary, who was as conscious of American fortunes as of British titles and who soon learned to

[280]

identify millionaires by the amount of their reputed assets, the marriage would be "eminently suitable": Alice was a "nice girl ($15,000,000 incidentally)." Carl's eccentricities, however, were to make the young woman cautious and the romance "finally petered out."

The pattern of the Berensons' days in New York repeated that of their previous visits, though the additional years of expatriation made them feel even more alien in their native land. The country had returned to "normalcy" with the egregious Warren Gamaliel Harding about to occupy the White House, accompanied by Calvin Coolidge as vice-president. The wartime boom had given a hectic flush to life in New York and the signs of great wealth and extravagance glittered on Fifth Avenue. The Berensons found themselves in "a whirl of millionaires" who escorted them through one palatial mansion after another. The Blumenthal house seemed a veritable museum. Helen Frick, the "wraith-like daughter" of her recently dead father, showed them the treasures in the exquisite palace which he had reared on Fifth Avenue. Henry Goldman, they thought, had a few very fine things, including, of course, the Giorgione which Bernard had recommended to him.

Now in their mid-fifties, their health a little more precarious than before, they found the incessant luncheons and dinners, however kind the intention of their hosts, more and more wearing. They were repelled by the sight of the women at the formal parties who acted "exactly as they did before the war," dressing themselves "like skittish girls, [and] hanging their wrinkled necks with fabulous jewels." At one millionaire dinner party "the table literally groaned under orchids, caviar, turtle soup and golden plate." Twenty-two old people sat around "guzzling champagne and all sorts of wine (in spite of prohibition)." All the women seemed even fatter than Mary and were "nearly naked and hung with ropes of pearls and diamonds." After dinner opera singers appeared and "yelled horrible music," and "B.B. nearly fainted away." A "typical morning" was spent with Miss Frick "($30,000,000)" and with Otto Kahn "(endless millions)," the day ending with the Archer Huntingtons "($180,000,000)." In the interval they lunched with the luxuriously bearded Indian poet Rabinrath Tagore and had tea with the Rockefellers. The succession of entertainments followed each other with such rapidity that when Berenson was asked whether he enjoyed himself, he replied, "I don't know, I just spin."

The prospects that the Duveens opened up inspired a sense of euphoria, and Bernard sent word through Mary to her sister, Alys, who was to undergo surgery, that she should not hesitate to ask for money. Besides, Mary added, "I am quite half the show, so to speak, so it is thy own sister's earned money (how easily earned!) which is waiting for

[281]

thee." Much as Mary disapproved of the "squillionaires" whom they found "very hard to digest," she was honest enough to acknowledge that their relations with them meant "cash and I tie myself to that sordid fact."

It was a killing pace to which they had committed themselves, and Bernard, less robust than his wife, tended to faint under the pressure of business. Not so Mary. "I," she said, "have a greater incentive, for I have Descendants. You can't imagine how I want to be *sure* that no grandchild of mine need 'stand behind a counter' as Grandpa Smith said of his." After all, Bernard had no offspring to care for but only a visionary expectation of founding an Institute and providing for his Boston relatives, objectives far less important in her eyes than his, though she was quite aware how seriously he took his responsibilities toward his family. He had just given his sister Bessie, who had been very ill, a thousand dollars extra for her doctor's fees, and he was establishing a trust "for the whole family, three of whom he entirely supports, and the other three in part."

Among Berenson's cousins in Boston were three lawyers—Arthur Berenson, head of the firm; Bernard Berenson; and Lawrence Berenson. Arthur, who had previously attended to some of Bernard's American affairs, drew up the family trust instrument. A power of attorney was given to Lawrence Berenson, a younger member of the firm. It was Lawrence who later became Berenson's American lawyer and investment counselor, a post that, as a successful New York lawyer, he filled with the utmost loyalty throughout the long negotiations with Harvard to establish the Harvard University Center for Italian Renaissance Studies at I Tatti, work for which he refused pay from his expatriate cousin.

For the holidays Bernard and Mary went up to Boston, this time taking lodging at the Copley Plaza. They were horrified by the presence of a spittoon in every room. The passage of time seemed to have tarnished Boston and Bostonians. They no longer seemed "so grand and important." To the anglicized Mary, the people's voices were "quite horrible," so inferior to the cultivated speech of her Oxford friends. Carl Hamilton and Alice De Lamar accompanied them to Boston, arrangements having been made for them to see Mrs. Gardner's collection. As a sort of payment in kind, Carl brought with him to show the aged Isabella a Mantegna, the Piero della Francesca, the Alvise Vivarini portrait, and two Fra Angelicos, all in four large suitcases.

Alice De Lamar, in an account of the visit, gives a vivid portrait of Mrs. Gardner in those last years of her reign at Fenway Court. On a table in the center of the Venetian patio lay a "clutter of tins of biscuits, cartons of grocer's products, magazines, bottles and jars . . . medicines and pills.

In a thronelike chair beside the table, wrapped in an ermine robe and chiffon scarves, was what appeared to be a mummy carved in ivory wearing a somewhat disordered, yellowing white wig piled on the head. . . . She managed to hold out a parchment bird's claw to greet B.B." Berenson, with due emphasis, said that he "now wished to introduce the really important guests he had brought—Mantegna and Fra Angelico." Isabella's face "lighted up" and Carl's two Japanese servants displayed each painting in turn while she gratefully scanned them through her lorgnette. So deeply touched that "tears stood in her eyes," the formidable old woman—too paralyzed now to be able to show the way her treasures should be viewed—said, "Go upstairs, all of you. Go through the house and see everything and take plenty of time."

All the Berensons came to call on Bernard and Mary at the Copley Plaza—"the little mother the best of the lot," said Mary, "so neat and dainty, holding herself so erect, with a young trim little figure in spite of her seventy-three years. The brother is heavy and uneducated, but has no harm in him. Senda has got great and squat and looks very Russian. Her voice pierces one's ears. . . . Bessie's hair is quite white . . . [she] giggles and throws herself about like a spoilt child"; Bessie was living in New York and trying "to do sculpture." Accustomed to a house full of servants, Mary learned to her amazement that in postwar America women did all the housework, as servants were not available.

From the Copley Plaza Berenson posted his views to Natalie Barney, the ambiguous Circe in Paris: "It would be delightful if we were well enough to enjoy our opportunities. But neither of us can any longer stand the fun. . . . I like the men well enough, but the women! When the sex attraction is over, how few of them attract. I remain faithful to old loves, however, and I truly revel in Isabella Gardner, although she is 85 and immobile."

A message to Belle Greene in New York repeated his lament: "How simple it would be if I did not care so much for you." His letter elicited a lengthy homily: "I honestly cannot see that I am anything except an ineradicable memory." She reminded him that she had not made the "slightest move" to bring herself into his "active living—not even here in New York—as I so easily could, because I have a hunch that it is not *me* that you need but the rush and wear and tear. . . . There is some antagonism on my side and a Christlike, all-enduring, all-suffering Patience and Forbearance on yours. . . . I am trying to 'analyze' my antagonism. I know that its roots lie in remembering the really innocent . . . utter and world-excluding worship I once gave you. . . . I think it really ceased to exist when I left you to go to London. . . . It rarely occurs to me that you are someone with whom I have been in personal (and acute)

touch. On the few times that I come closer to you, I cannot but sense an obscuring wall of Pretense and Effort. . . . It is high time that we released each other." But as soon as he departed for Europe her mood changed: "Already it has begun, dear B.B. I *miss* you horribly, just horribly."

After the holidays the social wheel turned ever faster as Berenson shuttled back and forth between old friends and acquaintances and new. Carl Hamilton came in one night in triumph carrying under his arm Botticelli's portrait of a youth in a red cap which Berenson had discovered in the Schickler Collection. He had just bought it from Duveen, on credit like all the others, for $250,000. It too would return to the Duveens and later adorn the Mellon Collection at the National Gallery of Art. The Berensons saw a good deal of the sculptor Paul Manship, who had done a "fine bust of old Mr. Rockefeller." At the Vanderlip mansion up the Hudson, to which they traveled in the Duveen motorcar, Bernard "cast a gloom" over his host by telling him that one prized painting was only a Marco Palmezzano and that his Mino da Fiesole was a forgery. There were renewed dinners with the Rockefellers, who were still "too much wedded to Chinese vases" to develop a taste for Italian Primitives. One night they dined in "Art Jewry with Mrs. William Salomon and Sir Joseph Duveen" and the next night with the Italian ambassador, and they ended the week with a dinner at their apartment for the painter Cecelia Beaux and other luminaries.

Among their many luncheons, Berenson most prized those with Walter Lippmann and "his lovely little wife," for among all those whom he had come to know he thought Walter the ablest and brightest. Through Lippmann he appears to have met Judge Learned Hand, who was famous for his scholarly opinions. The meeting began a warmly admiring friendship. Hand's wide reading and breadth of interests matched those of Berenson. Berenson spent an evening also at the home of William Bullitt, an evening doubtless spiced with Bullitt's contempt for Woodrow Wilson, a contempt that would one day inspire his excoriating study of Wilson in which Sigmund Freud collaborated.

One expedition took the Berensons and Hamilton to a preview of the Exhibition of War Portraits at the Metropolitan. Mary had declared "they *must* go . . . the Curator would insist! B.B. sounded adamant. 'I'm *not* going: I *hate* receptions, with all those pushing crowds!' " Mary had her way and after dinner the party, which included Walter Lippmann, Archer Huntington, the senior Mrs. Harriman—Carl's patroness—and Berenson's sister Rachel, proceeded "in a fleet of three stately limousines which Carl had engaged." They got through the reception line and to the galleries where the three portraits by Cecelia Beaux of Cardinal Mercier, Admiral Beatty, and Georges Clemenceau seemed the only ones worth

looking at, according to Mary, among "the dreary waste of Tarbells and other mediocrities who painted the infamous crew at Versailles."

The sight of the war leaders whom Berenson had come to despise was evidently too much for him: before long it was noticed that he had disappeared. Hamilton, sent to investigate, discovered that he had wandered off to a remote gallery and taken a nap on a Directoire couch. A burly Irish guard had discovered him and roared, "You can't sleep here!" Ordered to "Get up and get out of here," Berenson had slowly risen and with "devastating dignity" said, "Take me to the Curator—at once." When the guard described Berenson's offense, the curator broke into laughter and declared, "I feel sure Mr. Berenson may be permitted to enjoy an undisturbed nap in any museum in the country."

Professionally there were the unavoidable and frequent conferences at the Duveen gallery, sessions which Berenson counted on to strengthen the Duveens' confidence in him in the face of the postwar invasion of German experts. There were of course the usual chores of the expert— valuations of paintings as of the Duccios from the Benson Collection and advice on purchases of paintings whose photographs the Duveens had ready for him. There could also be no slackening of his study of the Italian paintings in American collections, the constant absorbed review of their features to hold their place in his memory. He went out to Englewood, New Jersey, to inspect his friend Platt's collection and up to Yale to check the Jarves Collection. In New York, besides the Italian paintings of the Metropolitan, there were the choice masterpieces at the Frick and in other private collections. Ahead lay visits to the Walters Collection in Baltimore and the Widener Collection in Philadelphia.

In New York Berenson got a fresh taste of the suspicion ever present in the art trade and of the dislike other dealers had for Joe Duveen. Belle Greene turned over to him a rambling confidential letter which she had just received from Jacques Seligmann, to whose son Germain she had entrusted some sort of confidential mission that related to Berenson. Though Seligmann denied working against Berenson's interests, he reminded her, "You must not forget that Berenson is intimately associated with the Duveens: in consequence he must be my enemy, it is impossible otherwise." He went on to unburden himself about the "underground work" that he assumed Berenson was carrying out in America against him and threw in for good measure the accusation that Philip Lehman had returned a beautiful wood bust to Dikran Kelekian, a dealer specialist in early art, because Berenson had said it was new. This was not the first—nor would it be the last—business confidence that Belle shared with Berenson. Her role at the Morgan Library placed her at the center of

the art trade and her friendship was coveted by every dealer. For Berenson she provided a valuable listening post in America.

Rumors about Berenson involved more than his role in the art trade. The rising tide of Red baiting in America had become associated with anti-Semitism, of which Henry Ford's *Dearborn Independent* was a principal mouthpiece. Many of Lenin's associates, including Leon Trotsky, were known to be Jews and many Russian immigrants had welcomed the overthrow of the czarist regime. Carlo Placci wrote Berenson in February 1921 asking him whether the alleged "anti-Jew document of the U.S. Secret Service" was true. What that document was remains obscure. Evidently the ubiquitous Placci had picked up word among his diplomatic and military friends that Berenson was himself under investigation. The fact was that a confidential report from a naval attaché at the American embassy in Paris to the director of Naval Intelligence stated that Berenson had recently returned to America and that Maurice Paléologue, the former French ambassador to Russia, had described him "as a dangerous individual in character." The attaché, T. R. Magruder, suggested that "it might be well to observe this individual's movements in connection with propaganda relative to (1) the Zionist movement, (2) the world's unrest, (3) the Third International, and the Soviet system." He concluded that "it is possible" that this report "may corroborate other reports."

Once set in motion, the bureaucratic wheels continued turning. The attaché's report progressed to General Dennis Edward Nolan, director of military intelligence for the American Expeditionary Forces; from him it went to W. L. Hurley in the office of the undersecretary of state; and from Hurley to J. Edgar Hoover, who was at this time special assistant to Attorney General Alex Mitchell Palmer, author of the ruthless anti-Red raids of 1920. Hoover's agent interviewed the secretary of the Harvard Class of 1887, who "stated the subject was not the kind of man to indulge in radical views." The agent also noted that Berenson gave an informal talk at the Fogg Museum on March 14 and that his wife "also spoke on March 15 but the place and subject were not reported." (Mary gave a lantern slide talk at the Fogg on Carl Hamilton's pictures.) Hoover transmitted the report to Hurley. Since by that time Berenson had left the country, further investigation was dropped, but the echoes of the affair never quite died away for some bureaucrats and it cast a shadow of mistrust on Berenson's patriotism.

His patriotism had in fact revived. Bernard wrote to Edith Wharton of his renewed respect for America. The amazed Edith responded, "And to think of the United States being the Promised Land after all. A letter in which you announced this discovery so took my breath away that I have

sat gasping ever since. I suppose the answer is that we all have our elective countries deep down in us."

Toward the end of February 1921 the Berensons' schedule took them to Bryn Mawr, where Mary delivered a lecture on the masterpieces in Carl Hamilton's collection, her first lecture in a dozen years. Her hospitable cousin President Carey Thomas arranged a series of banquets, Bernard having said he would like to meet people. Though most of the guests were academics, at one of the dinners they met the very engaging Gifford Pinchot, conservationist head of the Pennsylvania Commission of Forestry, and his "gorgeous" wife, the former Leila Brice. They spent four or five days at Dr. Barker's famous clinic at Johns Hopkins University in Baltimore. In a thorough going over by a dozen or more doctors, they had "every square inch x-rayed and examined, blood pressure and metabolism (oxygen and carbon) tested, blood analyzed, bile pumped (B.B. said it was 'awful') and new glasses ordered." To Mary's horror she was told she was forty-four pounds overweight. Bernard wrote his mother that his examinations had been "on the whole, satisfactory. . . . Unfortunately, they have little to suggest that I don't know already." Mary, more forthrightly, wrote her sister that Bernard "learned what he already knew—he is nervous, too thin, and digests badly."

In Washington for a week, they dined with Mrs. Borden Harriman; lunched and had tea a few times with Senator Henry Cabot Lodge, Woodrow Wilson's foe; met with Hutchins Hapgood's publicist brother Norman and his young wife; looked up Aileen Tone; and dined with Prince Antoine Bibesco, the Rumanian minister to the United States. Berenson also scheduled a conference with James Parmelee, an art collector and trustee of the Corcoran Gallery, whom he had met on a previous visit. The most interesting meeting of the week was probably the one with Associate Justice Louis Brandeis, whose opinions had once worried him. Berenson came away apparently satisfied he was not a dangerous radical. Felix Frankfurter, professor of law at Harvard, with whom Berenson had renewed acquaintance in Boston, had planned to join them but had been called away to "a study of the administration of criminal justice" in Cleveland. "It was good to have had that long afternoon with you [in Cambridge]," he wrote, "and to have had both of you for an evening. . . . I count on you not to forget me."

Unfortunately, neither Berenson nor Brandeis left a record of their encounter. One recollection that may well have diverted them was that of their chance meeting thirty-four years earlier in Boston. Brandeis, then a young lawyer of thirty-one, had written to Alfred Brandeis in January 1887, "Saturday at the Salon met an extraordinary man— Berenson, I think, is the name, a student at Harvard of great talents—

particularly literary talent. A Russian Jew I surmise, a character about whom I must know more. He seemed as much of an exotic lure as the palm or cinnamon tree. He is the most interesting character I have found for some time."

Again in Cambridge, Berenson met with some of the Harvard students at the Fogg Museum in March and gave the talk mentioned in the government report. Arthur McComb, a young art historian, wrote John Dos Passos, who was in Spain working on his novel *Three Soldiers:* "The great Berenson proved to be a small bloodless exquisite creature. He made a few remarks worth passing on. He slammed Sirén by stating that it was impossible to distinguish any of the Giottoischi except Bernardo Daddi and Taddeo Gaddi. Giottino is a myth. Anybody who says to the contrary is a charlatan. (Sirén has written two volumes on him.) About your man Lo Starnina, he connects nothing with him except the three Alhambra paintings, which were done either by him or under his influence. Again Whistler came in for the remark that 'he was responsible for the theory that the artist must be an inspired idiot.' "

There remained the duty calls in Boston and Cambridge, visits with Paul Sachs and Edward Forbes at the Fogg, a last dinner with the family in Brookline, and a touching farewell with Mrs. Gardner. Business and social responsibilities attended to, Bernard and Mary left for New York with Mrs. J. Montgomery Sears and her daughter, who were coming down to see Hamilton's pictures. The few days remaining before their sailing on March 22, 1921, were crowded with society and more business. Cecelia Beaux, the Danas, and Paul Manship graced a large afternoon reception at the Park Avenue apartment, Carl being temporarily absent in the West trying to remedy his deteriorating finances.

The day before they sailed they stopped in at Henry Reinhardt and Son and were dazzled by the sight of a *Madonna and Child* by Giovanni Bellini which Walter Fearon had acquired from Boehler of Munich. It had come from the Prince Hohenzollern-Sigmaringen Collection. Fearon had reduced his asking price from $100,000 to $75,000, and Bernard at once directed Mary to offer it to Mrs. Gardner, who had nothing by that great Venetian master in her collection. The picture, "a severe yet radiant Madonna," Mary wrote, "made our hearts ache for you," for Giovanni Bellini "was the Tree of Jesse of the whole Venetian school."

When some time afterward he urged upon Mrs. Gardner another acquisition, a Gothic statue of Saint Paul which René Gimpel was offering for $100,000, he added that much as he liked the Bellini, "I should not hesitate to chuck it for Gimpel's Gothic statue." On the back of the envelope of Berenson's missive Mrs. Gardner noted, "Swift [her financial adviser] has decided that I have no money for anything." She

underestimated both the temptation of the Bellini and her own bargaining powers. She acquired it on liberal credit terms from Fearon, as she reported to Berenson, for $50,000. As for Gimpel's statue, his price erected "an impossible wall."

For the return voyage Berenson chose the luxuriously refitted *Aquitania,* Sir Joseph's favorite ship. The suites had the air of an art museum, each one hung with reproductions of a famous master. From shipboard, before the liner put out to sea, Berenson sent an affectionate note to "Dearest Isabella. . . . Hold the fort till my return and keep it warm and cozy." He was not to see her again nor was he ever to make a return voyage to the United States.

Bernard and Mary took their last backward look at Bedloe's Island and its hospitable statue amidst a gala throng of millionaire travelers who filled the first class of the sumptuous Cunarder. Their fellow passenger the ever-resourceful Elsie de Wolfe had secured a table for the three of them and Mrs. William K. Vanderbilt, whose elegant presence assured them an agreeably aristocratic voyage. Mary disembarked at Southampton to rejoin her kin, and Bernard submitted himself to the rigors of landing at Cherbourg, where the flood of waiting emigrants to America overwhelmed the facilities.

XXIX

Early Art and the
Land of the Pharaohs

A LETTER from Ralph Curtis awaited Berenson in Paris, urging
him to come down to visit, as the weather at the Villa Sylvia
was "perfectly Duveen." But days of chores faced him before
he could join the Curtises and stop with Edith Wharton at Hyères. First,
he had to have a thousand dollars' worth of fashionable dentistry "in the
hands of a pirate," work which Mary assured Mrs. Gardner he could
have had done in London for one hundred dollars—"but B.B. is unable
to resist fashion." Second, he had to huddle with Edward Fowles over
the scores of entries in the "X" Book and in the many-columned ledger
pages recording the firm's transactions. And having spent a great deal on
the trip to America, he had also to impress Fowles with the need to
extract a substantial remittance out of the always-reluctant Sir Joseph.
Moreover, the medical school education of Karin and her husband now
added a fresh drain of £1,700 a year on his resources.

He enjoined Mary to check their hoard of "pictures, Chinese scrolls,
bronzes, etc." in their London vault and see that they were properly
aired, a task she performed with dispatch. He told her that German art
dealers were buying frantically even in Italy, a sure sign that inflation in
Germany was worsening. He also told her not to plan on visiting her
family in September because of his design to spend three months in
Egypt that winter. After Egypt he proposed to archaeologize in Greece
with Kingsley Porter. During his short stay in Paris he joined the
medievalist Joseph Bédier at the Trocadéro for study sessions on the casts
and sculpture there. Etienne Houvet's monumental volumes on the sculp-
tures at Chartres were fascinating him with their revelations of anony-
mous masters. Soon Kingsley Porter would be writing him "how closely
akin those adossed statues" in Egypt "are in spirit to Chartres and
Loches."

After he visited with the Curtises, Mary joined him at Edith Wharton's "romantic monastery on the rocky hill" above Hyères, where he had had "ten days of walk and talk and sail with Edith." The two itinerants reached I Tatti on April 26, 1921, in time to welcome a stream of visitors and house guests. Elsie motored down from Cannes with her architect friend Ogden Codman, who Nicky imaginatively assumed was her *cavaliere servente*. Elsie was lavish of advice on "how to gay up the rooms," which tended toward Renaissance formality. Lytton Strachey, flushed with the success of his *Queen Victoria,* loitered at I Tatti for three weeks in the company of G. Lowes Dickinson, the "Goldie" who had long been his intimate friend. The self-conscious Strachey found little to approve. "B.B.," he informed a correspondent, "is a very interesting phenomenon. The mere fact that he has accumulated his wealth from having been a New York guttersnipe is sufficiently astonishing but besides that he has a most curious complicated temperament—very sensitive, very clever—even, I believe, with a strain of niceness somewhere or other but desperately wrong—perhaps suffering from some dreadful complexes—and without a spark of naturalness or ordinary human enjoyment. And this has spread itself over the house which is remarkably depressing. . . . One is struck chill by the atmosphere of a crypt . . . and then, outside a dead garden, with a view of a dead Tuscan landscape."

Senda and her husband, Professor Herbert Abbott, lingered on into June, while "hordes" of Russian exiles came by with their tales of outrages. One of them, Serghei Sazonov, the czar's foreign minister, was under sentence of death in absentia. When Mrs. Chanler, a devout Roman Catholic, put in an appearance with her daughter, Mary arranged to have mass held for them in the little chapel on Corpus Christi Day. A frequent visitor was Alice De Lamar, who, with her distractingly pretty companion, Evangeline Johnson, had rented Lady Sybil's Medici villa. Nearly every evening the Berensons drove with them to a distant hilltop at sunset for a leisurely picnic as the shadows lengthened in the valleys.

Visitors could be counted on to bring Berenson up-to-date on the gossip of the fashionable world. The most titillating of the summer concerned Gladys Deacon, who had once so bewitched Berenson. The duke of Marlborough, recently divorced by Consuelo Vanderbilt, legitimized his relation with Gladys, according to Elsie de Wolfe, at an "appalling" ceremony. Mrs. Cole Porter (the former Linda Thomas) corroborated Elsie's account; the ceremony, she wrote, was "the most incredibly vulgar performance I have ever witnessed." The walls of the drawing room of Gladys's cousin Eugene Higgins, where the wedding took place, were "alive with pictures of nude women." Walter Berry served as a groomsman. The guests included the American and Italian

ambassadors, a maharajah, four princesses, a countess, and a sprinkling of commoners, among them Elsie de Wolfe. As the duke had been the offending party in the divorce, no Anglican clergyman could be found to officiate, and a Scotch-Presbyterian minister had come to the rescue. At Gladys's insistence "obey" was omitted from the vows.

With this exploit Gladys passed out of Berenson's life, though not from his memory. He came to feel that she had somehow betrayed him, and he recalled her with a degree of bitterness. "I decided to stop seeing Gladys Deacon," he later told his friend the Italian writer Umberto Morra, "when I convinced myself that in human relationships she offered nothing but an offensive arbitrariness, pursuing people in a flattering and ensnaring fashion, only so as to be able to break off with them noisily when the fancy struck her." He was to encounter her only once after her marriage. While he was walking in Paris one day in 1934, after the death of the duke of Marlborough, an "old horse drawn coupe stopped beside him and a woman clothed in mourning got out." He did not at first realize that the somber apparition was Gladys. She poked a finger at him and cried, "Horrible B.B., you mean you don't recognize me?" Her companion was the painter Boldini, who impressed Berenson as "an even more deplorable figure all bundled up in shawls."

To SATISFY Frederick Sherman's repeated requests for an article, Berenson turned to the portrait of a youth in a red hat which Hamilton had purchased from the Duveens. In a short article he recalled the intense rapture which the sight of this painting had inspired in him when he first saw it in a "Paris expert's junk shop under a fierce light. . . . Often would this exquisite, wistful face appear before me, and I could only murmur to myself: 'No, it cannot be! Painters never express the whole of their art so completely in one single head.' . . . True, it is more Botticellian than any other Botticelli in existence. He must have uttered this completest note of his own music just before he was seized by the Savonarolian madness . . . just at the moment when he was most peculiarly and poignantly and, if I may say so, most extravagantly himself." The *Portrait of a Youth,* after it was surrendered to Duveen, passed to the Clarence Mackay Collection and subsequently, in 1937, to that of Andrew Mellon and then by his gift to the National Gallery of Art, where it carries the name of Botticelli, attested by a majority of the art historians who have studied it.

Before the summer of 1921 was out Berenson also produced a longer and more scholarly article, "Two Twelfth-Century Paintings from Constantinople," a piece inspired by his new interest in medieval art. The paintings were impressive Byzantine pictures of the enthroned Madonna holding the Child and, if of the Constantinople school, they were unique

surviving examples of painting on canvas. "Imagine," he wrote, "that all the pictures done in Paris by Frenchmen had disappeared, and that we could grope at their character from nothing better than the surviving canvases of such imitators—to name the most famous—as Sargent, or Zorn, or Liebermann, or Sickert, or Mancini, or Sorolla. What a revelation it would be to discover a masterpiece by Manet or Degas." The two panel paintings which he had recently come upon in the Kahn and the Hamilton collections in New York seemed to him to epitomize in similar fashion the art of medieval Constantinople. Both panels are said to have come from the Church of Calahorra in Aragon, Spain.

Berenson presented his thesis with "diffidence," because "in medieval studies I am a neophyte." Rather than wait for years in order to "demonstrate my thesis with all the necessary scholarship," he had decided "to present my idea, or, if you will, my fancy, at all events my intuition, to other students to confirm or deny." One of the paintings, the Kahn panel, had been published in the *Burlington Magazine* in 1918 by Osvald Sirén with an attribution to Pietro Cavallini that was "not only wrong, but utterly misleading . . . and thereby stifled interest." Berenson was convinced by the details of color and ornamentation of both paintings that they had been done "under the shadow of Santa Sophia" and were probably part of the loot carried off from Constantinople after its sack by the Venetians in 1204.

He did not offer the article to Sherman for *Art in America* but gave it instead to his enterprising friend Ugo Ojetti for his important art journal *Dedalo*. A man of many interests, Ojetti was also director of the leading Milanese newspaper, *Corriere della Sera*. His writings on Italian art alternated with novels and short stories and a travel book on the United States. Fluent in English, he translated the article for the magazine, the first of nearly a dozen articles which Berenson was to supply to him during the next eleven years.

The provocative challenge Berenson threw out in the article was taken up by a number of art historians. Berenson's conjecture that the panels were from the Constantinople school held its ground, though his dating is now regarded as several decades too early. The two works now repose in the National Gallery in Washington, assigned to the "Byzantine School of Constantinople, XIII Century," there being good evidence that the Constantinople school continued into that century. Hamilton's panel went back to the Duveens and then entered the Mellon Collection. Kahn's widow gave her panel to the National Gallery in 1950.

His modest stint of writing completed, Berenson turned his thoughts to more delightful matters. "Poor B.B.!" Mary informed the vacationing Nicky, "he had arranged his various honeymoons with his vari-

ous ladies so very carefully—Mrs. Lanier in Venice from the 20th to the end of the month, and Baroness La Caze from September 12 till I come back [from England] and now suddenly the Baroness writes that she is coming to Venice on the 20th and that upsets all his plans." He survived the change and went off with Baroness La Caze to Siena and the hill towns in search of early Christian art.

Although Mary had tried to bring herself to agree with Bernard's philosophy that "marriage is a sacrament tempered by adultery," the La Caze junket tried her resolve. "It is impossible," she wrote, "to express the ice that I feel imprisoned in, thinking of thee touring round Italy with a woman who lives as thy wife. However, it is the same as the children's toys and plans to them, and one wouldn't or couldn't have it different." Berenson was an incorrigible philanderer, and his blend of romantic aestheticism and exquisite sensuality seemed irresistible to women. On his drive with a new female companion he would "press an ardent kiss upon the beauty's lips," a lovely Italian contessa confided to a friend, after her first drive with him. She musingly added, "His immaculate beard was so soft and silky."

While touring with the Baroness La Caze, he found time to pour out his meditations to a new friend, the Comtesse Philomène de Lévis-Mirepoix, whom he had met at Edith Wharton's shortly before his trip to America. In reply to his reflections she wrote, as translated from the French, "I love your vast and tranquil wisdom where all sounds fall quiet to allow your silent thoughts to rise, thoughts so pure which you teach me and which until now I did not know." He told her that he lived "in a suspended world" of thought but that he never confounded it with "material reality," and she replied, "It is just what I must do and it is what you must teach me."

Of a poetic and independent nature, Philomène was a graceful and attractive neighbor of Edith at Hyères. A passionate love affair with a married man had left her with a child that she had chosen to rear. An air of romance hung about her that captivated Berenson, and the scores of letters they exchanged during the next quarter century breathed a shared ecstasy of feeling. He became, she said, the Guru of her fragile thoughts and his letters were "a lamp to give light in hours of self-doubt and indolence." Her charm and "exquisite sense of humor" suggested a perfect traveling companion, and Berenson invited her to join his party in their forthcoming visit to Egypt.

After an absence of five years from Siena, Berenson returned to it with the keenest appreciation, especially of the Donatello *St. John Enthroned* in the cathedral. He had to hurry back to I Tatti with Baroness La Caze to meet Sir Joseph, who was arriving with his daughter and Edward Fowles

for a four-day conference. The visit, Bernard reported to Mary, who was still in England, "was as great a success as it could be without YOU. Nicky was helpful." Joe Duveen was at his most expansive, full of optimism, breathing affection and enthusiasm. Eager as always to further his own expertise, he hung on Berenson's comments as they talked about paintings, trying to memorize telling words and phrases. From time to time he would nudge Edward and say, "Try to remember that."

Although a business recession in the United States had nearly paralyzed the art trade, Joe was still predicting—quite correctly as it turned out—an imminent boom market in Italian paintings. His assurance of a substantial payment against the steadily accumulating thousands of pounds in fees removed the last obstacle to Berenson's projected "expedition" to Egypt. In planning the trip he was fortunate to have the counsel of Robert Greg, who had been head of the British Agency in Cairo. With his wife and the popular London hostess Lady Sybil Colefax, Greg came by for luncheon, and the two men talked long of Egyptian archaeology, Greg's hobby.

Berenson's own hobby of early art continued to keep him on the move through the autumn of 1921. In Venice he joined forces with Paul Manship and grew ecstatic over the "light, the color, the works of art." But the persistent hectoring of the gondoliers inspired such a rage that he almost quit his beloved Venice. At the Palazzo Barbaro, where Mrs. Gardner had once presided, he spent the evening with the James Dunns, who were returning to America, and was amazed to see the American diplomat do his own packing for the journey. What most stirred Berenson in Venice was the spectacle of St. Mark's Square. "It would take literature," he said, "to convey my impression of enchantment, my hunger, my sense of unworthiness, my despair." Fortunately, Mrs. Chanler carried him away from "the pedantic path of iconography," and with her he went off to the lonely isle of Torcello to find solace in its Byzantine relics.

On Mary's return from England in October the pair went down to Rome in vain quest of a flat in the hope of Bernard's spending a few months there in medieval study. He had "such a head of steam" for early medieval and early Christian art that he hated to "draw across his track the huge red herring of Egypt." The impulse to put off Egypt passed, however, and they returned to I Tatti to assemble the considerable baggage of books and other impedimenta for their extended absence. Even in the final week of preparation in early November the "I Tatti bus," as Nicky was to call it, was busy ferrying guests from the railroad station to the villa. Santayana and Charles Strong dropped by on their way to Rome and Walter Lippmann and his wife stayed for a few days. On one

day "the dear little pair with shining happy faces," as Mary pictured
them to Mrs. Gardner, were sent off in the Berenson motorcar to San
Gimignano.

The time for departure finally arrived and Bernard and Mary set sail
from Naples for Alexandria on November 17, 1921. In his bags Bernard
carried James H. Breasted's classic *History of Egypt;* Alfred von Kremer's
learned study *Orient under the Caliphs,* which had been recently trans-
lated; Macaulay's version of Herodotus' ancient account; and Annie and
James Quibells' *Guide to the Cairo Museum.* Just before sailing both were
struck by the thought that since Nicky had become so much a part of
their lives, she ought "to be in on it," and they posted an invitation for
her to join them by the next boat.

The two travelers did not tarry at Alexandria but went on immediately
to Cairo. To Bernard's romantic vision the sight of the myriad minarets
of the city as they came into view must have seemed to welcome him
back to the world he had once dreamed about as a student at Harvard.
There he had read in the original Arabic *The Thousand and One Nights.*
He could hardly have forgotten the eloquent invocation to the "Mother
of Cities": "He who hath not seen Cairo hath not seen the world." He
dismissed the too-worshipful dragoman, who persistently addressed him
as "Father," and established himself at the historic Shepheard's Hotel
overlooking the Nile. The dazzling sunshine and exotic ambience, the
colorful life that pulsated along the Sharia Maspero below his window,
so captivated him that he said he did not care if he stayed there "all the
rest of his life." Word of his arrival soon spread. He and Mary were
warmly welcomed by Robert Greg, who was now in charge of the
Ministry of Foreign Affairs. They also met Bernard's old acquaintance
Sir Ronald Storrs, the British governor of turbulent Jerusalem. In his
memoirs Storrs recalled that he "took 10 off" Berenson for his Pro-
Jerusalem Society to further the restoration of its monuments.

Another old acquaintance, Anna De Koven, the wife of the composer,
lavished her admiration upon Bernard. His eyes, she said, were "the
most beautiful ever created . . . his soul the most refined and exquisite,
and his figure that of a divine youth." He ruefully commented he
"would gladly have a paunch instead, if he could digest with it." They
invited Mrs. De Koven to live at I Tatti during their three-month ab-
sence, and she gratefully accepted the invitation. She would have for
company Nicky's sister, Alda, and brother-in-law, Bertie von Anrep.
Displaced and despoiled by the Russian revolution, Anrep was at loose
ends, "perishing for want of something to do."

A swarm of "savants of Egyptology, Arabology, and Coptology"
soon gathered about the Berensons. The most distinguished caller

among the archaeologists was "old Flinders Petrie," who at sixty-eight, "grey and hairy like a prophet," was en route to his excavations at Abydos. Professor of Egyptology at the University of London, Petrie had begun his long series of notable excavations along the Nile in 1880. Also among the savants were the James E. Quibells of the Museum of Egyptian Antiquities; Cecil M. Firth, in charge of the Sakkara excavations; and Achille Creswell, an authority on Arab architecture. With the lively and expressive Achille Patricolo, superintendent of Arab monuments, they explored the old city and the Mameluk tombs. Though less erudite than the "pedantic and dogmatic" Creswell, Patricolo was a far more companionable guide. People rather fought for the privilege of taking them about, Mary reported, so that they had to go in a "clandestine fashion with some of our cronies so as not to offend the specialists."

Early in their stay in Cairo the Berensons visited with Viscount and Lady Allenby, although they shared the Conservative belief that Allenby as British Resident of the Protectorate had unwisely given in to the populace and endorsed Wilson's democratic principle, as Mary put it, of "savagery for the savages." Nationalist fervor had continued to erupt in widespread strikes and occasional riots, punctuated by the assassination of a few British officials, but foreign visitors like the Berensons were able to go about unaffected by the revolutionary ferment. Toward the end of December 1921 they learned of "great rows in Cairo" and demands that the British clear out. But all the Berensons saw when they ventured out of their hotel were "a few broken street lamps and soldiers everywhere." Berenson's only mishap was to catch a cold one day on a windy minaret.

Since they were important American visitors, the United States representative held a reception in their honor. The affair brought together a striking array of notables of the Byzantine society that moved between the residency and the court of Sultan Ahmed Fuad, the former Khedive of Egypt. The "cultivated and affable" sultan followed suit by inviting them to his court. Berenson rose to the occasion and, according to Mary, was never "more brilliant or thrilling." If Fuad had any inkling that he would soon be king of Egypt, he let fall no hint of that prospect.

Fortunately only a few letters and cabled requests for opinions on pictures from the Duveens came to distract Bernard from his new avocation as an Egyptologist. One notified him that a Giotto which he had promised his cousin Arthur had been sent on to Boston. Arthur wrote that he had explored, at Bernard's entreaty, the possibility of his investing in conventional business enterprises and had concluded that in that recession year, given Bernard's reputation and knowledge of values, it would be much safer and more profitable for him to invest in paintings.

On New Year's Day Berenson sent his greetings to Mrs. Gardner, as

he had regularly done for many years, telling her he had a cordial invitation from Sir Ronald Storrs to spend three weeks with him in March in Jerusalem. Meanwhile, he said, "we are in the midst of a revolution. The naughty infants think they would prefer a world without grown-ups." He expected to start up-river on the tenth for Wady Halfa in the Sudan near the Second Cataract of the Nile so as to view on the way Ramses' great rock temple of Abu Simbel, which was then on the river's edge.

Nicky's arrival after Christmas added an agreeable dimension to the Berensons' lives. She had a refreshing curiosity for all the "marvels" and a way of assimilating knowledge of the monuments that recalled Berenson's feats of memory when he was younger. Under Nicky's serenely competent direction, the complicated packing for the voyage up the Nile on the S.S. *Egypt* took place with the help of their new dragoman Abudi, who had accommodated himself to Berenson's slow and methodical manner of sightseeing.

At the vast complex of Sakkara, their first stop, Bernard and Mary, doubtful of the wisdom of riding donkeys, elected to be dragged in a sand cart. That roughly jolting vehicle invited no second trial. At Beni Hassan, Berenson mounted a donkey and took to that mode of conveyance with agility. By the time they reached Luxor he had become "a famous assineer, on his spirited little grey ass," enjoying it "like a boy, laughing and playing tricks and jumping around on the ruins."

Traveling in Egypt, they found, was "furiously expensive" and the requests for baksheesh unrelenting, but at Luxor comforting word reached them that a "fat check" of £5,000 from the Duveens had arrived at Baring Brothers in London. A few days later any lingering anxieties were dissipated when Berenson learned that Arthur Sulley had sent a check for £5,000. By the end of 1922 another £5,000 would be forthcoming from Sir Joseph. These sums, together with £2,000 return on investments, would produce a gross income of approximately £17,000 ($85,000) as recorded by Berenson in his loosely kept pocket ledger. His contributions to his family trust and to Mary's dependents could for the present continue undiminished.

Beyond the First Cataract and the Old Aswan Dam they resumed their voyage on the S.S. *Thebes* and wound their way past the temples of Abu Simbel and "between the diorite rocks of the Second Cataract." The stark, eerily empty landscape was a constant enchantment, especially when the sandstone cliffs glowed pink in the setting sun. On the return down-river, though the planned three-week visit at Luxor lengthened to a month, Berenson complained of being "snatched away before he had seen anything." The poetical Philomène de Lévis-Mirepoix joined the party at Luxor, fitting in pleasantly with all of them. Personable, gay,

and "unrepentant of her irregular past," she gazed at the ruins with eager curiosity. Berenson remarked of her mind that it stretched like an elastic but came back again to its follies. Always the schoolmaster, he wished to improve her; besides he felt "too rheumatic and full of aches to flirt."

At neighboring Thebes Berenson had a disconcerting encounter with an Egyptologist whom he met at lunch at the American House at Deir el Bahri. The fellow scarcely acknowledged his overtures. Baffled, Berenson asked, "What is the matter? Why do you look so sullen and why won't you be civil?" "I'll tell you," he burst out. "That damned Joe Breck so rammed you down my throat that I got to hate the name of Berenson." The overenthusiastic Joseph Breck was the curator of decorative arts at the Metropolitan Museum of Art.

The temples at Luxor and neighboring Karnak proved an overwhelming seduction. Bernard told his mother that he never went out without the scarf she had knitted for him during his visit. The "little old man," as he described himself to her, "in the white pith helmet, with the blue-green scarf" had "grown to be all but a landmark." Mary had by this time begun to travel among the ruins by donkey, and though only a small one could be found, her onetime skill as a horsewoman asserted itself and she mounted her incongruous bulk upon it with unexpected ease. But the exposure of her complicated Victorian underclothing worried Bernard. "Mary, you are too shocking a sight for a Muslim population." "Nonsense, Bernard," she replied. "The unveiled face of a woman is so shocking for these people that they do not pay any attention to the rest." One of Nicky's first duties during their stay in Luxor was to arrange for a riding skirt for Mary, buttoned front and back like her own. Thereafter Mary sallied out on their daily expeditions without further offense to imagined Muslim sensibilities.

After Berenson had somewhat slaked his craving for sight of the great columns in the hippostyle of Karnak and for the marvels of the Luxor temples, whose grandeur made him feel as if his "whole life has been a preparation for it," he daily shepherded the women across the Nile to the west to the Valley of the Kings. Their donkeys carried them three or four kilometers through the naked hills of tumbled rocks on which no green thing grew to the excavations where the archaeologists and their teams of fellahin patiently dug away at the vast mounds of debris. Each day they brought lunch and tea things and never stopped looking "until the sun went down."

Scores of tombs challenged Berenson's curiosity. The Egyptian archaeologist Norman de Garis Davies let them climb down into the tomb of a nobleman which had just been penetrated. Half-asphyxiated by the ancient dust, Berenson was amazed at the extraordinary "freshness and

intensity of color of the hieroglyphs." He learned that Howard Carter and the earl of Carnarvon, having noted that Theodore Davis had turned up some discarded objects identified with King Tut-ankh-amen, had decided to dig through the mountains of old rubble to bedrock in the hope of finding his tomb. The work had gone on for six seasons with essentially barren results, but neither Carnarvon nor Carter had given up hope. Lunching with the two men at their desert site, Berenson felt that "thirty years" had dropped off his "aching back" and he frisked and leaped "even as a gazelle." Ten months later on November 5, 1922, Howard Carter was to uncover the steps cut in the solid rock below the tomb of Ramses VI that led downward to the golden treasures of King Tut's tomb. Even without that revelation, Berenson felt that his experiences at Luxor were the most "life-enhancing" he had ever known. No other art, it seemed to him, approached Luxor's in intensity.

By the first of March the river level had begun to fall, and the remaining voyage down-river became an increasing succession of groundings on sand bars and the occasion for a deafening tumult each time the crew kedged the ship free. They were hung up so long at Assiut that Mary and Philomène, impatient for family news, dragged Bernard from his dreamy meditations and entrained for Cairo. In their absence from the city a revolution of sorts had taken place. Lord Allenby had ordered the rebellious nationalist leader Peter Zaghlul deported to Aden, and in mid-February 1922 a limited independence for Egypt had been proclaimed. Within a fortnight Sultan Fuad assumed the title of King Fuad I. Berenson maintained a distance from these developments, spending the remaining days of his stay in a hotel near the pyramids and at Shepheard's Hotel in Cairo, dividing his time between studying the excavations at Sakkara and reveling in the archaeological treasures of the Cairo Museum.

Early in April 1922 the Berensons landed at Venice. There Mary, still suffering from her "Cairo fever" and a return of cystitis, was attended by the English doctor Wilfred Blaydes, who had in the distant past pursued her with desperate passion. Married now to a woman whom Mary judged "not quite a lady," Blaydes was leading "a nice quiet cultivated life." Bernard too found himself "far from well." He felt a letdown from the exhilaration of the trip and returned to I Tatti momentarily bored and "too stupefied to turn to anything." After four months' immersion in the antiquities of Egypt in which time stood still among the millennia of history, he had to face again the restless tyranny of his profession as an art expert.

Germany and the Stelloni d'Italia

THE "usual bustle" of guests greeted the Berensons on their re-
turn to I Tatti from their Egyptian trip in the spring of 1922. If
on the surface Berenson radiated wit and charm to his guests, he
managed to suppress the gnawing financial anxieties that he read in his
pocket ledger of his account at Baring Brothers. In the first six months of
the year £12,700 was to dwindle to less than £2,000. As a result, amidst
the flood of correspondence with Edward Fowles and Sir Joseph counsel-
ing for or against the purchases of paintings or supplying attributions,
there were long letters protesting against the firm's policy of restricting
his access to other dealers and of delaying the semiyearly payments of
£5,000 for months after they were due. Bernard instructed Mary, "Do in
heaven's name tell [Edward Fowles] to let me have some money." Sir
Joseph at last came through with a postdated check, as "things are very
tight."

The discussion about the Duveen "embargo" on Berenson's recom-
mending pictures to other dealers continued through the remainder of
the year. In December 1922 Mary sent off a long letter to "My dear Jo"
which, after explaining the tangled circumstances surrounding the possi-
ble availability of a Bellini, turned to the "more serious business" of
Bernard's relation to the firm. "If now and then he could do the dealers a
good turn by recommending some minor picture which you would not
in any case want," Mary explained, "nearly all the pictures to be sold in
Italy would come to him as they used to do." Fowles assured Berenson
that Sir Joseph never objected to his offering paintings to others so long
as their "chief competitors do not get works that we have not seen."

The protestations of good faith on both sides did not eliminate the
mutual suspicions that lurked beneath the surface, however, and the issue
was never forthrightly settled. What were major and what minor paint-

ings could not always be easily determined, and sellers could not be asked to wait while the Duveens made up their minds. Moreover, the secret maneuverings in the trade prevented any really systematic procedure from being worked out. What may also have disturbed Sir Joseph were Berenson's substantial dealings with Arthur Sulley in London, an association which in fact yielded Berenson £6,100 in fees in 1922. Duveen had doubtless not forgotten his "distress" at having been bypassed by the Berensons in Sulley's sale of the Bellini *Feast of the Gods* to Carl Hamilton three years earlier.

In the long-running contest between Berenson and Sir Joseph, Fowles served as best he could as a sort of mediator. Occasionally he advised the Berensons how to deal with his imperious master. At the same time he needed to protect his principal. An occasion to try to do so arose early in September 1922 when he met Berenson at the Hotel Bristol in Berlin. Berenson had arrived with Nicky Mariano, who had been traveling alone with him for the first time as his secretary and valet, having been carefully instructed in the latter role by Mary's Elizabeth. Fowles had been solicited by Sir Joseph to obtain a certificate of authenticity from Berenson for a reputed Botticelli in the estate of the late William Salomon of New York, a painting bought from Duveen on the recommendation of Sirén. To Duveen's embarrassment the art critic Maurice Brockwell, who had once been Berenson's secretary, had declined to include it as a Botticelli in a sales catalogue of the Salomon pictures.

Berenson was furious at the request, according to Nicky, and categorically refused. He wrote to Mary, "Yesterday evening Edward and I patched up some sort of letter. He assured me that JD had hoped I would guarantee that the beastly Salomon portrait was a Botticelli." In the "patched up" letter of September 8 to "Messrs Duveen," preserved in the Duveen files, Berenson temperately explained that he had seen the painting at a "big dinner and reception" given by Mrs. Salomon in New York but had not been able to give it "very careful attention. This much, however, I can say, that it is not by Botticelli, but it might conceivably be by Jacopo del Sellajo, whose better works, until not long ago, were frequently ascribed to Botticelli himself." In his old age Fowles in a lapse of memory wrote that Berenson suggested the painting "was an unusually late work of Botticelli."

Duveen, disappointed by the failure of Fowles' mission, noted in a memorandum, "I felt on the whole compelled to acquiesce in Mr. Berenson's possible ascription of it to Jacopo del Sellajo." In November, still hopeful, he sent on a set of Salomon photographs to Berenson. Mary replied, "The difficulty, as you are aware, lies in the Young Man's

Portrait, which is now called not Botticelli, but Sellajo, and in the 'Luini.' We cannot (with the best will in the world) guarantee either—the first is 'close to Sellajo' but does not really correspond with anything we know of his. The second is obviously a Giampietrino."

In the end, according to Fowles, Duveen agreed to buy back all of the Italian paintings from the estate.

Mary was scheduled to interview Sir Joseph in Paris, and Bernard urged her to have Fowles "coach" her for the meeting. "He thinks the most important matter is to insist upon [the] regularity and frequency of accounts," he wrote. "It is two years at least since we have had any. Edward thinks we ought to have them every six months." Bernard thought a simple code could be devised identifying the pictures in the "X" Book and indicating whether they were sold "advantageously or not." "Do consult Edward on this point. . . . I really like him and want in every way to help make him one of us." *That* he never became, and though their amicable relations continued for the rest of their lives, Fowles retained ambivalent feelings about Berenson, who was, he felt, too aggressively self-seeking. Thus he speculated in his memoirs that Berenson was reluctant to attest the "Botticelli" portrait because he had derived no profit "on the initial purchase." He underestimated Berenson's virulent contempt for Sirén's judgment, a subject on which Berenson could hardly contain himself. "JD is fearfully worried over the Salomon business," he exploded to Mary at the period of Fowles's mission. "No wonder. Not only was the sainted Salomon most mercilessly overcharged but the so-called Botticelli portrait is an utter swinery."

Mary had sent Bernard a detailed list of the points that she thought she ought to take up with Duveen. "As to policy—we must have a free hand, and he must trust our judgment." His refusal of a Crivelli, since sold to an outsider, "did a lot of harm to thy prestige and discouraged dealers from showing thee things." She would, of course, go over all matters with Edward "before Jo arrives." The conference appears to have gone off agreeably enough. Joe promised that hereafter all sales would be reported for entry in the "X" Book as soon as they were concluded, "hair by hair," and since the 10 percent export tax had been reduced to 5 percent, he intended to pay it in "an open and above-board way." A second talk seemed equally satisfactory. In the presence of Fowles and young Armand Lowengard, Sir Joseph's nephew who had been brought into the business, Duveen agreed that Berenson should be free to offer pictures the firm did not want to private people and that Berenson could buy for the firm "anything urgent and important *on his own authority*." As for arrears, he would "really pay us quickly *if we would cable him*."

Having got these partial concessions out of him, Mary felt moved to advise Duveen that he should give his wife "a holiday from his overpowering self."

Her business with the Duveens completed, Mary joined Bernard and Nicky in Berlin, where they all made the rounds of the galleries and indulged in an "orgy of opera." Against his better judgment Bernard let Mary persuade him to meet his "arch enemy," Dr. Wilhelm von Bode. The meeting was a fiasco. Bode "was horribly rude, scarcely paid any attention to us and rushed off several times without a word."

The Berensons had spent several weeks in Germany earlier in the summer, having driven up in their car from Florence with Parry at the wheel as always. Bernard had felt relief escaping from the supernationalist frenzy with which Mussolini was infecting Italy. "Oh the joy of being in a country that has not won the war," he exclaimed. "I will have to do henceforth only with people who know they are beaten, with statesmen who have failed, with diplomats who have been dismissed." It did his heart good, he wrote from Munich to Mrs. Gardner, to see again "such exemplary order, such competence, such cleanliness and such friendliness."

To his ailing father Bernard wrote that the German people were "at least as civilized and as gifted as any of us." The German culture of his father's circle had been the liberating influence of his boyhood. "I don't know what I don't owe," he went on, "to the talks I used to overhear between you and your friends." When later in the year Albert, who was then seventy-seven, had to be moved to a nursing home, Bernard sympathized, "I think of you very often and always with love."

Bernard's pleasure during his travels in Germany was tempered by the knowledge that the German people were approaching an economic abyss. Runaway inflation was carrying the deutschemark lower and lower. By the end of August 1922 the rate was 2,300 to the British pound. The Berensons felt like "brutes to live in luxury for almost nothing"—a sumptuous dinner for all of them cost about four dollars American currency, about half a month's salary of "a Professor or Museum director," and they felt ashamed that "our side" was going on year after year "piling misery on the best people . . . the middle and learned classes." Berenson wrote Mrs. Gardner that the working people "cannot earn enough to eat."

Berenson's dependence on Nicky had been growing almost since her first days at I Tatti. Even before the tour of Germany he confessed to her, when she was away with her sister, Alda, "Old Nick I feel only half alive without you and I can't quite believe that if I go into the library I won't find you, or that you won't come back for dinner tomorrow at latest."

Her intelligence and endearing nature had also made a conquest of Mary, who appreciated her role as a protector against Bernard's volatile rages. As Bernard's fondness for her mounted, his other distracting "loves" came to have less urgent appeal for him. He felt himself to be "a reformed character" and philosophized that he had become painfully aware that with "almost vanishingly rare exceptions, women are time wasters and men bores." Nicky was clearly the wonderful exception. As for her affection for him, it had become central to her existence. Being with the Berensons, she said, had taken all the sting out of being an Old Maid, though there were to come times when his philanderings anguished her.

The trio returned from Germany early in October 1922, and the autumn found Berenson again at ease in his study. "I meditate, I read, I walk, I talk," ran his summary to Charles Du Bos. He acknowledged that his years had begun to weigh upon him. He regretted, he said, that Proust—who had recently died—"did not live to feel, to analyze, to record the first approaches of old age." It was a task he would himself undertake late in life in his own diary. As if in anticipation of that future, Nicky was moved from the villino across the road to a comfortable apartment on an upper floor of the Villa I Tatti. There she would reside until Berenson's death thirty-seven years later.

On his arrival Berenson had found a discomforting inquiry from his cousin Lawrence, who had begun his devoted service as Bernard's American lawyer and man of affairs. The Internal Revenue Service had challenged the deductions in his 1040 income tax report. Berenson's lengthy rationale has a timeless interest for the independent professional. "Unfortunately," he began, "I have never regarded myself hitherto as a man of business. . . . So I had no occasion for keeping accounts. . . . From an aesthetic and spiritual point of view, it is regrettable that a person of my kind and in my position should be forced to treat himself and to organize himself as a business." As to the difference between personal and business expense, he continued, "I do not earn money by trade. I earn it by enjoying such authority and prestige that people will not buy expensive Italian pictures without my approval. . . . To keep that authority I must keep myself in constant training by contact with works of art and by being surrounded by them in my own home." At least three-quarters of his expenditures were on "travel, books and photographs and reproductions. Travel in my present state of health and greatly diminished forces implies the constant presence of my wife, a secretary and servants. My wife is all but as good at my job as myself and without her and my secretary I could not possibly get through the work I undertake, or a journey. My home is little more than a library." He bought books primarily to stimulate his "aesthetic sensibility."

Lawrence informed him that using the figures Bernard supplied of his expenses, including professional gifts and Italian taxes, he reported a 1921 net taxable income of $20,000 out of a gross of $90,000.

Life at the villa seemed singularly peaceful that October in spite of the burgeoning Fascist turmoil that was sweeping Italy. Guests could always be counted on for agreeable diversion. Aileen Tone evoked nostalgic memories of Henry Adams as she sang her eleventh- and twelfth-century songs in the Music Room. Israel Zangwill put in a welcome appearance, "much mellowed," though his bonnet was still "full of bees." He was now working on a play, *The Fording House,* in which a Socialist regime replaces the monarchy, a kind of forecast of what was about to happen to Italy. Preparations for the Fascist March on Rome had already begun, but in Zangwill's tolerant eyes "the events of those days resembled comic opera more than a real revolution." When one day the Fascist leader Curzio Malaperte took Zangwill about Florence and tried to persuade him that a revolution against the government was under way, what Zangwill saw was that the authorities appeared to be actually collaborating with the Fascists. The following day, October 28, 1922, the March on Rome took place while Mussolini prudently waited in Milan for word of its success. On the thirtieth he arrived in Rome and took over the post of prime minister.

Some weeks later Berenson wrote Judge Learned Hand that the mark was 6,000 to the pound when he left Germany in early October and now [in December] was 35,000. "One of the most appalling fatalities of history was first England's and then our interference in the race between France and Germany as to which should be the Boche-ist. It has produced a disequilibrium that it will take generations to right. . . . Here we are all pretending like five year olds that Santa Claus will bring us all things. . . . And all by believing in Mussolini and the *Stelloni d'Italia* [Italy's lucky stars]."

René Gimpel, who was among the guests the day after Mussolini took command, recorded in his diary that the talk at the table ran much on fascism and that Berenson commented with heavy irony, "These Fascists are the same people who requisitioned my most precious wine three years ago in the name of the Florentine Soviet Committee; then they were Communists. They don't know what they are. . . . I've lived here for thirty-two years and I've never seen a government, and that's their way of governing, like their police who lie low during strikes. . . . But nevertheless everything works in this country. That's because Italy isn't a nation; it is a civilization." After dinner, Gimpel's account continued, "Berenson, that model of integrity, tried to sell me pictures, and very bad they were." If these pictures were indeed inferior, the same could not

be said of the succession of paintings Berenson was recommending to Duveen, Gimpel's brother-in-law. He asked Mary, for example, to urge upon Fowles and Lowengard the purchase not only of Bardini's Fra Angelico but also Liechtenstein's portrait *Ginevra de' Benci*. Whether the price of the latter masterpiece was too high or the tender was withdrawn, the portrait remained in the Liechtenstein Collection for another half century.

By the Christmas season the villa was again bursting with guests. To the absent Nicky, Berenson wrote, "Beloved, I miss you so much that I cannot write to you and I do all I can not to think of you." His sister Bessie, he told her, was a transformed person since becoming a sculptor. "She is now alive, zestful, intelligent and perceptive." Mary's sister, Alys, was also on hand and they were awaiting the arrival from Jerusalem of Sir Ronald Storrs, "successor to Pontius Pilate," who was said to be coming to court a granddaughter of Rockefeller residing in Fiesole. There was the usual run of young art historians—Arthur McComb and Richard Offner, among others. Paul Manship had already come and gone. The Hapgoods horrified Mary with their lurid tales of their bohemian existence, and she thanked her guardian angel that deterred her from letting Hutch make love to her "or I would have been in that hysterical book." She was referring to Hapgood's novel *An Anarchist Woman* (1909), with its tales of "getting drunk and kissing each other all over the place and chewing strange plants and going temporarily crazy."

Their most exciting dinner guest was William Bullitt, full of boisterous vivacity, who came with his young wife. After Woodrow Wilson and Lloyd George had repudiated his mission to Lenin, he had indignantly turned from affairs of state to roaming about Europe for a leading Hollywood maker of films. He could still be counted on to be voluble on his betrayal. Amends would be made to him years later when Roosevelt appointed him ambassador to the Soviet Union.

The Egyptian journey whetted Berenson's appetite for travel and archaeological adventuring. However much he longed for quiet, as he so frequently professed, an inner restlessness demanded other horizons. Since his arrival on the Continent thirty-five years earlier, almost every year had found him journeying ceaselessly about Europe. His five long visits to America had obviously confirmed the habit of travel. Happily the archaeological trip to Greece with the Kingsley Porters was being planned for the spring, and sustained by that prospect he began work after his holiday guests departed on a long essay which would demonstrate that, in spite of his active service as an art expert, he was primarily a scholar in art and archaeology. He resented the legend that was growing up about him, as he was to say in his *Sketch for a Self-Portrait,* that he

"ranked with fortune-tellers, chiromancists, astrologers and not even with the self-deluded of these, but rather with deliberate charlatans" and that he had "invented a trick by which one could infallibly tell the authorship of an Italian picture." An article applying his method to a particular case, would, he hoped, explode that myth.

The essay turned out to be a remarkable tour de force and belied his complaints of fatigue, though the writing of it during the first two months of 1923 was not without a few violent outbursts of rage against Mary. To Senda he deplored the "nasty little injustices and the betrayal of a suspicious, self-seeking egoism" and the "scenes" that he seemed to need to relieve his discontents. Nor did it help that he sometimes felt that she and her brother were in some sort of league against him with their thinly veiled air of moral and social superiority. After an eruption that ended weeks of seeming harmony, Mary in a moment of bitterness confided to her diary, "If he only knew how it makes me despise him, and he pretending to be so immeasurably superior and mysteriously saintly that I 'don't understand' him in the least. Silly little puppet."

Despite the tense ambience, Berenson managed to give free rein to the far-ranging insights of the new article, "A Possible and an Impossible 'Antonello da Messina.' " The "possible" Antonello was a Saint Sebastian, a half-ruined fresco in the Museo Civico of Verona attributed to the school of Girolamo dai Libri. "The instant I looked at the fresco with a seeing eye," he wrote, "I mean with all faculties co-operating, I felt that it must be by Antonello." He then proceeded to demonstrate in a few pages how he confirmed that intuition by means of comparisons with telltale aspects of Antonello's known works. Admittedly the resemblances and parallels were hypothetical, and he left it "to fellow students" to decide "whether this ruin of a once wonderful design is to be admitted to the canon." He never gave up his hypothesis, and the fresco was identified as Antonello's a half century later in his Venetian List. A recent catalogue of Antonello's works assigns it to Girolamo dai Libri, with the explanation that critics have not shared Berenson's view.

The main thrust of the essay concerned the "impossible" Antonello. Berenson had never seen the painting, a *Madonna and Child with the Infant John,* and had only recently come upon a photograph of it from one of his correspondents. Though its current whereabouts were not known, it had received much attention from critics and was commonly ascribed to Antonello. In 1927 when the painting was acquired by the Metropolitan Museum of Art, the ascription to Antonello, despite Berenson's article, had the impressive support of Adolfo and Lionello Venturi, Wilhelm von Bode, Max Friedländer, Tancred Borenius, and other experts, but in the end Berenson's opinion prevailed.

The painting, Berenson argued, did not exhibit the artist's "mood, his music, his tempo." More important, the details, the "quantitative things," the shape and drapery of the face, the treatment of the hands, and so on, were not those of Antonello. The reed cross in the Infant John's hand was a motif that did not appear in Italian painting until after Antonello's death, and, as he demonstrated by a dazzling survey of Italian Renaissance paintings, the Infant John figured only in Florentine and Perugian works during the fifteenth century. Other anomalies, such as the motif of the Child leaning away from the Madonna, the type of hood, and the folds of the Virgin's drapery, all indicated a later date. Replying to critics who had attacked him for excessive Morellianism, he declared: "To reach my conclusion it was not necessary to depend on the Morellian methods of connoisseurship alone. These may be all-important in determining the difference between a copy and [the] original, or between one painter and another in a small group, but in this case the more palpable, more obvious, less subjective, and almost purely quantitative methods of archaeology suffice."

Not only were his methods free from any suggestion of legerdemain, but they also utilized the full resources of the trained mind. Intuition might provide a necessary hypothesis, Morellianism might offer confirmation at one level, but central to his method were the circumstances of "historical probability." He summarized those applicable to the "impossible Antonello" in "seven labor-saving" criteria, their character suggested by the following examples: "A picture containing a reed cross is not earlier than the last decade of the fifteenth century; a Madonna deliberately leaning back, away from the child . . . is not found in the fifteenth century; a picture in which a curtain is drawn across a considerable portion of the sky . . . is little, if at all, earlier than 1480."

The article did not have an easy birth. It opened a "new field in our studies," Mary proudly wrote to her mother-in-law. She firmly added, however, that "it was certainly very carelessly written, and it took two weeks of very hard work on my part and on the part of Bobby Trevelyan, who is staying here, to put it into possible English." Trevy, who, like Mary, balked at Bernard's purple passages and parenthetical asides, recalled that the "rows were awful." Bernard's highly personal idiom largely survived the assault, though, as Mary added, "it was really a miracle that divorce proceedings were not to follow immediately." In March the article was sent off to Ojetti to be translated, and it appeared two months later in the June 1923 issue of *Dedalo*.

Berenson sent an offprint of the article to Fowles. Fowles had it translated, because he did not understand Italian sufficiently well to follow a long article. It would thus also be accessible to Sir Joseph, who often

adopted the language of Berenson's analyses as his own. He so prized Berenson's presentations that he was having "bound all the letters he [had] received from Berenson over a period of fifteen years . . . with an index." Gimpel advised his brother-in-law to bequeath the volume to the British Museum together with the firm's business correspondence.

Fate decreed otherwise, and the letters, which Fowles inherited, were ultimately left to the Metropolitan Museum, together with the New York office correspondence, under restriction until the year 2004. According to Fowles, the valuable files of the Paris branch had to be destroyed for want of a willing depository.

With the essay on Antonello safely out of the way and peace restored with his "board of editors," Berenson eagerly set out on his expedition to Greece in a party which included Mary, Nicky, and Logan. It would be his first return to the idealized land since his visit there in 1888 as a young man of twenty-three.

The Case of
La Belle Ferronière

THE return to Greece after the lapse of thirty-five years was a deeply moving adventure in nostalgia. On that first visit Berenson had seen the land as the visual illustration of the Greek classics he had been translating at Harvard, and he had felt himself a true Hellenist for whom Homer was still a living presence. For many years thereafter he had begun his day with a few pages of an antique text. How amazingly his personal circumstances had changed since long ago he had shared the deck of the little steamer with its motley passengers and their livestock on the passage to Piraeus! His solitary and dusty marches with his meager purse of drachmas were long past. Then he could afford only a limited reconnaissance, as when he made his "comfortless" journey to the recently uncovered Olympia. But his vision of the Parthenon crowning the Acropolis never faded, and he spoke of it as a kind of talisman to the end of his days. Once when Louis Gillet wrote that he planned to visit Athens, Berenson exclaimed, "I never cease regretting that as a youth I did not dedicate my life to Athens rather than to Florence."

He came now to Athens affluent and famous and filled with a grander vision of the significance of the past. His travels in Egypt had awakened in him a sense of the remarkable continuity of the aesthetic experience. In Egypt he had seen it carried back for distant millennia. It was thus with fresh eyes that he looked upon the artistic remains of antique Greece, and undoubtedly there took root in his mind the conception of the continuity of Mediterranean art that would one day demand expression.

Sailing from Brindisi the Berensons joined forces with the Kingsley Porters in Athens by April 23, 1923. Determined to make every moment of the Greek tour count in his study of antique art, Berenson tired out the whole party with "his passionate sightseeing." No longer a mere tourist, he haunted the Athens museums in the mornings, where he fixed his eye

upon the recently recovered sculptures. He climbed the Acropolis to the Parthenon with Nicky to watch the sunset coloring the Pentelic marble. There were rapid excursions in the Porters' car to nearby Daphne, Eleusis, Marathon, and Sounion.

In Athens he conversed with the international archaeologists who made it their headquarters, the heads and associates of the French, German, British, Italian, and American schools. Wilhelm Doerpfelt, who had been responsible for much of the success of the Olympia excavations, was on hand to brief him. He conferred with Alan J. B. Wace, director of the British School at Athens, who had worked at Mycenae and Sparta, and with Wace's American colleague Carl William Blegen, a member of the group that had taken part in the reexcavation of Troy and worked in the digs of the Peloponnesus. He felt closest kinship to the Italian archaeologist Doro Levi. Levi, a Jew, was soon to be dismissed by the Fascists from his chair at the University of Cagliari, and Berenson later helped him find refuge in the United States.

Following the days in Athens there were excursions to Corinth and a journey across ancient Arcadia to Andritsaena and the great temple of Apollo at Bassae. At Olympia Berenson's weary companions somewhat deprecated the sculptures in the museum, and to combat their heresy he insisted on returning with them the next day to convert them to a proper appreciation. He succeeded with all except Porter, who, to Berenson's annoyance, took an interest only in archaic Byzantine art. On one occasion, however, when there seemed too much awe in the air at the theater of Dionysius and Nicky remarked how wonderful it must have been to see a performance there, he said, "Do not forget they were all munching garlic while watching the show."

Some of the expeditions embraced places off the beaten track in the Peloponnesus—Nauplia, Epidaurus, Mycenae, Nemea, and Sparta— and to ensure comfort at the country inns the travelers were accompanied by a motor truck "carrying field beds and a cook." Every morning their dragoman would courteously inquire whether they had been troubled by fleas. Their pilot, a Milanese chauffeur, rather deplorably lacked Greek, with the result that Berenson made do with the Greek of Homer and Thucydides. Sometimes truck and car had to be abandoned and mountain trails had to be negotiated by donkeys. So the ascent was made to the medieval Turkish citadel of Acrocorinth. Wearing his white topee against the sun, his slight figure astride the donkey, Berenson fearlessly trotted along the narrow trails that skirted deep ravines, diverted by this mode of transport as much as he had been in Egypt.

One journey took Berenson to the monastery of Hosios Loukas with Nicky and the Porters, Mary and Logan going on by boat to Delphi, as

both were out of sorts. The eight-hour ride across the mountain spurs brought them to the great Byzantine monastery-shrine on the flank of Mount Helikon. At dinner when a whole roast lamb was brought in, their host, a great bearded monk, honored Berenson and Nicky by carving out the eyes and placing those delicacies on their plates. In the morning they studied the remarkable series of mosaics of the Church fathers.

The extensive ruins at Delphi littering the slopes above the precipitous gorge that descends to the sea marked the dramatic end of the month-and-a-half tour. Here the mystic Oracle issued her riddling commands to all Greece. To Berenson the place seemed a kind of religious marketplace, which in its prime must have looked like the well-known cemetery at Genoa, "filled with hideous little sanctuaries one on top of another." The descent from Delphi to the port led through the great olive orchards that filled the valley and the plain. En route to Venice the travelers spent a final day of sightseeing at Corfu, that loveliest of the Ionian islands. In the small museum they gazed in wonder at "the grinning, powerful, life-enhancing" archaic Gorgon that dominated the room.

The Berensons arrived in Florence with "the music of Greece still echoing" in their ears. Settled at I Tatti at the beginning of the summer of 1923, they could scarcely draw breath before being caught up in a rush of activity. There were unmistakable stirrings of the art market. Berenson cautioned young Lowengard that "the dikes that have held up . . . the speculation in works of art in the past six or seven years are breaking." Important things were coming on the market and the Duveen firm needed to get busy. Practical matters would have to be taken up with Sir Joseph, who was momentarily expected in Paris. But the prospect of listening to Duveen's rodomontade at the gallery in the place Vendôme was more than Berenson could face. He therefore dispatched Mary to Paris on the first of July, a chore that she welcomed as it would permit her to go on from there to England again to pamper her grandchildren.

Mary found Duveen in good fettle, full of "encouraging business and friendliness," boasting as usual of triumphs past and to come in the presence of the long-suffering Edward Fowles and Armand Lowengard. He had "high hopes" for Hearst and felt sure of Rockefeller. She could bear it, Mary wrote Bernard. "In fact I like it, once in a way, for Jo triumphans is necessary to us and besides it is a vital spectacle." When she had confided to Sir Joseph that they had settled £5,000 on Nicky, he said, " 'It's the best investment you ever made,' and he beamed all over when I said that it was because of him we could do it." The trust had been in existence for almost a year, the money invested "in good Brazilian stock that pays 7% so that she will be provided for if we die sud-

denly." The Duveens, Mary learned, had not taken back all of the pictures sold to Carl Hamilton. He had managed to pay for the Fra Filippo Lippi, the Piero della Francesca, two Fra Angelicos, a Lorenzetti, and several other paintings, and thus had been left with a respectable collection. His investment was to pay off: the Piero della Francesca *Crucifixion* would bring $375,000 and the Fra Filippo Lippi *Madonna and Child* $125,000 at auction in 1929.

In Mary's absence Bernard kept her posted daily on life at I Tatti. A visit by Salvemini had alarmed him, for he learned that though he had been denied a passport by the Fascist authorities, he planned to cross the frontier anyway. Lady Sybil depressed Bernard by remarking that it was a pity that Salvemini was going to England to speak against the Fascisti. The Fascist movement was in full bloom. "Freedom of the press has been abolished," Bernard sadly reported, and the streets of Florence were placarded with *Basta Col Parliamento Evviva Mussolini.* "What a queer fish man is. A hundred years ago the same species of Italian was making fish eyes at *parliamento* and *libertà* and all the other catchwords he is now abbasso-ing." To Mary, fresh from the heady presence of Duveen, Italian politics seemed irrelevant. "Cheer up, old man," she responded. "$100,000 a year isn't bad."

One of the "Big Fish" whom Duveen wished to entice into Italian acquisitions was the multimillionaire head of Western Union, Clarence Mackay. He wanted the Berensons to join him and the tycoon in Paris in mid-September. Berenson thought it "a particularly crazy idea." Joe "ought to know by this time it is no use my attempting to tout for him." Besides, "attempting it damages what awe the midases might have for my name." Joe added a further request that when Berenson came to Paris he examine the "so-called Leonardo" which was to be on view at the Duveen gallery in the place Vendôme.

The "so-called Leonardo" was *La Belle Ferronière,* a painting owned by Mrs. Harry J. Hahn. A reporter from the *New York World* had asked Joe's opinion of it in June 1920 when Mrs. Hahn had offered it to the Kansas City Art Institute as a Leonardo. Joe, who prided himself on his expertise, had unhesitatingly replied that it was a copy of the original in the Louvre. Thus had begun the most famous cause célèbre of the art world. Soon afterward Duveen incautiously complicated the matter by adding that, like other experts, he doubted that Leonardo da Vinci had painted the Louvre *La Belle Ferronière.* Armed with these opinions, Mrs. Hahn filed suit in New York against Duveen in November 1921, charging slander of title. Duveen's lawyers thought at first it would be sufficient to obtain affidavits from art experts abroad based on a comparison of photographs. It was subsequently arranged that the experts should examine

the two paintings, and the Hahns sent their picture to Paris for the purpose.

When Mary told Duveen that she and Bernard would arrive by airplane, he protested, "Surely you would not be so careless as to travel, both of you, by flying machine. You have no right to do so, for the sake of us all, I mean the art world." It was a needless protest, for Bernard did not share Mary's enthusiasm for air travel. To view landscapes in that fashion, he felt, destroyed all normal responses to spatial relationships and violated the nature that he so passionately loved. This had been his conviction since his first sight of the planes at the Le Mans meeting in 1908, and there is no indication that Mary ever succeeded in getting him aboard an aircraft.

Duveen followed up his written request for Berenson's presence in Paris with a telegram in which there was now no mention of a meeting with Clarence Mackay. "Our American lawyer [Louis Levy] . . . who will be in Paris . . . especially for Leonardo case wires us that he begs you to examine pictures and give your evidence in writing. . . . I hope you will help us, Joe." Berenson tried to beg off. Another telegram arrived: "Much disappointed. In fact cannot take refusal. You will have to stand by and help us. Everybody expects your opinion on this matter. . . . Do not disappoint me. . . . Joe."

Reluctantly Berenson agreed, and he and Mary picked up Nicky in Switzerland and entrained for Paris. His reluctance was understandable. He must have recalled that he had once attributed *La Belle Ferronière* to Boltraffio, "the ablest of Leonardo's pupils." And much more recently in his iconoclastic essay on Leonardo he had said of the painting, "I fear . . . in discussing Leonardo we cannot safely count her as his," though suggesting the possibility that the painting might be Leonardo's "in no matter how limited a sense."

By the time Bernard arrived in Paris the dispute had become an international sensation. Once the New York court authorized the taking of depositions by art experts in Paris, the newspapers in New York, Boston, and Paris were on the qui vive for details. The London *Times* declared that the case seemed "destined to create almost as great a commotion in art circles as the theft from the Louvre of 'La Gioconda' in 1912." It was reported that "Madame Andrée Hahn" was suing for $500,000 damages, charging that Duveen's criticism had prevented the sale of the painting to the Kansas City Art Institute.

The examination of the expert witnesses was to take place on September 3, 1923, in the office of the American consul general, with Berenson appearing as Duveen's first witness. Earlier on that day he spent an hour examining the Hahn picture with a magnifying glass at the Duveen

gallery and then went on to the Louvre to see *La Belle Ferronière*. Then, accompanied by the Duveen lawyers, he proceeded to the American consulate, where the Hahns awaited him with their lawyers, Hyacinthe Ringrose and George Campbell. In the course of the hearing Ringrose vigorously "attacked the witness from every angle." Berenson appears not to have lost his composure during the ordeal, though he was hard put to contain his fury. After three solid hours of questioning, a reporter heard Berenson timidly request that he be allowed to stop to have his tea, at which women in the audience were heard to murmur, "Isn't he just *too* sweet."

At the beginning of the cross-examination, Nicky, who had come in late, softly asked Mary, "How is it going?" Mary, quick to misjudge her husband, whispered back, "Bernard has already made a fool of himself." Nicky thought his answers "simple and convincing," and the reporters' accounts bore her out. Berenson testified that he had known the Louvre picture for forty years, and though he had at first doubted its authenticity, he had since changed his mind and was now positive it was by Leonardo and that the Hahn picture was "a bad copy." "The copy has nothing like the vitality of Leonardo's work. The eyes lack Leonardo's sparkle. . . . The treatment of the hair in it was like that of a wig and quite different from da Vinci's style." What was most conclusive was that "the parapet in the Louvre picture was absent" from the copy. When Ringrose pressed him on why he had not informed the experts at the Louvre that he had changed his mind about the attribution, Berenson haughtily replied, "There aren't any experts at the Louvre."

Ringrose also asked, "You've given a good deal of study to the picture in the Louvre?" "All my life, I've seen it a thousand times." "And is it on wood or canvas?" Berenson reflected a moment, "I don't know." Ringrose scoffed, "What, you claim to have studied it so much, and you can't answer a simple question?" Berenson retorted: "It's as if you asked me on what kind of paper Shakespeare wrote his immortal sonnets." Sir Joseph reported this diverting exchange to his brother-in-law. Gimpel, who did not greatly admire Sir Joseph, added in his diary that Duveen had not told him—what had come out in the press—that Ringrose had presented Berenson as a mere employee of Duveen and asked whether he had been paid. Berenson, who was under oath, had had to reply, "Yes." Gimpel gloated, "So compromised in the face of the intellectual world his mask fell, that mask which so many enemies have sought to tear away."

The cross-examination of Berenson continued the next morning. Under questioning he frankly admitted that he was not an expert on techniques or the chemical composition of pigments in paintings or the

mechanical manner in which painters go about their work. He explained that through a lifetime of study of Italian paintings he had accumulated knowledge that almost amounted to a sixth sense so that he was able to place a painting in its exact school or era. His entire study was based, he said, on the examination of paintings and not on a knowledge of the methods of producing them.

Having done his duty by Sir Joseph, Berenson immediately left for London, pleading ill health and fatigue. The hearing dragged on for another two weeks as expert after expert was exhaustingly grilled by Ringrose. All agreed that the Hahn picture was a copy. The parade of Duveen's distinguished experts was interrupted for one day when all nine adjourned to the Louvre to scrutinize the two paintings, which had been removed from their frames and laid side by side on a table in the office of the curator of paintings. The men spent two hours scrutinizing the paintings with their magnifying glasses. The "jury" was unanimous: the Louvre painting was an original by da Vinci, the Hahn a copy.

Roger Fry, one of the experts, was quoted a few days later in the *New York Times* as saying that he could tell the Hahn picture was a copy without knowing the original existed. In his account to Vanessa Bell Fry wrote, "You see I was called up to Paris to give evidence about the absurd case of the so-called *Belle Ferronière*. I tried not to go but Duveen insisted, so I thought I must and I expect to be well paid for it."

Sir Joseph returned to New York and, oozing confidence, he boasted to an interviewer at the Plaza Hotel that he had acquired many noted masterpieces while in Europe, including works by Frans Hals, Vermeer, Holbein, Rembrandt, Van Dyke, Gainsborough, Reynolds, and Bellini. To Mary Berenson he wrote that he hoped Bernard's "coming to Paris to testify in the Hahn matter did not fatigue him too much. I am indeed most grateful for the wonderful assistance he rendered."

Duveen's satisfaction proved premature. One continuance followed another until the case at last came to trial in 1929, the suit now reduced to a claim for $250,000 damages. What had seemed simple in 1923 became troublesomely complicated under the cross-examination of the Hahns' new attorney, who relentlessly ferreted out every contradiction or improbability in the testimony of the witnesses and in the depositions made in 1923. He particularly stressed that Duveen paid the experts for their "certificates." Langton Douglas frankly admitted on the witness stand that he had gone into expertizing because he needed the money. The jury reported their inability to agree, the vote standing 9 to 3 against Duveen, and the judge ordered a retrial. Sir Joseph had spent days on the stand exuding confidence in his own expertise to no avail. He settled the case out of court for $60,000 in October 1929.

[317]

Comments in the New York City newspapers reflected a general feeling that the lawsuit was absurd. As the *Evening Post* put it, "How can anyone outside of a comic opera expect the authenticity of an old painting to be settled by a lawsuit? . . . A verdict of damages against Sir Joseph Duveen might have meant the silencing of all expert comments in our country. This would have been a very real calamity."

Berenson maintained the attribution of the Louvre painting to Leonardo da Vinci in his 1932 Lists, and the ascription was repeated in the posthumous List of 1963. The Louvre catalogue continues to give the painting to "School of Leonardo" in spite of the fact that in 1952 for the five hundredth anniversary of Leonardo's birth Madeleine Hours, a Louvre official, x-rayed all of its "Leonardos" and found that the x-rays showed the technique of *La Belle Ferronière* was similar to that of the *Mona Lisa*. She communicated her findings to Berenson. Conservative art historians, however, still are doubtful of the attribution to Leonardo.

Impressed by the comic opera aspect of the trial, the British Catholic writers Hilaire Belloc and Gilbert Chesterton concocted a burlesque mystery novel of the case, *The Missing Masterpiece.* Duveen is displayed in the character of Sir Henry Bensington as a self-proclaimed expert and dealer and as a master of shady money-making stratagems. Berenson enters as Edward Mowlem, an art expert whose testimony runs on in an arcane and confusing stream. The *New York Times* objected that "Mr. Belloc never allows the reader to forget that he is prejudiced against the Jewish race, to the detriment of his artistic judgment as well as his former reputation for fair play."

Upon his arrival in London after the Paris hearings, Bernard discovered he had made a mistake in acquiescing in Mary's scheme to rent her daughter Ray's apartment for their stay. Doubtless Mary thought it an ingenious way of increasing Bernard's subsidy to the impecunious pair, but her fastidious husband was soon railing against the bohemian untidiness of the place fit only for "intellectual cave dwellers." Mary's sister, Alys, had not improved matters by engaging a novice woman driver ignorant of the streets of London. For Nicky, who accompanied the Berensons everywhere—to the salons of London friends, on weekends to Oxford and Cambridge, and once to Robert Benson's great country house with its impressive array of servants—the sudden plunge into that harried social existence proved an unsettling though useful initiation. Returning to Big Chilling, they met Salvemini, who was staying with Alys and Logan. They learned that he was studying English, determined to speak in England on the dangers of Italian fascism.

At one "stormy luncheon party" in London at which Bernard displayed his unfortunate propensity for waspish ridicule of popular taste,

Trevy brought over Augustine Birrell, the writer and statesman, and Raymond Mortimer, a rising young journalist, both of whom Berenson was eager to meet. Early in the conversation Berenson lashed out at the current canonization of Rupert Brooke, the soldier-poet who had died in Greece on the way to Gallipoli. Brooke's war poems were on everyone's lips at the time, and the legend of the handsome youth cut off in the midst of great promise commanded universal reverence. It was no moment to point out that Brooke's poetry suffered from mellifluous sentimentality. Both visitors protested Berenson's sacrilege, and Birrell "was almost beside himself with indignation." Mortimer later forgave Berenson his iconoclasm and became a warm friend, but Birrell kept his distance thereafter.

When the Berensons returned to Paris, Bernard held court at the Hotel Beau-Site. Here old friends like Abbé Mugnier brought the amusing gossip of French high society and Edith Wharton opened her arms to him. With Philomène de Lévis-Mirepoix he and Mary shared the memories of their life-enhancing days in Egypt. Natalie Barney still cast her ambiguous charms and Baroness La Caze her all-too-intelligible authority. It was an ambience in which Berenson could toss off his outrageous paradoxes to an appreciative audience. At a tea one day René Gimpel found him "surrounded by an admiring group of sophisticated young women who were reminding him of all his witty remarks . . . such as: 'O God, grant me this day my daily idea, and forgive me yesterday's.' " Gimpel and Berenson fell to discussing the recent novel *Le Grand Écart* by their younger acquaintance Jean Cocteau, who at thirty-four was one of the literary stars of Paris. Berenson agreed with Gimpel that the book was "very banal" and he elaborated, "The boy is just a brilliant talker I love listening to, but not half as much as he loves someone to talk to! And whenever he opens his mouth he takes you straight to paradise."

If Berenson scorned the Duveens and their connections as clamorous money-grubbing vulgarians, an opinion he did little to conceal, Joe Duveen's nephew young Armand Lowengard, who had joined Gimpel at the tea, entertained an equally unfavorable though discreetly concealed opinion of Berenson. After Berenson and Gimpel departed that afternoon, Armand broke out, "It pains me to visit that hypocrite. . . . You've seen how the snob plays at being disinterested in the eyes of the world. . . . He'd like us to pay his expenses in Paris and give him an advance on his commissions; . . . well, you ought to see his letters asking for money, the baldness of it." What especially exasperated Armand and Gimpel was Berenson's attitude that dealers were below the intellectual salt and therefore fit only to be patronized and unceremoniously called to

account as by a British milord. It was an attitude that left a long trail of resentment.

Bernard and Mary ran up to Brussels briefly to see the collection of Adolphe Stoclet at his magnificent Villa Stoclet on the avenue Tervuren. Stoclet, a banker and railway magnate, was a man near Berenson's age who had built up "a truly glorious collection of Byzantine and Italian primitives; of enamels and Chinese things and the finest existing collection of Egyptian things," a collection that offered a breadth of artistic and archaeological interest that touched Berenson at every point. It was a feast of eye and mind that the Berensons were to repeat four years later with Nicky when again the priceless treasures were "brought out from cupboards and drawers to be relished long and quietly" in the presence of Stoclet and his wife.

While Berenson paused in Paris before joining Mary at Bad Gaustein in August 1923 for a "cure," news came that Premier Henri Poincaré had "graciously" accepted the proposal of Secretary of State Charles Evans Hughes that a commission of experts meet to determine Germany's actual capacity to continue paying reparations. Reparations had come to a standstill because the French occupation of the Ruhr early in the year had accelerated the collapse of the mark to nearly 300 million to the pound. Poincaré, determined not to be cheated of revenge, was insisting that the experts should not be permitted to reduce the French reparations claim nor rescind the occupation. Upon hearing this news, Berenson, now reduced to almost total cynicism, declared: "It would be like arranging a marriage in the hopes of an heir on whom all the nations depended but first emasculating the bridegroom."

London and Paris had diverted Berenson as always, but the incessant activity which he craved levied a tax upon his reserves of energy, which Bad Gaustein could scarcely restore. He had been determined to make good in two months all that he had missed in staying away from Paris and London for three whole years. In consequence he arrived at I Tatti early in November 1923 feeling "broken and stunned with fatigue." He arrived, however, with a fresh supply of photographs which his reconnaissance of museums and private collections had yielded and soon, in spite of weariness, he and Mary set to work on them.

XXXII

The Archaeology of Art

REESTABLISHED among the familiar comforts of I Tatti in the late autumn of 1923, Berenson found himself drawn to a new and engrossing project. It grew out of a visit he had made to Walter Berry's apartment shortly before he left Paris. There he had pored over a sumptuously illuminated antiphonary that he recognized as of Sienese origin. The anonymous work with its forty exquisite miniatures instantly challenged his detective instinct, and he arranged to write up his find for the *Gazette des Beaux-Arts*. The miniatures, he deduced, were the work of the fourteenth-century artist Lippo Vanni and could be made to serve as a key to Vanni's artistic personality.

As far back as 1900 Berenson had been shown a photograph of a triptych signed by the then very little known Vanni. Since that time the studies of his friends F. Mason Perkins and Giacoma de Nicola had established the existence of a considerable Vanni oeuvre, sufficient, with the addition of the Berry miniatures, to establish his chronology and artistic identity. The more Berenson pondered the matter, the wider he ranged among the early Sienese painters in order to place Vanni firmly in his age. He conjectured that Vanni's work could now be discerned in a small panel in the Jarves Collection at Yale, in a triptych in the Walters Collection, and in a painting owned by Colonel Michael Friedsam.

The essay on which he embarked, with its array of striking parallels, was the kind of scholarship in which he excelled. Completed in February 1924, the piece appeared in the *Gazette des Beaux-Arts* in May, translated by Seymour de Ricci, the noted Jewish bibliophile. The English version did not appear until 1930 when it was collected with seven other similarly learned essays in the 1930 Yale edition of Berenson's *Studies in Medieval Painting*. By that time Walter Berry had given the precious

miniatures to the Fogg Museum, where they continue to be recognized as significant examples of Vanni's work.

The writing that winter had taken a good deal of resolution, for not only had Berenson suffered a recurrence of physical malaise but the "I Tatti bus" had brought increasing contingents of visitors and guests. Edith Wharton had arrived for a stay almost as soon as the Berensons had returned, and she enlisted Nicky to accompany her on her lingering forays in the antique shops of Florence. They were all joined one day by the forty-one-year-old Crown Prince Gustaf Adolf of Sweden and his bride, Lady Louise Mountbatten. Charles Loeser had brought the royal pair to I Tatti. The prince, more than six feet tall, towered over his host. British educated, he had a scholar's interest in archaeology and during 1922 had spent six weeks in Greece studying the various digs. Like Berenson he was also interested in ancient Chinese ceramics and was a discriminating collector of art.

This meeting was the first of many and was to be followed by a voluminous exchange of letters on shared interests. On his return to Sweden Prince Gustaf found copies of Berenson's books waiting for him, and in graceful return he sent photographs of paintings in his collection. Personally modest and simple in manner, he must have been somewhat amused by the marked deference that Berenson paid him on his return visits. After his accession to the throne in 1950, Berenson would sometimes address him with old-fashioned courtesy as "Sire" and earn the gentle reproof that the king wished to be treated merely as another guest.

While Berenson labored over the Lippo Vanni article, the relentless transformation of Italy by Mussolini and his Blackshirts swiftly gathered momentum. By the first of the year 1924 the Fascisti in Florence began to threaten the Berensons' estate manager, who resisted their demands for contributions. Thoroughly frightened, the servants urged the Berensons to give in and pay the tribute of $250. That unpleasant duty fell upon Mary.

There were other crosses for Mary to bear. A new estate manager had been employed, and he found that much waste and extravagance had taken place in the villa, giving Bernard reason to angrily deplore her management. When she further annoyed him by incautiously proposing that her daughter Karin should come for a visit with her children, he forbade anything longer than a "short holiday." Her daughter Ray was already there with her young son, Christopher, upon whom Mary doted despite his sex. She professed to be conscious all the time that Bernard was "on the watch" to see that she did not spend too much time with the child away from her duties to him, especially the duty of getting off

replies to queries from Fowles in Paris. In the margins of Fowles's letters Bernard would usually jot down a few words of the point to be elaborated.

Matters were not eased when the Duveen semiannual check for £5,000 due on January first had not arrived in the middle of February and was then deferred to March. To Mary it was a "disaster," for it meant delaying remittances to her children, who anxiously depended on them. She resented Bernard's want of sympathy and toyed with the idea of deserting him, only to reflect that her daughters depended on the £800 to £1,000 a year which he supplied. Fortunately by the end of the winter Christopher had succeeded to some degree in winning Berenson's tolerance, though, as Mary explained to Mrs. Gardner, "B.B" was "in principle like Charles Lamb, who, when asked how he liked children, replied 'Boiled.' "

Among the many queries relayed by Fowles that season was one whose drastic implications would not become manifest for thirteen years. Joe desired an opinion on "Lord Allendale's Giorgione"— Adoration of the Shepherds—which had evidently caught his fancy as a possible acquisition. It had been attributed to Giorgione by Crowe and Cavalcaselle, but long ago Berenson had challenged the ascription. In his 1894 Venetian Painters he had given it to Catena and in an 1897 article in the Gazette des Beaux-Arts he had described it as a copy of a lost original by Giorgione. Now in a draft dictated to Mary he said, "The Allendale Nativity is a picture that has tormented me for thirty-five years. I have studied it from every point of view and have never yet reached a satisfactory conclusion. I saw it again as recently as last October and went away baffled. . . . I would suggest parenthetically that the author . . . may be Campagnola. . . . That it was somebody very close to Giorgione may be readily assumed. . . . The most likely suggestion as to the author of the original is in part Giorgione himself, but it is not safe to dogmatize."

The winter and spring of 1924 proved to be one of Berenson's most productive seasons as a writer on Italian art. From the essay on Lippo Vanni he turned at once to the writing of a brief article in which he applied "quantitative" archaeological criteria to the study of a reputed Botticelli altarpiece in the Florence Accademia that Bode in his recent book on Botticelli had attributed to the master. Thirty years earlier Berenson had not admitted it "into the Morellian canon." He now acknowledged that Bode was right. What had misled him, he explained, was that the heads of the Madonna and Child had been repainted in a style different from Botticelli's, and he had failed to take that into account when he first studied the painting. The archaeological study of the head, especially of the coiffure, revealed that it was of a later date than the

rest of the painting and hence should have been disregarded. He could not resist adding, however, that proof that the remainder of the painting was an autograph rested on "connoisseurship," which was the product of "natural skill and training." Later study led him to change his mind, and in his posthumous List he relegated the altarpiece to "school work." A recent authority, Ronald Lightbown, believes the cartoon at least was probably by Botticelli.

Almost without pause Berenson undertook a much longer essay, "Nine Pictures in Search of an Attribution." He labored over it at intervals between February and August of 1924 and took the manuscript with him to the mountain resort of Poggio allo Spino. The article demonstrated by archaeological research and by a complex and exhaustive array of parallel features that not only the nine widely scattered panels but also twelve others in the Este Collection at Vienna could probably be attributed to Domenico Morone. His aim, he declared, was to tell "younger men what an old explorer like myself has to do when he starts out to find the author of a work of art." Though "the quarry may not be worth the pains expended in pursuit. . . . I, for one, love the sport. Only one must enjoy it for no utilitarian or pretentious reason, but for its own sake and because it exercises eyes, mind, and judgment."

During the spring Berenson interrupted his work on the Morone article to dash off for the June issue of *Art in America* a brief detective piece, "An Annunciation by Botticelli," in which he proposed that a small painting recently purchased by Louis Hyde of Glens Falls, New York, presumably on his advice, ought to be ascribed to the master, and confidently predicted that the ascription "will not be seriously questioned." He was joined in his attribution by a young Japanese professor of art, Yuki Yashiro, who was just completing a book on Botticelli for the Medici Society. Berenson had given Yashiro help during his visit to Florence, and the two began a lively correspondence that flourished for the next quarter century. In a footnote to his article Berenson praised him as "one of the most competent and earnest students of Botticelli." As for the bold prediction of the article, the attribution has been accepted by no fewer than nine authorities, beginning with Yashiro and Raimond Van Marle and including Ronald Lightbown, whose magisterial two-volume study and catalogue of the works of Botticelli was published in 1978.

Berenson regularly stole time from his writing to pore over book catalogues. His appetite for books in the most varied fields was insatiable and the flow of volumes for his library continued to grow, whether costly folios on art, learned treatises in French, German, and Italian, or notable works of fiction. Periodicals arrived by the score from all over Europe and America. Mary complained to Senda that he was spending

"oceans" on the library and "won't have enough to endow the place."
He was himself somewhat daunted and asked Belle Greene for advice,
for he and Mary were at the time discussing the revision of their wills.
Belle cautioned that I Tatti would have either to be united to "some
larger institution" or to have a sufficient endowment and a wise board of
trustees, or it would "degenerate into a wayside inn for loafing schol-
ars." The disposition of his collection, she said, was much on her mind.
If no other solution could be found, the collection ought to be left to the
Fogg Museum, and she suggested he write to Paul Sachs at Harvard. Her
suggestion to enlist Sachs, with whom he had long been in communica-
tion, confirmed his own strong leaning toward Harvard, and the first
soundings soon began.

The dependence of the Berensons on Nicky's energy, intelligence, and
sunny disposition had now become almost total. After the insecurity and
hardship of the war years in the Baltic provinces Nicky deeply ap-
preciated the refuge that she and her family had found at I Tatti. Her
impoverished sister, the Baronessa Alda von Anrep; Alda's husband,
Egbert; and their son, Cecil, continued to occupy the villino, and Egbert
had begun to help in the running of the estate. Now Nicky endeared
herself even further to Mary by confessing that she enjoyed the "food
part" of housekeeping. To Mary that was the "best news I have had for
an age. . . . And if you take it over I should bless you forever."

The calm of the summer of 1924 was disturbed for a time by the news
that Sir Joseph had employed Wilhelm Valentiner to prepare an illus-
trated catalogue of the Duveen exhibition of Italian Primitives which had
been held in New York that spring. Berenson was indignant. Having
frequently discussed plans for the catalogue with Duveen, he thought it
had been decided that he was to do it. He worried that this was a sign that
he had lost credit with Sir Joseph, and when Joe cabled that the exhibit
"is marvellous . . . causing enormous sensation here . . . such a wonder-
ful achievement is due largely to your rare judgment and knowledge to
which it is a magnificent tribute," he thought the praise disingenuous and
gloomily predicted that all was over with his connection with the Du-
veens. Valentiner, as advisory editor of *Art in America,* was in fact a
shrewder choice, since, unlike Berenson, he was not known as being
previously employed by Duveen.

Duveen returned to England after the exhibition and conferred with
Mary during her visit to England late in June 1924. Glorying in his new
conquests, he was especially vain of having "roped in" the taciturn An-
drew Mellon. And quite unconscious of having offended Berenson, he
proposed that the Berensons join him as his guests at St. Moritz. Beren-
son saw to it that Mary should decline the invitation. If Duveen wished

to see him he must come to I Tatti. After their meeting Mary reported that she also had conferred with Joe's lawyer, Louis Levy, who agreed that the Berensons should have freer access to other dealers in need of encouragement, for "the big fish live on little fish," and again she urged the need for full and regular accounts from the firm. "We never see the accounts," she declared to Joe. "We are in a sense partners in your great Italian adventure. . . . B.B.'s advice would be more valuable to you if he knew what you sold and how much you got for each picture." She also reminded him that half-yearly remittances needed to be paid on time, for "you swim in ever widening and deepening floods and have endless credit for times of drought. We sail our little bark on a shallow stream," and "many people who are dependent on us . . . sail lighter barks in still shallower streams." Though Joe was all sympathy and understanding, her eloquent appeal had no effect. The remittance due July 1 arrived October 15.

In spite of Joe's dilatoriness and the equivocal arrangement for the catalogue, Mary was convinced that they ought to agree to his request to see him in Florence in the fall. "With all his faults and wickednesses, if you like, he is useful to us," she confided to Nicky. "It is clear that my skin is made of rhinoceros hide, and . . . I think of nothing but money. The truth is I have the paying out of it to do and I know how each comfort and luxury and refinement that B.B. insists upon mounts up."

After Mary's return she and Bernard escaped in August to Poggio allo Spino, a square block of a house near the Consuma pass which commanded a view of the high valley of the Mugello and the mountains beyond. Though inelegantly furnished and with few of the facilities of I Tatti, it had become their favorite refuge. They "donkeyed" along the mountain trails, visiting the churches tucked away among the slopes, though Mary, whose rheumatic knees "hurt like fury," wished there were someone else to go with Bernard. To Bernard the region was pure delight. He rhapsodized to Nicky over "the freshness of the air and the jewel-like sparkle of the foliage, the rank and slightly alcoholic smells." He heard "the babbling of brooks, the rustle and swish of the wind in the trees and then for a moment fifty-five years fall away and I am an exquisite instrument in the hands of that mighty musician Nature that I was in early boyhood." Nothing so empurpled his prose as a vista that composed itself against the horizon. Once, at the austerely beautiful site of ancient Baalbeck, he wrote that it "confirmed my conviction that all visual art exists only to teach one to appreciate landscape."

Carlo Placci was among the friends who, like Judge Learned Hand and his wife, made their way up to Poggio allo Spino. Placci's company was more agreeable now that he had become "very anti-Fascist." He pro-

fessed, however, to being puzzled how Italy had succumbed, failing, Berenson observed, "to connect causes and consequences as the patriodiots in all countries do." Like many other conservative and nationalistic Italians, Placci had doubtless been shocked by the brutal assassination on June 11, 1924, of Giacomo Matteoti, a right-wing Socialist deputy who had opposed Mussolini's move to destroy the independence of Parliament. When Matteoti's naked body was found, it had been decapitated. For a few weeks a wave of revulsion against the Fascisti swept the nation. Count Sforza publicly denounced Mussolini, but Benedetto Croce, fearing political chaos, addressed the Senate with the plea that fascism be allowed time "to complete its process of change," a plea that he was afterward to regret.

Mary, who hated the cold and discomfort on the windswept mountains, insisted that they return to I Tatti on September first, scarcely a day too soon to welcome Sir Joseph, Lady Duveen, their maid, their valet, their daughter, and a friend of their daughter. The six-day visit went off "beautifully" and the euphoric Mary told the absent Nicky that "we all became real friends." Joe bubbled with spirits and energy until midnight and it was very hard to make him go to bed. Mary, however, had a hard job ahead of her "to screw money out of him" and persuade him to keep them "au courant in accounts," from all of which arrangements, she said, B.B. "wants to be kept like a god on an altar free from human wrangling." Bernard, for his part, counted the hours until Nicky's return. He admitted that "Duveen turns out ever so much more interesting and agreeable than I expected."

On his return to Paris Joe wrote that he had bought from F. Kleinberger a Botticellian tondo depicting a Virgin and Child which they had discussed during his visit. Mary had previously seen the painting and Bernard had at the time confirmed her opinion that it was indeed a Botticelli autograph. At that time Kleinberger had expected to sell it to Colonel Michael Friedsam, and since the attribution greatly enhanced the value of the painting, he offered Berenson an honorarium of 100,000 francs. Friedsam, who disliked round pictures, decided not to take the tondo. Duveen thought it a "veritable masterpiece," and wrote Mary with regard to Bernard, "I am increasingly conscious of his great genius." The grateful Kleinberger now sent the honorarium. Berenson, embarrassed, informed Duveen of the circumstances and indicated he was willing to have the 100,000 francs deducted from his account with the firm rather than give "the slightest suspicion" that he was taking an unfair advantage. Unfortunately Joe's reply was not preserved.

In spite of Joe's enthusiasm, the tondo, though frequently exhibited, remained unsold until 1940 when it was acquired by the Samuel Kress

Collection. Since 1961 it has hung in the Kress regional collection at the El Paso Museum of Art. Though late in life Berenson questioned his attribution, the painting is listed as a Botticelli in the posthumous List. The Kress catalogue gives it to a "follower."

The fate of this painting became linked, after a fashion, with a painting from the Thaw Collection, *Young Man with a Red Hat,* which Berenson had once believed to be by Fiorenzo but now assigned to Botticelli. Sir Joseph believed it could be sold for a "Botticelli price" if Berenson would publish an article about it and the tondo. Once again Berenson refused the request. He would not write to order, for he wished to preserve his "rank not merely as a connoisseur but as a scholar and a humanist." Fowles, protesting that he was making it very difficult to sell the two pictures, pleaded that there was "no question of boosting the Firm." Berenson need not even mention "our name. . . . We are not running after cheap publicity, but to sell these pictures at a big price" they needed his backing. Berenson remained adamant.

Only a month earlier the firm had asked Berenson to publish an article in *Art in America* on the *Entombment of Christ,* which Henry Goldman had purchased from Duveen as a Fra Angelico. Fowles thought it important for the article to appear at the beginning of the season to inspire collectors. Berenson flatly refused: it could not help looking "as if his pen was in the service of his interests." If Goldman doubted "this noble picture," he suggested, "Sir Joseph had better take it back" and teach him a lesson. The chastened collector kept the painting, and after his death in 1937 it was reacquired by Duveen Brothers. Recradled and restored at considerable expense, it went into the Kress Collection as "attributed to Fra Angelico." The National Gallery of Art subsequently assigned it to Jacopo del Sellaio.

By this time Edward Fowles had come to look upon himself as something of a connoisseur, and on one occasion that autumn he ventured to argue with Berenson when Berenson refused to confirm the attribution to Raphael of a *Madonna and Child Holding a Lily* which was being offered to the firm. Berenson said that it was not a Raphael but possibly a Lo Spagna. Fowles could hardly contain his indignation. He conceded that there were weaknesses in the drawing but insisted that drawing was not Raphael's forte and that Berenson had "taught the world to look upon Raphael as the great Master of Space-Composition and a loveable illustrator." He went on at length to compare the painting with the Cowper and Granduca Madonnas and contrast it with Lo Spagna's work.

This challenge to his authority was too much for Berenson, and he deputed Mary to set Fowles in his place. "We read your letter with admiration and yet with a little dismay," she wrote. "B.B. says you have

just reached—if you will allow him to say so—*l'âge dangereux* in connoisseurship. . . . B.B. has a feeling that you are among the few who are capable of going on and ultimately distinguishing between a master and a follower." Even putting aside the Lo Spagna hypothesis, the painting was clearly not a Raphael. Fowles accepted the reproof without visible demur and resumed the usual budget of queries and reports of progress in negotiations. Whatever resentment he may have borne he saved for his posthumously published memoirs.

Soon after the Duveens' visit in early September 1924, the Berensons and Nicky went south for a three-month working holiday in Rome, the holiday Bernard had contemplated before his trip to Egypt. One excursion followed another to museums, churches, and archaeological digs. In a transport of appreciation Bernard would seize Mary's arm and cry out, "Oh Mary, isn't this wonderful. How happy I am." At the Vatican he examined illuminated manuscripts with Adolfo Venturi, the eminent art historian with whom he had long since ceased to quarrel. Eugénie Strong, now much mellowed in years, graciously showed them the underground basilica at the Porta Maggiore, and other scholar-specialists took them in hand.

It was while they were in Rome that Mary conceived the idea for several "surprises" with which she expected to astonish Bernard, and she ran up to Florence for a few days to see about them. There would be an open fireplace in his bedroom, for he liked to spend a few hours there each morning reading. The wine cellar and the servants' hall were being relocated, and other improvements were under way. She was doing all this because Bernard "will not take any practical interest in anything except his own profession." A young woman from Chicago, a Miss Richert, was engaged to work on the Lists, the large-scale revision of which Bernard now projected, and all his materials had been "roughly arranged" for him to begin work on as soon as he got back. The most striking of the surprises was to have been a clock tower which Mary had ordered to be built on the roof. Designed by Cecil Pinsent, it was to be carried out by a Florentine architect. That surprise, however, had to be deferred for lack of time. "We are as different as can be," she admitted to Bernard's mother. "I am all for experiments and he gets exasperated at the very notion." Her realization of that fact did not stay her impulses.

As usual there was no escaping special chores for Sir Joseph. A wealthy new collector had appeared on the scene that autumn, the American newspaper magnate William Randolph Hearst, and Mrs. Hearst and Mrs. Helen Young were dispatched to call on the Berensons in Rome. "I shall be so glad if you will make a fuss over them," Sir Joseph wrote, "as Hearst is a big buyer of [Italian] primitives." The Berensons made a

suitable fuss, but the optimistic expectations were to go unrealized. With Christmas approaching, Sir Joseph sent a mark of his esteem—and gratitude—to Berenson, delivered personally by Fowles, a gorgeously regal dressing gown that "positively took our breath away."

With Rome now in full control of the Fascists, Berenson's circle of acquaintances was reduced, for he found it hard to repress his acid disapproval. Even Lady Sybil, Geoffrey Scott's estranged wife, had "gone native"; she spoke with "the deepest sympathy of Fascisimo," he told Mary. "I was aghast." The menacing political climate did not disturb his friend George Santayana, who had settled in Rome. When asked, "Didn't the war sadden you?" he answered, "Not particularly." He lived so alone, he said, that he felt sometimes as if he had forgotten how to talk. "This is not the case with Bernard," Mary reflected. Nicky went to gaze on the bellicose posturing of Mussolini in the company of Mary's friend Lina Waterfield, now a reporter for the *Observer*. Neither Bernard nor Mary risked that depressing sight. Instead they conferred with anti-Fascists like deputy Giovanni Amendola, the courageous publisher of *Il Mondo* and leader of the Aventine opposition in Parliament against Premier Mussolini. Only a short time before, Amendola had presented to the king a memorandum of the serious charges against Mussolini. Fearful of losing the throne, the king had pleaded, "Don't make me read it; take it back."

In early December 1924 the Berensons left Rome, Bernard's cynicism about Italian political life deepened by what he had learned about the progress of fascism from his conversations there. A few weeks later Amendola published his charges against Mussolini, hoping to force his dismissal. The tactic had no effect. On the last day of the year the minister of the interior ordered raids upon the homes of the anti-Fascist leaders and the seizure of all opposition newspapers. Within three days Mussolini boldly provoked the call for total power. In Florence the Fascist militiamen swarmed through the streets, machine guns and rifles in hand, shouting, "Mussolini the Dictator. . . . Let's finish off the enemy." The following May Amendola persuaded Croce to draw up a countermanifesto against the Fascists, but the battle was already lost. Ordered to leave the health spa of Montecatini, Amendola was ambushed on the road and so severely beaten that he died a few months afterward.

For a foreign resident like Berenson, made hostage by his "estate," his great library, and his collection of art, there was nothing to do but swallow his indignation and pay tribute money to the local Fascists, who hated him but still feared the power of his American passport.

16. *Nicky on donkey in Greece, 1923*

17. *Berenson on donkey in Greece, 1923*

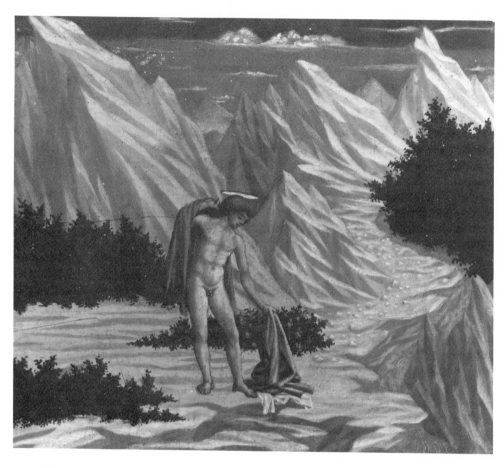

18. Domenico Veneziano, Saint John in the Desert, *gift to Carl Hamilton*

19. Giovanni Bellini, The Feast of the Gods

20. Kenneth Clark, 1926

21. *Don Guido Cagnola,*
editor of Rassegna d'Arte

22. *Joseph Duveen,*
Baron Millbank

23. *Rachel Berenson*
(Mrs. Ralph Barton Perry)

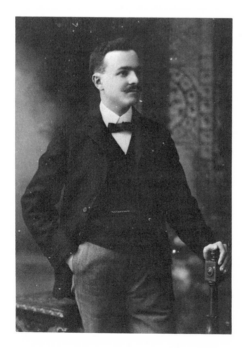

24. *Abraham Berenson,*
Bernard's brother

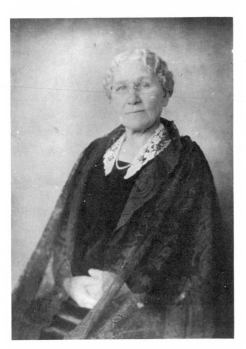

*25. Judith Berenson,
Bernard's mother*

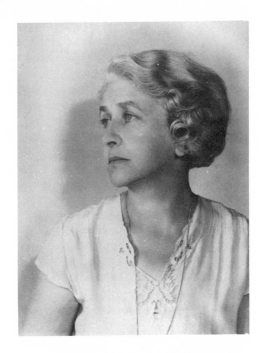

26. Elizabeth ("Bessie") Berenson

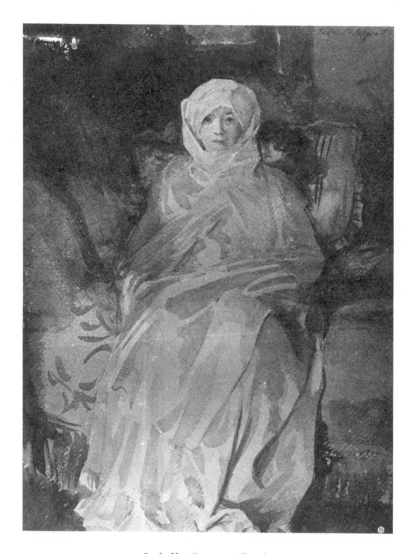

27. Isabella Stewart Gardner,
portrait by John Singer Sargent, 1922–1923

XXXIII

On the Way to Truth

FOREIGN visitors continued to come and go in Italy with customary freedom, enjoying the tourists' rounds safely insulated from the terror that stalked the streets by night. A visit by William Rothenstein had to be put off because the Berensons' "limited accommodations" would be filled until summer. Early in 1925 Mary's brother was already there, Trevy was due to arrive, grandchildren were on hand. Bernard's sister Bessie came for a long stay. Princess Mary of Thurn and Taxis would soon be due; Philomène de Lévis-Mirepoix was arriving, as was Louis Gillet, who was finally finishing his translations of Bernard's "Four Gospels," his four small books on the Italian Renaissance painters.

There were, besides, the usual business callers. René Gimpel brought a painting for inspection, hoping to have it passed as a Bellini despite the fact that Berenson had attributed it first to Vivarini and then to Lotto. When Berenson held to Lotto, Gimpel, suspicious and disappointed, conjectured that he did so only to spite Nathan Wildenstein, who had a stake in the picture.

Among the "tourists of the season" was William M. Ivins, Jr., the curator of prints at the Metropolitan and a fellow admirer of Belle Greene. A Harvard graduate, he had studied for a year in Munich and caught the virus of art appreciation. He took a law degree at Columbia, but his heart was in print collecting and in 1916 he founded the print department at the Metropolitan. In the forty-three-year-old Ivins Berenson immediately recognized a kindred spirit. "I wish I could see you very often," he wrote to him after their first meeting. "How sad that the handful of people who really life enhance are apt to be centrifugally located or disposed. Edith Wharton is at Hyères. I have a few playfellows in Paris, as many in London, as many again in New York. Here none, alas! except such as are brought like Elijah's food by the ravens." On

Ivins' return to New York Belle Greene wrote that he was "awfully keen about you."

Since the death of convivial and witty Ralph Curtis in 1922 Berenson had had no correspondent with whom he could so freely unbend. The hundreds of letters exchanging intimacies and ribald jests and gossipy news of each other's world had ended. In Ivins he found a warmly cherished replacement. In their years-long interchange no subject would be too sacred for comment and no feeling too intimate to be concealed. When Ivins sent the manuscript of an article which disappointed Berenson, he exclaimed, "Art is an experience, an ecstasy, a mystic union and why in Hell didn't you say so?" It was to Ivins that he could write in his mid-sixties, "I am old, Billie, I feel more and more disinclined to make an effort. . . . So I have more time for dawdling and day-dreaming than I used to. And the demon of sex gets more chances than when I was too busy for him. I dar~say he will be exorcized by money worries which grow more and more preoccupying all the time." In his hundreds of letters Berenson recreated for Ivins the life he had made at I Tatti and peopled it, sometimes unsparingly, with all who impinged upon it.

Financially the new year of 1925 began on a comforting note. Hanging over Berenson had been a debit of £10,200 interest on fees which had been credited to him on sales to William Salomon and then canceled, in accord with the 1912 agreement, when the pictures were taken back after Salomon's death. Edward Fowles now wrote that Joe had ordered the interest waived. "This act of his," Berenson responded, "gives me a human and recherché pleasure out of all relation to the money involved." Then, reverting to a discussion of theirs concerning the reliability of attributions, he reminded Fowles that changes were inevitable. When, for example, he had prepared the Johnson catalogue, he had ascribed a Madonna to Eusebio da San Giorgio. "I should hesitate to do so now [that I am] more aware of the great complexities of the subject." But he got "a certain peace of mind," he said, from knowing that "I am bringing to bear on the problem all that I know and all that I feel. . . . If I fail I remain unashamed. I have done all I can do." He explained that in his articles of the past several years he had begun to look more analytically at the process of attribution. It had, he believed, two distinct aspects: the critic must know first "when a thing was painted and then by whom." Until that first inquiry was made, the search for the identity of the artist could not begin.

It was this principle that Berenson was now applying to a long and recondite essay on three medieval manuscript series of illuminated miniatures illustrating the *Speculum Humanae Salvationis* (Mirror of Human Salvation), a Dominican Latin manual of devotion which first appeared

about 1324. It took two solid months of research and continued the kind of ingenious and learned detection he had devoted to Walter Berry's antiphonary. Medieval art had become a passion; he valued the escape it provided from an increasingly intractable world. Here, in his study, in cerebral pursuit of more and more esoteric lore he could in some measure cut himself off from the sordid concerns of the art-dealing world.

Montague Rhodes James, the noted medievalist, had invited Berenson to write "A Discussion of the School and Date" for his edition of a manuscript of the manual owned by T. R. Riches. Shortly after finishing the "Discussion," which dealt with the Riches manuscript and those possessed by the Bibliothèque Nationale and the Paris Arsenal, Berenson adapted it to a two-part article in the *Bolletino d'Arte.* The English version of the article was included in 1930 in his *Studies in Medieval Painting,* where it was lavishly illustrated with seventy-eight reproductions from the *Speculum* and with cognate paintings from more than a dozen churches and collections, including the collections of Otto Kahn, Kingsley Porter, and the Museum of Fine Arts in Boston, as well as the Morgan manuscripts.

The essay confirmed his "first impression" that the sophisticated miniatures in the Riches manuscript and its companion in the Bibliothèque Nationale were done "during the last quarter of the Trecento." Determining the place of origin of the popular illuminations in the Arsenal manuscript obliged him to consider a problem which had interested him, he said, for thirty years, "the problem of provincialism in art and its close relation to . . . most of the phenomena of decline and decay" in art. After ranging over the whole field of early Italian art, he deduced that the artist of the Arsenal *Speculum* must have come from the region around Foligno, Spoleto, and Chieti and that he must have worked "just after rather than just before 1400."

A tour de force of detection, the essay exemplified Berenson's lifelong devotion to minute scholarly research, a devotion which filled the shelves of his library with recondite works and learned periodicals in each of the fields which he successively explored. For his analysis of the *Speculum* he drew, for example, upon materials as varied as the Ashburton and other Catalan manuscripts, the Chinese Lohans, the *Livre des Merveilles,* the Queen Mary's Psalter, a Morgan Library manuscript, Von Loga's *Malerei in Spanien,* O. von Falke's *Kunstegeschichte der Seidenweberei,* Stryzgowski's *Lehrkanzel,* and Breasted's *Oriental Forerunners of Byzantine Painting.*

While Bernard preoccupied himself and Nicky with work on the *Speculum,* Mary and her assistant wrestled with the monumental revision of the Lists. Half of the revision was finished and ready for "his seal," but

he declined to look at a single item until he finished his article. Though the flow of requests from the Duveens was increasing, he usually managed to keep his distance from such concerns by turning them over to Mary with his laconic notations. When, however, the problem of attribution was especially difficult, he requested large photographs or even insisted that he see the painting itself.

Mary made her annual escape to England, more than earning that holiday by attending to business in Paris and London. Joe, she reported, had sold the Heseltine Botticelli to John D. Rockefeller and was confident that he had snared Andrew Mellon as a client. Sulley showed her the Bellini *Orpheus,* which had come out "jewel-like" from its cleaning, but Widener had "beat down the price" so Bernard's fee would be only £1,000. The painting was once one of the prizes of the National Gallery of Art.

From Paris, after a gathering at Edith Wharton's Pavillon Colombe, Mary told of having "received a rather ghastly impression" from the "crackling of dry anecdotes and a cackling of laughter at them." The conversation, "worse than mediocre," made her long for his. What was only too evident from the "two or three remarks on politics" was that the members of this wealthy and official circle were "all Fascists," like members of similar circles in America. The subject of politics had been "dropped like a snake," but not before Edith had declared that Bernard ought to avoid politics and added "the deadly remark that after all thee was a stranger in Italy."

Berenson had had long talks with Gaetano Salvemini after his return from England in 1924. Salvemini's opposition to the Fascists placed him in peril, and Berenson had urged him to find a post out of Italy. But, like Giovanni Amendola, he still thought the Fascist tide might be turned back. A professor of history at the University of Florence with a worldwide reputation, he was especially hated by the Fascists for having opposed Italian expansionism in the Adriatic. On June 2, 1925, after a compositor accused of setting type of a clandestine newspaper *Non Mollare* (Don't Weaken) told his Fascist interrogators that Salvemini was known to him, Salvemini was arrested in Rome and incarcerated in the Florence prison. Two thousand Italian scholars and writers published a protest in Turin and letters of protest poured in from abroad.

Shortly after the arrest, Salvemini's wife, Fernande, sent a message to Berenson urging him to gather notices of the outrage in the foreign press. The message was brought by young Count Umberto Morra, a student of literature and fluent in English. His family having close ties to the king, he was presumably above suspicion by the Fascists. Part of his mission was to ask Berenson to lend his passport to Salvemini. It had

been suggested that there was a sort of resemblance between the two men: they had similar beards and similarly shaped heads. But the scheme was not feasible.

After forty-five days in the Murati prison Salvemini was released provisionally when his lawyer pointed out that his only accuser had been found guilty and therefore could not testify against him. The release angered the Fascist crowd in the Florence courtroom, and in the fracas that ensued seven or eight persons were taken to the hospital while Salvemini and the rest sought safety in shops whose owners quickly pulled down the metal shutters. On August 5 the king issued a general amnesty which included Salvemini. A few months later, deprived of his professorship at the University of Florence for publishing "unpatriotic propaganda" in an English periodical, he fled to England and began lecturing at King's College on the evils of fascism. In England he "found a home" with Mary's sister, Alys, and her brother, Logan, a fact that became known to the Fascisti in Italy and increased their animosity toward the Berensons.

Berenson and Salvemini did not meet again until after the end of World War II, when Salvemini returned to Florence from his long exile in the United States, where he had held a post at Harvard as lecturer. "Among my friends," Berenson wrote in 1952, "Salvemini is one of the brightest, sunniest, as well as best-intentioned to be fair and just." Count Morra's mission proved for him, as he later said, of inestimable worth. It introduced him into a lifelong intimacy with the Berenson circle, an intimacy which would bear fruit in his Boswellian volume *Conversations with Berenson*.

For Berenson the chief excitement of the summer of 1925 was the arrival in Italy of Belle Greene with a young woman companion. Accompanied by Nicky, he joined the two at Perugia and then drove about the Tuscan hill towns with them and as far south as Orvieto. For the first two days he found Belle "rather wild and shrieky," but soon she proved congenial. She did not seem to him a day older "or better or worse-looking than four years ago in New York." They shared their common enthusiasm for illuminated codices, but he was still unable to persuade her to linger in front of paintings, and she put him in mind of Sir Joseph's peremptory "Next!" She was impervious to any criticism of Italian fascism, having been enormously impressed by her ship's steward's kissing Mussolini's photograph in her presence. Berenson tolerated her heresy, for, as he wrote after her departure on August 1, "she is a very wonderful, exciting, life-enhancing personality and she stirred and whipped me up for my good."

Another of the summer's guests, Arthur Upham Pope, a connoisseur

of Persian art, found a fellow enthusiast in Berenson, and he eagerly joined the ever-growing circle of devotees. His response to their first meeting suggests something of Berenson's personal magnetism. "If the truth be told," he wrote Berenson in the course of a long letter about aesthetics and Persian art, "the sound of your voice and the sight of your library stirred the unsleeping pain of insufficient knowledge to new virulence." The exchange between master and disciple endured to the last years of Berenson's life when Pope, on his seventy-fourth birthday and Berenson's ninetieth, wrote that he was feeling his years and "vividly envying" Berenson's "prodigious vitality."

The Berensons retreated to their mountain refuge in August, but there was little interruption in the procession of visitors. Mary, who wore her prejudices on her sleeve, deplored the arrival of Bernard's cousin Arthur and his wife, Jessica. Jessica, however, had changed her hair and looked like a presentable French lady, and the truth was that her talk "was not at all awful." However, "more awful people" followed, namely, Kleinberger's daughter and son-in-law. The son-in-law brought "a fat check," which "gilded his visit." He also brought a request from Colonel Michael Friedsam to catalogue the Italian pictures in his collection. Friedsam, who had been Benjamin Altman's associate, had become head of the firm after Altman's death in 1913. He too was an important collector and like Altman favored the northern painters. Berenson reluctantly agreed to do the chore for a fee of £2,000. Kleinberger had said Friedsam "wouldn't think anything of it unless he had to pay a big price for it."

One day at tea their guests were their Italian landlords and the Cyrus Adlers of Philadelphia. The Adlers had come up presumably at the suggestion of the Abraham Flexners, who had visited I Tatti earlier in the year. Then sixty-two, Adler was president of both the Dropsie College for Hebrew and Cognate Learning and the Jewish Theological Seminary in New York. A trained scholar in Semitic languages and Assyriology, he reawakened Berenson's interest in the subjects that had absorbed him at Harvard. Berenson "itched" to ask him questions about Hebrew scholarship and Jewish history, but his aristocratic Italian landlords "could not be swayed toward the subject." An affable and kindly individual, Adler "looked unmistakably Jewish." To Berenson the contrast with the other guests was instructive: "Our landlords had every advantage in manners and looks but oh the agony of making talk with them."

The holiday in the mountains had to yield to "the ukase from Kaiser Joe Duveen" that he would like to confer with the Berensons in Rome the first week in September. The Berensons took Duveen and his lawyer, Louis Levy, who had accompanied him to Rome, on a *giro* to Siena, where Berenson, in Mary's opinion, excelled himself in brilliant talk.

Berenson found Joe in "great form." "He is really intelligent," he wrote Nicky, "and at last I get in him sparks of real feeling in the presence of works of art and even a desire to linger before them."

Levy was so impressed by Berenson that he "uttered the gratifying sentiment that he was so precious that the world might [well] love to give him all possible conveniences and luxuries." The exchange of compliments ended in an arrangement under which Levy took charge of Berenson's investments. What was even more gratifying was that Mary extracted from Joe two checks of £5,000 postdated January and July of 1926. Perhaps reassured by the congenial atmosphere of the meeting, Sir Joseph soon afterward made another attempt, "as a personal favor," to get Berenson to write an article, this one for the *Burlington* on the "Fra Angelico" recently bought by Henry Goldman. In the margin of the letter Bernard curtly wrote, "Impossible."

The strenuous exertions of the days with Duveen and Levy depleted Berenson, and their departure was followed by days of "suicidally low" depression and fatigue. But however low in spirit he may have been, he could respond with alacrity and enthusiasm to a sufficiently interesting interruption. One came in the person of a handsome young Oxonian of twenty-two, filled with a passion for Italy and, like the young Berenson, carrying with him Burckhardt's *Cicerone* and *Italian Renaissance*. He came on a pilgrimage to Florence with an older companion, Charles Bell, an English art historian and longtime keeper at the Ashmolean. They were put up by Bell's formidable friend Janet Ross in her ancient villa on Poggio Gherardo within sight of I Tatti. The young man was Kenneth Clark; his object was to meet the great authority on Renaissance art. In the long retrospect of *Another Part of the Wood* the visit was somewhat dampened by the clammy bed sheets at Janet Ross's castellated villa and by the ordeal of dining alone with Mrs. Ross.

On the evening of September 12 Mrs. Ross took Clark down to I Tatti for dinner. "The boy turned out a perfect dear," Mary wrote Nicky. "B.B. was enraptured with his intelligence and culture." The next day he came to a luncheon whose ritual of courtly deference to Berenson rather offended the wealthy young aristocrat, at least in the wintry recollection of his autobiography. The impressionable Mary assured Nicky, "You are sure to like him and he is as keen as snuff on most of the things we are for. . . . After more talk with him B.B. invited him to come and work under himself for two or three years and the young man was enraptured." The offer in an uncanny way fulfilled Clark's schoolboy ambition. He did tell Berenson that there was an obstacle: his father wanted him to be a lawyer.

A few days after the meeting with Clark, the Berensons took to the

road again to join Nicky in Munich, traveling by easy stages northward, stopping with hospitable friends and refreshing their memories of paintings in places along the way. How much Berenson looked forward to seeing Nicky again may be gathered from his letter to her urging her to get a room near theirs at the fashionable Continental: "I could not bear being in Munich without having you with us all the time." He enclosed a check for £100 so that she might have sufficient spending money. "I have looked forward so much to tasting you again and beginning to live my normal life again. For you are the real center of that life, and without you I no longer feel at home with myself." Mary was equally ardent. "Nicky, we long to see you. You are the sunshine of our lives."

The Germany they visited was on the road to economic if not political recovery, and the prospects for stability were much in evidence after the frightful inflation of two years earlier. The new mark introduced in the autumn of 1924 by Finance Minister Hjalmar Schacht replaced a trillion inflated marks. In effect a capital levy, it reduced the national debt to less than $250. Under the Dawes Plan the burden of reparations was eased with an enormous loan, and foreign private investment poured in to finance the rehabilitation of industry. The Pact of Locarno in October 1925 promised further stabilization with the imminent withdrawal of Allied troops from the Rhineland and the guaranteeing of borders. Thus the Berensons spent several weeks in Munich, Salzburg, Vienna, and Budapest agreeably enough attending the opera and theaters and visiting the country houses of old friends. Berenson was almost as much at ease in the German language as Nicky, and her partiality for the people who in a sense had been her compatriots could not help strengthening his sympathy for the defeated Germans.

They all returned late in November 1925 from the diversions of ten weeks of travel, music, and sightseeing to an accumulation of chores. Overshadowing all was the task that was to become a lifetime obsession, the revision of the master List. "I am proceeding apace with the Lists," he reported to Paul Sachs at the Fogg Museum a few months later. "I do not flatter myself that my attributions are final, but I dare hope that, at the worst, they are on the way to truth and not to error."

XXXIV

The "Two Sposini"

I N December of 1925 while Berenson was himself recuperating from
his travels in Germany, Israel Zangwill came by on a whirlwind
journey for a much-appreciated few "hours of rest," as he put it, "in
a house reminding him of Henry James's story of 'The Great Good
Place.' " On his return to London he wrote of stopping off in Milan,
where he witnessed a violent affray outside his hotel between Fascists and
their opponents. With a foreigner's detachment, he had been able also to
appreciate one of the bizarre aspects of the Italian regime. He took tea
with Mussolini's "sub-editress," "of course a Jewess." In Paris he had a
heated argument with Salomon Reinach over the German reparations
issue. Reinach, very much the French patriot, bristled at word of Beren-
son's charitable views: "So he has returned to his pro-German vomit."

The political climate in Italy continued to deteriorate. In January 1926
Dino Grandi, a former Blackshirt leader, took the headship of the For-
eign Ministry and proclaimed the "century of Italian power." The Ber-
enson circle grew more constricted as the opposition was driven under-
ground or went into exile. The Berensons had to advise Walter Lippmann
not to visit them after Henry Coster, the American vice-consul in Flor-
ence, conveyed warnings to them said to have come from "Mussolini's
headquarters." To frustrate possible spies among their visitors, the Ber-
ensons used the code name "Teddy" when expressing their contempt for
Mussolini. "It made things safer and also a bit ridiculous."

While Mary, Nicky, and their assistants busied themselves with the
endless tasks of checking entries, reading proof, and verifying materials
for the projected edition of the Lists under Bernard's often impatient and
irascible supervision, he devoted himself to the more interesting enter-
prise of deducing the correct or probable attribution of two paintings
that had recently come to his attention. One, in the Palffy Collection at

Budapest, which the curator had graciously taken down from the wall for his closer study when he was there the preceding November, was a Michelangelesque *Portrait of a Woman* ascribed to Titian and so signed. The signature of Titian, he argued, was not controlling: the true test was in the painting itself through comparison with known parallels. The Titian stood up under the "true test," and Berenson went on to conjecture that the lady was a member of the Farnese circle. The article, translated by Seymour de Ricci, appeared in the March 1926 *Gazette des Beaux-Arts.*

The other painting, *Madonna and Angel,* had recently been acquired by the Museum of Fine Arts in Boston as a Piero della Francesca. In an article in *Art in America* Berenson challenged the ascription, analyzing the various elements of the painting—for example, the "V-shaped opening of the Virgin's tunic"—that convinced him the painting could not be by Piero. By whom then? The painting brought to mind two others that seemed by the same hand which he had attributed to Bartolomeo della Gatta, Piero's follower. In the thirty years that had since elapsed he had become dissatisfied with the attribution, which, he explained, "like many another," had come "near enough for a provisional hypothesis." Now a chance clue in a faded fresco on a bell tower at Città di Castello had provided the revealing link among the paintings: "The best working hypothesis I can now frame—all [were] painted by Luca Signorelli." And so attributed, the paintings took their places in the Lists, and the *Madonna and Angel* took on the new identity at the Boston museum.

Young Kenneth Clark returned early in the new year to a warm welcome at I Tatti. Two months of awe-struck pilgrimage to the art cities of Italy convinced him he had found his true métier, the study of Renaissance art, whether his parents approved or not, and he talked enthusiastically of "devoting his life to working with B.B. and carrying on his work." The Berensons saw him as "another very congenial and reliable and satisfactory prop for our declining years."

Clark's conquest of the Berensons discomfited Alpheus Hyatt Mayor, a young art historian then working at I Tatti, for there had been talk of his staying on at I Tatti. Logan amusedly observed to his sister Alys, "It is just like a little court here with favorites and changes of favor and jealousies." He thought Clark's "knowledge and reading and his power of expressing himself are certainly prodigious for his age. He likes it here immensely, loves the good talk and . . . [being] rich, popular and independent, he is not much concerned as to what happens." His task would be to assist Berenson with the revision of the *Drawings of the Florentine Painters.* The month he spent at I Tatti that spring was to serve as a sort of trial run, and he left again for England determined to return.

To help with the long-range project on the Lists, Mary had recently engaged as an additional secretary Pellegrina Del Turco, a young Florentine woman, "graceful, gay, quick-witted with a natural gift for appreciating art and poetry." It was not long before Mary observed that "poor old Nicky is in real trouble over B.B.'s having taken a slightly amorous fancy to Pellegrina. She suffers but quite needlessly." It was only the first of such emotional trials that Nicky was to endure during her forty years with the incurably romantic Berenson. Her own rise in favor had outraged the redoubtable Naima Löfroth, Berenson's Swedish masseuse who regularly came up for weekends. A woman with a "fierce Nordic temper," she was not easily placated, according to Nicky, but there finally arose between them a sort of "armed truce."

No favorite, however, was immune from Berenson's Jovian rages. His inherited touchiness seemed to grow more sensitive with age, and his bouts of gastrointestinal illness aggravated his outbursts. Mary was always the main target, nor was she behindhand in her own exasperating counterattacks. Better able to contain her anger, she raised his to a higher pitch by her cool and biting satire, so that in impotent frustration he lashed out at all around him as if berserk. After one deplorable exchange Mary confessed to her diary, "No doubt I am more provoking than I realize. This is my blind spot." Unfortunately she continued to thrust her children and grandchildren at him as the true center of her life. Her idea of happiness, she admitted to her sister, was to spend ten days at Big Chilling "with the people I love."

Bernard was conscious of his own blind spot, for in his remorseful birthday greetings to Mary he wrote, "I wish you well, dear companion of my life. I ask only that we may never be parted. With all my rages so furious and denunciations so eloquent, I love you as I love the human not-me, and my denunciations and rages are through you directed at that; but I would not and could not be without you." It may well have been that what made life tolerable for the two was that they so thoroughly vented their hostilities that each outburst was succeeded by a remorseful and even affectionate calm. After one of his rages, Mary recorded in her diary, Bernard looked "so ill and tired and old and miserable [that] I opened my arms and he came trembling and laid his silly furious unkind, ungoverned throbbing head on my shoulder."

Mary's decision to lend some money to an old friend that spring festered into raging argument that ended with his shaking his fists hysterically at her, his face distorted with passion, shouting curses, damning Nicky for seeking to mollify him, raging against Mary's children and grandchildren, and in hopeless despair beating his head against the wall, crying out that Mary had ruined his life. There was nothing left for him

but to run away. A species of calm arrived when Mary rang for their maid to pack his things.

At such despairing moments all the contradictions that lurked beneath the surface of his life arose to torment him. What had become of the aesthete's dream of savoring intensely the beauty of the world around him, of living life, as he once hoped, as a sacrament? For a moment he saw himself, like the farmer in Thoreau's vision, condemned to push his burdensome house and possessions single-handed down the road of existence, and athwart his dream of fair women stood Mary's monumental presence like a satire on sexuality. What must have deepened his self-disgust at such times was the knowledge that he had willingly and even gratefully surrendered to her the management of so much of their worldly affairs and daily lives. He could hardly help being aware that she often looked down upon him as a rebellious child and proffered her advice with patronizing insistence. Even her daughter Karin resisted her will to dominate, demanding that she "not thrust her advice upon her again."

With the tightening of Fascist control in Italy, uncertainties about the Berensons' status increased. The American banker Thomas Lamont learned from Walter Lippmann that the Berensons, who were contemplating two months' travel in Sicily in the spring, feared that they might be denied reentry to Italy if they traveled abroad as it was known that they were friendly with Salvemini and that he was entertained by Mary's brother in England. Lamont therefore sent Berenson a copy of a letter of protest he planned to write to the American ambassador in Rome. "It would be a shocking revelation to citizens of America if they found it true that the present government of Italy were disposed to take discriminatory action against American citizens of such high standing and character." Berenson suggested to Lamont that he might also drop a hint that "while I am the most utterly private and unpolitical of persons, I am not without friends in America who appreciate what I have done in the course of forty years to make Italy known, understood, and loved and who would take it ill if . . . I should in any way be molested or hindered in my work." The threat did not materialize, and Henry Coster, the American vice-consul, agreed to stay in the villa to protect it during the Berensons' absence.

Shortly before their departure for Sicily, Paul Sachs of the Fogg Museum came for a "heart-to-heart" talk about the ultimate disposition of I Tatti. They reached a "working understanding" that the Institute of which Berenson dreamed would become part of Harvard University. On his return to America Sachs had a "long pow wow" with Belle Greene at which he told her "the glorious news." "I am so thrilled and

pleased and happy for and about you," she wrote "B.B.," "that you should have done it so handsomely, so really scientifically. . . . In my deeply-considered opinion *your* name *must* be connected with it. It simply must always be known as your foundation."

The Sicilian adventure took them at a leisurely pace all around the island. They dreamed away hours at Taormina, where on the heights amid the remains of the ancient Greek theater the eye swept the rugged coastline and came to rest on distant Mount Etna. Everywhere, from Messina to Agrigento, the dim past came alive for them in the monumental ruins. Out would come the "invaluable tea basket" as they lingered in the lengthening shadows of an afternoon. Mary and Nicky gloried in Berenson's inspired commentary. "His understanding of beauty, of art, of Italy, of history" freed them, they felt, from the taint of being "mere idle or self-indulgent tourists." At Palermo they encountered Edith Wharton and her party, guests on a steam yacht which she had chartered for an Aegean cruise. Mary's brother was among the group, as was Margaret Chanler, the learned musician whom Berenson had met in the prewar circle of Henry Adams and Edith Wharton. The Berensons and "their charming familiar spirit," Nicky Mariano, took Edith and her friends to the recently opened cloister of Santa Chiara, a seventeenth-century structure of such loveliness that Mrs. Chanler thought it would cure the "aesthetic dyspepsia" of the classical traveler.

On their return Count Morra joined them in Naples, where Berenson met Benedetto Croce for the first time. Croce was now thoroughly disillusioned with Mussolini, and the two men would henceforth share their distaste for fascism. Though ill at the time, Croce received Berenson with cordiality. But to the unmetaphysical Berenson the "philosophy of spirit" had little attraction, and he reported to Thomas Perry that "like most philosophers that I have known, he is very stupid or at least one-tracked in Wilsonian fashion. . . . But he is patently the most candid, innocent and goodest of Italians."

Berenson thought Croce's approach to aesthetics too exclusively literary, and their correspondence across the years showed a certain reserve. In their occasional meetings, to Berenson's dismay, Croce never asked him what he "felt and thought." But in spite of their differences Berenson professed to retain "a deep affection" for him. On his death in 1952 he characterized him as a "narrow conceptualist and anti-psychologist and anti-empiricist" who was nevertheless "the great influence on intellectual life in Italy."

It was at this time that a remarkable newcomer entered Berenson's gallery of women friends. She was a young Neapolitan writer, Clotilde Marghieri. A close friend of Pellegrina, Clotilde had married into a

prominent patriarchal clan after an unusually scholarly education. It was not long before Berenson was writing to her. "I have a sense that we are destined [to be] great, very great friends." That letter was the first of hundreds that the two exchanged in a correspondence that continued almost to the end of Berenson's life. They enjoyed verbalizing all the subtle complexities of platonic love for each other, ruminating on its wonders in an ethereal fashion that sometimes skirted the edges of intenser passions. He could write, "You are one of the few I should like to form a constellation with myself included floating through the infinitudes of spaces till the end of time." Five years after their first meeting and after rapturous exchanges of endearing fantasies spun out in sentimental vaporings, she charmed him with her wish to be his "last love." "Your frail body, your delicate spirit," she asked, "can they undertake such a responsibility?"

Their letters glowed with a perpetual adolescence, a sense of being in love with love, and through the uninhibited analyses of their feelings they created an Arcadian idyll of Eros. A few years before her death in 1981, Clotilde published their correspondence in an Italian version. The more prosaic details of existence, of travels, of books and people came to fill a larger place in their letters, but the organ note of romantic love vibrated far into Bernard's sunset years. What Berenson constantly demanded of Clotilde was total possession of her spirit. He craved the details of her existence as if to submerge himself imaginatively in her identity.

In her *Forty Years with Berenson,* Nicky calls the many women to whom Berenson paid court "B.B.'s Orchestra." And the image is apt, for he drew forth from them notes of the most varying pitch and harmony across the whole scale of love, from the most spiritualized to the most passionately and physically consuming. Which notes actually brought the lovers to bed seems now of little moment. For even there, passion tended to be strangely transmuted and idealized by Berenson's aestheticism. It has been said he made of it a kind of mystical experience. Clotilde's chastity may have remained inviolate, as she insisted, but, in the spirit, love was surely consummated. To Nicky, who had succeeded to the virtual role of wife by the time of Berenson's meeting with Clotilde, the appearance of a newcomer in that "Orchestra" was at first a desolating experience and she "went through agonies of despair and doubts."

On their return to I Tatti Berenson took to his bed with a severe attack of colitis, leaving Mary free to carry out her ambitious plans for improving the villa. The chief one, in her eyes, would be the imposing clock tower of which she had dreamed for twenty years. Something, she

thought, was called for "to lead the eye up and end the line of the garden path." The clock would have a blue face and gilt hands, and the tower, she hoped, would have a glassed sunroom for her sunbathing. In addition, the floor of the entrance hall was to be dignified with mosaic and strips of green marble. She was encouraged to go ahead with the improvements, she declared, because Bernard was "so keen to leave this place as an Institute for Humanistic Studies." He now felt easier about the financing, convinced—apparently from what the enthusiastic Belle Greene had written—that as soon as his scheme was definite it would be "splendidly endowed by sympathizers." Absent, of course, from all calculation was the coming of the Great Depression and the Second World War.

With the house cleared for the builders, the Berensons took off for their mountain sanctuary at Poggio allo Spino for the month of August. While Bernard nursed his colitis and his recurring grievances against Mary, she kept busy at her typewriter transcribing the Friedsam catalogue from Bernard's disorderly notes. Even on his sick bed Bernard wrote on, and Mary had to "work like a demon" to keep up. The catalogue, which had been "a great weight" on their minds, was completed by the middle of August 1926 and work on the Lists resumed. The extensive catalogue remained unpublished, Friedsam having decided to put off publication until he stopped buying. On Friedsam's death in 1931 it accompanied his bequest of the great collection of paintings and objects of art to the Metropolitan Museum of Art. Some of Berenson's descriptions were incorporated in an article on the bequest in the museum *Bulletin*.

Once well enough to walk in the woods with Mary, Bernard strolled with his eye heavenward hoping, as he did each month, to catch a glimpse of the new moon, an event which had a strong superstitious attraction for him. "Well, we managed to see the moon," Mary informed Nicky, "but only just in time to prevent the disaster of seeing it first on a Friday the thirteenth. . . . Yesterday B.B. was desperate . . . but just as the car drove up to the door at seven the clouds parted and she appeared, whereupon B.B. went through his customary rites and retired to his room full of contentment." What those rites were has gone undescribed.

Before the month of August was out Mary had to go north to Venice to join Joe Duveen's family party. In spite of the luxury which Joe provided, she chafed against her enforced submission and the frantic social pace in which it involved her. From the Lido she informed Bernard that Joe presented her to everybody and even "dragged" her round to balls, but "no important talk yet, only boasting." There was much busi-

ness to talk about, not only the state of accounts but also the proposed Institute. Duveen had assured Berenson he would be glad to endow it and serve as one of the trustees. On the Lido Duveen had taken up again with a former mistress, now married, and insisted that his wife receive her. The strain between them led to such heated arguments that Mary commented to Bernard, "Our quarrels, thine and mine, are love-making by comparison."

Belle Greene, who Berenson heard had been "purpling Italy with passion" for the past few weeks, was also in Venice. She regaled Berenson with word of Duveen's business strategy. He was on the trail of Andrew Mellon in Europe, he had told her, and he had a reservation on every train leaving Paris awaiting calls from his spies as to Mellon's whereabouts, saying, "You know what I am when the quarry is in sight." In Paris he did catch up with his "quarry," and Mary, who had accompanied the Duveens there and was lodged at the Ritz, wrote that he had "had a wonderful afternoon with Mellon." Louis Levy was on hand and urged that Bernard should not commit himself to the "Institute" until the money was definitely promised. He talked so persuasively of the market boom under way in America that Mary gave him permission to "play with the $25,000" they had available at the Duveens to invest at the moment. He thought he could do "something big with it" if they would risk losing the interest for a little while. "I said, go ahead. He wants to make you rich!"

Though Mary declared it was "ghastly" to be with the Duveens, her collaboration promised to be highly profitable. Valuing her expertise, Joe took her about to examine his finds in Paris and afterward in London. He triumphantly announced that Mellon was eating out of his hand and promised Mary an extra £5,000 for her services. He said that though "English pictures gave him his money, it is the Italian pictures *alone* that gave him his prestige." Thanks to the pressure from the Berensons and Levy, the Duveens had sent a recapitulation of transactions in the spring of 1926 which showed that of 242 paintings in the "X" Book, 173 had been sold and only 69 remained in "stock." On second thought Joe gave Mary half of the £5,000 and a large check against accumulated fees. She hurried off both checks to Bernard by registered mail.

In Mary's absence Belle Greene arrived at I Tatti for her promised visit, a visit that Mary feared Nicky might resent, particularly since she had been asked to accompany Berenson and Belle on their travels to Ravenna and then to Genoa, the port from which Belle was to sail on the new *Roma*. If Nicky felt any jealousy, she did not show it; moreover, Berenson's fondness for Belle had lost much of its fervor. Belle, as Nicky recalled, was "full of zest for sightseeing and altogether at her best, *bon-*

enfant, gay, quick, and responsive, ready to enjoy whatever we were looking at under B.B.'s guidance." She prudently shared a bedroom with Nicky during their travels. When on her return to New York Belle "carefully explained" the location of their bedrooms to Billie Ivins, an ardent suitor of hers, Ivins said that he "would have given a lifetime to change places with Nicky."

After Belle's departure Berenson set off for the north, again accompanied by Nicky. They met Mary at Turin, and he seemed not to notice that she had had her hair fashionably bobbed in Paris, a step that he had forbidden her to take. Unreproved, she continued on to I Tatti to see to the renovations and the progress on the clock tower while Bernard and Nicky stayed on at Turin to work on the corrections of the Lists. They proceeded next to the Brera Gallery in Milan, which, in spite of the fact that some of the paintings were now shielded by glass, he still considered "one of the most enjoyable galleries in Europe." In October Kenneth Clark turned up in Milan "full of zest," and Berenson again found him "delightful and most promising." He and Clark studied the drawings at the Ambrosiana together in such a congenial fashion that Nicky felt Clark "would be what B.B. needs" for getting the revisions of the *Drawings* "into shape." At an evening dinner party for the editor Ugo Ojetti, Clark showed a reassuring grasp of Italian. His accent was "very good," and he also displayed facility in German, having already read Wölfflin's difficult prose.

For company, in the absence of Bernard and his co-workers, Mary had Senda and her husband, Herbert, as guests in the villino, the Anreps by this time having moved down to Florence. Senda, she wrote, has "thy trouble, B.B., in an accentuated form, that is to say sagging of the great intestine," and she included a diagram to illustrate the deformity. The news could not dim the comfort of her earlier report to Bernard, who was anxious about their finances again, that £20,000 had come in, presumably the arrears of fees from the Duveens. His income this year would appear to have been the largest he had ever earned, certainly well over $100,000. The receipts included £3,000 from Sulley and £500 from Wildenstein. Nevertheless, given the haphazard character of his personal bookkeeping, he must have remained rather uncertain what the exact state of his finances was.

With Clark, the new protégé, Berenson and Nicky set out on a tour of art towns like Treviglio, Bergamo, and Brescia. The tour was marred somewhat by a misadventure at Brescia. Late one night members of the Fascisti militia charged them with having stolen some sacred objects at Treviglio and threatened to take them all off to jail. Nicky dissuaded them by pointing out they could not run away since their car was parked

in a distant garage. The intruders searched their rooms, and, finding nothing, took their departure. Nicky theorized that the thieves must have bribed the sacristan to "denounce us as culprits to the police." The tour with Clark proceeded thereafter without incident, and whatever tests Clark faced he successfully passed. Berenson found him "thorough and painstaking" in his study of works of art, and in their evenings on the road he thought him "genial and lovable and always consumed with intellectual passion."

By the time they returned to I Tatti, Berenson showed every sign of having become very fond of Clark, and Mary found it "quite moving to see how Kenneth admires B.B. He says he has never before been with a person who, in three weeks, never repeated himself." As for Berenson's bursts of temper, Clark took them in stride. They were much less fearful to him, Mary concluded, "than similar traits" in his own unpredictable father. Warming to his role as schoolmaster, Berenson sallied out again with Clark and Mary to study the artistic masterpieces of Trento and Padua, and it was not until late November 1926 that he put Clark to work in the library.

The construction of the clock tower had proceeded with such dispatch that on Bernard's return Mary, who thought it looked "very well," displayed it to him. Obviously displeased, he "only grunted." Even she suspected that it was "too big." When in the following spring he cast his eye upon it and inspected the garden walk which Cecil Pinsent had redesigned, he was overcome with despair and shouted at her, "You simply don't care how I feel. Your one idea is to give that insolent, unbearable Cecil something to do." There was no help for it but to have Pinsent reduce the size of the structure, but the improvement, though "somewhat better," pleased no one. The tower would remain and in time become to visitors an admired feature of the façade, but the massive clock machinery eventually fell into disrepair and the hands remained fixed at 10:07.

Again at his desk Berenson tackled the large arrears of work on the everlasting Lists which were the ground scheme of his existence. He told Charles Du Bos he had "all the joys and sorrows of homecoming. A whole world seems to wait to jump at one the moment one gets back. . . . It seems one has become an institution, for some a quarry, for others a raft, for others still, mere carrion." For one amorous visitor he was something more interesting, as he confided to Billie Ivins. She was a Dutch matron separated from her husband and "brainy enough for our kind of good time between f——s."

Berenson had the satisfaction at the turn of the year of knowing that Louis Gillet's French version of his books on Italian Renaissance painters

had at last been published. The elegant volumes in the "Editions de la Pléiade" were admired by the *Revue des Deux Mondes* as jewels of typography whose essential idea was that a work of art was sufficient unto itself with a nature and laws independent of other human activities. Edward Fowles informed Berenson that a Paris bookseller said "they are selling like hotcakes." On the occasion of the publication Ojetti delighted Gillet by publishing a notice in the *Corriere della Sera* of his work as a prominent writer. Gillet contributed a laudatory article on Berenson to *La Revue de Genève,* which was republished in translation in the November Boston *Living Age* under the title "Bernhard Berenson: An American Aesthete Abroad."

The publication of Gillet's edition had been negotiated by Charles Du Bos, whom Berenson had met many years earlier as a member of Edith Wharton and Paul Bourget's circle. Grateful for his help, Berenson wrote to him, "I must insist on your taking for yourself whatever royalties may accrue from the sales." Du Bos, a prolific contributor to the literary journals, flourished in recurring ill-health somewhat like Berenson himself. Berenson counseled him, "You must live, my dear boy, on what is best in yourself, and that is your purely contemplative, intransitive side."

The letters of Berenson and Du Bos constituted an ardent dialogue on art and literature. Once, for example, when Du Bos told of his dismay on reading a recent book on Giotto that rejected the Assisi frescoes, he asked Berenson for his opinion. Berenson explained that he too in his youth "had refused to accept the Giottos in the upper church. . . . That was the time when we were all possessed by the *Geist der statts verneint* [the spirit of contradiction]. That spirit is very old fashioned now. At present I witness a race as to who shall attribute the greatest number of works to a great master. . . . All the *apocrypha* are rapidly becoming canonical." He urged Du Bos to read the recent book of his learned friend Pietro Toesca, with whom he had begun what became his most voluminous correspondence with an Italian art historian. "It is the most remarkable volume," he said, "on the history of Italian art that has ever appeared."

A few weeks after Clark began his work with Berenson there was disconcerting news. "The youth I have annexed to help me out," Berenson wrote Ivins, "announced that he has been annexed and is about to marry." The news of Clark's engagement was far more disturbing to Berenson than his laconic report suggested. The self-absorbed young man, thirty years younger than his host, seemed for his part quite unaware that he had been less than frank with the Berensons, who had counted on an unattached apprentice. When shortly after Christmas, while Berenson was at his morning toilet, brushing his teeth, Mary

brought Clark to the door saying he was off to be married, all that the disgruntled Berenson could muster was, "I don't mind." The young man never forgot the remark nor did he forgive it in the reminiscences of his old age.

The twenty-three-year-old Clark hastened back to London for his marriage, which took place on January 10, 1927, his plans for a simple ceremony at the registry office firmly countermanded by his fiancée in favor of a church wedding. To Mary this was an auspicious sign: "It won't do any harm for her to have the upper hand." Though referred to in the London *Times* as Elizabeth Winifred Martin, Clark's bride was from the beginning called Jane. She was "certainly a complication," Mary admitted to Logan, though it was possible "she will be the right sort." Jane, when she arrived, seemed "neither pretty nor smart," but she was "very sensible and keen on work." The Berensons' policy must therefore be "to make the best of it, while it lasts, and not speak against either of them."

The newlyweds settled into the "Cloister," the building attached to the ancient church of San Martino which was on the hillside above I Tatti. It had been added to the estate in 1920. Jane, eager to justify her new role, said she was looking forward "immensely to setting to work on the Drawings." Nicky felt drawn to the "two *sposini*," and within a few months thought that the young man was "improved by being associated with Jane's nature and temperament." She had a "sensual" rather than a "cerebral" way of looking at beautiful things and "a natural taste and eye for color." "I don't wonder," she wrote to Mary, "that he with his slightly puritanical nature delights in her."

To the reserved young Oxonian the anti-Fascist talk that was now the staple of the Berenson salon had little attraction, and he secretly deplored Berenson's "laudable, but monotonous" vituperative diatribes. The lively free-for-alls during that first winter with Hutchins Hapgood, Umberto Morra, Trevy, Logan, and the young Cyril Connally, Logan's secretary, were a different matter. They often read aloud of an evening and were especially charmed by Morra's beautiful rendering of Italian texts. Among those congenial companions Hapgood was Berenson's favorite. "The contrast between him and me is pretty," Berenson with some puzzlement told Ivins. "He loves booze and harmony with himself on a lower level and believes in the PEEPLE to the nth power. . . . And yet I greatly prefer him to all but a few bipeds now alive."

If Bernard sometimes found himself puzzled to understand the vagaries of his own character, for Mary there was no such obstacle. She had psychologized him in season and out and now conceived for herself a new and major project, "a book about Bernard and his method." Hence,

early in 1927 when she went up to Berne for a month's course of treatment with the "famous Dr. Kocher," she took with her part of the hoard of letters that she and Bernard had exchanged in the nineties. "His character is exactly the same—after all my attempts to modify him," she told his mother. To Nicky she was more detailed: "B.B. at 25 was almost exactly what he is now—mystical, ecstatic, and scientific as regards pictures and interested in origins and development and influences, anti-democratic, anti-philosophic, believing in culture above all else." Mary's ambitious book had to be put aside when she returned to I Tatti, not to be picked up again for nearly five years. It finally bogged down in the overwhelming masses of letters.

XXXV

The End of Profit Sharing

THE anti-Fascist tirades went on with undiminished vigor at I Tatti, but the times called for watchful speech outside and, unsure of the privacy of letters, the Berensons restrained their pens. They were grateful to Walter Lippmann for his scathing editorials on Mussolini but admitted that, for them, "silence is best." Antibolshevism, however, was a safer matter, and when Kerensky asked Berenson's help in reaching the American public, Berenson gave him a letter to Lippmann in which he urged Lippmann to help Kerensky meet "the right people" if he found him "worthwhile." He also took the occasion to caution Lippmann about the reputed Antonello da Messina which the Metropolitan had just bought. It was the painting Berenson had rejected as the "Impossible Antonello." He instructed Mary to write on the same point to Joe Duveen, who had himself been interested in buying the painting. Mary pointed out to him that if the painting had been sold on its own artistic value, it might have been worth only five or six thousand dollars. "The extra sixty thousand is due to its being called Antonello."

Berenson's exhaustive exposure of the "Impossible Antonello" could not be gainsaid, and his rejection of the attribution finally prevailed. In 1941 the painting was assigned by the museum to Michele da Verona, and subsequently it took its place under that name in the Metropolitan catalogue of European paintings.

The *Three Essays in Method,* which brought together "Nine Pictures in Search of an Attribution," "A Neglected Altarpiece by Botticelli," and "A Possible and an Impossible Antonello da Messina," was published by the Clarendon Press in a lavishly illustrated quarto volume early in 1927. Joe Duveen sent several copies of the book to Belle Greene to be given to the trustees of the Metropolitan to show them the error of their ways. She also sent copies to Yale, Harvard, and Princeton.

In the preface, dated "Taormina 29 April 1926," Berenson stated his rationale for the use of photographs: "It is pleasant and seemly to be acquainted with original works of art. It is even necessary to know them if one is required to pronounce whether a given picture is an autograph, a studio version, or a contemporary copy. But for the plainer archaeological purpose of determining when and where and by whom a given design was invented, a good reproduction is enough." The purpose of the book, he said, was "to canalize guessing" and "lead the study of art . . . out of the hocus-pocus into the unpicturesque but fruitful fields of fact and calculation, so that critics may ultimately exercise their activities on a line with the astronomer and the chemist, rather than with those of the astrologer and the alchemist."

Reviewers of *Three Essays* acclaimed it as once again demonstrating Berenson's preeminence in his field. The *New Statesman* declared it "in some ways the most remarkable book" Berenson had written. The *Spectator* praised the "shrewd, humorous, cogent analysis." To the *Times* reviewer it was "the least alarming book on the subject of artistic attributions we have ever read" and it had the "consoling value" of reminding the reader "that purely artistic considerations do not exhaust the interest of painting." In the United States Frank Jewett Mather, Jr., praised it in the *Saturday Review of Literature* as showing the value of "archaeology" in correcting the "aberrations" of mere connoisseurship.

Increasingly Berenson was being sought out by young American art students to whom he usually gave the run of his library. He did, however, require a proper deference. In May 1927 the youthful Meyer Schapiro, who like Berenson had been brought to the United States as a child from Lithuania by his Jewish parents, put in an appearance, full of brash confidence. As a young socialist bred in the Brownsville ghetto of Brooklyn, Schapiro apparently found it hard to repress his disapproval of the luxury of I Tatti and its aristocratic protocol. The youth's self-assurance amused Berenson and invited irony. It must have seemed a parody of his own youthful pretensions. He described the visit to a friend: "Yesterday a very handsome youth named M. Schapiro sent up his card on which was written Columbia University. . . . It turned out he had been sent by Creswell [the Islamicist] whom he had seen in Cairo and Riefstahl whom he had seen in Constantinople. He is acquainted with the entire personnel of the arts and the entire literature: he has worked years and years on Coptic art and as many again on the local school of Azerbajan; decades he has spent in Spain and Southern France, and as for the remotest corners of Byzantine and Cappadocian art, he has explored, delved and assimilated it all. I put him to the test by showing him my jade libation cup and my little bronze candlestick and he praised

them and discoursed about them as sweetly as Solomon did about the hyssop in the wall."

The success of the *Three Essays in Method* gave a fresh incentive to Berenson to push on with the revision and amplification of his Lists, and he pursued the task with obsessive intensity. Early in June 1927 he reported from Venice, "I have only Bellini and Sodoma to do of all the northwest Italians and odds and ends." Duveen, understandably, was rather worried about the implications of the project for the firm. That Berenson sometimes changed his mind about the authorship of a painting had been a continuing source of uneasiness to him. To Mary, Bernard assigned the job of calming his anxiety. She lectured him that when scientists correct mistakes and doctors revise diagnoses, "their power to do so is the measure of their honesty and competence. B.B., who is *passionately* honest in his work in Italian pictures, is obliged sometimes to alter his opinion either because he has learned more about the painter or because a picture has been cleaned or because a photo has given a wrong impression." Progress on the Lists, she explained, was necessarily slow. Berenson had spent three months, for example, on Tintoretto and Veronese alone, for "they had never been carefully and critically studied."

Determined not to compromise his reputation as a disinterested scholar, Berenson remained adamant on one point: he would not list pictures in the hands of dealers. Once a painting went to a collector, he would on request confirm an attribution he had made. He had attributed the Italian pictures in the Duveen stock, but he had not regularly done so for other dealers; hence a Duveen listing would appear a mark of special favor. Alarmed, Fowles protested that there were a large number of Italian paintings in stock still unsold and that most of their clients would consider he had not passed the pictures which were not printed in the Lists. Mary quieted him by pointing out that since the revised Lists would not be ready for a few years, the problem need not yet be faced. The controversy was thereupon dropped, and the correspondence and cables resumed their usual burden of opinions on possible purchases and prospective clients. One letter attempted to clear up what had become something of a mystery, the defection of Henry Walters since the end of the Great War. Fowles wrote that Walters "is entirely in the hands of Seligmann & Company. . . . They must have concocted all sorts of stories against all of us."

There had been six months of steady application to work following Berenson's return to his desk in November 1926, and now with the approach of summer he was again impatient to travel. His object would be to visit his royal friend in Sweden, Crown Prince Gustaf Adolf. His

leisurely itinerary would take him to Vienna, Prague, Dresden, and Berlin, and on the way he would "do nothing but look at works of art and listen to music." They would travel in their usual well-provisioned style aboard their "mastodonic Lancia car" with Hugh Parry as pilot.

In July during a week of gallery going and music in Berlin, an urgent wire came from Joe Duveen. Joe had recently purchased for $2.5 million the Robert H. Benson Collection, described in the *New York Times* as the most important private collection of Italian art in Europe, the 114 paintings representing six Italian schools. Duveen had proposed that Berenson accept a fixed sum as compensation instead of the usual 25 percent of the profit on the sale of each picture. Berenson set his fee at 10 percent of the purchase price. Duveen requested a reduction in that figure. Berenson, who had first studied the great collection in the nineties in the company of Herbert Cook, indignantly replied that he could not accept less than the 10 percent. "I shrink with horror from bargaining. The treaty between us with regard to the 'X' Book is in many ways far [more] favorable to you than it is to me. . . . It involves me in all direct losses. . . . You can make a huge money profit out of the matter, beside all the 'Glory, Kingdom, and Power' that you get out of it." It was becoming apparent that a new arrangement was needed if he were to avoid fresh contention with Sir Joseph, but that would have to wait until he could confer with Louis Levy later that month in Hamburg.

Prince Gustaf welcomed the travelers in his usual unceremonious way at his summer home near Stockholm. The pleasant dinner was equally unceremonious, but the presence of the princess and royal nieces from Greece required curtseying from Mary, something "my stiff old bones do not readily lend themselves to." A passionate archaeologist, the prince had "thousands of things to talk about with B.B.," and when an aide-de-camp came in to signal discreetly that it was time for the Berensons to leave, he exclaimed, "Oh you can't go yet," and he went on talking about his travels in China, Japan, and India.

Though so often a semi-invalid at home, Berenson seemed rejuvenated as they bustled from one entertainment to another. From Stockholm they drove on to Oslo, where a circle of "jolly painters and museum directors took" them "to their bosoms." Late hours and "exhilarating liquors" were the rule. At dinner with the superintendent of art, the abstemious Berenson was seen to "drink a cocktail, followed by claret at dinner (Chateau Lafitte, 1897) and champagne." They got home at midnight and Bernard rose in the morning no worse for the wear. And the day before, while motor boating among the islands, Nicky and Mary could not believe their eyes when they saw him pour a stiff whiskey and soda *and drink it.*

The party reached Hamburg in time to meet with Levy on August 19 for preliminary talks about a new contract. Berenson was all nerves, but Mary felt confident of Levy's friendship. When she admitted that they had got a very great deal of money from Duveen, Levy replied, "You can't get too much. B.B. has made the whole reputation and prestige of Joe Duveen." He declared that the old contract was "abominable because it placed Berenson wholly at Joe's mercy." He proposed a new contract giving Berenson a retainer to be paid twice a year and relieving him of sharing losses. As things now stood, he was in effect a secret partner and "liable for the losses and taxes."

Mary felt quite in her element in the conference, but, as she described it to Senda, "B.B. is too funny when business is talked. His features fade into what Nicky and I call his Russian steppe expression and he seems thousands of miles away." She added that they had made their wills, a thing which had weighed much on her mind, for she was "more personal than B.B." and had less enthusiasm "for an Institution." In the course of their business talks the subject of their wills had come up and Bernard, who had hitherto objected to providing for her grandchildren, suddenly "gave way and said Yes he would charge the estate with $2,000 a year to each of my beloved grandchildren. No words can say what a weight this takes off my mind."

Business completed, Mary hastened to England, and Bernard and Nicky joined the Kingsley Porters for a series of excursions in north-western Germany and Holland hunting medieval monuments and church treasures as well as paintings and drawings in museums and private collections. When the Porters departed for Paris, they left Berenson and Nicky to their note taking in the Dutch museums. The two were joined by Mary in Amsterdam and they all crossed to London from Paris with Duveen and spent three days examining the great collection of early Italian paintings acquired from Robert H. Benson, the merchant banker. Sir Joseph, full of amiability, introduced them to some of his most important clients. According to Mary, Bernard surpassed himself in these interviews, displaying "a depth and width of learning" that even she found surprising and that left Duveen "dumb and amazed."

Through the good offices of Lady Colefax the Berensons settled themselves in the comfortable establishment of Lady Horner in Fitzharding Street. Berenson resumed his researches in the print room at the British Museum, where he was soon joined by Kenneth Clark. They went on together to study the drawings at Windsor Castle and at the Ashmolean in Oxford. The chief drain on Berenson's energy proved to be the ceaseless influx of guests at their open house. There were also gatherings

at other places, one, for instance, at which Berenson and Roger Fry patched up a sort of truce and another at which they met Austen Chamberlain and listened to him tell of his encounter with an affable Mussolini, who, when he discovered he was visible to the crowd outdoors, immediately thrust out his lower jaw and assumed the formidable scowl that was his trademark.

Never before in England had Berenson attracted so much friendly interest or been shown such professional respect. His new book had carried the day for him. Lord D'Abernon, chairman of the Royal Commission on National Museums and Galleries, asked for his view, for use in the commission's report, on the relative excellence of British collections and on the arrangements of exhibits. Though too much pressed for time to submit a formal memorandum, Berenson, ten days later, dispatched a 2,500-word statement giving detailed answers to Lord D'Abernon's questions. "My impression is," he wrote, "that taken all round, for both quality and quantity, you have here in London incomparably the finest collections in the world." Some branches of art, however, were better represented elsewhere, folk art in Budapest, Vienna, and Scandinavia, for example. England had nothing to compare with the examples in Berlin of "early Islamitic art" from Meshata and Samara or the "frescoes, textiles and illuminations from Chinese Turkestan." Berlin, Leipzig, Munich, Hildesheim, and Hamburg, "taken together," had finer ethnological collections, and Paris and the Vatican were richer in Byzantine and Carolingian illuminated manuscripts. "But all deductions made," Berenson concluded, "your collections represent the whole world's art as no others anywhere."

In her diligent record of the people they saw in London, Mary posted the names of some 104 individuals and couples, and her list was patently incomplete. Most were old friends and acquaintances, like Trevy, Gaetano Salvemini, Arthur Waley, Desmond MacCarthy, Graham Wallas, Yuki Yashiro, Lady Colefax, the William Rothensteins, and Herbert Cook. Some were new, like Lady Cholmondeley, Lord and Lady Lloyd, Arnold Bennett, and Edmond Gosse.

Much as Berenson relished the crush, he became "sadly overtired." But when they crossed to his beloved Paris on November 3, 1927, he seemed to draw a reviving breath. There Carlo Placci was on hand. His former love Baroness La Caze greeted him, as did the witty and "beguilingly ugly" Madame de Cossé-Brissac. He met with his *Gazette* translator, Seymour de Ricci, and the perdurable Salomon Reinach and enjoyed the challenge of Paul Valéry's erudite talk. Arthur Sachs and his wife called, and fashionable Elsie de Wolfe, now Lady Mendl, brought

her unfading glitter to their Hotel Beau-Site. Mary's Paris list ran to 126 and included, what seems most to have impressed her, three princesses, five duchesses, one grand duchess, six baronesses, a prince, and a baron.

In the mornings Berenson, accompanied regularly by Nicky and Kenneth Clark, worked in the Louvre print room from eleven to one checking the Florentine drawings. "I look forward all the previous afternoon and evening to this work," he wrote Billie Ivins. He told him also of his enjoyment of high society, of seeing Martha Hyde, Linda Porter, Mrs. Wharton, "my very beloved Abbé Mugnier, Abel Bonnard and scores of others, chiefly lovely women and scholarly and literary men, all making a noise as if they enjoyed seeing us." Edith Wharton had recovered her poise after the recent death of Walter Berry and her salon flourished once more. There the Berensons again met Paul Bourget, "grown very old and mangy." He congratulated them on "living under Mussolini's beneficent rule; 'the first man who has the courage to assert the bankruptcy of universal suffrage,' " a sentiment with which Edith expressed strong agreement.

Berenson was of course never free from calls upon his services. An amusing one came from F. Steinmeyer in New York, requesting a letter of authentication for a Bellini that Solomon Guggenheim had just bought. Guggenheim feared his family would "make fun of him should the picture not be right. . . . If he had your letter he can proudly show both picture and letter to every one."

In a sense, all this stimulating activity was a marking of time while waiting for the new Duveen contract to be drawn up. Weeks passed as the negotiations dragged on. An "excruciating talk" with Fowles on November 24, 1927, seemed to lead nowhere, but on the twenty-ninth the final details of two agreements were worked out, the first settling the claims under the old arrangement and the second providing the terms of the new. The existing agreement for profit sharing would end January 1, 1928; Berenson waived any claim on works of art not sold by that date, and the firm agreed to relieve him of any liability for losses on items returned after that date.

The second agreement, dated January 4, 1928, was to run until December 31, 1932. The preamble reflected Berenson's stubborn insistence that his services were those of an independent consultant: "Appreciating your preeminent position as an authority on great Italian pictures . . . we wish to arrange for your retainer for these purposes. While you are to be entirely free and untrammeled in your artistic and scientific judgments, it will be of great value to us to have the benefit of your learning, judgment, advice and general assistance." Under the terms of the agreement Berenson was obligated to supply "upon request" his "unbiassed opin-

ion and certificate as to any Italian picture" acquired by the firm, already owned by it, or being considered with a view to acquisition. For these services Duveen agreed to pay him an annual retainer of £10,000 payable semiannually. In addition Berenson would receive 10 percent of the cost of all purchases made on his recommendation. Duveen also agreed to pay £50,000, as Berenson had requested, for his services in connection with the purchase of the Benson Collection.

The new contracts thus promised a divorce from the complicated financial arrangements which the firm often made with collectors. Joe's dilatory habits, however, did not change, and the Berensons' correspondence with Fowles and with Joe himself continued to be interspersed with urgent pleas for prompter payment on account of the arrears under both the old contract and the new.

With the negotiations for the new contract finally out of the way, the Berensons and Nicky joined Edith Wharton at Hyères shortly before the Christmas holiday. After a few days Mary and Nicky departed for I Tatti, leaving Bernard to enjoy "the longest rest in seven years" in the exquisitely furnished house whose luxury and strict daily ritual met his fastidious standards. His sense of comfort could only have been more deeply felt when Mary wrote the day after Christmas of the mishaps at I Tatti—the hot water system that had broken down, the lamps that were starved for electricity, and the bells that refused to ring. Hyères also offered escape from the sight of Mary doting on her "descendants" who arrived for the holidays and from the Christmas festivities which aroused all his latent dislike for the day.

When the holidays were over and the coast was clear Berenson immediately returned, applied himself to the Lists, and appeared to thrive working at "high pressure." As the weeks passed he noted that he had made progress through the Umbrians and the "tangle of the early Perugini." In early March 1928 his particular "torment" was the Giorgione problem. "I accept our canon," he said, "perhaps as much out of inertia as conviction. The 'Concert' must be Giorgione, because it is too great for Titian. . . . The Madrid 'Medici' has too oval a face, etc. and yet both are more Titianesque than most early Titians. So if Giorgiones they are, we return to our conclusion of forty years ago, namely that he was Titian's sole inspiration until his [Titian's] old age." When he reviewed the completed Lists in the following year, he again bogged down in what he called the "Giorgione quicksand."

The rarity—and great value—of paintings attributable to Giorgione had made the quest for his pictures one of the most tantalizing of all to the art trade. Fowles had again inquired concerning Lord Allendale's *Adoration of the Shepherds,* which the family steadily exhibited as a Gior-

gione, and he sent an enlarged photograph of the painting for study. Still puzzled, Berenson ventured, "Is not the most probable solution that the landscape was put in by Giulio Campagnola and the rest by the youthful Titian?" The opinion evidently discouraged Duveen, and whatever negotiation had begun for the purchase of the painting came to a halt. But the allure of the Giorgione name was hard to resist and Duveen did not lose his interest in the painting.

No matter how scrupulously Berenson did his work for Sir Joseph, rejecting the enthusiastic proposals of paintings almost as often as approving them, to many in the outside world he was seen as Duveen's compliant accessory. Early in 1928 he received a long letter from his cousin Arthur reporting a malicious attack upon him. Arthur had become acquainted with Lord Abdy, who had personally sold a French painting to Jules Bache for $75,000 which Bache now wished to return. The resentful Abdy felt that the Duveens were somehow responsible, and then, seeking another scapegoat, he had gone on to attack Berenson's association with them, citing as evidence of impropriety the recent sale by Duveen to Bache of a *Madonna and Child with Saints* from the Benson Collection as a Giovanni Bellini. He complained that Berenson had once attributed the painting to Basaiti in his *Venetian Painters* of 1894 and in his 1916 *Venetian Painting in America* had suggested that the painting came from the studio of Bellini. Now he had promoted it to an autograph Giovanni Bellini.

To Lord Abdy, smarting under the loss of his own sale, the return of the painting to its original dignity under the aegis of Duveen seemed highly suspect. His criticism of Berenson was based as much on ignorance as on malice. Berenson had no financial stake in separate sales since the £50,000 award under the new contract covered his services for having expertized all the Italian paintings in the Benson Collection. He maintained the ascription to Bellini in his revised 1957 List. The 1980 catalogue of European paintings in the Metropolitan Museum, to which the Bache Collection was bequeathed, gives the painting to "Giovanni Bellini and Workshop."

Arthur warned his cousin that the honorable lord was spreading his slanders to whoever would listen in New York. He counseled stoicism: "There is no way of meeting this situation for men in high positions except to do one's duty conscientiously, fully, and to remain completely oblivious to all criticism. The world has unbounded, unlimited faith not only in your judgment but in your integrity. . . . I think it will take much more than the Abdys or the Offners to pull you down."

There was a certain irony in Arthur's bringing in Offner's name as an enemy of Bernard's. It was true that Richard Offner had deeply offended

Bernard in 1924 in his article questioning the attribution to Cimabue of the painting which had been sold to Carl Hamilton in 1919. Offner had just recently made handsome amends in his new book *Studies in Florentine Painting*. His "deepest debt," he acknowledged, was to "Mr. Bernard Berenson of whose accomplishments every student of Italian art, and of criticism generally, bears reverent recognition. To his stimulus, to the quality of his culture, to his penetration, to the accessibility of his incomparable library, I have owed endless profit and inspiration from the early stages of my study."

XXXVI

Afloat on a Golden Flood

THE winter of 1928 passed uneventfully with the usual flurry of society and students. Robert Trevelyan arrived, suddenly affluent after having eked out an existence for many years with the help of post-obits. The death of his mother, according to report, made him the owner of six thousand acres and an income of ten or twelve thousand pounds a year. Bessie, now much taken with her sculpture, visited in the spring, and the censorious Mary found her whining voice a trial. Later in the year Rachel and her scholarly husband, Professor Ralph Barton Perry, made their visit. Bernard, increasingly attracted to him, wrote Nicky that Perry "did everything to draw me out and made me talk, effacing himself."

The sensation of the winter was the visit of the famous monologist Ruth Draper. "Florence is crazy over her," Bernard informed Mary. Her performance of "Vive la France" was so moving that "there was no applause and not a dry eye." At I Tatti she gave her "Three Ages" and "The Irish Peasant Woman" just for Berenson and Nicky.

By this time Berenson's hope of training a successor in Kenneth Clark had pretty well dimmed. Clark's marriage had been a disappointment and now Jane Clark's pregnancy added a complication. The pair returned to England for the birth of their son Alan, which occurred April 13, 1929. Clark had taken with him the unfinished manuscript of a book he had been working on. With Logan's encouragement the witty and gracefully written pages poured forth with a rush, and almost immediately after his son arrived Clark sent off the completed manuscript of *The Gothic Revival* to his publisher and began thinking of another book that might deal with the history of classicism in England. Work on the revision of Berenson's *Drawings,* he now felt, need occupy only a limited part of the year. When he returned to Florence later in the year to study

the drawings at the Uffizi, he found himself more interested in exploring the problems of Leonardo da Vinci than in advancing the revision. To Mary, with whom Clark was on easier terms, he acknowledged that he "loathed the pettifogging business of correcting notes and numbers." She grumbled in frustration, "All that he wants out of it is . . . whatever kudos he will get from the association. He has an ingenuous self-centered nature and B.B. needs devotion."

Clark seems to have felt under obligation to continue in some way the "collaboration with Berenson," as he referred to it when talking to William G. Constable, the assistant director of the National Gallery. Berenson, frankly recognizing the changed circumstances, wrote to Clark in May 1929 that he had decided to "give up our plan of collaborating on the new edition of the Florentine drawings." He felt he had no right to keep him hanging on "for the ever retreating day when I shall be ready" to prepare the new edition. When that day came he would need not a collaborator "but an assistant" who would be at his "beck and call to fetch and carry." It would be absurd to expect him "to leave house and wife and child and friends to devil for a cantankerous old man. . . . I want you to believe, dear Kenneth, that it is to save our friendship that I am giving up our working together. . . . You should devote your gifts for scholarship and your gift for words to a task which will prove one of those contributions to the history of ideas and taste which by their mere existence advance culture."

In his reply Clark wrote, "I found the Florentine Drawings a wonderful training and a happy excuse for working with you, but you, I am afraid, must have found it rather an irritant, keeping you from original work. . . . As things are, the time I spent on it was one for which I can never be sufficiently grateful. . . . All the work I do in the history of art will have foundation in what I learned from you." He asked permission to dedicate his book on classicism to Berenson.

Following his initial disappointment Berenson took a sympathetic interest in Clark's advancement, as their voluminous correspondence testifies, and it pleased him to regard Clark as one of his former pupils. The two drew closer together as Clark rose in the world with the help of Berenson's recommendations and testimony. Looking back on their early association, Clark once recalled sitting beside Berenson and, while helpfully buttering his toast, hearing him talk to a sympathetic lady in which "the flow of ideas, the range of historical reference, the intellectual curiosity and unexpected human sympathy were certainly beyond those of anyone I have known." It was this quality of mind that drew Clark back again and again to I Tatti. After Berenson's death Clark wrote, "I owe him far more than I can say and probably more than I know."

months Berenson thought it politic to place $50,000 with him for investment.

The relation of the two rather testy men ran an eccentric course. To further Bache's "education," Berenson invited him to come to Florence, "pure of heart," in the fall of 1928. Bache, not readily intimidated, replied, "How can you expect a man who has been compelled to rub elbows with most of the art dealers of civilization and many of the experts to be 'pure of heart' or even almost pure?" He nevertheless accepted the invitation and presented himself late that summer at Poggio allo Spino. To Berenson's dismay he was principally interested in having a catalogue prepared of the Italian pictures he had already acquired from Duveen and in having Berenson authenticate a "Bellini" which a friend had offered him. He explained that it was a painting he did not want to accept unless convinced it was "by the master," and "worthy" of his collection. Eager to please Bache, Sir Joseph had seconded his requests. Berenson vigorously declined both chores. He did not forget his commitment to Duveen, however, and pressed Bache so energetically to make exclusive use of the firm that Bache protested that of his fifty-six pictures, except for the French ones bought from Wildenstein, all but five were bought from Duveen. "I wonder how many I would have to buy from Joe so that I do *not* disappoint you 'frightfully.' " Berenson, resenting the gibe, pointed out that he had no special financial interest in Joe's sales. Besides Joe "could sell a coffin to Tutankhamon, . . . and he would end by selling to others what he did not sell to you."

The dispute was patched up after a fashion, and when Bache returned to New York he wrote that Professor Walter Pach, in a lecture at Bache's home, "constantly referred to you as practically the only real authority on early Italian art." Berenson continued for a while to recommend paintings to Bache but with limited success. "While I share your enthusiasm for the early pictures, although hardly pretending to understand them fully," Bache explained, "the trouble is that Joe's idea of their value is based entirely on their rarity and his ideas and mine are distinctly at variance." He was tired of paying several hundred percent profit and being laughed at.

It was characteristic of Duveen's hypersanguine temperament that he thought Berenson's conference with Bache at Consuma in the autumn of 1928 had been successful, and he continued to urge Berenson to gratify Bache. In the next year he suggested that Berenson at least write a preface to lend its cachet to the Bache catalogue prepared by the firm. Berenson exploded, "You tormented me last autumn to 'expertise' a Bellini for Bache, and now you want to force my hand to do what I refused to do for Bache when he was here." Again Sir Joseph backed down.

Berenson never relaxed his guard with Sir Joseph, for he always sus-
pected ulterior motives behind the bluff camaraderie of the man, and he
kept on the alert to forestall any effort of Sir Joseph to treat him as an
employee. When Joe wired asking him to see a reputed Botticelli that a
dealer, Tolentino, wanted to show him, Berenson warned him, "I no
longer receive anybody here as the chances of trouble are far too immi-
nent for me to risk them . . . the least of which might be being sub-
poenaed as a witness. I need not tell you what, if this happened, would be
the effect upon my nerves." Fowles immediately replied for Joe that all
the members of the firm were being again reminded not to refer "any
dealers or picture owners direct" to Berenson.

In the midst of his agitated exchanges with the Duveen firm, Berenson
learned that the father from whom he had inherited his volcanic temper
died that summer at the age of eighty-three. The message Bernard wrote
to his brother, Abie, did not lack for irony: "I who had for many years
little to suffer from the disagreeable side of him, must confess to having
had a soft spot in my heart for him. He was very gifted and eloquent and
fascinating, but spoilt, inadequately educated and uprooted. I always
wondered what would have become of him if he had had my chance."
Albert had remained a free thinker to the end, and in accord, it appears,
with his wish, his body was cremated. A few months later the Berensons
filed copies of their wills with Joseph E. Haven, the American consul in
Florence, with instructions that in the event of their deaths they wished
to be cremated and to have their ashes deposited in the Allori Cemetery.
That stern resolve was to give way at the last to Nicky's sense of reli-
gious propriety.

Berenson also deposited with Haven a letter explaining his desire to
create "an academy where American students can perfect themselves in
the history of the arts and especially of the arts which flourished in Italy
or fed these arts." It was the first formal statement of his intention to
bequeath I Tatti to Harvard. His friends at Harvard, he said, had ex-
pressed "their delight with my idea." There was a growing demand in
America for teachers of art history and for directors of museums, and
nowhere in Europe was there a school where Americans could pursue
such studies as distinct from archaeology. He hoped that I Tatti would
"fill this gap." His library already included thirty thousand carefully
selected volumes and several times that number of photographs, and if he
was spared for another ten years, he expected to leave a collection of
photographs which might, "on its own ground, be unrivalled."

Duveen's triumphant season in 1928 made him more exuberant than
ever, and when Mary stopped off in London to confer with him after her
cure at Bagnoles, he expressed "white hot enthusiasm for our Institute."

Six weeks later Duveen descended upon I Tatti for a short visit like a god in a whirlwind. He bounced in to Berenson's bedside and "discoursed amiably, loudly and heartily." Mary took him on an exhausting run through the Pitti, the Uffizi, and the Bargello as he called out imperiously before each masterpiece, "Next." Berenson put aside the Lists for a day and drove out to San Sepolcro with him and Mary on a "spree." At San Sepolcro a painter was copying the Piero and volubly expressing his opinions, and Joe went wild with annoyance. Then came lunch. Though the pasta was good, the rest of the meal was mediocre, and Berenson flew into a rage at the proprietor and flung out of the place. Mary recounted that "the only person who liked the row was Joe, who said it was worse than any of *his* rows."

The storm passed like a summer shower, and before the evening ended at their mountain lodge near Consuma, Berenson handled Duveen so diplomatically that he promised to settle "all past debts and to endow the Institute very liberally" and even to pay an extra £7,500. In addition he promised to endow two fellowships. Since Bache and another affluent visitor had each promised to endow two, Mary could inform Bernard's mother, "We have six fellowships already promised (all by Jews!) and can ourselves endow several more."

The work on the Lists had called for the most painstaking review of the paintings and their locations. In the course of restudying thousands of photographs in his collection, Berenson discovered that he had photographs of a great many paintings which he was now unable to locate. Collections had been broken up or weeded out, and many paintings had passed through dealers' hands into a kind of limbo, dealers often declining to disclose the identity of a purchaser for fear that critics might dispute the important name under which a painting had been sold.

The idea came to him to publish "descriptive studies" of the "missing" or "homeless" pictures in the hope that the owner-collectors might come forward. He paused long enough in the work of verification to prepare an illustrated article on "Missing Pictures of Arcangelo di Cola." It appeared in the July 1929 *International Studio* and was followed by four illustrated articles, published at intervals during the next few years, on "missing" Sienese and Florentine paintings of the fourteenth and fifteenth centuries. With the demise of *International Studio* in 1931, the two articles in the Florentine series appeared only in the Italian *Dedalo*. In these pieces he recalled his first acquaintance with each of the "waifs and strays" and rehearsed and occasionally revised his opinions concerning their attributions and their places in the artistic tradition of their period.

Owner-collectors did not rush forward to comply with Berenson's requests, and location of the whereabouts of many of the missing pic-

tures was postponed for nearly forty years. In 1971 the art historian Dr. Hanna Kiel, who had long been associated with Berenson, collected the articles in their original English versions in an illustrated volume called *Homeless Paintings of the Renaissance.* She had been able to run to ground more than 250 of the paintings in museums and private collections, leaving 150 or so still without a known habitation. Her study also revealed that Berenson had revised the attribution of 34 of the 250 paintings she had succeeded in locating.

How difficult the determination of an attribution could be is illustrated in two articles in the Kiel collection on the authorship of the famous Cook tondo *The Adoration of the Magi,* the wonderfully populated roundel with the iridescent peacock on the manger, which Berenson had examined in the nineties in the collection at Richmond, Surrey. It had long been attributed by distinguished authorities to Fra Filippo Lippi, and Berenson had so identified it in his original Florentine List. In the first of the articles, titled "Fra Angelico, Fra Filippo and Their Chronology" and originally published in Italian in the *Bolletino d'Arte,* he told of his subsequent misgivings about the attribution: "I saw too much Fra Angelico in it to be satisfied with the ascription to Filippo Lippi, and too much Filippo to let me assign it to Fra Angelico. So I concluded that it must be work done by the first under the strong influence of the second." Reconstructing in elaborate detail the chronological sequence of Filippo's paintings alongside that of Fra Angelico, he now deduced that there was "relatively little of Fra Filippo in the painting. . . . It is a picture designed entirely by Fra Angelico in the early forties of the Quattrocentro, and finished by Fra Filippo."

When the article was reprinted in *Homeless Paintings,* the *Times* called it "the best single historical essay" that Berenson had produced. But in spite of Berenson's impressive demonstration, the question was not laid to rest. Soon afterward Lionello Venturi published a refutation supporting the attribution to Fra Filippo. Berenson's good friend Pietro Toesca, a leading Italian art historian, also held out for Filippo in the 1934 *Enciclopedia Italiana,* and he was followed by other Italian critics.

In the second article, titled "Postscript 1949: The Cook Tondo Revisited" and first published in *Homeless Paintings,* Berenson returned to his original attribution. Having got round to restudying Filippo, he wrote, "I can no longer descry the touch of Fra Angelico's hand in the *Tondo,* much as I still perceive there his unusual influence." Turning to the old charge that he too readily changed his opinions, he declared, "I never could understand why in the 'exact sciences' the method of trial and error was accepted universally and rejected in a pursuit so nebulous, so undisciplined, so difficult to control as the attribution of works of art. . . . If I

had leisure, I would reconsider every attribution I ever made." In his reconsideration of the tondo, he explained, he had available to him photographs of details and a color plate of the whole sent by Samuel Kress, who had bought the painting in 1947. "I went over the ground again and again and ended with the conviction that but for the probable exception of the women pouring with their children out of Bethlehem to see the arrival of the Magi, no visible part of the picture betrayed Fra Angelico's hand, much as the whole owed to his spirit."

Still a doubt seems to have remained, for when Berenson's posthumous List of Florentine paintings was published in 1963, the painting was listed twice, once under the name Fra Angelico ("finished by Filippo Lippi") and once under that of Fra Filippo Lippi ("begun by Fra Angelico"). In Fern Rusk Shapley's catalogue *Italian Paintings* in the National Gallery of Art, the magnificent picture is given as the joint production of the artists.

IN MID-SEPTEMBER of 1928, soon after Joe Duveen's energetic sightseeing "spree" with Bernard and Mary to San Sepolcro, the Berensons set off with Nicky for a two-month archaeological expedition in Turkey. Berenson's interest in Byzantine art as a key element in the evolution of western Mediterranean art had become a preoccupying interest, and this was a journey he had long anticipated.

With Istanbul as a base, their first objective was Adrianople, the oriental-looking city near the Bulgarian border, with its half-ruined palace of the early sultans and the magnificent sixteenth-century mosque of Selim II. On their return on the Orient Express they encountered Eric Maclagan, Bernard's old friend from the Victoria and Albert Museum. It was a fortunate meeting, for Maclagan, like Bernard, was a devoted Byzantinist and an ideal companion for visits to the Istanbul mosques. In Santa Sophia the two men, freed of their shoes, reposed in a corner, Bernard "quivering with nervous energy," while the faithful, summoned by the muezzin, knelt under the great cupola and recited their prayers to Allah. To Henry Coster Berenson wrote that Santa Sophia "is . . . perhaps the most sumptuous building interior I have ever seen. But as a space-effect several mosques of Sinan [sixteenth-century Ottoman architect] and his pupils here and in Adrianople seem far more successful."

A creature of habit, Berenson tried to follow his I Tatti routine when he traveled. In the morning in Istanbul he read until time to dress and go out. He returned at one and lunched, napped until three, went out again, and came back exhausted late in the afternoon to read in bed. Dinners were followed by reading aloud, a role that usually fell to Nicky. But for

ten days Maclagan read from Gibbon to recapture the ancient background. To Berenson's surprise Gibbon, "the old periwig," struck him this time as "at once too smart, too monotonous, and too mannered," though he still thought his narrative hypnotic.

In Istanbul change was everywhere apparent. Under Ataturk a Westernizing social revolution had been initiated in the new republic of Turkey: the Roman alphabet had replaced the Arabic, the fez had become illegal, and the law establishing Islam as the official religion had been revoked. The thronged streets of the city presented a motley spectacle, for the new requirement of European dress had to be met with hurried supplies of secondhand clothes from Europe, often ill matched and ill fitting. The men's caps were worn reversed so that the forehead could touch the ground in prayers.

Berenson struck up a cordial friendship with Theron Damon, who was a brother-in-law of the president of Roberts College, and Damon accompanied them on many of their expeditions. Joseph Grew, the American ambassador at the time, with whom Berenson had become acquainted at the Paris Peace Conference, was on the point of leaving the city but arranged for the loan of his steam launch to the party for a trip up the Bosporus. With the young Turkish art historian Aga Oglu, the Berenson party crossed to Asia Minor to explore the beginnings of Turkish architecture at Konia in Anatolia, the ancient capital of the Seljuk sultans. The sight of the mosques with their floating domes high overhead recalled to Berenson his early admiration of the Italian Renaissance churches, which had not been deformed by the introduction of the long Gothic nave. Here to his "delight and surprise" he found "the Renaissance ideal realized in a completeness that Brunelleschi and Bramante never imagined." It was the visits to the great mosques that gave him the most satisfying hours. "I shall always see Bernard," Mary wrote to his mother, "his hands clasped tight, stealing round from one pillar to another gazing up in rapture at the cupolaed ceilings of these mosques, quivering with joy."

The return to Florence was made in slow stages by way of Athens and Salonica and, after crossing the Adriatic, a stopover at Forli to dine with the lovely Pellegrina, now the Marchesa Paulucci de Calboli and mistress of "a hundred-roomed palace." By the end of November 1928 Bernard was back at his desk at I Tatti at work on the Lists. To Billie Ivins he wrote, "I am fumbling about with photos and notes and catalogues. How long, O Lord, how long! Or secretly do I want the task to last forever because I enjoy it and because way down I fear I'm good for nothing else? Maybe." Earlier in the month Ivins had defended his interest in aesthetics, and Berenson had told him that when he was young he

too "aestheticized," but now he thought that "worrying about aesthetics and reading about it after thirty may be due to impotence." Once past "puberty" people should "learn to modulate the words, look, look, look!!!" And as if in obedience to his own injunction he had already begun to plan an extended visit in the spring to Syria and the British mandate in Palestine to enlarge his vision of the past.

Berenson passed a restless winter at I Tatti sustained by the prospect of a tour in the spring among the ancient monuments of Syria and Palestine, the tour he had had to cut short after his stay in Egypt in 1922. Research went forward for the series on homeless paintings, and tinkering with the revised Lists never let up. Urged by the Yale University Press to submit a book for publication, he directed Mary to hunt up his essays on medieval subjects and began readying them for publication in the volume *Studies in Medieval Painting,* which was issued the following year. The administration of Princeton University invited him to come over to receive an honorary degree. It was a tempting offer but Berenson, nearly sixty-four and doubtful of his health, recoiled from the thought of another strenuous transatlantic visit and declined the honor.

The devoted *ménage à trois* sailed for Beirut aboard a ship captained by a Zionist and transporting Jews to Palestine, a circumstance that inevitably inspired discussion. The Berensons' attitude toward Zionism in those days before Hitler was not sympathetic. Mary, who used to dispute the subject with Zangwill, pretty well reflected Bernard's view of the "homeland" established by the Balfour Declaration: "It seems a crazy idea to bring all these incongruous people to this barren land already inhabited by hostile Arabs." Bernard had been thoroughly briefed earlier on the complexities of the question by Robert Greg and Ronald Storrs, both of whom tended to be sympathetic to the Arabs.

The Berenson party arrived at Beirut on April 3, 1929, and were entertained at lunch by the French high commissioner. Four days later, joined at Haifa by Mrs. Margaret Chanler and her companion Barbara Parrott, they started for Jerusalem with "a whole trunkful of books" on the Holy Land—a trunkful soon to be supplemented by a large box of books to accompany them on their trip into Syria.

In Jerusalem, their center for visits to archaeological and historical sites, a friend of Berenson's, "an Anglicized Levantine," brought them an invitation to visit the Grand Mufti and to spend an afternoon on the terrace of the great Mosque of Omar, the Dome of the Rock. Escorted by Professor Baldi of the Institute for Biblical Studies, they were shown some of the structures not open to the public. Then the Grand Mufti and his suite all in turbans and robes came to meet them in the gardens of his

palace. The exotic scene in the westering sunlight reminded Mrs. Chanler of a Carpaccio painting.

The sight of the old Jews in their long prayer shawls at the Wailing Wall on the Sabbath seemed to move Berenson deeply, as if carrying him back in sentimental memory more than half a century to his childhood in Lithuania, where on Yom Kippur he heard the pious cry out, "Next year in Jerusalem!" At Hebron, however, the "fearful noise" of the Jews at the wailing wall made him "quite sick at the sight." At the Christian shrines Mary offended Nicky, a rather devout Catholic, by scorning what she called the "pagan forms of worship" in which the faithful kissed sacred stones and venerated relics. To Nicky they were "childlike and touching manifestations of faith." At the Blue Mosque, Mary, impartial in her skepticism, reflected, "The people I care about do not prostrate themselves in that absurd and revolting attitude with their foreheads on the floor and the less honored part of their persons sticking up."

They left Tiberias for Damascus on April 26, and by May 3 Berenson was "fairly aching with fatigue" from his industrious visits to the mosques. To Mary he defended his zeal by saying, "I may never be in Damascus again. I must see all I can." While she rested, he and Nicky accompanied a French architect to see what Mary scoffed at as "some more filthy monuments," resentful of the fascination that they held for Bernard and Nicky. From Damascus they all motored across the trackless desert 150 miles to the oasis of Palmyra, keeping their course by the line of sight of the French watchtowers stationed at long intervals in the desert. Fascinated by the immense complex of ruins, many still awaiting excavation, they took their afternoon tea on the steps of a marble mausoleum and beguiled themselves with the fancy that here a "second Cleopatra," Zenobia, daughter of Antiochus, had once reigned as queen of Palmyra. At a spring outside Palmyra they were amazed to see tens of thousands of camels being watered in orderly fashion on their way to summer pasture.

After Mrs. Chanler was obliged to leave for Paris, the Berenson party continued their search for ancient architecture at Antioch, Aleppo, Baalbek, and Kalat-Seman, not reaching Alexandria for the return to Florence until June 1. Berenson arrived at I Tatti "all but broken down," he reported to Charles Du Bos, "with endless arrears of work, correspondence, and semiprofessional reading." Du Bos's recently published *Journal,* so rich in literary associations, filled him with regret, he said, for a career "for which I still believe I was more fitted than the one I have actually pursued."

XXXVII

"Prince of Art Critics"

THE Duveen firm continued anxiously to await the publication of the Lists, for they would record the fortunate collectors who had acquired Italian paintings through the firm and add importantly to its prestige. To Fowles's urgent inquiry of progress, however, Berenson replied discouragingly a few weeks before leaving for the Holy Land, "My Lists are far from ready. . . . As a matter of fact, I expect that even a year hence it will not be too late to admit corrections, and I fervently hope that by that time most of the Benson pictures and those of the previous stocks will be tucked away in bona fide collections." There remained in fact a great deal to do on the revision. The fifteenth-century Venetians lay ahead, a task on which Nicky collaborated until mid-July, after their return, while Mary, much to Bernard's relief, was happily dictating the draft of a book on their recent travels to her new secretary, the young art historian Evelyn Sandberg Vavalà.

While Berenson worked away on the Lists, the flow of inquiries from Fowles continued to distract him with calls upon half-buried recollections of paintings. Although in his recommendations to the Duveens he more often than not was positive in his acceptance or rejection of a suggested painter, his decision sometimes was conditional on further study or was left hovering on a borderline. In one such case, however, he was prepared to give the firm the benefit of the doubt. Fowles had asked him about a reputed Titian, and Berenson replied that he was "not completely convinced it was an autograph," although he "could in conscience now pass it if need were. But I am not enthusiastic about it. It may be a studio version." When thus put on notice of Berenson's doubts, Fowles would usually drop the matter. To Fowles and Joe Duveen, in need of an unequivocal attribution, Berenson's doubts were annoying. Thus Fowles could write in frustration,

"Only when we have *your latest* opinion can we decide whether to buy."

One of the most exciting of Fowles's inquiries came in the summer of 1929. He sent a Lumière Autochrome color photograph of what appeared to be an extraordinary find, the *Madonna of Humility* by Masaccio, the painter most noted for his realistic frescoes in the Brancacci Chapel of Santa Maria del Carmine in Florence and regarded with Giotto as a founder of Italian Renaissance painting. "I am glad you think well of it," Fowles had written, "but I am afraid it will be difficult to make such people as [Mellon] understand its importance." Berenson was so excited by the find that he agreed to publish the painting in *Art in America* even though it was still in a dealer's hands. "I am so eager to communicate to fellow students the discovery of a Madonna hitherto unknown but manifestly by Masaccio," ran the opening line of the short article, "that I do not hesitate to break the rule of a lifetime." The full-page frontispiece illustration of the painting bore beneath it "Messrs. Duveen Brothers." The discovery was to have a confused sequel.

In the flush of discovery Berenson thought the attribution so self-evident that it needed no detailed analysis, confident that "no one will dispute either the quality of the Madonna here published for the first time, nor its attribution." He included in the article three full-page illustrations of other Madonnas ascribed to Masaccio to illustrate the common origin of the four paintings. The colors of the newly discovered painting were, he admitted, "for Masaccio unusually bright and even gay." The discovery seemed to demand more than the usual hyperbole. "Here was something," he exclaimed, "which, in essence, was without equivalent since the builders of the Pyramids and the sculptors of the Chephren."

When the article was submitted to Sherman for *Art in America* by Duveen, who had brought it from England, Sherman at first refused publication, explaining that he shared Berenson's objection to publishing pictures in the possession of dealers. In December Belle Greene wrote that she was "finally able to bring Sir Joseph and that awful Sherman together in the publication of your article." (It came out in the February 1930 issue.) She confessed, however, that she had told both Duveen and Sherman that she thought Berenson's "eulogy of Sir Joseph silly and boomerangish." The offending "eulogy" declared that if similar rarities appeared, he would not hesitate to "publish them even if they were in less magnificent keeping than the hands of Messrs. Duveen Brothers." Joe assured her that she was "mistaken as it came spontaneously from [Berenson's] heart."

It did prove difficult to convince Mellon of the painting's importance,

and the Mellon Foundation did not acquire it until 1937. In his Lists Berenson held to his scruple about not including dealers' stocks. The painting did not receive listing until the posthumous volume of 1963, by which time it had long been identified as a Masaccio at the National Gallery in Washington.

The picture has turned out to be one of the most puzzling of Mellon's acquisitions. The painting Berenson saw reproduced in the color photograph had in fact been heavily restored for the Duveen firm but so skillfully that Berenson was evidently unaware from the color photo of the extent of the restoration. His attribution to Masaccio, according to the learned discussion in the 1979 Shapley catalogue, was accepted by many scholars during the next decade. In the meantime, while the painting was still unsold it was subjected to further restoration, apparently to give the "two figures more Masaccio-like expressions." The result was a botched work of art, and because of the excessive overpainting the picture was finally relegated to storage to await proper cleaning.

What has deepened the mystification surrounding the painting has been the discovery in the Duveen files of three photographs of details of the picture after cleaning and before the first Duveen restoration. The photographs show "extensive abrasion and, in places, complete loss of pigment." Enough of the original was visible, however, to persuade Sir John Pope-Hennessy of Masaccio's "hand in the painting." Philip Hendy considered the "ruined" picture authentic and dated it before 1426. The National Gallery of Art now lists the painting as "Attributed to Masaccio."

That the tide had set in against extensive restoration was demonstrated at the close of 1929 by a long letter in the *Times* from Ettore Modigliani, director of the Brera Museum, concerning an exhibition of Italian paintings at Burlington House, in which he scored the "incredible" alterations to which Renaissance paintings had been subjected by maladroit restorers. "Today," he said, "restoration does not go beyond repairing the actual damage . . . in the background or less important parts of a picture." The *Times* illustrated his point with a few before-and-after photographs of paintings in the exhibition. It was with reason, therefore, that Fowles wrote to Berenson, "We find today we have to be more and more careful about restoration which I am sure you will agree." Berenson agreed so thoroughly that some months later, when he criticized as hasty and excessive the restorations of a Pesellino, a Botticelli, and a Ghirlandaio, Fowles wrote that the firm was "very upset by B.B.'s adverse opinion." Madame Helfer had "not been hurried by Sir Joseph in any way. . . . To the Pesellino and small Ghirlandaio very little was done, with the exception of carefully touching out the bare spots. The

Botticelli 'Madonna' was a more serious work as the dark blue drapery was in bad condition and folds had to be reconstituted. For this work we supplied Madame Helfer with all the photographs we could find suitable."

IN MIDSUMMER of 1929 Nicky left for a holiday in England with her young nephew, Cecil, stopping off at Cologne to order photographs. Mary soon followed her to England, leaving Bernard up at Consuma, where he entertained "curious Americans, particularly of the seed of Abraham," who approached him as if he were "a miracle-working rabbi of Galicia." The visit of the young art historian Rensselaer Lee made him feel that "one could address one's whole self to him," and Berenson urged him to write of the revival of the taste for the *primitifs*. Walter Muir Whitehill, another American student who came by for advice, was in the middle of writing his thesis at the Courtauld Institute in London on eleventh-century Spanish architecture. Subsequently he became a much-admired figure in the cultural life of Boston as director of the Boston Athenaeum and he was a welcome visitor over the years at I Tatti.

While Berenson relaxed on the mountain heights at Poggio allo Spino during August, the prospect of endless affluence never seemed brighter. Fowles sent him a gratifying report of the state of his account with the firm. In addition to his retainer of £5,000 due on July 31, the firm owed him £10,000 as a fee on the purchase of thirteen paintings bought since the first of the year. As another £10,000 was already owing, the total for the year was £25,000. Half was to be paid immediately to Baring Brothers and the remainder in October, the firm being "very short at the present moment on account of recent purchases."

Welcome word had also come that the Clarendon Press had decided to bring out a popular single-volume edition of his four books on the Italian Renaissance painters to be issued before the planned edition of the revised Lists, and he was asked to supply a revised text immediately. He went to work at once at I Tatti. Though the changes were slight, he found the review "a difficult and painful task." "The man who wrote those little volumes," he reflected, "should not have let himself be led astray into picture fancying and expertising. He should have gone on to write the aesthetics and history of all humanistic art. That and that only would have meant success." No regret rose to the surface more frequently— and vainly—than that one.

Preparing the text of *The Italian Painters* proceeded much more rapidly than Berenson had expected, as had the collecting of the essays for his *Yale Studies in Medieval Painting*. With both works dispatched to the printers, he went off in mid-September to a holiday at Hyères that was

spoiled somewhat by an annoying hoax at the villa of Charles de Noailles adjoining Edith Wharton's place. His young fellow guests on the occasion were Jean Cocteau and Georges Rivière. The de Noailles had hung a work on the sitting room wall which they said had been created by Picasso. Bernard indignantly described it to Mary, who was still in England: "This masterpiece consisted of a surface about the size and shape of the London *Times*. Not too far from the top was a circle of sepia about five inches in diameter. Under it to the left was a column of small print as if it had been photographed from a newspaper. To balance this there was fixed with thin headless nails a piece of ordinary brown sacking. Cocteau insisted that this was as complete and satisfactory a work of art as any Raphael. . . . I tried to make him consider the matter in detail and with the least possible irony. It infuriated him but he kept pouring out lava torrents of sheer verbiage that physically overwhelmed me. . . . Rivière agreed entirely with Cocteau. . . . I had never before been treated as such an outsider." Robert Norton, a fellow guest at Edith Wharton's, tried to persuade him that it was all a hoax—as in fact it was—but Berenson would not be convinced.

When he later visited the de Noailles, his hostess said she had hidden the "Picasso" and would not expose it again to his "insulting" eyes. The crude montage had been made by Cocteau, who resented Berenson's scorn of abstract painting, and the conspirators had played their roles to the hilt.

After a week at Hyères Berenson departed for Spain in the company of Mary, Nicky, and Count Morra to take up the hunt for candidates for his Lists. The moment they reached Madrid he was off to the Prado, carrying his old notes with him to compare present impressions with previous ones. Learning of Italianate paintings in the cathedral at Cuenca to the east of Madrid, he spent two mornings studying them with the aid of ladders, candles, and a magnifying glass. They were the work of Ferrando Llanos and Ferrando Yanez de la Almedina, who, he concluded, were pupils and close followers of Leonardo, and he added them to the Lists. Mary informed her family that he was enjoying himself so much that he "forgets that I ruined his life."

After Madrid the Berenson "caravan" traveled about from Toledo, reaching Valencia, the "Iberian Chicago," toward the end of November for the International Exposition, their enjoyment of it considerably marred when they all fell wretchedly ill. Again Berenson returned to Edith Wharton's sheltering roof for the Christmas holidays to await the departure of Mary's numerous family from I Tatti. He planned to arrive in Florence on January 12, the day Mary's high-spirited grandchildren were to leave.

Edith Wharton surrendered her guest to the solicitous care of Nicky, and the two travelers got back by mid-January 1930 to an I Tatti purified of children and grandchildren. They found Mary happily engrossed in the manuscript of her book on their pilgrimage to the Holy Land, relieved at sixty-six to "shuffle off on Nicky" the exacting work on the Lists. Unlike her, she said, Nicky was "extremely accurate and painstaking." Rachel, who with her husband was visiting Bernard, wrote her mother that Nicky was "so merry and warm-hearted and *hard working,* I pray that B.B. may never have to live without her." Now thoroughly immersed with Berenson in the Lists, Nicky turned over her job as librarian to her sister, Alda.

Hospitable to friends and foreign visitors, if not to Italian residents of Florence, Berenson kept open house so that luncheon, tea time, and dinner broke the day's work with the kind of intellectual talk he craved. One day Count Morra, who was now like a member of the family, brought up an engaging young friend of his who had recently published at the age of twenty-two a highly successful first novel, *Gli Indifferenti,* under the pseudonym of Alberto Moravia, having prudently abandoned the unmanageable Pincherle Alberto di Carlo e di Teresa de Marsanich. To the Berensons he seemed a precocious boy. Soon he was turning up "almost every day at teatime . . . an amusing mixture, so mature and yet such a child and so straightforward and passionate in his opinions and ideas." Berenson was so delighted with him that by the end of the year he said he felt "almost as if Moravia was his own godchild." He "lacks a sense of humor," Berenson remarked to Morra, "but instead possesses in the highest degree a sense of the absurdity of things. . . . He perceives reality clearly, and more than anyone else is capable of indignation . . . like a Hebrew prophet—a rare thing in Italy."

The spring months of 1930 had brought the usual varied succession of guests in addition to such regular habitués as Logan and Trevy. There had been the poet laureate John Masefield and the Morgan partner Thomas Lamont, who was on his way to a conference with Mussolini about the Italian loans. The financial outlook had become uncertain since the disastrous crash of the stock market on "Black Friday" in October. Like President Hoover, Lamont remained optimistic of recovery and no doubt reassured Berenson that his American investments were not in danger. The very ominous implications of the crash seem not to have been sensed. Fowles had written two months after the crash, "I suppose the slump on Wall Street has somewhat adversely affected business."

Billie Ivins, already white-haired at forty-nine, put in an appearance, only to be lectured by Berenson on his adolescent and even "pubescent" ideas on aesthetics. The best writer on the subject, Santayana, knew

as much about the matter, Berenson insisted, "as our ancestors knew about the heart of Africa when it was uncharted." Ivins delighted to match heresy with heresy; to the dismay of his associates at the Metropolitan Museum he ridiculed the Venus of Milo as "the final epitome of all the Dumb Doras—utterly devoid of thought, emotion, and expression."

Guests at the Berenson table were sometimes trapped in a "Götterdämmerung of languages." On one occasion the Countess Lützow brought the Duchess of Beaufort and an English friend; they were joined by Friedrich Sarre, the German museum curator, and Eustache de Lorey, the French archaeologist. Sarre knew no English and his French was as "rocky" as Mary's. De Lorey spoke no German. Mary rescued the two men by taking them off to admire Bernard's Persian manuscripts more or less in silence.

Harvard folk were always especially welcome. With Professor George H. Edgell, then dean of the School of Architecture, Berenson could talk of his plans for the I Tatti Institute, which was now a subject for earnest discussion at the Fogg Museum. It was a subject to be discussed also with his cousin Lawrence Berenson, whose pretty wife mitigated for Mary his ardent support of Zionism. Lawrence passionately opposed intermarriage, but as he talked of it without unpleasantness, neither Bernard nor Mary protested.

Louis Levy came down to Florence to discuss some of the complications arising from the new contract. What was of equal concern to Berenson was the fate of the large investments Levy had made for him. Levy tried to assure him that they had not been seriously affected by the panic. Berenson had not looked forward to Levy's visit. "He represents business and I hate business," he wrote to Nicky. "He worships success and I loathe it. He entertains every standard which displeases me and enjoys every prospect which to me is vile. However, as he is a *bourgeois utile* I must make the supreme sacrifice."

The chief hitch which had arisen was over the settlement of arrears under the old contract. The discussions developed a confusing wilderness of figures which led Berenson to send off a long letter to Sir Joseph telling of his shock at learning that instead of the £25,000 which he was to receive for "arrearages," the firm wished to deduct £7,000 for losses. Once again he reminded Duveen that this sort of thing was a great drain on his intellectual resources, "serving in some degree to impair my mental activities." The firm's delays in carrying out the settlement particularly distressed him because they endangered the plan "towards which my life's ambition drives me and to which all my earnings will be devoted . . . to endow my institution for the perpetuation of scientific and cultivated art study."

Bernard deputized Mary to meet with Levy and Duveen later in the summer in Paris to settle up the "Duveen business." She told Nicky she was "awfully glad to help B.B. recover his peace of mind," though she disliked the thought that "B.B. is to hoard it all up for future yahoos to come to I Tatti." Levy followed the meeting with Mary with a document to "My dear Joe" of more than ten typewritten legal cap pages, generally sympathetic to Berenson, reviewing in detail the state of accounts. He also presented the request Berenson had made for additional compensation for his admittedly important role in cultivating Jules Bache. So taken to task, Sir Joseph disgorged £8,000 on the arrears and gave his usual assurances for the future.

The sessions in Paris in which there was such tantalizing talk of the many thousands of pounds owed to Bernard revived Mary's sense of grievance. From Haslemere she unburdened herself to Nicky: "When a man and a woman have both worked up to the limit of their abilities, the rewards of their labor should be divided between them, and not come as a largesse." She felt that for many years Bernard had cruelly humiliated her "every time he gave the allowance" to her daughters. The upshot of her long and painful recital was the suggestion that if Bernard were to put ten thousand lire to her account, it would raise her income to "something over two thousand pounds" and she, for her part, "would cease making any fuss, and *you* would not be bothered any more. I should pay everything connected with the children, outside of his yearly allowance" to them. In an emotional follow-up letter to Nicky she protested, "Should I have worked and toiled to have a crowd of American hoodlums get more a year than the beings I love? . . . See if you can fix it up."

Six weeks after the meeting in Paris Levy sent Berenson a statement of securities held in his account. The stocks and bonds which had been purchased for $458,000 now had a market value of about $325,000. The decline in the market value of Berenson's investments, however, had only begun. By the autumn of 1932, while President Hoover still hoped for prosperity "round the corner," the securities would fall to one-third and even one-fourth their cost. The long and successful climb back from the depths of the Depression would not begin until the autumn of 1933.

By the end of the summer of 1930 Berenson had got the thousands of entries in his Lists into almost final form. The arrival of Edith Wharton at I Tatti offered a respite from minutiae and off he sallied with her and Nicky to make a round of visits in Tuscany and to exhibit its picturesque landscapes. They called on Lady Sybil's brilliant daughter, Iris, at La Foce, where she and her husband, Marchese Antonio Origo, were creating an impressive estate in a run-down region. As a child in the shadow of her mother she had felt shy before Berenson. Now a young matron

and a gifted writer, she was on the way to becoming one of his most perceptive friends. At Count Morra's villa near Cortona they encountered Moravia and the Kenneth Clarks. Jane Clark looked so ill that Berenson invited the Clarks to I Tatti for a rest.

Logan, the most regular of annual guests, looked on with amused detachment at the transplanted version of English country house at the villa as if it all might be subject for another volume of his *Trivia*. "I find it very pleasant here," he wrote to his secretary, Robert Gathorne-Hardy, "in the luxury and splendor of this great Italian villa. Mrs. Wharton is here, and Santayana nearby. We are a little group of not unsuccessful people; old and ill and gay and disenchanted, and our tongues wag as freely I think as any tongues in Europe. The long perspective of elderly people, their wealth of ironic reflections and observations and improper anecdotes does much to compensate them—does indeed, I believe, more than compensate them for the loss of youth and the injuries of time."

Before the end of the year the Clarendon Press brought out *The Italian Painters of the Renaissance* to a flattering reception, all reviewers agreeing on Berenson's preeminence as a connoisseur. As the *Nation and Athenaeum* put it, "Attributions signed by him are attached to pictures in American collections like the Papal seals which guarantee the authenticity of relics." The universal admiration this edition received is reflected in its translation into French, German, Spanish, Italian, Swedish, Hungarian, Serbo-Croatian, Russian, Flemish, Dutch, and Japanese.

In the same year that *The Italian Painters* appeared, the Yale and Oxford University presses issued *Studies in Medieval Painting*, a handsome quarto volume with 168 illustrations which brought together eight articles originally published between 1913 and 1925. The preface reiterated Berenson's thesis that research "proceeds by trial and error and must guard against any assumption of infallibility." Commentaries were supplied to two of the essays. To "A Newly Discovered Cimabue," Berenson added that after its publication Edward Fowles had discovered that Carl Hamilton's triptych formed part of a polyptych of the Artaud de Montor Collection, and though he did not mention that Richard Offner had questioned the Cimabue attribution, he suggested that Pietro Toesca's recent discussion of Giotto in his *Storia dell'Arte in Italia* provided "hints" which, "if they were taken up," would confirm his attribution. To the essay dealing with the triptych attributed to Allegretto Nuzi and formerly owned by Carl Hamilton, he offered "a few additions to the early phase of Nuzi's career." Like the "Cimabue," this painting went back to the Duveens and was acquired by Mellon in 1937. In Berenson's posthumous List only the left panel is attributed to Nuzi. The other

panels, according to the Shapley catalogue, are the work of his collaborator Puccio di Simone.

The *Studies in Medieval Painting* tended to put its reviewers on their mettle. Frank Jewett Mather, Jr., conceded that the essays left their subjects in better order than they were before, and he praised the essay on the *Speculum Humanae Salvationis* as a "thrilling feat of detective work," but he disputed the Constantinople origin of the Hamilton and Kahn Byzantine Madonnas, arguing they were indisputably of Italian origin. Edward Jewell in the *New York Times* agreed with Mather about the Madonnas but concluded that what mattered most was "Berenson's delightful enthusiasm." Roger Fry thought the article on Nuzi "valuable and interesting," but he considered Berenson's conclusions in the other pieces improbable and declared, with irritating condescension, that it was an "ungrateful task" to show the deformation caused by the "provincial isolation" of the *Speculum*. The reviewer in the *International Studio* was unreservedly enthusiastic. He praised Berenson's "extraordinary ability to develop even in reference to very second-rate pictures both his archaeological and critical technique," and then went on to observe shrewdly that "one problem in the criticism of art interests Mr. Berenson beyond all others: The decline and recovery of form in the art of visual representation." Berenson must have welcomed that critical perception, for that theme had been sounded by him as far back as 1907 in the conclusion of *The North Italian Painters* and it underlay his increasing interest in the art history of Mediterranean cultures. A dozen years later it would find expression in *The Arch of Constantine, or the Decline of Form*.

The conference seemed to proceed smoothly. Joe, "cordial and caressing" as usual, said Italian paintings were still "his great card and he needed thee more than ever." He declared that the "£10,000 retainer was the safest investment we ever made, that it was sure even if he did not sell another Italian for years." He was "full of hope for the future," Mary wrote, "so, I think, we need not worry."

Three weeks later the Bank of England suspended payment in gold, setting off an immediate devaluation of the currency and sending shock waves throughout the world's financial markets. It could be only a matter of time before all other currencies must follow suit. The hopeful settlement with the Duveens became an early casualty. Since most of the money the Berensons lived on was held at Baring Brothers in English pounds, their income dropped by a quarter with the fall of the pound. As for their American investments, the accelerating depression meant the reduction of dividends. It looked as if they would have to get by on one-third of their former outlay. They would have to dismiss the butler and one of the gardeners, Mary informed Bernard's mother, and entertain less. Bernard wrote his brother, Abie, that he had had very serious losses and expected more and was therefore hurrying off a check "that would provide Blessed Mother with a maid for six months more."

Again at his desk in October he felt overcome by lassitude as he tried to force himself to prepare an essay on Signorelli and a catalogue of his drawings. His efforts seemed in vain; he could "get up no steam," he told Billie Ivins, but habit at last asserted itself and the thirty-seven-page article on Signorelli's drawings took shape and was published the following spring of 1932 in the *Gazette des Beaux-Arts*. It would eventually find its place in the revised edition of the *Florentine Drawings* with the explanation that the omission of Signorelli from the original edition was the result of his having taken "too regional a view of art history."

One of the more engaging aspects of Berenson's nature was his interest in fostering young talents. At this period he became interested in Max Ascoli, a young professor of jurisprudence, who like Salvemini had been an outspoken critic of fascism. His writings had been banned and he too had been imprisoned for a short time. When, under constant police surveillance, he decided to seek asylum in America, Berenson gave him an introduction to Judge Learned Hand, who reported a favorable impression of him though not of his mastery of English. Whatever Ascoli's shortcomings in English may have been, he quickly overcame them. Two years after his arrival in New York he joined the graduate faculty of the New School for Social Research, and soon he was publishing his idealistic views of the possibilities of American democracy. Later

he became editor and publisher of *The Reporter*. He kept in friendly touch with Berenson for the next quarter century.

Mary had been ill a good deal of time since her return to I Tatti, and in October 1931 she underwent surgery in the hope of putting an end to her chronically painful cystitis. As she now seemed convalescent in her wheelchair, Bernard sought his regular asylum from the Christmas ritual. Long-familiar companions converged on Edith Wharton's retreat—Robert Norton, diplomat, poet, and painter; Gaillard Lapsley, an American medievalist and Cambridge don; and John Hugh Smith, a cultivated English banker. "We tell stories," Berenson recounted to Ivins, "we discuss books and politics or people, we walk a good deal and in the evening we read aloud together. There is no such company as three men with one woman whom they all love without having been or wanting to be her lovers." To Mary he added a less flattering detail: "We wrangle, we disagree." He was immensely comfortable in Edith's "paradise." "I have often reproached myself," he continued, "for making more fuss over Edith than over other guests. I gather from Elizabeth [the maid] that she in turn is the same over me."

Berenson seemed somehow to thrive even though beneath all, as he wrote from Hyères, the "Economic Black Death" was raging. So far, however, he had no cause for serious alarm. Levy had written that he had let go most of the stocks in Berenson's portfolio and had accumulated "a large cash balance with a few of the best securities still held." But in spite of the reassuring statements emanating from the White House, the financial outlook grew steadily grimmer. In March of 1932 came the news that Ivar Kreuger, the highly regarded Swedish "Match King," had committed suicide in his Paris hotel after returning empty-handed from his consultations with American bankers for money to save his tottering Kreuger-Toll Company.

The falling of financial dominoes began with the bankruptcy of a Berlin bank, and before the year was out the incredible tangle of Kreuger's fraudulent financial operations throughout the world was spread out day after day in the press. By August the firm was adjudged bankrupt in the United States, the billion-dollar empire having shrunk to $88,000,000 of assets and $250,000,000 of debts. Berenson had himself invested almost a million lire in the company, he told Clotilde, and it was "all lost to the last penny." At the current rate of exchange the loss was something less than $50,000, a substantial sum but a relatively minor part of his resources.

There were none of the usual festivities for Mary that Christmas of 1931. During Bernard's absence she became seriously ill, and for three

weeks her sister took charge of her with the help of two nurses. After Bernard returned, a disheartening relapse proved the prelude to a near-fatal infection. Toward the end of January "we all but gave her up," ran one of his bulletins to Ivins, "and in these days of suffering she has called for me as often as she could breathe, and look happy, and hold my hand." A critical moment came, Mary afterward wrote his mother, when she "heard one doctor say to another, 'She is going,' and I felt happy to go. Then I heard from what seemed a hundred miles away, Bernard's voice crying out, 'Don't desert me, Mary.' . . . There was so much love and despair in his voice that I had to respond to it and I said in my mind, 'I won't desert you' and I held myself back from dying."

Once on the mend, though still "a great worry," she found diversion again in rereading and assembling the letters which she and Bernard had exchanged forty years ago, still hopeful of reducing them to a biography. Walter Lippmann, of whom she was fond, came down from Geneva, and she had herself wheeled into the library at tea time to visit with him. To Ivins Berenson continued to note progress in his wife's condition. He thought it "a wonderful thing" to have her "on any terms."

Mary's dangerous illness brought Bernard up sharply and made him more considerate of her. "He is very nice this year," she wrote. "We all hold our breath for fear it is too good to be true. But he is never cross, he never fusses about anything, he is full of jokes and jollity." She said too that she had changed her tactics; instead of sneering at him for the defects in his writing, she "looked for the good things first." Her report, if overdrawn as her reports frequently were, nevertheless indicated a change. John Walker's cheerful presence doubtless did much to brighten life for all of them at I Tatti. He was proving "the most talented and delightful pupil we have ever had," Mary asserted, and a great improvement on Kenneth Clark and his ambitious wife, who thought I Tatti a "very small place."

In March of 1932, with Mary improved in health, Bernard and Nicky again joined Edith Wharton at Hyères. Paul Valéry was there mumbling his comments at table so that his meaning often had to be guessed. "He was as charming, simple and conversable as in the days before the flood of popularity," Berenson observed. "I got him started on Racine" and he made "an interesting prophecy . . . that a time would come when French classicism . . . would appear as a mere episode of a highly aristocratic and artificial kind." Berenson also had a long talk with Aldous Huxley about D. H. Lawrence "for whom, as you know, he had a cult." Huxley expounded that for Lawrence "sex was cosmic contact." Berenson continued, "Of such contacts as of other carnal contacts cometh satiety in the end."

During a visit to the Malinowskis nearby, "We talked anthropology of course," he wrote, "and I pumped them hard . . . but the art side of the subject had evidently not attracted much of his attention." Later as he strolled with Bronislaw Malinowski "he began to talk politics. I could scarcely believe my ears. Here was a real live Pole who expressed before he heard my opinion a hatred as great as mine for patriotism, nationalism, dictatorship, messiahs, Pilsudskis, etc. etc. . . . The London School of Economics has indeed performed a miracle. It has completely humanized a Pole." Malinowski, a world expert on primitive societies, had taken his doctorate in his native Krakow and later studied with Edward Westermarck in London and was at the time on the faculty at the University of London.

Edith returned with Berenson and Nicky to I Tatti and then went down to Rome, where they later joined her. Meanwhile Mary, who had come down with another disabling infection, departed for Switzerland with Logan to seek medical treatment. It was now clear that chronic invalidism would be her portion. Sightseeing and archaeology kept Berenson busy in Rome. He paid his respects at the Swedish Archaeological Institute, of which his friend Axel Boethius was director, and made a point of meeting the head of the German Institute, Ludwig Curtius, whose recent book in German on Pompeian wall painting he had found engrossing.

In the face of the deepening worldwide depression, life continued to go on at I Tatti with little change of pace or luxury, though the letters to Berenson's family tended, as a precaution against extravagance, to emphasize the financial uncertainties. During the early spring of 1932 a succession of regulars like Logan and Trevy and relays of visitors had enlivened the luncheon and dinner hours and provided Bernard with an appreciative audience. Robert Herrick dropped in a few times for lunch, one day with a fellow American novelist, Winston Churchill. Herrick—his cruel satire of Berenson long since forgiven—talked with Edith Wharton about a biography of Henry James that he hoped to do. With a shelf of serious novels to his credit, he had recently retired from his post at the University of Chicago and had spent the winter in Florence with the Churchills in a villa on the south bank of the Arno above the city. Mrs. Peter Cooper Hewitt, now divorced and well on in years, was also on hand, as well as his old friend Carlo Placci. Sometimes there were diversions that called them all down to town, as when Stravinsky conducted his *Petrushka*. Of a quiet evening Nicky read to Bernard and his sister Bessie from Balzac's *Le Curé de Tours*.

What now preempted the morning working hours was the painstaking revision of the *Florentine Drawings*. Walker was well settled in as assistant

in residence. He and Berenson were joined this year in their work by the talented art historian Fern Rusk Shapley, wife of John Shapley, a professor of art at the University of Chicago. Her collaboration led, years later, to her joining the staff of the National Gallery of Art when Walker became its director. Nicky too was enlisted in the revision. Later that summer Bernard wrote to her from Consuma, "I have been doing the Credi drawing and am deeply touched by the way you have prepared the material for me. It was done with love as well as care and competence." Berenson and his devoted assistants were to be engaged in the laborious task for long intervals during the next five years.

The "Book of Revelation"

AT the end of June 1932 Berenson received a distinctly unsettling letter from Joe Duveen in which he stated, as diplomatically as he could, that he was forced to retrench—his business had come to a standstill, his overhead was enormous, and insolvent clients had left him with doubtful claims. "On account of this condition," he concluded, "I am reluctantly obliged to ask you to discontinue the existing retainer between us, in the hope that by personal conference with you I may be able to make such other arrangement as may be mutually satisfactory." He also said that being short of cash, he was again "obliged to postpone" settling the outstanding old account. Berenson had little choice but to acquiesce. "Although no pill has ever been more charmingly sugared and presented," he replied, "it nevertheless is a bitter pill and I fear I made a wry face in swallowing it and it has taken me two days to recover my composure." A face-to-face meeting could not be avoided, and the prospect of that meeting hung over the last summer weeks at Consuma.

Berenson started for London at the beginning of September 1932, sad to leave the green silences of the forested slopes and dreading "the sordid, nasty encounter with jackals" in Paris. He rejoined Mary in London only to find her once again in the middle of a painful bout of cystitis. Crossing to Paris, he presented himself at the Duveen gallery to learn his unhappy fate. The agreement to which he affixed his signature as of September 6 was to run to December 31, 1933, but with the continuance of the depression it was kept in force until 1936. What was most bitter about the "pill" was that the annual retainer of $50,000 was reduced to a euphemistic "retainer arrangement" to pay him $20,000 annually in quarterly installments made up in part by payments on the firm's debt to him and in part by payments of interest at 6 percent on the balance owed

seemed to intoxicate himself with thoughts of her, losing himself in fancied raptures.

The need to possess, to empathize completely with a person, haunted him always. It was a passion both to lose and to find himself in another and in a sense to dominate the other as an extension of himself, as when he said to Clotilde, "I have above and beyond everything wanted to get under your skin so as to feel rather than to know what was going on inside of you." For all his cerebration, his encyclopedic learning, he was first and last a man of feeling. As he acknowledged to Umberto Morra, who had begun a Boswellian journal of Berenson's conversation, "I was born for sensual contemplation. I mean exactly that—sensual, voluptuous; not for mathematical contemplation." And to his friend Charles Du Bos, when discussing Choderlos de Laclos' *Liaisons Dangereuses,* he reflected, "As I get on in years I realize more and more than what saves the soul from hell is having a body capable of feeling volupté." In his idealizing fancy voluptuousness took on a spiritual and half-mystical character, transforming sex itself into a kind of worship.

By the middle of 1932 Berenson had the satisfaction of knowing that his Lists, a work that had obsessed him and his fellow workers at I Tatti for six years, had at last been published by the Clarendon Press at Oxford. Titled *Italian Pictures of the Renaissance,* the 723-page volume provided "a list of the principal Artists and their works with an index of places." It had been an enormously complicated undertaking, combining in one greatly augmented alphabetical list the original Lists contained in Berenson's four small volumes of the turn of the century. Though the early Lists had been corrected and amplified in a number of revised editions many years earlier, the intervening decades of travel and study had brought a vastly increased array of paintings within Berenson's view. The new volume listed his attributions of some 18,000 paintings of nearly 350 painters. He had reviewed, and in many cases revised, all of his former listings after restudying the thousands of photographs in his library and, whenever possible, the paintings themselves. Another quarter century would elapse before the enormously difficult task of revision and amplification would again be undertaken.

The new Lists were conceived within a much broader framework than that of the original ones. The goal that Berenson had proposed to his friend Enrico Costa forty years earlier as they sat at a café in Bergamo had been to dedicate their entire lives to connoisseurship "to distinguish between the authentic works of an Italian painter of the fifteenth and sixteenth century, and those commonly ascribed to him." Now, in his preface, he explained that in his original Lists, moved by a kind of "dandiacal aestheticism," he had included only autograph paintings.

Fortified by his "experience of the artist at his highest" and by his long study of the methods of artistic production in the Renaissance, he had come to feel that "one may well afford to relax from the earlier severity" and trace an artistic personality to the limits of its influence. He was therefore including "not only pictures which the artists painted with more or less assistance, but such as were turned out in their studios from their designs, and even copies as well, providing they faithfully transcribe lost works." To "distinguish such works from absolutely autograph pictures" he adopted a number of symbols: *p.* (in part by the artist), *g.p.* (in great part), *s.* (studio), *c.* (copy), and *r.* (ruined, repainted, restored). This plan obviously did not create pristine autograph works of hitherto rejected ones, but it did allow the student to observe the ramifying nature of the artist's work and influence.

The paintings attributed to Giovanni Bellini illustrate how the Lists had grown. The 1902 third revision of his *Venetian Painters* listed 40 paintings of Bellini's in fourteen locations. Now thirty years later 145 autograph pictures were reattributed or newly located, of which 69 were identified as either early or late; in addition 23 were listed that Berenson believed were in great part or in part by Bellini, 6 whose attributions he thought doubtful, 15 studio paintings, and 3 significant copies. The fourteen locations had grown to fifty-five.

As Berenson's "pupils" had come to speak half-humorously of the original four volumes as the "Four Gospels," they quickly baptized the new volume the "Book of Revelation." The revelation was offered, however, with a saving grain of salt. Berenson reminded his readers that even the most honored attributions were by their nature provisional, serving as guideposts on the way to greater certainty. "More and more work will be required . . . before this task will be adequately accomplished."

Though not widely reviewed, being essentially a reference work, the *Italian Pictures* received respectful attention in the journals. For the *Zeitschrift für Kunstgeschichte,* for example, the volume was the most noteworthy publication of the year on Italian painting. The critic pointed out that Berenson's "expansionist" principle had been announced in one of his *Dedalo* articles in 1931 on "homeless" Florentine paintings and was opposed by the "contractionism" of Richard Offner in his work on the Florentines. Alfred Nicholson in the *Art Bulletin* thought Berenson's new "attitude, though obviously dangerous if taken by a lesser authority, fixes many guideposts for future study, meanwhile leaving domains of relative certainty scrupulously surveyed." C. H. Collins Baker in the *Burlington Magazine,* though somewhat skeptical of Berenson's expansionist principle, called the work "an impressive achievement of scholar-

sors expelled from German universities was published that spring. In one of her weekly letters to Bernard's aged mother, Mary wrote, "We are heartbroken at this terrible streak of brutality that has appeared among them. So many of our friends, too, are rendered destitute—because they belong to the cleverest race in Europe."

Relief committees in England, France, and the United States intensified their efforts to place the bewildered victims who succeeded in making their escape. An unprecedented migration of talent began, especially to England and America. A loophole in the stringent American immigration law allowed the entry of scholars and professionals; and to employ some of the teachers from Germany, the New School for Social Research in New York formed an Institute for Advanced Study, soon to be called the "University in Exile." It was largely subsidized by Colonel Michael Friedsam. Richard Offner, whose doctorate in art history was from the University of Vienna, was named to head the Institute of Fine Arts which formed part of the "University." It seemed to Berenson all too apparent that the Institute was to become the center in America of a Germanic kind of art history in which primary emphasis would no longer be on the appreciation of art but on the recondite areas of iconography and symbolism. To his easily excited nature such an emphasis was an abomination to be resisted at all costs, for to him "seeing" the art object was all important, all else was secondary.

One of the first German-Jewish scholars whom Offner recruited was the noted Erwin Panofsky. In previous years Panofsky had served as a visiting professor of art history in the United States, dividing his time between Hamburg and New York University. Deprived of his professorship at the University of Hamburg in the spring of 1933 while he happened to be in New York, he elected to settle in the United States. His elaborate treatise on the influence of Greek symbolism on the art of the Renaissance was one of the signs of the new direction art history would take in America, as was his earlier treatise on ancient art theory. An example of his "iconographical exegesis" written in collaboration with Fritz Saxl had appeared in English in the *Burlington Magazine* in 1926. The learned footnotes almost equaled the text.

Once settled into dislike of Panofsky, Berenson gibed for years at his influence. With Margaret Barr, the talented wife of Alfred Hamilton Barr, director of the Museum of Modern Art, he raised the question, after her first visit to I Tatti in the mid-1930s, of how the appreciation of art should be taught, and he told her of his objection to "wonderworking Rabbis and cabalistic spell-binders with all their enticing irrelevancies." Panofsky, he charged, was a "poseur" and "the Hitler of art study," and Professor Charles Morey of Princeton was his Hinden-

burg. Their friendly correspondence crackled a bit as Margaret Barr, who had helped polish the English of Panofsky's published lecture at Princeton, "Classical Mythology in Medieval Art," did not hesitate to defend him.

When Paul Sachs sent a confidential cable that Harvard was contemplating inviting Panofsky to join the art department and asked for Berenson's opinion, his reply was so "enigmatic" that Sachs wrote it was "quite frankly disturbing, for 'all others' spoke with unvarnished enthusiasm." It was not until 1947 that Panofsky was invited to spend a year at Harvard as the Charles Norton Professor of Art.

Panofsky had become Berenson's special bogeyman among the German-Jewish refugees in New York who, he was convinced, had done their "utmost" to undermine his reputation in America. Undoubtedly their teaching was opposed to his, but his belief that they campaigned against him would appear to have been the product of his suspiciousness rather than of the fact. As Mary had explained to Roger Fry, suspiciousness was one of the "thorns" in Bernard's character, as was his vehement resentment when others seemed to trespass on the "sacred soil" of his specialty. To Umberto Morra he rationalized, "It's not that I have a suspicious nature. . . . It is the fruit of my ingenuousness and candor. It is the sense that everyone knows how to deceive me by entering my good graces . . . and then profit from it."

That German scholarship in the United States had become excessively technical, Panofsky himself ruefully admitted twenty years later. Looking back upon the course of art history in America, he recalled that the vocabulary of art history which had been employed by German art historians (himself included) had developed into a technical language that was "hard to penetrate." The compulsion, he said, to make themselves clear in English "went a long way to loosen our tongues."

How different Berenson's approach to art was from that of the refugee scholars comes out in a letter to Billie Ivins on how to teach art appreciation. "In the first place eschew metaphysics [and] mathematics," his prescription read; give "a small stiff dose of psychology and then anything and everything, even sheer anecdotage that will arouse, stimulate, feed and overfeed 'wanting to know,' i.e. curiosity, so that overfed it falls back and ruminates. This rumination in prepared natures will change into contemplation and this will enable the work of art to leave its imprint on the spectator as on a sensitive plate. . . . Lots and lots of 'home reading' of the history, anecdotage and literature backgrounding the work of art to inspire a savage lust to possess it followed by detailed enumeration of all that is notable in the work of art. The hypnotic effect of merely detailed showing is immense and permanent."

Not only did he oppose emphasis on iconography and the minutiae of history, he also deplored emphasis on technique. "Above all," he wrote, "do not interest the poor spectator in technique. That might lead him to make messes à la Roger Fry or Ned Forbes but never to appreciation." Returning to the subject of technique in a letter to Daniel Varney Thompson, an assistant professor of art at Yale, he declared, "Our disagreement is about the emphasis. My contention is that the work of art is first and last an aesthetic phenomenon, as such its appeal is the central fact and not the question of how it got to be. . . . In short I regard all questions of 'technique' as ancillary to the aesthetic experience."

The subject haunted him. In another long letter he reflected on the humanizing purpose of the representative arts: "Their business is to teach man how to hold himself, how to look, what gestures to make, what attitudes to take, etc., etc., all of which react violently on his psychology and tend to make him the civilized being we hope he may at some far distant date become. . . . In so far as representation *grosso modo* achieves these ends it is ART. . . . To my ideal history of art all sorts of savants would bring tribute. . . . The delvers into archives would surely be among them. So would the student of materials, the chemistry and the technique, etc., etc. But neither singly nor collectively do they constitute a history of art. So talk not to me of an objective history of art. . . . How can you expect the history of man's visions, dreams, aspirations, bellyaches, lusts, despairs, triumphs, asphyxiations, liberation ad infinitum to be written without appraising them. And every appraisal is necessarily subjective."

The subject hit an exposed nerve in Berenson. He felt the direction the study of art was taking cast a dark shadow on the future of I Tatti in the hands of Harvard. To young Thompson he wrote, "The prospect of turning over this garment that I have spun out of my life, to turn it over to be worn by youngsters brought up on the droppings of [Elias Avery] Lowe [author of works on paleography and ancient codexes] and [Hans] Mackowsky [writer on Michelangelo's symbols] etc., etc., etc. is anything but pleasant." In one letter to Ivins he mourned that if he could not get a publisher for the revised *Florentine Drawings,* he might have "to pay for it all for Panofsky to pilfer and befoul." For years his unhappy fulminations against the rising menace of "Pan" and his associates rumbled through his letters.

THE TUMULTUOUS developments in Germany, though they appeared to threaten the peace of Europe, hardly affected the tempo of life beyond its borders. Of more urgent concern to people like the Berensons was the increasing financial crisis. Bernard felt obliged to turn down Senda's

request for additional funds. Mary apologized to her for their continuing to live at I Tatti in luxury, explaining that it was unavoidable because Bernard was "so frail and fastidious" that she felt he could not leave the house "he has built up and loves so passionately."

Nor was it possible to abate the hospitality of I Tatti as old and new friends congregated round the luncheon table and sat unwittingly for pen portraits in Berenson's letters. Logan, Berenson told Ivins, "is a rotten-ripe old sybarite of words . . . of bon mots and good stories." Desmond McCarthy "is less amusing, but far more interesting. . . . He can be deep and wistful and metaphysical and whimsical and tender and irresponsible altogether and all in one of the finest minds I encounter." Otto Klemperer, still director of the Berlin State Opera—in Florence in mid-March to conduct a concert—came up bearing a letter from Roger Sessions. He burst in with volcanic energy, "a huge, vehement, wild-eyed, loud-voiced, very handsome Jew about forty-five, a superb musician, and as jolly and simple as a roistering big boy." In the evening he played for them a cantata he had composed on the theme of David and Bathsheba, "thumped the piano and sang all the parts, including the chorus." On June 7 came the news that the Nazis had ousted him from his post. Fortunately, he got away to the United States before the end of the year and became the director of the Los Angeles Philharmonic.

Early that spring Franz Werfel, a Viennese friend of some years' standing, sent Berenson a copy of the *Forty Days of Musa Dagh,* his powerful novel just published in German. Berenson was stirred by Nicky's reading of the long and harrowing narrative of the Turkish genocide of Armenians during World War I. For forty days a heroic community of Armenians held out against the Turks on a mountain top until they were providentially rescued by a French warship. "If I except Gobineau," Berenson wrote Werfel, "I know no other writer who can in fiction render the character of a people as you have in your story."

Werfel visited I Tatti in May, "such a rococo cherub with just the least touch of Jew in his face. How intelligent and sane he was. . . . He chuckled over the burning of his books by the Nazis." His visit had been preceded by that of the distinguished art scholar Adolphe Goldschmidt, successor to Heinrich Wölfflin at the University of Berlin. A leading authority on medieval art, he shared Berenson's antipathy to the excesses of Teutonic culture history. He too philosophized with Berenson over the plight of the Jews in Germany. He declared, as Berenson was to recall, "it would take a thousand years before the feeling about Jews as outsiders disappeared entirely." Long after their meeting Berenson reflected that "if the Jew wants to act as if a non-Jew (as was my case before Hitler) he is still uncanny to others, even to the most civilized and

advanced 'gentiles.' " Berenson thought Goldschmidt "a great dear and a sage," a notable exception to the refugee scholars who drowned the work of art in an ocean of pedantic exegesis.

Like a professor eager for the advancement of his doctoral students, Berenson took a keen interest in his protégés. The one whose star was rising most rapidly was Kenneth Clark. Not yet thirty, he received a telegram from Prime Minister Ramsay MacDonald in the early autumn of 1933 offering him the directorship of the National Gallery in London. What particularly pleased Berenson was the statement in the London *Times* that Clark had "worked for two years with Mr. Bernhard Berenson, at Florence, the authority on Italian art." As Berenson read the account, Clark's work with him was offered "as his chief title" to consideration. When Berenson learned that the post of curator of paintings at the Museum of Fine Arts in Boston was to become vacant, he urged Paul Sachs to try to get it for John Walker. He pointed out that Walker was as old as Kenneth Clark and had also studied with him for two years. And if not Walker then he proposed Daniel Varney Thompson, for whose advancement he had come to feel a responsibility.

Among the many who regarded Berenson as a benign older colleague, if not an actual tutor, no one had been closer than his friend Arthur Kingsley Porter, with whom Berenson had roamed about Europe on archaeological quests. Berenson had helped arrange for the publication of his monumental work on Romanesque sculpture in the Pantheon series. Their exchange of letters had been a feast of reason. On July 8 Porter, who had a "love for the rain and mist and the storms of Ireland," was drowned in the Bay of Donegal. The news of his death came on the same day as his last letter. Bernard "wept so he could hardly read" the letter to Mary.

Porter had once written to Berenson that he had done many nice things for him "but never anything for which I am more grateful than pushing me into the Spanish Romanesque field once more." Pressured by the demands of life as a Harvard professor, he remarked, "I feel you have found the solution of a problem that is deeply troubling me—how to be gregarious and a scholar when the two things are essentially incompatible—but your way out won't work with unclever me, and I shall have to find another." Most touching of all his tributes was his frank avowal, "I am very fond of you. I wonder if you realize how much so, and how deeply you have influenced my way of looking at things."

Later that year Berenson received a letter that brought a second piece of shattering news. It told of the death of his sister Rachel at the age of fifty-three. The news reduced him, he said, "to a numbness which makes it hard to say anything about her." To his brother-in-law Ralph Barton

Perry, he could find no words, "not even halting ones." Replying to condolences from Paul Sachs, he wrote, "There is nothing to say about death," but for "poor Ralph one cannot do too much. I know that you will do all that is possible to comfort him." To his eighty-six-year-old mother he held off writing for a month, finally sending what sympathetic words he could manage.

THE KING'S list of January 1, 1933, announced that Sir Joseph Duveen had been elevated to the peerage as Baron Millbank, a title that enormously pleased him. It was given in recognition of another of his benefactions, the gift of a new wing to the portrait gallery. Duveen thanked the Berensons for their "charming messages," which meant more to him and his wife, he said, "than hundreds of the congratulations" they had received. Whether he was any less disingenuous than Berenson is hard to say. For Berenson the new honor did not raise his opinion of the expansive Duveen or of the trade in which he flourished. Despite the lull in business, requests for opinions continued to come in from Fowles, but there was little progress with long-overdue arrears. The depreciation of the dollar after the abandonment of the gold standard introduced a fresh complication, for it reduced the value of the balance owed. Berenson therefore went up to Vienna with Nicky in the late summer to meet with Duveen and Levy in an attempt to get terms that would make up for the loss.

The mission "achieved nothing," Bernard ruefully reported to Mary. "Yesterday morning we were within an ace of a complete break, and that was averted only by suspending discussion. . . . I got more of an insight than ever before into J.D. He is as innocent and as predatory as any of the big carnivores of the jungle. No scruples, no remorse, no regrets, no resentment, no friendship, no enmity, no yesterday, no tomorrow." The imperturbable Duveen gave no hint of any disagreement when, immediately afterward, he wrote to Mary that he had had a delightful time in Vienna where it had been "such a great pleasure" to see "B.B. and Nicky." He also congratulated her on the publication that year of *A Modern Pilgrimage,* her book about their travels in Palestine and Syria, which was being very favorably reviewed.

In the months ahead it fell to Fowles to mediate the peace between the evasive Duveen and the importunate Berenson. The drastic reduction of his "retainer" had proved a very bitter pill indeed to Berenson, and he balked at making any further concessions. So when he was asked to give an opinion on the Oppenheim Collection he grimly replied, "You of course are asking my opinion for the firm and on the usual terms, that is 10% of what you pay out on each item. Moreover you are going to keep all that I tell you to yourself and not pass it on to others. I cannot afford

to give my opinions gratis. I am sorry to dot my i's and cross my t's but henceforth I must let no equivocation of any kind come between Lord Duveen and myself. He is perfectly free to chuck me and I shall remain on the best of terms but if he wants me to go on advising him he must make up his mind to pay. I cannot afford to go on as I have the last few years."

He felt obliged to go on, nevertheless, and there was no break in his professional counsel. When Duveen asked some time later for an opinion on a *Portrait of a Man* in the Whitney Collection, Berenson duly drafted his commentary: "Probably Raphael although I used to think it Ghirlandaio." He requested an x-ray or violet-ray photograph to make sure it was not a Ghirlandaio "faked up to look like a Raphael" by Elia Volpi, who had owned the picture "thirty-five or so years ago."

It was obvious that Berenson performed his necessary chores for the firm with very little relish and with a sense of self-abasement. So far as his many correspondents might know, he was a person of independent means, for almost no reference to his distasteful relation to Duveen or to any other dealer disfigured his copious letters to his friends. And if at last driven to allude to the subject, he did so in the most general way, as when he wrote to Clotilde, "I have business to attend to on which my entire future depends. I simply cannot bear to attend to it, or put pen to paper."

Parted from Duveen and Levy, who, Bernard said, were at least "first rate tellers of stories," he and Nicky embarked on a month of sightseeing and visits to old friends like the prince and princess of Thurn and Taxis and the faithful Addie Kahn, the widow of Otto, who was expected up from Biarritz. They journeyed also to Werfel's summer home which he and his wife, the beautiful Alma, former wife of Walter Gropius and widow of Gustav Mahler, had established at Breitenstein near Vienna. They found Werfel alone in the cottage, where after a sumptuous lunch they "talked and talked." Werfel was delighted to learn that they had explored the country around Antioch and Aleppo where part of the action of his novel *Forty Days* took place. In the forefront, however, was the Nazi situation and the growing campaign against the Jews in Austria. Werfel was finding it baffling to come to terms with the "culture shock" of losing his identity as a Viennese. The following year he and his wife fled before the advancing Nazi battalions. After lengthy tribulation they reached America in 1940 and made their home in California, joining the colony of displaced writers and artists that included, among others, Thomas Mann, Bruno Frank, and Bruno Walter.

From Vienna the travelers crossed into Czechoslovakia to visit the ill-fated President Masaryk, whom Berenson had come to know during the

exciting days in Paris when the Peace Conference of 1919 was rearranging the map of Europe. Berenson made no record of the meeting in Prague, but the talk could not have been any more cheerful than that in Vienna, for the Nazi stirrings about the Sudetenland had already begun and it was evident that the Czech Nazi party had illegal links with that in Germany. Military preparations for defense were already under way. Bernard and Nicky returned to Venice with a sense of relief. It had been ten years since Berenson had paid a "real" visit to Venice, and he found the place overwhelmingly beautiful. "Except for the space effects of Saint Sofia and its bay sustained on slender porphyry columns," he wrote Mary, "we have seen nothing comparable to San Marco." For the first time he was seeing everything "in terms of sheer beauty."

Work on the *Drawings* went steadily forward after Berenson got back to his desk in mid-October. By Christmas it was time for his customary holiday, especially since Alys was coming out to keep Mary company. Bernard left them to rejoice in Mary's new hobby of psychoanalysis and made his annual escape to Edith Wharton's villa on the Riviera. With Alys he was never at ease. He thought her "pleasant enough but I always feel with her as with an enemy during a truce. At bottom we are at war for she is and remains an -ist of every kind, feminist, prohibitionist, philanthropist and she despises me or at least disapproves of me for being such a pagan."

As the drum beating had grown louder over Central Europe toward the close of the year, Berenson's Christmas greetings to Judge Learned Hand struck an orphic note: "Babes and sucklings are getting impatient. They are telegraphing to their various *Führers* for peremptory declarations . . . to be led in martial array to the conquest of the cosmos." Roosevelt's dramatic leadership in the United States also had its disturbing aspects. From Graz Berenson had responded to a letter from Judge Hand: "Yes, the outlook at home is not pleasant. If the New Deal succeeds I should not feel happy over it. I distrust every . . . kind of messiahism. . . . The same impatience is probably the bottom reason for Hitlerism and every kind of fascism and indeed of Bolshevism itself." Now in his Christmas letter to Hand his thoughts turned homeward: "How strange it is that I, who lived in America from my eleventh to my twenty-second year only, . . . feel so much more at home with an American of our kind than with any other biped whatever." In his ninety-third year he would still declare that he did not feel Italian and that he was an American and Boston was his home.

Cheering news had arrived that autumn which had strengthened his sense of identity with his "homeland." James Bryant Conant, the newly appointed president of Harvard, thought the idea of an Institute at I Tatti

was "wonderful." He expressed "the utmost appreciation" of Berenson's generosity and declared he would recommend acceptance by the corporation. Berenson's notion of "advanced humane scholarship," he wrote, agreed with his own administrative objectives. The report which had been submitted to Conant bore the signatures of Berenson's loyal partisans at Harvard: Paul Sachs, Edward W. Forbes, George Harold Edgell, and Ralph Barton Perry. On October 30, 1933, the corporation voted that it was "enthusiastically receptive of Mr. Bernard Berenson's proposal to bequeath his villa and collection to Harvard University," with the reservation, however, that there should be sufficient income from the estate "or [funds] specifically given for the purpose" to provide for its maintenance.

Though the main hurdle—an adequate endowment—had yet to be surmounted, the campaign to assure acceptance of the bequest seemed on the way to success. Even Mary now referred to the establishing of the Institute as a joint undertaking in the preface of *A Modern Pilgrimage*. Nearly all the books she needed for her research were, she declared, "in our own library which my husband has collected with great care for future students who, as we hope, will benefit from the 'Institute for Humanistic Studies' which we mean to found under the auspices of our common university, Harvard."

X L I

Life in "Mussolinia"

WHEN he returned from the Riviera in January 1934 Berenson plunged again into the endless complications of the revised *Drawings*. Every book and article on the drawings of the more than fifty principal artists and their followers that had appeared since the first edition in 1903 had to be scrutinized and their additions to the canon of each artist evaluated. Determined to produce as complete a presentation as possible, he fought his way through treatise after treatise. Most of these were in German, for the history of art as a learned discipline had originated in Germany and had been most systematically developed there. The magnitude of his self-imposed task may well have appalled him. In his original catalogue he had analyzed some 2,800 drawings. He had now to restudy all of them, add more than a thousand, assign each to a place in the text, and set aside a suitable photograph of each for the volume of illustrations. The two chief figures were of course Leonardo and Michelangelo. Of the 363 large quarto pages that would comprise the catalogue volume, 40 would be devoted to Leonardo (with 88 drawings added to the original 251) and 80 to Michelangelo and his school (with 85 drawings added to the original 226).

The revision of the chapters on Michelangelo gave the most trouble. Berenson vehemently cursed the German authors for the "bog of pedantry into which they have brought the subject and the poison mists of interpretation (mostly against him) they have wrapped around it." As the year wore on into autumn, he complained to Billie Ivins that "Panofsky and his tribe" had almost weaned him "from all the studies connected with the so-called art of the last five centuries" and made him "long to get where I shall never hear the names of Panofsky, Popp [Dr. Anny E.], Tolnay [Charles De], Bodmer [Heinrich], etc."

When Dan Thompson happened to allude to "followers" of Berenson

who suffered in the shade while Professor Morey of Princeton and his associate Panofsky "inherit the earth," Berenson erupted: "Pray, who are my followers? . . . Perhaps you have in mind Edgell, or McComb or Offner or who? Rest assured they are no followers of mine. Excellent they are, the last named would heave a ton of bricks at you if he heard you whisper that he is my follower, but after taking from me all they could—and how little it was!—they have gone their own way and it is not my way, not by a great many degrees of the compass. And yet I greatly prefer these gentlemen to certain spell-binders and irrelevancy-mongers from darkest Judeo-Germany who I understand are threatening to invade Harvard." It did not add to his composure to receive word from Belle Greene a few days later that Morey and Panofsky were to lecture at the Morgan Library on illuminated manuscripts.

Overwhelmed with the scholarly minutiae, Berenson began to dream of the liberating book that had haunted his imagination, "the book which will be the cream of my experiences." He had long thought of it as "The Decline and Recovery of the Arts," and its vague outlines tantalized and terrified him. Once free of the *Drawings,* he told Ivins, as his seventy-first year approached, "then will come the ordeal. Shall I still be able to organize and start on the big undertaking I have laid out? If I can I shall enter into a happy old age. If not?"

The prolonged scrutiny of Michelangelo's work inevitably produced moments of revulsion. "Pity he survived the Medici Chapel," he remarked to Thompson. "It might have been better had he finished his career with the completion of the Sistine Ceiling. I feel the spell of his later work and cannot get away from it any more than I can from Wagner. My soul and my mind revolt from both as from something obscenely overpowering. . . . And to these followers of his who try to out-Michelangelo Michelangelo I must devote the best hours of a month in order that my chapters and notes on Mike's drawings may be as free from more misinformation as possible. In scholarship what counts is what one discards."

That he was able to avoid the sort of nervous debility that had plagued him as a result of his prolonged struggles with the first edition of the *Drawings* thirty years earlier was doubtless thanks in part to the initial help he had received from Kenneth Clark, but more especially to the dedicated assistance of John Walker, Nicky Mariano, and Fern Shapley. The work of revision continued on into 1935. In August of 1935 he told Umberto Morra that Michelangelo was his "daily poison." He worked on, he said, "out of bad habit," requiring "the task as hygiene" just as he required his Swedish gymnastics, though he had more faith in the gymnastics. By mid-November of 1935 he spoke of putting in the "last

touches." Then he was "plunged into the agony of coming to terms" with the Clarendon Press. "They are so frightened that I . . . am sorely tempted to tell them to go to Heaven." In early January 1936 he was "able to relieve" the Clarendon Press with the news that the University of Chicago Press had "come forward" offering all the illustrations he wanted and assuring him that they would not charge more than $25 for the three quarto volumes. It was to be a "working edition" such as he had always wanted for the use of students. Progress toward the publication proceeded during 1937 with the aid of a subsidy from the Carnegie Corporation, and in September 1938 the revised *Drawings* was finally published.

During 1934 Bernard, chastened by Mary's worsening health, so bridled his temper that Mary informed his mother in May that "not once since I was taken ill has he lost his temper with me." Her condition seemed genuinely to give him anguish, and his anxieties about her failing health ran like a leitmotif through his letters to his friends. Nevertheless her "lamentations over her bodily distress" often seemed to him exaggerated. Long afterward, when extreme old age gave him a keen acquaintance with his own bodily pains and weaknesses, he felt remorse at having sometimes dismissed her sufferings as imaginary. Her recurring hypochondria flourished in the soil of very real physical afflictions, the most recent, she wrote Carl Hamilton, being "glandular blood poisoning in the groin." To Learned Hand Berenson lamented, "Always the same bladder. You would think it was a Zeppelin from the place it took in my worries."

What must have fed Bernard's recurring doubts was the curiously intermittent character of her relapses. Nicky, who was much in her company, thought her case one of "mild recurrent madness; 'happy' alternating with depression. . . . If you look back on the last three years," she pointed out to Bernard, "it has been like that all the time; a few months of astonishing improvement and much better spirits, greater mental energy and then collapse of both mental and physical conditions." Whether bedridden or not, Mary busied herself with one literary project after another. Again and again she returned to piecing together long sections of Bernard's early letters toward composing his biography. At the same time she finished off, with the help of John Walker, her list of "Beautiful Italian Pictures." She worked also on the manuscript of *Across the Mediterranean* and helped her daughter Karin revise her lectures on psychoanalysis for a projected book.

In London that June Mary, during her annual visit, dined with Lord Duveen and enjoyed being chauffeured to lunch in his imposing Rolls Royce. She found him unchanged, "boasting all over the place" and

tile, except when he thought of the miscreants who in his judgment were corrupting art history, especially in that "bouillon de culture, the German-Jew refugee university" in New York.

Mary was at last able to satisfy her great longing to hold her first great-grandchild in her arms when her granddaughter Barbara arrived on March 23 with her baby, Roger. Barbara had impulsively married a Finnish sailor the year before in Australia during a long cruise. The marriage quickly ended in divorce. The infant was made at home in a bassinet in Mary's room so that she was able to dote daily to her heart's content. Five days later Bernard and Nicky took leave of this scene of great-grandmotherly bliss and embarked on a six-week expedition to the Barbary coast. He assured his sister Bessie, with what sincerity one can only surmise, that he was "loathe to go on a journey without Mary, but I have little hope that she will ever travel again." In spite of their many quarrels Mary had in fact been his alter ego, a role that Nicky had perhaps not fully mastered, her dependence on him lacking the important sanction of marriage.

The stages of their journey were marked by daily letters bearing postmarks from Naples, Palermo, Tripoli, and the historic backcountry, Cyrene, Malta, Syracuse, Messina, Herculaneum, Naples, and the many ancient sites between. For Berenson the trip was an additional survey of the ancient and medieval monuments of Mediterranean art that he hoped to assimilate into his projected magnum opus, "The Decline and Recovery of the Arts." In Libya the most imposing site was Leptis Magna, "the noblest ruins of the Hellenistic world." As for the vast remains at Cyrene, the sight of them gratified a wish that had been inspired by his reading of Pindar as a student at Harvard.

Berenson had already been in correspondence with the governor of Libya, Italo Balbo, the Italian air minister who had commanded the armada of seaplanes that visited Chicago during the World's Fair of 1933. At their first meeting Balbo burst upon them with head and shoulders thrust forward—"a most faun-like and Dionysiac head, radiant and joyous"—and swept them into his study where he kept "the most precious objects that had been discovered in Tripoli." The art and architecture was Hellenistic rather than Roman, he agreed, as the talk coruscated in pell-mell fashion over archaeology and the ethnology of Libya. Balbo seemed "the most life-enhancing creature" Berenson had ever met. At dinner the next day he found him just as "exuberant, talkative, discursive, with endless pet theories of his own about history, and art and politics." Berenson exchanged a number of letters with Balbo until the end of the following year; then Balbo must have come to realize that the

Fascist authorities did not approve of his acquaintance with an anti-Fascist American.

While still in Tripoli Berenson found there was no escaping the urgent calls upon his services by the Duveens. In great anxiety Fowles wrote of a "dilemma" from which he wished to escape with Berenson's conniv-ance. Baron Thyssen wanted to buy two Dreyfus paintings which he believed were by Cossa, but which Berenson had identified as by Ercole Roberti. The baron did not want Ercole Robertis. Fowles asked whether Berenson would support their sale as Cossas. Berenson's first reaction was to reply, "What you ask me to do I had rather not call by its right name." Then more temperately he wrote, "The profiles . . . are not by Cossa. What can I do about it?" Fowles anxiously wired that their client believed the artist was Cossa "because all German experts give this at-tribution. . . . Should we sell as Cossa would you flatly contradict?" Berenson replied, "Sorry, would have to." The paintings eventually entered the Kress Collection and bear the name of Ercole Roberti. Fowles's plea was of course not the first of its sort that Berenson refused to grant nor—at a more critical juncture—the last.

At Cyrene Berenson and Nicky had been joined by Henry Coster and his wife. Coster, still another Harvard graduate whom Berenson had taken under his wing, had given up his post as American vice-consul in Florence a few years before. He had married Nicky's friend Byba Giu-liani in 1926 and, after inheriting part of his mother's large estate, had settled down in Florence to the life of a scholar. The preface of his learned monograph *The Iudicium Quinquevirade,* a study of the judicial commis-sion established in A.D. 376, just published by the Medieval Academy of America, acknowledged his indebtedness to Berenson: "His stimulating conversation first roused my interest in this period; his wise and patient guidance has constantly helped me in my study of it."

Mary found her own relish for travel so roused by their letters that she immediately projected a book based on them. This task occupied her off and on for a few years. The book, *A Vicarious Trip to the Barbary Coast,* was finally published in England in 1938 by Constable and Company.

The approach of Berenson's seventieth birthday on June 26, 1935, inspired "his English admirers" to express "our indebtedness, our grati-tude and our homage" to him in a letter to the editor of the London *Times.* "It is over forty years since there appeared those four closely packed essays . . . which were a revelation to those of us who were beginning to study and to enjoy the art of the Renaissance, slim predeces-sors of the two massive volumes on the Drawings of the Florentine Painters of which we are now promised a revised edition." The signers

am again out in the blue, and not pinned down entomologically to a microscopic subject." The writing, however, only whetted his appetite for more archaeology, and two months later he set off with Nicky on "a wonderful spree" into the Yugoslav interior to see "inaccessible monasteries." In their absence Mary felt sufficiently recovered to journey once again to her daughter Ray's "Mudhouse" at Haslemere.

For the passionate traveler the journeying into the Yugoslav interior was pure adventure; much of the seventeen hundred kilometers of their wanderings through the mountains and wild gorges of central Yugoslavia was off the beaten path of tourists. They slept at "Cetinje, at Děcane, at Novi Pazar, at Sarajevo, and at Mostar, in monasteries and gendarmeries," and got as far south as Prizren. The jagged circle of their motor tour brought them back to Dubrovnik, where Bernard looked up appreciatively to the "silver grey bastions and soft pink roofs" of the city. "The sea horizon is a Giorgione," he told Edith, and the stretch of seacoast "incomparably more of a garden of Eden than any bit of the French or Italian Riviera." If the dramatic scenery was a revelation, the art equally dazzled. The medieval frescoes at Gracanica were among the finest in Serbia. More than a thousand frescoes decorated the walls of the lovely monastery near Peć. The monumental figures on the walls of the church of Sopaćani near Novi Pazar bore a kinship with the paintings of Giotto and Duccio. Mosques as well as churches exhibited the art of the remote past as at Mostar, whose twenty-four mosques showed the interfusion of Turkish, Orthodox, and Byzantine art resting like archaeological layers upon the towns. For Berenson the visual record was a vast palimpsest to be deciphered for his new book.

Serious study ended with a day at Prince Paul's country place at the resort center of Lake Bled north of Trieste, which the sightseers reached after their drive north along the coast and through Zagreb. Thrust into the cockpit of the Balkans, the prince regent had to deal with perils on his vulnerable frontiers as well as among the fractious nationalities that made up his own country. "Hearing him talk for hours together," Berenson told Coster, "did one's heart good. He took such a European and human view of politics and as Regent he has a certain power; he may just possibly help avert or at least defer the threatening horrors."

Not one to pass heedlessly through Europe, he and Nicky proceeded to Salzburg for an "orgy . . . of music, people, and food." Encountering young John Pope-Hennessy there, "the budding or rather dawning new grand lama of British art criticism," Berenson informed Margaret Barr, "I vented my usual outburst against your God Pan and he looked grieved and softly and silently vanished away." To rest his "old bones" after the debauch of Salzburg, he departed for Grusbach in Czechoslovakia to

spend ten days at the country place of his "beloved hostess" the Countess
Biba Khuen Belasi and her husband, Count Carl. "We wrangle hours
together, for they are Nazi-minded," he wrote. "I listened with them to
the world's news according to the dispensation of Hitler. . . . A queer
world has resulted from the efforts to make it safe for democracy—safe
for the dregs and the big bubbles that take shape out of the scum."

After hunting out "late Roman things" at Speyer, Worms, Mayence,
and Trier, the travelers headed for Rotterdam to take in an important
exhibition of Old Masters. They reached London by the end of the first
week of September for the meeting with Joe Duveen that Berenson had
been postponing for months. Duveen had been anxious to see him be-
cause a very valuable new client, Samuel Kress, needed to be cultivated.
Fowles had written that Kress's recent purchases "show him to be a
serious collector and likely to be the greatest we have ever had for Italian
art." When informed that Kress wished to see him during the summer,
Berenson, still smarting from his experience with Jules Bache, had re-
plied, "In keeping Mr. Bache safe for Duveen I have earned the vindic-
tive hatred of all and sundry." That Kress might become "the greatest
buyer of Italian art" was a fact "that does not personally interest me
unless my financial relations with the firm are greatly altered to my
advantage."

The conference with Duveen resulted in a new contract which was to
run from January 1, 1937, to December 31, 1938. Berenson's annual
compensation was increased from $20,000 to $40,000, and Duveen
agreed to liquidate the outstanding debt of nearly $150,000 in two yearly
payments. The contract contained the proviso that either party might
terminate the agreement on December 31, 1937, if due notice was given
on or before September 30. It also provided that Berenson was to have
"no claim whatsoever for commissions or fees on purchases or sales."
The contract, in spite of the increase in the so-called retainer, was hardly
one with which Berenson could have been happy, because the firm could
make unlimited calls upon his services—business admittedly being very
much on the upswing—with no comparable increase in his compensa-
tion. Its chief advantage for Berenson was that the long-outstanding debt
to him would at last be liquidated.

To Mary's practiced eye Duveen, though "bragging and blustering as
if he were in perfect health," was "very, very ill," and she discovered
that he had undergone a colostomy. She did not think he could live much
longer. He did survive for nearly three more years and, according to
Sam Behrman, "his last words, addressed to his nurse, were, 'Well, I
fooled 'em for five years.' "

After much socializing and gallery-going during the September weeks

XLII

The Allendale Nativity

A SENSE of urgency took possession of Berenson with the approach of 1937. For too long he had harbored the feeling of "arrested development" that marked his thirty-year association with Joe Duveen. The new book, he hoped, would be his carte de visite to posterity. He turned down Edith Wharton's "dear enticing invitation" to make his usual holiday visit, explaining that he at last had begun to produce and "must stick at it now until I come to a stop." He was writing on matters that really count, "whether they get printed or not," for he had the "illusion of pulling things out of the depths."

It was not that he scorned his past achievements. He carefully enumerated them in his 1937 report to the secretary of his Harvard class on its fiftieth anniversary. He was bequeathing I Tatti to Harvard; he had published a significant array of books and articles; "directly and indirectly" he had been responsible for pictures in the Gardner, Johnson, Widener, and Walters collections; and "most of the other Italian paintings" in public or private collections had gone to America with his "visa on their passport." But those achievements were behind him. It was the future that was important, for he ended his report, "I am now at work on a book that will sum up my conclusions about art and its history."

To a similar request from the secretary of the Boston University Class of 1887, of which he had been named an honorary member, he responded with a revealing warmth of feeling: "Dear Companions of the Dawn, you asked me at the twilight of life to tell you what success has meant for me. I fear you mean worldly success. If that is so, it has meant means for travelling, for buying books, for gathering friends under my own roof, to have access to libraries and private collections and to be treated like a tolerably respectable passenger on the ship of life. . . . Real success I have enjoyed, but secretly as it were. I count success as freedom

to live according to one's nature, to be free to exercise one's better function. . . . Because I have been able on the whole to remain a free man, I count myself as having had a fairly successful career. Recognition means little. Honours I have seldom had and never sought. I have no degrees or title. I have remained for fifty years a student and I wish for more years to work as a student in the field of art."

Doubtless this idealizing retrospect was sincere, as most sentimental idealizing tends to be. And like most it could not help being less than frank. His freedom had come at a price that he never ceased to regret, for it had been freedom intertwined with bondage—bondage to the art trade, to dealers like Duveen who thrived in its corruption, and to rich barbarians of culture. As for fame and recognition, he seemed, at least while this ideal vision of himself filled his mind, to forget the ambition that had launched him on his career as an art expert when he and Enrico Costa had sat in the square at Bergamo nearly fifty years ago. He had cherished his reputation as a connoisseur with a fierce tenacity. He would be at the head of his profession though the heavens fell, as he would soon insist to Lord Duveen himself.

The creative afflatus kept him at his desk mornings at I Tatti as the days lengthened into spring, and, as he deprecated to Edith Wharton, he wrote as many as a hundred words a day. The elegant ritual of luncheon, tea, and dinner in which a succession of visitors and house guests played their civilized roles seemed to hold the ugliness of the outside world at bay. Politics had become an obsession, and Berenson's contempt for the "Duck," as the household referred to Il Duce, inspired his passionate rhetoric. Echoes of it were bound to reach Fascist ears in town, but as an important American he still remained out of reach.

The new book went forward from the intimations with which he had concluded *The North Italian Painters* thirty years before. To Morra he explained, "I am seeking to demonstrate that after any period of great artistic maturity there follows a period of impoverishment, of barbarization, of decadence, which always repeats the same forms of involution: the enlargement, stiffening and geometricization of contours."

Much as he deplored what he thought were the mistaken emphases at the Fogg on the technical aspects of art study, he eagerly received the youthful art historians who were sent to him for guidance in their work, and with them as with Ivins and Thompson he proselytized, with a similar lack of success, for his view of the main responsibilities of art history. A fresh recruit appeared early in the year, sent by Paul Sachs, a young man of twenty-three, Sydney Freedberg, who was to become one of his most loyal supporters. Berenson found him "remarkably responsive" to his probing queries, though prudently reserved on matters of

art, no doubt aware of his host's sharp tongue and of his antipathy to the "skyscraper pedantry" the refugee art historians were popularizing in academia. Freedberg became a distinguished professor of art at Harvard and later chief curator of the National Gallery of Art in Washington. It was in 1937 also that Margaret Barr recommended to his hospitality Agnes Mongan, with whom he had been in correspondence for a number of years. As a curator at the Fogg Museum she was to become one of Berenson's most appreciated allies for the next twenty years.

The imminent opening of the third Florence "Maggio," the month-long music festival in May that drew visitors from all over Europe, was a signal to Berenson to put down his pen and flee the "pitiless" telephoned importunities of old friends arriving in town for a day or two and insistent on seeing him. Laden with the usual baggage of books and tea things, he started for Brindisi with Nicky to take ship to Cyprus. Mary took herself off to the seacoast at Viareggio, "after rooking £400 out of me," he wryly commented to Edith Wharton, "for a month's cure afterward" at Vienna.

En route to Brindisi Bernard and Nicky stopped off at Rome for a dinner with the director of the American Academy, Chester Aldrich; "Harry" James, Henry James's nephew; and Morgan partner Thomas Lamont, who was in Rome to have what he discreetly described to the press as "a purely courtesy" audience with Mussolini. The two aesthetic travelers could only have been relieved to escape the wartime atmosphere of Rome, where the newspapers celebrated the heroic exploits of the hundreds of wounded Italian soldiers invalided home from Generalissimo Franco's battlefields in Spain. The threatening international situation received an oddly macabre emphasis before the summer was out: an Italian insurance company offered gas masks as premiums with its policies.

The three weeks in Cyprus and the stay in Rhodes displayed Berenson again as an indefatigable sightseer of ruins and scenery. At Famagusta he thought that the Byzantine church of St. Barnabas must have in its best days rivaled St. Mark's in Venice. He felt himself living "in a dreamland, in a fairy world, in perpetual ecstasy except when in the earliest morning hours sand flies pungently" recalled him "to the flesh and its sufferings." So he passed his time, he confided to Bessie, "to drink in sensations . . . and to muse and day dream." At the other end of the Mediterranean German dive bombers swept down upon Guernica, the "holy city" of the Basques, to test the efficacy of the new technique, but the news was so garbled that its epochal significance was lost in the press.

On his return home he found waiting for him an appealing request from twenty-three-year-old Benedict Nicolson to come to Florence to

study Italian painting under his guidance, a possibility Berenson had suggested earlier in the year in a talk with his father, diplomat Harold Nicolson. That autumn he welcomed the new disciple, who came from working at the National Gallery in London as an attaché under Kenneth Clark. Impressed by Ben's sensitive discernment, Berenson sent him in the following year to study at the Fogg. The intimacy that had then begun to develop between them endured to the end of Berenson's life. After service in the British army during World War II, Nicolson turned to writing on art and soon became the editor of the prestigious *Burlington Magazine*.

On Bernard's return Mary, long reconciled to the congenial role of wife emeritus, betook her baffling ailments to Haslemere, where in the bosom of her family she could indulge them with fewer qualms. As the summer slowly passed she diverted Bernard with frequent reports of the mysterious vagaries of her condition. Her pains, she said, seemed to have paralyzed her brain but they had set free her soul in a way she could not describe. It was as if her soul "had crossed the border and begun to taste the joys of the next life." The litany was one he had heard before, and he dutifully responded in his diary letters with expressions of affection and concern. It was as if each had settled into roles from which long habit barred even the thought of escape.

Increasingly the links between I Tatti and Harvard strengthened. Professors Edgell and Forbes came on informal missions to study the possibilities of the place and to be studied as critically by Berenson. One can only imagine the vivacity and bite with which Berenson must have launched his attack that summer in Morra's hearing on the "bastardization and geometricization" of " 'non-objective art' as they call it in New York." This passion, which is "both snobbish and genuine, on the part of the public," he said, "gives me a glimpse of the raptures with which even the people most greatly endowed with taste must have admired barbarian art objects when the last fires of Alexandrian art had gone out and these people were already satiated by the clumsy attempts produced out of the decadence of Rome."

In late summer of 1937 Berenson retreated to Poggio allo Spino as habit required, immersed at the break of day in Chateaubriand's *Memoirs* or a book by Kafka and later wandering over the mountainside intoxicated by the cloud-dappled sky and the haze-shrouded forest vistas of beech and pine dotted with islands of ghostly birches. Learned Hand and Sybil Colefax drove up from Florence for luncheon, and Walter Lippmann, fresh from the success of his *Good Society,* came to tell of his soundings among leaders in London, Paris, and Geneva. "The world situation is not brilliant," Berenson concluded.

[431]

One day in August the shattering news came that Edith Wharton, the most treasured of his literary friends, had quietly died at her villa near Paris in the lingering wake of a stroke a few months earlier. The news came when his own vigor had begun to run low. He felt himself on the brink of a nervous collapse. "A great mass of the iceberg of life" on which he lived "broke off and plunged into the abyss," he mourned to Dan Thompson. Edith Wharton carried with her "a great part of my past and no little of the present. All that a woman who was neither wife nor mistress could be to a man she has been to me for a good thirty years." To Nicky he wrote that he felt "numb and dumb and as if my bodily temperature had lowered to the freezing point." Her death seemed but another sign of the "crumbling" of his universe.

A very different breach with the past impended, one, however, that would prove to be a kind of liberation. The first stirrings had begun in May when the expert chores which he was increasingly called upon to perform for Duveen were interrupted with a seemingly innocent query conveyed by Fowles from Duveen: "To whom do you attribute the small Allendale picture? His impression is that years ago you used to call it 'Early Titian.' " The reference was of course to the Allendale *Nativity,* later called *The Adoration of the Shepherds.* Joe Duveen immediately followed Fowles's letter with a telegraphic inquiry. Luxuriating at that moment in Cyprus, Berenson saw no urgency in the matter, not even when Duveen sent a second telegram setting out the arguments for attributing the painting to Giorgione. A few days later Duveen cabled again, "Anxiously waiting reply my wire." Berenson finally cabled, "In all probability early Titian." What Berenson did not know at the moment was that Duveen was on the point of purchasing the picture, having in view its sale to either Mellon or Kress at an enormous price.

The painting had been exhibited as a Giorgione as recently as 1930 at the Royal Academy, and as far back as 1924 Duveen had begun to dream of engineering the sale of such a valuable rarity. The matter hung fire during the rest of the summer of 1937 while Fowles, as Duveen's intermediary, began to negotiate a new contract with Berenson that would replace the contract due to expire December 31, 1938, with an agreement providing more favorable terms for the discontented Berenson.

When on August 3 Fowles informed Berenson that the terms of the "new arrangement" were in the main acceptable to Duveen, he included the disturbing proposal that he bring the Allendale painting up to Poggio allo Spino, "as certain details depend upon whether you will be able to make this picture a desirable acquisition." The thought of a disagreeable debate with Fowles was more than Berenson was willing to face, and he immediately protested, with some color of truth, "I am in a bad way. If I

don't take the greatest care I shall have a complete breakdown. In my present state I must not see anyone on business, not even you, no matter how pressing. Still less am I in condition to go into a question so supremely delicate as the authorship of the Allendale 'Nativity.' " He suggested also that he was considering giving up his connection with the firm.

That threat appears to have alarmed Fowles, and, addressing himself to Nicky in a letter dated August 13, 1937, he argued that though Berenson had once told him he could live in a quiet way "without working," he believed it would "entail many restrictions on his present style of living and certainly would entail worries as to the placing of funds." He pointed out that there had been a great improvement in the firm's business and that he "would like to see B.B. benefitting therefrom as well as ourselves." He conceded that the matter of the Allendale picture might cause him a little worry and rashly went on to say that there was no need to be nervous about it, as "all other so-called critics have accepted it as Giorgione, and if we don't buy it, the Mellon Trust will acquire it themselves direct. . . . I realize this kind of business upsets B.B.'s exceptionally high strung nature, but really there is no need to worry in such case where we have everyone else with us." He could hardly have made a less prudent suggestion, especially as in his next letter, dated September 3, he declared to Nicky that he had had no intention "in any way to force B.B.'s opinion on the picture" but had inferred, when he talked with him at Perugia, that he did not wish to express an opinion until the terms of the new contract had been agreed upon. Hence he thought that if his "opinion on the picture was favorable to us, it should be included in the new arrangement."

Fowles now had to confess to Nicky that the mire was deeper than Berenson knew. Duveen had decided to go ahead with the purchase because competitors were in the market and he had therefore acquired the picture "for a very large sum . . . one of the largest prices we have ever paid for an Italian picture; not a Catena, nor even a Titian price, but a Giorgione price. . . . The present position is that having purchased this picture as a Giorgione, we must sell it as Giorgione even if B.B. does not uphold this attribution." Fowles did not mention that the negotiation for the purchase had been concluded almost a month before, on August 5.

Furious at the affront to his authority, Berenson dictated an indignant rebuttal, sent over Nicky's signature, denying that the opinions of the critics were "as universal as you imagine." He cited George M. Richter's recent *Giorgio da Castelfranco,* published with "the full authority of the University of Chicago," in which Richter spoke of the picture as a "copy of an original perhaps, but only perhaps by Giorgione." And he pointed

among the apocrypha supplied years later to Behrman by Louis Levy, who was a great admirer of Duveen's resourcefulness. Duveen did not sail to New York until August 29.

As John Walker recalled the circumstances, he was with Berenson when a telegram arrived from Joe Duveen announcing the purchase of the Allendale *Nativity* "for 60,000 guineas" ($300,000 at the time). Berenson said, "If Joe Duveen paid that much for the picture, he must think it is by Giorgione, and it isn't. It's by Titian. Obviously, he thinks he can sell a Giorgione to Mr. Mellon, whereas he can't sell a Titian. He is capable of pretending I too think the picture by Giorgione. . . . Please write his son [Paul], who is a friend of yours, and tell him my opinion, so there can be no question.' " Walker afterward learned from David Finley that "the picture had never been offered to Mr. Mellon," Duveen having intended it for Samuel Kress. Duveen may never have made a formal offer to Mellon, but for a time at least he had hoped to interest him in the painting. He probably knew that Duncan Phillips, one of the trustees of the Mellon Educational and Charitable Trust, had urged its acquisition for "the Washington Art Gallery" in spite of his reservations about it. Mellon's death in August made it all the more urgent to maintain the Giorgione attribution in order to obtain a "Giorgione price" from Kress, and it explains Fowles's eager pursuit of Berenson during September.

It was not until December 11, 1937, that Lord Allendale's sale of the *Nativity* received public notice. On that date the painting was reproduced in the London *Times,* and Maurice Brockwell was quoted as saying that it had been sold "privately." Neither the purchaser nor the date of the sale was revealed. In 1938 Duveen, armed with Georg Gronau's favorable opinion published in *Art in America,* sold it to Samuel Kress as a Giorgione for an undisclosed sum. The purchase was to be kept secret until revealed with suitable fanfare at the inauguration of the National Gallery in 1939. Kress swore the director, David Finley, and his chief curator, John Walker, to secrecy. To their astonishment the *Nativity* was displayed "in the window of the Kress store on Fifth Avenue to celebrate Christmas."

The debate over the authorship of the painting was not stilled, though an increasing number of critics came to share Gronau's opinion. Twenty years later in his 1957 list of the "Venetian School," Berenson modified his opinion and attributed the painting in part to Giorgione with "Virgin and Landscape probably finished by Titian." The 1979 Shapley catalogue of the National Gallery of Art, now calling the painting *The Adoration of the Shepherds,* accepts the ascription to Giorgione, at the same time listing among five dissenters Professor S. J. Freedberg, who opted for early Titian in his 1971 *Painting in Italy, 1500–1600,* and Ellis Waterhouse, who,

in his Glasgow lecture in 1973, disregarding Berenson's altered opinion, declared, "I agree with Berenson that Titian must be responsible for the picture."

Ironically, in the midst of Berenson's dispute with Fowles and Duveen, Samuel Kress came up to Consuma to keep the appointment which Sir Joseph had proposed the year before. Bernard reported to Mary that bachelor Kress drove up in his private car accompanied by "a *femme du monde* . . . a well-groomed hard lady of fashion, who was obviously running Kress. . . . In the course of our talk, Kress turned out to be the easiest of rich men to deal with." It was his "clever and attractive" companion, as John Walker has noted, who had "brilliantly" devised for Kress the hobby of collecting Italian art and in the 1920s had put him in touch with the recently ennobled Florentine collector and dealer Count Contini Bonacossi of Florence, from whom he made hundreds of purchases. The friendly acquaintance between Kress and Berenson begun with their meeting continued for many years and drew in his brother Rush. Shortly afterward Kress sent photographs of the paintings in his collection for Berenson's attributions, a noncommercial chore that Berenson was always willing to perform for private collectors and curators since he thereby increased his own great study collection. Amusingly enough, Walker was present while Berenson was examining the photographs and was able to astonish Kress with the accuracy of his attributions when Kress showed him the paintings in their shadow boxes in his two-story penthouse in New York.

Berenson went up to Vienna for medical treatment in the late autumn. During a two-month stay he passed much of his time in frequent consultation with the famous laryngologist Dr. Heinrich von Neumann in the treatment of his "hereditary catarrh" and "four hours a day" with a dentist who looked after his abscessed teeth and initiated him into the humiliating ordeal of old age—being fitted with false teeth. He was spending, he said, more than $5,000 on medical fees.

Fortunately there were agreeable distractions of an evening. He sat through five hours of *Parsifal* without "a moment of boredom." And after a performance of Beethoven's *Missa Solemnis* he renewed acquaintance with the conductor, Bruno Walter, and his Jewish wife. He felt especially at home with Franz Werfel, whom he loved, he told Senda, "almost as much as I love Walter Lippmann, or Prince Paul, or Johnnie Walker. He is a man appealing, eloquent, deep, and human, and so tender . . . a deeply religious person, though practising no cult and not satisfied with my Nirvana." He thought him after Thomas Mann "the finest writer in German now living." He visited also with his "very great friends, Count and Countess Carl Khuen Belasi," but their approval of

fascism considerably tempered his pleasure and finally was not to be borne.

It was while he was in Vienna that he learned of his election to the American Academy of Arts and Letters. The news came in a letter from his cousin Arthur enclosing a clipping from the *New York Herald-Tribune*. The honor gave them all a chance, Arthur said, to bask in reflected glory. Arthur was disappointed, however, that Harvard had yet to bestow recognition on him.

Still deeply resentful of Sir Joseph's "betrayal," Berenson sent from Vienna to Royal Cortissoz a defense of his attribution to Titian of the Allendale painting: "You are acquainted of course with the Allendale picture, one of the most fascinating Giorgionesque pictures ever painted. The problem of how to attribute it has preoccupied me for many years. I naturally left no name untried. Finally, some ten or twelve years ago, the light dawned upon me, and I began to see that it must be Titian's, perhaps his earliest work, but only half out of the egg, the other half still in the Giorgionesque formula—the landscape, namely. Recently I have seen the picture again and was in raptures over its enchantment and beauty. And yet the longer I looked, the more and more I saw in it the emerging art of Titian. It is my deepest conviction that this attribution will ultimately win through." Cortissoz had recently reviewed the Richter and Phillips books on Giorgione in the *New York Herald-Tribune*. Now, in "Giorgione Again," inspired by Berenson's letter, he returned to the problem and quoted the passage from Berenson's letter describing how he had arrived at the attribution to Titian.

Berenson wrote also to Duncan Phillips. "I am convinced," he said, "that I could persuade you that though the Allendale picture is as Giorgionesque as you please, it has no touch of Giorgione's own hand. . . . My proofs? They are in my own head . . . [and] cannot easily go into words, for they come from that sixth sense, the result of fifty years' experience whose promptings are incommunicable." He then "buttressed" that intuition with five pages of detailed analysis, concluding, "If we wish to confine ourselves to what will be universally accepted, let it be 'School of Giorgione,' or, as I hope will in the long run win through, 'Titian E[arly].' "

When Cortissoz sent him a copy of his article "Giorgione Again," Berenson cabled his gratitude and followed the cable with a long letter reporting that Phillips had explained to him that since the Mellon Trust already had at least three Titians, it would be difficult to persuade them to get another. "Therefore he wanted to drag in the name of Giorgione somehow." In effect he had asked Berenson's consent to "present the picture as by Giorgione—no matter how little Giorgione—and Titian."

A week later, while still brooding over the matter, he again wrote to Cortissoz, enclosing a copy of his response to Phillips and explaining that he had written him with the "hope of turning him away from the idea that the Allendale picture was 'somehow' in the Pickwickian sense vaguely Giorgione's—nowhere in particular but all-overish as it were."

In the last days of December 1937 Fowles sent the wish that his new leisure would permit Berenson to devote his time and energies to his "Great Task," the book that would be the summing up of his career. He felt confident, he wrote, that "our future relations, which have all these years been so cordial—thanks to your sincerity and impartiality—will continue . . . friendly and beneficial to us both." Change was already in the air. Louis Levy wrote that Berenson's request to have the remainder of his claims paid to him fitted in with "the plan of liquidation." The liquidation would take place in May when the firm's charter expired, and Duveen, because of his declining health, would become an employee of the new corporation. The payment arrived in February and at last closed his old account with the firm. Official announcement of his resignation having been delayed, the accounting department had deposited a $10,000 retainer fee in March of 1938 at Baring Brothers. The refund was duly arranged.

Lord Duveen died in New York in May 1939, a victim of cancer. What Berenson's private feelings were appear to have gone unrecorded. One can surmise that they may have been as ambiguous as those of "a famous rival dealer" who said, "We miss him, but we are glad that he has gone." He sent a letter to Fowles, who replied, "I very much appreciated your beautiful letter of sympathy. It was really very painful for me to see that wonderful vitality and exuberance which we all appreciated so much gradually fade away. Armand and myself hope to continue on the same lines of business and it will not be easy at the commencement as business is very poor everywhere." Berenson's sense of grievance against Sir Joseph ran deep and he never forgave him or Levy. As a very old man he wrote in his diary, "If Duveen abetted by his lawyer had played fair by me I should have at least double the capital I now have. I should be able to endow I Tatti as I hoped to do instead of leaving it perhaps a mere library and not the lay monastery for leisurely culture that I dreamt of."

Negotiations for the acquisition of the Duveen firm by Armand Lowengard, Edward Fowles, and Bertram Boggis began by May 24, 1938, and the purchase was completed before the end of the year. By 1958 Fowles had bought out his associates. Six years later, at the age of seventy-nine, he sold the entire collection in the gallery, valued at fifteen million dollars, to the Norton Simon Foundation, together with the five-story mansion in which it was housed.

[439]

XLIII

The Drawings Revisited

THE "Great Task," the book on decline and recovery in art, grew more formidable as its compass widened, and Berenson's pen flagged; he reread what he had written, and though there were passages that seemed to say what he wanted, he felt unable to go on. "My wife is tearing it all to pieces," he told Dan Thompson. "She is amazing. Here she is too ill, poor dear, to do anything but play patience and read detective novels. Yet she pounces on my manuscript as she used to do in her past and most ferocious years, so in the course of demolition displays a mental energy, acumen, and subtlety, simply amazing." As for his own health, he ruefully wrote his mother, "I have become a barometer, but a suffering one and I ache in all my bones when it is cold and damp. Just now I ache dreadfully in my *false teeth*."

When he rescued his manuscript from Mary, he returned to "dribbling out every day a few lines. . . . I dare not re-read. I dare not reflect,—I write putting down what passes through my head." No longer obliged to render opinions on potential acquisitions for Duveen, he found himself almost burdened with freedom as he sought to marshal his reflections on art. Patently on the defensive for his view of art study, he tended to lose himself in prolegomena.

The fragment of manuscript which survives from 1938 shows him returning to the thesis with which he concluded *The North Italian Painters of the Renaissance* in 1907, where in a final section, "The Decline of Art," he had theorized that Italy was the only country where the figure arts, especially in painting, had passed "through all the phases from the imbecile to the sublime . . . and back to a condition" of "essential barbarism." What marked the stages of decline and recovery was the absence or presence of the "ideated sensations" which communicate "a direct effect of life-enhancement."

Decline and recovery in the figure arts, he now believed, was a universal process, but he proposed to limit his study to "the twelve hundred years or so of European art, extending from Constantine the Great to Charles V" because the history of that period was "more generous in the quantity as well as the quality of the materials offered." The plan of the book, as he envisioned it, called for the study of the following elements of the "overwhelmingly anthropomorphic" art of those twelve hundred years: "1. Anatomy, 2. Proportion, 3. Modelling, 4. Functional line, contours, 5. Tactile values, 6. Draperies, 7. Action, movement, gestures, communication of energy, 8. Lifelikeness, 9. Expression of head, face and figure, 10. Perspective, space, 11. Composition, 12. Color."

As he slowly proceeded with the writing, he felt more and more driven to explore the aesthetic, ethical, and historical premises which lay back of his analysis. What indeed was Art, to which he had devoted his life? What were its humanistic values? What had motivated his avid study of ancient art for so many years and inspired his wanderings among the ruins of Egypt and the Near East? These were reflections that pressed insistently for exploration. The challenge to turn inward, to make a searching examination of his own approach to art history, doubtless resulted from what he saw as a decadent movement in art history, the one espoused by Panofsky and his colleagues. Equally deep in his consciousness was his animus against the movements in contemporary art, the cults of primitivism, of cubism and surrealism, of abstract and nonobjective art.

His discursive essays trespassed on each other each time he returned to his desk. Thus the discussion of the Arch of Constantine as the paradigm of development with which he began the first essay gave way to the discussion of "aesthetics, ethics, and history" that was to preoccupy him until late in 1941. He had turned aside to that discussion, he afterward wrote, with the idea of writing "little more than a preface to a book on 'Decline and Recovery in the Figure Arts,' " but the thing ran away with his impatient thoughts and the preface became a book, *Aesthetics and History in the Visual Arts,* published in 1948.

As he struggled at his desk he drew strength from having young people within reach. Umberto Morra, Johnnie Walker, and the Italian writer Guglielmo Alberti all had the run of I Tatti, he said, as if they were his sons. He felt his mind was still keen and zestful, looking was a rapture, and reading "a voluptuous delight." Philip Hofer, a fellow book collector, came by with his wife. An assistant director of the Morgan Library, Hofer was about to take up his duties as curator of the Department of Prints and Graphic Arts at the Harvard Library. Their talk brought to mind again the desperate plight of the "refu-Jews," as Beren-

interested in the architecturally far more important Ponte Trinità, the bridge on whose artistic merits Kriegbaum was the leading authority. It was the Ponte Trinità that was subsequently dynamited by the retreating Germans while the Ponte Vecchio was spared.

On the way to Smyrna the Lloyd ship *Triestine* stopped at Rhodes, then an Italian possession, and the passengers went ashore to sightsee. As Berenson and Nicky were returning to the ship in the late afternoon, they were mystified to see the shops being closed and flags hung out. The mystery was cleared up at dinner when their waiter brought in for dessert "a huge chocolate cake decorated with a swastika in spun sugar." Asked to explain the reason for the embellishment, the waiter said in Italian, "Because to-day the Fuehrer arrives in Italy." Unable to contain his disgust, Berenson exclaimed in a shrill voice that it was a day of shame. The ship's purser at an adjoining table turned crimson, covered his ears, and left the table, "obviously in a rage." Nicky, fearful of the consequences, hurried after him. As he angrily paced back and forth on the deck, she shrewdly asked him whether his father was happy with what was going on in Italy. "As a matter of fact," he replied, "he hates it all." That concession was all she needed. "You cannot expect these older men grown up in a liberal tradition to approve the Fascist regime." Then she told him of Berenson's long devotion to Italian culture. As a result of her tact Berenson and the mollified purser had a friendly talk, and Berenson later sent him a copy of Cecchi's translation of *The Italian Painters of the Renaissance*.

At Smyrna Berenson was joined by his old friend the British diplomat Sir Robert Greg. Through his influence and that of the British consul general they obtained "a car, a driver, a truck, a Greek cook, tents, field-beds, provisions" and two Turkish boys for "all the rough work," and were off on a camping trip which thoroughly satisfied Berenson's "nomadic instincts." He wrote to his mother that they were to visit places "whose names have been ringing in my ears ever since school days, Sardis, Ephesus, Miletus, etc. etc. . . . We have already been to Pergamum than which there is nothing grander and more beautiful." He also took the opportunity to ask her to tell his sister Bessie that he had read most of Faulkner, that he liked *Pylon,* and that "she ought to read *Sanctuary* and *Light in August*." Age had not dimmed his liking for novels and he kept abreast of them in English, French, German, and Italian.

Camping in the back country reduced the party to rather primitive expedients: the limited supply of water had to be boiled and wayside shrubbery or ditches "made the necessary retirements quite easy." In the mornings Nicky would first go into "B.B.'s little tent and find him generally awake with a white knitted cap on his head and ready for a cup

of tea." The change from the ordered luxury of I Tatti to the regimen of the camp seemed, oddly enough, to have invigorated him. He had had a wonderful time, he said, in Lydia, Caria, and their Greek cities, "scarcely one sight meeting our eyes that Hammurabi or Sesostris might not have seen," the ruins "beggaring for splendor everything one sees in Italy." By comparison "Rome in its greatest moment must have looked small and provincial." It was a journey that would swing his imagination into ever-widening circles when he returned to his manuscript on decline and recovery in art.

On their way back they stopped for a day at Istanbul, and Berenson wrote to Louis Gillet of his shock at the signs of neglect and decay in Santa Sophia. "This noblest temple in Christendom, this house of prayer and uplifting of the soul to God under no matter what appellation, this space which has been filled with the audible yearnings of millions of hearts, has been reduced to a garish, shabby, empty, 'Muze.' " He urged Gillet as a distinguished publicist to write to the president of the new Turkey, Mustapha Kemal Ataturk, to restore the edifice to worship, "whether to Mohammed or Christ."

They returned to Italy on June 12, 1938, Berenson's mind filled with what he had traveled for, "sublime scenery and grand ruins, what fifty years of intensive art study have trained me to enjoy." He would now stay put for a while to digest what he had seen and "work on the book," so far as his duties as perpetual host permitted. One agreeable chore occupied him during a visit from Worth Ryder, a professor of art at the University of California at Berkeley, who had come to Florence seeking an art historian for his department. Berenson, whose antennae picked up all the scholarly vibrations in Florence, invited Walter Horn, a postgraduate student of Romanesque sculpture who was then studying the architecture of the Baptistery of San Giovanni, to dine with the visitor. "I witnessed," Horn recalled, "the unusual spectacle of someone at the table of Bernard Berenson—who usually absorbed all the possible conversation—captivating the party with stories of the Wild West." That Horn had been a devoted student of Erwin Panofsky in Hamburg did not seem to chill his friendly reception.

At Ryder's suggestion Horn emigrated to America. Panofsky, then in New York, arranged a few lectures for him that led to his being taken on at Berkeley. What he afterward said of Panofsky's lectures throws some light on Berenson's antipathy for the man's approach to art. "He would come into the classroom," Horn wrote, "never looked at the class, [and] opened the manuscript which he had carefully worked out at his desk at home. He never spoke a free word in the four or five years I studied with him, except of course in seminars."

[445]

recalled "those wonderful talks" that "you made possible for me with Beneš and yourself" back in 1918. Efforts in Breitner's behalf led to his appointment to the Claremont College graduate faculty in 1939.

While living thus at I Tatti in the delusively quiet eye of the hurricane that raged over Europe, Berenson received his author's copies of the three impressive volumes of the revised edition of the *Drawings of the Florentine Painters*. They were published in September 1938 by the University of Chicago Press and issued at the projected price of $25. The first volume contained the liberally annotated text, the second the much-expanded catalogue, and the third a gratifying thousand illustrations. The cost of publication was shared by the university's art department and the Carnegie Corporation. It was not a sumptuous publication like its folio-sized predecessor, but for the art student it was an edition that was a great deal more accessible.

The notes to the *Drawings* were liberally studded with his agreements and disagreements with the Teutonic scholars through whose tomes he and Nicky had diligently plodded, but what he gave with one hand he tended to take back with the other. He had to admit that they had made important contributions. He said, for example, that Dr. Anny E. Popp's "sumptuous volume" on the Medici Chapel, published in 1922, was "valuable for its reproductions, amusing in its reconstruction and teeming with suggestions" and that Dr. Popp had "occasional flashes of insight illuminating the obscure chronology of Michelangelo's drawings." And he conceded she had corrected his Michelangelo chronology. But he elaborately justified his earlier attribution of certain drawings to an assistant of Michelangelo whom he had chosen to name "Andrea di Michelangelo" against her ascription of them to Antonio Mini. In the same vein he said he regarded Karl Frey's monumental work on the drawings of Michelangelo as "indispensable" but warned users of it that the illustrations were "untrustworthy" and protested that Frey "in his text seldom quotes me correctly."

The three volumes of the *Drawings* reflected the maturing and revision of many of Berenson's judgments. One of the most important alterations occurs in his treatment of Verrocchio: he replaced an entire chapter with an article he had published in 1933 in which he set forth his view of the correct relation among Verrocchio, Leonardo, and Lorenzo di Credi and indicated a significant number of changes of attributions. With disarming frankness he explained that the chapter he was replacing was written fully thirty years ago, "when I had not yet found myself and could defend conclusions the more vehemently the less they were my own, taking refuge in hypercriticism from timidity and uncertainty." Among works which he had once attributed to Verrocchio and now gave to

Leonardo were the Florence *Annunciation,* the Liechtenstein *Ginevra de' Benci,* and the Munich and Benois Madonnas. In the general introduction to the first volume he warned that in the matter of attributions "the ultimate appeal is to our feeling. From that responsibility, no mechanical test, no material consideration, no peering in looking glasses, magical or not, can save us."

Twelve of the fifteen articles on the drawings of various Florentine painters which Berenson published between 1932 and 1935 went into his revised text and the remaining three into the appendixes. The extensive new notes, added in brackets, provided a running commentary on his many changes of opinion as well as a critique of the judgments of later writers. He did not, after all his anxious reconsideration of it, rewrite the chapter on Michelangelo, though he added a prefatory warning to the reader on the uncertainties in which the subject was mired. He included in his discussion of the followers of Michelangelo a section on Raffaello da Montelupo because, he explained, no other artist, except Sebastiano del Piombo, "was the author of so many drawings still ascribed to Michelangelo."

Perhaps the most heartwarming letter of congratulation to come to Berenson upon publication of the *Drawings* was the one from Kenneth Clark. "It is with a real pang of emotion," he wrote, "that I have unpacked and opened the volumes of the Florentine Drawings. They are intimately connected with the whole of my life: with my early ambitions and my first apprenticeship, and also with a good many regrets at the later course of my career. For all these reasons I needn't tell you how touched I am by your reference to me in the introduction [preface]; and I am almost equally delighted by what you say about my Windsor Catalogue [*Drawings of Leonardo*] in your second volume. The work I did on the Leonardos was the direct fulfillment of my apprentice work for you and so is my best contribution to your great work." In citing Clark's *Catalogue of the Drawings of Leonardo da Vinci in the Collection of His Majesty the King at Windsor Castle* Berenson had noted that the "introduction is informing and delightful and the catalogue all that a catalogue should be." Clark spoke also of his recent visit to I Tatti. He enjoyed it, he said, as "a period of tranquillity and rational discourse. Much as I enjoyed the landscape and the library, it was your company, dear B.B., which was the real joy of our visit. . . . There was a flow of reason and learning combined with a genial warmth which made me feel I was living in a golden age of culture, a sunset of culture no doubt, but none the less beautiful for that."

As an American publication the revised *Drawings* somehow escaped review in both England and France—possibly review copies did not go

abroad—but it was enthusiastically noticed in art journals in the United States. Frank Jewett Mather, Jr., reviewing it in the *Art Bulletin,* pointed out that the 1903 edition had effected the first "wholesale purge" of the subject and was "perhaps the most important book on Italian art that has appeared since the twentieth century opened," marking "the tardy coming of age of . . . one whom we had supposed to be only a connoisseur." A. Hyatt Mayor in the *Magazine of Art* found the new portions "even more charmingly written than the old ones" and the revision of the text "most interesting where Berenson's admirable candor has allowed his early opinion to be printed beside his present reservations or flat contradiction." Royal Cortissoz' long review in the *New York Herald-Tribune* illustrated the intellectual riches of the volumes with telling passages of Berenson's "clairvoyant" analyses. "What unifies the entire work," he said, "is Berenson's central flame of ardor and devotion, his rich store of knowledge and his sheer critical genius."

A tribute in *Time* magazine accompanied by Berenson's portrait described him as the "greatest living connoisseur of Italian art" whose . . . life has been such a courtship of opportunity by intelligence as only the Melting Pot is supposed to produce." Berenson was now at work, the reviewer reported, on a book "which art scholars regard as about the most monumental thing since Gibbon's *Decline and Fall of the Roman Empire.*"

The passage of years confirmed the high opinion of the work. In 1955 Adrian Stokes declared in his *Michelangelo* that Berenson "brought order to Michelangelo studies." In 1968 an Italian version of the *Drawings* was issued, prepared by Berenson's gifted disciple Luisa Vertova Nicolson, with the assistance of Nicky Mariano. In 1970 the University of Chicago Press reprinted its volumes in a "Collector's Edition." The London *Economist,* using a comparison that would have gratified Berenson, assured its readers that "the memory of Renaissance painting owes more" to Berenson "than to any other man since Vasari."

XLIV

Toward the Abyss

THE satisfaction Berenson may have felt at having finally put the revised *Drawings* behind him was obscured by his anxieties about the future of I Tatti in an increasingly destabilized Europe. After Munich he sardonically commented, "So Hitler's house will not only be painted pink [on maps] but it will be enlarged thanks to Clemenceau, Poincaré, Lloyd George, and Wilson." With growing fatalism he declared that even if Italy went in with Germany, he would prefer to stay on his Tuscan hillside. At the same time he acknowledged to Paul Sachs that "the rising tide of anti-Semitism may reach me and sweep me out of Italy."

For the first time anti-Semitism had a personal implication. Under pressure from Hitler's Germany, Italy had recently adopted laws restricting the ownership of property by Jews of Italian nationality and, as an embassy subordinate cabled Ambassador William Phillips, who was absent in Washington, there was a possibility that "provisions of a similar nature may be extended to foreigners of Jewish origin owning property in Italy." The cable continued, "After discussing the matter with Berenson it was thought that you may wish to talk over with the authorities of Harvard University the suggestion that the Corporation might take over the property at the present time and permit Mr. Berenson to keep a life tenancy." Ambassador Phillips wrote to the Italian Foreign Minister, Count Galeazzo Ciano, to learn whether the proposed transfer, which had been approved back in 1932, might still take place. Ciano replied in March 1939 that there would be no obstacle to the transfer.

John Walker interviewed President James Bryant Conant in Cambridge and came away with the impression that "some such scheme could be worked out." Thus reassured, Berenson sent an itemized statement to Sachs showing that $40,000 a year would be needed to run I

Tatti and meet his private expenses. He said he would have no objection to Harvard's taking over his American investments for the purpose, provided that he would be assigned "the same income I have now," as he no longer earned anything, having "ceased relations with Duveen." He also forwarded to Sachs a copy of his will, drawn up in 1928, which provided a substantial number of generous annuities to his multiple dependents.

The discussions moved along without any serious hitch, but alarming European events moved faster. Madrid fell at the end of March 1939 and a triumphant Franco joined the company of Fascist dictators. With Spain secured among his friends, Hitler was free to turn his talents to other ventures in aggression. Flouting his previous assurances, he invaded the remainder of Czechoslovakia, and Mussolini, not to be outdone by his German colleague, occupied Albania in April, making the Adriatic an Italian lake. In May 1939 Italy and Germany signed a mutual defense pact. On the other side of the globe Japan, having driven Chiang Kai-shek to Chungking, was attempting to consolidate its position in China and was making friendly overtures to Germany.

There was reason for Berenson to fear that Harvard had become "lukewarm and perhaps frightened" by the rapid march of events. "They may not like the responsibility in this historical horizon," as he put it to Philip Hofer in April, "and they may not see much advantage. Of course I think differently. My library and my place could and should form an ideal centre for the mature and really intellectual study of the whole Past of Art." Even if war were to come, it should be borne in mind "that French, Spanish, and German institutions have weathered wars and centuries."

Despite the assurances of the Italian government, Harvard seemed to temporize, but at last on July 6 William Claflin, treasurer of Harvard, sent on a document that he and Berenson's cousin Lawrence had drafted in which Berenson agreed to convey I Tatti to Harvard subject to the life tenancy of himself and Mary, together with $700,000 in securities—"substantially my entire means of support"—as an endowment to provide up to $20,000 for the upkeep of I Tatti and $20,000 a year as an annuity to Berenson. How far money could be made to go at that date can be gleaned from the statement of expenses Berenson prepared. The yearly flood of books and periodicals and binding came to $5,000. The librarian (Alda) and two secretaries accounted for $4,000. Egbert Anrep's salary as general manager was $1,000. The farm manager got $450. Taxes on the whole estate amounted to $750.

Lawrence, who understood Bernard's hopes for his Institute, saw to it that the document included a statement of Bernard's vision of the future

of I Tatti. The statement read in part: "My primary purpose in making this gift . . . is to further, under the supervision of the Department of Fine Arts at Harvard, research and education in Italian art and in the Mediterranean culture as centered in Italy and focused in Greco-Roman-Byzantine-Italian art, along the lines to which I have devoted my life . . . to provide facilities . . . for those who wish to study art visually rather than the technique of its creation. . . . I do not mean it to be a work-shop for the petty and parochial study of Italian art. . . . I should wish these students to have the privilege of dividing their time between travel and residence at I Tatti."

Once submitted to Harvard, the proposal had to be reviewed by the corporation. In the interval Berenson occupied himself with his usual pursuits. His life was lived with the same kind of fatalistic acceptance that villagers have on the slopes of Mount Etna. Americans flocked to Europe until late summer; neutral Italy and Switzerland remained completely accessible through 1939. All sorts of interesting visitors had ushered in the year. William Milliken, the director of the Cleveland Museum of Art, was an early visitor. Arthur McComb, a Harvard graduate and gifted art critic, came and vanished "like a ghostly apparition." Kenneth Clark, now an important figure in the international museum world, came down with his wife for "a good visit" for the first time in years. Berenson wrote his sisters, "I feel proud of him as my pupil." John Walker was still based in Rome as assistant director and professor in charge of fine arts at the American Academy, and his schedule permitted frequent visits to I Tatti. He had been in Rome for four years, occupied in part with the agreeable task of taking the Prix de Rome fellows about Italy in a bus and talking to them about art and architecture. Now on August 1 he was to take up his new duties as an executive officer and chief curator of the National Gallery of Art in Washington. Berenson enjoined him to write once a week.

Gossip of the American art world—especially gossip about the Fogg—continued to come in from Berenson's well-disciplined correspondents. Possessed by his maggot, he taunted Mrs. Barr that Wilhelm Koehler, professor of fine arts at Harvard, was getting more and more things into his own hands "just as if he were a Jew and not a mere German." From Ben Nicholson, now at the Fogg, he received refreshing word: "I cannot describe to you how happy I am to be in Cambridge." Although Ben did not quite hit it off with Professor Sachs, he admired him immensely, and as for Edward Waldo Forbes, he thought him "one of the most honest persons" he had ever met. Ben's father, a member of Parliament, who was busy lecturing in the United States on "peace with honor," sent Berenson an excerpt from one of his son's letters with the thought that it

before the advance of Franco's rebels. "All the Velasquez are at the show," he wrote to Mary at Haslemere, "and hold their own more than ever, the Grecos less than ever." The great drawback at Geneva was that the crowds prevented a suitably long look at any one picture. Fowles, with whom he continued to exchange friendly letters, promised to tell him how the Spanish art treasures had been spirited out through the initiative of painter José Maria Sert, Lord Duveen, and David Weil, assisted by the directors of the French national gallery. Prince Paul, who was also at the exhibition, believed a general European conflict was inevitable, and he made a point of urging Berenson not to return to Italy. Berenson was not to be dissuaded.

On his leisurely return Berenson spent a few days at Don Guido Cagnola's luxurious villa near Varese and then paused at I Tatti only long enough to collect his impedimenta for his regular stay up at Casa al Dono. Letters concerning the planned transfer to Harvard had continued to fly back and forth. One had suggested that since his proposed annuities would require additional capital of $200,000, he should sell some of his works of art. Disturbed by the painful suggestion, he protested, "I can do no such thing in my lifetime."

The array of annuities in Berenson's will which were to be a charge upon the proposed gift must have seriously disturbed the Harvard officials, who could foresee a lengthy and troublesome administration of the estate. Lawrence Berenson was thus obliged to come over from the United States to work out the terms of still another arrangement. The plan for a transfer was now made contingent upon the raising of a fund of a few hundred thousand dollars to take care of the annuities. A new will executed at the same time bequeathed the estate to Harvard. The result was that I Tatti was not to be handed over to Harvard at once and possibly not even in Berenson's lifetime. On the thirtieth of August, two days before the blitzkrieg, Berenson wrote Walker, "Perhaps even as I write the dogs of war are loose."

Life on the heights among the pines came to an abrupt end upon the outbreak of war. The storm signals had gone up on August 21, when Moscow announced the signing of a nonaggression pact with Nazi Germany. On September 1 the German Luftwaffe, which had tested its dive-bombing technique in Spain, swarmed into the Polish skies, while below the flame-throwing tanks roared across the border and the world beheld the fantastic spectacle of Polish cavalry overwhelmed by the onrushing armor. Two days later Great Britian and France, uncomfortably bound by their treaties, declared war on Germany. For the moment Italy, busy with its imperial role in Albania and Ethiopia, professed neutrality.

Gasoline became the first casualty in Italy. Private cars were ordered

off the roads after September 3. Berenson hurried down to I Tatti, where the unnatural silence, beautiful and serene, seemed to him like the calm in the center of a hurricane. "I try to be resigned," he said, "and half succeed." With his Fiat immobilized, he summoned a public taxi to take him into the hills for his daily downhill stroll, until the restriction on gasoline was partly lifted a month later. Mary, in England, was at least out of material danger. Bernard heard of no one in Florence who wanted to "join the Boches" except the rabid anti-Semite Senator Giuseppi della Gherardesca and his flock who congregated at Doney's fashionable tea-room. As the spiritual head of the Italian anti-Semite party, Gherardesca, the former podestà of Florence, kept a malignant eye upon Berenson, whose anti-Fascist sentiments were well known to the Florentine Black-shirts.

The shortage of gasoline was soon followed by shortages of tea and coffee, and a shortage of winter fuel loomed, but actual privation was still far in the future. The exodus of foreigners began, and by mid-September only thirty-eight Americans were left in Florence. Samuel Kress came up to I Tatti a number of times during the autumn and talked about his donation to the Mellon gallery "and all its implications." Knowing of Walker's particular interest, Berenson wrote him that Kress "is kindly, affectionate, brotherly, but still full of suspicion in the wrong place and utterly gullible with foreigners." Berenson had in mind especially Kress's attachment to Count Contini Bonacossi, from whom Kress had already bought a large number of paintings. "I mentioned that the Cook collection was for sale and he recoiled as if I was assaulting him."

The military campaign in Poland took scarcely a month, and the mortuary peace of Warsaw descended while Germany and the Soviet Union arranged the partition of Poland. Once again Europe enjoyed a breathing spell, and travelers in the still neutral countries attended to their usual chores. Berenson went up to Venice at the end of September to see the Veronese exhibition and to say farewell to his old friend Addie Kahn, who was about to sail to Egypt. The exhibition, which he thought "better than its reputation," confirmed his conviction that Veronese was "one of the few greatest painters of all time."

During his stay in Venice he encountered by merest chance a fellow expatriate whom he had not seen for years, an elderly man concentratedly enjoying his food at a nearby table. It was George Santayana, his face and figure broadened out since Berenson had last seen him. They met on two occasions and each promptly recorded his doubtful pleasure in the reunions. Berenson looked him up at the Danieli Hotel and found him peering at a book through a magnifying glass. "We talked for an hour and a half chiefly about himself," he told Mary. "The impression he

were too enveloping, the modelling too *searching* for Castagno." "Connoisseurship is an art not a science," he concluded. Near the end of his life Berenson returned to the Castagno attribution, the attribution that had been maintained at the National Gallery of Art.

As the war fever in Italy intensified and guns took priority over butter, Berenson began to burden his letters to America with pleas for tea and coffee. On one to Walker, Nicky annotated, "Coffee is more urgently needed than tea at present!" Fowles wrote from New York that Kress "had done all he possibly could to ensure your general comfort during these exceptional times." He also reported that Armand Lowengard had joined his regiment, presumably at the still undisturbed Maginot Line, and having become partially paralyzed from exposure, had been invalided back to Paris, where he carried on the much-diminished business at the Duveen Gallery in Paris with the residue of stock. The more valuable objects of art had been shipped to America.

For all Berenson's resolution to stick out the deepening crisis in Italy, he busied himself with exploring alternatives, including possible residence in Switzerland. Ambassador Phillips came for a weekend in mid-November to go over the situation, and a week later Bernard and Nicky descended again upon Rome, hungry for the latest political news. They divided their time between diplomatic and artistic circles and made repeated visits to the Vatican galleries. They returned to an altered Florence. A great many of Berenson's Italian friends, caught up in the patriotic fervor of the Duce's imperial vision or fearful of being branded anti-Fascists, stopped coming to I Tatti. "Our world is reduced," Berenson informed Henry Coster, who had left for the United States. There was "scarcely a sign of the 'High-life' " which "meets daily at Doney's to hear G. Gherardesca read out passages from divers books tending to prove that Jews are 'sub-human' and must be wiped out."

Berenson was comforted to learn that his friend Doro Levi, who had taken refuge in America and on whose behalf he had been active, was to give a lecture series at Harvard. Berenson was one of the persons financing the series. At the moment Levi was at Princeton, where Berenson thought he was too much with his "fellow refu-Jews in their concentration camp" at the university. Levi was to hold lectureships but not appointments at both Princeton and Harvard until 1945. After the war he returned to Europe to become director of the Italian archaeological school at Athens.

Berenson's world at the opening of 1940 was indeed reduced, but far greater isolation was in store for him. The tightening net still had a few openings and, despite delays, letters still got through. Among his English friends the absence hardest to bear was probably that of Trevy, who

for more than forty years had been one of the most welcome of guests and one of the most patient critics of Berenson's prose. In default of himself he sent a copy of *The Abinger Chronicle* that featured a long poem "To Bernhard Berenson." It ended with the lines:

> But most I wish myself with you
> Dear friend, amid those cypress-wooded hills that mount
> Beyond Vincigliata and quarried Ceceri
> To where by San Clemente we so often have seen
> Tuscany spread its grave and gracious landscape out
> From Vallombrosa to the far Carraran peaks.
> A vision of enchantment, a delight more deep
> Than ever elsewhere spirit or sense may hope to know.

As noncombatants Americans could still travel. One newcomer who made a favorable impression on Berenson turned out to be Robert Berenson, one of his American second cousins. Only twenty-six, Robert was the European representative of the Grace Lines and already an important figure in the shipping industry. His next visit to I Tatti, four years later, would be as aide-de-camp of General Mark Clark. Among the few other callers that season were Natalie Barney and her longtime lover Romaine Brooks. They had taken up residence in Florence in the Via San Leonardo for the duration of the war. Natalie, now a venerable sixty-three, still had traces of the beautiful poet who had once bewitched him. She was still "the Empress of Lesbos," he declared to Clotilde, "so enchanting that I forgive myself for having been so much in love with her more than twenty-six years ago. And she would have returned my flame had I not been—as she discovered to her horror—a male."

Myron Taylor, President Roosevelt's personal representative to the Vatican with the rank of ambassador, had a villa in the vicinity of Florence and continued to be a welcome guest at the Berenson table. Ambassador Phillips and his wife came for a stay in the depopulated spring season and were soon followed by Walter Lippmann, who, recently divorced and now married to Helen Armstrong, was making a last reconnaissance with Helen in Europe. His visit was followed by that of Dorothy Thompson, a newspaper columnist whose crusade against fascism in the *New York Herald-Tribune* and on the radio had earned her the title of "First Lady of American journalism." Handsome and vitally feminine at forty-seven, she swept in upon Berenson with a certain brashness, as she afterward reminded him, just up from her interview in Rome with Pope Pius XII. Without her saying so the pope had noted she was a Protestant. "Why? Because I didn't kiss your ring?" she had asked. "No," he replied, "because you have such faith in the limitless power of

culture group . . . with no regard for their private interest and the common good of us all. . . . It is hard to reason myself out of the fear," he reflected, "that I am merely an affectionate, caressing creature, satisfying a need almost psychological, rather than a person with a heart."

He had been charged with paying too much attention to women. In his defense he said, "My kind of person turns to women, surrounds himself with women, appeals to women, not in the first place and perhaps not at all for reasons of sex . . . but for the one deciding reason that women, especially certain society women, are more receptive, more appreciative, and consequently more stimulating."

He recalled the "doubts, hesitations and despairs" about his writing. Was it not because he had been born to talk and not to write, "to converse," in fact, "rather than talk and then only with stimulating interlocutors"? He could scarcely recall when he had not deplored the inadequacy of words to communicate what he felt, or thought, or even knew. As a result he always "scribbled" with the idea of helping himself to find out what he was thinking, addressing himself to an "internal interlocutor," and had not disciplined himself to marshal his arguments "in the most effective, the most persuasive and most memorable way."

It was the inner self to which his introspection kept returning in his voyage of self-discovery, as in his meditations on his philosophical and religious beliefs. No passage in the *Sketch* so thoroughly exhibits the aesthetic core of the "humanism" which he professed as his attitude toward Christianity and the Church. He looked back with homesickness, he said, on the "magical world" created by Israel, Greece, and Rome, a world to whose myths and rituals he could not return "any more than one may creep back into one's mother's womb. So I regard myself as a Christianity graduate in the sense in which I am a college graduate." Though there was much on the theological and institutional side of the Holy Church which was distasteful, though as a historical entity it had been "subject to the frailties, greeds, and lust of the individuals who through the ages have composed it," it was for him "humanity's grandest, completest and most beautiful achievement." Shorn of its theology, its myth, and its ritual, the Church remained the mother and nurse of art.

As a graduate of both Judaism and Christianity, he felt, he was still the religious person he had always been, "concentrated and intensified" in his faith: "Faith in IT, and faith in humanity." "IT," he explained, is "every experience that is ultimate, valued for its own sake. IT is the moment to which like Goethe one can say, 'Stay, stay, thou art so fair,' " except that he had not asked such epiphanies to linger because he knew they would be followed by others as beautiful. For his first thirty years,

he said, "almost everything that meant anything was IT." Then he was pushed out of Eden to join men and women who "were inevitably doing something for the sake of something else." But now at long last he has returned to his "long interrupted ITness"; experience and age have enriched it with "an awareness, an understanding, a gratitude, a joy" not open to the young. To extract from the chaotic succession of events in the common day "what was wholesome and sweet, what sustained and fed the spirit," to live life "as a sacrament," was to make of life itself a work of art.

His was the enlightened Epicureanism that Pater had taught him, and he had clung to it with tenacity throughout his life. Its influence is implicit in all the analyses and observations of *Sketch for a Self-Portrait*. And in the epilogue he held to his faith, his hope to keep his "perception and judgment, to be supplied with creature comforts and to go on taking interest in events, enjoying books, enjoying art and music, but above all enjoying nature and people."

Soon after Berenson started writing the *Sketch* he began a companion enterprise, a diary initially recording his thoughts and impressions as a person isolated in wartime Italy. The first entry bore the date January 1, 1941. The last entry would be dated April 15, 1958. When word came to him on January 14, 1941, that his old and estranged companion Carlo Placci had died at the age of eighty, he turned to his diary to inscribe a long reminiscence. For ten days he looked back on the half century of their close and sometimes troubled friendship.

Berenson felt bitter that Placci had avoided I Tatti following Italy's declaration of war on France the preceding June, especially because Placci's social existence had been so deeply rooted in French and English society. "Yet what other conduct could I have expected of Carlo Placci!" he reflected. "He was so completely socialized that death itself might have seemed preferable to being boycotted by the people in whose midst he was living." It was Placci who had opened up Florence to him in the early years of their friendship, and he freely acknowledged the social debts he owed him, but he also recalled Placci's illiberal and time-serving political opinions over which they had quarreled. He remembered him as an amusing and witty companion on many journeys who yet could be sarcastic and disobliging. Among his virtues was the fact that he was an accomplished "dilettante in music and a tolerable pianist" and man of letters. But the final impression that the desultory essay conveyed was that "dear Carlo Placci" was, as Berenson "saw him, put up with him, loved him, and to a limited extent knew him," an essentially superficial person.

Life went on almost serenely during the spring and summer of 1941

not to be molested. Later that day Mussolini issued the declaration of war against the United States, and a group of fanatical Fascists immediately stormed into the Florence police headquarters to demand Berenson's arrest. The unsympathetic assistant police chief infuriated the fire-eating delegation by waving Ciano's telegram before their eyes. Balked of their prey, they left breathing vengeance against Ciano.

Trying to understand Gherardesca's zeal in leading the cabal against him, Berenson recalled that the Florentine had been the commissioner of Florence when he had refused, under the threat of condemnation proceedings, to sell the strip of land needed to widen the road, the strip that later, repentant, he had given to the city. He assumed that the patriotic commissioner had never forgiven him. The chief charge against him now, he said, was that he was "debauching the snow-white lambs of his fold" so that "instead of being inculcated with the teachings of Hitler and Rosenberg they may imbibe the 'Judeo-demo-plutocratic' milk of humaneness."

Berenson began the new year of 1942, as he wrote in the diary, "as a civilian prisoner, in this Italy where I have resided for fifty-four years. . . . Of all the improbabilities that could have been suggested when I first trod its earth in September 1888 none would have seemed more fantastic than that in my lifetime Italy would be at war with the United States. . . . Yet here we are and here I am . . . despite orders from Washington, prayers of friends at home, and the warnings, the urgent advice of people devoted to us here." Setting aside the material considerations for his remaining in Italy, he noted three "spiritual" reasons for staying: he had become so identified with the "humanized majority of Italians" that he could not bring himself to desert them in this trying time; if he left Italy he might be obliged to serve against it (this he thought the determining factor); and he was filled with curiosity to see whether the Italian people would treat him (as he believed they would) "as humanely as possible."

For him as an official enemy alien, life became increasingly circumscribed. Advancing age too was taking its toll. His daily walks were shortened, though his lyrical response to the Tuscan landscape at each turn of the road was undiminished. Sometimes on his walks he encountered a contingent of tall British prisoners shepherded by their diminutive captors, but all converse was forbidden. Often he now chose for his walks the bosky paths around the secluded laghetto above I Tatti where Mary had once disported herself in the shaded pool with Gertrude Stein and other women friends. Mary, now long inactive, had settled into the life of a semi-invalid and passed her days working on a biography of her daughter Ray.

Berenson's writing—the *Sketch for a Self-Portrait* and the diary—was,

next to his insatiable reading, his chief literary employment. In the diary he penned soliloquies often touched off by the book at hand. As he put down Herodotus, for example, he wrote that he was impressed by the striking parallel between "the present war and the war with Persia": the Persians sought to impose their new order over all of Asia as the Nazis desired to dominate Europe. He also began to keep a journal record of his reading, in which he scrupulously noted his reactions to the books he read or listened to each day. The extraordinary scope of that record struck him afterward as being sufficiently arresting to warrant publication of the entries for 1942, a task which he undertook in his ninety-fourth year in a volume ironically titled *One Year's Reading for Fun.*

Day after day, without a break, Berenson went adventuring among the books in his library. "I read," he explained, "in the first place to feed a ravenous curiosity not unlike the thirst of Münchausen's horse, insatiable because the rear half had been shot away, and there was nothing to retain what poured through his mouth. Then I read for sheer entertainment: verse, prose, narrative of all kinds. . . . Finally I read books that, as I peruse them, stimulate my own thinking, interrupted by much woolgathering, musing, and sheer idling."

The daily records of his reading are generally brief, rarely more than a hundred words. The entry for January 4 is typical of the hundreds that followed: "4 January, Glanced as usual at the Vatican sacristy sheet known as *Osservatore Romano,* and at *Deutsche Allgemeine.* Mary read aloud political article in November *Atlantic*—the last we shall see for the 'duration.' Mary again after dinner, Ranke on papacy at turn of the eighteenth century. Nicky, more Tarle, still Russian campaign. By myself many pages of Suarez's *Briand,* about Briand's visit to Washington. French seem incapable of understanding anything Anglo-Saxon. Nothing more remote from what I know of A. J. Balfour or [Charles Evans] Hughes than Suarez's attempt to characterize them." So the entries in his diary and his journal run their antiphonal way, the one tracking the ceaseless course of his introspection, the other carefully inventorying the print on which he fed and the innumerable writings they called to mind.

In June of 1942 when the American embassy staff was about to leave Italy, the chargé telegraphed the Berensons to join them. Berenson declined, insisting that their age and health stood in the way and pointing out that neither Mary's nurse nor Nicky would be permitted to accompany them. Though Berenson's decision had earlier been approved by Ambassador Phillips, it apparently earned the chargé's animosity, for Berenson's reputedly ample dossier in the State Department is said to contain, among other unflattering accusations, the charge of both "premature anti-Fascism" and collaboration.

[473]

The war had moved a frightening step closer to I Tatti when decrees of March 4 and 24 subjected the property of enemy aliens to so-called sequestration. Thanks to the intervention of Carlotta Orlando, daughter of the ex–prime minister Vittorio Orlando, the sequestrator assigned to I Tatti was a friendly anti-Fascist, Marchese Filippo Serlupi Crescenzi, a wealthy Italian lawyer and art collector, who had diplomatic rights as ambassador of San Marino to the Holy See. On June 18 Marchese Serlupi completed the obligatory inventory of all the Berenson possessions at I Tatti. The document, prepared with the assistance of "Signorina Elisabetta Mariano," ran to nearly seventy pages. It was witnessed by Dr. Giovanni Poggi, superintendent of the Florence Gallery, by the Berensons' attorney Mario Alberto Carocci, and by the estate manager, Geremia Gioffredi.

The inventory presents a remarkable overview of the treasures which the Berensons had accumulated. Of the nearly 125 paintings on the walls of the rooms and corridors, all but three or four were of the Italian Renaissance. Shelved in the five rooms of the library and scattered about in Berenson's study, Nicky's office, and elsewhere throughout the thirty rooms of the villa were more than 34,000 volumes catalogued in 127 bound registers. The photographic archives contained approximately 95,000 items. Distributed about the rambling villa were ten Chinese sculptures as well as sculptures from Egypt, Siam, Indo-China, and Japan. Apparently overlooked—or already secreted—were the priceless Persian manuscripts. Every piece of furniture, modern and antique, every pot and pan, and every piece of silverware found a place in the interminable lists. The inventory of the grounds, of the garage, and of the chapel and villino was equally thorough. The marble or plaster statues in the gardens were identified and all the vases counted. More than forty varieties of ornamental plants and flowers were listed—59 dwarf lemon trees, 40 poinsettias, 240 azaleas, and so on. The project undoubtedly occupied days. In her recollection of the affair Nicky declared Berenson endured it all with philosophic resignation.

With the inventory completed, Marchese Serlupi retired to his own extensive estate on the hillside at Careggi above the city, and the Berensons remained unmolested except for one day in July when the police made a routine search of the house in pursuit of some British officers who had escaped from Castello Vincigliata with the rumored help of Berenson. As a military precaution the house telephone was cut off, but thanks to Marchese Serlupi's protest it was reinstalled in the estate manager's house. When Nicky, who had been advised to thank the prefect of police personally, went down to his office in Florence, he reminded her

loudly that Berenson was an enemy alien, but at the door, out of earshot of his subordinates, he softly whispered he would try to protect I Tatti.

An alarm of a different sort disturbed Berenson when he applied in August for an extension of his American passport through the American consulate in Switzerland. He received word that under Section 404 of the Nationality Act of 1940 he would lose his citizenship because he was an alien-born citizen who had been out of the United States for more than the statutory five years. He got word to his cousin Lawrence in New York, who immediately contacted the State Department. Lawrence was soon able to notify him that a law signed by President Roosevelt on October 9 postponed the effective date of the draconian Section 404 until October 14, 1944. As a result the Berensons were able to obtain another six-month extension of their passports through the Swiss consul in Florence.

Although they were granted official permission to go up to Casa al Dono toward the end of the summer, Nicky was warned that permission to return to I Tatti might be denied. As Berenson put it to Walker in a letter enclosed in one sent by Professor Jirmounski from Lisbon, through "the usual stupid enemy we were tricked out of going up to the mountains." He implored Walker to try to send detailed news of himself, his family, his work, their friends in common, and of "what is going on in the art world." The clandestine channels of communication proved largely ineffective.

Letters had not altogether stopped with French intimates like the littérateur Jean Rouvier or Edith de Gasparin. They had of course to pass through German censorship, and the crabbed handwriting impelled the censor to request they be typewritten. Berenson's long letters, written in English and marked "In Englische sprache," could do little more than inquire about common friends and comment on his reading. To Rouvier, for instance, he told of his fascination with Kierkegaard's *Journal*, "suggestive, stimulating, enigmatical, and maddening." To Edith de Gasparin, he recommended that she try to get Trollope's novels. He told her that he had already devoured the whole series of political novels as well as the *Chronicles of Barset*. Her letters, he said, were so "suggestive and stimulating" that he feared he would exhaust time, paper, and "the amiable censor's patience" if he did justice to them.

The local Fascisti continued their campaign against Berenson, and early in October they filed a new denunciation against I Tatti with the usual charge of entertaining suspicious characters. The worried prefect of police cautioned Nicky that they must stop all contact with their friends. As a precaution Nicky gave him a list of the inoffensive visitors and

[475]

students who had been there. She also sent a report of Senator Gherar-desca's hostile activities against Berenson to the Swiss chargé in Rome, "in case *something more grave* affects him."

In November of 1942 the strident boasts of the Fascists were suddenly muted in Florence and the atmosphere changed. Passing through the library where the radio was kept out of hearing, Nicky turned it on on Sunday morning November 8 and learned that the Allies had successfully landed in Algeria. It seemed to mark the turning point of the war, for in the preceding month General Bernard Montgomery had routed Rommel's "Afrika Corps" at El Alamein west of Alexandria and the relentless pursuit of the German and Italian legions had already begun. To Italians generally it was becoming clear that Hitler had used their country as an instrument in his own grandiose scheme of conquest. The disillusioned Ciano recorded in his diaries that Italy had been deceived again and again as to Hitler's intentions.

In defiance of the proscription, Italian friends began to come up to I Tatti as pessimistic rumors about the course of the war began to circulate. Confined to his ivory tower, Berenson lost himself in his books and the receptive pages of his diary while Mary more and more relived the past in memory, ministered to by her nurses. Little Funtyki continued to delight both Berensons. While his parents were away they celebrated his sixth birthday, giving him his "heart's desire, a magnificent helmet, a gun with a folding bayonet, a sword in its scabbard and a belt." Proudly arrayed in this panoply, he marched down the road, but when some soldiers called out, "You are one of us and must come with us," the little fellow promptly discarded his military trappings. The temperamental Markevitches were now living in the villino, their domestic quarrels only too obvious to their hosts. In the brilliant Igor, however, Berenson found the intellectual companionship he needed.

The landing of the Allies in Sicily on July 10, 1943, signaled what seemed the beginning of the end. Nine days later Mussolini, desperate for help, met with Hitler at Feltre, but the situation was beyond remedy. Conspiracies to overthrow his government were already afoot among his close associates, including his son-in-law Ciano. In the crisis posed by the invasion of Sicily and an allied air attack on Rome, the conspirators called for a meeting of the *Gran Consiglio*. On the night of July 24 Count Dino Grandi, who carried a live grenade on his person in case of an "emergency," moved a vote of no confidence in Mussolini. It passed by a vote of nineteen to seven. By morning the king had named General Pietro Badoglio prime minister, and Mussolini was arrested as he left the king's residence and taken into protective custody. People everywhere rushed into the streets to express their joyful relief. Berenson's barber,

"drunk with happiness," came up from Florence to tell him "how people embraced in the streets without knowing each other." A great procession formed singing the songs of the *Risorgimento*, and crowds shouted for the end of the war.

The rejoicing proved premature. The war went on, and it was not long before the die-hard Fascists came out from hiding to take their bloody revenge under Nazi auspices, especially against the Partisans and their suspected friends. The Fascists' leader, Captain Mario Carità, head of the Office of Political Investigation, now began, in the words of David Tutaev, "his wholesale repressions, ceaseless interrogations, all of which were accompanied with the most degrading brutality and humiliations." At his headquarters in the Villa Triste on the Via Ugo Foscolo, "Padre Ildefonso played Neapolitan songs and Schubert's *Unfinished Symphony* on the phonograph to drown out the cries of the tortured."

It was not until September 3, 1943, that General Badoglio negotiated a preliminary armistice with the Allies and fled to Allied-controlled southern Italy. By that time the German armored columns had overrun northern and central Italy and the hated ally had become the much more hated occupying power. Mussolini, confined in a hotel in the Gran Sasso, was daringly rescued on September 12 by German paratroopers and installed in the north by the Germans as dictator of occupied Italy. In the south the king as sovereign declared war on Germany and Fascist Italy, and the protracted and costly advance of the Allies against bitter German resistance began.

Orlando's daughter had already hiked down from Campilioni to I Tatti to warn that if the Germans seized control and restored the Fascists, Berenson as an American, a well-known anti-Fascist, and a Jew would be treated as "enemy number one." When the radio announced the full armistice on September 8, Nicky decided to get the advice of the sequestrator, Marchese Serlupi. The full seriousness of Berenson's danger became apparent to her the following morning when she alighted from the bus at the Piazza San Marco. Military vehicles filled with German officers had just arrived before the Italian military headquarters to take over control. Marchese Serlupi offered refuge in Le Fontenelle, his villa high above the Medici palace of Careggi and about three miles north of the Arno, confident that the Germans would respect the diplomatic immunity symbolized by the white and yellow papal flag which flew above the villa. He gathered up Berenson and Nicky and they left at once, telling Mary only that they would be in touch with her and would return as soon as possible.

[477]

X L V I

The Peace of Le Fontanelle

MARY was not told of Bernard and Nicky's destination for fear that she would unthinkingly reveal it to any inquirer. Nicky's sister, Alda, was left in charge of I Tatti, and the bedridden Mary remained in the special care of her maid and nurses. With the help of Giovanni Poggi, the superintendent of art in Florence who had assisted at the inventory, and of Friedrich Kriegbaum, the more valuable paintings and sculptures were taken up to Le Fontanelle or sent down to Alda's apartment on the Borgo San Jacopo, where they were carefully walled up. As a precaution the photographs of these objects were removed from the local archives and the sequestrator's inventory retyped to omit them. The remaining paintings were spread out to hide the vacant places on the walls. As for the library, some volumes were partly walled up at I Tatti, and 20,000 volumes, together with the photograph collection, were secreted at the Quarto, the great villa on the slopes of Mount Morello near Le Fontanelle belonging to Serlupi's mother-in-law, Baroness Kiki Ritter de Zahony. Berenson, who occasionally lunched there during his confinement at Le Fontanelle, described it as "that huge Noah's ark, haunted by the ghosts of Demidoffs and Leuchtenbergs, of Thiers, and of Princesse Mathilde." It made him happy to pass some hours there "in the midst of proportions, colors, chairs, tables, pictures, the most livable with, that have ever been seen." Other portions of the I Tatti library were deposited with their friend Giannino Marchig, the painter and restorer. What remained at I Tatti was strategically distributed on the much-lightened shelves. The notable library at Le Fontanelle with its impressive collection of incunabula gave assurance that Berenson would not lack books to challenge thought.

There had been good reason to secrete the paintings. For some time

Hermann Goering's "art buyers" had been busily on the prowl for vulnerable collections. Even as early as the spring of 1942 one of them, Berenson now learned, had made inquiries of Kriegbaum about the art collection of the famous Bernard Berenson. Kriegbaum assured him that "there were no paintings except of Catholic subjects, and no books of more than local interest." Now the Gestapo had established a headquarters in Florence, and the German consul Gerhard Wolff was asked where the famous Berenson could be found. Wolff, a secret anti-Nazi, replied that he had fled to Portugal via the Vatican.

When one day there arrived in Florence one of Hitler's "personal art buyers," the consul was obliged to accompany this "former Berlin carpet seller," Herr Sepp Angerer, on his tours. Greatly impressed by Count Bonacossi's collection, he turned to the count and said, "What a pity you're not a Jew!" Both Wolff and the count looked puzzled. Herr Angerer "drew a hairy finger across his throat, saying: 'If you were a Jew, we would do just that! And all the paintings would be ours.' " The consul anxiously summoned Nicky to warn her that Berenson should not be found at I Tatti. He was relieved to learn that he was already in hiding. Later Wolff came up to Le Fontanelle to assure Nicky that he would do all he could to protect the contents of I Tatti.

It did not take Mary long to discover that Bernard had gone somewhere into hiding. What all hoped would be a short stay, to be ended with the early arrival of the Allied troops, settled into months of waiting as the battle lines crept northward from one heavily defended position to another. Affectionate letters went back and forth between I Tatti and Le Fontanelle. Bernard told "Darling Mary" that he was resting and, to throw her off the track, enjoying a "complete change of scene, of climate, of voices and of talk." For her part she wrote disconsolately of her presentiments that she might never see him again.

In one of her depressed moods she lamented, "I see that I have been a horrible person," and, as frequently before, she told of wishing she could "fade out of the memory of everyone—my own, first of all." She had had much pain, but Dr. Capecchi had assured her that her "vital processes" were all right. Having fallen out of bed, unable to reach the bell "for nearly an hour," she had now engaged a night nurse. For diversion she was reading aloud to Alda from Macaulay's *History,* finding it "better than a score of novels."

Bernard informed her that he was immersed in Byzantine history "so as to be able to find my way when I attempt to write about its art." We "take two walks daily in this enchanting Riviera with its lush flora, eat well, and spend much time resting. . . . I arrange the day very much as I

tance," Berenson wrote in his diary, "gentle, tender, incapable of evil, and was doing nothing but good."

Berenson afterward learned that the Nazis had ordered Kriegbaum on September 9 to have the library of the German Institute packed and sent to Germany. As reported in David Tutaev's *The Man Who Saved Florence,* the German consul, pleading there was no time to pack, arranged to have Dr. Poggi take the place under his protection. Dr. Hanna Kiel, an art historian and anti-Nazi refugee from Germany who was a friend of Kriegbaum, was left to lock up the institute and deliver the consul's private papers for safekeeping to the Swiss consul. Dr. Kiel subsequently met Berenson and became a lifelong habitué of I Tatti and an editor and German translator of his works.

Consul Wolff recalled meeting Berenson at the Villa Quarto: "a small grave, bearded man stooping under a heavy blanket, which was constantly slipping off his shoulders," with whom he "perambulated slowly about the gardens." They conversed amicably, chiefly about German literature. Berenson was to write in the epilogue of his published war diary, "Unforgettable proofs of friendship were given me by the German Consul, Gerhard Wolff, and by the assistant chief, now chief of police, Virgilia Soldani Benzi."

When information came from Consul Wolff that Jews were being rounded up in Rome and shipped in cattle cars to Germany by the Gestapo, the report set Berenson to thinking of the irrationality of the anti-Semitism that treated Jews as an alien people in a nation's midst. The truth, he reflected, was that, except for a small percentage, "Jews are exactly like other people of the same class everywhere." Hence Hitler's belief in the world "omnipotence of the Jews" was "a belief so absurd that it comforted me." His racial policy was a fatal mistake. He was wasting energy "upon helpless Jews instead of concentrating upon dangerously determined enemies . . . and could not possibly win the war. . . . I am confident that the majority of Jews would have been good Nazis in Germany if they had been allowed to be," Berenson reasoned in a diary entry. "Far from being internationalists, the great majority of assimilated, bourgeois Jews tend to be nationalists in the aggrandizing annexationist sense of the word." In the support of this opinion he called to mind the "Jew Disraeli who invented British imperialism," and Leopoldo Franchetti and Sidney Sonnino, who had involved Italy in the Balkans. In France "the three Reinachs were rabid patriots." And in Italy with rare exceptions bourgeois Jews had been Fascists, "and some of them ardent and active ones."

Illogical as the persecution of the Jews might be, it was nevertheless a painful fact of contemporary existence, and now that he found himself

intimately affected by it, the subject gave him no peace. Wasn't there a salutary lesson to be drawn from the Nazi horror? The more he thought of it, the more he felt the quixotic need to give his advice, to deliver a sermon to his "fellow scapegoats" in the United States. It was thus that in May of 1944 he began "a small book" that he thought of titling an "Epistle to the Americanized Hebrews" or "A Letter to American Jewry." In it he recurred to his conversation with Dr. von Neumann. Jews were "fellow whipping boys, or even the fellow victims of the first line of defence against the disinherited and discontented."

"Perhaps," he argued, "if the German Jews had mingled with the humbler layers of their fellow-countrymen, it would not have been so easy to subject them to the cannibal treatment they have suffered. The German Jews might reply that they had no proletarians. That is not the case in America." Therefore, since jealousy and envy remained motives of conduct, he urged, "Do not stir it up. Even if you were as innocent as the angels you could not escape its venom, and you are far from that. . . . It is the irresponsible wealth, as well as the arrogance in the high ranks of Jewry, that led to the periodical persecutions and massacres of the puta- tive descendants of Abraham, Isaac and Jacob; spiritual wealth more even than material, is apt to rouse secret resentment. . . . So you whom Hitler has for years to come reduced to being a thing apart, a stranger in your land, cannot be too modest, too unassuming, too discreet." He rejected as parochial the agitation for the return of Jews to a Zionist state in which only Hebrew was employed. Such a new Zion, he feared, would be just another ghettoized member of the nationalistic ghettos of the world.

During the months at Le Fontanelle one earnest political homily after another filled pages of the diary. Pondering the aspirations of the con- tending Allied and Axis powers, he asked himself, "When we have thor- oughly beaten them how should we treat the Germans? If I had my way it would be either as convalescents or as incurables. The latter I should segregate, isolate, and see to it that they did no mischief, whether by word or deed. . . . I repeat what I have said more than once: that there is no way of punishing a people, even if we had a right to. . . . We could have stopped Hitler in time, as we easily could have stopped Mussolini, if we [had] wanted to. So I question whether, in justice, we have any right to punish those Germans who could not help submitting to force that we had allowed to grow overwhelming and irresistible."

Like animated table talk the diary entries veered freely from one topic to another. Berenson descanted on the Wagnerian cult of the irrational by the Nazis as a parallel of the Freudian freeing of the subconscious in the individual. "The immediate result is an excited interest in what goes on beneath the belt to the exclusion of the head and members." He recorded

his dream of "depoliticizing nationality." Yet he wrote of blushing "with pride and satisfaction" one evening in December when his host "came out with a panegyric of Franklin Roosevelt." Of the racial theories of the Nazis, he remarked that a "claim for racial purity can be made in good faith only by those who know no history and forget human nature." The outcry against the Allied destruction of Monte Cassino he called "cynical propaganda," for "the buildings and decorations were no earlier than of the seventeenth century and in no way remarkable for that period. . . . What connoisseur would dream of placing it beside the Escorial or [the ancient Austrian monasteries of] Sankt Florian or Melk!"

In spite of the occasional Allied air raids in the vicinity and the frightening detonations of shell bursts that reverberated among the hills, life pursued its intellectualized course at Le Fontanelle. Day after day, week after week, Berenson recorded the eddies of his introspection, incessantly taking his intellectual temperature. Pen in hand he tried to pin down the ephemera that flitted through his mind trailing their clouds of associations. Aperçus, impressions of persons and places, reminiscences of the distant past, opinions of here and hereafter crowded his pages, often setting off a train of erudite historical associations. The incessant journalizing proved an instrument of self-discovery, of *becoming* in the Emersonian sense. More and more, during the isolation of the war years, his thought turned inward upon the potential self as he doggedly explored its complex geography. The exploration of that self was to become the principal occupation of the rest of his life.

As the Anreps could move about freely, having the double credentials of German and Italian, the private letters between Bernard and Mary went back and forth with some regularity. Mary, fretting against her inactivity and able, she said, to work an hour a day, offered to edit whatever manuscript he was working on. He tactfully explained it had to be first put in order. For useful occupation he urged her to collect the photographs, documents, and memorabilia of her life, everything she wished to preserve. The materials would be safe at I Tatti. Her offspring, he suggested, had no permanent seat in England. "The Institute I hope to found at I Tatti may last for generations, centuries even. Sooner or later somebody among the students who will frequent it will take it into his head to write up the kind of life [which was] lived at I Tatti when it was a private home." She dutifully followed his advice.

Mary's condition ran its usual course of alternating despair and relative euphoria. Having difficulty holding a pen, she engaged a secretary to typewrite her letters. At a particularly low moment she dictated a letter to Nicky telling her that she was dying and her doctors refused to give her medicines that might kill her. "I think of you," she said, "with the

deepest love. If I die in time I hope you will marry B.B." She added, perhaps with unintended ambiguity, "You will have my deep sympathy." Nicky thanked her for her "beautiful letter" but responded that she did not think she and B.B. would ever marry. "Surely everybody would find my living near him and for him perfectly natural. So why should we change?" Another day in a buoyant mood Mary informed Bernard that she was dictating her autobiography. Bernard, glad to learn of this distraction, urged her to let her memory "loose." "As for me, if you speak of me at all, let it be a figure in YOUR life. Make it all as egocentric as you spontaneously feel." By this time the retreating Germans, though always "correct," had taken over most of I Tatti, which had first been occupied by Italian officers, and Mary was carried up in a chair by four soldiers to Nicky's apartment on the top floor.

Thanks to the tact and to the proficiency in German of Nicky's sister, Alda, and her husband, Egbert, and to the business connections in Berlin of their son, Cecil, the succession of Wehrmacht officers and men, numbering a few hundred, behaved correctly and did little damage. One of the latest visitors at I Tatti was Field Marshal Albert Kesselring, commander of the German armies in Italy. As the Allied forces moved closer, the relative security of the Florentine villas was increasingly threatened, Le Fontanelle far more seriously than I Tatti because it lay directly in the path of the German retreat.

Interspersed now among comments in the diary on the books being enjoyed and speculations on the parallels between the distant past and the harrowing present were increasing entries concerning the situation of the refugees on the exposed hillside. "The terrace of this villa," Berenson wrote, "facing the heights, hills, and mountains that environ the vale of Florence southward and westward, is like the dress circle of a theater, Florence itself being the orchestra and the hills beyond the stage. From this dress circle by moonlight yesterday July 31, 1944, we enjoyed—not in a physiological but in the aesthetic sense of the verb—a marvellous spectacle accompanied with appropriate music . . . the growl, the rumble, the roll of cannon that sounded antiphonal. . . . A distant mountain flamed up like Vesuvius."

The days passed with more and more thunderous explosions as the Germans dynamited factories, power plants, and roads to delay the Allied advance. Around the first of August the evacuation of the neighborhood of the Arno was ordered, for the bridges and the neighboring buildings had been mined. Only the Ponte Vecchio, the bridge for which Hitler had once expressed a preference, was to be spared. The tremendous explosions on August 3 and 4 left mountains of rubble and in them Ammanati's graceful masterpiece, the bridge of Santa Trinita, vanished

crown prince of Sweden had in fact reached him the preceding spring. Offered the use of the diplomatic pouch, Berenson had been able to assure Prince Gustaf that he was well and pleasantly situated. He had brought along "enough books of my own treating of subjects connected with my work" and "the days rush by with astonishing velocity."

On the afternoon of September 2 Major Sampson sent an armored car to take Berenson to I Tatti. On the way down they stopped near the Uffizi and Berenson walked over to the Ponte Vecchio to view the devastation. "The piles of ruins," he noted, were "heaped high as in eighteenth century drawings of the Roman compagna."

At I Tatti he found Mary in sorry straits, now entirely bedridden. "She was suffering spasms of acute pain, and her speech was clogged." The stray shells and the concussion from the American artillery emplacements in the adjoining fields had done no damage, he optimistically thought, that "$5,000 would not repair." Most of the windows were gone and the *fattore*'s house was smashed. But he carried away "a disastrous impression," chiefly because of the "squalor, filth, [and] disorder" in the immediate vicinity, "a combination of city refuse heaps, automobile cemetery, and gypsy camp." There was no cook, he learned, since there was little food on hand. There were at least twelve persons to feed, he reported to his cousin Lawrence, and he listed their needs of "hams, flour, cereals and other items," though, he added, "I may be crying for the moon."

He returned immediately to Le Fontanelle to wait for I Tatti to be made habitable. At Le Fontanelle one of his first callers was the thirty-year-old art historian Frederick Hartt, then a second lieutenant in the United States Army Air Corps. Hartt had already begun his difficult and dangerous job as head of the Fine Arts Commission for the Fifth Army, surveying damaged monuments and recovering art which had been hidden away for protection. An art student in Florence, he had called on Berenson before the war and had had to endure the scornful criticism of two teachers whom he admired, Richard Offner and Meyer Schapiro. Now at the pitiful sight of the frail figure who warmly welcomed him, his lingering resentment vanished. From that moment Berenson became, as he said, one of his cherished "monuments." In his official report of the visit he wrote that Le Fontanelle had been "perforated with at least thirty shell holes of small calibre" and that he found Berenson in a "weak and somewhat shocked condition."

A few days after his return to Le Fontanelle Berenson was delighted to receive a visit from "a tall well-made, rather Socratic-faced youngster" whom he recognized as Robert Berenson, the second cousin who had visited him just before the war. An infantry captain, Robert was aide-de-

camp of General Mark Clark. Bernard recorded that his wife was the "daughter of the most fashionable dressmaker in Paris, the Italian Schiaparelli." Cousin Robert sent a report to John Walker in Washington of a dinner with B.B. and "his extremely rich friends." They were attended by "three flunkies all dressed up," but the elegantly served repast consisted only of "miserable bean soup" and a main course of creamed potatoes. He therefore planned to go up to I Tatti shortly with General Clark and bring "a 'formidable' dinner." He wrote also of driving up to I Tatti to see Mary and finding her "just about alive," somewhat incoherent, but "still as sweet and lovely-looking in her tired old age."

Robert continued to keep in touch with Berenson from his business headquarters in Paris. In the "ultra-smart society of which he was a favorite," he passed as Berenson's nephew. The "uncle" took pleasure in Robert's success in the shipping world, where he became a partner of Aristotle Onassis and rose to prominence in international finance. Their friendship suffered a slight strain at one period when Robert sought advice on how Onassis might dispose of some paintings which he held as security for a loan. It might have been even more embarrassing to Berenson had he lived to the day when Robert's daughter Marissa was displayed in *Playboy* magazine and inaccurately described as Berenson's grandniece. *Time* magazine, even more egregiously, called her his granddaughter.

The excitement of the Liberation with its stream of well-wishers evidently proved too much for the seventy-nine-year-old Berenson. He came down with a violent dysentery, his body, he said, "turned into a drain, a sewer." When he recovered ten days later, he poured out in his diary his pent-up reflections on the postwar political settlement. The Germans should not be treated "vindictively or with short-sighted selfishness but with reason and even humanity." The Nazi leaders, however, should be punished severely and all their loot either restored or replaced by equivalents, though, recalling the disillusioning aftermath of World War I, he opposed money reparations. East Prussia ought to go to Poland, if Poznan were relinquished. As for Italy, "I hope we shall be easy with her and do nothing to offend her pride as a nation." Regional autonomies ought to be promoted and the Italians should be tactfully encouraged "to stop training their young to be rhetoricians, forensic orators . . . and rapt admirers of verbal performances." Parliamentary government should be reestablished not only in Italy but in all lands, including Spain, where free speech and a free press "have been silenced by tyrannies in panic fear." A "Danubian Confederation" and a similar confederation of the Scandinavian countries and Finland should be estab-

lished. The six-and-a-half-page entry concluded with a dream he had had "again and again" since his "earliest maturity," the dream that language groups should cease being identified with states. "If that depoliticizing of nationalities could be achieved, we could encourage each language group to cherish its own individuality . . . thus enriching the rest of us."

Berenson returned to I Tatti on September 23, 1944, like a traveler who had been away on a strangely accidented voyage where perforce he had been free of the burdens and responsibilities of home. He had tried to "pierce the fog" that had isolated him, he told Lawrence, but "it was made impenetrable by censorship all round." Now the complex machinery of existence of which he was the prime motor began to turn again. At the sight of the broken garden walls and the scorched and trampled fields he "sank into a pool of despair" but revived when the "dear Anreps" and the servants led him into the house, where everything had been restored "in a most magical fashion." Bookshelves were filled again and objects of art reassembled in their familiar places. That night he sank gratefully into his own bed, his head and shoulders comfortably supported by familiar pillows. On the morrow he would wake to a whole new set of responsibilities.

28. Edith Wharton, 1925

29. Edith Wharton's estate at Hyères

30. Clotilde Marghieri

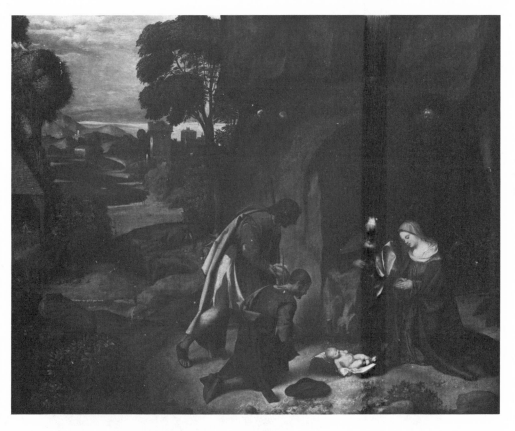

31. Giorgione, The Adoration of the Shepherds
(Allendale Nativity*)*

*35. Berenson and
Katherine Dunham*

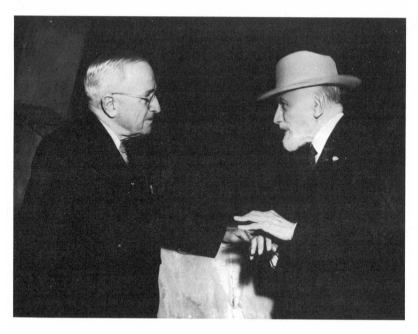

36. Berenson and Harry Truman, 1956

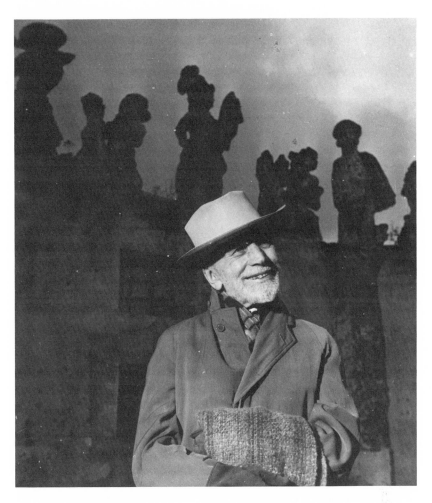

37. Berenson at Venice exhibition, 1953

38. Ilex wood below I Tatti

39. Façade of I Tatti today

XLVII

Patriarch of Florence

T HE Tuscan Committee of National Liberation had organized "a clandestine local government" to take over the administration as soon as the Germans were driven out, and normal existence slowly returned to the stricken city during the late autumn and winter of 1945. For Berenson his accustomed walks on the woodland paths near I Tatti had to be deferred until the German mines could be removed. There were shortages of food and fuel for a time, and Berenson lamented that they had been "ever so much better off" in hiding—except for the month under fire—than since the "liberation." Fortunately conditions steadily improved. A small car feebly running on methane gas could be used to bring up provisions, and parcels of food sent by friends in America helped enliven the diet. By the end of winter electric power was restored and the evil-smelling oil lamps could be discarded.

Mary's health showed no improvement and she was confined entirely to her room. Ben Nicholson, who had come up in his British uniform and listened to her "small frail voice," reported that "she looked more ill than I had ever remembered her," although her conversation was "as sparkling and sharp as ever."

In December a correspondent of the *New York Times,* Herbert L. Matthews, interviewed Berenson about the salvage work to be done in Florence. In the course of their conversation Berenson deflated a story which had been circulating that four Partisans died trying to save the Santa Trinita bridge. Matthews' report also included an account of Frederick Hartt's "thrilling task of supervising" the rescue of art works and the repair of German vandalism. How dangerous that task was close to the battle lines Hartt was to tell in the moving narrative *Florentine Art under Fire* (1949). One can imagine with what anguished interest Beren-

when he was gone, she answered quite simply that she would write about him.

Frail as he was and often complaining of fatigue and aches and pains, he was now swept by a wave of ambition. The overthrow of the Fascist regime in Florence freed him from the twenty-year opprobrium which he had borne as an anti-Fascist, and he was accepted as one of the most distinguished of Florentines. It was as if he had been reborn and given a fresh identity. He had scarcely settled down again at I Tatti when he was made president of a special commission for the restoration of artistic buildings and monuments damaged in the war. His opinions were sought after as an elder statesman of Florence, and he made his debut in that role in April 1945, contributing to the first issue of the newly founded review *Il Ponte* an article titled "Come ricostruire la Firenze demolita?" in which he urged restoring the dynamited river-bank structures to their former historic appearance to maintain the architectural harmony of Florence. Modernization could be internal as in ancient buildings elsewhere. The rebuilding of the Santa Trinita exactly as it had been before its destruction, with its subtle curves and ivorylike patina, should be the key to that restoration.

When the French consul Count Reynald de Simony suggested that it might be a good idea, the war in Europe having ended on May 8 and peace having just been established between Italy and France, to sponsor an exhibition of French art owned in Florence, Berenson seized upon the idea with alacrity and agreed to write the preface to the catalogue. To the consul fell the job of rounding up the paintings and compiling the catalogue for the exhibition, scheduled to open at the Pitti Palace on June 27, 1945. Nicky sat up nights revising proofs in English, French, and Italian of not only the preface but the text of the catalogue as well.

Though the preface of more than five thousand words had to be completed in nine days—to allow time for the translations—Berenson wrote with zestful and perceptive discrimination of the works of many of the 120 artists represented in the exhibition, his urbane commentary displaying an impressive familiarity with the works of artists from the French Primitives to Modigliani. Writing with "an eye" to the Italian public who "were more touchy than a *femme enceinte*," he tactfully began by saying that Italian art exercised such a dominating attraction in Italy that one easily forgot that there existed other schools of art. Italian art had, he declared, influenced French painters from the beginning of the fourteenth century, and traces of that influence could be detected in pictures in the exhibition. In Cézanne and Renoir, for example, there were, if not actual recollections of, certainly parallels to the early Italian centuries, and Watteau showed debts to Veronese, Titian, and Rubens.

His lively survey of the centuries concluded with a warning against new heresies. Had the "isms" of the past sixty years, he queried— "impressionism, pointillism, ism after ism"—in any permanent way refreshed, embellished life or proposed ends that might lead to life-enhancing art? Cézanne, Renoir, and their fellows had brought art up to the wall on which was written, "They shall not pass." They had captured tone, light, ephemeral tints which already had begun to fade. The pilgrimage of art into the future would demand patience and humility.

Berenson had obviously enjoyed returning to his métier after the year's confinement at Le Fontanelle, looking at pictures again with a practiced eye and seeing them in all their subtle relationships. And at the opening of the exhibition people crowded about him as at a personal reception and showered him with congratulations, perhaps as much for having survived the German occupation as for helping to launch the exhibition. He had emerged from the war years with a keen hunger to resume his place in the world at the center of his web of associations. As one of his correspondents remarked, "Your appetite for people is wonderful. I admire it without quite understanding it." Berenson tried to explain that appetite to himself. "I often wonder at my being so ready to make new acquaintances, and how eager I am for new friends, new loves. Mere animal need for novelty plays a great part of course. Yet there may be something else, the possibility that a new friend, a new love may reveal a new facet, a new side, a new angle of ourselves to ourselves."

The summer of 1945 brought a variety of interesting visitors, some in time for Berenson's eightieth birthday on June 26. Many were connected in one way or another with the military, and the end of the war in Europe lent an almost festive air to their visits. Berenson was particularly delighted to meet the poet Peter Viereck, who was a sergeant in the psychological warfare branch of the Fifth Army. Viereck was happy to escape "army togetherness" in the quiet gardens at I Tatti, where he could work on his first book of poems, *Terror and Decorum*. After surviving many rejections, the volume won the Pulitzer Prize in 1949. Berenson had been much impressed by Viereck's *Metapolitics: From the Romantics to Hitler,* which Mario Praz had lent him, and he liked his poetry and encouraged him to publish.

Another satisfying visitor was Alan Moorehead, an Australian war correspondent of the *Daily Express* whose dispatches from the Far East, the Mediterranean, and northwest Europe had been widely acclaimed. Berenson already knew his books *Mediterranean Front* and *End in Africa.* Moorehead, "knowing nothing," as he said of himself, "of painting or architecture, or indeed of half the subjects which were discussed so easily and in so many different languages in that elaborate and platonic house,"

A letter to Belle Greene, now a woman of sixty-two, "deeply moved" her to reminisce, "We knew a grand time and lived a grand life." Judge Learned Hand admired the "stoic streak" that enabled him to carry on during his "incredible experiences under Nazi domination." He sent a lengthy account of the American participation in the war on the home front. Bruno Walter wrote that at nearly seventy it was too late to transplant himself "another time," much as he had once wished to settle near Florence after the war. America, where "it is good to live," had received him with "open heart." He sent affectionate greetings from fellow Californians Franz and Alma Werfel. Within a few months Werfel, whose *Song of Bernadette* and *Jacobowsky and the Colonel* had made him famous, died after a lingering illness.

Closest to Berenson's heart were the developments at the Fogg Museum and the negotiations which had been resumed with Harvard concerning the future of I Tatti. Still disturbed "by the way art studies were going at home" and assuming that the new head of the Fogg would eventually "direct and control" the I Tatti Institute, he hoped, he told Paul Sachs, that the person chosen would have a Greco-Roman-Renaissance-Franco-German-English training and "*zum Schauen geboren* [be born to see]," and that he would be "generously interested in present as well as past."

In July Berenson went to Siena for four days. It was his first outing in four years, and he "walked about in ecstasy" in the sun-drenched Campo dominated by the brownish-red shaft of the Torre del Mangia. At last he fully tasted freedom. With the surrender of Japan on August 15, 1945, the exodus of Allied troops from Florence became a general retreat and life resumed its civilian character, though shortages of necessities persisted. For the first time since the early days of the war Berenson was able to spend the end of the summer up at Casa al Dono, where he could recapture, as he said, the peaceful and monotonous isolation he had experienced during the first months at Le Fontanelle. He and Nicky took up with them for revision the manuscripts of three books—the autobiographical musings that would become *Sketch for a Self-Portrait,* the draft of *Aesthetics and History in the Visual Arts,* and the manuscript of *Rumor and Reflection.*

His cousin Lawrence came to Casa al Dono in September to prepare a new will covering his Italian property. The main provision, as before, was the bequest of I Tatti for an institution to be known as "The Harvard Institute for the Study of Italian Art and Culture." The will incorporated much of the language of the proposal drafted in 1939, including the statement that it was Berenson's "primary purpose" to further "research and education in Italian art and in the Mediterranean world." It recorded

Berenson's hope that Elizabeth Mariano would be retained as librarian and her sister, Baronessa Alda, as assistant librarian. Elisabeth Mariano was named as one of two executors, the other to be chosen from among John Walker, Paul Sachs, Lawrence Berenson, Philip Hofer, and Ralph Barton Perry. Among other provisions were a number of encumbering personal bequests. This will was to stand until in his eighty-ninth year Berenson substantially modified these bequests.

During his visit Lawrence, a committed Zionist, insisted on seeing Bernard's "Letter to the American Jews," about which Bernard had written him. He was "peremptory in his advice not to publish it." Unwilling to give up the project, Bernard turned over the manuscript to him for correction. Lawrence found much to question in the emotional homily, being far more keenly aware of the sensitivity of American Jews to such patronizing advice at a time when the appalling extent of the Holocaust was being revealed. He perceived too that Bernard had insensibly absorbed during his long life among European Gentiles many of the stereotypes of the anti-Semites. He deferentially noted lapses and inconsistencies in the "Letter." "I do not believe," he wrote, "that you have lost your Jewish belief in an intellectual aristocracy and the hereditary yearning for learning. Here you are not an assimilationist. . . . You accept the best in Jewish thought and the beauty of Christianity. . . . Most of the Zionists are almost aggressively emancipated, I fancy, from traditional Jewish rites and beliefs. Their ideal seems to be a totalitarian nationalism utterly different from the regime of the ghetto."

Though Lawrence tactfully agreed with the cautionary drift of the essay, in the end his veto prevailed. Lawrence's advocacy did leave its mark, and not long afterward Bernard wrote in his diary, "I am a convert not to Zionism but to the necessity of finding a place for the Jew, not only safe from the heritage of Hitler but from his own gnawing frustration and inferiority complex." The Zionist question, however, was not easily dismissed from mind. With the founding of the State of Israel three years later in 1948, he accepted the fate of "Hitler Jew" thrust upon him, and though a "graduate" of both Judaism and Christianity, he approved of the new nation and even hoped that one day it might rule an empire from the Nile to the Euphrates.

Another guest at Casa al Dono that summer was Luisa Vertova, the twenty-five-year-old daughter of Giacomo Vertova, the Italian philosopher and educator. She had studied art history at the University of Florence, but when the museums were emptied at the outbreak of the war she turned to Greek drama and was graduated in 1942. She first became acquainted with Berenson in 1943 while he was "sequestrated" at I Tatti. A victim of wartime privation, she found refuge after the Liberation in

ture as "Fake," "Perhaps a Fake," or "Forgery"; correct an attribution—
"Bernardo Daddi—More likely Allegretto Nuzi"; or add a quali-
fication—"With—but not—Perugino," "Close to but not Perugino
himself," "So-called Bellini probably forgery." Of an alleged Pontormo,
he ventured, "Probably a Flemish painter who worked in Florence
around 1556." Occasionally a longer commentary was needed, as in the
case of a reputed Lo Spagna: "School of Perugino. Composition derived
from Raphael's Sposalizio. Close to Lo Spagna but scarcely an auto-
graph." In one telegram he cautioned, "Not good enough for Francesco,
probably Giacomo Francia." It appears that Berenson supplied an opin-
ion to the firm on approximately seven hundred paintings and earned
$700,000 in thirteen and a half years, to the considerable enhancement of
the endowment for I Tatti.

Berenson also developed a closer relation with Count Contini
Bonacossi after the war, having come to his defense when he was
charged with collaboration with one of Goering's agents who had requi-
sitioned paintings in Italy. Contini supplied about 550 Italian paintings
to Samuel Kress and the Kress Foundation before and after World War II.
Kress, who very much appreciated Berenson's defense of Contini "dur-
ing the long period of strain," encouraged the two to work together on
his acquisitions. Contini persuaded Berenson after the war to make a
considerable number of attributions for paintings that were sold to Kress
and presumably paid him for his services. Although the vicissitudes of
the war years had dimmed Berenson's interest in connoisseurship, the
old compulsion returned and he wrote, "When I am put before paintings
to attribute I am like the war-horse who smells powder and hears the
trumpet call."

XLVIII

At Home in the House of Life

THE new and liberal arrangement with Georges Wildenstein helped somewhat to relieve Berenson's anxieties about the financial future, and he resumed with obvious relish his literary activities. More than ever before he felt his true vocation was that of a writer. From time to time he punctuated his letters and his diary with severe injunctions to himself. He was "heavy with things to say," or he had "a dreadful urge to write." He dreamt of a book "that would justify my having lived." No image was too violent for his desire. He felt it a physical compulsion to "print what is in me to excrete and never discuss the feces." In another figure he said, "I am like an habitual drunkard, I cannot leave off and still try to write." Impatient of fame, he hoped even at eighty-five to do two more books; "then I should get rid of part of the feeling that I have lived to no purpose." He must write and publish because he owed the world "more than I can conceivably repay."

The stimulus was more than internal. Rehabilitated as a patriotic anti-Fascist, he found his writings in demand by Italians. He opened his campaign with the publication of his portrait sketch of Carlo Placci in the 1946 May and June issues of *Il Mondo*. The translation was by Arturo Loria, the talented essayist and journalist who had become devoted to him. The English version appeared in June in Cyril Connolly's *Horizon*. In Florence the sketch produced something of a scandal among Placci's friends, and three of them, "women and fellow citizens," published a protest in *Il Mondo* against the "almost libellous" portrait. Berenson defended his candor in a later issue. He suggested that instead of condemning him, the protesters should publish their own view of Placci.

To Billie Ivins he had reported early in the year that he was returning to his "swan-croak" on questions of "Aesthetics-Ethics-and-History" which he had written at the beginning of the war. It was, he said, "the

Gospels according to St. Bernard." On rereading it he was pleased that "it reads smoothly and the contents are worth reading." This too-comforting appraisal yielded to second thoughts as he went from one "last revise" to another. Nicky, he said, was "in despair" over it, "finding it so haphazard" and "lacking in serrated logic." Nevertheless, by the end of the year Mario Praz had begun to translate *Aesthetics and History* into Italian. At the same time Guglielmo degli Alberti was preparing the Italian version of *Rumor and Reflection,* and a Roman publisher even talked of bringing out two or three volumes of Berenson's early essays. "In short," Berenson wrote to Margaret Barr, "I am being discovered here." Already Del Turco of Florence had under way an Italian translation by Raffaello Franchi of his 1926 *Three Essays in Method,* the volume to include also two other early essays. Publication followed in 1947. *Aesthetics and History in the Visual Arts* made its debut in 1948, the original version published by Pantheon in New York and Praz's Italian translation by Electa in Milan. Berenson hoped that it would serve—if life permitted—as a preface to his long-meditated volumes on decline and recovery in the visual arts.

In the introduction to *Aesthetics and History* Berenson acknowledged that his pages were "anything but systematic and scientific." They were "a pell-mell of stray thoughts, desultory thinking aloud, generalizations, reminiscences, confessions," but they had one thing to recommend them: "They exhibit the cross section . . . of a mind that for a half century and more has been dwelling upon art problems of many kinds, not only historical but aesthetical." Though Berenson's passion for sermonizing about the proper way to study art did frequently lead him down distracting bypaths, the essay is far from being a "pell-mell of stray thoughts."

A principal theme is that, contrary to current heresies, there are artistic standards of value; there is "a relative absolute in art which is determined by our psychophysiological condition and mental make-up." He had enunciated the standards for the visual arts in his four small volumes on the Italian painters of the Renaissance in which he had theorized that great art, working through "ideated sensations," produces "a direct effect of life-enhancement" and that in "figure painting . . . the principal if not the sole sources of life-enhancement are Tactile Values, Movement and Space Composition," that is to say, "ideated sensations of contact, of texture, of weight, of support, of energy, and of union with one's surroundings." In *Aesthetics and History* he restated the theory in almost the same terms. He added the requirement of "spiritual significance," which he defined as a variant of the element in a painting perceived through what he had come to call "a sense of quality." He explained that "ideated sensations . . . are those that exist only in the imagination, are produced

by the capacity of the object to make us realize its entity and live its life.
. . . What the artist has to do is to oblige the spectator to feel as if he were
the object represented."

The first duty of the critic and historian of art, therefore, is to enjoy the
work of art "intuitively and spontaneously." Only after that has been
experienced is he "called upon to analyze and interpret." It was this
injunction, the critical importance of "seeing," that he had urged upon
students, in season and out, and it had been the theme of his running
debate with Ivins. Scholarly inquiry concerning the artist, his technical
methods, or his work as an aspect of the history of culture should be
subordinated to the direct experience of the work of art itself.

In the second part of the essay he turned to the historical determinants
of the subject matter of art, of what he chose to call "illustration" as
distinct from "decoration," his term for the formal elements. Here in
rich and allusive detail, drawing upon his encyclopedic knowledge of
history and archaeology, he sketched the centrifugal development of the
visual arts of the Mediterranean and Atlantic peoples from the earliest
Egyptians to "the continued glories of French painting down to Degas
and Cézanne." Keenly aware of the rising vogue of avant-garde and
nonobjective art, he warned that "art history should not dwell too much
on waves of fashion, winds of doctrine, or the maunderings of primitiv-
ism, but should pick out the most life-enhancing moments," those
which, reflecting the heritage of Hellenism, sought to "humanize" man-
kind.

The book was a sustained polemic in defense of his critical standards,
and it attracted widespread attention in America and England and on the
Continent. For the most part critics accepted the discursive character of
the book as a given, for the author had himself admitted the impeach-
ment. There were those who, like Professor Frank Jewett Mather, Jr., in
the *Magazine of Art,* thought "the outline of an esthetic and a directive for
the historian of art . . . captivating for its variety and energy" and a
"tirade against the antihumanists of a Carlylese scope and vehemence."
The *Saturday Review of Literature* described it as "a thrilling and persuasive
discussion," an "apologia of a great humanist" of "transcendent impor-
tance" at a time when "discouraged and baffled art critics are resigned to
unintelligibility as the price of freedom in the arts." A writer in the *Times
Literary Supplement,* while not wholly agreeing with Berenson's analysis,
characterized the essay as a "magnificent assessment of those values
which might yet preserve the visual arts in health." For the "second
Renaissance" which may emerge from the chaotic nature of contempo-
rary art, "Mr. Berenson is acting as a magnificent John the Baptist."

Though the book had its admirers, it could not stem the wave of the

future. Even his two most distinguished "pupils," John Walker and Sir Kenneth Clark, felt the need to qualify their praise. Both saw the essay as essentially a personal credo. Walker, in the *Gazette des Beaux-Arts,* called it the brilliant "soliloquy of a great connoisseur on why certain beautiful objects had for him a deep and exhilarating meaning." Clark, in the *Burlington Magazine,* described it appreciatively as "a simulacrum" of Berenson's talk, which "for the first time . . . will convey to posterity his extraordinary powers." He went on to say that the limitations of the "doctrine of ideated sensations" were "far narrower than the boundaries of Mr. Berenson's experience" and to note that Berenson's essentially physiological theory of tactile values owed more to William James and Henri Bergson than to Hellenistic tradition, but he concluded that the author's powers of appreciation "greatly and gloriously outrun his theories."

There was no lack of dissenting voices, of those who in one degree or another shared Lincoln Kirstein's view that the book was "the mirror of a mandarin rather than the edifice of a philosopher." Kirstein thought it a "book of cultural memoirs, discursive, crotchety, studded with charming aperçus . . . neither carefully written nor edited." Though Clement Greenberg in the *New York Times* deplored Berenson's "high-handed philistinism toward contemporary art," he conceded that he "owns one of the finest sensibilities ever applied to the study of art." In his article "Homage to Bernard Berenson" in *Horizon,* Raymond Mortimer criticized Berenson for applying too narrowly his definition of "art as an instrument for humanizing mankind" with the result that he put contemporary art under a violent ban, alienating "many among his juniors who otherwise might have become his most congenial admirers." He admitted, however, that owing in part to Berenson's "nefarious influence," he had had "to modify" his own view of aesthetics, and that along with Berenson he found "ominous the coincidence between the taste for the art of savage peoples and the lapse of Europe into savagery."

Professor Henry D. Aiken of Harvard faulted the writing as "opinionated and often confused," and went on to make a comment which revealed that gossip had already distorted Berenson's refusal to leave Italy at the outbreak of the war: "One may perhaps question the sincerity of a man who for many years resided voluntarily in fascist Italy and is now belatedly concerned about the dangers of totalitarianism to the integrity of the artist."

In *Commentary* Meyer Schapiro suggested that Berenson's hostility to contemporary art put him in bad company. "Amidst the general decline of our age," he wrote, "three powerful, ruthless men, Stalin, Mussolini and Hitler, have repudiated modern art and exoticism. What a terrible

thing to recall to Mr. Berenson who was born in Vilna and who regards art as 'the surest escape from the tedium of threatening totalitarianism.' " Schapiro's wit was tempted by Berenson's pronouncement that "the nude erect and frontal has through all the ages . . . been the chief concern of the art of visual representation." "Nothing is so capable of stimulating our tactile sense," Schapiro slyly suggested, "as the image of the nude human body, and the frontal most of all." He admitted, however, that "happily" Berenson's "ideas about art are not altogether so forbiddingly classical and reactionary as would appear" from the passages he had "maliciously" excerpted. "Tactile values," he pointed out, was in fact an advanced idea in the 1890s but one that present-day classicists would reject. He conceded that what Berenson had to say "about his experience of quality and his insight into the accomplishment of an artist is very often striking and reveals in fulsomeness and force of statement a strong personality, sovereign in its field."

The extraordinary interest the book aroused must have gratified Berenson and reassured him that even though bypassed in some quarters and contradicted in others, he was still a force to be reckoned with. His mature convictions had been posted on the door of the world, and, an optimist to the last, he could hope that they might prevail.

The wartime writing which evoked a response in far wider circles was the *Sketch for a Self-Portrait,* published in 1949 simultaneously in London and New York, and, in Loria's translation, in Milan. Berenson sent off copies of his "glimpses into that chaos . . . we are accustomed to call self" to a great many friends and acquaintances as though they were personal letters. As Nicky carefully noted, 101 copies of the American edition were given away, 85 of the English edition and 69 of the Italian.

One of the first to respond was Harold Nicolson, who felt it a "joy" to encounter an autobiography "which really did manage to face the mirror." He said that "the book was widely talked about and I have not heard a single word which is not one of delighted respect for it." The patrician Nicolson was one of those who, though not an "enemy friend," yet had somewhat ambivalent feelings toward him. Commissioned to review the *Sketch,* he had confided to his diary, "I do my review of Bernard Berenson's *Sketch for a Self-Portrait.* Here again I have the conflict between sincerity and good feeling. He asks himself why he had not been able to inspire in others the confidence and affection he feels for them. Of course the answer is that he debauched his talent to make money and that he was hard and selfish to his contemporaries. But he was good to young people and he did teach them all a zest for beauty. How can I insult a man of eighty-five. . . . Raymond Mortimer in such a quandary would not review the book at all."

wrote for the Communist papers. To Hugh Trevor-Roper, the brilliant young historian at Oxford with whom he had begun a lively correspondence, he wrote that Morra "has been almost a son in this house for over twenty-five years. . . . Now it turns out he is an active, impenetrable, impermeable fellow traveller." Berenson's distaste for communism had become his chief political obsession. The Soviet Union, he wrote to Margaret Barr, "is probably the greatest threat to all WE hold dear that civilization has ever had to face."

He feared that the "Stalinites will soon be on the Atlantic." "I confess," he told Henry Coster, "I prefer the Nazis—despite everything." In Berenson's view Nazism had been an aberration, a violent but passing disease that could not blight the immense contributions of German culture, the heritage of Goethe and Schiller in which his own deepest aspirations were rooted. His "great fear and dread" was totalitarianism. The Catholic church, being itself totalitarian, seemed best able to resist the Soviet variety, but its "unswerving purpose of reducing the whole of mankind to its Paraguayan slavery" would "in the long run surely be worse than Soviet totalitarianism." In the face of political and philosophical dilemmas he found himself circling back and forth, tugged in contradictory directions. "I am in fact," he admitted to Edith de Gasparin, "a mystic with one foot in the Acropolis and the other in the Temple of Jerusalem."

Perplexed though he was by the menacing political and social outlook, his mystical humanism would not allow him to yield to pessimism. He scorned the nihilistic "wail of despair" coming out of France from the Existentialist cult gathered around Jean-Paul Sartre and the gospel of his *L'Être et néant* (Being and Nothingness) and Albert Camus and his *Le Mythe de Sisyphe*. "Why not rather admit," he insisted in his diary, "that there is a formative energy in our make-up that drives us to the formation of a society with its hierarchies, its morals, its imperatives, its arts, its sciences, its religions all tending to make a House of Life in which we each may find a home? It is essentially William James's 'will to believe'— to believe that we can build, to improve, to adorn, a ship which is carrying us from eternity to eternity propelled by a Power we cannot know, but about purposes we need not despair. In short even though life be a vale of tears it is one in which it is pleasant to weep."

The succession of writers and guests in 1946 now began to rise to the flood that would continue during most of the remaining years of his life, stimulating and delighting him even as it brought exhaustion. General Mark Clark came to Italy to decorate the Partisans. In a conversation with him Berenson conceded that only war would stop the Soviets, but after that what? Clark was followed by Walter Lippmann and his wife,

and this time talk ran on the growing specter of Italian communism. With the critic Alfred Frankfurter and David Finley, director of the National Gallery of Art, there was much satisfying talk of the art world. John Pope-Hennessy, of the Victoria and Albert Museum, resumed his visit to pore over photographs with his elderly friend.

At Casa al Dono Addie Kahn, now seventy, challenged him with her frank sympathy for the Soviets and the Arabs, and the two old friends agreed to disagree. For four days they were enchanted by Ruth Draper and the sparkling impersonations she gave each evening. For four weeks the Serlupis enjoyed the hospitality of the Berenson ménage on the mountainside. The much-traveled Arabist Freya Stark, who was now a twice-a-year habitué, put in an appearance, and with her Berenson shared his appreciation of older Arab culture.

If advancing years limited Berenson's avid explorations on foot, there were still the resources of the auto, and he made full use of them. His manuscripts could wait but not his wanderlust. Driven out of Vallombrosa at last by the cold, he decided to wander about to Siena, Pisa, and Milan and reach Venice in time for the exhibition of Old Masters. In Venice he visited the Italian financier Count Vittorio Cini at his palace filled with paintings and sculpture. When Cini was Mussolini's finance minister, it was he who had extended a protecting arm over Berenson. Having voted in the Council of Ministers to oust Mussolini, he had been tried by the short-lived Fascist republic and sentenced to Dachau, but in the chaos of those last days he found refuge in a hospital near Padua and threw financial support to the Partisans. Berenson found him a "handsome, fascinating man, vigorous and with a certain radiance that enchants me." In his booming voice he protested Berenson's earnest objection that the evidence in the Nuremberg trials was "faked up" and that the proceedings were illegal. At the exhibition Berenson found that he could not view paintings unmolested. "Fellow students" came by to discuss his "authoritative judgment," and soon a crowd of onlookers would fall in behind them to listen as he peered at the paintings with his magnifying glass.

He returned to I Tatti and another orgy of reading. Arthur Koestler's *Thieves in the Night* inspired indignation at the "British perfidy" in "separating off Transjordania and allowing no Jews to settle there." Palestine was much in the press during that violent year. Britain as the mandate power had severely restricted Jewish immigration, using its warships to intercept immigrants. The Irgun and the Stern Gang responded with terrorist raids on British military posts. At the same time clashes with the Arabs multiplied and the whole area was rent with disorder. "Decidedly Britain is betting on the wrong horse," Berenson

reflected. "The Jew is now ready to till the soil and shed blood, and it will make him master of the Arab world" unless Britain interferes "or the Soviets take up the Arab cause." From a sympathetic reading of Bertrand Russell's *History of Western Philosophy* he turned to the stories of Kafka and from those to Kierkegaard's *Angoisse*. So the reading went on with untiring relish. Ivins sent him his new book, *Art and Geometry,* and Berenson "gulped it down at a draft." "Some of it stuck in my throat . . . and some gave me heartburn. . . . All the same it is beautifully wicked and elegantly wrongheaded." As usual he and Ivins were at loggerheads and seemed to enjoy the argument.

His diary for 1946 comments on more than seventy books that challenged his appraisal, an extraordinarily wide range from the Book of Job to Madame de Staël's *Sur l'Allemagne* and Heinrich Wölfflin's *Gedanken zur Kunstgeschichte,* with excursions to Richard Halliburton's *Sam Slick* and Edmund Wilson's *Wound and the Bow,* all to be stored up in his still unimpaired memory to lend a grace to conversation. The buying of books, he felt, had "become a disease" for which happily there was no treatment, and year by year the forty thousand prewar volumes continued their march toward the final fifty thousand. Sometimes he felt that the library was his greatest achievement.

In the spring of 1947 Berenson went down once again to Rome after an absence of seven years. Roman society was cordial and he enjoyed being coddled and flattered. At a gathering where he met with Count Carlo Sforza, the minister of foreign affairs, he was comforted to find himself treated as an equal. Stephen Spender and his wife were in Rome and Berenson took them on a sightseeing tour, but the poet disappointed him. "From Spender I got no response, although I poured out my ointment box of epithets. If he were not an Englishman I should have thought him insensitive to visible things."

Spender seems to have carried away an agreeable impression, for when he became coeditor of *Encounter* he asked Berenson to contribute a piece on his acquaintance with Matisse. Berenson sent on the article, "Encounters with Matisse," and received Spender's enthusiastic praise, but for some reason it was not published and Berenson prudently salvaged it in his 1958 *Essays in Appreciation.* A German version appeared in *Der Monat* in July 1959. The concluding sentence of the article suggests that Berenson's distaste for contemporary art was not wholly undiscriminating: "My conclusion about Matisse is that in the neck-and-neck race with Picasso for the highest place in the art of the last fifty years he ended by coming in second."

Slowly and reluctantly Berenson gave ground to old age, lamenting his various infirmities but determined to hold to his course. As he ap-

[512]

proached his eighty-third year, his afternoon naps claimed more hours, but once up he seemed as sprightly as ever. Sensitive to cold, he shielded his bald head with the ever-present fedora. The cashmere shawl about his shoulders became a permanent accessory and would at last "serve" as a shroud in the grave. Seated on the terrace, he covered his thin knees with a lap robe. He felt the "machine going to pieces," but the methodically ordered regimen kept it going at a seemly pace. On his birthday the modest feast challenged his rebellious digestion and he mused, "Instead of clubbing the overaged to death, we now feast them into the grave." Yet he could not live without his congenial table companions. Thinking of Percy Lubbock living solitary in his villas since the death of Lady Sybil, whom he had married after her divorce from Geoffrey Scott, Berenson half envied his "capacity for being alone." For himself he needed "the stimulus and caresses of women and the talk of real men."

His desire for new acquaintances grew with the years, and he cast his invitations upon the waters of talent hoping to bring in richer fare. For example, in 1947, moved by Rosamond Nina Lehmann's *Ballad and the Source,* he sent her a "fan letter" and invited her to visit him. She promptly accepted and brought with her her lover the poet Cecil Day-Lewis. Though Day-Lewis did not relish Berenson's admiration of Rosamond, he was aware that his own love affair with her could not last. He later dedicated a long elegy to her, its setting I Tatti among "these statues, groves, books, bibelots, masterpieces."

Once begun, the letters between Berenson and Rosamond flowed without break for ten years. Her frequent visits enchanted him: in his ninety-third year he was to write, "Rosamond Lehmann arrived yesterday to stay a week. . . . As magnificently beautiful as ever, even if a trifle stouter. Only her eyes have the rusty look of age. [She was then fifty-six.] Wonderfully, harmoniously grand features, dazzling white hair, beautiful throat and arms untouched by years. I know nobody so life-enhancing."

The "I Tatti bus," manned again by Hugh Parry, had now gone back in service to meet the train and bring up the unending procession of guests. If Berenson sometimes dreamed of quiet repose, feeling that Nicky and his friends overestimated his strength, Nicky understood his lurking restlessness and, as his alter ego, diligently arranged for visitors and planned extended excursions if only to ascertain whether a church did or did not continue to exist.

Thus in the autumn of 1947, reluctantly taking leave of his aerie at Vallombrosa, he and Nicky started off on a giro by motorcar to Rimini to inspect the famous Malatesta Temple for whose restoration Rush Kress had recently given $50,000. They drove back across the Apennines

to Bologna to scout the paintings at the Pinacoteca Nationale, then proceeded to the aged Don Guido Cagnola's great Villa Gazzada above Lake Como for a few days' respite. With Don Guido they sought out the newly discovered pre-Ottonian frescoes in the ancient church of Santa Maria Foris Portas at the ruins of Castelseprio. Determined to scrutinize the unique frescoes at close range, Berenson climbed up to them on a shaky ladder. Don Guido, not to be outdone by his younger contemporary, also clambered up for a look.

On the road again they went down to the Brera in Milan to view the recently uncrated altarpiece by Piero della Francesca, whose tridimensional figures stood out in "a matchless way." The recent vogue for that painter had inspired Berenson to plan an essay which would show that the vogue was due to a great extent "to a need for justifying" a parallel cult for Cézanne's similar "unfeelingness and inexpressiveness." It was as a result of this perception that he subsequently published in Italian in 1950 and in English in 1954 a little book, *Piero della Francesca or the Ineloquent in Art,* in which, with much learning, he traced the history of portraiture to show that all notable figure artists "have been ineloquent, unappealing, unalluring, ungesticulating," and purely "existential." What linked Piero to Cézanne was that he was "almost as indifferent" to physical beauty as Cézanne. Both were more aware "of bulk and weight than of looks." The book's insights were presented, as the *New Yorker* said, with "urbanity, scholarship and occasional humor"; the *Times Literary Supplement* praised the book as "a brilliant exposition of the technique of style analysis."

Motoring south from Milan, the travelers descended to Genoa, to picturesque Portofino, and thence to Lerici, below La Spezia, to visit Lubbock in his "palace of delight." Returning, they lingered for a few days in the pine woods of Viareggio, then circled back for a day at Lucca, where Berenson "worshipped the cathedral with its sumptuous black and white," reaching I Tatti after two weeks' absence. Within a week he was off again for Arezzo, Assisi, and Rome. During the month in Rome he gave himself up to familiar pleasures: "mooning," as he said, on the Palatine Hills, enjoying High Mass and the Caravaggios at San Luigi dei Francesi, studying again the paintings at the Farnesina, and taking Raymond Mortimer of the *New Statesman* and Ambassador James Dunn and his wife on sightseeing excursions.

While in Rome he was sought out for an interview by a rising young American critic, Alfred Kazin. Kazin had missed him earlier in the year at I Tatti, where he had been shown about the villa by the aging Leo Stein, who was working in the library. In his journal Kazin said of the villa that Berenson had "shaped the whole with an inflexible exactness of taste that

is just a little chilling." The impression carried over to their meeting at "the grand Hotel Hassler." Berenson rather liked his visitor "as a human being" and laconically noted, "He seemed intelligent." A half century younger than Berenson, Kazin appraised him with the unsentimental eye of a New York Jew who was familiar with his legend and reputation. He did not approve the way Berenson distanced himself from other Jews. Nevertheless, as a conscientious reporter he drew a telling portrait of the man. He saw him, he wrote, as "an old courtier in his beautiful clothes, every inch of him engraved fine into an instrument for aesthetic responsiveness and intelligence. He spoke English with such purity and beauty of diction, blandly delivering himself of words, one by one, that he might have been putting freshly cracked walnuts into my hand. . . . Remembering his extraordinary library, one had a picture of him at I Tatti as another Voltaire at Ferney, a kind of European intelligence office—yet subtly remote from the pressure of events."

They talked of Henry Miller, whose *Tropic of Cancer* Berenson had just read. Berenson somehow gave him the impression that he was familiar with all of Miller's works and detested them. (*Tropic of Cancer* was in fact the first book of Miller's he had read, and he had written in his diary that though it was "the most indecent, most scatalogical book I ever waded through," it was not "the dirtiest" because it was "saved by something genuinely Dionysiac.") Of Kafka Berenson had remarked, "There is a very small light of reason burning in the world. Mr. Kafka tried to put it out." Kazin was surprised at the way in which Berenson looked up to Santayana, rejecting "the faintest criticism of the great man." Berenson admitted, however, he had not yet read his memoirs, Nicky having advised him not to, saying "he would be too distressed."

Long afterward, when Kazin published his own memoir, *New York Jew,* he salvaged a striking vignette of his last sight of the imperious aesthete. Berenson was standing on the hill above the Spanish Steps watching the sunset. "A young American, excited to recognize him, walked over in a babble of enthusiasm. Berenson coldly waved him away: 'Young man! You're standing in the way of the sunset!' "

boast—"What splendid pen pals we are"—could soon apply to Berenson's exchange with Hemingway. After Mary's visit Berenson sent copies of his *Sketch for a Self-Portrait* and *Aesthetics and History* to the Hemingways in Cuba. Hemingway replied, "You write very well 'General,'" and Mary added, "I am finding your *Aesthetics and History* as stimulating as my favorite champagne." Ernest soon took over the correspondence in his exuberant and unbuttoned prose—misspelling, profanity, and all—and the delighted Berenson did what he could to keep the confidences, wartime reminiscences, rough-hewn fantasies, outrageous anecdotes, and unorthodox opinions flowing. One of the many lurid ones ran, "Picasso is a good friend of mine but he would sign and sell his laundry lists or used condoms if there was a buyer."

Hemingway warmed to Berenson's solicitous interest in him and saw in him a potential father or brother, "if you ever wanted to father a really bad boy." There were at times a pathetic dependence upon Berenson's attention, and a boyish assertion. After he was severely burned in a brush fire in Africa, he sent Berenson a large and rather horrifying photograph of his terribly burned left hand.

When Berenson later queried him about the reputed symbolism in *The Old Man and the Sea,* Hemingway assured him, "There isn't any symbolism. The sea is the sea. The old man is an old man. The boy is a boy and the fish is a fish. . . . All the symbolism that people say is shit." Then he diffidently asked Berenson to write a few sentences about the book "that could be quoted by Scribner's. You are the only critic that I respect and if you really liked the book it would jolt some people I do not respect." In the *Scribner's* advertisement Berenson's tribute led all seven endorsements. "Hemingway's *Old Man and the Sea,*" Berenson wrote, "is an idyll of the sea as sea, as un-Byronic and un-Melvillian as Homer's himself and communicated in a prose as calm and compelling as Homer's verse. No real artist symbolizes or allegorizes—and Hemingway is a real artist—but every real work of art exhales symbols and allegories. So does this short but not small masterpiece."

When in 1954 Hemingway promised to visit him, Berenson felt "a certain dread to seeing and knowing him in the flesh. . . . His letters seemed written when he was not quite sober, rambling and affectionate. I fear he may turn out too animal, too overwhelmingly masculine, too Bohemian. He may expect me to drink and guzzle with him." Hemingway, then in Venice, took sick, and the opportunity to meet never came again. He too felt apprehensive at the thought of a meeting. He had earlier written to Berenson, "I am too shy to come and I hate to go anywhere in an état de manifeste inferiority."

Long letters continued to pass between them until two years before

Berenson's death. In 1954 when Hemingway had just been awarded the Nobel Prize and was interviewed in Cuba by long-distance telephone, he told the journalist Harvey Breit, "I would have been happy—happier—today if the prize had gone to that beautiful writer Isak Dinesen, or to Bernard Berenson, who has devoted a lifetime to the most lucid and best writing on painting that has been produced."

Early in January 1949 Sturges Riddle, the Episcopal rector in Florence, brought up to I Tatti another American novelist, the sixty-four-year-old Sinclair Lewis, accompanied by his companion Mrs. Powers. Berenson found Lewis "more presentable" than he expected, for word of his guest's "hard drinking and slovenly ways" had preceded him. What caught his searching attention was not Lewis's ravaged complexion but his "fine blue eyes and tolerable pronunciation." Berenson had kept abreast of his immensely successful novels.

Lewis's companion, who years before had looked on indulgently at her pretty daughter's romantic affair with the middle-aged novelist, had stepped into her place after the young woman's marriage. While Nicky looked after her, Lewis and Berenson found common ground in their passion for "mongrel" word coinages like Berenson's "metafuzzical," "Refu-Jews," and "Angry-Saxons." Their first meeting featured a lively exchange on the state of the novel in the United States. They agreed in their admiration for Faulkner and Robert Penn Warren. Berenson, however, insisted that Edith Wharton's *Ethan Frome* was only a short story; Lewis considered it a novel and her masterpiece. Lewis came up once a week to I Tatti during his two-month stay in Florence. The following year when he returned to Florence other distractions occupied him, and in spite of cordial invitations he visited only twice. His decline had grown more tragically marked, and at the end of 1950 he died in Rome abandoned by friends, the diagnosis "acute delirium tremens."

Berenson took a good deal of pride in the variety of his notable guests. "Billy Rose one day," he exulted to Ivins, "Katherine Dunham another and a third Georges Bonnet." The irresponsible Billy Rose, one of the "Clowns in chief" of New York, impressed him as the "quintessence of cleverness." Dunham arrived attired "like an Egyptian queen." Later when he saw her performance in Rome he wrote, "It wakes up and brings to life in one even like myself the sleeping dogs of almost prehuman dreads, aversions, aberrations, appeals." Peggy Guggenheim, who had become notable for her eccentricities, paid her court on the same day as Katherine Dunham. She was, Berenson thought, "silly but not stupid, a good sort despite her financial freedom to do what she likes." When he asked her what she was going to do with her large avant-garde collection of art, to his mock horror she impishly replied she would leave it to him.

was during this trip also that he met Prince Alphons Clary-Aldringen, an Austrian aristocrat. Alphons tells of the meeting in his memoirs, recounting how at a fashionable tea their hostess led Berenson to an armchair, "where he sat as if on a throne, receiving guests, one after another just as in an audience." The prince took "an instant liking" to Nicky. Though she was then sixty-one "and a little plump," he thought it immediately obvious that she must "once have been enchanting." At the gathering a young man who made the mistake of addressing Berenson as "Professor" was icily rebuffed. He returned with an offering of cake and now tried "Maestro." The rebuff was even colder. Berenson never escaped from these honorific titles. Letters from the director of the Louvre always began "Cher maître," as did those from Marc Chagall and others.

Berenson hurried back from Venice to "receive a houseful of guests," as he put it, "coming up from Rome to inaugurate the baptistery doors," which had been restored to their pristine beauty. There were, however, more important reasons for his presence in Florence. A few days after his return the mayor of Florence conferred on him the freedom of the city as an honorary citizen. Then, on the eve of his eighty-third birthday, which brought a flood of congratulatory messages, he "dressed in blue" and drove down to the Palazzo Strozzi to be honored by the Italian government at an international meeting of art historians and critics for his services to Italian art.

There were speeches in his honor by the professor of fine arts at Pisa University and by the superintendent of fine arts of the Province of Florence. The minister of public instruction, the noted jurist Guido Gonella, presented him with two bronze medals. One, specially struck in Berenson's honor, bore his profile on one side and on the other the legend "A Bernardo Berenson / Il Primo Convego / Internazionale Per Le Arti Figurative / Firenze Giugno, 1948." The other, nearly five hundred years old, by Matteo de' Pasti, had been found at Rimini in a wall of the Malatesta Temple damaged during the Allied bombardment. An engaging fantasy published in the *Nazione* of Florence reported that when the temple was bombed, the artists of the Renaissance flew down from heaven and handed to a member of the crowd a book "by one who loves us as few others do. His name is Berenson." They said, "Go and find him. . . . Without his genius and his zeal, no one could write of us as he has written. He has revealed us to ourselves."

Despite the distractions of guests, travels, and honors, Berenson reserved time at his desk or in bed during 1948 and 1949 for his writing. He busied himself with two essays, he said, out of a planned four. What all of these were went unrecorded. One of them, the small book *Seeing and*

Knowing, reached print in 1951 in Luisa Vertova's translation and in London in 1953 in the original English. The English edition, embellished with eighty-eight illustrations, was dedicated "To the Memory of Belle Greene, Soul of the Morgan Library." She had died in 1950.

Seeing and Knowing had its origin in a visual revelation Berenson experienced at the end of the *Palio* in Siena when "the sun had just set and the afterglow flushed from the red palaces" and he saw streaming into the piazza what looked like a floral canopy but what he knew was in fact the multicolored crowd of human beings. It was the most vivid of the experiences through which he had discovered the contradiction between what one sees and what one knows. His survey in *Seeing and Knowing* of the successive conventions by means of which artists have effected a compromise "between retinal vision and conceptual looking" led him to prophesy that the "anarchic" heresies of "so-called" abstract art which reject any rational compromise between seeing and knowing would inevitably pass away and be replaced by "sculpture and painting as arts based on the human nude as the essential and vital factor in figure representation." In the "polyglot etymological puns and soap bubbles" of Joyce's *Finnegans Wake,* he wrote, the words at least have some "trace of meaning," but "the lines, dots, squares and circles, and other geometrical diagrams" of abstract painting "were related to each other only in the executant's impenetrable selfhood." Among illustrations exhibiting the conventions of representative art he included Picasso's lifelike drawing of Vollard and, on the opposite page, as an example of Picasso's "frivolously intellectualistic" distortion, a geometrical sketch of 1938 titled "Woman."

The essay drew critical outrage at Berenson's lapse "into something close to sheer vituperation." It was "little more than a statement of Berenson's prejudices," wrote one critic. Only his friend the painter George Biddle, in the *New York Times,* had a kind word to say: it had always been his "own credo" that "great art must retain a wholesome balance between seeing and knowing."

One political event of 1948 that deeply stirred Berenson was the proclamation of the new state of Israel. The event became one of the subjects of a spirited interchange with Trevor-Roper, whose brilliantly successful *Last Days of Hitler,* published the year before, furnished an appropriate background. The terrorism that preceded the founding of the new nation was disturbing. Berenson commented, "I fear it is the Stern gangsters who will have monuments put up to them"; but then he added, "no people reaches statehood except through blood, filth, and terror. If you read such remarks about Jews in Poland and the Warsaw ghetto as appeared in the *Spectator* you understand why all of them from *Zentraleurop*

want Palestine no matter on what terms. And now that a Jew is ready to dig the soil, fight and die nothing will stop him unfortunately and unhappily. On the other hand he may establish a power that England may regret having embittered as she has Ireland."

In his diary he protested against the "*Spectator*-minded Anglo-Saxon" who was indignant that the Jews were violently dispossessing the Arabs. "How did his Celtic, Saxon, Jute, Danish, Norse ancestors come to England? As suppliants begging to be admitted (as indeed the Jews in Palestine for decades)? They came with fire and sword sparing no one. And how about America?" When some years later his friend Stewart Perowne, the English Orientalist, hoped that when the fate of Israel was decided, the Jews would return to their spiritual mission, Berenson protested that they were human like the rest of mankind: "Why should they only be perpetually subject to persecution, to discrimination, to legalized or administrative annoyance, and—wholesale extermination as practised a few years ago by the Nazis?"

In the years that followed, Berenson increasingly reconciled himself to the Jewish identity which at last had been thrust upon him. When he came to read Kafka's "minutely detailed self-awareness" in his diaries, he wondered whether such "narcissism" exhibited in the case also of Bergson, Proust, and his own self was not really due "to our Jewish origins. Hunted, always insecure, our ancestors must have developed unusual gifts of inner as well as outer observation, which nowadays turns us into psychologists, scientists, novelists, critics." He came to feel himself "a typical 'Talmud Jew,' " his chief pursuit "learning"—that "and brooding, dreaming, yearning, longing. . . . Only my Talmud now ignores Jewish learning and is concerned with everything that is human."

He recalled that the New England education which he had eagerly embraced had so obliterated "the fantastically concentrated ghetto world" of his childhood "that it took Hitler and perhaps old age to revive it, bring it back to my daily divagations." The Holocaust had "made a place of security for the remainder imperative." Moreover, he saw Israel as bringing civilization to the Mideast, replacing the bedouin who had "scarcely put foot on the lowest rung of civilization." After three thousand years the Jews were "still creative," whereas the Arab was "nowhere." Israel, he believed, could be made "a bulwark of Western humanity and security."

Berenson perceived himself as a Jew who had made his way in a pervasively hostile world rife with anti-Semitism. Being "intelligent, quicker, abler," Jews "cross the interests or vanity of gentiles, and are resented accordingly—the way Roger Fry resented my authority in Bond Street, and as good as declared war against me if I did not leave

London to him." But being a Jew, as Berenson was aware, was an immensely complicated affair, as complicated as least as being a Christian among a multitude of sects and social classes. For Berenson, as for many another Jew, there were more diverse and hostile tribes among Jews than ever populated Judea, from the secular atheist to the ultraorthodox Hasid. He reserved his chief disapproval for one that his imagination created, the German-Jewish art historians, and up to the end of his life he warned John Walker to keep clear of them.

If his discriminations were often unreasonable as he surveyed his fellow Jew or "fellow scapegoat," his appreciation of being part of their larger fellowship was genuine. When Baroness Germaine de Rothschild told him of the fortunate recovery of a grandchild, he responded, "We Israelites are fabulously vital." As a nonagenarian he wrote, "I am more and more amazed to discover how seldom I meet an interesting thinker, scholar, or writer who does not turn out to be a Jew, half-Jew, or quarter-Jew." That he could number himself in their company now gave him a good deal of satisfaction. There was a peculiar pleasure in recalling his long-buried self: "How easy and warm the atmosphere between born Jews like Isaiah Berlin, Lewis Namier, myself, Bela Horowitz, when we drop the mask of being goyim and return to Yiddish reminiscences, and Yiddish stories and witticisms."

His belated recovery of the Jewish identity that had been "obliterated" in his youth did not displace the manifold other identities which flourished side by side in his complex personality. Nor did it make any easier his dogged effort to unravel the puzzling contradictions of his elusive "self" as he probed his consciousness for a page in his diary.

L

Master of the Inn

ERENSON'S ambivalent conceptions of his own nature were illustrated when *Life* magazine featured him in the April 11, 1949, issue not long after *Time* had brought him worldwide notice on the occasion of his honors from the Italian government. *Life* dispatched a crew to photograph him in his domain, and he enjoyed seeing the varying photographic revelations of his personality. Yet when he philosophized about himself of an early morning with a writing board on his knees, he paradoxically thought of himself as a very private person. The full-page photograph in *Life* of him seated at his desk, with copies of the de luxe Italian edition of *Aesthetics and History* spread out before him, depicted a handsome and distinguished-looking aristocrat, a strong, calm graybeard whose penetrating and philosophic gaze permitted no evasion.

He had welcomed the photographer and his crew, but the story which accompanied the photographs did not please him. It began by saying that he had established "an Olympian reputation as an art expert" and had made "a mint of money out of it as well." He lived in "an elegant villa suitably remote from the world's vulgarities." The writer spoke of his "punctilious and fastidious daily life" under Nicky's "watchful supervision." A succinct account of his beginnings under the patronage of Mrs. Gardner asserted that his interest in art "came suddenly and flamboyantly." The characterization could hardly have been more offensive to his view of himself. He protested to Walker that the article was "disgusting," adding, "I have never sought notoriety and now that in a petty way it has come it is in the most shoddy vulgar way. I must deserve it I suppose." That he had sought fame as a writer on art was quite another matter.

Berenson's discovery by *Time* and *Life* removed the last shred of his

[526]

scanty privacy. He now became an international personality to be sought out by the merely curious and the tuft-hunter. On the way to his bath he would sometimes be startled by the sight of visitors being conducted through a corridor by a secretary to view the Primitives on the wall and he felt he had become merely part of the exhibit. One result of the increased publicity was that he became good "copy," and guests from time to time published appreciative articles on I Tatti and its venerable master.

The *Life* article made him the object of fan letters. There was already under way a project that would introduce him to a more sophisticated audience. The successful Broadway playwright Samuel Behrman had been at work for several years, during intervals of dramaturgy, on a series of articles for the *New Yorker* magazine on Joseph Duveen. Louis Levy had written a memoir of Duveen some years earlier in which, as Belle Greene told Berenson, he made him out to be the "unrecognized son of the Father and the Holy Ghost." Levy lent Behrman the "marmoreal panegyric," and Behrman so effectively satirized it to William Shawn, the editor of the *New Yorker,* that Shawn challenged him to do a "Profile."

Behrman soon discovered Berenson's pivotal position in Duveen's career, and Shawn suggested that an entire article in the series be devoted to Berenson. Walker, with whom Behrman had become friendly when digging away in the archives of the National Gallery of Art, proposed to Berenson that he talk with Behrman when they could all be in Venice for the Bellini exhibition in June of 1949. Berenson approved the idea. He was anxious to meet the writer of Joe Duveen's life, he said, "and put him straight" about his connection "with his lordship," for there was "a fatal tendency" in what was written about himself "to get everything wrong, and what is worse, vulgar."

With much trepidation Behrman met Berenson at lunch on the terrace of the Europa Hotel in Venice. He was so impressed and excited by his encounter with this "tiny Jove" that, as he wrote to Paul Sachs in the fall, he didn't "know what the Hell" he was eating. The fifty-eight-year-old Behrman added that he wished he "could have sat at his feet twenty years ago. I feel that my life would have been immeasurably enriched had I been able to do so." At one of their interviews Berenson, indisposed, was in bed with just his head visible. "He looked gigantic," Behrman recalled. "Certainly his looks were extraordinary . . . transcendent. The sentences rippled from him at once casual and lapidary." One memorable sentence that Behrman was obliged to omit on the lawyers' advice ran thus: "Duveen was at the center of a vast, circular nexus of corruption that reached from the lowliest employee of the British Museum,

right up to the King." Twenty years later, in his *People in a Diary,* he felt free to include it. Shocked by what he was learning of Duveen's methods, Behrman wondered how Berenson kept himself "free of centripetal suction."

Many years afterward Kenneth Clark, apparently inspired by Behrman's metaphor, depicted Berenson for the British Broadcasting Corporation as being "on the highest pinnacle of the mountain of corruption; he didn't do anything positively dishonest, but he couldn't get down." What that "nexus of corruption" was Behrman vividly described in the Andrew Mellon section of the *New Yorker* "Profile." Duveen knew the enormously persuasive power of money shrewdly spent upon the domestic staffs of prospective clients or upon benefactions to a museum director with a too-limited budget. He built an informal network of spies, in effect a system of commercial espionage, to enable him to be the first to learn of the whereabouts of a painting to be bought or sold or the whereabouts of a purchaser to be intercepted in his travels. Though Berenson had declined to play a role in that sordid system, the knowledge that he had contributed to the success of the system by his eloquent "certificates" and had greatly profited from it had long weighed on his conscience. It was an experience that he tried to erase from memory. The name "Duveen" rarely appears in his diary, and when it does he merely mentions him as an "art broker" who affected him "negatively, if at all."

Another vivid characterization that Behrman was not permitted to publish reflected the singular impression he had received of "B.B." "Duveen was like the captain of a pirate ship, bearing in its solitary cabin the prisoner he had abducted, and he the most sensitive and civilized consciousness in the world." After Behrman returned to New York he wrote to Nicky of his plan "to write along about Duveen for a good space . . . and then launch into B.B. (I can't wait to launch!) and to show that the whole tremendous edifice of sales, taste and so on, were all based on one perception, and one intelligence, and two eyes, all residing in Florence, Italy." Behrman sent the draft of his article on Berenson to him and incorporated his corrections.

A large part of the article depicted Berenson's walks about Venice during the days of the Bellini exhibition at the Doges' Palace. The sprightly oracle moved slowly through the crowds, a diminutive figure in "brown fedora, brown suit, gleaming walking stick and brown boots," frequently "raising his hat to passing acquaintances." At the entrance of the Doges' Palace after "much hat lifting and embracing," he talked briefly with a German who began to weep and moved off. Berenson, his face grimly set, explained that the man was the director of the Dresden museum. " 'He returned to his former post but the Russians

came and carted everything off. . . . What made my friend cry was not alone that they took the things off but that *they were so badly packed!* "

As the little procession moved about, Freya Stark came up and Berenson "greeted her ecstatically," joking to a companion that "she was intended by Providence to be a Bedouin." Then before the pictures he "went to work with his tools—a flashlight, a magnifying glass, and slung over one shoulder, a pair of opera glasses." When his torch "cast a light on the hills behind Vicenza" depicted in one painting, he remarked, " 'Exactly what it is today, isn't it Freya?' " He asked her whether she remembered the Latin poet who described the scene. She began to recite the verses and Berenson "took over and recited the rest." Before another picture, *The Dead Christ Supported by Angels,* in which only part of one of the cherubs was visible, he exclaimed, " 'The audacity of Bellini! What a dazzling innovator he was to allow that child's head to remain invisible! And look—look at those adorable children. Look at their faces! They know they ought to be sympathetic.' " Before a nearby altarpiece of a Church father in a heavily brocaded robe grasping a staff, he broke out, " 'See the *weight* of that hand! And the *weight* of the brocade!' " Before another painting the flashlight swept across he declared without hesitation, " 'This Bellini is *not* a Bellini!' " The little group then stood before a painting from the Louvre, *Christ Blessing.* "At this picture Berenson stared a long time, saying nothing at all."

IN THE spring of 1949 Berenson reported to Walker the arrival of a fresh contingent of curators which included Alpheus Hyatt Mayor, curator of prints at the Metropolitan Museum of Art, and Henry Sayles Francis, curator of paintings and prints at the Cleveland Museum of Art. Berenson listened raptly to talk "teeming with museum gossip." He counseled Mayor and Francis and their fellow curators in person and by letters on attributions, and they in turn sent photographs of new acquisitions of Italian paintings for his ever-growing photograph collection. With their help and that of dealers he kept track for his Lists of the changing locations of paintings as private collections were broken up and sold.

One especially interesting change of location had occurred, as Germain Seligman informed him. The firm had just agreed to sell to the Kress Foundation a Mantegna *Portrait of a Man* which Berenson had expertized for Germain's cousin Georges before the war. It joined the Kress Collection at the National Gallery of Art, and Germain, in appreciation of Berenson's long past services, sent a check for $16,000 as compensation.

By this time a substantial correspondence had arisen with Samuel Kress and his brother Rush. Berenson had now received a list of queries from the elder Kress, who was particularly concerned about the attribu-

tions of two important paintings in his collection. One of these was the Cook tondo *Adoration of the Magi*. It was this inquiry that prompted Berenson to write the "Postscript 1949: The Cook Tondo Revisited," which Hanna Kiel published in *Homeless Paintings* together with his 1932 *Bollettino d'Arte* article "Fra Angelico, Fra Filippo and Their Chronology."

The other painting about which Kress inquired was the Allendale *Nativity*, purchased as a Giorgione in 1938 from Duveen after Berenson broke with the firm. Berenson told Kress that he had had the picture in his study twelve years ago, "and short of having it again under my eye, no further photos could help me."

What was to have an important bearing on Berenson's own work was Kress's request for advice concerning the publication program that the foundation was undertaking. Berenson urged the foundation to "publish books that in the present state of anarchy commercial-minded publishers do not dare to print." "I, for one," he assured Kress, "am ready to forego any profits on what you will bring out." Of his own works he suggested as a starter *A Sienese Painter of the Franciscan Legend*, a work that was particularly dear to him, and an essay of his on the "Adoration of the Magi," for which he said a thousand copies in English and five hundred in Italian would be sufficient since the essay would appeal only to specialists. Neither of these suggestions was taken up. His second proposal, a new illustrated edition of his *Italian Painters of the Renaissance*, proved more attractive. He had already sent on to Kress a copy of the Italian third edition, which had come out in the preceding year.

As BERENSON reviewed the passing weeks in the autumn of 1949 "the mental landscape" seemed "dull and dim." Guests made their way up to Casa al Dona as usual, but he felt he "could no longer participate in controversial talk," so that at times he found himself in the strange position of a silent bystander. Sure relief, however, lay in travel and sightseeing. At the Vatican galleries in Rome with the archaeologist Gisela Richter, daughter of Jean Paul Richter, he was almost as much diverted studying the faces of tourists as reexamining his "old sticks and stones" on the walls. At Naples he clambered about Pompeii with the archaeologist Amedeo Maiuri. He passed a few days with his "oda-lisque" Clotilde at her luxurious villa, La Quiete, and got back to I Tatti on October 20 in time to welcome the Lippmanns. Philip Hofer, the Harvard bibliographer and book collector, who had been his guest in the villino for six weeks, had been succeeded there by Derek Hill, the young English painter whose intimate companionship Berenson was to enjoy for the next few years while Hill painted the Tuscan landscape.

The guest rooms of I Tatti continued to be filled as if he were "keeping a boarding house with free meals and lodgings." It was "excessive but not unpleasant." Count Contini Bonacossi, with whom he was now quite friendly, came up to see him and provocatively announced he had sixty paintings to show him. Berenson "coaxed a bit and was shown some twenty. The rest no doubt all intended for Kress, his one and only buyer. So be prepared for the best," he told Walker, who advised the Kress Foundation. Since Pichetto, the restorer at the National Gallery of Art, had died, Kress urged Berenson to get together with Contini to recommend a successor. Mario Modestini, Contini's restorer, was persuaded to accept the post and was soon expressing horror at Pichetto's overrestorations.

Berenson's free "boarding house" was a salon in almost continuous session whose "Thursdays" were held every day. Alfred Frankfurter came to report on the current American taste in art. Axel Boethius, the eminent Swedish archaeologist, now rector of Goteberg University, whom Berenson had not seen for twenty years, renewed his visits, sometimes in the company of his fellow archaeologist Crown Prince Gustaf. Another returnee was Percy Lubbock, whose *Edith Wharton* had come out two years earlier. The two men talked of long-dead Henry James, whose letters Lubbock had published in 1920. Berenson saw much that year of the "always delightful *causeur*" Harold Acton and the devoted Arturo Loria, on whom he increasingly relied as a translator. Hugh Trevor-Roper came for a stay and dazzled him with his grasp of history and current politics, and he listened with keen pleasure to the Oxford don's intimate tales of academic politics.

As the years fled by, time grew more precious. Berenson was now nearing eighty-five, and despite "endless cosseting each day" and Emma's "frictions, inhalations, attentions to nose, to gums, to throat, to ears," he kept hearing the sound of the distant drum. Would he be alive next year—or even on the morrow? He felt himself a voice crying in the wilderness of an irrational and heedless world, and whether he would be listened to or not he was determined to speak out, to have his say while he still had breath, to hurry his doctrine into print while there was still time.

The diary of his war years, ready since 1945, was still unpublished. "Sick of approaching cap in hand on my knees to Angry-Saxon publishers," he had turned to an Italian publisher, and the volume was brought out in the beginning of 1950 in an Italian version—*Echi e Riflessioni*—translated by his friend Count Guglielmo degli Alberti. At least Italians who had lived through those four years with him, years of *Fascismo,* warfare, and privation, would find his pages rewarding. The publisher's faith was supported by favorable reviews.

had not seen since before World War II. A paradoxical reason for travel, he confessed, was to get away from "all the reminders of what I want to do, but shall not." The car was finally loaded with its piles of old-fashioned luggage, a box of books, and the inevitable tea things and he, Nicky, and the indispensable Emma set out on May 16 on a leisurely ten-day drive to Paris with the imperturbable Parry in the driver's seat. "Old Paris," he exulted after he settled himself in the Prince de Galles Hotel for a month's stay, "is more of a whore than ever—more alluring." Literary people "make flattering declarations." Arthur Koestler impressed him as a stimulating talker, though "a deeply convinced supernaturalist." He retraced the way, on June 8, to the Villa Trianon, where Anglo-American society used to congregate, and found his aged contemporary Elsie de Wolfe, the only survivor of the fashionable "Trinity" who had once lived there. The refurnished house was more exquisite than ever, but Elsie looked "scarcely alive, a skeleton with a head fantastically dressed up, a pair of dark eyes into which all life has retreated and concentrated, as if for a last, a supreme effort." She seemed wild with excitement to embrace him. Fighting off death with a certain élan, she entertained visitors almost to the end. A month after his visit, her secretary-companion replied to Berenson's inquiry with word that she was dying. Her death came on July 12.

In his abbreviated daily walks, Berenson found Paris more "delightful than ever, mostly because the visible is on a human scale." It was a relief to get "away from Italy's petty problems" and its "provincial citizens." His French friends welcomed him as at a homecoming after his fourteen years' absence. He made the rounds to Jean Rouvier, the writer-diplomat, met with Count Reynald de Simony, and dined with Marie Laure de Noailles, the writer who had been part of Edith Wharton's circle. He found Jean Cocteau flourishing as poet-dramatist and filmmaker, whose *Enfants Terribles* and *Orphée* had just been screened. At afternoon teas at the Louis Gillets he met Nancy Mitford and Sylvia Thompson. It was a pleasure to see again the fascinating Philomène de Lévis-Mirepoix, whom he took to dinner. She seemed more human, more stimulating, more vibrant than ever. Kenneth Clark and Ben Nicolson came over from England, bringing news of the British art world from their posts at its center. He had a cheering visit also with Derek Hill, his former neighbor in the Villino Corbignano, and he spent a pleasant hour with Sumner Welles.

In the Salle des Sept Maîtres at the Louvre, where he was seated in state, the director, Georges Salles, an old friend and admirer, presented him to department heads and trustees, and he reciprocated their "flattering phrases" as gracefully as he could. He haunted the museums with

undiminished appetite and even spent days at the "up-to-date" exhibits, by way of discipline. Though less shocked than he had expected, he could not help exclaiming to Margaret Barr, "What a reversion of values and what a helot revolt against draughtsmanship. Serves them right, them who admire them." At the Louvre he looked at medieval sculpture in the company of the noted art historian Marcel Aubert. His greatest delight, however, was to roam the aisles of a bookstore, his fingers itching to pick up every book he saw. He would have liked to "buy and send home half the shop."

He visited for a few days at the Château de St. Firmin near Chantilly as the guest of Sir Alfred Duff Cooper and Lady Diana. His old London friend Lady Sybil Colefax, one of his favorite correspondents, now eighty-one and desperately ill, insisted on coming over to see him and even accompanied all of them to view the paintings at Chantilly. She survived the visit by only a few months.

From Paris the sentimental travelers loitered down to the cathedrals of Chartres and Bourges. They drove on to Grenoble and Digne, Berenson visiting old confrères or sightseeing from the car—not, as long ago, "poking" his nose "into every alley." At Nice he called on his "contemporary" Matisse, who seemed "highly satisfied with himself" and "very different from the anxious, half-starved, apostolic peasant" Berenson had first met. Matisse seemed sure that his work in the chapel at Vence would be his masterpiece. He talked of the Steins and of the visit he had once made to I Tatti. Berenson came away unimpressed by the two "very bumpy" sculptures in the studio.

Berenson had carried with him to Nice a letter he had received in Paris from Mally Dienemann, the highly intellectual widow of a German rabbi who had died in Israel shortly after his release from a concentration camp in 1939. She was now living in Chicago, and, having been greatly moved by his *Sketch for a Self-Portrait,* she had begun a correspondence with him in 1949. In the course of their interchange she had challenged his admiration for Christianity. "You speak of God and the love of God," he wrote in reply to her letter, "but I use a different vocabulary. In the cathedrals of Chartres and Bourges I felt exalted, transfigured, and could not but be deeply grateful to the inspiration which produced them. No metaphysical or historical considerations can contradict the visual, the verbal, the musical art. And none as much as what Christianity has created and revealed and through its daily ritual continues revealing. So I am happy to find God *sub specie* of Christ, the Virgin, the Saints and for me they are TRUTHS without being FACTS. . . . I feel at home in every house of prayer."

In spite of Mrs. Dienemann's great admiration for him, his arguments

gio. The highly personal monograph finally took shape and, impatient to have it published, he offered it to the Electa Press when American and British publishers held off. Dedicated to the memory of the Italian art critic Aldo de Rinaldis, it came out in 1951, translated by Luisa Vertova. In 1953 the original version was issued by Chapman and Hall in London. By then the small book competed with Roger Hinks's much-praised academic study, a kind of work that was anathema to Berenson. Hinks ironically conceded that Berenson's book might be read "with amusement and profit."

In *Caravaggio, His Incongruity and His Fame* Berenson, drawing on sixty years of study and reflection, took the reader by the hand to adventure through the works of the artist. Against the current admiring claim of Caravaggio's modernity he issued his dissenting opinion: "In every way Caravaggio makes on one like myself the impression of an early Cinquecento Venetian out of his time, out of his place and—out of his technique." The recent craze for Caravaggio was, he believed, based not on the "quality" of his work but on his romantic temperament.

The cultist nature of the vogue led Berenson into uninhibited digressions against the "German-minded authors" for whom a "work of art is only a springboard from which to plunge into turbid depths of the subumbilical subconscious or to rise with leaden wings into an empyrean whence they bring down theories, pseudo-histories, misinterpretations, romances, occult theologies," and so on. His invective ranged over the function of eclecticism, the meaning of the "baroque," the nature of "mannerism," and the question of value in art. He was particularly vehement in his attack on the efforts to associate Caravaggio with the baroque, insisting that Caravaggio "deserved to be regarded as the most anti-baroque artist of the XVII century."

Reviews of Berenson's peppery judgments were naturally mixed. Even the loyal Ben Nicolson disarmingly suggested that Berenson's view "must be taken in the light-hearted spirit in which it is written." The *Apollo* leniently remarked that Berenson's procedure of saying "anything that comes into his head" was "palpably worthwhile where a head such as his is the source of instruction and delectation." The *Connoisseur* similarly thought the monograph a "mosaic of brilliant thoughts and musings." Walter Pach agreed with Berenson that mere historicity should give way to the recognition of artistic quality. Clearly evident to all was that time had not weakened Berenson's aesthetic passions nor diminished the vigor of his rhetoric.

L I

Garnering the Past

BERENSON resented the unwillingness of English and American publishers to take his volume of selections from his war diary despite the attention *Time* and *Life* had given him. Hence, when in the spring of 1951 Max Schuster of the firm of Simon and Schuster came to lunch and asked him whether he had a manuscript available, Berenson grumbled, "Only my war diary and nobody wants that." Schuster asked to be allowed to take it to his hotel. The next day he phoned to say that he had hardly slept, hurrying from one diary entry to another. "I will not only publish it," he said, "I will make a best seller of it." It was astounding, he thought, that the book had had to wait for him. "What is the matter with American publishers," he wrote to Richard Simon, "if they can't tune in on a notable, noble, and gloriously yea-saying humanistic work like this?" It happened that almost simultaneously Constable in London agreed to bring out a British edition in a shortened version.

No longer sought after by English and American journals, Berenson directed his busy pen in 1951 to Italian and French publications. One article, "The Importance of Fashion in the Dating of Pictures," appeared as the introduction to the catalogue of the Turin exhibition, *La Moda in Cinque Secoli di Pittura*. In another article in *La Revue des Arts* he conjectured that a Giorgionesque *Sacred Conversation*, given to Sebastiano del Piombo, should be assigned to Domenico Mancini. In his youth he had admired it as Giorgione's. The "game" of attribution had obviously lost none of its fascination for him. Inspired by the forthcoming exhibition of the paintings of Tiepolo in Venice, he contributed to another French periodical an article on the painter about whom he had once expressed reservations. Now, "owing to a maturer judgment and to a much wider

to Billie Ivins in January of 1952 that there were six young men present, three from Harvard and Yale and three from Oxford. He thought the Oxford trio abler and more knowledgeable.

"Hosts from over the seas" continued to stream through the house, among them friends and acquaintances who spanned the whole gamut of intimacy. What was remarkable was how quickly mere acquaintance often blossomed into comradeship. His relations with two members of the Biddle family followed this course. After World War II Berenson became acquainted with Francis Biddle and his wife, Katherine, a poet. Francis had been attorney general under President Franklin Roosevelt and had served as a judge in the Nuremberg war crimes trials. The two men shared the Harvard tie and soon became "close friends," according to Francis, though they differed strongly in political philosophy.

Francis' brother George, an artist who had accompanied the American troops in the Mediterranean campaigns, had recently published the volume *Artist at War,* illustrated with some of his paintings. Berenson read it and wrote to Francis that he was eager to meet its author, and early in 1952 George Biddle came to I Tatti with his wife, Helene, a sculptor. His first impression was somewhat critical. He was surprised by Berenson's "small stature and look of fragility." "Yet one senses," he wrote in his diary, "the desire to dominate and something of a showman." He found Berenson outspoken and opinionative, and rather too ready to disapprove. When their talk turned to Santayana, whose portrait Biddle had painted, Berenson declared, "He is completely without warmth or feeling," but of Santayana's *Life of Reason* he conceded, "Yes, that is a great book."

In June when Berenson and Nicky were on their way to study architecture in Apulia, they stopped off for a night at the George Biddles' at Amalfi, and in the autumn the Biddles spent a night at Casa al Dono. Berenson "lay in front of the open fire," Biddle recorded in his diary, "covered by a white shawl, fragile, slightly deaf, his beautifully modulated voice so low that it was difficult to hear him. At times a gentle Satanic expression." They talked especially of Italy and of the Italians, who, Berenson thought, were now unfriendly to America. Berenson seemed to enjoy being called an "old pessimist"; "he loves to appear *farouche,*" observed Biddle.

From these beginnings sprang a cordial correspondence, Biddle speaking up for the claims of the modern in art and Berenson expressing fears that "what used to be called 'fine arts' may have to wait until we have passed through a dark age." In 1959 Biddle, on learning of "dear B.B.'s" death, was put in mind of Berenson's generous remark about Arthur Schlesinger, Jr., "I shall always be grateful to that young man for his *Age*

of Jackson." It inspired Biddle to write in his diary, "I shall always be grateful to that old man for his zest for life, his appetite for ideas and his love for human beings."

In the same season of 1952 John Walker sent on a pair of ornamental visitors, young and pretty Jacqueline and Lee Bouvier. They met him as he came out of the ilex wood at I Tatti, and as soon as they had sat down he began to speak to them of love. "Never follow your senses. Marry someone who will constantly stimulate you." Most of their conversation was about "life-enhancing and life-diminishing" people and the need to avoid the latter. They thought him a sage, "a kind of god-like creature, in the way he doesn't fit in with the hurly-burly pattern of our present world." Jacqueline became one of his fans and continued to send him artlessly gossipy letters for several years after her marriage to Jack Kennedy, whom she had met later in 1952 while working as an inquiring photographer for the *Washington Times-Herald*. When she and Kennedy were married in September of 1953, Berenson cabled his good wishes to the pair.

A peculiarly notable addition to the roster of visitors in 1952 was J[ean] Paul Getty, the sixty-two-year-old oil billionaire and art collector who some years before had founded the Getty Museum at Malibu in California. Reputed to be the world's richest man, he had already formed a notable collection of paintings and objects of art. Eager to meet Berenson, whose authority he greatly respected, he welcomed an invitation to tea one day while he was in Florence with the writer Ethel Vane, who was collaborating with him on a book about his collection.

A young library assistant escorted Getty and his companion through the rooms and corridors of I Tatti, Getty glancing "longingly at the fine pictures and art objects adorning both corridors and staircases." At tea time Berenson seated himself in his usual corner of the settee near the fireplace and the guests ranged themselves closely about him. To Getty, "the unostentatious luxury, the atmosphere of culture, the prevailing harmony were soul satisfying." Berenson's mind, he thought, "is like quicksilver, yet he has all the serenity of the historian." To Ethel Vane, "that slightly arrogant set of the head, the chiselled bone-structure of the face and those beautiful hands were an artist's delight." Later when Getty talked of the visit, he declared, "I Tatti and Bernard Berenson are an event and a privilege I shall always remember. I have never been more impressed in my life."

During the following four years Getty became an appreciative correspondent. He and Berenson exchanged photographs of antique sculptures and shared opinions on art. The acquaintance, however, had a curious sequel. The pale, stern-faced Getty, besieged by thousands of

L I I

"The Last Aesthete"

BERENSON had long ago acknowledged to Charles Du Bos that he had "a good human desire for 'fame,' " but he wished it to be "unanecdotic" and "impersonal." Fame had come to him, but it was now being overshadowed by his "celebrity" as a phenomenon around whom legends already clustered. The stream of visitors to I Tatti took back to England and America their varied impressions of the exquisitely ordered existence of the intellectual kingdom of I Tatti and its aristocratic ruler, who, in old age, had arisen out of the ashes of the war like a phoenix. A writer in the *New York Times* hailed him as a prophet who foresaw the perils that now confronted the Western world. When Santayana had died in 1952, an editor of the *New York Times* discussed the remarkable intellectual achievements of the two men as a reproach of the little most people achieve with their minds. At the close of 1953 the psychologist Martin Gumpert published an article identifying "Ten Who Know the Secret of Old Age"; the group included, besides Berenson, Frank Lloyd Wright, Abraham Flexner, Winston Churchill, Somerset Maugham, Learned Hand, Konrad Adenauer, Arturo Toscanini, Bertrand Russell, and Bernard Baruch.

Obviously Berenson's life was ripe for exploitation, and when he returned from Rome in December 1953 he was confronted with a disconcerting request from Mark Longman of Longmans Green & Company. He was asked to approve their inviting Sylvia Sprigge, a former war correspondent for the Manchester *Guardian,* to write "a personal portrait" of him as a kind of pendant to his own *Sketch for a Self-Portrait.* Berenson drew back in alarm. He had enjoyed the deference that had been paid to him and the many friendships that his prominence had brought, but had recoiled fastidiously from the journalistic prying that inevitably accompanied it.

Berenson had met Sprigge in 1945 when she had come up from Rome. She was then forty-two. An able linguist in French, German, and Italian, she had made a reputation as a newspaper correspondent and as a translator of Italian works. Berenson enjoyed her attentions and they became friends. A frequent guest thereafter at I Tatti, she studied her host with affectionate curiosity. Whether she or Longman conceived the idea of the book is not clear; but, as she told Nicky, "once I get going I don't give up easily." She finally obtained Berenson's reluctant consent to a "portrait" or "profile."

"Why do I wriggle and toss at the idea of being biographied?" Berenson asked himself in the confessional of his diary. "Is it only because there are so many big and little episodes I wish forgotten? Of course I have much behind me that I hate to recall, and hope will not be remembered against me. Every kind of lâcheté, meanness, pettiness, cowardice, equivocal business conduct (due more to ignorance and the ethics of art dealers than to my own nature), humiliations, furtiveness, ostrichism, etc. Yes, all these and more and worse that rise and denounce me in the hours of the night when I am not quite awake, and defenseless against all the nastiness that an uncontrolled mind churns up from the foul depths of memory. How passionately one wants to forget! No—not these only or chiefly. I dread having my life written as 'the success story,' as it is bound to be, seeing that economically and socially I had to make my way from nothing at all. Yes, economically and socially, but I never from the earliest dawn of consciousness felt proletarian or inferior to the highest class anywhere."

Berenson feared the journalist in Sylvia Sprigge, believing that it was "impossible for her to conceive of my life except as a vulgar success story." Though the projected book was always discussed as a "portrait," Sprigge privately saw her task as a full biography, and she proceeded to collect what materials she could. Meanwhile, Longman seems to have begged out of the project, and it was taken over by William Collins. The firm's literary adviser acquiesced in Berenson and Nicky's insistence that the book be approached "from the point of view of the personal relationship" of Sprigge's eleven-year friendship, but pointed out at the same time that it would have to have a "broader" scope in spite of Berenson's "strong views about the use she might make of his childhood and youth."

Alarmed to learn that Sprigge planned to go to the United States to "look things up," Berenson reminded her that he had given "reluctant consent" only for a profile or portrait and for that no research should be required. He pointed out that others, like Behrman, had wanted to do a biography but had accepted his "no." He also explained that no one was

fiction as a means of depicting the implications for good and evil of the progress of science and invention. What especially caught his eye was Bradbury's declaration, "I very much enjoy, I *relish* writing science fiction." For him, Bradbury wrote, "fun was the handmaiden, if not the progenitor, of the arts."

This perception so chimed in with Berenson's own notion about creativity that he sent Bradbury a "fan letter" saying that it was the first time he had "encountered the statement by an artist in any field, that to work creatively he must put flesh into it, and enjoy it as a lark, or as a fascinating adventure." He ended with a cordial invitation to Bradbury to visit I Tatti. Bradbury was able to report that John Huston had engaged him to write a scenario for *Moby Dick* and that he would therefore be coming to Europe in the spring.

Bradbury and his wife arrived in April, the thirty-three-year-old Bradbury looking like a football player and towering over his host. One day at lunch, after Berenson had read Bradbury's *Fahrenheit 451*, he said he had been fascinated by the finale in which the "Book People" memorized the books to save them from the "Burners." "You could do a sequel," he suggested, "when the Book People are called in to recite their memorized books and remember them all wrong. . . . Think of it! *Crime and Punishment* remembered by a fool. Machiavelli's *Prince* mouthed by a numb-skull. *Moby Dick* recited by an alcoholic cripple. . . . What fun, what variations, what satire. Write it down."

After the screenplay of *Moby Dick* was finished, the Bradburys again visited Berenson, this time at Vallombrosa, and Bradbury reported the joyful reunion in his article in *Horizon*. "The old teasings, the gentle arguments," he wrote, bombarded him "before, during, and after lunch, and took up again after a very long siesta, at late afternoon tea." At their parting Berenson admonished him, "When you go to museums, only stay for an hour at a time! Don't exhaust the body so as to exhaust the eye and tire the mind." His young friend embraced the trembling body and said, "Oh, B.B. I always will." It was as his "everlasting son," Bradbury afterward said, that he would remember him.

Berenson returned to Venice after the Bradburys departed in the spring of 1954 in order to restudy the Venetian painters for the projected volume in the Phaidon series. The Venetian masters had been "like a religious experience" at his first sight of them in 1888, and even after seventy years of familiarity something of that feeling remained. For two months he haunted the Scuola Grande di San Rocco, the Gallerie dell'Accademia, the Scuola Grande di San Marco, and the Scuola di San Giorgio degli Schiavoni. He thought Tintoretto's paintings at San Rocco com-

pared favorably with Rembrandt's for "interpretation and craftsmanship."

At the opera house in Venice he heard the pianist Walter Gieseking play Beethoven, and as the unearthly murmur of the crowd rose "like the muted roar of breakers on a rocky shore," he wished he could have paralleled his *Seeing and Knowing* with a *Hearing and Knowing*. "More and more," he reflected, "I become aware of how much antecedent knowing was injected into seeing, hearing, and smelling as well." He attended a high mass at St. Mark's conducted by Cardinal Spellman and was "carried away by the performance. . . . All my senses, sight and sound, were ravished and my mind as well."

He was still in Venice on his eighty-ninth birthday, and cables and telegrams poured in from well-wishers in America and Europe. Members of the Institute for the Study of Venetian Art met after dinner to drink his health, while he lost himself in thought like a bystander. "Why can I never feel that I belong?" he pondered. Introspection drew an invisible wall about him so that no matter how assiduously he sought company, the inner self seemed somehow to feel extinction in the multitude.

With the extensive new wing of the library completed in 1954, I Tatti took on increasingly the aspect of a scholarly institute. Earlier in the year some thirty members of a European "cultural union" descended upon Berenson to visit the library. One of them, Jean Wahl of the Sorbonne, pleased him with word that Henri Bergson often spoke of him. But so large a group oppressed him. He enjoyed more the arrival in the autumn of the "flower of what is best in art-historians" who daily frequented the library—Frederick Hartt, Richard Offner, Margaret Rickert, and two Guggenheim fellows beginning their year abroad, Charles Seymour and Berenson's old acquaintance Sydney Freedberg. Yet even they left him unsatisfied. "Not one of them," he lamented to Ivins, "has any notion of placing the hypnotizing object of his 'research' in a universal scheme of things, of what it all meant through the ages, what it should mean now."

His friendly association with the scholarly Offner, whose learned criticism of his attributions had once irked him, showed the mellowing effect of old age, of Berenson's growing willingness to let bygones be bygones. As one whose writings now reached the widest international audience, he could afford to be indulgent. He still had a caustic tongue for intellectual pretenders, however, and he sometimes jumped too readily to an untenable conclusion. Discussing music one day with a group in the salon, he launched out in a characteristically perverse fashion, asserting that there were only two composers of any importance, Wagner and one

other. A young guest burst out indignantly, "B.B., you don't know what you are talking about. You don't know anything about music and ought to keep such opinions quiet." While the rest of the group stood stunned by this blasphemy, Berenson quietly yielded: "You are quite right. I don't know anything about music and I'll keep quiet on the subject." Such graceful concessions may have been rare, but they did occur.

Callers studied their host with varying degrees of sympathy, fitting the legends that had grown up around him to the reality they found at I Tatti. One friend, somewhat put off by Berenson's heterodox pronouncements, would finally conclude that he was "lovable but not likeable." A far warmer estimate was that of Ralph Barton Perry, whose wife, Berenson's sister Rachel, had died twenty years before. Now at eighty-one Perry wrote, "I want you to realize what your fraternity and kindness have meant to me and what, in fact, it has meant to me for many years to own you for a brother. . . . 'In law' means nothing as applied to Rachel's family. This applies peculiarly to you, who are closer to me than my blood brother, as much as I love him. It is an uncalculated, simple affection, mingled from my point of view with moral and intellectual admiration."

One of the more interesting visitors in the fall of 1954 was the Russian-born painter Marc Chagall, who came up to I Tatti with his wife. Neither looked Jewish to Berenson's critical eye, yet, to his wonderment, Chagall painted "nothing but ghetto life." This struck him as an anomaly. It led to the curious assessment that in his own face and features he could trace "a Germanic something." Berenson relished Chagall's simplicity and candor, and the sixty-seven-year-old painter carried back to France a cordial impression of their meeting. He regretted only one thing, he wrote to "Cher Maître," not to have known Berenson earlier. He thought that contact and talk with him would have helped him in his life and his work where he often was a little puzzled to know where he was.

During 1954 Berenson varied his work on the Venetian catalogue with a number of essays in his columns in the *Corriere della Sera*. One, "Wishful Attribution," dealt with the "universal tendency to ascribe a given work of art to the greatest artist to whom wishful thinking and excited imagination can ascribe it." In another, "For Whom Art," he sought to rescue art from the obscurantism of pedantic critics. In still another article he commented on the Guido Reni exhibition in Bologna, which he attended in September. He conceded Reni's achievements as an "illustrator" and praised the admirable arrangement of the exhibition. He too had once admired Reni but had concluded that he could no longer be

regarded "among the great" because his paintings woefully lacked tactile energy. The current interest in him was, he contended, an example of the tendency of the young toward faddish enthusiasms in art.

As part of his preparation for the revised catalogues to be published by Phaidon, he now dispatched his assistant Luisa Vertova on a long visit to America to check the Italian Old Masters in the collections there. Her researches carried her as far as San Francisco, where she was entertained by Berenson's friend the diplomat-financier James Zellerbach. William Milliken reported from Cleveland that he went round the museum several times with her and thought her "an extremely able and knowing person," one with "a first-rate eye."

Among the I Tatti guests in the spring of 1955 was Samuel Behrman, whose *Duveen* was being featured in the local bookstalls in an Italian version. Four years had passed since his rapturous and admiring interviews with Berenson in Venice. The luxury of the elaborately ordered existence at I Tatti, where host and guests still dressed for dinner, seemed to his playwright's eye like something out of one of his Broadway successes; at least he so reproduced the scene when long afterward he described the weekend in his *People in a Diary*.

There were guests at every meal, and when Behrman asked Nicky how Berenson stood it, she replied that though he railed at the succession of visitors, once, when she had tried to ration them, he confessed that he missed them. At dinner Berenson "volleyed the conversation through three languages, French, Italian and German, with occasional dips into Latin." At an animated luncheon with Peter Viereck and his wife, for which Nicky had arranged a "New England boiled dinner," Berenson was "in wonderful form." Harold Acton, just back from Paris and full of admiration for Manet's sensational *Olympia,* joined the guests at dinner. Earlier, walking in the garden, Behrman and his host had compared notes on their boyhood memories. Though there had been few if any Jewish observances in the Berenson household after the family's emigration to America, Berenson astonished his guest with his knowledge of Jewish lore and its antecedents in Minoan civilization.

It was at this time, on the eve of his ninetieth birthday, that Oxford University offered him the honorary degree of Doctor of Letters. The belated offer revived his grievance against the British establishment, which had so long excluded him. "Had it come years ago," he thought, "how I should have rejoiced." Now he could only think of the words in which to "couch my refusal." Besides, to accept would require his participating in the elaborate ceremony, the very thought of which exhausted and frightened him. He sent off his regrets and then, to escape the double peril of the May music festival and the threatening celebra-

tion of his birthday, set off with Nicky on a two-month archaeological tour. Their itinerary would take them by leisurely stages to Tripoli and Calabria.

Rejecting the advice of his "air-minded" friends, he took the express train to Reggio Calabria, only to discover that stumbling and pushing his way through six or seven crowded and swaying cars to the dining car was an ordeal for which he was no longer fitted. At Tripoli as the distinguished guest of the Countess Anna Cicogna, the attractive younger daughter of the Italian financier Count Giuseppi Volpi, he was whisked away from the quay to her picturesque villa while Nicky attended to the customs formalities. Days passed agreeably enough, what with walking in the garden, reading or being read to, "chatting, dreaming, [and] watching the sunset from the roof terrace."

Accompanied by the superintendent of monuments, Ernesto Caffarelli, he revisited the imposing reconstructed theater at Sabratha. Too tired to tour all the ruins, as he had twenty years earlier, he contented himself with the dazzling mosaics and portrait busts in the museum. Elaborate arrangements were made for him to spend four days at the great Roman ruins at Leptis Magna, where, with Caffarelli as guide, he rode through the vast area on a "kind of pushcart" on rails propelled by four workmen.

In Calabria he archaeologized for ten days with obliging friends, studying sites from Reggio to Cosenza and beyond and dutifully recording in his diary his impressions of churches, tombs, mosaics, and scenic views. His notes on the art and monuments soon appeared in a series of columns in the *Corriere della Sera*. They were a loving fusion of past and present sightseeing and learned recollection, as when he wrote of being "stirred almost to tears" at Cosenza at the Ponte Alarico as he recalled from his boyhood the romantic German verses by August Platen on the burial of the heroic Alaric in the bed of the stream. Though he had not read up for the tour of Calabria, his many years of study had left a vivid trail of historical associations and vestiges of the writings of half a dozen authors, including Norman Douglas, whose *Old Calabria* he had read and reread. The columns earned him the Italian Cenide Art Criticism Prize for articles on Calabria, a prize of 100,000 lire ($150).

With undiminished zest he continued on to Naples for an appreciative hour among the antiquities of the museum and then to Rome, where he spent several days making his usual rounds. At the Borghese Gallery the photographer David Seymour caught a striking view of him contemplating Canova's reclining figure of Napoleon's sister. It and the Bernini sculptures—the *David,* the *Apollo and Daphne,* and the *Rape of Persephone*—seemed to him more illustrative than plastic"; both sculptors,

he thought, "sin by lack of grip." Of the paintings at the Borghese only Correggio's *Danae* now gave him "complete satisfaction," and at the Capitoline Museum there were few works he could enjoy on "purely artistic grounds." He now needed, he said, the sauce of historical knowledge before he could in most cases abandon himself "to unadulterated enjoyment to the point of ecstasy."

He reached Assisi in time to celebrate his ninetieth birthday there on June 26 by reexamining the great frescoes of the basilica. He doubtless felt a certain appropriateness in his presence at the shrine of Saint Francis on that day, for at I Tatti for more than half a century he had daily lived with the great Sassetta painting of the saint. Francis of Assisi was the saint he most admired, and he had expressed his profound reverence for him long ago in his articles on the Franciscan legend.

While at Assisi Berenson received a touching greeting from Luisa Vertova, his gifted assistant: "I love you so much, dearest B.B., that I selfishly hope you will, during your journey, devote a minute's thought to the girl who blossomed up under your wings, whom you took up starved, eager and full of curiosity." Among friends at Assisi, he encountered his former disciple F. Mason Perkins, now eighty-one. Long resident there, where he had become a devout Catholic, he died within a few months of their meeting.

In honor of Berenson's birthday the July 4 *Newsweek* featured an illustrated article captioned "B.B. The Last Aesthete." It told how Berenson traveled accompanied by Nicky; by Emma, his cook and nurse; and by Parry, his Welsh chauffeur. "Each day his huge black Fiat limousine, vintage 1938, rolled up to one stopping place after another precisely on schedule." Crammed into the vehicle were fourteen pieces of "old-fashioned luggage" and the shawls and paraphernalia to keep the always-cold Berenson warm. "The world honored him," the account continued, "as a great art critic, a cataloguing canonist who has made his name as inseparable from the study of Italian Renaissance painting as Blackstone's is from the English common law. . . . [He is] one of the world's few remaining symbols of the cultivated humanist. . . . He is probably the world's last great aesthete."

enty-seven, was astonished to find Berenson, at ninety, "as alert and gay as ever." He found his flashes of erudition in his talk of aesthetics and philosophy fascinating, and when he left, he felt that his host's "spirit had refreshed and aroused his own."

Although Berenson religiously spent hours in daily naps, he constantly amazed observers by his vitality. "There was nothing feeble about him," wrote Cecil Beaton, the famous British photographer who had come by to photograph him. "He seemed alert and filled with great strength and agility. His mouth recalled a shark, his eyes were pale, his skin a fine vellum parchment." Beaton felt a charismatic quality in the aristocratic old man who "seemed almost a mystical moral to our shortsighted pragmatism."

Nicolson, his wife, Vita, and their son, Benjamin, arrived early in August 1955 for Ben's marriage to Luisa Vertova and were put up at I Tatti. The ceremony took place in Florence in the customary Sala di Matrimonio of the Palazzo Vecchio with the old councilor arrayed in evening tails and black tie and patriotic cummerbund. Neither Berenson, who was at Casa al Dono, nor the ailing father of the bride was able to attend. After the ceremony the Nicolsons drove up to Vallombrosa to visit Berenson and found him looking even smaller than formerly and "as frail as an egg-shell." He seemed "seriously deaf" but as "alert and waspish as ever." Berenson was delighted to learn how much he and Nicolson agreed about people and events, "e.g., Munich, and about the peacemaking organizations of UNO, etc., so busy bustling and buzzing today."

No sooner was Berenson recovered from an attack of bronchial fever than he embarked in mid-September with all his "aches and pains" in his vintage automobile for the last days of the Giorgione exhibition at the Ducal Palace in Venice. The international exhibition of Giorgione and the Giorgionesque displayed an array of paintings brought together from all over the world, of which thirty-five were assigned to Giorgione himself. The Allendale *Nativity* was shown as the joint work of Giorgione and Titian, with the central group attributed to Giorgione, William Suida being cited, however, as giving the painting to the young Titian.

Berenson discovered that he was himself part of the spectacle at the Ducal Palace. An American painter asked to shake his hand; a young woman wanted his autograph; a class of students wished to be photographed with him. More exciting was his meeting with Mary McCarthy, who was at work on her book on Venice. Known in the United States as "our best-looking authoress," she was, at forty-three, a striking personality. She had paid her satiric respects to American universities in

The Groves of Academe, and her most recent novel, *A Charmed Life,* had earned the dubious characterization "intellectual brilliance without heart." After his departure she wrote to him that being in his company was "one of the unexpected rewards of having come here and undertaken this preposterous task. Thanks to your *Lotto* and other writings, I've had the loan of your eyes here."

While Berenson was in Venice he talked with André Visson, the Russian-born political writer for the *Reader's Digest* who had visited I Tatti in 1947 with his wife. After briefing Berenson on the disturbing international situation, he passed on a pleasanter piece of information, that Isaiah Berlin had opened his Auguste Comte Memorial Trust lecture with a quotation from *Rumor and Reflection.* In that book Berenson had protested against the mistaken doctrine of the "inevitability of events and the Moloch still devouring us today, 'historical inevitability,' " and Berlin had made this affirmation the theme of his address in which he argued for "the existence of a limited but nevertheless real area of human freedom."

When Lippmann wrote that the University of Chicago had awarded him an honorary degree, Berenson was able to reply, "Boast for boast, I can outdo you altogether; on the 4th of this month [November 1955] I was given an honorary degree at the Sorbonne," the eulogy being delivered by Le Doyen Renouvin. The document joined his already sizable collection of awards, medals, and certificates of appointment to learned societies in Europe and America.

On his return from Venice Berenson became increasingly aware of difficulty in hearing. Like fellow sufferers everywhere, he learned to "smile and nod approval" and to shake his head as if hearing. "I suit my responses to the faces," he wrote, "and not to the words of people who talk to me." He was safe, however, in a tête-à-tête, and Nicky always steered a responsive guest to the sofa beside him. In spite of growing physical disability, Berenson continued to welcome a heterogeneous succession of visitors. All he could offer in his own justification, he said, was "that like all higher animals I prefer the presence of my kind to solitude and silence." That autumn he particularly enjoyed the presence of His Majesty Gustaf Adolf VI, king of Sweden, as a house guest. Gustaf had ascended to the throne in 1950. Now seventy-three, he roused Berenson's "utmost envy. Not because he is a king on a throne, nor that he has all the advantages of his position. . . . I envy him for boyishly enjoying as a 'lark' everything he has to do, all the inspections, all the receptions, all the speechifying, all the listening, all the deciding . . . and all the ceremonial of a king on a throne. And he enjoys digging at fresh excavations, and is indefatigable at sight-seeing and discussing works of art unsignalled. . . . What can life offer more than that?"

On Christmas Eve Berenson suddenly became dangerously ill. He later recorded in his diary the scene at his bedside. He had caught Dr. Capecchi's "desperate look" toward Nicky and the attendants and, amused at the efforts of all to hide their despair, he had said, "If you think I am dying, tell me so, for I have various matters to attend to before I die." They all denied their fears, but he afterward learned that Dr. Capecchi had given him up and had asked what arrangements had been made for administering the last sacraments. The crisis passed as quickly as it had come on, and the rhythm of life returned to the usual meticulous regimen, with Berenson checking with his assistants the final touches to the manuscript of the catalogue of the Venetian painters.

The coldest winter in eighty years came to Tuscany with a fierce tramonta blowing and the Arno sheeted in ice. Snow blocked the familiar paths on the Fiesole hillsides, and Berenson, again confined to his bed, received callers at his bedside, their presence strictly rationed by Nicky. She gamely kept at her post though barely recovered from a broken ankle she had suffered while accompanying Berenson on one of his abbreviated walks. Like a medical chart, his diary recorded the progress of his ailments. "I have been living the life of an invalid," he wrote on February 2, 1956, "preoccupied with bladder and intestines, doctor once and even twice a day, thermometer to take temperature every hour or so, high fever at times, potions, pills, tablets every half hour." Weeks of antibiotics made him cry out, "O Death where is thy sting, O grave thy victory." If not for Nicky, he said, he would have done away with himself. To Ivins he wrote, "I have had two calls to dine with the gods. Churlishly I refused and they reacted by making me deathly sick."

A visitor brought to his bedside copies of his letters to Henry Adams during the early years of the century. Berenson's laconic comment, "Quite interesting." Only a short time before, he had reread Adams' letters to him. He thought their pessimistic "outpourings" about Adams' associates had been addressed to him because he was "an outsider." It somewhat annoyed him that Adams had never addressed him as " 'Dear Berenson,' and of course not as 'B.B.' " He little knew how few even of Adams' familiars presumed to call him "Henry." To his interviewer, Berenson spoke of his admiration for Adams as a writer and fellow aesthete. He avowed himself a "disciple" of Adams, who, he said, had fostered his interest in the medieval architecture of France.

THE BURDEN of the years grew heavier. Berenson complained that "huge stretches of memory have sunk into oblivion, like icebergs in the warm ocean." Names eluded him and even his own attributions began "to lack validity, because I forget how I made them." Fortunately the dark

moods did not last, and when he worked free of them he wrote or dictated his columns and attributions with unimpaired opinionativeness. Walking up and down on the terrace in the spring, he "felt something soft, caressing in the air, and a smell and taste as of a nosegay in my nostrils and on my lips." Word arrived that John Walker had been chosen to succeed David Finley as director of the National Gallery of Art. Though he had been hoping that Walker would be the first director of the I Tatti Institute, the news was deeply gratifying. "Of course you must accept," he wrote. "Directing the National Gallery is a far more important task than directing I Tatti."

During the spring of 1956 the artist Petro Annigoni, whom Berenson had known since 1947, came to do a pen-and-ink sketch of him. He and Berenson shared "to a great extent, the same feelings about the excesses of modern art," and Berenson had strongly seconded him in his campaign against "the reckless cleaning of Old Master paintings." When the sketch was completed, Berenson looked quizzically at it and said, "In this portrait I am impressive, a personality to be taken seriously. Other people . . . have taken me seriously. I never." The sketch commanded a full page in the August *Connoisseur*. In it Berenson, almost as large as life, looks out gravely into the unfathomable distance, the bearded face burdened with thought.

While Annigoni was at work on the sketch, Van Wyck Brooks and his wife, Gladys, were invited for a four-day stay, a visit described in her book *If Strangers Meet*. They arrived from Rome one afternoon just in time for tea. The guests stood conversing in the living room, and Berenson suddenly appeared as "noiselessly but inevitably, as a shadow moves along a wall." To Gladys Brooks, the slim, diminutive figure seemed to lack "any corporeal dimension." The Brookses stayed on for more engrossing talk after the others left and, though seated on either side of their host, had to speak "clearly and distinctly" to make themselves heard. Suddenly, at 7:30 Berenson, without a word, took his leave. He reappeared at the dinner table precisely at 8:00 in dinner jacket and black tie.

Mrs. Brooks was impressed by the flattering amenities of I Tatti. "Our small Fiat was taken from us, to reappear washed and polished, our clothes were unpacked and pressed and shoes polished." In their comfortable suite of rooms, "the blinds were closed at evening and fresh flowers were brought in the morning. Breakfast we ate in our little sitting room beneath walls hung with gold brocade, and holding small treasures of painting by Nattier and Pietro Longhi, the Venetian."

The Brookses observed how their aged host thriftily rationed the hours of each day. His great enemy was cold, and when he sat receiving,

"like another Voltaire, the pilgrims from all the world who filled the house at lunch, tea, and dinner," he held a hot-water bottle on his knees beneath a plaid rug. The talk ranged widely, avoiding abstraction and "metafussics," for Berenson seized always upon the concrete whether of science fiction, international trade, or the Risorgimento. To make a point he quoted Ovid or a line from German poetry.

Each day at 12:30 the Brookses joined Berenson to drive up the hillside for a distant view of Florence and to begin a stroll downward. One day Berenson unlocked the gate on the road above I Tatti and took them through the overgrown path to the pool in the grotto where stood the turret and classical temple which Queen Victoria had once visited. Berenson explained that the pool filled the old quarry where Donatello had obtained "the *pietra serena*" for his sculptures.

A warm sympathy for Harvard and the New England past united Berenson and Brooks. Brooks, at seventy, with a great shelf of books on the varieties of American experience behind him, could share with Berenson the latter's pleasure in "Do you remember . . . ?" Intellectually they had come out of the same matrix with a similar fastidiousness. Later, when Brooks sent him a copy of *Scenes and Portraits,* Berenson remarked, "How much of it could enter into my own autobiography!" Half the names were of people he had known or known about. Letters frequently passed between them until Berenson could no longer hold a pen in hand. In that year, 1958, Brooks sent him *The Dream of Arcadia: American Writers and Artists in Italy, 1760–1915.* One of its chapters dealt with Berenson, and the volume bore the dedication: "To Bernard Berenson with affection."

Once back at his desk, Berenson resumed the congenial work of the Kress-financed catalogues. With the revision of the Venetians substantially out of the way by April 1956, he moved on to review the attributions of the Florentines in the 1936 Italian edition of the Lists, leaving his staff to check the printed sources in the library and assemble the photographs. He was to continue to work sporadically on the Florentine attributions for two more years until sight and strength failed him. The completion of the Florentine Lists was entrusted by Nicky to Michael Rinehart, a young art historian trained at Harvard, who began his assignment at I Tatti in September 1959 shortly before Berenson's death. Luisa Vertova Nicolson selected the 1,478 illustrations, although she did not agree with many of Rinehart's changes of attribution. In 1963 the extremely complicated task of revising the Lists of the Central and North Italian schools fell to Luisa Nicolson, as well as the difficult job of deciphering Berenson's corrective memoranda.

The revised catalogue of the Venetians came out in 1957 and "added 68

new Lists to the 80 old ones." The 1,333 illustrations filled most of the two substantial quarto volumes. The two volumes of the Florentine school, issued posthumously in 1963, added "24 new Lists" to the 77 old ones. As for the Central and North Italian schools, more than 50 new Lists supplemented the previous array of 200 in the 1936 edition. This concluding catalogue was finally published in 1968, the entire first volume listing the artists, the second and third presenting 1,988 illustrations.

A fresh honor agreeably interrupted the carefully programmed spring days of 1956. As a result of the initiative of Professor Roberto Longhi, the Academic Senate of the University of Florence voted to award Berenson the honorary degree of Doctor of Letters and Philosophy. Because of Berenson's advanced years and recent ill health, the ceremony took place in the library of I Tatti. The rector of the university "made a beautiful speech" that was "free," in Berenson's opinion, "from rhetoric and adulation, yet highly appreciative, cordial, almost familiarly affectionate." The assembled company received copies of a lengthy Latin poem, written by Hugo Henricus Paoli, which paid high tribute "Ad Bernardum Berenson, Athenai Florentini, Doctorem Honoris Causa."

If Longhi had an ulterior motive for proposing the honor, as a Berenson protégé has intimated, Berenson showed no awareness of it even though he half-humorously regarded Longhi as his "arch-adversary." Longhi is said to have been anxious to conciliate Berenson, who had begun to replace him as a principal adviser of Contini Bonacossi in his dealings with the Kresses. It seems rather improbable, however, that Longhi had much reason to fear his ninety-one-year-old rival. In any event, the two men "met very naturally and cordially like old friends." Adversary or not, Berenson considered Longhi "the most gifted among Italian art historians and critics."

Berenson journalized that though the occasion had been delightful, "it does not change my feeling of failure, of inadequacy, of incompetence." The insistent repetition of such entries in his diary suggests that he must have been aware of a certain hollowness in his protestations. He may have wished—even hoped—for preeminence as a writer and thinker but he also was keenly aware of the limitations of his talent. A further sign of the esteem of Italians for Berenson came soon after the honor from the University of Florence when on May 22 President Giovanni Gronchi conferred on "Professor" Bernard Berenson the honor of Cavalier of the Great Cross of the Order of Merit of the Republic of Italy.

Mary McCarthy put in her appearance in the spring, and Berenson readily yielded to her energetic charm—and adulation. Resuming his favorite role of cicerone of nature as of art, he took her "to Gricigliano, back by Sieci along the Arno, Tuscany at its most enchanting moment, a

wonder and a joy for my eye." But, he noted, "Mary scarcely opened her eyes to all this beauty"; yet he felt sure she would write about it and be evocative, for "the accomplished writer need not feel." She later sent him a copy of her *Venice Observed,* eager for his approval, but he felt obliged to be critical. She thanked him for his "gentle rap on the knuckles," but on longer reflection declared, "You are wrong, I think, about the Venice book. I don't propose to put it behind me or turn over a new leaf. On the contrary, I feel quite proud of it."

Their lively exchange of news and opinions continued at frequent intervals. He undoubtedly found her sardonic frankness of expression a diverting novelty. In one of her letters she recalled with a certain relish having let Berenson and Nicky read from *The Group,* the novel about "8 Vassar girls" on which she was working, the chapter which began with the arresting command, "Get yourself a pessary." When she returned to Florence the following year for the research that would lead to her *Stones of Florence,* Berenson put her up at I Tatti for some days. "I cannot understand her literary values," he told the English publisher and writer Hamish Hamilton. "I mention them only, as her historical and artistical notions are beneath my respect. For instance, she despises Steinbeck, particularly his *Grapes of Wrath,* which seems to me the most important thing done in America since *Main Street.* So we quarrel kittenishly all the time. She is indeed damned attractive."

A far more tractable visitor followed on Mary McCarthy's heels in the spring of 1956 among the usual returnees. Berenson had received a letter in March from Edward Ashley Bayne, an economist with the American Universities Field Staff in Rome, asking whether ex-President Harry Truman, who was touring Europe, might visit him. Berenson immediately sent an invitation to Truman, who had told Bayne that it had been "a long-held ambition to meet Berenson."

Truman arrived with his wife, Bess, and three members of their party for a luncheon that ran on until three. Recalling the occasion, he wrote, "My secretary still bemoans the fact that he had no pencil or pad to record your epigrams at luncheon that day. When the five of us returned to the hotel we could remember only three of them accurately." During the luncheon Berenson had asked, "When can we meet tomorrow?" Truman said, "I rise early, you know." He would be taking his seven o'clock walk along the Arno, but "I could be here at nine." "Splendid," replied Berenson. Truman kept the appointment and the talk went on for the rest of the morning.

At tea that afternoon Berenson was asked his impression of his distinguished guest. With careful deliberation he said, "I have been talking with one of the great historians of the world!" He sent a clipping of a

photograph of Truman and himself to his cousin Lawrence, remarking, "I was enchanted with the almost naive simplicity and shrewd candor of my guest. I rarely enjoyed meeting anyone as I did him." In his diary he wrote his impression of the seventy-two-year-old Truman, "as unspoiled by high office as if he had got no further than alderman of Independence, Missouri. In my long life I have never met an individual with whom I so instantly felt at home. . . . Ready to touch on any subject, no matter how personal. . . . If the Truman miracle can still occur, we need not fear even the [Joseph] McCarthys."

The biographer Merle Miller asked Truman about the visit and got this reply: "We just had to look him up. He was the best in his line, and if I've learned one thing in life, it's that you have to pay attention to what the experts say. . . . Old Berenson was one of the nicest fellows I've ever met, and he took us all over the house and explained to us what to look for in a painting. And when we got to those museums in Florence and elsewhere, we knew a little about it. . . . He was really a remarkable fellow, and I wish I'd got to know him better." When at the end of the year Truman wrote to Berenson and recalled his pleasant visit to I Tatti, he penned a postscript: "I wish the Powers-that-be would listen, think, and mock at things as you have!"

Among the numerous pilgrims who followed during the summer, there came one from a world quite different from the Trumans'. On June 30, 1956, the aging Somerset Maugham appeared, accompanied by the middle-aged Alan Searle, who was "the nanny of his second childhood." The highly successful playwright and novelist had also become a "living legend." He too had built a pleasure dome to which pilgrims made their way—the Villa Mauresque at Cap Ferrat on the Riviera. Berenson recorded in his diary, a "lined, wrinkled face, senile mouth, kindly expression (or is it of mere resignation?). Stammered. Utterly unaffected." They talked of writing, but to the omnivorous Berenson Maugham did not seem "*au courant* with up-to-date novelists": he deplored the prevalence of fornication in fiction, disliked Faulkner, and knew nothing of Mary McCarthy. Berenson took the pair through his collection of Primitives, but Maugham, whose own considerable collection ran to Impressionists and Postimpressionists, "showed a fantastic absence of feeling for visual art." His companion, Berenson thought, "had better taste and more genuine interest," but "all in all, Somerset Maugham is a good talker."

The pair returned a few days later for more literary talk, and they were joined by Harold Acton and Arturo Loria. Berenson argued that great fiction creates characters so distinctive that they seem to exist apart from the book in which they appear, and he cited the Bible figures of David,

Everywhere he found improvement in the lighting, but unfortunately it brought to view the "deterioration, dust and dirt almost too harshly." At the Opera del Duomo he was again moved by the charming sculptural quality of Luca della Robbia's *Cantoria* with its children blowing trumpets with puffed out cheeks. Donatello's *Cantoria*, by contrast, looked like "the work of a painter using clay or stone or bronze instead of pencil or pigment." The memory-haunted reflections found their way into his diary and appeared on October 14, 1956, in Loria's translation in two long columns in the *Corriere della Sera* titled "Rivistando Firenze."

Hugh Trevor-Roper rallied Berenson on his prevalence in the news. The *Times* not only had carried a photograph of him and Nicky at the Belvedere Fort but earlier in the summer had devoted the first page and all of the second of the *Literary Supplement* to a sympathetic review of his career on the occasion of the recently issued bibliography. Trevor-Roper even reported seeing a photograph of Berenson in a newspaper from far-off Mexico. In addition, a review by Francis Henry Taylor of the revised *Lotto* in the *New York Times* in July praised Berenson not only as "a great detective" but also as having the "greater gift of perception."

Berenson was again in the news when he protested in his column and by letter a plan to send forty of the choicest masterpieces of the Florentine museums to be exhibited at the Metropolitan and the National Gallery of Art. The Italian government had proposed the exhibition as a goodwill gesture, and the roster of artists—Michelangelo, Cellini, Donatello, Botticelli, Raphael, Titian, among others—promised a sensational experience for Americans. Berenson's letter to the press warned that old masterpieces became more and more valuable with the passage of time and that the sea air was bound to harm them. It helped intensify the storm of protest against the loan that had erupted in Florence. Four Florentine artists barricaded themselves in a turret of the Palazzo Vecchio and showered down leaflets, and the mayor promised them bread, water, blankets, and a confessor. In the end the authorities at Rome were obliged to back down and the exhibition was called off.

Berenson had cabled his objections to John Walker of the National Gallery and James J. Rorimer of the Metropolitan. Rorimer had countered that they had not been in a position to refuse the Italian government's offer, but that both he and Walker had informed the State Department they would not object to its withdrawal. Rorimer teased Berenson, "Would you prefer going on the *Andrea Doria* or would you prefer the Italian airliner which had an unhappy fate last night?" The great new Italian ocean liner, the *Andrea Doria*, had recently gone to the bottom on July 26 off Massachusetts after colliding with the *Stockholm*.

The sense that time was running out on him increasingly preoccupied

Berenson as he reflected on the fate of I Tatti as a Harvard institution. Dean McGeorge Bundy came over for a conference that seemed to reassure him for a time, but still not at ease about the matter he decided to put down in writing his ideas for the future of the institution as he had been contemplating doing for some time. The piece, titled "The Future of I Tatti," substantially repeated the suggestions contained in his 1945 will, in which he had declared, "My ideal is that they [the fellows] should become ripe humanists and not mere teachers of facts about the arts."

He would wish fellowships established, he now wrote, that would "provide leisure and tranquility to sixteen or more promising students." He recommended that each fellowship run for four years to give the fellow leisure to mature. To ensure continuity, the appointments ought to be rotated, four added each year to a first four. Fellows should be recruited from the United States, Canada, England, Sweden, Norway, Denmark, and the Netherlands. (France and Germany were not included because those countries already had institutions in Florence.) They should be persons "whose attitude toward art and literature and thought . . . [was] not merely archaeological . . . but psychological and empirical, founded on direct and loving contact with the work of art and not on book learning." He "would like the fellows of I Tatti to . . . take as models Goethe and Winckelman, Ruskin and Pater, Burckhardt and Wölfflin, rather than mere antiquarians or mere attributors of the type of Cavalcaselle, Bodmer and their likes."

Though Berenson hoped to fix the character of his institution as a kind of aesthetic and humanistic priesthood to counter the prevailing heresies of historicism and iconography among art critics and historians, he seems, at times, to have realized that his scheme was more visionary than practical. To his cousin Lawrence he referred to his prepared statement as "My Dream for the Future of I Tatti." While he would have liked to tie the hands of his successors, he soon came to realize that the knot might come undone. The press had recently reported that the Portuguese government had ruled that a majority of the trustees of the Gulbenkian Foundation to be set up in Portugal must be Portuguese citizens. As a result of the ruling, Lord Radcliffe, whom Gulbenkian, as a naturalized British subject, had named as executor, resigned. Berenson wrote to Walker that the Gulbenkian case is "a good lesson for me—if I need one! I have no illusions what in every probability will happen to I Tatti, once I am out of the way!"

Seductive as his scheme may have been, Berenson's ideal looked back too far into the past to Walter Pater's aestheticism to attract the new breed of scholarly art critics and historians. The historical problems that Panofsky, Schapiro, and Offner had opened up to the serious student of

reached to within twenty miles of the Suez Canal. "I was thrilled," he exulted, "by the Israeli attack on the ridiculous troops of the lunatic subhuman Egyptians." As he had at the time of the 1948 war, he felt a curious surge of patriotism for Israel. "The complaint made by even the most friendly disposed gentiles," he remarked to the Baroness Liliane de Rothschild, "has been that Jews would neither till the soil nor fight. The proof to the contrary, given by the Israelis, is perhaps the most important revaluation of Jewry that has happened in my time. It is the prime reason why we should not only be proud of Israel but give it support."

In an oddly personal way Berenson had come to feel himself an apologist for the Jews. As a young man he had moved by preference in a social world in which, he believed, Jews were resented for being "more intelligent, quicker, abler" than others. Now, he mused, as if thinking of his own experience, the Jew as a Jew "may be pushing, indiscreet, and a snob, but surely that is the fault of a world which persists in boycotting, ostracizing him, so that he never feels at home, is never wholly accepted." In his diary he protested, "Where is there another people who has produced unceasingly for 3,000 years individuals of genius, creators in every field requiring use of mind, as Jews have?" Berenson occupied the paradoxical position of believing in assimilation and at the same time believing that the world needed the leavening influence of the Jew. The troubling contradiction faced secular Jews everywhere. Yet that these beliefs could subsist together suggests that the heart, as Pascal noted, has its own singular logic.

THE FINAL touches on the volumes of the Venetian school occupied the last months of 1956 and the early months of 1957. In December Luisa sent a sample of the title page from the Phaidon office in London for his approval. Preoccupied with the Lists, he had given up for the time being the luxury of contributing a column to the *Corriere della Sera*. By June he was able to put his signature to the preface. His idea, he said, had been "to represent every phase of each artistic personality and of its followers and their followers so as to persuade us that it is the inferior painter and not a Giotto, a Michelangelo, a Bellini, a Giorgione, a Titian, a Tintoretto, who is responsible for the inferior production." This expansionist idea had marked his departure, as he explained in the 1932 preface, from the "dandiacal aestheticism" that had produced the "earlier severity" of his Lists.

The artist among the Venetians who most challenged him appears to have been Giorgione, whose wide influence he had hitherto neglected. He now abundantly made up for this neglect. In 1932 he had cautiously listed twenty paintings as by Giorgione, adding only three to the 1894

List. The new roster listed forty-two, including the Allendale *Nativity* as completed by Titian and the Glasgow *Christ and the Adultress,* which he had once given to Titian. He also finally admitted into the canon the Benson *Holy Family,* which he had assigned to Catena when it was exhibited in the New Gallery in 1894.

When he reflected on the whole problem of attributions in the privacy of his diary, he decided that "most of the mistakes I have made in my career as attributor of pictures have been due to a far too narrow and dogmatic concept of the painter." He had "rectified" that mistake as concerned Giorgione, but now that he had begun to work on the Florentines, he was finding "the Giotto nut . . . hard to crack." Still struggling with the question, he wrote that though Giotto was "a central figure in universal art history," he "yet remains a problem, and to me an insoluble one, more than any other in my range of continuous study." He left sufficient notes and memoranda, however, for Nicky and her associates to include in the posthumous *Florentine School* a few additional works in scattered collections and to particularize more fully the frescoes at Assisi, Santa Croce, the Peruzzi Chapel, and the Arena Chapel in Padua, as well as the works of his followers.

The publication of the *Venetian School* in 1957 was greeted as "an outstanding artistic event," the lavish number of plates being seen as of especial value to the student. Vittorio Moschini praised the two quarto volumes in the *Burlington,* though he questioned Berenson's depreciation of recent Venetian studies, and Berenson's friend Germain Bazin of the Louvre warmly welcomed the work in the *Gazette des Beaux-Arts.* The most searching scrutiny of the volumes appeared in a long review article in the *Art Bulletin.* The author, Erika Tietze-Conrat, was the learned collaborator and widow of the famed Viennese art historian Hans Tietze, whom Berenson had known when he was director of the Kunsthistorisches Museum in Vienna. Victims of the Nazis, the husband and wife had emigrated to the United States in 1938 to join the community of refugee German-Jewish art historians. Alluding to Berenson's contempt for iconographical studies, Madame Tietze-Conrat declared, "There is an abyss between us which can never be bridged." She pointed out a number of errors in the captions to paintings which could have been avoided had Berenson paid attention to iconographical research, and she faulted him for "subjectively" limiting his choice of "followers and their followers." Her criticism, she concluded, was "directed against what Berenson omitted rather than what he did." If the heavily documented article had been brought to his attention when it appeared in December of 1958, he would doubtless have agreed that the abyss between them was unbridgeable.

In contrast to Mumford's reverential demeanor was the gay warmth of a visit from Vivien Leigh and Lawrence Olivier. Berenson felt very much in their element. There was no need to play the sage. "Vivien looked remarkably herself," he reported to Hamish Hamilton. "Not a wrinkle on her throat and her eyes more beautiful than ever. Larry is such a charmer, so warming, so handsome as well. We talked, we chatted, we laughed as if we had seen each other all along and not seven and more years since we last met." Mary McCarthy, who was staying at I Tatti for a few days, joined them all at lunch. On returning to London, Vivien Leigh sent him souvenirs that she had picked up in Yugoslavia during their "exciting and fascinating tour." The "happiest memory," she added, was being at I Tatti with him.

One of his visitors roused Berenson to defend his favorite rationalization that Catholicism was essentially "detribalized Judaism" and had made Judaism obsolete. His adversary was Dore Schary, the prominent Hollywood producer and playwright, who was a practicing Jew. On his return to America Schary wrote that he "was ready to enter the lists again at any time to resume our discussion about Judaism and Catholicism."

Professor Kenneth Murdock arrived with his wife on a kind of reconnaissance at the urging of President Nathan Pusey of Harvard. Dean McGeorge Bundy had strongly recommended him to Berenson as a leading member of the faculty, a specialist in American literature, and the recent administrator of the Program in General Education. When Berenson somewhat patronizingly remarked, "I suppose you are seeing everything you can in all the galleries," Murdock frankly admitted that they had each searched the books on Italian paintings published by Skira to make up their lists of what to see and had then combined them. He also said they were especially interested in Antonello da Messina and Fra Angelico and a certain sculptor. Berenson approved the painters as masters, but scornfully dismissed the sculptor. Mrs. Murdock, not one to be easily patronized, thought him impudent but held her tongue. At tea, however, she sat beside him and he put his cold hand on hers and held it throughout a pleasant conversation. On Pusey's behalf, Murdock canvassed Berenson's plans for the future of I Tatti, and Berenson pressed upon him the desirability of keeping I Tatti independent of the Fogg.

Murdock, who was on the eve of retirement, was evidently being considered for the post of director of Berenson's Institute when it should come to Harvard. What impression he made upon Berenson at the time went unrecorded. He did subsequently accept the position and become the first director of I Tatti under its new name, The Harvard University Center for Italian Renaissance Studies.

L V

"A Scene from Rembrandt"

THE Tuscan spring of 1957 had again worked its wonders, and Berenson felt fit for yet one more *giro,* the one that was to prove his last. It was a tour of professional duty enhanced, as always, by pure pleasure. The palace of the Capodimonte on the heights overlooking Naples had just been restored as a great public art museum, and Berenson entrained for Naples to make his inspection. As the palace had until recent years been the property of the duke of Aosta, a friend of Berenson's, he doubtless came by invitation for a private viewing in the company of the art historian Bruno Molaioli, a member of the Fine Arts Service. The contents of the Galleria Nazionale had just been transferred to the palace. The tasteful arrangement and modern lighting delighted him. "I was speechless with admiration," Berenson wrote, "and every preconception against it, and I had many, vanished so completely that I cannot recall them."

At the Museo Nazionale della Ceramica, now housed in the Villa Floridiana, where he had once been a frequent guest, he luxuriated in the antique "treasures of silver, gold, crystal, glass, ceramics." The "invention, the variety" took his breath away. "I panted with eagerness to indulge my appetite for them," he wrote, "to live with them until I had memorized every one." By comparison, "what has been done in the West since is crude and heavy and unimaginative." His one regret was that he could not dart about Naples, as when he was young, ferreting out "this and that church or cloister, or gallery."

To be on the move again seemed to restore him. His infirmities were forgotten, and once again he became a quivering sensorium whose eyes caressed the objects of contemplation. From Naples he went up to Rome. Among the antiquities in the Museo delle Terme he felt "how freely I breathe in the midst of all that is exhibited here." His appetite for

work on the endless Florentine Lists, but the need to write for print gave him no rest. He found a successor translator to Loria, and again his signature appeared at the bottom of his occasional columns in the Milan newspaper, though his growing enfeeblement required increasing help from the devoted staff that ministered to him.

Inquiries continued to come in from curators around the world. For some years Berenson had replied to them through Nicky and more recently through William Mostyn-Owen. Of an alleged Botticelli, for example, Nicky informed a curator, "Mr. Berenson has come to the conclusion that the Madonna belongs into his 'great part' group." Later, to an inquiry concerning a reputed Bartolommeo di Giovanni, Mostyn-Owen wrote, "For the time being at any rate Mr. Berenson is sticking to his attribution to Granacci." There was no letup as well in the professional inquiries from the Wildenstein firm on the photographs they sent to Berenson for attribution.

The painful deterioration of his spine steadily progressed so that he at last had to give up the pleasure of replying to his personal correspondents in his own hand. As he explained in a typewritten letter to Hamish Hamilton in mid-January of 1958, "My hand has been and remains too wobbly to be legible, even by an expert of my writing like you." For some time he continued to hope, though in vain, that he would return to his pen. He did struggle on until mid-April 1958 to keep his diary with no apparent diminution of mental energy or self-awareness. In the very last entry which Nicky was able to decipher, he looked back upon his life with Rhadamanthine severity: "So much in my past that I hate to evoke. Short of violence, I have been capable of every sin, every misdemeanor, every crime. With horror I think what I should have become if I lived the life of an ill-paid professor, or struggling writer, how rebellious, if I had not lived a life devoted to great art and the aristocratically pyramidal structure of society that it serves, or worse still if I had remained in the all but proletarian condition I lived as a Jewish immigrant lad in Boston. So I remain skeptical about my personality. It really seems to have reached its present integration in the last twenty years, with the wide and far vision I now enjoy, with *tout comprendre, c'est tout pardonner,* expecting little and trying to be grateful for that, the serenity for which I am now admired. But I keep hearing the Furies, and never forget them."

He was ending, he said, "as a myth whose saga I can scarcely recognize as having any resemblance to my deep down self." To the reporter and the photographer who came from *Life* magazine for an article to be called "Expert Outliving His Legend," he said mock seriously, "I keep reading stories about Bernard Berenson and I wonder who is this person going

around with my name." He posed at his desk for one of the photos, his features drawn and sharpened by age. In another photo, Dr. Alberto Capecchi is shown saying good-by after his regular morning visit. "All the arts," Berenson is quoted as saying, "must singly and together create a humanized society and its masterpiece, free man."

As the reopening of the Santa Trinita bridge approached, Berenson again became good copy. In October 1956 *Newsweek* had reported the progress on the reconstruction of the famous span, noting that sixty million lire ($96,000) had been collected by an international committee "headed by the venerable art critic Bernard Berenson." In the following March the *New York Times* said that the work was nearly complete and that, thanks to the committee which Berenson led, the bridge was being restored exactly as it had been. The Italian press hailed the coming event with long accounts of the tragic destruction by the retreating Germans. One account was accompanied by Berenson's recollections of the bridge as he first saw it from his window high up above the Arno nearly seventy years earlier and of his horror in August of 1944 when he gazed upon its ruins.

On March 16, 1958, the architectural masterpiece of Ammanati, which had first spanned the Arno in 1569, was solemnly opened to traffic. In his dedicatory address the Italian prime minister, Adone Zoli, praised Berenson's "crusade" for the restoration of the bridge "where it was and how it was." The *New York Times* captioned its story "Reconstruction of Beautiful Bridge a Triumph for Berenson at 92," his ninety-third birthday being three months away, and illustrated it with a photograph of him. An accompanying editorial declared, "The world has owed much to Mr. Berenson for a long time. It is peculiarly happy circumstance that has enabled him to dramatize a lifetime of service to the best in the arts in this crusade for an old bridge." Mary McCarthy thought it "charming that the *Times* should have run your photograph instead of the bridge's." It reminded her "of the time that Edmund Wilson, lecturing on Joyce, was asked to autograph *Ulysses.*" A marble plaque on the façade of the Palazzo dei Padri delle Missioni, the edifice overlooking the south end of the bridge, identifies Bernardo Berenson as presiding over the COMITATO PER LA RECOSTRUZIONE DEL PONTE and lists the names of the major donors and collaborators.

ON FAVORABLE days during the early spring of 1958 Berenson would suddenly be quite his own self again. He still managed to come down twice a day to see a friend or two and to take a few steps in the garden when the sun was shining. Bronchial and bladder complications set him

"an increasing zest for all sorts of life and every form of art." He described the author as "an impressive and entertaining monument in a perpetual renaissance."

More astonishing than this gathering together of work from the past was the fact that he continued to send lengthy two-column articles to the *Corriere della Sera* either dictated to Nicky or compiled in part by her. One published November 18, 1958, on the letters of Ruskin to Norton reviewed his appreciative rereading of the significant works of Ruskin and Pater. Three weeks later he discussed Goethe and the Romantics based on his reading of Frau Ricarda Huch's volume on the subject. Early in January 1959 his subject was the dialogues of Plato, and he praised the good sense and courage of Benjamin Jowett's 230-page introductory analysis of *The Republic*.

Ceaselessly active, his mind retraced the myriad paths of his reading and experience as he made up in reflection what was denied him in physical activity. Every few weeks during the first half of 1959 he would harvest his observations. La Bruyère's *Characters* put him in mind of the differences in the administration of criminal law. In another piece he spoke of the fascination of historical writing which had been first inspired by his reading of the Old Testament as a boy of ten. In a critical review of the historical theories of Guglielmo Ferrero, he concluded that all authority decays and finally collapses like the one-hoss shay of Oliver Wendell Holmes. Van Wyck Brooks's *Flowering of New England* led to an exploration of nineteenth-century America and the European associations of George Ticknor and Nathaniel Hawthorne. Reflecting on their world, he declared he owed to Emerson a great part of his intellectual values, his hopes and his fears, and not a little of his prejudices.

When momentarily short of ideas for these columns, he had recourse to passages from his diary of early 1957—a miscellany of objections to Jungian psychoanalysis, of considerations of the varied representations of the human figure, of his responses to his reading of Dumas. He speculated on the influence of Nietzsche on D'Annunzio and told of his reading of Kierkegaard and his pleasure in the exchange of letters between Hugo von Hofmannsthal and Stefan Georg. After a silence of a few months, during which the space that the columns occasionally occupied was filled by Alberto Moravia, Emilio Cecchi, Giovanni Papini, and other regular contributors, he supplied in August a piece compiled from undated pages from his diary.

The learnedly discursive columns continued intermittently during Berenson's ninety-fifth year. Whatever energy remained in him he invested in this enterprise, rescuing from his diary and from unpublished manuscripts passages of self-scrutiny and of intellectual excursions

among the scholarly tomes in his library. His last contribution of miscellany, "Pagine di Diario," under the heading "L'Ultimo Scritto Di Berenson," would appear on October 11, 1959, five days after his death.

In a headnote to this "last writing" of Berenson, the newspaper's "special correspondent" declared that the great critic had to the very end retained perfect control of his "mental faculties and the brilliance of his extraordinary genius." The two long columns exhibited a characteristic mélange of reflections. One on Florence Nightingale was retrieved from a dozen years earlier. Another, from 1950, was adapted to suit his ninety-fifth year: "I wonder what the B.B. of twenty-five would think of the B.B. of ninety-four? Would he be too awestruck to approach him or would he prefer not to bother about a conceited, spoilt, egotistical old man? The B.B. of twenty-five was both too shy and too proud to approach famous men. . . . What use could they have for him and why should he bore them and expose himself?" Berenson left his question hanging. Memory had indeed failed him. Whatever shyness he had had he had overcome as a Harvard student in the presence of prominent professors and leading Bostonians. Forgotten was his attempt at Oxford to meet Walter Pater and his successful meeting in Rome with the great art historian Giovanni Cavalcaselle. Nor had there been any shyness in his association with art historians like Morelli, Frizzoni, and Richter in Italy.

The passages in this last column were the reflections of a survivor into the time, as he said, of "a new king who knew not Joseph." For him "the great age" had been the nineteenth century, "the age of Bismarck, Arnold, and the Goncourts." And he addressed to the present age with fresh emphasis the ideas that were central to his creed. "My chief desire," he wrote, "when I look at something is to enjoy what I see. I have the impression that to most historians of art the question of the enjoyment of the quality of the work of art does not have much importance." As for his frequent use of terms like "humanism," he explained, he meant by them any literary activity that made for the humanization of man. Humanization was the "faculty to put oneself in the skin, the heart, even the muscles of another, ideally to react in a sense like the other." The absence of that imaginative power was "the source of all cruelty and atrocity." In art that imaginative power corresponded to *Einfühlung,* empathy, "the ability consciously and unconsciously to feel and experience the object contemplated as one feels the relaxing of one's arm, hand, and feet." Thus across the more than sixty years that had passed since his *Florentine Painters,* he asserted the final implications of "tactile values."

"To become as old as I am," Berenson once observed, "is not an adventure to be recommended." Immobile for most of his last year, his

and loved him as their patriarch. She asked to be allowed to call the parish priest to administer the sacraments. Attentive to her words, he mutely nodded his head.

The end came quietly that night, the village priest of San Martino a Mensola having earlier performed the last rites. The silent sufferer passed almost imperceptibly from sleep to death. The doctor had his hand over the dying man's heart, "to feel its last beat." In the dimly lit room those who had been closest to him stood in sorrowful attention, his sister Bessie; Nicky and her sister, Alda; Geremia Giofreddi and his daughter, Fiorella; Emma and the night nurse; and all the house servants. "It could have been a scene from Rembrandt," Alda reflected.

By chance the first person to be notified of his death was King Gustaf of Sweden. He had telephoned from Bresciano to announce his forthcoming visit and, learning of Berenson's grave condition, had telephoned again. The telegram that was sent to him, according to the report in the press, told him that he "would never again find his friend in the Villa I Tatti."

Condolences flooded in from all over the world. They included personal messages from Antonio Segni, the prime minister of Italy, and from Pope John XXIII, whom he had met at a cultural conference in Venice. Under a banner headline, "He will be remembered as a Great Italian," in the *Corriere della Sera,* his friend Emilio Cecchi, one of Italy's leading literary figures, filled most of a page with an account of Berenson's development and a eulogy of his many achievements and his intellectual courage. Cecchi concluded that Berenson had much to teach regarding the intellectual servility and dispersion of the present time.

Berenson lay in state in a walnut coffin lined with white silk on the great fifteenth-century table in the large library. Tall candles burned near the bier. Seated or standing close by were workers just come in from the olive groves and "the most humble characters of his court," the maid servants in black dresses and white aprons and the other members of the domestic staff. Too small now for his clothes, Berenson was wrapped in an ivory-white cashmere shawl that covered his head and the lower part of his ravaged face and was folded along his body. One could barely make out the thin ivory profile and the little white beard. The long delicate fingers were at last bereft of touch. A "magnificent Sienese cross" lay upon his body. To one observer he looked like a medieval saint.

All day long hundreds of mourners filed by the small monklike figure, "artists, scholars, public authorities." Among the first was the prefect of Florence, who brought the condolences of Giovanni Gronchi, the president of the republic. The former queen mother of Rumania, a fond

neighbor to whom Berenson had given, as a kind of bequest, a little painting of the Madonna, paid homage accompanied by the duchess of Aosta. Lamps were placed along the path leading from the gate to light the way for the pilgrimage that went on into the night.

Late the following afternoon the casket, covered with oak leaves and roses, was carried on the shoulders of the I Tatti workmen. At the head of the procession that wound its way up to the little church of San Martino for the funeral was a company of hooded monks of the Misericordia, walking with lighted torches behind a great black cross bordered in gold. In their white capes they had a spectral appearance in the failing afternoon light. Behind them marched the Florentine footmen in red, an honor guard of arm bearers in medieval helms and with halberds in hand. They were followed by a long row of children from the Mensola school, each carrying a flower. After them came the seminarians from Fiesole and then a group of nuns in their white wimples and black veils. Princes, diplomats, intellectuals, people of the countryside paced slowly in the cortege that stretched for nearly half a mile from the door of I Tatti. Contadini dropped their hoes in the olive groves and came down the hill to the roadside to watch, shielding their eyes against the setting sun. The scene, wrote an observer, looked like a thirteenth-century Sienese painting.

Among the many notables identified by the reporter for the *Nazione* were Elena of Rumania, Prince Paul of Yugoslavia and his wife, Ambassador James Dunn, the Marchese Serlupi Crescenzi, Count Vittorio Cini, Count Contini Bonacossi, Roberto Longhi, Clotilde Margorieri, and Professor Jean Falloth representing the Sorbonne. The parish priest pronounced the benediction over the casket in the center of the little cinquecento church, the solemn scene graced by the paintings of Taddeo Gaddi, Zanobi Machiavelli, and Neri di Bicci. As the church was only large enough to receive the chief dignitaries, the others crowded the square before the portals. From within came the deep sonorities of the *canto gregoriano* chanted by the seminarians.

To Berenson, who had not been anxious about "salvation" and who scoffed at Catholic theology, the Renaissance pomp would nevertheless have been singularly gratifying. Had he not lived, in a sense, like a Renaissance prince in his little domain? as the reporter for the *Corriere della Sera* observed.

Berenson had obviously long forgotten the instructions he gave to the American consul, during World War I, that his body be cremated, and he had not left any word as to where he should be buried. He had once said to Nicky on a journey, "Remember, if I should die on this trip, I do not want my earthly remains to be trundled about. Wherever I die, there let

me be buried." She fulfilled his wish more literally, perhaps, than he had anticipated. She obtained permission from the authorities to inter him in the I Tatti chapel close to the house itself. So when the coffin was brought down from the church, it was reverently placed before the chapel door. Later, Mary's coffin would be brought down from Settignano and she would be buried beside him.

It was as if the stage were being set for the playing out of one of Berenson's romantic fantasies: "If one can conceive of life after death," he had once written, "I would like to be the protective spirit of my home and my library. I would like to live in it and make use of it as the archangels did in one of the short stories of Anatole France." Berenson's astral spirit may not be hovering protectively about his beloved I Tatti, but his influence upon the character of the place remains indelible and pervasive.

SELECTED BIBLIOGRAPHY

NOTES

INDEX

Selected Bibliography

Manuscript Collections and Archives

Archives of American Art, Washington, D.C.
Berenson Archive, Harvard University Center for Italian Renaissance
 Studies, Villa I Tatti, Florence
Bryn Mawr College Library
Dumbarton Oaks Archives, Washington, D.C.
Fogg Museum Archives
Isabella Stewart Gardner Museum Archives
Barbara Strachey Halpern, Oxford, England
 Robert and Hannah Smith family papers
Harvard University Archives
Harvard University, Houghton Library
 Richard Berenson collection
Library of Congress
 Manuscript Division
Louvre Museum Archives
Massachusetts Historical Society
Metropolitan Museum of Art
National Archives, Washington, D.C.
Luisa Vertova Nicolson collection
Bernard B. Perry collection, Bloomington, Indiana
Ralph Barton Perry, Jr., collection, San Rafael, California
Philadelphia Museum of Art
 John G. Johnson collection
Peter Viereck collection
University of Virginia, Alderman Library, Manuscripts Department
Mrs. Arthur Wagner, Chicago
 Mally Dienemann collection
John Walker collection
The Walters Art Gallery, Baltimore
Yale University, Beinecke Rare Book and Manuscript Library
Yale University, Sterling Memorial Library

The Writings of Bernard Berenson, 1904–1969

All of Berenson's writings, whether books or articles, were composed in English. Some made their first appearance in Italian or French translation as indicated in the *Bibliografia di Bernard Berenson* prepared by William Mostyn-Owen and published by Electa Editrice in Milan in 1955 and complete to that date. The *Bibliografia* also lists the various other translations—in Dutch, German, Swedish, and Spanish—and reprints of Berenson's books. His *Viaggio in Sicilia*, published in 1955, has not appeared in the original English, except for portions included in *The Passionate Sightseer*. After 1955, translations, especially of the collected edition of *The Italian Painters of the Renaissance*, appeared in Italian, French, German, Russian, and Japanese. This bibliography is adapted from and supplements that of William Mostyn-Owen.

BOOKS

The North Italian Painters of the Renaissance. New York and London: G. P. Putnam's Sons, 1907.

A Sienese Painter of the Franciscan Legend. London: J. M. Dent & Sons, 1909.

Catalogue of a Collection of Paintings and Some Art Objects. Vol. 1, *Italian Paintings*. Philadelphia: John Graver Johnson, 1913.

Pictures in the Collection of P. A. B. Widener at Lynnewood Hall, Elkins Park, Pennsylvania. Vol. 3, *Early Italian and Spanish School*. Philadelphia: private edition, 1916.

The Study and Criticism of Italian Art. Third Series. London: George Bell & Sons, 1916.

Venetian Painting in America: The Fifteenth Century. New York: Frederick Sherman, 1916.

Essays in the Study of Sienese Painting. New York: Frederick Sherman, 1918.

Three Essays in Method. Oxford: Clarendon Press, 1926.

"A Catalogue of Paintings in the Collection of Michael Friedsam." New York: Metropolitan Museum of Art, proof sheets only, 1929.

The Italian Painters of the Renaissance. Oxford: Clarendon Press, 1930. New edition. London: Phaidon Press, 1952.

Studies in Medieval Painting. New Haven: Yale University Press; Oxford: Oxford University Press, 1930.

Italian Pictures of the Renaissance. Oxford: Clarendon Press, 1932.

Drawings of the Florentine Painters. 3 vols. Chicago: University of Chicago Press, 1938.

Diary, 1945–1946. Unpublished typescript.

Preface to the *Catalogue of the Exhibition of French Paintings in Florence*. Florence: Pitti Palace, 1945.

Aesthetics and History in the Visual Arts. New York: Pantheon, 1948.

Sketch for a Self-Portrait. London: Constable; New York: Pantheon, 1949.

Alberto Sani: An Artist out of His Time. Florence: Electa, 1950.

Rumor and Reflection, 1941–1944. London: Constable; New York: Simon and Schuster, 1952.

Caravaggio, His Incongruity and His Fame. London: Chapman & Hall, 1953.

Seeing and Knowing. London: Chapman & Hall, 1953.

The Arch of Constantine or the Decline of Form. London: Chapman & Hall, 1954.

Piero della Francesca or the Ineloquent in Art. London: Chapman & Hall, 1954.

Italian Pictures of the Renaissance: Venetian School. 2 vols. New York and London: Phaidon Press, 1957.

Essays in Appreciation. London: Chapman & Hall, 1958.

One Year's Reading for Fun: 1942. New York: Alfred A. Knopf, 1960.

The Passionate Sightseer. London: Thames; New York: Simon and Schuster, 1960.

The Bernard Berenson Treasury, 1887–1958. Ed. Hanna Kiel. New York: Simon and Schuster. 1962.

The Selected Letters of Bernard Berenson. Ed. A. K. McComb. Boston: Houghton Mifflin, 1963.

Sunset and Twilight. New York: Harcourt, Brace & World, 1963.

Conversations with Berenson. Recorded by Umberto Morra. Trans. from the Italian by Florence Hammond. Boston: Houghton Mifflin, 1965.

Homeless Paintings of the Renaissance. Ed. Hanna Kiel. Bloomington: Indiana University Press, 1969.

ARTICLES

The following abbreviations are used to indicate the collection in which an article subsequently appeared in the original English:

ESSP *Essays in the Study of Sienese Painting*, 1918
EA *Essays in Appreciation*, 1958
HPR *Homeless Paintings of the Renaissance*, 1969
SMP *Studies in Medieval Painting*, 1930
SCIA *Study and Criticism of Italian Art*, Third Series, 1916
TEM *Three Essays in Method*, 1926
VPA *Venetian Painting in America: Fifteenth Century*, 1916
DFP *Drawings of the Florentine Painters*, 1938

"The Arundel Club." *The Nation*, 78 (Feb. 18, 1904), 129.

"The Donna Laura Minghetti Leonardo." *The Nation*, 78 (March 17, 1904), 210.

"Scoperte e primizie artistiche: Sassetta." *Rassegna d'Arte*, 4 (Aug. 1904), 125–126.

"Altre opere del Sassetta." *Rassegna d'Arte*, 4 (Sept. 1904).

"Cozzarelli, Neroccio, Cavazzola, Gentile da Fabriano, Puligo, Cariani, Tiziano, Pierino del Vaga." *Rassegna d'Arte*, 4 (Oct. 1904), 156–158.

"Due quadri inediti a Staggia." *Rassegna d'Arte*, 5 (Jan. 1905), 9–11.

"Un'altra replica per il Pollaiuolo a Staggia." *Il Marzocco*, 10 (Feb. 26, 1905), 3–4.

"Una Annunciazione del Pesellino." *Rassegna d'Arte*, 5 (March 1905), 42–43.

"The Lotto Portrait." *The Nation*, 80 (June 22, 1905), 501.

"An Early Signorelli in Boston." *Art in America*, 14 (April 1926), 105–117.

"Notes on Tuscan Painters of the Trecento in the Städel Institut at Frankfurt." *Städel-Jahrbuch*, 5 (1926), 3–28. [SMP]

"While on Tintoretto." In *Festschrift für Max J. Friedländer*. Leipzig: E. A. Seemann, 1927.

"The Missing Head of the Glasgow 'Christ and the Adultress.' " *Art in America*, 16 (June 1928), 147–154.

"Missing Pictures by Arcangelo di Cola." *International Studio*, 93 (July 1929), 21–25.

"Quadri senza casa: Arcangelo da Camerino." *Dedalo*, 10 (Aug. 1929), 133–142. [HPR, 13–20]

"A New Masaccio." *Art in America*, 18 (Feb. 1930), 45–53.

"Quadri senza casa: Il trecento senese. Parts I, II. *Dedalo*, 11 (Oct., Nov. 1930), 263–284, 328–362.

"Missing Pictures of the Sienese Trecento." Parts I–IV. *International Studio*, 97 (Oct., Nov., Dec. 1930), 31–35, 27–32, 67–71; 98 (Jan. 1931), 29–35.

"Missing Pictures of Fifteenth Century Siena." Parts I–III. *International Studio*, 98 (Feb., March, April 1931), 24–29, 37–41, 17–22.

"Quadri senza casa: Il quattrocento senese." Parts I, II. *Dedalo*, 11 (March, April 1931), 627–646, 735–767. [HPR, 49–76]

"Quadri senza casa: Il trecento fiorentino." Parts I–III. *Dedalo*, 11 (July, Aug., Nov. 1931), 957–988, 1039–1073, 1286–1318. [HPR, 77–154]

"I disegni di Alunno di Benozzo." *Bollettino d'Arte*, 25 (Jan. 1932), 293–306. [DFP, 11–13]

"Quadri senza casa: Il trecento fiorentino." Parts IV, V. *Dedalo*, 12 (Jan., March 1932), 5–34, 173–193. [HPR, 77–154]

"Les Dessins de Signorelli." *Gazette des Beaux-Arts*, 74 (Jan.–June 1932), 173–210. [DFP, 30–45]

"Due o tre disegni di Benozzo." *L'Arte*, 2 (March 1932), 90–103. [DFP, 328–330]

"Quadri senza casa: Il quatrocento fiorentino." Parts I–III. *Dedalo*, 12 (July, Sept., Nov. 1932), 512–541, 665–702, 819–853. [HPR, 155–198]

"Un Dessin de Botticini au Musée du Louvre." *Gazette des Beaux-Arts*, 74 (July–Dec. 1932), 275–278. [DFP, 72–73]

"Fra' Angelico, Fra'Filippo e la cronologia." *Bollettino d'Arte*, 26 (Aug. 1932), 49–66. [HPR, 199–242]

"Alcuni disegni che si ricollegano nella Trinità del Pesellino." *L'Arte*, 5 (Sept. 1932), 357–377. [DFP, 88–92]

"Three Drawings by Fra' Filippo Lippi." *Old Master Drawings*, 7 (Sept. 1932), 16–18. [DFP 83, 84]

"Disegni inediti di 'Tommaso.' " *Rivista d'Arte*, 14 (1932), 249–262. [DFP, 78–79]

"Nova Ghirlandajana." *L'Arte* 3 (May 1933), 165–184. [DFP, 340–342]

"Ristudiando i disegni di Cosimo Rosselli." *Bollettino d'Arte*, 26 (June 1933), 537–547. [DFP, 146–150]

"Nouveaux dessins de Signorelli." *Gazette des Beaux-Arts*, 75 (July–Dec. 1933), 279–293. [DFP, 30–45]

"Verrocchio e Leonardo, Leonardo e Credi." Parts I, II. *Bollettino d'Arte*, 27 (Nov., Dec. 1933), 193–214, 241–264. [DFP, 49–68]

"Filippino's Designs for a Death of Meleager." *Old Master Drawings*, 8 (Dec. 1933), 32–33.

"Tre disegni di Giovan Battista utili da Faenza." *Rivista d'Arte*, 15 (1933), 21–33. [DFP, 69–70]

"Andrea di Michelangiolo e Antonio Mini." *L'Arte*, 4 (July 1935), 243–283. [DFP, 357–367]

"I disegni di Raffaello da Montelupo." *Bollettino d'Arte*, 13 (Sept. 1935), 105–120. [DFP, 256–263]

"Come ricostruire la Firenze demolita." *Il Ponte*, 1 (April 1945), 33–38. [EA, 1–9]

"Da un diario." *La Nuova Europa*, 2 (May 13, 1945), 5.

"Are Words Late Comers in Poetry?" *Rivista di Letterature Moderne*, 1 (March 1946), 5–6.

"A Latin Profile," (Carlo Placci). *Horizon*, 13 (June 1946), 385–400.

"Painting and the National Income." *The New Statesman and Nation*, 33 (Jan. 25, 1947), 68–69.

"Aan Dr. Max J. Friedländer, Ter Gelegenheid van Zijn 80en Jaardeg." *Maandblad voor Beeldende Kunsten*, 33 (May 1947), 99–102.

"Un codice illustrato del maestro di S. Miniato." *Rivista d'Arte*, 26 (1950), 93–101. [EA, 21–28]

"Zanobi Machiavelli." *Burlington Magazine*, 92 (1950), 345–349. [EA, 29–38]

"Am Bach des Vergessens. Gedanken über die Erinnerung." *Die Welt*, 7 (Jan. 9, 1951).

"Testimonianza a Benedetto Croce nel suo ottantacinquesimo compleanno." *Il Mattino d'Italia*, Feb. 25, 26, 1951.

"Giovan Battista Tiepolo." *L'Illustrazione Italiana*, 80 (June 1951), 57–66. [EA, 56–66]

"Une 'Sacra Conversazione' de l'école de Giorgione au Louvre." *La Revue des Arts* (June 1951), 67–76. [EA, 44–55]

"Tiepolo à Venise." *Arts, Chronique des Arts et de la Curiosité*, 317 (June 29, 1951).

"Importanza della moda nella datazione delle opere d'arte." *Arte Tessile e Moda*, Torino, 1951, 35–39. [EA, 39–43]

"Diario." Parts I–IV. *Corriere della Sera*, March 3, 26; April 23; May 26, 1953.

"Viaggio in Sicilia." Parts I–VIII. *Corriere della Sera*, June 28; July 10, 30; Aug. 22; Sept. 9, 18; Oct. 21, Nov. 13, 1953.

"Lorenzo Lotto: Resulting Impression." *Art News*, 52 (Nov. 1953), 21–25, 51–55.

"Pellegrinaggi Lotteschi." *Corriere della Sera*, Nov. 6, 1953.

"Picasso." *Corriere della Sera*, Dec. 24, 1953.

"Manoscritti miniati." *Corriere della Sera*, Feb. 2, 1954. [EA, 78–86]

"Esposizionite." *Corriere della Sera*, March 10, 1954. [EA 87–93]

"The Restoration of Paintings, Leonardo's 'Last Supper.' " *Manchester Guardian*, April 13, 1954.

"Attribuzioni nostalgiche." *Corriere della Sera*, April 15, 1954. [EA, 84–100]

"A chi l'arte?" *Corriere della Sera*, May 25, 1954. [EA, 101–107]

"Diario veneziano." *Corriere della Sera*, June 26, 1954.

"San Marco, tempio e museo bizantino." *Corriere della Sera*, Sept. 2, 1954.

"Diario romano." Parts I, II. *Corriere della Sera*, Oct. 20, Dec. 24, 1954.

"Guido Reni." *Corriere della Sera*, Nov. 26, 1954. [EA, 117–123]

"Decline and Recovery in the Figure Arts." In *Studies in Art and Literature for Belle da Costa Greene*, ed. Dorothy Miner. Princeton: Princeton University Press, 1954.

"Goethe's Promise." In *This I Believe*, vol. 2, ed. Raymond Swing. New York: Simon & Schuster, 1954.

"Notes on Giorgione." *Arte Veneta*, 8 (1954), 145–152. [EA, 108–116]

"Wishful Attributions." *Manchester Guardian*, Jan. 17, 1955.

"Cos'e e dov'e l'Europa." *Corriere della Sera*, Feb. 1, 1955.

"Diario romano." Part III. *Corriere della Sera*, Feb. 18, 1955.

"Considerazioni letterarie." *Corriere della Sera*, March 24, 1955.

"Madame de Staël." *Corriere della Sera*, April 24, 1955.

"Storia vivente." *Corriere della Sera*, May 25, 1955.

"Diario tripolino." *Corriere della Sera*, July 17, 1955.

"Fra Angelico." *Corriere della Sera*, Aug. 28, 1955.

"Ritorno in Calabria." Parts I–III. *Corriere della Sera*, Oct. 18, Nov. 6, Dec. 16, 1955.

"Leonardo's Last Supper Resurrected." *Art News Annual*, 24 (1955), 31–32.

"Colonizzazione." *Corriere della Sera*, Jan. 26, 1956.

"Arte popolare." *Corriere della Sera*, March 22, 1956.

"Giorne di autunno in Romagna." *Corriere della Sera*, April 24, 1956.

"Il Cardinale Lambertini." *Corriere della Sera*, June 17, 1956.

"La smania di muoversi." *Corriere della Sera*, July 28, 1956.

"Rivistando Firenze." *Corriere della Sera*, Oct. 14, 1956.

"I Carracci." *Corriere della Sera*, Oct. 25, 1956.

"Diario napoletano." *Corriere della Sera*, July 23, 1957.

"L'arte de vedere." *Corriere della Sera*, Aug. 14, 1957.

"La vita e l'arte." *Corriere della Sera*, Sept. 25, 1958.

"Gliocchi strani." *Corriere della Sera*, Oct. 9, 1958.

"Rileggendo Ruskin e Pater." *Corriere della Sera*, Nov. 18, 1958.

"Goethe ed i romantici." *Corriere della Sera*, Dec. 9, 1958.

"Ritorno a Platone." *Corriere della Sera*, Jan. 2, 1959.

"Morale e moralisti." *Corriere della Sera*, Jan. 13, 1959.

"Storie affascinanti." *Corriere della Sera*, Jan. 30, 1959.

"Americani dell'ottocento." *Corriere della Sera*, Feb. 10, 1959.

"Churchill e Trevelyan." *Corriere della Sera*, March 11, 1959.

"D'Annunzio, drammaturgo e uomo." *Corriere della Sera*, March 24, 1959.

"Pagine di diario." Parts I–VI. *Corriere della Sera*, April 10; May 5, 20; June 6; Aug. 14; Oct. 11, 1959.

Other Works

BOOKS

Acton, Harold. *More Memoirs of an Aesthete*. London: Methuen, 1970.

Adams, E. B. *Israel Zangwill*. New York: Twayne, 1971.

Adams, Henry. *Mont Saint Michel and Chartres*. New York: Penguin Books, 1986.

Annigoni, Pietro. *An Artist's Life as Told to Robert Wraight*. London: W. H. Allen, 1977.

Bacon, Leonard. *Semi-Centennial: Some of the Life and Part of the Opinions of Leonard Bacon*. London: Harper & Brothers, 1939.

Barney, Natalie. *Traits et portraits*. Paris: Mercure de France, 1963.

Beaton, Cecil. *The Face of the World*. New York: Day, 1957.

Behrman, S. N. *Duveen*. New York: Random House, 1952. New edition. Boston: Little, Brown. 1972.

———— *People in a Diary*. Boston: Little, Brown, 1972.

Berenson, Mary. *A Modern Pilgrimage*. New York: Appleton, 1933.

Berti, Luciano. *Masaccio*. University Park: Pennsylvania State University Press, 1967.

Biddle, Francis. *A Casual Past*. Garden City, N.Y.: Doubleday, 1961.

Birnbaum, Martin. *The Last Romantic*. New York: Twayne, 1960.

Brandeis, Louis D. *Letters of Louis D. Brandeis*. Vol. 1. Albany: State University of New York Press, 1971.

Brant, Sebastian. *Ship of Fools*. Trans. Edwin H. Zeydel. New York: Columbia University Press, 1944.

Brooks, Gladys. *If Strangers Meet*. New York: Harcourt, Brace & World, 1967.

Brooks, Van Wyck. *An Autobiography*. New York: E. P. Dutton, 1965.

Brown, David A. *Berenson and the Connoisseurship of Italian Painting*. Washington, D.C.: National Gallery of Art, 1979.

Brown, J. Carter. "A Personal Reminiscence." In *Looking at Pictures with Bernard Berenson,* ed. Hanna Kiel. New York: Abrams, 1974.

Budd, Louis J. *Robert Herrick*. New York: Twayne, 1971.

Cabanne, Pierre. *The Great Collectors*. New York: Farrar, Straus, 1963.

Carter, Howard, and A. C. Mace. *The Tomb of Tut-ankh-Amen*. New York: Cooper Square, 1963.

Cater, Harold D. *Henry Adams and His Friends*. Boston: Houghton Mifflin, 1947.

Chanler, Margaret. *Autumn in the Valley*. Boston: Little, Brown, 1936.

Ciano, Galeazzo. *Ciano's Diary, 1939–1943*. London: W. Heinemann, 1947.

Clark, Kenneth. *Another Part of the Wood*. London: J. Murray, 1974.

———— *The Other Half: A Self Portrait*. London: J. Murray, 1977.

Clary-Aldringen, Alfons. *A European Past*. London: Weidenfeld & Nicolson, 1978.

Crawford, W. Rex. *The Cultural Migration*. Philadelphia: University of Pennsylvania Press, 1953.

Day-Lewis, Cecil. *An Italian Visit*. London: J. Cape, 1953.

Day-Lewis, Sean. *C. Day-Lewis*. London: Weidenfeld & Nicolson, 1980.

Diringer, David. *The Illuminated Book*. New York: Philosophical Library, 1958.

Dizionario biografico degli italiani. Vol. 28. Rome: Istituto della Enciclopedia Italiana, 1983.

Du Cann, C. G. L. *The Loves of George Bernard Shaw*. New York: Funk & Wagnalls, 1963.

Eisler, Colin. "*Kunstgeschichte* American Style: A Study in Migration." In *The Intellectual Migration,* ed. Donald Fleming and Bernard Bailyn. Cambridge, Mass.: The Belknap Press of Harvard University Press, 1969.

Encyclopedia of World Art. Vol. 9. New York: McGraw-Hill, 1964.

Fielding, Daphne V. *The Face on the Sphinx*. London: Hamish Hamilton, 1978.

Fowles, Edward. *Memories of Duveen Brothers*. London: Times Books, 1976.

Fry, Roger. *Letters of Roger Fry*. Ed. Denys Sutton. 2 vols. London: Chatto & Windus, 1972.

Gallo, Max. *Mussolini's Italy*. Trans. Charles L. Markmann. New York: Macmillan, 1973.

Gallup, Donald. *The Flowers of Friendship: Letters Written to Gertrude Stein*. New York: Alfred A. Knopf, 1953.

Gathorne-Hardy, Robert. *Recollections of Logan Pearsall Smith*. New York: Macmillan, 1950.

Gervasi, Frank. *The Case for Israel*. New York: Viking Press, 1967.

Gide, André. *The Journals of André Gide*. Trans. Justin O'Brien. 4 vols. New York: Alfred A. Knopf, 1947–1951.

Gimpel, René. *Diary of an Art Dealer*. Trans. John Rosenberg. New York: Farrar, Straus & Giroux, 1966.

——— *Journal d'un collectionneur, marchand de tableaux*. Paris: Calmann-Lévy, 1963.

Greenberg, Clement. *Art and Culture*. Boston: Beacon Press, 1961.

Grey, Edward, First Viscount. *Twenty-five Years*. 2 vols. London: Hodder and Stoughton, 1925.

Guggenheim, Marguerite. *Confessions of an Art Addict*. New York: Macmillan, 1960.

——— *Out of This Century: The Informal Memories of Peggy Guggenheim*. New York: Dial Press, 1946.

Hahn, Harry J. *The Rape of La Belle*. Kansas City: Glen Publishing, 1946.

Hardwick, Elizabeth. *A View of My Own*. New York: Farrar, Straus & Cudahy, 1962.

Harnan, Terry. *African Rhythm—American Dance: A Biography of Katherine Dunham*. New York: Alfred A. Knopf, 1974.

Harriman, Florence J. *From Pinafores to Politics*. New York: Henry Holt & Co., 1923.

Harris, C. R. S. *Allied Military Administration of Italy, 1943–45*. London: H. M. Stationery Office, 1957.

Hartt, Frederick. *Florentine Art under Fire*. Princeton: Princeton University Press, 1949.

Hemingway, Ernest. *Ernest Hemingway: Selected Letters 1917–1961*. Ed. Carlos Baker. New York: Charles Scribner's Sons, 1981.

Hemingway, Mary. *How It Was*. New York: Alfred A. Knopf, 1976.

Hendy, Philip. *European and American Paintings in the Isabella Stewart Gardner Museum*. Boston: Trustees of the Isabella Stewart Gardner Museum, 1974.

Heydenreich, Ludwig. *Leonardo da Vinci*. 2 vols. New York: Macmillan, 1954.

Holmes, Charles J. *Self and Partners (Mostly Self)*. New York: Macmillan, 1936.

Holroyd, Michael. *Lytton Strachey*. New York: Holt, Rinehart & Winston, 1980.

House, Edward M. *The Intimate Papers of Colonel House*. Arr. Charles Seymour. 4 vols. Boston and New York: Houghton Mifflin, 1926–1928.

———, ed. *What Really Happened at Paris*. New York: Charles Scribner's Sons, 1921.

Hoyt, Edwin P., Jr. *The House of Morgan*. New York: Dodd, Mead, 1966.

Isabella Stewart Gardner Museum General Catalogue. Boston: 1935.

Jackson, Stanley. *The Sassoons*. New York: E. P. Dutton, 1968.

James, Henry. *The Letters of Henry James*. Ed. Percy Lubbock. 2 vols. New York: Octagon Books, 1970.

Jenkins, Roy. *Asquith*. London: Collins, 1978.

Jullian, Philippe. *D'Annunzio*. Trans. Stephen Hardman. New York: Viking Press, 1973.

——— *Prince of Aesthetes: Count Robert de Montesquiou*. Trans. John Haylock and Francis King. New York: Viking Press, 1968.

Kaplan, Justin. *Mr. Clemens and Mark Twain*. New York: Simon and Schuster, 1966.

Kazin, Alfred. *New York Jew*. New York: Alfred A. Knopf, 1978.

Leftwich, Joseph. *Israel Zangwill*. New York: T. Yoseloff, 1957.

Le Vane, Ethel, and J. Paul Getty. *Collector's Choice*. London: W. H. Allen, 1955.

Lewis, R. W. B. *Edith Wharton*. New York: Harper & Row, 1975.

Lightbown, Ronald W. *Sandro Botticelli*. 2 vols. Berkeley: University of California Press, 1978.

Linklater, Eric. *The Art of Adventure*. London: Macmillan, 1948.

Luhan, Mabel Dodge. *European Experiences*. New York: Harcourt Brace, 1935.

McComb, A. K. *The Selected Letters of Bernard Berenson*. Boston: Houghton Mifflin, 1964.

McDougall, Walter A. *France's Rhineland Diplomacy*. Princeton: Princeton University Press, 1978.

McMullen, Roy. *Mona Lisa: The Picture and the Myth*. Boston: Houghton Mifflin, 1975.

Mack Smith, Denis. *Italy: A Modern History*. Ann Arbor: University of Michigan Press, 1959.

Magidoff, Robert. *Yehudi Menuhin*. Garden City, N.Y.: Doubleday, 1955.

Marghieri, Clotilde, ed. *Lo specchio doppio: carteggio 1927–1955 di Bernard Berenson, Clotilde Marghieri*. Milan: Rusconi, 1981.

Mariano, Nicky. *Bernard Berenson: An Inventory of Correspondence*. Florence: The Harvard University Center for Italian Renaissance Studies, 1965.

——— *Forty Years with Berenson*. New York: Alfred A. Knopf, 1966.

Mather, Frank J. *The Collectors*. New York: Henry Holt & Co., 1935.

Clark, Kenneth. "Art in My Life." *Listener,* 92 (Oct. 10, 1974), 32.

De Lamar, Alice. "Some Little Known Facts about Bernard Berenson and the Art World." *Forum* (Houston), 12, no. 3 (1975), 23.

Jacobson, Herbert. "Being with Berenson." *Columbia University Forum,* 3, no. 4 (Fall 1960), 32–36.

Kazin, Alfred. "From an Italian Journal." *Partisan Review,* 15, no. 6 (May 1948), 550–567.

Taylor, Francis Henry. "The Summons of Art." *Atlantic Monthly,* 200, no. 5 (Nov. 1957), 121–131.

Notes

Notes are keyed by page and line number. The Selected Bibliography gives full citations for works cited in abbreviated form in the notes. The source of a quotation is indicated at its beginning, and in the case of an interrupted quotation the context will ordinarily show its extent.

Since the chief source of unpublished letters and manuscripts is the Berenson Archive at the Harvard University Center for Italian Renaissance Studies, the Villa I Tatti, Florence, reference to that repository is intended whenever no other location is given, except for Bernard and Mary Berenson's letters to Mrs. Gardner, which are at the Isabella Stewart Gardner Museum in Boston. The letters exchanged among the following members of the Smith family—Hannah, Logan, Alys, Mary, and Mary's children—are part of the Smith family papers, the originals of which are possessed by Barbara Strachey Halpern, Mary's granddaughter. Those items for which copies are not available at I Tatti are noted as being among the Smith family papers in Oxford, England.

The following abbreviations are used:

AAA	Archives of American Art, Washington, D.C.
ASR	Alys Smith Russell
BB	Bernard Berenson
BBP coll.	Bernard B. Perry collection
BG	Belle da Costa Greene
BW	Barrett Wendell
D	Duveen Brothers
EC	Elizabeth Cameron (Mrs. James Donald)
EW	Edith Wharton
Forty Years	Nicky Mariano, *Forty Years with Berenson*
F	Edward Fowles
HA	Henry Adams
HS	Hannah Whitall Smith (Mrs. Robert)
JD	Joseph Duveen

25:25 Ibid.
 31 HS to M, Feb. 25, 1905.
 35 HS to M, Aug. 17, 1905.
26:1 BB to Robert Trevelyan, April
 13, 1905.
 18 M to HS, June 25, 1905.
 23 BB to Mrs. G, June 28, 1905.
 31 M to HS, July 20, 1905.
 42 BB to M, Aug. 28, 1905.
27:10 BB to M, July 8, 1904.
 12 M to BB, Aug. 3, 1905.
 15 M to BB, Aug. 15, 1905.
 25 M to BB, Aug. 23, 1905.
 30 BB to M, Aug. 26, 1905.
 32 BB to Michael Field, Aug. 23,
 1905.
28:1 BB to M, Aug. 5, 1905.
 12 M to HS, Sept. 19, 1905.
 13 Ibid.

28:15 M, Diary, Sept. 19, 1905.
 22 M to HS, Sept. 20, 1905.
 32 M to HS, Sept. 25, 1905.
 37 M to HS, Oct. 11, 1905.
 41 Ibid.
 42 Ibid.
29:7 M to HS, Nov. 26, 1905.
 18 Incorporated in BB, *Italian Paint-
 ers* (1952), 187.
 23 M to Karin Costelloe, Nov. 29,
 1905.
 26 M to Mrs. G, Nov. 9, 1905.
 30 M to HS, Dec. 12, 1905.
 36 M to BB, Dec. 23, 1905.
 37 BB to Mrs. G, Dec. 14, 1905.
30:8 *NYT*, May 21, 1910.
 11 Translated from article.
 27 M to BB, Jan. 1, 1906.

IV. Pathway to Duveen

31:8 John Jay Chapman to BB, March
 16, 1906.
 12 M, Diary, Feb. 22, 1906.
 24 M, Diary, Feb. 15, 1906.
 25 Eugene Glaenzer to BB, Feb. 15,
 1906.
32:3 Ibid.
 12 Eugene Glaenzer to BB, Aug. 9,
 1906.
 24 M to HS, March 26, 1906.
 39 M to HS, March 3, 1906.
33:1 M, Diary, Feb. 9, 1906.
 5 M to HS, Feb. 13, 1906.
 12 M to Mrs. B, May 5, 1906.
 25 M to HS, May 10, 1906.
 35 Ibid.
 38 M to HS, June 4, 1906.
 43 M to HS, June 3, 1906.
34:2 M to HS, June 4, 1906.
 4 Ibid.
 16 M to HS, June 12, 1906.
 22 M to HS, July 3, 1906.
 24 M to HS, July 12, 1906.
 31 M to HS, July 21, 1906.
 36 BB to Abie Berenson, June 26,
 1906.
 41 BB to Abie Berenson, Nov. 2,
 1907.

35:7 M to Senda Berenson, Aug. 19,
 1906.
 10 BB to M, Aug. 29, 1906.
 18 M to BB, Aug. 5, 1906.
 23 BB to Mrs. G, July 25, 1906.
 29 BB to M, Aug. 10, 19, 1906.
 36 BB to JGJ, Nov. 7, 1906, JGJ
 coll.
36:2 BB to JGJ, Jan. 7, 1907.
 20 David Croal Thomson to BB,
 Dec. 21, 1906.
 23 Lockett Agnew to BB, Feb. 10,
 1907.
 39 Mrs. G to BB, Aug. 17, 1906.
 41 M to HS, Sept. 19, 1906.
37:1 M to HS, Oct. 4, 1906.
 4 M to HS, Oct. 5, 1906.
 6 M to HS, Oct. 8, 1906.
 10 M to HS, Oct. 5, 1906.
 13 M to HS, Oct. 9, 1906.
 19 BB to Mrs. G, Oct. 25, 1906.
 23 Ibid.
 25 Ibid.
 27 Whitehill, *Museum of Fine Arts*,
 788.
 32 BB to M, Oct. 30, 1906.
 35 BB to M, Oct. 31, 1906.
38:7 BB to M, Nov. 1, 1906.

38:13 Mrs. G to M, Nov. 23, 1906.
14 Ibid.
24 BB to M, Oct. 30, 1906.
27 M, Diary, Nov. 23, 1906.
31 M to Senda Berenson, Nov. 26, 1906.
38 Lady Sassoon to BB, Sept. 2, 1908.
40 Lady Sassoon to BB, Aug. 6, 1908.
42 Lady Sassoon to BB, n.d.

38:44 Lady Sassoon to BB, n.d.
39:19 F, *Memories,* 31.
21 *NYT,* June 29, 1906.
37 Otto Gutekunst to BB, Dec. 22, 1909.
41 Behrman, *Duveen* (1952), 126.
40:8 F, *Memories,* 33.
28 Ibid.

V. The "Fourth Gospel"

41:6 M to HS, Dec. 18, 1906.
7 M to HS, Dec. 19, 1906.
12 M to HS, Dec. 21, 1906.
14 M to HS, Dec. 22, 1906.
21 HS to M, Feb. 7, 1907.
26 M to HS, Jan. 7, 1907.
42:13 M to HS, Jan. 11, 12, 1907.
16 M to HS, Jan. 30, 1907.
22 M to HS, Feb. 19, 1907.
28 Ibid.
29 M to HS, March 4, 1907.
43:4 M to HS, Jan. 9, 1907.
10 M, Diary, Jan. 25, 1908.
22 BB to M, Sept. 5, 1908.
23 M to HS, Jan. 26, 1908.
27 M to HS, Feb. 22, 1907.
44:1 M to BB, Aug. 30, 1908.
3 BB to Mrs. G, Aug. 14, 1909.
8 Mrs. G to BB, Aug. 15, 1909.
13 M to HS, May 5, 1907.
20 M to BB, April 15, 1907.

44:25 BB to Mrs. G, July 21, 1907.
27 BB to M, July 17, 1907.
31 BB to Senda Berenson, Aug. 11, 1907.
45:1 Jullian, *Prince of Aesthetes,* 159.
10 M to Senda Berenson, March 3, 1907.
17 BB to M, Aug. 2, 1907.
26 BB to Senda Berenson, Aug. 11, 1907.
42 M to HS, March 31, 1908.
46:3 *Publishers Weekly,* Nov. 23, 1907.
47:21 *Independent,* April 2, 1908.
24 *Outlook,* Nov. 3, 1907, 615.
25 *Spectator,* June 6, 1908, 901.
28 *Kunstgeschichtliche Anzeigen,* 1908, 77.
31 Roger Fry to BB, Jan. 11, 1908.
33 *Burlington,* March 1908, 347–349.
48:17 Bacon, *Semi-Centennial,* 218.

VI. A Home in Exile

49:6 M, Diary, Sept. 14, 1907.
15 BB to M, Aug. 2, 1907.
22 M, Diary, Jan. 26, 1908.
50:8 BB to M, April 2, 1908.
12 M, Diary, Jan. 27, 1908.
21 M to HS, Sept. 16, 1907.
26 BB to M, Sept. 28, 1907.
29 M to BB, Sept. 24, 1907.
31 David Carrick to author, Feb. 24, 1980.
38 BB to M, Sept. 22, 1907.
51:3 BB to M, Sept. 23, 1907.
5 Ibid.

51:8 BB to M, Sept. 25, 1907.
18 Adams, *Mont Saint Michel and Chartres,* 105.
29 F, *Memories,* 36–40.
52:1 BB to Mrs. G, July 14, Aug. 31, 1907.
2 BB to M, Sept. 28, 1907.
6 BB to Mrs. G, Aug. 31, 1907.
12 Mrs. G to BB, Sept. 9, 1907.
13 Mrs. G to BB, Oct. 28, 1907.
16 Mrs. G to BB, Sept. 9, 1907.
24 Hendy, *European and American Paintings,* 187.

52:27 F, *Memories*, 33, 34.
 36 JD to BB, Dec. 12, 1907.
 42 JD to BB, Dec. 19, 1907.
53:22 Otto Gutekunst to BB, Jan. 12, 1907.
 30 M to HS, June 7, 1907.
 32 Fry, *Letters*, 287.
 38 Roger Fry to Helen Fry, June 2, 1907, in Fry, *Letters*, 288.
54:20 BB to Robert Trevelyan, Nov. 18, 1907.
 29 Rothenstein, *Men and Memories*, II, 122.
55:1 BB to William Rothenstein, Sept. 10, 1907.
 6 M to HS, Nov. 30, 1907.
 15 BB to Robert Ross, Dec. 3, 1928, quoted in Speaight, *William Rothenstein*, 343.
 22 Rothenstein, *Men and Memories*, II, 126, 127.

55:26 Michael Field to BB, Nov. 20, 1907.
 35 M to HS, Oct. 24, 1907.
 39 M, Diary, Nov. 15, 1907.
 40 M to HS, Nov. 1, 1907.
56:2 M to HS, Nov. 7, 1907.
 6 M to HS, Dec. 15, 1907.
 13 M, Diary, Nov. 9, 1907.
 19 M, Diary, Dec. 14, 1907.
 28 Hoyt, *The House of Morgan*, 279–280.
 33 M to HS, Oct. 8, 1907.
 39 M to HS, Nov. 28, 1907.
 42 Ibid.
57:4 M to HS, Dec. 8, 1907.
 18 M to HS, Dec. 15, 1907.
 23 M to HS, Dec. 14, 1907.
 30 M to HS, Jan. 7, 1908.
 38 M to HS, Feb. 24, 1908.
58:1 Ibid.
 7 M to HS, June 14, 1908.
 13 M to HS, June 7, 1907.

VII. Matisse and the Highroad of Art

59:4 BB to BW, Sept. 30, 1918.
 14 M to Mrs. G, Jan. 11, 1908.
 23 M to HS, Feb. 24, 1908.
 25 BB to M, April 19, 1908.
60:4 M to HS, Feb. 17, 1908.
 9 M, Diary, Feb. 20, 1908.
 10 BB to M, April 2, 1908.
 20 BB to M, March 1908.
 25 Ibid.
 29 M to Mrs. G, Jan. 23, 1908.
 30 BB to M, March 29, 1908.
 36 BB to Gladys Deacon, n.d., in Vickers, *Gladys, Duchess of Marlborough*, 116, 117.
 39 M to family, April 30, 1908, *Smith papers*.
61:18 M to HS, May 27, 1908.
 24 M to HS, June 12, 1908.
 29 M to HS, June 17, 1908.
 31 M to HS, June 14, 1908.
 34 Courtesy of Leon Katz, from manuscript notebooks of Gertrude Stein.
62:3 M to HS, June 19, 29, 1908.
 11 BB to Abie Berenson, Aug. 21, 1908.

62:21 M to HS, June 28, 1908.
 23 BB to JGJ, June 30, 1908, JGJ coll.
 29 M, Diary, June 30, 1908.
 31 BB to M, July 28, 1908.
 39 M, Diary, June 30, 1908.
63:4 M, Diary, June 28, 1908.
 10 BB to Mrs. G, Aug. 2, 1908.
 16 M to HS, July 14, 1908.
 22 Mrs. G to BB, Aug. 17, 1908.
 29 BB to Abie Berenson, Aug. 21, 1908.
 33 BB to M, Aug. 16, 1908.
 36 BB to M, Aug. 29, 1908.
 40 Ibid.
 42 BB to M, Sept. 5, 1908.
64:7 BB to M, Aug. 9, 1908, in Vickers, *Gladys, Duchess of Marlborough*, 113.
 14 Mrs. G to BB, Sept. 4, 1908.
 22 M to BB, Sept. 22, 1908.
 30 BB to M, Sept. 17, 1908.
 40 BB to M, Sept. 24, 1908.
65:2 BB to M, Sept. 20, 1908.
 7 HA to EC, Sept. 22, 1908, Mass. Hist. Soc.

65:16 BB to M, Oct. 1, 1908.
 21 BB to M, Oct. 11, 1908.
 30 BB to M, Sept. 20, 1908.
 40 BB to M, Oct. 9, 1908.
66:7 Ibid.
 18 *Encyclopedia of World Art*, IX, 590.
 27 M to BB, Sept. 19, 1909.
 31 BB to Mrs. G, Aug. 27, 1909.
 40 *Nation*, Oct. 29, 1908, 422.
 42 Ibid., Nov. 12, 1908, 461.
67:10 Carlo Placci to BB, Dec. 16, 1908.

67:21 M to Rachel B. Perry, Oct. 20, 1908, BBP coll.
 29 M to HS, Oct. 6, 1908.
 38 *NYT*, Oct. 10, 1908.
68:3 Louis Gillet to BB, [1908?].
 15 BB to Louis Gillet, Nov. 6, 1912, in "Letters of Louis Gillet and Bernard Berenson," *Botteghe Oscure*, 17 (1956); also I Tatti Archive.

VIII. America the Plutocratic

69:8 M to HS, Oct. 26, 1908.
 18 M to HS, Oct. 27, 1908.
 26 Ibid.
70:23 HA to EC, Aug. 21, 1903, Mass. Hist. Soc.
 27 M to HS, Nov. 5, 1908.
 33 M to HS, Nov. 19, 1908.
71:4 M to HS, Nov. 30, 1908.
 9 M to HS, Nov. 19, 1908.
 35 M to HS, Jan. 10, 1909.
72:8 *Gardner General Catalogue*, 1935, 196.
 14 M to Mrs. G, Feb. 14, 1909.
 23 M to HS, Nov. 30, 1908.
 26 *NYT*, Jan. 11, 1909.
 32 M to HS, Dec. 3, 1908.
73:15 M to Ray Costelloe, Feb. 18, 1909.
 17 BG to BB, Feb. 23, 1909.
 20 BG to BB, n.d.
 32 BB to JGJ, Nov. 11, 1908, JGJ coll.
74:8 M to HS, Dec. 15, 1908.
 18 Joseph Widener to BB, March 20, 1912.
 25 M to HS, Dec. 5, 1908.
 30 M to HS, Jan. 22, 1909.
 33 M to HS, Jan. 10, 1909.

74:34 M to HS, Jan. 22, 1909.
 37 M to HS, Dec. 22, 1908.
75:4 BB to Mrs. G, Dec. 24, 1908.
 12 M to HS, Dec. 24, 1908.
 18 Ibid.
 28 BB to Mrs. G, Dec. 24, 1908.
 34 HA to Mary C. Jones, Jan. 9, 1909, Mass. Hist. Soc.
 38 JD to BB, Dec. 29, 1908.
 41 M to HS, Jan. 3, 1909.
76:11 M to HS, Jan. 5, 1909.
 22 M to HS, Feb. 6, 1909.
 34 Ibid.
77:9 Ibid.
 15 Ibid.
 25 HD to BB, n.d.
 31 M to HS, Jan. 25, 1909.
78:13 M to Mrs. B, Feb. 14, 1909.
 21 M to Mrs. G, April 25, 1909.
 25 M to HS, Feb. 11, 1909.
 36 M to HS, Feb. 9, 1909.
 41 M to HS, March 5, 1909.
79:6 M to HS, March 9, 1909.
 7 M to Mrs. G, March 19, 1909.
 18 M to HS, n.d.
 24 M to Mrs. G, March 22, 1909.
 34 BG to BB, March 17, 1909.

IX. The Pursuit of Life Enhancement

80:13 David Croal Thomson to BB, n.d., 1909.
 16 BG to BB, March 17, 1909.
81:6 BG to BB, n.d.
 8 Ibid.

81:10 Ibid.
 26 BB to M, April 18, 1909.
 35 BB to M, April 8, 1909.
82:5 BB to Mrs. G, April 10, 1909.
 12 JD to BB, April 3, 1909.

82:17 BB to Senda Berenson, June 29,
1909, BBP coll.
22 BB to M, April 8, 1909.
29 M to BB, April 13, 1909.
37 BB to M, April 15, 1909.
39 M to BB, April 18, 1909.
83:5 M to Mrs. G, April 21, 1909.
16 BB to M, April 25, 1909.
24 Ibid.
28 BB to M, April 29, 1909.
34 BB to M, April 28, 1909.
84:17 BG to BB, March 17, 1909.
18 BG to BB, April 9, 1909.
22 BG to BB, 1909, n.d.
24 BG to BB, 1909, n.d.
25 BG to BB, April 1909.
28 BG to BB, 1909, n.d.
41 BB to M, June 11, 1909.

85:2 BB to M, Aug. 9, 1909.
12 M to HS, May 5, 1909.
17 BB to Mrs. G, May 5, 1909.
22 M to HS, June 10, 1909.
35 JD to BB, May 25, 1909.
39 Henry Duveen to BB, May 17,
1909.
86:1 BB to Benjamin Altman, May 25,
1909, copy by M.
10 Behrman, *Duveen* (1972), 224.
20 M to HS, May 30, 1909.
29 BB to M, June 15, 1909.
31 M to family, Dec. 10, 18, 1909,
Smith papers.
87:12 Henry Duveen to BB, June 1909.
18 BB to Benjamin Altman, July 5,
1909, copy by M.
36 BB to M, Aug. 1, 1909.

X. The Red Robe

88:5 BB to M, June 17, 1909.
11 BB to M, June 19, 1909.
16 BB to M, June 13, 1909.
89:2 M to HS, July 23, 1909.
7 M to Mrs. B, July 23, 1909, RB
coll.
12 BB to Mrs. G, Aug. 27, 1909.
15 M to HS, Aug. 21, 1909.
18 BB to M, June 23, 1909.
23 BB to M, Aug. 12, 1909.
27 HA to Bancel LaFarge, June 28,
1909, in Cater, *Henry Adams,* 658.
29 HA to EC, June 27, 1909, Mass.
Hist. Soc.
32 BB to M, Aug. 12, 1909.
38 BB to René Gimpel, June 28,
1909, AAA.
90:2 BB to René Gimpel, July 13,
1909, AAA.
15 BB to M, Aug. 21, 1909.
20 BB to M, Aug. 3, 1909.
25 BB to Mrs. G, Aug. 4, 1909.
31 Mrs. G to BB, Aug. 13, 1909.
36 BB to Mrs. G, Aug. 27, 1909.
39 BB to M, Aug. 25, 1909.
91:2 Taylor and Brooke, *The Art Deal-
ers,* 76.

91:8 *Congressional Record,* June 12,
1909.
13 BB to M, Sept. 6, 1909.
21 BB to M, Sept. 11, 1909.
30 BB to M, Sept. 16, 1909.
32 BB to M, Sept. 11, 1909.
42 BB to M, Sept. 13, 1909.
92:11 BB to M, Sept. 25, 1909.
15 BB to M, Sept. 16, 1909.
22 BB to M, Sept. 2, 1909.
32 M to HS, Oct. 10, 1909.
37 M to HS, Oct. 16, 1909.
93:1 *NYT,* Oct. 24, 1909.
4 BB to M, Oct. 21, 1909.
10 David Croal Thomson to BB,
Oct. 6, 1909.
22 D to BB, Oct. 27, 1909.
32 BB to Mrs. G, Nov. 16, 1909.
41 BB to M, Oct. 2, 1909.
94:7 HA to EC, Sept. 17, 1909, Mass.
Hist. Soc.
19 HA to EC, Sept. 27, 1909, Mass.
Hist. Soc.
22 HA to Ward Thoron, Oct. 11,
1909, Mass. Hist. Soc.
24 HA to EC, Oct. 12, 1909, Mass.
Hist. Soc.

94:31 HA to BB, Sept. 28, 1909.
38 M to BB, Sept. 19, 1909.
41 BB to M, Sept. 16, 1909.
95:21 BB to M, Sept. 26, 1909.
26 BB to M, Oct. 2, 1909.
40 Lewis, *Edith Wharton*, 217–218.
96:6 BB to M, Oct. 7, 1909.
15 BB to M, Oct. 24, 1909.
20 BB to M, Jan. 25, 1910.
26 BB to M, Oct. 7, 1909.
31 BB to M, Sept. 1909.
97:16 M to BB, Sept. 24, 1909.

97:19 M to HS, Oct. 31, 1909.
32 Ibid.
39 M to HS, Nov. 4, 7, 1909.
40 BB to BW, Dec. 9, 1909, Harvard University Archives.
98:1 BB to JGJ, Nov. 8, 1909, JGJ coll.
7 M to HS, Nov. 12, 1909.
10 M to HS, Nov. 21, 1909.
17 M to HS, Dec. 10, 1909.
20 M to HS, Dec. 26, 1909.

XI. *The Ixion Wheel of Business*

99:6 *Rivista d'Arte,* Jan.–Feb. 1909, 3–6.
24 BB, *A Sienese Painter,* 9–10.
100:1 *Dial,* Sept. 1910, 119.
3 *Athenaeum,* July 23, 1910, 103.
5 *Nation,* Feb. 2, 1910, 123.
6 *North American Review,* Sept. 1910, 429.
16 Arnold Bennett, *New Age,* Oct. 21, 1909, reprinted in Arnold Bennett, *Books and Persons* (New York: Greenwood Press, 1968), p. 158.
22 BB to Ivins, Aug. 8, 1954.
35 M to HS, Jan. 7, 1910.
37 M to HS, Jan. 9, 1910.
101:2 BB to Mrs. G, Nov. 7, 1910.
4 BB to Mrs. G, Jan. 23, 1911.
9 BB to M, May 12, 1910.
13 M to HS, Nov. 13, 1910.
17 JD to BB, Jan. 1, 1910.
20 JD to BB, Feb. 12, 1910.
23 *Newsweek,* May 18, 1935, 27; and *Literary Digest,* Jan. 13, 1934, 11.
41 BB to Senda Berenson, Oct. 9, 1909, BBP coll.
102:5 M to HS, Feb. 1, 1910.
13 BB to M, Jan. 28, 1910.
17 BB to M, Feb. 6, 1910.
23 M to HS, Feb. 1, 1910.
103:1 BB to JGJ, n.d. 1910, JGJ coll.
8 BB to Mrs. G, July 8, 1910.
12 BB to HA, Nov. 27, 1910, Mass. Hist. Soc.

103:17 BB to M, June 9, 1910.
21 M to HS, Feb. 21, 1910.
34 M to HS, April 9, 1910.
104:4 BB to Roger Fry, March 3, 1910, in Sutton, *Fry,* 329.
8 Roger Fry to BB, April 24, 1910, in Sutton, *Fry,* 329.
16 M to HS, Feb. 19, 1910.
18 BB to M, Feb. 25, 1910.
27 M to BB, Aug. 31, 1910.
32 M to HS, April 5, 1910.
35 JD to BB, March 1, 1910.
40 M to Ray Costelloe, March 19, 1910, Smith papers.
105:2 JD to BB, April 25, 1910.
9 Ibid.
19 M to HS, April 21, 1910.
23 M to HS, May 24, 1910.
29 BB to EW, Easter Sunday, 1910.
37 M to HS, June 18, 1910.
42 M to HS, June 17, 1910.
106:6 M to HS, May 20, 1910.
9 BB to Mrs. G, April 17, 1910.
31 M to HS, May 21, 1910.
35 Ibid.
42 BB to JGJ, Feb. 24, 1910, JGJ coll.
107:11 BB to EW, July 15, 1910.
19 BB to Senda Berenson, Aug. 4, 1910, BBP coll.
27 BB to Mrs. G, July 18, 1910.
29 BB to M, July 6, 1910.
41 BB to M, July 19, 1910.
108:17 BB to M, July 6, 1910.

134:41 LD to M, March 19, 1912.
135:7 BB to M, March 15, 1912.
 16 BB to LD, March 29, 1912.
 19 BB to M, March 19, 1912.
 25 LD to BB, March 21, 1912.
 29 JD to BB, May 21, 1912.
 36 D to BB, June 7, 1912.
136:5 *NYT,* April 16, 1916.
 11 John Pope-Hennessy, "The Martelli David," *Burlington Magazine,* April 1959, 138.
 17 JD to BB, May 21, 1912.
 24 LD to BB, Jan 18, 1912.
 27 JD to BB, Feb. 6, 1912.

136:33 BB to LD, May 1, 1913.
137:5 BB to M, March 23, 1912.
 6 Henry Duveen to BB, Feb. 14, 1913.
 8 Copy, BB to HD, Feb. 25, 1913.
 10 BG to BB, Nov. 16, 1912.
 19 Copy, BB to HD, Feb. 25, 1912.
 38 M to ASR, Jan. 1, 1912, Smith papers.
138:6 Rachel B. Perry to Senda B. Abbott, March 13, 1912, RB coll.
 12 M to ASR, Jan. 20, 1912, Smith papers.
 21 Cecil Pinsent to M, June 15, 1912.

XV. The "Merchants" and the "Expert"

139:8 BB to EW, March 23, 1912, copy at I Tatti.
 16 Ibid.
140:11 M to BB, April 9, 1912.
 14 BG to BB, May 3, 1912.
 17 BG to BB, Aug. 12, 1912.
 19 BG to BB, Nov. 16, 1912.
 27 BB to Ralph Curtis, May 14, 1912.
141:8 Ralph Curtis to BB, May 18, 1912.
 14 BB to M, July 1, 1912.
 25 BB to Mrs. G, Oct. 11, 1888.
142:3 BB to M, April 26, 1912.
 11 M to Mrs. B, June 5, 1912, RB coll.
 13 M to Mrs. B, May 28, 1912, RB coll.
 17 Senda B. Abbott to M, July 26, 1912.
 22 BB to M, June 2, 1912.
 23 BB to M, June 25, 1912.
 30 BB to M, June 29, 1912.
 34 BB to M, July 3, 1912.
 38 BB to Mrs. B, June 26, 1912.
143:2 BB to Henry Walters, Jan. 16, 1912.
 10 Unsent letter, BB to JD, May 18, 1912.
 21 BB to JGJ, April 20, 1912.
 28 BB to JGJ, Jan. 10, 1913.
 34 BB to M, July 12, 1912.

143:37 BB to M, July 11, 1912.
144:2 BB to M, July 24, 1912.
 6 BB to M, July 26, 1912.
 12 EC to BB, May 31, 1912.
 13 BB to EC, June 2, 1912.
 18 BW to BB, June 24, 1912.
 21 BB to HA, July 17, 1912.
 34 HA to BB, Aug. 1, 1912.
 42 BB to HA, Aug. 15, 1912.
145:28 Sybil Cutting to BB, July 18, 1912.
 32 BB to M, July 12, 1912.
 42 BB to M, July 19, 1912.
146:7 BB to M, July 10, 1912.
 17 Contract dated Sept. 25, 1912.
 23 Ibid.
147:23 Ibid.
 36 D to BB, Dec. 18, 1912.
148:16 BB to Otto Gutekunst, June 7, 1927.
 38 Jacques Seligmann to BB, Oct. 20, 1915.
149:4 Seligman, *Merchants of Art,* 127.
 18 Gimpel, *Journal d'un collectionneur,* 225.
 32 BB to M, Aug. 31, 1912.
 34 M to ASR, Sept. 16, 1912, Smith papers.
 37 M to ASR, Sept. 29, 1912, Smith papers.
 42 BB to Henry Walters, Oct. 21, 1912, Walters Art Gallery.

150:3 BB to Henry Walters, Nov. 9, 1912, Walters Art Gallery.
4 JD to BB, Nov. 21, 1912.
6 JD to BB, Dec. 5, 1912.
11 JD to BB, Dec. 19, 1912.
22 *Encyclopaedia Britannica*, 11th ed., XVI, 447c.
25 BB to LD, Jan. 29, 1913.

150:29 LD to BB, Feb. 16, 1913.
39 BB to JD, Jan. 14, 1912.
151:9 Wilhelm Bode, "Portrait of a Venetian Nobleman by Giorgione in the Altman Collection," *Art in America*, Oct. 1913, 229.
17 Pignatti, *Giorgione*, 130.

XVI. Last Season of the Belle Epoque

152:17 *NYT*, Feb. 2, 1913.
153:24 LD to BB, Oct. 28, 1912.
26 M to ASR, Nov. 18, 1912, Smith papers.
30 Ibid.
38 George Santayana to Mrs. Frederick Winslow, Dec. 6, 1912, in Santayana, *Letters*, 336.
154:1 Spalding, *Roger Fry*, 166.
5 M to BB, Dec. 13, 1912.
6 M to ASR, Dec. 23, 1912, Smith papers.
13 Mather, *Collectors*, 177.
16 M to ASR, Dec. 18, 1912, Smith papers.
18 M to ASR, Dec. 19, 1912, Smith papers.
28 M to ASR, Jan. 1, 1913, Smith papers.
34 M to ASR, Dec. 23, 1912, Smith papers.
155:6 BB to Gertrude Stein, Nov. 23, 1912, in Gallup, *Flowers of Friendship*, 66.
16 M to ASR, Feb. 17, 1913, Smith papers.
27 *Gazette des Beaux-Arts*, March 1913, 190.
35 Ibid., June 1913, 461.
42 BB, *Study and Criticism of Italian Art*, Third Series, 62.
156:6 Ibid., 65.
31 F, *Memories*, 83.
34 BB to LD, Feb. 23, 1913.
38 LD to BB, Feb. 13, 1913.
157:3 Terisio Pignatti to author, March 18, 1982.
8 M to ASR, March 29, 1913, Smith papers.

157:34 M to family, April 29, 1913.
158:2 LD to BB, May 9, 1913.
10 *NYT*, Nov. 15, 1913.
13 M to Mrs. B, April 10, 1913.
16 BB to JGJ, April 31, 1913.
19 M to ASR, April 22, 1913, Smith papers.
22 BG to BB, April 12, 1913.
27 M to Geoffrey Scott, May 12, 1913.
40 M to BB, June 13, 1913.
41 M to BB, July 1, 1913.
159:3 M to BB, Aug. 29, 1913.
29 Florence Blood to Gertrude Stein, June 21, 1913, in Gallup, *Flowers of Friendship*, 81.
34 BB to M, June 23, 1913.
40 Gabrielle D'Annunzio to BB, n.d., 1913.
160:3 BB to M, July 3, 1913.
5 Jullian, *D'Annunzio*, 248.
8 BB to M, July 3, 1913.
17 BB to M, July 4, 1913.
23 Ibid.
33 BB to M, June 21, 1913.
41 BB to M, July 10, 1913.
161:10 Ibid.
16 BB to M, July 19, 1913.
20 BB to M, July 20, 1913.
26 M to BB, July 2, 1913.
29 BB to M, July 14, 1913.
31 BB to M, July 24, 1913.
35 BB to M, July 25, 1913.
162:11 Lewis, *Edith Wharton*, 348.
22 BB to M, Aug. 12, 1913.
25 BB to M, Aug. 9, 1913.
34 BB to M, Aug. 12, 1913.
39 Ibid.
163:4 BB to M, Aug. 16, 1913.

187:24 BB to EC, Oct. 7, 1914.
32 BB to M, Oct. 7, 1914.
188:3 M to Geoffrey Scott, Oct. 30, 1914.
11 Henry James to Rhoda Broughton, Oct. 1, 1914, in James, *Letters*, II, 408.
20 M to Mrs. B, Nov. 9, 1914.
24 JD to BB, Nov. 23, 1914.
28 D to BB, Dec. 18, 1914.
31 Henry Duveen to BB, Oct. 23, 1914.

189:1 *New York Herald*, Nov. 22, 1914.
13 M to Senda B. Abbott, Nov. 18, 1914, BBP coll.
24 BB to Mrs. G, Nov. 22, 1914.
29 M to Senda B. Abbott, Nov. 18, 1924, BBP coll.
41 M to Ray Strachey, Nov. 9, 1911, Smith papers.
190:11 BB to Mrs. G, Dec. 13, 1914.

XIX. A Time for Writing

191:7 M to ASR, Jan. 9, 1915, Smith papers.
8 BB to BW, Jan. 31, 1915.
13 BB to Mrs. G, Dec. 13, 1914.
16 BB to BW, Dec. 17, 1914.
23 D to BB, Dec. 18, 1914.
192:4 D to BB, June 3, 1915.
10 Henry Walters to BB, Dec. 31, 1914, Walters Art Gallery.
19 Henry Walters to BB, Jan. 23, 1915, Walters Art Gallery.
24 M to ASR, Dec. 27, 1914, Smith papers.
193:15 BB to Abie Berenson, June 24, 1915.
19 M to ASR, March 15, 1915, Smith papers.
27 BB to Louis Gillet, n.d., 1915.
35 M to ASR, May 18, 1915, Smith papers.
194:1 M to ASR, May 8, 1915, Smith papers.
4 M to ASR, March 15, 1915, Smith papers.
5 M to ASR, Oct. 19, 1915, Smith papers.
9 M to Senda B. Abbott, July 7, 1915, RBP coll.
13 EW to BB, Feb. 10, 1915.
15 BB to EW, May 12, 1915.
22 EW to BB, Sept. 11, 1916.
24 M to ASR, March 15, 1915, Smith papers.

194:40 JD to BB, July 14, 1915.
195:10 Ibid.
13 BG to BB, Jan. 10, 1915.
15 BG to BB, Feb. 19, 1915.
21 JD to BB, July 14, 1915.
33 M to Mrs. B, May 27, 1915, RBP coll.
196:11 BB to Louis Gillet, June 15, 1915.
16 M to BB, June 19, 1915.
18 M to BB, June 26, 1915.
34 BB to M, June 29, 1915.
40 Ibid.
197:11 M to ASR, July 5, 1915, Smith papers.
13 BB to M, Aug. 31, 1915.
17 BB to M, Aug. 7, 1915.
20 M to ASR, Sept. 22, 1915, Smith papers.
25 BB to M, Aug. 12, 1915.
30 M to BB, July 15, 1915.
33 BB to M, July 27, 1915.
37 BB to Mrs. B, Aug. 2, 1915.
198:1 BB to M, Aug. 7, 1915.
7 M to BB, Aug. 8, 1915.
12 BB to M, Aug. 7, 1915.
16 BB to Abie Berenson, Sept. 3, 1915.
22 BB to Senda B. Abbott, Sept. 4, 1915, BBP coll.
28 BB to M, Aug. 9, 1915.
31 M to BB, Aug. 13, 1915.
199:7 BB to M, Aug. 22, 1915.
17 M to ASR, Oct. 2, 1915.

199:20 BB to M, Sept. 9, 1915.
 23 M to ASR, Oct. 24, 1915.
 34 M to ASR, Oct. 27, 1915.
200:2 BB to Louis Gillet, Oct. 30, 1915.
 8 M to BB, Aug. 6, 1915.
 14 BB to BW, Dec. 8, 1915.
 19 Henry Walters to BB, Jan. 18, 1916.

200:23 BB to Paul Sachs, Jan. 31, 1916, in McComb, 78.
 28 BB to EC, Christmas Day, 1915.
 32 BB to BW, Dec. 8, 1915.
201:11 BB to BW, Dec. 8, 1915.

XX. Paris in Wartime

202:5 M's draft, BB to D, Jan. 16, 1916.
 9 LD to BB, June 23, 1916.
 15 BB to LD, June 6, 1916.
 25 BB to M, Feb. 15, 1916.
203:8 BB to M, Feb. 11, 1916.
 14 Ibid.
 21 BB to M, Feb. 16, 1916.
 27 M to BB, Jan. 25, 1916.
 30 M to BB, Jan. 26, 1916.
 31 BB to M, Feb. 12, 1916.
 35 BB to M, Feb. 7, 1916.
 41 M to Roger Fry, April 15, 1916.
204:3 BB to JGJ, April 14, 1916, JGJ coll.
 8 M to Roger Fry, April 15, 1916.
 9 Roger Fry to BB, April 21, 1916, in Sutton, *Fry*, 396.
 17 BB to Roger Fry, April 25, 1916.
 29 M to Roger Fry, April 27, 1916.
205:25 BB to Abie Berenson, July 1, 1916.
 30 M to ASR, June 11, 1916, Smith papers.
 33 M to Senda B. Abbott, July 8, 1916, BBP coll.
 41 M to ASR, Aug. 11, 1916, Smith papers.
206:7 Ibid.
 16 M to ASR, Sept. 6, 1916, Smith papers.
 26 M to ASR, Aug. 13, 1916, Smith papers.
 28 M to ASR, Oct. 2, 5, 1916.
 31 M to BB, Nov. 14, 1916.
 37 EW to BB, Sept. 11, 1916.
 42 Geoffrey Scott to BB, Nov. 16, 1916.
207:8 BB to M, Nov. 5, 1916.

207:10 BB to M, Nov. 12, 1916.
 16 Budd, *Herrick*, 91.
 23 Wickes, *The Amazon of Letters*, 151.
 36 Barney, *Traits et portraits*, 40.
208:1 Lewis, *Edith Wharton*, 391.
 8 Otto Kahn to BB, Sept. 27, 1916.
 21 BB to M, Nov. 9, 1916.
 29 M to BB, Nov. 9, 1916.
 36 BB to M, Nov. 13, 1916.
 39 BB to M, Nov. 10, 1916.
 41 Ibid.
209:6 BB to M, Nov. 10, 1916.
 12 M to BB, Nov. 13, 1916.
 15 BB to M, Nov. 21, 1916.
 20 BB to M, Nov. 26, 1916.
 24 M to BB, Nov. 23, 1916.
 34 M to ASR, Dec. 22, 1916, Smith papers.
 40 Frederick Sherman to BB, Dec. 15, 1916.
210:1 BB to Mrs. B, Jan. 1, 1917.
 5 M to ASR, Jan. 9, 1917, Smith papers.
 8 M to ASR, Jan. 7, 1917, Smith papers.
 11 M to ASR, Jan 8, 1917, Smith papers.
 14 M to ASR, Jan. 2, 1917, Smith papers.
 16 M to ASR, Jan. 17, 1917, Smith papers.
 21 BB to Dan Fellows Platt, Jan. 30, 1917.
 35 BB to Mrs. G, Oct. 26, 1916.
 37 BB to Mrs. G, Jan. 1, 1917.
 40 BB to Mrs. G, Jan. 7, 1917.
211:6 Mrs. G to BB, March 18, 1917.

XXI. Venetians Restudied and Leonardo Dethroned

212:3 BB to BW, Feb. 25, 1916.
213:19 *International Studio*, Dec. 1917, 84.
 22 *The Times Literary Supplement*,
 April 26, 1917.
 34 *Art and Archaeology*, Aug. 1917,
 125.
 37 *Nation*, March 15, 1907, 316.
214:6 BB to BW, Jan. 22, 1917, Harvard University Archives.
 19 McMullen, *Mona Lisa*, 218, 219.
 24 *Burlington*, Oct. 1915, 31.
 28 *Gazette des Beaux-Arts*, May 1914,
 379-386.
215:24 Reprinted in BB, *Italian Painters*
 (1952), 65.

216:22 Definition by Richard Offner in
 Dial, Nov. 18, 1917, 447.
 42 EW to BB, Jan. 29, 1917.
217:5 EW to BB, Feb. 14, 1917.
 14 *Literary Digest*, Sept. 9, 1917, 31.
 15 *Boston Transcript*, Aug. 1917, 105.
 16 *Current Opinion*, Aug. 1917, 115.
 20 *Connoisseur*, May-Aug. 1917, 46.
 27 *The Times Literary Supplement*,
 Feb. 22, 1917.
 36 *International Studio*, Dec. 1917, 84.
 40 *Nation*, May 13, 1917, 663.

XXII. From Art Expert to Military Adviser

219:3 M to Senda B. Abbott, Sept. 8,
 1917, RBP coll.
 5 BB to M, Oct. 29, 1917.
 7 M to ASR, Jan. 23, 1917.
 10 M to ASR, Sept. 8, 1917, Smith
 papers.
 13 M to ASR, Jan. 23, 1917, Smith
 papers.
 16 M to ASR, March 7, 1917, Smith
 papers.
 18 M to ASR, March 12, 1917,
 Smith papers.
 20 M to ASR, March 17, 1917,
 Smith papers.
 28 BB to Natalie Barney, Jan. 19,
 1917.
220:2 BB to Natalie Barney, n.d., 1917,
 in Wickes, *The Amazon of Letters*,
 154.
 7 BB to Natalie Barney, Jan. 19,
 1917.
 18 BB to Natalie Barney, n.d., 1917,
 in Wickes, *The Amazon of Letters*,
 157-158.
 40 BB to Natalie Barney, Aug. 16,
 1955.
221:3 M to ASR, April 4, 1917, Smith
 papers.

221:5 BB to Ralph Barton Perry, April
 18, 1917, Harvard University Archives.
 9 *NYT*, April 2, 1917.
 14 BB to M, April 11, 1917.
 17 BB to Abie Berenson, May 26,
 1917.
 30 BB to M, Easter Sunday 1917.
 34 EW to BB, April 17, 1917.
222:6 M to ASR, March 13, 1917,
 Smith papers.
 10 M to Mrs. G, May 27, 1904.
 15 M to ASR, July 30, 1917, Smith
 papers.
 19 LD to BB, April 1917.
 21 LD to BB, May 3, 1917.
 28 LD to BB, May 1917.
223:3 M to ASR, April 17, 1917, Smith
 papers.
 6 BB to M, July 5, 1917.
 11 Published Oct.-Dec. 1918,
 Gazette des Beaux-Arts.
 38 BB to Dan Fellows Platt, July 8,
 1917.
 41 Arthur K. Porter to BB, Aug. 27,
 1917.
224:17 LD to BB, June 9, 1917.
 22 F to BB, July 10, 1917.

224:26 F to BB, June 28, 1917.
 28 JD to BB, July 11, 1917.
 33 M's draft. BB to F, July 14, 1917.
 38 F, *Memories,* 98.
225:2 Ibid., 101.
226:2 Ibid., 102.
 6 Ibid.
 25 BB to M, Nov. 1, 1917.
 33 BB to M, Nov. 11, 1917.
 38 Ibid.
227:1 George Santayana to Logan Pearsall Smith, Nov. 27, 1917.

227:4 BB to Dan Fellows Platt, Jan. 14, 1918.
 7 BB to M, Dec. 6, 1917.
 18 BB to M, Dec. 13, 1917.
 21 M to BB, Dec. 28, 1917.
 26 Consul Dumont to Ambassador Page, Dec. 14, 1917.
 34 House, *Intimate Papers,* III, 283.
228:12 BB to M, Nov. 30, 1917.
 15 BB to Mrs. G, Nov. 29, 1917.
 23 M to family, Jan. 2, 1918.
 26 BB to M, Dec. 23, 1917.

XXIII. Domestic Crisis

229:13 BB to Carlo Placci, Nov. 22, 1917.
 18 BB to Carlo Placci, Dec. 22, 1917.
 27 BB to M, [July ?] 27, 1918.
230:2 M to BB, Dec. 12, 1917.
 6 M to BB, Jan. 10, 1918.
 7 M to BB, Jan. 14, 1918.
 12 Sybil Cutting to BB, Jan. 3, 1918.
 17 Sybil Cutting to M, Dec. 15, 1917.
 19 BB to M, Dec. 24, 1917.
 24 M to Geoffrey Scott, Dec. 20, 1917.
 29 M to Geoffrey Scott, Jan. 10, 1918.
 35 BB to M, Feb. 8, 1918.
231:17 BB to M, Dec. 4, 1917.
232:41 BB to Ralph Curtis, Feb. 3, 1918.
233:1 BB to BW, April 30, 1918.
 14 *NYT,* April 14, 1918.
 18 Lewis, *Edith Wharton,* 410.
 19 BB to BW, July 10, 1918, Harvard University Archives.
 21 BB to M, May 1, 1918.
 33 BB to M, Jan. 2, 1918.
 39 BB to M, Jan. 22, 1918.
234:9 Proust, *Correspondence,* VI, 241, 242.
 14 Ibid., 247.
 26 BB to Mrs. Mildred Bliss, Nov. 14, 1917, Dumbarton Oaks Archives.

234:36 BB to M, Feb. 6, 1918.
 41 BB to M, May 1, 1918.
235:2 BB to M, May 18 (?), 1918.
 7 BB to M, May 10, 1918.
 9 BB to M. May 20, 1918.
 25 BB to Ralph Curtis, Feb. 3, 1918.
 30 Lewis, *Edith Wharton,* 408.
 37 BB to M, Feb. 11, 1918.
236:2 BB to M, Jan. 19, 1918.
 7 BB to M, Feb. 25, 1918.
 9 BB to M, Jan. 26, 1918.
 19 M to BB, Jan. 5, 1918.
 22 LD to B, Jan. 24, 1918.
 29 *Forty Years,* 43, 44.
 31 Ibid., 43.
 32 Brandt, *Ship of Fools,* 217.
 35 M to BB, Nov. 15, 18, and 20, 1918.
237:1 N to author, interview in June 1961.
 2 BB to BW, April 30, 1918, Harvard University Archives.
 3 M to BB, Jan. 1, 1919.
 7 M to BB, May 2, 1918.
 11 M to BB, May 4, 1918.
 15 M to BB, May 15, 28, 1918.
 19 M to BB, May 7, 1918.
 22 BB to Mrs. G, May 21, 1918.
 28 BB to Ralph Curtis, May 31, 1918.
238:10 M to BB, June 9, 1918.
 12 M to BB, June 11, 1918.
 17 Dated May 11, 1918.

XXVII. An Island of Relative Solitude

268:2 M to Allyn Cox, Oct. 10, 1919.

5 M to Mrs. B, Oct. 25, 1919, BBP coll.

15 BB to Mrs. B, Jan. 9, 1920.

17 BB to BW, Nov. 27, 1919.

269:8 M to JD, Oct. 27, 1919, copy by M.

15 M to F, Oct. 20, 1919, copy by M.

26 LD to M, Dec. 5, 1919.

30 Copy to BB of agreement dated Oct. 31, 1919.

32 Copy of Carl Hamilton's letter to D, Nov. 10, 1919.

36 List of Carl Hamilton's purchases in BB's hand.

270:20 M to Walter Dowdeswell, Feb. 25, 1920, copy by M.

25 F, *Memories,* 122.

32 F to BB, Feb. 11, 1920.

35 F, *Memories,* 122.

42 M to F, March 24, 1920, copy by M.

271:4 M to F, April 1, 1920, copy by M.

17 LD to BB, Feb. 14, 1920.

20 LD to BB, March 2, 1920.

24 F, *Memories,* 126.

28 Ibid., 129.

32 F to BB, March 23, 1920.

33 F to BB, March 25, 1920.

38 M to Carl Hamilton, March 10, 1920, Bryn Mawr College Library manuscript collection.

272:4 BB to BW, Nov. 27, 1919, Harvard University Archives.

10 Ibid.

19 M to Carl Hamilton, Dec. 6, 1919, Bryn Mawr College Library manuscript collection.

21 *Forty Years,* 29.

24 *Nation,* May 29, 1920, 735.

37 *Forty Years,* 30.

273:12 Logan P. Smith to ASR, Jan. 29, 1920, Smith papers.

30 *Forty Years,* 31.

34 Shone, *Bloomsbury Portraits,* 216, 217.

274:1 Ibid., 217.

4 *Forty Years,* 30.

5 M to Mrs. B, May 8, 1920, RB coll.

11 Shone, *Bloomsbury Portraits,* 50.

20 *Forty Years,* 31.

26 Ibid.

31 M to BB, May 28, 1920.

32 M to BB, June 2, 1920.

37 *Forty Years,* 35.

42 *Art in America,* Oct. 1920, 251–271.

275:6 Frederick Sherman to BB, Feb. 15, 1920.

17 Shapley, "Cimabue," *Catalogue of the Italian Paintings,* I, 134.

29 *Freeman,* Aug. 25, 1920, 569.

36 F, *Memories,* 127.

276:9 BB to Mrs. B, June 14, 1920.

23 M to Mrs. G, June 19, 1920.

30 BB to M, July 6, 1920.

34 BB to M, July 21, 1920.

277:1 Ezra Pound to BB, March 13, 1920.

16 BB to M, July 6, 1920.

20 BB to M, July 11, 1920.

24 BB to M, July 4, 1920.

29 M to BB, July 17, 1920.

278:3 BB to Mrs. G, July 18, 1920.

9 BB to Mrs. G, Aug. 12, 1920.

12 BB to BW, Aug. 22, 1920, Harvard University Archives.

17 BB to M, Sept. 13, 1920.

22 BB to M, Sept. 28, 1920.

27 M to BB, Sept. 23, 1920.

30 Quoted in M to BB, Sept. 23, 1920.

40 Gimpel, *Diary,* 146.

279:6 M to Carl Hamilton, Nov. 4, 1920, Bryn Mawr College Library manuscript collection.

11 René Gimpel to BB, Oct. 26, 1920.

14 M to ASR, Nov. 4, 1920, Smith papers.

17 BB to Ralph Curtis, Oct. 20, 1920.

27 M to ASR, Nov. 1920, Smith papers.

XXVIII. Suspect in the Promised Land

280:4 De Lamar, "Some Little Known Facts," 24–32.

15 M to ASR, Jan. 19, 1921, Smith papers.

19 Ibid.

24 Ibid.

281:2 M to Ray C. Strachey, Dec. 17, 1920, Smith papers.

12 M to ASR, Dec. 17, 1920, Smith papers.

22 M to ASR, Dec. 7, 1920, Smith papers.

25 M to N, Jan. 17, 1921.

31 Ibid.

37 *Forty Years,* 36.

41 M to ASR, Dec. 2, 1920, Smith papers.

282:2 M to ASR, Dec. 21, 1920, Smith papers.

7 M to ASR, Jan. 14, 1921, Smith papers.

29 M to Ray C. Strachey, Dec. 24, 1920, Smith papers.

39 De Lamar, "Some Little Known Facts," 30.

283:9 M to Carl Hamilton, Jan. 2, 1921.

11 De Lamar, "Some Little Known Facts," 30.

14 M to ASR, Dec. 24, 1920, Smith papers.

24 BB to Natalie Barney, Jan. 5, 1921.

30 BG to BB, Jan. 4, 1921.

284:4 BG to BB, March 22, 1921.

284:5 M to Mrs. G, Feb. 2, 1921.

17 M to ASR, Feb. 2, 1921, Smith papers.

19 Ibid.

29 M to Mrs. G, Jan. 19, 1921.

35 De Lamar, "Some Little Known Facts," 28, 29.

285:34 Jacques Seligmann to BG, Feb. 25, 1921.

286:13 202600-1413-4, March 25, 1921, State Dept., June 9, 1921.

40 EW to BB, Feb. 16, 1921.

287:4 M to Mrs. G, Feb. 28, 1921.

13 M to Mrs. G, March 5, 1921.

17 BB to Mrs. B, March 4, 1921, BBP coll.

19 M to ASR, March 10, 1921, Smith papers.

21 M to Mrs. G, March 6, 1921.

33 Felix Frankfurter to BB, March 28, 1921.

41 Louis Brandeis to Alfred Brandeis, Jan. 15, 1887, in Brandeis, *Letters,* I, 73.

288:5 Arthur McComb to John Dos Passos, March 16, 1921, University of Virginia Manuscripts Department.

8 Ibid.

34 M to Mrs. G, March 21, 1921.

39 BB to Mrs. G, March 13, 1921.

289:9 BB to Mrs. G, March 22, 1921.

16 M to Mrs. G, April 23, 1921.

XXIX. Early Art and the Land of the Pharaohs

290:3 Ralph Curtis to BB, March 23, 1921.

5 M to Mrs. G, April 23, 1921.

8 BB to M, March 30, 1921.

15 BB to M, April 7, 1921.

17 M to BB, April 10, 1921.

22 BB to M, April 11, 1921.

26 Arthur K. Porter to BB, Nov. 29, 1921.

291:2 BB to Mrs. G, May 3, 1921.

291:7 *Forty Years,* 41.

9 M to Mrs. G, May 14, 1921.

12 Holroyd, *Lytton Strachey,* II, 392.

30 M to Mrs. G, Aug. 31, 1921.

37 M to Mrs. G, July 16, 1921.

38 M to Mrs. G, Aug. 21, 1921.

292:8 Morra, *Conversations,* 56, 89.

15 Vickers, *Gladys, Duchess of Marlborough,* 162.

24 BB, "A Botticelli Portrait," 26–30.

318:15 Heydenreich, *Leonardo*, I, 181.
 22 *NYT*, May 18, 1930.
 31 *Forty Years*, 88.
 41 Ibid., 90.
319:21 Gimpel, *Diary*, 246.
 36 Ibid., 248.

320:6 M to Mrs. G, Oct. 23, 1923.
 10 *Forty Years*, 167.
 24 M to ASR, Nov. 3, 1923, Smith papers.
 32 BB to Mrs. G, Nov. 17, 1923.

XXXII. The Archaeology of Art

322:7 Lewis, *Edith Wharton*, 461
 8 M to ASR, Nov. 11, Dec. 10, 1923, Smith papers.
 30 M to ASR, Jan. 8, 1924, Smith papers.
 38 M to ASR, Jan. 9, 1924, Smith papers.
323:9 M to ASR, Jan. 17, 1924, Smith papers.
 12 M to Mrs. G, May 29, 1924.
324:42 M to Senda B. Abbott, June 9, 1924, BBP coll.
325:4 BG to BB, July 27, 1924.
 9 BG to BB, Aug. 6, 1924.
 21 M to N, July 31, 1924.
 29 M to N, Aug. 1, 1924.
 30 JD to BB, June 29, 1924.
 39 M to BB, July 17, 1924.
326:5 Copy, M to JD, July 25, 1924.
 18 M to N, Aug. 5, 1924.
 23 *Forty Years*, 212.
 30 BB to N, Aug. 22, 1924.
 38 BB to William Ivins, May 6, 1929, AAA.
327:2 BB to N, Aug. 24, 1924.
 11 Gallo, *Mussolini's Italy*, 188.
 17 M to Mrs. B, Sept. 12, 1924, RB coll.

327:22 M to N, Sept. 4, 1924.
 24 BB to N, Sept. 4, 1924.
 37 Draft, BB to JD, Oct. 1924.
328:4 Shapley, *Paintings*, I, 124.
 11 Draft copy, M to F, Dec. 26, 1924.
 17 F to BB, Nov. 15, 1924.
 21 Draft, M to F, Dec. 19, 1924.
 23 Ibid.
 26 Shapley, *Paintings*, 425–426.
 34 F to M, Dec. 23, 1924.
 41 Draft copy, M to F, Dec. 26, 1924.
329:14 M to Mrs. B, Oct. 12, 1924, RB coll.
 17 *Forty Years*, 120.
 26 M to Mrs. B, Oct. 12, 1924, RB coll.
 34 M to Mrs. B, Nov. 9, 1924, RB coll.
 40 JD to BB, Oct. 8, 1924.
330:7 BB to M, Dec. 23, 1924.
 11 M to Mrs. B, Dec. 7, 1924, RB coll.
 13 Ibid.
 21 Gallo, *Mussolini's Italy*, 188.

XXXIII. On the Way to Truth

331:4 M to William Rothenstein, Feb. 20, 1925.
 14 Gimpel, *Diary*, 281.
 23 BB to William Ivins, Nov. 13, 1925, AAA.
332:10 BB to William Ivins, Jan. 13, 1926, AAA.
 12 BB to William Ivins, Oct. 12, 1931, AAA.

332:24 Draft, BB to F, Jan. 8, 1925.
333:41 M to Mrs. B, Feb. 22, 1925.
334:4 Draft, BB to F, June 27, 1925.
 7 M to BB, July 15, 1925.
 16 M to BB, July 11, 1925.
 33 *The Times*, July 14, 1925.
 36 *Forty Years*, 124.
335:8 *The Times*, July 14, 1925.
 10 Ibid., Aug. 5, 1925.

335:12 Ibid., Dec. 2, 1925.
21 *Sunset*, 278.
28 *Forty Years*, 124, 125.
32 BB to M, July 22, 1925.
36 *Forty Years*, 125.
39 BB to Bessie Berenson, Aug. 21, 1925.
336:3 Arthur Pope to BB, Aug. 3, 1925.
9 Arthur Pope to BB, Feb. 9, 1955.
24 M to N, Aug. 18, 1925.
34 BB to N, Aug. 22, 1925.
36 Ibid.

337:1 BB to N, Sept. 25, 1925.
4 M to N, Sept. 11, 1925.
8 BB to N, Sept. 11, 1925.
10 F to BB, Nov. 3, 1925.
16 M to N, Sept. 11, 1925.
31 M to N, Sept. 13, 1925.
35 Ibid.
39 Clark, *Another Part of the Wood*, 129.
338:5 BB to N, Oct. 10, 1925.
11 M to N, Oct. 10, 1925.
31 BB to Paul Sachs, April 8, 1926.

XXXIV. The "Two Sposini"

339:3 Israel Zangwill to BB, Nov. 14, 1925.
9 Ibid.
15 Gallo, *Mussolini in Italy*, 200.
17 M to Walter Lippmann, Feb. 18, 1926, Yale University Library manuscript collection.
19 M to Walter Lippmann, April 19, 1926, Yale University Library manuscript collection.
20 Ibid.
340:11 *Art in America*, April 1926, 105.
29 M to ASR, Jan. 5, 1926, Smith papers.
30 M to Ray C. Strachey, Jan. 12, 1926.
34 Logan P. Smith to ASR, Jan. 9, 1926, Library of Congress Manuscript Division.
341:1 *Forty Years*, 193.
4 M, Diary, Jan. 1926.
8 *Forty Years*, 11.
10 Ibid., 32.
20 M, Diary, Feb. 20, 1927.
23 M to ASR, April 10, 1927, Smith papers.
26 BB to M, Feb. 12, 1927.
34 M, Diary, April 14, 1927.
342:16 Karin C. Stephen to M, March 8, 1926, Smith papers.
25 Draft copy, Thomas Lamont to N. F. Fletcher, March 19, 1926.
30 BB to Thomas Lamont, April 14, 1926.

342:38 M to ASR, April 12, 1926, Smith papers.
42 BG to BB, July 8, 1926.
343:12 M to Mrs. B, June 8, 1926, RB coll.
29 BB to Thomas Perry, June 2, 1927, in McComb, 99.
35 *Sunset*, 146.
37 Ibid., 284.
344:2 Copy, BB to Clotilde Marghieri, June 3, 1927.
8 Copy, BB to Clotilde Marghieri, Jan. 17, 1928.
13 Copy, Clotilde Marghieri to BB, Dec. 12, 1931.
32 N to author, Aug. 1, 1967.
36 *Forty Years*, 192.
41 M to Mrs. B, July 25, 1926.
345:1 M to ASR, Nov. 18, 1926.
10 M to Mrs. B, July 25, 1926, RB coll.
18 M to N, Aug. 5, 1926.
30 M to N, Aug. 13, 1926.
41 M to BB, Aug. 29, 1926.
346:3 M to BB, Sept. 1, 1926.
6 M to BB, Sept. 3, 1926.
8 BB to William Ivins, Aug. 7, 1926, AAA.
10 BG to BB, May 25, 1926.
16 M to BB, Sept. 2, 1926.
24 M to BB, Sept. 8, 1926.
29 M to BB, Sept. 11, 1926.
33 Ibid.
41 *Forty Years*, 153.

347:5 BG to BB, Oct. 5, 1926.
 8 *Forty Years,* 154.
 14 BB to M, Oct. 25, 1926.
 15 BB to M, Oct. 21, 1926.
 19 *Forty Years,* 155; N to M, Oct. 24, 1926.
 26 M to BB, Oct. 27, 1926.
 28 M to BB, Oct. 20, 1926.
 38 *Forty Years,* 155, 156.
348:5 M to ASR, Nov. 18, 1926, Smith papers.
 10 M to ASR, Oct. 10, 1926, Smith papers.
 14 M to ASR, Nov. 18, 1926, Smith papers; Clark, *Another Part of the Wood,* 27.
 24 M, Diary, April 11, 1927.
 34 BB to Charles Du Bos, Dec. 19, 1926.
 39 BB to William Ivins, Dec. 24, 1926, AAA.
349:2 Back cover of *Revue des Deux Mondes,* Feb. 15, 1927.
 5 F to BB, Feb. 8, 1927.

349:15 BB to Charles Du Bos, Dec. 19, 1926.
 18 Ibid.
 24 BB to Charles Du Bos, Jan. 22, 1927.
 35 BB to William Ivins, Dec. 16, 1926, AAA.
 41 Clark, *Another Part of the Wood,* 165.
350:8 M to ASR, Jan. 14, 1927, Smith papers.
 11 M to Logan P. Smith, Jan. 4, 1927.
 13 M to ASR, Jan. 27, 1927.
 20 M to BB, Feb. 7, 1927.
 22 N to M, June 3, 1927.
 29 Clark, *Another Part of the Wood,* 153.
 32 BB to M, Jan. 30, 1923.
 35 BB to William Ivins, March 8 (?), 1927, AAA.
351:3 M to Mrs. B, Feb. 6, 1927.
 5 M to N, Feb. 5, 1927.

XXXV. The End of Profit Sharing

352:5 M to Walter Lippmann, Feb. 26, 1927, Yale University Library manuscript collection.
 8 BB to Walter Lippmann, Feb. 26, 1927, Yale University Library manuscript collection.
 14 M to JD, March 11, 1927.
353:14 *New Statesman,* May 28, 1927, 221.
 15 *Spectator,* May 14, 1927, 861.
 16 *The Times Literary Supplement,* June 9, 1927.
 21 *Saturday Review,* Oct. 1927, 149.
 33 BB to Arthur K. Porter, May 1929, quoted in Helen Epstein, "Meyer Schapiro," *Art News,* May 1983, 60.
354:6 BB to N, June 9, 1927.
 12 M to JD, March 11, 1927.
 36 F to BB, June 7, 1927.
355:4 *Forty Years,* 161.
 26 M to Mrs. B, July 24, 1927, RB coll.

356:3 M to ASR, Aug. 19, 1927, Smith papers.
 9 M, Diary, Aug. 20, 1927.
 12 M to Senda B. Abbott, Aug. 21, 1927, BBP coll.
 22 *Forty Years,* 165.
 28 M to ASR, Sept. 4, 1927, Smith papers.
 33 M to Mrs. B, Sept. 19, 1927, RB coll.
357:5 *Forty Years,* 169.
 9 Lord D'Abernon to BB, Oct. 11, 1927.
 15 Copy, BB to Lord D'Abernon, Oct. 21, 1927.
 40 M to ASR, Nov. 20, 1927, Smith papers.
358:6 BB to William Ivins, Nov. 17, 1927, AAA.
 13 M to ASR, Nov. 13, 1927.
 19 F. Steinmeyer to BB, Nov. 18, 1927.
 26 M, Diary, Nov. 24, 1927.

358:27 F to BB, Dec. 27, 1927.

359:17 BB to William Ivins, Jan. 20, 1925, AAA.

20 M to BB, Dec. 26, 1927.

28 M to Senda B. Abbott, March 23, 1928, BBP coll.

30 BB to M, March 5, 1928.

38 BB to M, July 24, 1929.

41 F to BB, April 18, May 4, 1928.

360:11 Arthur Berenson to BB, Jan. 23, 1928.

33 Ibid.

361:1 Richard Offner, "A Remarkable Exhibition of Italian Paintings," *The Arts,* May 1924, 264.

3 Richard Offner, *Studies in Florentine Paintings* (New York: F. F. Sherman, 1927), preface.

XXXVI. *Afloat on a Golden Flood*

362:2 M to Senda B. Abbott, Feb. 24, 1928.

7 M to ASR, May 15, 1928, Smith papers.

10 BB to N, Sept. 5, 1928.

13 BB to M, Feb. 25, 1928.

24 Clark, *Another Part of the Wood,* 172.

363:4 M to N, Feb. 9, 1929.

12 Copy, BB to Kenneth Clark, May 1929.

24 Kenneth Clark to BB, June 20, 1929.

38 Clark, *Another Part of the Wood,* 156.

41 Quoted by Iris Origo, in *Sunset,* xii.

364:15 F to BB, Feb. 6, 1928.

22 JD to BB, June 16, 1928.

28 *NYT,* May 11, 1928.

32 Draft, BB to F, May 11, 1928.

33 JD to BB, June 16, 1928.

39 Arthur Sulley to BB, Jan. 23, 1928.

40 Arthur Sulley to BB, May 19, 1928.

365:16 M to BB, Feb. 28, 1928.

19 M to BB, June 11, 1928.

24 M to N, Aug. 28, 1928.

27 M to N, Sept. 4, 1928.

33 Copy, BB to Jules Bache, Aug. 5, 1927.

366:5 Jules Bache to BB, Aug. 11, 1928.

14 Jules Bache to BB, Jan. 7, 1929.

20 Jules Bache to BB, Feb. 8, 1929.

23 Copy, BB to Jules Bache, Feb. 26, 1929.

366:27 Jules Bache to BB, April 3, 1929.

29 Ibid.

35 JD to BB, Aug. 22, 1928.

38 BB to JD, July 23, 1929.

367:5 Draft, BB to JD, June 30, 1928.

10 F to M, June 30, 1928.

15 BB to Abie Berenson, Aug. 1, 1928.

28 Copy, BB to Joseph Haven, Dec. 10, 1928.

32 Ibid.

42 N to BB, July 24, 1928.

368:2 BB to N, Aug. 31, 1928.

6 M to N, Sept. 2, 1928.

15 Ibid.

19 M to Mrs. B, Sept. 8, 1928, RB coll.

369:34 Kiel, *Homeless Paintings,* 235.

370:31 M to ASR, Sept. 26, 1928, Smith papers.

33 BB to Henry Coster, Oct. 3, 1928, in McComb, 104.

371:2 Ibid.

26 M to Mrs. B, Oct. 16, 1928, RB coll.

29 Ibid.

36 M to Senda B. Abbott, Nov. 27, 1928, BBP coll.

38 BB to William Ivins, Dec. 19, 1928, AAA.

372:1 BB to William Ivins, Dec. 7, 1928, AAA.

24 M to ASR, April 3, 1929, Smith papers.

32 Chanler, *Autumn in the Valley,* 248.

36 Ibid., 250.

373:10 *Forty Years*, 205.
 13 M, *Modern Pilgrimage*, 56.
 17 M to family, May 3, 1929, Smith papers.

373:24 Chanler, *Autumn in the Valley*, 258.
 35 BB to Charles Du Bos, July 6, 1929.

XXXVII. *"Prince of Art Critics"*

374:6 Draft, BB to F, March 2, 1929.
 23 Draft, BB to F, Jan. 2, 1929.
375:1 F to BB, Jan. 16, 1929.
 8 F to BB, March 25, 1929.
 9 *Art in America*, Feb. 1930, 45.
 18 Ibid.
 23 Ibid.
 33 BG to BB, Dec. 12, 1929.
 37 *Art in America*, Feb. 1930, 45.
376:8 Shapley, *Catalogue of the Italian Paintings*, I, 303.
 14 Berti, *Masaccio*, 94.
 17 David A. Brown to author, Dec. 4, 1985.
 21 Shapley, *Catalogue of the Italian Paintings*, I, 304.
 27 *The Times*, Dec. 31, 1929.
 35 F to BB, May 30, 1930.
 39 F to M, Nov. 7, 1930.
377:7 N to BB, July 25, 1929.
 9 BB to N, July 26, 1929.
 12 BB to N, July 25, 1929.
 20 F to BB, July 29, 1929.
 33 BB to M, Sept. 5, 1929.
378:6 BB to M, Sept. 21, 1929.
 17 *Forty Years*, 177; BB to N, Dec. 31, 1929; Lewis, *Edith Wharton*, 493.
 20 BB to M, Jan. 10, 1930.
 24 M to ASR, Oct. 1, 1929, Smith papers.
 34 M to family, Oct. 7, 1929, Smith papers.
 35 BB to William Ivins, Nov. 22, 1929, AAA.
 40 M to Mrs. B, Dec. 29, 1929, RB coll.
379:5 M to Mrs. B, Feb. 21, 1930, RB coll.
 8 M to Mrs. B, March 8, 1930, RB coll.

379:10 M to ASR, Jan. 27, 1930, Smith papers.
 20 M to N, May 11, 1930.
 21 N to M, Aug. 12, 1930; *Forty Years*, 218.
 24 M to ASR, Oct. 26, 1930, Smith papers.
 25 Morra, *Conversations*, 37.
 41 BB to William Ivins, March 17, 1930, AAA.
380:4 *New Yorker*, Sept. 15, 1960, 99.
 15 M to ASR, May 16, 1930, Smith papers.
 22 M to Mrs. B, June 12, 1930, RB coll.
 24 M to ASR, May 27, 1930, Smith papers.
 25 Ibid.
 26 BB to N, May 1930.
381:1 M to BB, May 22, 1930.
 3 M to N, June 28, 1930.
 6 Copy, Louis Levy to JD, Aug. 11, 1930.
 10 F to BB, June 24, 1930.
 14 M to N, Aug. 20, 1930.
 25 M to N, Aug. 30, 1930.
382:1 Introduction to *Sunset*.
 3 BB to M, Oct. 20, 1930.
 7 Logan P. Smith to Robert Gathorne-Hardy, Aug. 10, 1930, quoted in Gathorne-Hardy, *Recollections*, 21.
 19 *Nation and Athenaeum*, Jan. 25, 1930, 579.
383:4 *New York Herald-Tribune*, Feb. 8, 1931.
 9 *NYT*, March 29, 1931.
 11 *Burlington*, May 1931, 245.
 15 *International Studio*, Aug. 1931, 70.

XXXVIII. A New Disciple

384:2 M to Mrs. B, Dec. 7, 1930, RB coll.

3 M to ASR, Nov. 23, 1930, Smith papers.

4 Walker, *Self-Portrait with Donors*, 82.

7 *Forty Years*, 146.

8 Walker, *Self-Portrait with Donors*, 23.

12 *Forty Years*, 146.

17 Walker, *Self-Portrait with Donors*, 28.

385:1 Ibid., 83.

4 Ibid., 82.

9 M to Mrs. B, Dec. 7, 1930, RB coll.

12 M to Mrs. B, Feb. 24, 1931, RB coll.

18 BB to N, Dec. 26, 1930.

23 Ibid.

29 M to Mrs. B, Jan. 4, 1931, RB coll.

30 M to BB, Jan. 10, 1931.

35 M to BB, Jan. 14, 1931.

386:5 Mary's unfinished "Life of BB."

11 Ibid.

21 BB to N, Aug. 1931.

25 BB to N, Sept. 13, 1931.

35 *Forty Years*, 209.

387:10 BB to Robert Trevelyan, April 23, 1931, in *Treasury*, 170.

15 BB to Louis Gillet, April 7, 1931.

19 *Forty Years*, 209.

24 BB to Henry Coster, April 3, 1931, in McComb, 111.

27 BB to Gustaf Adolf, May 4, 1931, in McComb, 112.

32 M to Senda B. Abbott, June 2, 1931.

38 Morra, *Conversations*, 134.

40 M to Senda B. Abbott, June 6, 1931, BBP coll.

388:6 BB to M, Aug. 13, 1931.

9 M to BB, Aug. 25, 1931.

19 M to N, July 30, 1931.

31 F to BB, Feb. 19, 1931.

37 BB to M, July 30, 1931.

388:41 BB to N, July 31, 1931.

389:10 F to BB, June 16, 1930.

13 Walker, *Self-Portrait with Donors*, 105.

18 Ibid., 113.

20 Ibid., 115, 119.

25 Ibid, 113.

390:1 M to BB, Aug. 28, 1931.

16 M to Mrs. B, Sept. 30, 1931, RB coll.

19 BB to Abie Berenson, Oct. 26, 1931.

23 BB to William Ivins, Oct. 4, 1931, AAA.

28 BB, *Drawings* (1938), 30.

391:10 BB to William Ivins, Christmas Day 1931.

14 BB to M, Jan. 3, 1932.

20 BB to William Ivins, Jan. 9, 1932, AAA.

22 Louis Levy to BB, Jan. 26, 1932.

37 Clotilde Marghieri, ed., *Lo specchio doppio,* 153. Note error in Secrest, *Being Bernard Berenson,* 344. It was BB's loss, not Clotilde's.

41 ASR to Senda B. Abbott, Jan. 7, 1932, BBP coll.

392:3 BB to William Ivins, Feb. 1, 1932, AAA.

6 M to Mrs. B, March 1932, RB coll.

15 BB to William Ivins, Feb. 2, 1932, AAA.

17 BB to William Ivins, March 14, 1932, AAA.

20 M to Mrs. B, March 24, 1932, RB coll.

27 M to Mrs. B, April 6, 1932, RB coll.

30 M to Mrs. B, April 12, 1932, RB coll.

33 BB to M, March 29, 1932.

39 Ibid.

393:2 BB to M, April 1, 1932.

18 BB to M, June 2, 1932.

32 Nevus, *Robert Herrick,* 318.

394:6 BB to N, Aug. 4, 1932.

XXXIX. The "Book of Revelation"

395:1 JD to BB, June 30, 1932.
11 BB to JD, July 9, 1932.
396:22 Memo, William Phillips to Count Ciano, Jan. 2, 1939, in McComb, 155.
35 M to BB, Oct. 24, 1932.
39 Lewis, *Edith Wharton*, 419.
40 BB to William Ivins, Oct. 18, 1932, AAA.
397:4 BB to M, Oct. 9, 1932.
13 BB to M, Oct. 13, 1932.
23 N to Senda B. Abbott, Jan. 19, 1933, BBP coll.
26 BB to M, Dec. 23, 1932.
31 BB to N, Dec. 31, 1932.
35 BB to Clotilde Marghieri, Jan. 1, 1933.
40 BB to Clotilde Marghieri, Jan. 19, 1934.
398:6 BB to Clotilde Marghieri, March 12, 1935.
9 BB to Umberto Morra, Aug. 26, 1933, in Morra, *Conversations*, 156.

398:12 BB to Charles Du Bos, Nov. 9, 1933.
41 Preface dated Nov. 1931.
399:24 Walker, *Self-Portrait with Donors*, 95.
32 *Zeitschrift für Kunstgeschichte* (1932), I, 309.
37 *Art Bulletin*, Sept. 1932, 277.
41 *Burlington*, Aug. 1932, 93.
42 Ibid., 94.
400:2 *Gazette des Beaux-Arts*, Aug.– Sept. 1934.
7 JD to BB, Feb. 5, 1932.
8 F to BB, Jan. 8, 1932.
16 F to BB, May 28, 1935.
17 Draft, BB to F. Nicola, March 16, 1935.
26 JD to BB, Feb. 11, 1932.
34 M's draft, BB to F, March 19, 1935.

XL. The Role of Art History

401:6 BB to EW, March 28, 1933.
20 *NYT*, March 6, 1933.
21 Ibid., March 21, 1933.
402:2 M to Mrs. B, April 11, 1933, RB coll.
9 *NYT*, May 13, 1933.
13 Eisler, "*Kunstgeschichte* American Style," 569.
38 BB to Margaret Barr, June 12, 1936.
41 BB to Margaret Barr, June 23, 1936.
403:13 BB to William Ivins, May 28, 1933, AAA.
16 M to Roger Fry, April 27, 1916.
19 Morra, *Conversations*, 160.
24 Panofsky, "History of Art," in Crawford, *The Cultural Migration*, 92.
31 BB to William Ivins, Oct. 22, 1933, AAA.

404:5 BB to Daniel V. Thompson, May 16, 1934, AAA.
11 BB to Daniel V. Thompson, Jan. 24, 1935, AAA.
28 BB to Daniel V. Thompson, May 22, 1935, AAA.
33 BB to William Ivins, Dec. 11, 1935, AAA.
405:1 M to Senda B. Abbott, April 25, 1933, BBP coll.
7 BB to William Ivins, March 13, 1933, AAA.
13 M to Mrs. B, March 19, 1933, RB coll.
28 Copy, BB to Franz Werfel, March 26, 1933.
31 BB to William Ivins, May 14, 1933, AAA.
39 *Sunset*, 508.
41 Ibid.

406:2 Eisler, "*Kunstgeschichte* American Style," 556, 619.

7 Clark, *Another Part of the Wood*, 209.

10 *The Times*, Sept. 2, 1933.

12 BB to Paul Sachs, Nov. 1933, in McComb, 121.

22 Arthur K. Porter to BB, Nov. 26, 1928.

25 N to M, Aug. 2, 1937, in *Forty Years*, 221.

30 Arthur K. Porter to BB, Nov. 11, 1925.

32 Arthur K. Porter to BB, March 22, 1929.

37 Arthur K. Porter to BB, Dec. 23, 1929.

42 BB to Henry Coster, Nov. 19, 1933.

407:2 BB to Paul Sachs, Nov. 19, 1933, in McComb, 120.

5 BB to Mrs. B, Dec. 14, 1933.

10 *NYT*, Jan. 2, March 3, 1933.

12 JD to Berensons, Jan. 21, 1933.

407:23 BB to M, Sept. 3, 1933.

24 BB to M, Sept. 11, 1933.

30 JD to M, Sept. 13, 1933.

38 Draft, BB to F, June 7, 1934.

408:10 Draft, BB to F, Nov. 20, 1933.

20 BB to Clotilde Marghieri, Jan. 19, 1914.

23 BB to M, Sept. 3, 1933.

31 BB to M, Sept. 25, 1933.

42 M to Mrs. B, Sept. 17, 1933, RB coll.

409:9 BB to M, Sept. 30, 1933.

18 BB to N, Aug. 14, 1933.

25 BB to Learned Hand, Dec. 13, 1933, in McComb, 122.

30 BB to Learned Hand, Sept. 24, 1933, in McComb, 117.

35 BB to Learned Hand, Dec. 13, 1933, in McComb, 122.

410:1 James Bryant Conant, quoted in Paul Sachs et al. to BB, Oct. 11, 1933.

4 Paul Sachs et al. to BB, Oct. 10, 1933.

XLI. Life in "Mussolinia"

411:19 M to Mrs. B, April 1, 1934, RB coll.

22 BB to William Ivins, Sept. 5, 1934, AAA.

412:2 BB to Daniel V. Thompson, Sept. 17, 1934, AAA.

12 BG to BB, Sept. 24, 1934.

15 BB to Senda B. Abbott, June 25, 1934, RBP coll.

16 McComb, 134n.

17 BB to William Ivins, Jan. 1, 1934, AAA.

19 BB to William Ivins, June 14, 1934, AAA.

23 BB to Daniel V. Thompson, May 16, 1934, AAA.

38 Morra, *Conversations*, 205.

40 BB to William Ivins, Aug. 29, 1935, AAA.

42 BB to Louis Gillet, Nov. 14, 1935.

413:2 BB to Learned Hand, Nov. 17, 1935, in McComb, 130.

413:4 BB to Louis Gillet, Feb. 10, 1936.

13 M to Mrs. B, June 6, 1934, RB coll.

18 *Sunset*, 524.

23 BB to Learned Hand, Sept. 26, 1934, in McComb, 125.

28 N to BB, Aug. 25, 1934.

38 M, Diary, Jan. 1, 1934.

42 M to BB, June 17, 1934.

414:5 M to BB, June 16, 1934.

7 Clark, *Another Part of the Wood*, 227.

9 Ibid., 228.

11 M to BB, June 21, 1934.

14 Statement, Oct. 3, 1934.

20 Louis Levy to BB, Aug. 31, 1934.

22 BB to Henry Coster, Sept. 3, 1934, in McComb, 124.

39 BB to Learned Hand, Sept. 26, 1934.

415:1 N to BB, Aug. 24, 1934.

3 BB to William Ivins, Oct. 23, 1934, AAA.

415:6 BB to Bessie Berenson, Nov. 8, 1934, RBP coll.

12 Copy, BB to Clotilde Marghieri, Jan. 14, 1935.

16 BB to M, Jan. 11, 1935.

416:3 BB to Henry Coster, Oct. 25, 1935.

9 M to BB, Sept. 26, 1934.

13 BB to Bessie Berenson, April 28, 1935, RBP coll.

25 Ibid.

26 BB to William Ivins, March 19, 1935, AAA.

32 BB to M, April 2, 1935.

37 Copy, BB to Clotilde Marghieri, April 3, 1935.

417:8 Brown, *Connoisseurship of Italian Painting,* 27 and n.64.

37 *The Times,* June 26, 1935.

418:6 *Beaux-Arts,* July 5, 1935.

14 M to Mrs. B, June 30, 1935, RB coll.

17 Robert Cust to BB, July 10, 1935.

21 William Rothenstein to BB, July 4, 1935.

33 M to Mrs. B, June 30, 1935, RB coll.

34 *Gazette des Beaux-Arts,* July–Aug. 1935.

38 BB to Abie Berenson, June 24, 1935.

419:11 BB to Henry Coster, Oct. 30, 1935, in McComb, 127.

19 M to BB, July 24, 1935.

24 M to BB, Aug. 25, 1935.

30 M to BB, Aug. 2, 1935.

34 M to BB, Oct. 17, 1935.

420:7 *Forty Years,* 194.

9 Ibid.

11 BB to Henry Coster, Oct. 30, 1935; McComb, 128.

14 BB to Daniel V. Thompson, Oct. 10, 1935, AAA.

17 Morra, *Conversations,* 210, 211, 212.

26 M, Diary, Oct. 27, 1935.

41 BB to William Ivins, Feb. 17, 1936, AAA.

421:9 Preface dated Jan. 1, 1936.

421:13 BB to Daniel V. Thompson, Jan. 30, 1936, AAA.

23 Daniel V. Thompson to author, Dec. 14, 1979.

27 Garnett McCoy to author, May 15, 1980.

31 BB to Henry Coster, Feb. 28, 1936.

422:9 N, *An Inventory of Correspondence.*

17 M to Mrs. B, Jan. 16, 1936, RB coll.

26 Armand Lowengard to BB, Feb. 16, 1936.

33 BB to M, Feb. 25, 1936.

39 BB to M, Feb. 29, 1936.

41 BB to Senda B. Abbott, Feb. 27, 1936, RBP coll.

423:2 Arthur Berenson to BB, Feb. 18, 1936.

10 BB to Bessie Berenson, March 5, 1936, BP coll.

15 F to BB, March 24, 1936.

18 F to BB, Feb. 6, 1936.

24 BB's note on F to BB, March 27, 1936.

25 F to BB, May 4, 1936.

28 Shapley, *Catalogue of the Italian Paintings,* I, 55.

30 F to BB, Feb. 7, 1936.

36 F to BB, March 13, 1936.

40 BB to Henry Coster, April 7, 1936.

41 BB to Bessie Berenson, July 24, 1936. RBP coll.

424:3 BB to EW, July 6, 1936.

15 BB to EW, Aug. 2, 1936.

27 BB to M, Aug. 12, 1936.

32 BB to Henry Coster, Aug. 28, 1936, in McComb, 135.

37 BB to Margaret Barr, Aug. 21, 1936.

425:2 BB to Bessie Berenson, Aug. 22, 1936, RB coll.

13 F to BB, June 22, 1936.

17 On back of F to BB, June 22, 1936.

40 Behrman, *Duveen* (1952), 302.

426:4 BB to Margaret Barr, Nov. 20, 1936.

426:7 BB to Margaret Barr, Nov. 26, 1936.

11 BB to Margaret Barr, Feb. 7, 1937.

25 BB to Margaret Barr, Nov. 26, 1936.

426:33 BB to Margaret Barr, Dec. 7, 1936.

427:6 *NYT*, Dec. 24, 1936.

12 *NYT*, Dec. 4, 1936.

15 BB to Bessie Berenson, Dec. 15, 1936, RB coll.

XLII. *The Allendale* Nativity

428:2 BB to M, n.d., 1929.

4 BB to EW, Jan. 14, 1937.

7 BB to EW, Feb. 11, 1937.

429:20 BB to EW, Feb. 28, 1937.

30 Morra, *Conversations*, 237.

39 BB to Margaret Barr, Feb. 27, 1937.

41 BB to Daniel V. Thompson, Jan. 1, 1937, AAA.

430:5 Margaret Barr to BB, April 1, 1937.

11 M to Mrs. B, April 22, 1937, RB coll.

15 BB to EW, May 7, 1937.

18 BB to EW, April 7, 1937.

22 *NYT*, April 23, 1937.

28 Italian *Times*, Aug. 27, 1937.

33 BB to M, May 9, 1939.

36 BB to Bessie Berenson, May 22, 1937, RBP coll.

37 *NYT*, April 28, 1937; May 1, 1937.

41 Benedict Nicolson to BB, June 3, 1937.

431:15 M to BB, July 4, July 15, 1937.

23 BB to Margaret Barr, June 29, 1937.

27 Morra, *Conversations*, 239–240.

35 BB to M, July 10, 1937.

36 Morra, *Conversations*, 243.

41 BB to Bessie Berenson, Oct. 11, 1937, RBP coll.

432:5 BB to Daniel V. Thompson, Aug. 15, 1937, AAA.

8 Ibid.

10 BB to N, Aug. 12, 1937.

17 F to BB, May 7, 1937.

21 JD to BB, May 11, 1937.

25 BB to F, June 27, 1937.

432:42 BB to F, Aug. 7, 1937.

433:8 F to N, Aug. 13, 1937

22 F to N, Sept. 3, 1937.

28 Ibid.

37 N to F, Sept. 7, 1937, Metropolitan.

434:4 Ibid.

16 F to N, Sept. 13, 1937.

26 N to F, Sept. 15, 1937, Metropolitan.

32 BB to M, Sept. 23, 1937.

435:1 F to JD, Sept. 24, 1937, Metropolitan.

6 F to N, Oct. 18, 1937, Metropolitan.

16 Louis Levy to BB, Dec. 15, 1937.

17 Louis Levy to BB, Jan. 12, 1938.

28 Behrman, *Duveen* (1952), 180–183.

436:4 Walker, *Self-Portrait with Donors*, 94.

20 F to N, Sept. 13, 1937.

28 Walker, *Self-Portrait with Donors*, 142.

32 Ibid.

437:6 BB to M, Sept. 22, 1937.

11 Walker, *Self-Portrait with Donors*, 134.

27 BB to Bessie Berenson, Oct. 11, 1937, BBP coll.

28 Copy, BB to Royal Cortissoz, Nov. 1, 1937.

30 BB to Mrs. B, Oct. 24, 1937; Feb. 2, 1938, RB coll.

31 BB to Margaret Barr, Oct. 20, 1937.

32 BB to M, Nov. 1, 1937.

34 BB to M, Nov. 9, 1937.

437:36 BB to Senda B. Abbott, Oct. 18, 1937, BBP coll.
41 BB to M, Nov. 21, 1937.
438:4 Arthur Berenson to BB, Nov. 13, 1937.
10 BB to Royal Cortissoz, quoted in *New York Herald-Tribune,* Oct. 17, 1937.
26 Copy, BB to Duncan Phillips, Oct. 28, 1937.
36 Royal Cortissoz to BB, Oct. 18, 1937.
38 BB to Royal Cortissoz, Nov. 1, 1937, Yale University Library manuscript collection.

439:1 BB to Royal Cortissoz, Nov. 7, 1937, Yale University Library manuscript collection.
8 F to BB, Dec. 29, 1937.
13 Louis Levy to BB, Dec. 15, 1937.
23 Behrman, *Duveen* (1952), 92.
25 F to BB, June 7, 1930.
32 *Sunset,* 264.
37 Cablegram, Lowengard to F, May 24, 1938.
38 *NYT,* April 21, 1964.

XLIII. *The* Drawings *Revisited*

440:5 BB to Daniel V. Thompson, Jan. 9, 1938, AAA.
10 BB to Mrs. B, Feb. 2, 1938, RB coll.
13 BB to Daniel V. Thompson, March 3, 1938, AAA.
441:35 BB to Margaret Barr, Jan. 9, 1938.
37 BB to William Ivins, Feb. 19, 1938, AAA.
442:1 Ibid.
5 BB to Margaret Barr, Dec. 14, 1937.
10 Ibid.
28 BB to M, July 27, 1937.
35 BB to Margaret Barr, Nov. 28, 1938.
443:1 BB to M, April 24, 1937.
14 BB to Mrs. B, April 3, 1938.
23 Myron Taylor to BB, Nov. 4, 1938.
37 Alda Anrep to BB, May 14, 1938.
444:7 *Forty Years,* 259.
15 Ibid.
25 Ibid., 256.
30 BB to Mrs. B, May 7, 1938, RB coll.
39 N to M, May 16, 1938.
445:3 BB to Louis Gillet, June 1, 1938.
11 Ibid.
20 BB to William Ivins, June 11, 1938, AAA.

445:30 Suzaan Boettger, "An Interview with Walter Horn," *California Monthly,* June–July 1983, 9.
38 Ibid.
446:10 BB to M, July 22, 1938.
16 *Forty Years,* 222–223.
26 Ibid., 225–225.
31 Ibid., 264.
33 BB to Margaret Barr, n.d. [1938].
36 BB to N, Aug. 11, 1938.
447:1 BB to Bessie Berenson and Senda B. Abbott, Aug. 31, 1938; also M to BB, Sept. 6, 1938, RB coll.
8 BB to M, Aug. 28, 1938.
17 M to BB, Sept. 19, 1938.
30 BB to M, Sept. 21, 1938.
37 Felix Frankfurter to BB, July 1, 1938.
448:20 BB, *Drawings,* I, 353.
25 Ibid., Appendix, xxv.
28 Ibid., 161.
38 Ibid., 49.
449:21 Kenneth Clark to BB, Dec. 3, 1938.
450:2 *Art Bulletin,* Sept. 1939, 290–291.
7 *Magazine of Art,* April 1940, 236–238.
11 *New York Herald-Tribune,* March 19, 1939.
16 *Time,* April 10, 1939, 57–59.
29 *Economist,* Nov. 28, 1970, 55.

XLIV. Toward the Abyss

451:4 BB to M, Sept. 22, 1938.

7 BB to Bessie Berenson, Sept. 30, 1938.

8 BB to Paul Sachs, Sept. 1938.

14 Reed to William Phillips, Nov. 29, 1938.

23 Ciano to William Phillips, March 24, 1939, in McComb, 163.

26 John Walker to Paul Sachs, Feb. 2, 1939, in McComb, 158.

28 BB to Paul Sachs, Feb. 9, 1939, in McComb, 159.

452:21 BB to Philip Hofer, April 15, 1939, in McComb, 166.

453:16 M to Senda B. Abbott, Jan. 5, 1939, RB coll.

19 BB to Margaret Barr, Jan. 29, 1939.

20 BB to Senda B. Abbott and Bessie Berenson, Feb. 8, 1939, RB coll.

26 Walker, *Self-Portrait with Donors,* 32.

28 BB to John Walker, June 28, 1939, Walker coll.

33 BB to Margaret Barr, Nov. 28, 1938.

37 Benedict Nicholson to BB, Nov. 5, 1938.

39 Ibid.

454:1 Harold Nicolson to BB, Dec. 21, 1938.

12 Georges Wildenstein to BB, Jan. 16, 1939.

26 BB to sisters, March 29, 1939, RB coll.

31 BB to M, April 6, 1939.

35 BB to sisters, April 11, 1939, RB coll.

37 BB to M, June 11, 1939.

41 BB to William Ivins, June 27, 1939, AAA.

455:23 BB to M, June 18, 1939.

30 Nicholas Toll to BB, July 15, 1939.

35 BB to John Walker, July 14, 1939, Walker coll.

456:1 BB to M, July 30, 1939.

3 BB to John Walker, July 26, 1939, Walker coll.

4 F to BB, Aug. 31, 1939.

8 *Forty Years,* 266.

18 BB to John Walker, July 26, 1939, Walker coll.

28 Copy, BB to Dorothy Thompson, Sept. 2, 1939.

457:1 BB to Learned Hand, Sept. 15, 1939.

3 Ibid.

4 BB to John Walker, Dec. 4, 1939, Walker coll.

11 Copy, N to Micheli (Swiss chargé, Rome), Oct. 8, 1942.

17 BB to Henry Coster, Sept. 14, 1939.

18 BB to M, Sept. 3, 1939.

21 BB to John Walker, Sept. 7, 1939, Walker coll.

30 *Forty Years,* 267.

33 BB to M, Sept. 3, 1939.

38 BB to M, Sept. 30, 1939.

458:8 George Santayana to Mrs. Toy, Oct. 10, 1939, quoted in "Some Letters of Bernard Berenson," *Encounter,* Feb. 1964, 37.

27 BB to Learned Hand, Dec. 10, 1939, in McComb, 169.

31 BB to M, Oct. 3, 1939.

459:1 BB to John Walker, Oct. 5, 1939, Walker coll.

8 BB to Louis Gillet, Nov. 13, 1939.

25 BB to John Walker, Dec. 6, 1939, Walker coll.

38 Ibid.

460:7 Ibid.

8 F to BB, Dec. 6, 1939.

15 F to BB, Oct. 11, 1940.

19 BB to John Walker, Nov. 13, 1939, Walker coll.

21 BB to John Walker, Nov. 24, 1939, Walker coll.

23 BB to Ralph Barton Perry, c. 1939–40.

491:16 ASR to BB, April 3, 1945, Smith
papers.
19 *NYT*, Dec. 31, 1944.
492:4 Frederick Hartt to author, inter-
view, July 22, 1980.
7 BB to Margaret Barr, Aug. 26,
1945, in McComb, 217.
37 Copy, BB to Robert Trevelyan,
March 31, 1945.
40 *Treasury*, 241.
493:4 *Forty Years*, 295.
9 Ibid.
14 *Sunset*, 133.
26 Ibid., 342.
29 BB to John Walker, April 21,
1947, Walker coll.
31 BB to Paul Sachs, Nov. 22, 1946,
in McComb, 241.
38 BB to Margaret Barr, June 16,
1945.
494:8 *NYT*, Oct. 1, 1944.
13 English original in BB, *Essays in
Appreciation* (1948).
29 BB to Margaret Barr, Sept. 1,
1945.
495:12 BB to BG, July 11, 1945, in
Daniel V. Thompson letters,
AAA.
17 Martha Gellhorn to BB, n.d.
19 *Sunset*, 302.
40 Moorehead, *A Late Education*,
150.
496:1 Moorehead, *A Late Education*,
151–152.
35 BB to Margaret Barr, Dec. 5,
1944.
37 Behrman, *Duveen* (1952), 158.
41 Linklater, *The Art of Adventure*,
99–101.

497:4 Ibid.
33 BB to John Walker, Nov. 29,
1944, Walker coll.
498:1 BG to BB, April 28, 1945.
3 Learned Hand to BB, Feb. 18,
1945.
6 Bruno Walter to BB, July 11,
1945.
16 BB to Paul Sachs, May 9, 1946,
in McComb, 227.
18 BB to Paul Sachs, May 11, 1945.
23 BB to BG, July 1945, AAA.
499:10 BB to John Walker, Sept. 21,
1945, Walker coll.
28 BB, unpublished diary, Nov. 11,
1946.
34 BB to Lawrence Berenson, June
3, 1951.
38 Luisa Vertova to author, July 9,
1982.
500:8 BB to Henry Coster, Sept. 27,
1945, in McComb, 219.
15 BB to Margaret Barr, Nov. 9,
1945.
501:16 Lawrence Berenson to BB, March
24, 1947.
18 Lawrence Berenson to BB, July
22, 1947.
24 Daniel Wildenstein to author, in-
terview, Sept. 2, 1983.
27 Daniel Wildenstein to author, Jan.
5, 1982.
502:19 Samuel Kress to BB, Oct. 23,
1945.
21 "Contini Bonacossi," *Dizionari
biografia*.
25 *Treasury*, 272.

XLVIII. At Home in the House of Life

503:6 BB to William Ivins, Nov. 18,
1947, AAA.
7 *Sunset*, 100.
8 BB to William G. Constable,
May 20, 1948.
9 BB to William Ivins, May 26,
1948, AAA.

503:10 BB to Margaret Barr, Sept. 3,
1948.
12 BB to William Ivins, Jan. 1, 1950,
AAA.
14 BB to William Ivins, May 15,
Sept. 3, 1951, AAA.

503:21 BB to Margaret Barr, April 7,
 1946.
 24 *Il Mondo,* Oct. 5, 1946.
 26 BB to William Ivins, Dec. 18,
 1946, AAA.
504:2 BB, unpublished diary, Feb. 20,
 1946.
 3 BB to Peter Viereck, Nov. 7,
 1946, Viereck coll.
 4. BB to Margaret Barr, Oct. 1,
 1946.
 6 BB to Margaret Barr, Dec. 20,
 1946.
505:30 *Magazine of Art,* Feb. 1949, 73.
 33 *Saturday Review,* Jan. 1, 1949, 17.
 37 *The Times Literary Supplement,*
 April 7, 1950.
506:3 *Gazette des Beaux-Arts,* October
 1948, 294.
 6 *Burlington,* May 1949, 144–145.
 16 *New Republic,* Jan. 10, 1949, 16.
 20 *NYT,* Nov. 28, 1948.
 23 *Horizon,* Oct. 1949, 260–270.
 32 *Science and Society,* Summer 1949,
 280.
 39 *Commentary,* Dec. 1949, 614.
507:24 *Sketch,* 177.
 28 Harold Nicolson to BB, July 13,
 1949.
 34 Nicolson, *Diaries,* 171–172.
508:2 *Horizon,* Oct. 1949, 260.
 12 *NYT,* April 24, 1949.
 15 *New York Herald-Tribune,* May 1,
 1949.
 17 BB to William Ivins, May 5,
 1949, AAA.
 18 *New Yorker,* May 7, 1949, 112.
 21 *Punch,* July 13, 1949, 217.
 23 *Spectator,* July 8, 1949, 52.
 24 *The Times Literary Supplement,*
 Oct. 7, 1949.
 42 Walter Lippmann to N, June 11,
 1946.
509:4 N to Paul Sachs, June 1, 1946,
 McComb, 227.
 5 BB to Lawrence Berenson, May
 25, 1946.
 12 Copy, Charles R. Morey to
 American vice-consul, Rome,
 June 11, 1946.

509:20 *Forty Years,* 300.
 26 BB, unpublished diary, June 29,
 1946.
 30 BB, unpublished diary, July 3,
 1946.
510:3 BB to Hugh Trevor-Roper, Feb.
 17, 1948.
 7 BB to Margaret Barr, May 7,
 1946.
 10 BB to Henry Coster, July 29,
 1946.
 14 BB, unpublished diary, Feb. 28,
 1946.
 16 *Sunset,* 37.
 20 BB to Edith de Gasparin, July 17,
 1946.
 25 BB, unpublished diary, Dec. 10,
 1946.
 28 BB, unpublished diary, Dec. 16,
 1946.
 42 BB, unpublished diary, April 24,
 1946.
511:2 BB to Margaret Barr, Aug. 20,
 1946.
 8 BB to John Walker, Aug. 22,
 1946, Walker coll.
 12 Stark, *Dust in the Lion's Paw,* 272.
 25 BB, unpublished diary, Oct. 20,
 1946.
 35 BB, unpublished diary, Nov. 11,
 1946.
 42 Ibid.
512:6 BB to William Ivins, Dec. 18,
 1946, AAA.
 23 *Sunset,* 16.
 27 Ibid., 15.
 33 Stephen Spender to BB, Oct. 21,
 1956.
 35 *Der Monat,* July 1959, 128.
 38 BB, *Essays in Appreciation,* 133.
513:6 *Sunset,* 19.
 8 Ibid., 23.
 13 Ibid., 41.
 17 Day-Lewis, *C. Day-Lewis,* 174.
 22 Day-Lewis, *An Italian Visit,* 62.
 26 *Sunset,* 472.
514:3 Ibid., 40.
 6 *Forty Years,* 314.
 12 *Sunset,* 7.
 22 *New Yorker,* Nov. 13, 1954, 223.

514:24 *The Times Literary Supplement,*
Oct. 15, 1954.
 33 *Sunset,* 48.
 41 Kazin, "From an Italian Journal,"
556.
515:1 Kazin, *New York Jew,* 163.
 2 BB to Peter Viereck, March 17,
1948, Viereck coll.

515:8 Kazin, "From an Italian Journal,"
555.
 17 Ibid., 558.
 19 *Sunset,* 35.
 31 Kazin, *New York Jew,* 166.

XLIX. *Paradoxical Talmudist*

516:5 Hugh Trevor-Roper to BB, June
1, 1951.
 9 BB to William Ivins, May 26,
1948, AAA.
 11 ASR, introduction to Gathorne-
Hardy, *Recollections of Logan Pear-
sall Smith.*
 12 *Sunset,* 62.
 14 Ibid., 81.
 25 Ibid., 61.
517:10 Harnan, *African Rhythm—Ameri-
can Dance,* 117.
 21 Copy, BB to Clotilde Marghieri,
Feb. 27, 1950.
 23 Hemingway, *How It Was,* 229–
331.
518:1 Martha Gellhorn to BB, n.d.
 4 Ernest Hemingway to BB, Aug.
25, 1949.
 11 Ernest Hemingway to BB, Aug.
24, 1957.
 14 Ernest Hemingway to BB, Feb.
2, 1954.
 17 Ernest Hemingway to BB, Jan. 4,
1954.
 20 Ernest Hemingway to BB, Sept.
13, 1952.
 34 *Sunset,* 339.
 40 Ernest Hemingway to BB, March
29, 1954.
519:3 *NYT,* Nov. 7, 1954.
 10 *Sunset,* 116.
 18 Schorer, *Sinclair Lewis,* 775.
 22 *Sunset,* 116.
 28 Schorer, *Sinclair Lewis,* 806.
 31 BB to William Ivins, March 23,
1949, AAA.
 33 *Sunset,* 124.
 34 Ibid., 162.

519:35 Ibid., 279.
 39 Ibid., 124.
 41 Guggenheim, *Confessions,* 122–
123.
520:3 *Sunsets,* 125.
 4 Ibid.
 16 Ibid., 129.
 28 BB to John Walker, May 25,
1948, Walker coll.
 34 *Forty Years,* 307.
 39 *Sunset,* 83.
521:1 Ibid., 84.
 4 Rothenstein, *Brave Day, Hideous
Night,* 203.
 14 BB to Hugh Trevor-Roper, June
14, 1948.
 22 Rothenstein, *Brave Day, Hideous
Night,* 204.
 29 Guggenheim, *Confessions,* 122–
123.
 40 *Sunset,* 86.
522:2 Clary-Aldringen, *A European
Past,* 235.
 12 George Salles to BB, Aug. 10,
1949.
 14 BB to John Walker, May 25,
1948, Walker coll.
 18 BB to Edith de Gasparin, June 19,
1948.
 20 *Manchester Guardian,* June 23,
1948.
 33 *La Nazione,* July 24, 1948, trans.
Elizabeth Campbell Carney.
 41 BB to Margaret Barr, Sept. 3,
1948.
523:27 *New Yorker,* May 27, 1954, 30.
 28 *College Art Journal,* Summer 1954,
328.
 30 *NYT,* Jan. 31, 1954.

523:38 BB to Hugh Trevor-Roper, Sept. 25, 1948.

524:5 *Sunset,* 108.
13 Ibid., 443.
19 Ibid., 295.
25 Ibid., 302.
29 Ibid., 308.
36 BB to Lawrence Berenson, Aug. 14, 1954.

524:40 *Sunset,* 455.
525:7 BB to John Walker, Feb. 26, 1958, Walker coll.
13 BB to Germaine de Rothschild, Feb. 26, 1958, Walker coll.
14 *Treasury,* 381.

L. Master of the Inn

526:23 BB to John Walker, April 13, 1949, Walker coll.

527:11 Behrman, *People in a Diary,* 259.
15 BG to BB, n.d., 1947.
20 Behrman, *People in a Diary,* 259.
26 BB to John Walker, May 17, 1949, Walker coll.
31 Samuel Behrman to Paul Sachs, Oct. 24, 1951, Fogg Museum Archives.
37 Behrman, *People in a Diary,* 261.
40 Samuel Behrman to Paul Sachs, Oct. 24, 1951, Fogg Museum Archives.

528:7 Clark, "Art in My Life," 32.
9 Behrman, *Duveen* (1952), 239.
23 Behrman, *People in a Diary,* 133.
34 "The Days of Duveen," IV, *New Yorker,* Oct. 20, 1951, reprinted in Behrman, *Duveen* (1952), 147–189; (1972), 113–140.

529:24 BB to John Walker, March 16, 1949, Walker coll.
37 BB to John Walker, April 25, 1951, Walker coll.
39 Germain Seligman to BB, April 18, 1949.
41 Referred to in draft, BB to Samuel Kress, June 20, 1949.

530:10 BB to Samuel Kress, June 10, 1948.
20 BB to Samuel Kress, June 20, 1949.
27 *Sunset,* 140.
29 Ibid., 145.
32 Ibid.
35 Ibid., 146.

530:40 BB to Daniel V. Thompson, Sept. 18, 1949, AAA.

531:1 BB to John Walker, Nov. 28, 1949, Walker coll.
5 BB to John Walker, Dec. 18, 1949, Walker coll.
13 BB to John Walker, Sept. 14, 1949, Walker coll.
19 BB to William Ivins, Dec. 15, 1949, AAA.
24 BB to Clotilde Marghieri, Jan. 1, 1950, in *Lo specchio doppio.*
28 *Sunset,* 116.
36 BB to Margaret Barr, Christmas Day 1949; BB to William Ivins, April 5, 1950, AAA.
38 BB to John Walker, Feb. 12, 1950. Walker coll.

532:11 *Forty Years,* 308–309.
15 Reprinted in BB, *Essays in Appreciation,* 29, 32.
29 *Sunset,* 189.
33 Ibid., 464.

533:13 Ibid., 8.
17 Ibid., 180.
18 Ibid., 224.
19 Ibid., 308.
25 Mrs. Kenneth Murdoch to author.
29 Du Cann, *Loves of George Bernard Shaw,* 279.
33 *Sunset,* 183.

534:1 Ibid., 187.
7 BB to William Ivins, June 11, 1950, AAA.
15 *Sunset,* 117.
22 BB to Hugh Trevor-Roper, June 15, 1950.

552:26 *Sunset,* 332.
553:2 *Sketch,* 134–135.
 8 *Sunset,* 364–365.
 12 BB to Lawrence Berenson, Jan. 10, 1955.
 16 *Sunset,* 346.
 18 BB to William Ivins, July 9, 1954, AAA.
 27 Sulzberger, *A Long Row of Candles,* 968.
 42 *Nation,* May 3, 1953.
554:6 *Sunset,* 345.
 8 BB to Ray Bradbury, March 14, 1954, in Bradbury, "The Renaissance Prince," *Horizon,* July 1979, 59.
 14 Bradbury, "The Renaissance Prince," 56–66.
 26 Ibid.
 32 Ibid.
555:4 *Passionate Sightseer,* 52.
 15 *Sunset,* 351.
 22 Ibid., 343.
 26 BB to William Ivins, Nov. 21, 1954, AAA.
 39 Anecdote by John Pope-Hennessy to author.

556:14 Ralph B. Perry to BB, Dec. 9, 1954.
 24 *Sunset,* 363.
 29 Marc Chagall to BB, Dec. 28, 1954.
 35 Reprinted in English in BB, *Essays in Appreciation,* 94.
 37 Ibid., 101.
 39 *Corriere della Sera,* Nov. 26, 1954.
557:7 James Zellerbach to BB, Nov. 30, 1954.
 9 William Milliken to BB, Nov. 22, 1954.
 20 Behrman, *People in a Diary,* 264.
 25 Ibid., 267.
 37 *Sunset,* 388.
558:4 BB, *Passionate Sightseer,* 130.
 12 Ibid., 132.
 26 Reprinted in English in ibid., 148, 193.
 37 *Sunset,* 390–391.
 40 Ibid., 391.
559:7 Ibid.
 14 Luisa Vertova to BB, June 23, 1955.

LIII. Doctor of Letters and Philosophy

560:6 *Atlantic Monthly,* July 1955, 30.
 17 *Burlington,* July 1955, 227.
561:22 *Sketch,* 38, 39, 47.
 23 BB to Lawrence Berenson, Feb. 19, 1955.
 28 BB to William Ivins, April 39, 1955, AAA.
 32 BB to Edith de Gasparin, n.d.
562:1 Birnbaum, *The Last Romantic,* 53.
 5 Beaton, *The Face of the World,* 50.
 18 Nicolson, *Diaries,* 285.
 22 *Sunset,* 397.
 27 BB to William Ivins, Sept. 16, 1955, AAA.
 37 *Sunset,* 402.
 41 Allen Churchill, "The Author," *Saturday Review,* Nov. 5, 1955, 17.
563:2 Nov. 7, 1955, *Newsweek.*
 4 Mary McCarthy to BB, Nov. 10, 1955.

563:18 BB to Walter Lippmann, Nov. 23, 1955, Yale University Library manuscript collection.
 26 *Sunset,* 406.
 32 BB to William Ivins, Oct. 10, 1955, AAA.
 34 *Sunset,* 406.
564:2 Ibid., 415.
 9 BB to John Walker, Dec. 28, 1955, Walker coll.
 18 *Sunset,* 423.
 22 BB to Hamish Hamilton, March 8, 1956.
 24 BB to William Ivins, Jan. 19, 1956, AAA.
 28 BB to Hamish Hamilton, Jan. 12, 1952.
 29 *Sunset,* 407.
 34 BB to author, Feb. (?) 1956.
 40 *Sunset,* 421.

565:8 BB to John Walker, March 23, 1956, Walker coll.

13 Annigoni, *An Artist's Life*, 91.

26 Brooks, *If Strangers Meet*, 228.

566:1 Brooks, *An Autobiography*, 620.

12 Ibid., 622.

17 BB to William Ivins, Feb. 7, 1954, AAA.

29 *Sunset,* 432.

30 BB to Lawrence Berenson, May 31, 1956; BB to William Milliken, June 25, 1956, AAA.

34 Luisa Vertova Nicolson to author, Feb. 27, 1984.

42 BB, *Central Italian Painters*, xiii.

567:13 *NYT*, May 9, 1956.

14 *Sunset*, 433.

22 Luisa Vertova Nicolson to author.

26 *Forty Years*, 313.

27 *Sunset*, 49.

30 Ibid., 434.

41 Ibid., 435.

568:5 Mary McCarthy to BB, Aug. 28, 1957.

11 Mary McCarthy to N, Aug. 21, 1959.

568:16 BB to Hamish Hamilton, May 27, 1957.

28 E. A. Bayne, "The President and the Mediterranean," *American Universities Field Staff Report*, Southeast Europe Series, 12.

31 *Sunset*, 436.

32 Harry S Truman to BB, March 5, 1958.

41 E. A. Bayne, "The President and the Mediterranean," *American Universities Field Staff Report*, Southeast Europe Series, 12.

569:2 BB to Lawrence Berenson, May 31, 1956.

4 *Sunset*, 436.

11 Miller, ed., *Plain Speaking*, 359–360.

19 Harry S Truman to BB, Dec. 19, 1956.

24 Morgan, *Maugham*, 494.

26 Ibid., 575.

28 *Sunset*, 439.

570:3 Ibid., 440.

8 Brown, "A Personal Reminiscence," 15.

18 *Sunset*, 531.

LIV. Toward a "Humanistic Priesthood"

571:1 BB to John Walker, April 12, 1956, Walker coll.

3 BB, *Passionate Sightseer*, 170.

9 Ibid.

572:3 Ibid.

10 Hugh Trevor-Roper to BB, Aug. 18, 1956.

13 *The Times Literary Supplement*, June 29, 1956.

17 *NYT*, July 15, 1956.

19 *Corriere della Sera*, Oct. 22, 1956.

28 *NYT*, Oct. 15, 1956.

30 Ibid., Oct. 25, 1956.

38 James Rorimer to BB, Nov. 26, 1956.

573:2 McGeorge Bundy to BB, Sept. 18, 1956.

24 BB to Lawrence Berenson, Aug. 25, 1956.

31 *The Times*, June 16, 1956.

573:36 BB to John Walker, March 30, 1957. Walker coll.

574:11 BB to Lawrence Berenson, May 25, 1956.

33 Copy, N to John Walker, Nov. 27, 1959.

575:10 Quoted in *Time*, Nov. 5, 1956, 92.

23 BB, *Essays in Appreciation*, 151.

29 *Time*, Nov. 5, 1956, 92–93.

37 *Connoisseur*, Jan. 1957, 226–229.

576:1 BB to Mally Dienemann, Nov. 7, 1952, Dienemann coll.

12 *Sunset*, 455.

27 Luisa Vertova Nicolson to BB, Dec. 6, 1956.

577:2 *Art in America*, June 1928, 147–154.

7 *Sunset*, 521.

11 Ibid.

13 Ibid., 523.

Index

Abbott, Herbert, 124–125, 169, 291, 347, 385

Abbott, Lyman, 124

Abbott, Senda. *See* Berenson, Senda

Adams, Brooks, 174

Adams, Henry, 51, 65, 70, 107, 306, 343; BB's friendship with, 14, 15–17, 88, 89, 94–95, 112, 113, 115, 127, 129, 174, 182, 187; *The Education of Henry Adams,* 51, 75, 95, 466, 467; *Mont Saint Michel and Chartres,* 51, 64, 71, 95, 262; and Mary, 75, 94; *A Letter to American Teachers of History,* 95, 122; BB's correspondence with, 103, 112, 117, 122, 124, 144–145, 564; *Memoirs of Arii Tamaii,* 115; health, 144; politics, 178; death, 245–246, 247

Adler, Cyrus, 336

Aesthetics, 1, 46, 99, 344. *See also* Art appreciation and criticism

Aga Khan III, 231, 233, 244

Agnew, Lockett/Agnew galleries, 36, 76, 93, 127, 254, 266, 364

Albania, 229, 452

Alberti, Count Guglielmo degli, 504

Allendale, Lord. *See* Giorgione, *Adoration of the Shepherds (The Nativity)*

Altman, Benjamin, 108, 152; relations with BB, 76–77, 87, 88, 91, 133, 134; and *Olivares* (Velasquez), 85–86; as Duveen's client, 87, 96, 150–151, 173; death, 158,

336; bequest to Metropolitan Museum of Art, 176

American Academy of Arts and Letters, 438

Anderson, Hendrick, 105

Angelico, Fra, 580; *The Adoration of the Magi,* 369–370

Annigoni, Petro, 565

Anrep, Alda von, 274, 296, 304, 325, 338, 347, 379, 446, 484, 485, 492, 499, 592; in charge of I Tatti, 443, 452, 462, 478

Anrep, Cecil, 274, 325, 485

Anrep, Egbert (Bertie), 183, 274, 296, 325, 347, 452, 484, 485, 492

Anti-Semitism, 16, 161. *See also* Berenson, Bernard, anti-Semitism

Arentino, Spinello, *The Angel of the Annunciation,* 140

Art appreciation and criticism, 179, 332, 333, 365, 371, 402–404, 504–505, 521, 576

Art in America, 151, 173, 293, 325; BB's articles in, 152–153, 188, 192–193, 196, 200–201, 209, 212, 213, 274–275, 324, 340, 364, 375

Art world and market, 36; changes in appreciation, 5–6; rivalries in, 7–8, 39, 129; BB's influence in, 75, 99; affected by customs service, 90–91, 102, 119–120; flow of art from Europe to

[661]